KU-024-116

THE
KING'S
PAINTER

THE KING'S PAINTER

The Life and Times of Hans Holbein

Franny Moyle

HEAD
of ZEUS

An Apollo Book

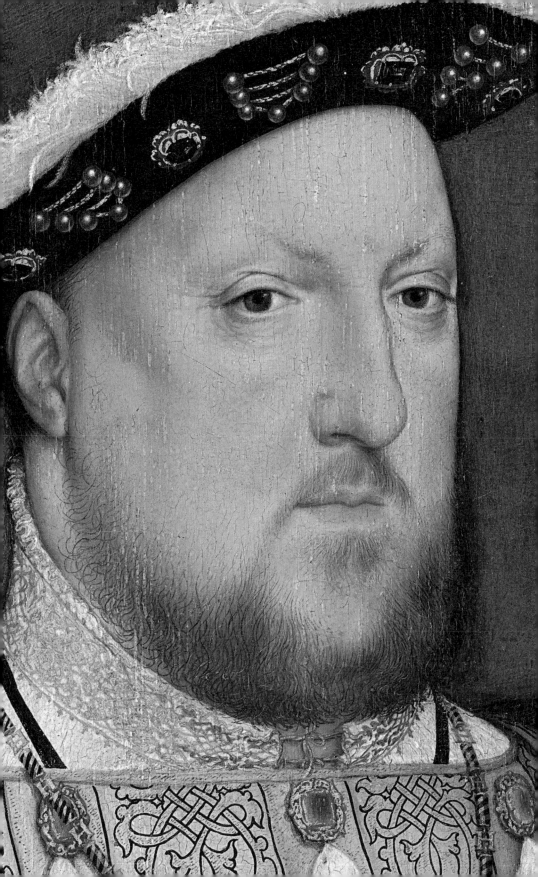

DEDICATION

I lost two dear friends shortly after finishing this book,
in the dark December of 2020.
One, Stephanie Theobald, a fine artist, was in the midst
of reading the manuscript for me when she died.
The other, gallerist, lithographer and collector Pierre Chave,
was a lifelong friend who helped shape my tastes and encouraged my
enthusiasms. Both were an inspiration to me.

It seems only appropriate that this book should
be dedicated to them, though I am profoundly sad
that they will never see this message
of love and gratitude.

ACKNOWLEDGEMENTS

It is daunting when one begins detailed research into a subject area to which others have already dedicated much of their professional life. It is hugely rewarding and reassuring when such experts are generous. Both Dr Susan Foister, Deputy Director and Curator of Early Netherlandish, German, and British Paintings, at the National Gallery in London, and Dr Bodo Brinkmann, Curator of Old Master Paintings, at Kunstmuseum in Basel, were just this. I am truly grateful for their encouragement.

One of the true privileges of working in this field is the experience of viewing original work. I must thank the prints and drawings departments of both the Kunstmuseum in Basel and the Royal Collection at Windsor Castle for allowing me to spend so much time with Holbein's wonderful drawings.

Bodo Brinkmann read and made very detailed notes on an early draft of this book, all of which were pertinent and heeded. Dr Brinkmann not only corroborated my identification of a very young Hans Holbein in a painting by his father, but in doing so made his own discovery of a portrait of Holbein's brother that I had missed. I am so particularly grateful to him for the care he has taken in assessing my work, the honesty with which he presented his comments, and above all his preparedness to pull me up and correct me. Linda Porter also took time to read and comment on the first draft manuscript; her observations have been wholly noted and were gratefully received.

Hannah Scheithauer was kind enough to translate some articles for me and Shomit Dutta helped me get through some passages of sixteenth-century Latin. Rosa Curson Smith undertook research into the More family for me, and Thomas Curson Smith helped fact check some aspects of the text.

ACKNOWLEDGEMENTS

Time and again I have been met with generosity when approaching various archive houses and locations. The Surrey History Centre was extremely helpful to me in trying to make sense of some of the fragments in its archive relating to Holbein. The churches in London with which Holbein was associated, Chelsea Old Church and St Katharine Cree, opened their doors to me, or where not possible because of the pandemic, have responded fully to my enquiries. In Basel, staff at the Church of St Theodore and the former Carthusian monastery of Margarethental – now an orphanage – allowed me to explore places pertinent to Holbein and the Amerbach families. In the latter I was able to see the original intended location of the *Dead Christ*, a spine-tingling experience.

My agents, Georgina Capel and Simon Shaps, always have my back. Richard Milbank and Georgina Blackwell at Head of Zeus have been the epitome of professionalism and tolerance. One day I will learn to spell, stop leaving hanging participles and work out how to use the accent buttons on my Mac.

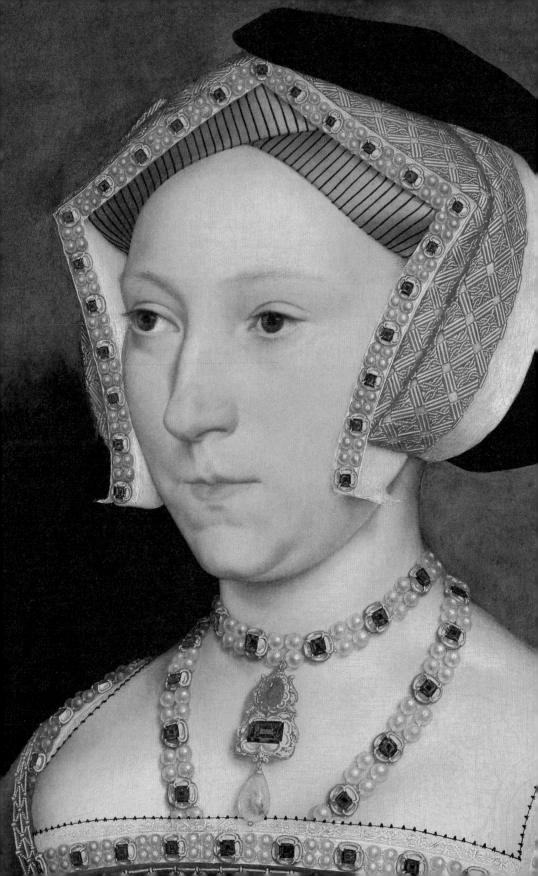

PREFACE

When Samuel Johnson published his *Dictionary of the English Language* in 1755, more than two hundred years after Holbein's death, he understood a biographer to be 'A writer of lives; a relator not of the history of nations, but of the actions of particular persons.' Though I am reluctant to challenge Johnson on many things, in this instance it is necessary to point out how very limiting this definition is. A life and the times in which it is lived are inexorably linked. In Holbein's case, the 'history of nations' could not be more relevant to his life. The political and religious turmoil of his era had such a profound effect on the course of Holbein's career that it would be impossible to offer an account of one without the other. After all, this is a man who lived through arguably the greatest upheaval in European history – the moment when Catholicism, a religion that had defined Europe and dictated the daily lives and material environment of generations – suddenly found itself at war with radical new thinking in the form of what would become called Protestantism.

If that *sounds* rather dry, the consequences on the ground were dramatic. The Reformation that spread across Northern Europe would chase a young Holbein from his hometown of Basel in Switzerland, the sound of the iconoclast mob ringing in his ears, to seek fame and fortune in a London he hoped, like Dick Whittington, would be paved with gold. In a case that could be seen as leaping from the frying pan straight into the fire, he found himself then at the heart of the Tudor court just at the moment that Henry VIII hurled his own country into a period of religious and political uncertainty, and adopted the mantle of the cruel tyrant that would ultimately define his reign, and threaten Holbein's own personal safety.

What is truly astonishing about viewing history through Holbein's story is his proximity to events. This is not a man watching from the sidelines, but a painter who, through a mixture of luck and determination, observed the most extraordinary events of his century up close. Here was someone whose profession, reputation and ambition secured him access to the most powerful men and women of his times. A name that continues to resonate today is Erasmus, a man whose pen was on fire, whose intellect was sought by kings and popes and whom Holbein embodied in a series of images that have described the scholar ever since. But the legacy of Holbein's portraits of the Dutch writer pale when compared to his record of the sixteenth-century English

court. Take the most recognized names of the Henrician moment and Holbein likely had a direct and proximate relationship with them: Henry VIII, Thomas More, Thomas Cromwell, Jane Seymour, and Anne of Cleves are but a few. His portraits of these people have become definitive. It is almost impossible to imagine Henry VIII and his entourage through anyone else's eyes but Holbein's.

Holbein's repertoire is wide. Beyond the monarch and his immediate circle he captured some of the greatest poets in England such as Thomas Wyatt; persecuted martyrs such as Bishop Fisher; the women making new strides for their sex such as Margaret Roper, and the foreign ambassadors who strode the corridors of Henry's palaces. Through his work we see a host of courtiers and their families as they rise and fall in favour, and we glimpse the power of merchants, the discoveries of astronomers, and the rise of lawyers. Holbein gives us a snapshot not just of Tudor royalty but of the socio-economic web woven around it. He immerses us in a lost world. In short, his work describes the Tudor period like no other, and we continue to see it as he did.

The question I am most often asked when I mention I am working on a biography is whether there are armfuls of letters, or a diary to draw on. While researching Holbein's life my inevitable reply was very much in the negative. Anyone taking on Holbein as a subject has to deal with the fact that primary written material relating to the artist is sparse, to say the least. Contemporary records are restricted to administrative documents held in the archives in Augsburg where he was born, in Basel where he lived as a young man, and in England where he worked for the last decade of his life. He is mentioned in other people's letters, and in poetry. His earliest biographer, Carel van Mander, scooped up as much anecdote as he could. But if Holbein ever put pen to paper other than to draw – and surely he did – his correspondence has long been lost.

The story of his life then is inevitably informed by a degree of detective work. At the heart of this are his paintings, drawings, engravings and designs. Where written records are lacking, this visual material that Holbein has left adds up to a chronicle as vivid as any journal. Through his work for the citizens of Basel, his references to the wonders seen in the palaces of the Loire belonging to Francis I and of course his output in London, one plots his trajectory across

sixteenth-century Europe. The allusions in his paintings and printed work to the debates of his time speak not only of the vivacious intellectual climate in which he lived, but of his own part in the cultural conversation of his time. His fascination with the science of his era is expressed through his own experiments in perspective and illusion.

The humanity expressed in the faces of those he observes tells us of a man capable of deep feeling. His enchantment with his young wife is clear in his drawing of her; two delightful miniatures of young boys made at the end of his life reveal the sentiments of a man who had fathered at least six children; the haughty demeanour of certain courtiers reminds us that Holbein, even at his most diplomatic, sometimes left his own comment for posterity.

Despite living during a time of plague, poverty and war, Holbein also lived in a moment when satirical humour was alive and kicking. Comedy, wit, irony and parody are tools at his disposal. His *Dance of Death* is not only a reminder of human frailty and mortality, but also a comedic and empathetic commentary on the social injustices of his time.

Of course the meticulous research of scholars over the last 150 years has contributed hugely to piecing together details of Holbein's career and domestic life, and as the footnotes, bibliography and acknowledgements in this book indicate I have relied greatly and with much gratitude on such work. But the fact remains that considered speculation not only forms part of Holbein scholarship more broadly, but also of this particular biography.

That Holbein and enigma go hand in hand is in fact quite appropriate. Mystery is a key part of Holbein's appeal. The elusive meaning of *The Ambassadors*, his world-famous depiction of two French diplomats, is a huge part of the painting's enduring popularity. Working in the era of discovery and wonder, the ability of the artist to layer his work with meaning that could be unpacked like a puzzle was all part of his brilliance. Holbein was known as the most 'cunning' painter of his day. On the one hand this is a term that alluded to his ability as an illusionist, whose grasp of mathematical perspective was so formidable, and whose observation and draftsmanship so exceptional, he could create persuasive, lifelike work. But the term also refers to the intellectual conceits he conjured to delight his viewers – *The Ambassadors* being very much a case in point.

I have attempted to resurrect Holbein's world. The winding streets of Augsburg's craft district are not so different from when Holbein ran down them as a child. Basel's colourful medieval houses perched along a fast-flowing Rhine are also remarkably preserved, and the routes Holbein would have walked from his home to those of various clients are easily retraced.

I have also tried to interpret the sixteenth-century world in a manner that is accessible for modern-day readers, even though some terms are technically anachronistic. Holbein lived during the Reformation, an era defined by religious evolution. The reformist religious movement now known as Protestantism had its roots in the writings of Martin Luther in Germany and others, such as Ulrich Zwingli in Switzerland, who effectively offered new versions of Christianity and envisaged a different kind of church existing outside Papal authority. Although the term 'Protestantism' was only coined in a limited sense in 1529 I have nevertheless used it to describe those of Holbein's contemporaries who were prepared to turn away from the traditional Catholic Church to embrace these new reformist ideas. Some, notably Erasmus, felt it was possible to reform the Catholic Church from within, without turning to a new path, and so though like Luther and Zwingli he is clearly part of a wider reformist movement, he could never be described as a Protestant.

Holbein's father was one of the most celebrated devotional painters in Northern Europe, enabling the long-held tradition that art was an interface between the now and the hereafter. This communion that art represented between different dimensions is a theme Holbein continued to explore throughout his career.

The interactive function of art, implicit in the worship of devotional imagery, is also something fundamental in Holbein's work. He is an artist who demands participation and interpretation from his viewer. Part of his negotiation of the difficult times in which he lived rested on his ability to build ambiguity into his work. Much of the meaning of his work is in the eye of the beholder.

The same can be said when it comes to interpreting Holbein's life. Across the following pages I note the facts, provide the evidence, reveal the work and now and again propose or speculate. In doing so I have made my version of Holbein, but I invite you, as you read this, to make your own.

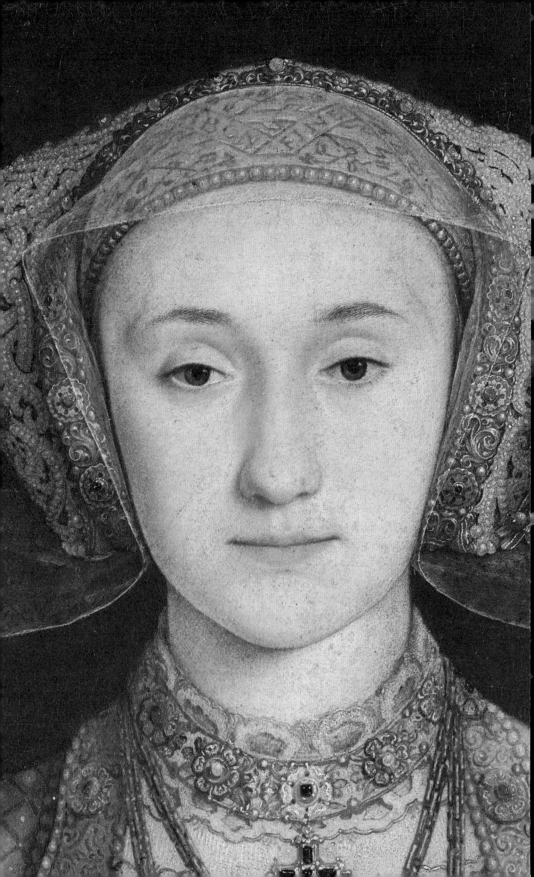

ANNE

For often man is more steryd by syght
than be heryng or redyngge[1]

September 1539. King Henry VIII and his court had been on progress through the Home Counties since August. The caravan of courtiers, servants, baggage, furniture, guards and provisions that rumbled slowly through English lanes had passed through Surrey, Hampshire, Wiltshire and Oxfordshire in six exhausting weeks. Finally it had reached one of the king's favourite manor houses at Grafton in Northamptonshire.

Charles de Marillac, the King of France's latest ambassador in England, had joined the progress at its inception. In between the stopping and starting, the unpacking and repacking, and the intermittent novelty of each new billet, he had found himself the subject of a sustained campaign by the king to improve Anglo-French relations. Of late these had been diplomatically bumpy, but then his master Francis I and Henry had danced around one another for many years now. Sometimes friends, now and then 'brothers', other times not, at this point in time France was regarded as a potential aggressor.

Hans Holbein, *Anne of Cleves*, oil and tempera on parchment, mounted on canvas, 1539.

At Grafton Marillac heard something that alarmed him sufficiently to send a letter to France. News was that the King's Painter, Hans Holbein, had arrived on business so urgent he was admitted directly. This 'excellent painter' had come from Germany with 'the portrait of the sister of the Duke of Cleves', Marillac revealed. He added that 'immediately afterwards' a courier followed with news 'that the said Duke's ambassadors have started to come to treat and conclude the marriage of this King and the said lady'.[2]

Henry spent many summers at leafy Grafton, plague permitting, and could stay from late August all the way through till October. The old stone house was the former home of his grandmother Elizabeth Woodville, and Henry had furnished it with a bowling alley, and extended its parklands for hunting. He had also equipped it with new chimneys and improved its facilities. As he arrived that summer, slate, lead and timber from the newly dissolved religious houses nearby were being stockpiled ready for the next set of improvements. But despite these new facilities that the king had added at Grafton, the manor was still modest compared to many of his other sumptuous properties. It had an intimacy and quietness he liked.

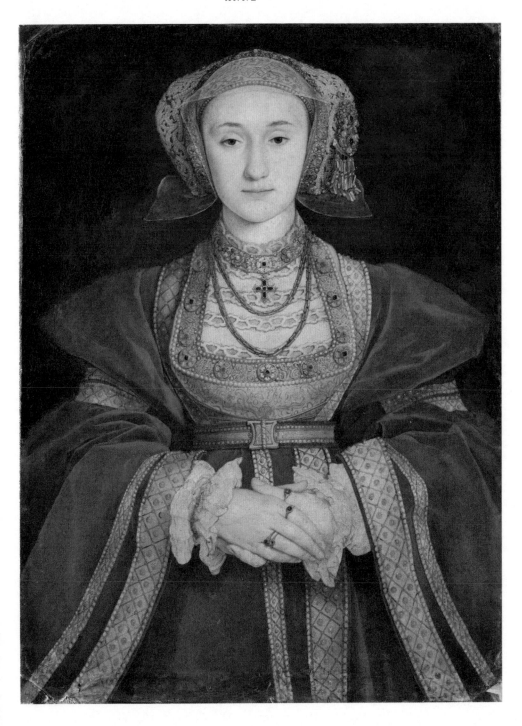

Grafton and its associations with Elizabeth Woodville spoke to a side of this forty-eight-year-old king for whom some simple pleasures remained important amid a life otherwise defined by pomp and turmoil. After all, it was at Grafton that Henry's grandfather, King Edward IV, had fallen in love with an English girl of only very mediocre status and married her in secret. Henry must have been keenly aware of this precedent when he too, in his last two marriages, had chosen to place his attraction to English women above political unions with foreign princesses. But now, as the French ambassador all too clearly witnessed, Henry really did seem prepared to change and make a political match with his fourth wife.

Henry was a man growing more obese. The strikingly handsome youth had become lost beneath a middle-aged man whose face was shrinking within thickening cheeks and a widening neck. One leg bound and ulcerated, he had become an irascible, mercurial and, frankly, cruel monarch who governed a country on the westernmost flank of a politically volatile Europe.

Henry presided over just 2.5 million subjects across England and Wales compared to the 16-million-odd ruled over by Henry's long-time rival, the Valois monarch Francis I of France. Meanwhile the Hapsburg Charles V, Holy Roman Emperor and King of Spain, had an even more populous kingdom that, in addition to his Spanish territories, stretched across today's Germany into northern Italy and encompassed the Netherlands, Burgundy, Bohemia, Austria, Naples, Switzerland, Sardinia and Sicily.

On the continent the traditional rivalries between France and the domains of Charles V were further complicated by new religious divisions between those states remaining loyal to the Catholic Church and those declaring their independence, influenced by reformist religious thinkers such as Martin Luther in Germany and Ulrich Zwingli in Switzerland. Broadly speaking, the north had declared for the new religion that would in time become known as Protestantism, the south for the old. Henry had thrown his own cat among the pigeons when he had torn England away from Papal authority and declared an independent Church of England, of which he was the spiritual guide and supreme head.

It had not been ideology that governed Henry VIII's actions. It was marriage that had driven a wedge between England and Rome. In

order to declare his union with first wife Katherine of Aragon null and void, so that he could marry his sweetheart Anne Boleyn, Henry VIII had defied the Catholic Church and removed England from the Pope's jurisdiction, dismantling a version of English life that had persisted for hundreds of years. Despite this seismic upheaval that gave the king leeway to wed his true love, Henry's marriage to Anne Boleyn had been short. After Anne Boleyn he had married a third time, to another Englishwoman, Jane Seymour. However, the death of the latter in 1537, after delivering Henry a son, had left him once more in need of a wife.

The religious changes that Henry had initiated were still ongoing. Now excommunicate, Henry had thrust England into fearful religious confusion as he continued to tinker with just what a new English church led by an English monarch might stand for. The lines between disagreement, debate, treason and heresy were finely drawn. Henry had already claimed the scalps of senior statesmen and churchmen who failed to endorse his marriage to Anne Boleyn in the terms he wished. He had also dealt brutally with those who objected to his dissolution of the infrastructure of traditional Catholicism in England.

Henry's systematic closure of England's old Catholic monasteries and religious houses had been carried out with the guidance of his most senior and powerful councillor Thomas Cromwell, a man with strong Protestant sympathies who simultaneously held the titles of Lord Privy Seal, Principal Secretary and Chancellor of the Exchequer.

Yet Henry's dissolution of monasteries was far from an indication of his embracing the new Protestant creed. As far as the king was concerned the Catholic treasure stripped from England's altars was a useful supplement to the royal coffers. Meanwhile, those daring to declare themselves a part of the new reformist, Protestant movement were as likely to be tried as heretics, burned and beheaded as those complaining about the dismantling of the old church.

Henry measured the value of religious reform in terms of the extent to which it served his own personal agenda. In doing so he had become the embodiment of contradiction. Though defiant in his right to independence from Papal authority, he remained at heart more of a traditional Catholic than not. The way forward in Henrician England was far from clear, even to Henry's closest observers.

Amid this already complex landscape, Henry faced new concerns. While his relations with Charles V and Francis I had see-sawed across

the years, he had always relied on the fact that France and the Empire were traditional enemies *of one another*. But now this was apparently no longer the case. The two superpowers had forged an alliance and consequently Henry had reinforced his coastal fortifications. He felt sure that England was about to be invaded.

One strategy to deter invasion was for England to ally with the group of German Protestant principalities known as the Schmalkaldic League. And it was this political manoeuvre, advocated by Cromwell, that had encouraged Henry to most recently consider taking a German princess as his next wife. But Henry had to make sure that the woman who could fulfil this political role, whose connections would deter Henry's adversaries from launching an attack on his realm, would still satisfy him as a companion. No matter the urgency of the moment from strategic considerations, from the perspective of a king whose enjoyment of women was profound and particular, he needed to get a sense of this Anne of Cleves before the match could be confirmed.

Fortunately Henry VIII had at his disposal one of the very few men in the world equipped to deliver the very essence of a potential bride to his door. And that man, Hans Holbein, had now made her likeness. As he rode back from the Rhineland at breakneck speed, rolled up in his luggage was a parchment on which depended the fate of England, and the happiness of a king. Holbein's portrait of *Anne of Cleves* was ready to be viewed. Not just Henry's court, but the whole of Europe was holding its breath in anticipation of the king's reaction.

Holbein occupied a unique position in English society in 1539. He was a painter whose stellar talent had secured him significant rank and regard in the eyes of the king. Holbein was one of the very small number of people who could secure time with this supreme monarch. Talk with him if invited. Regard him. This was a privilege bestowed on a very few indeed.

In addition to his particular success in the English court, Holbein's wider reputation was at its height. He was now the most famous painter in Northern Europe. He had at last been acknowledged as the successor to that other huge Northern European talent, the painter and printmaker Albrecht Dürer. In short, Holbein had achieved a level of fame, wealth and status for which he had been striving for thirty years.

Circumstances had been on his side. Holbein the Younger – so

known not because of any youthful attributes but because his father had been a painter with the same name – had first visited Tudor England in the 1520s, and returned there in the early 1530s. His arrival, from his hometown of Basel in Switzerland, came at a time when art was leveraged by Europe's Renaissance rulers as an indication of their cultural sophistication, a soft power currency that bought admiration from both their subjects and their counterparts on the world stage. Leonardo da Vinci's tenure at Francis's court earlier in the century had served to enhance the prestige of the French monarch, who still had that painter's *Mona Lisa* hanging in his chateau at Fontainebleau; since 1530 the Venetian painter Titian had been enjoying the patronage of Charles V; meanwhile Michelangelo was struggling with his huge fresco of *The Last Judgment* in the Sistine Chapel for Pope Paul III. If Henry VIII was to be seen as the equal of his more powerful peers in matters of taste and learning, he needed an artistic genius too.

In England Holbein had become a celebrity *avant la lettre*. The leading court poets circulated verses praising his work. Consequently much prestige was attached to securing a sitting with him. With such stardom came privileges that transcended established social hierarchies. Holbein's seventeenth-century biographer Carel van Mander took apparent delight in relating how an earl pestered to see Holbein's work in his studio with such assumption that he was thrown down the stairs by the painter. The violence of the act aside, such a flagrant breach of the strict social code that governed not merely the Tudor court but the wider sixteenth-century world would have done for anyone other than Holbein. But when the earl came to complain to Henry about his painter, it was the earl and not the painter who was admonished by the king.[3] Holbein's acknowledged genius had provided him with a degree of immunity to normal protocol.

Like Michelangelo and Leonardo, Holbein was a self-conscious embodiment of a new, invigorating vision of what an artist might be. Unlike the anonymous masters who had preceded him in England, this new kind of painter wanted to be seen as on a par with the artists of antiquity whose *name* defined their work, and even survived it: Apelles, Protogenes, Zeuxis, Parrhasius and Praxiteles.* And the humanist-influenced Renaissance courts in which this new breed of

* The names of medieval painters were not recorded and their work is now defined only by its ultimate location. Take for example the *Wilton Diptych*, or the *Westminster Retable*.

artist was operating encouraged this comparison, enjoying the allusion to a classical past.

It was the *verisimilitude* in Holbein's work that took away the breath of his contemporaries and largely accounted for his spectacular success. Few artists in the entire history of art can claim to match Holbein's eerie ability to create the illusion of real life in his work. It was the consistent *believability* of his paintings that endowed them with a near-magical quality for the sixteenth-century onlooker. Holbein's work was considered nothing short of a phenomenon, and perhaps it is only in the accounts of early cinema, and the marvel expressed by those seeing the work of the Lumière brothers in Paris in the 1890s, that we can get some kind of grip on just how much of a sensation Holbein's work created among its original viewers.* As Holbein's friend and admirer the poet Nicholas Bourbon pointed out:

> Oh stranger, do you like to see pictures which appear to be alive?
> Notice these, made by the hands of Holbein[4]

The impact of verisimilitude in the sixteenth century is perhaps better understood given the story of painting to this point. High-quality painting remained a luxury commodity and as such the very *experience* of seeing it was an event, carrying with it a sharpened level of anticipation and response that it is difficult for us to replicate today, in a world where it is relatively easy to see world-class pictures in the flesh and in good reproductions.

The form of art was also in transition. Consider the lack of emphasis on spatial realism in painting during a thousand-year-long medieval period, where iconography and symbolism were paramount in devotional art. The medieval eye had become accustomed to imagery in two dimensions, and the medieval reaction to it was interpretive. Only since the early fifteenth century, when Filippo Brunelleschi first illustrated the science of linear perspective in Florence, had spatial realism been introduced into art in a rigorous manner. But this new science of drawing was slow to reach English shores.

With the growth of humanism, a revived interest in the classical past, where scholars revisiting antique texts re-read accounts of painters

* The account, though apocryphal, is that in 1896 the first audience who witnessed *L'Arrivée d'un train en gare de La Ciotat* ran away from the screen for fear the train might burst into the auditorium.

able to fashion an illusion of the natural world indistinguishable from the real thing, the currency of verisimilitude was extremely high in sixteenth-century Europe. Renewed interest in the story of Zeuxis of Heraclea and his competition with Parrhasius of Ephesus in the fifth century BC set a new bar for Holbein and his contemporaries 2,000 years later. The story, related by Pliny the Elder, is that for the competition Zeuxis painted a bunch of grapes of such vivid credibility that a bird flew down to eat one. But when Parrhasius asked Zeuxis to draw aside a curtain to reveal his work, Zeuxis fell for his rival's brilliant trompe l'oeil, since the curtain was merely a painted illusion. This tale, along with Pliny's accounts of Apelles of Cos, the portrait painter in the court of Alexander the Great who could depict his subject with unparalleled accuracy, whetted the appetite of Europe's patrons, who aspired to own work that could deceive the eye and capture likeness with equal panache.

Some painters on the continent had already won the accolade of a comparison with the masters of the past. Charles V had heralded Titian as the Apelles of the century, but not before the same tribute had been applied to Leonardo. Not to be outdone by their Italian or Venetian counterparts, Dürer had also been hailed as the Apelles of the North by his countrymen. But the Renaissance came late to England. The mastery of perspective and verisimilitude, and the personality and intellect to deliver it in works of bravura and narrative depth, were largely lacking in the painters Henry and his courtiers had at their disposal. Until Holbein arrived.

Though it seems an obvious move, then, to send Holbein to capture the likeness of any potential new bride for Henry, the mission to make a portrait of Anne of Cleves had been given to the painter relatively late in the day. The fuller story of Henry's interest in the German princess had begun a whole year earlier, in 1538. Henry had been gently flirting with the idea of an alliance with the German states since the mid 1530s and had even been engaged in a dialogue about religious reformist thinking with the most powerful figures in the region, such as John Frederick I, Elector of Saxony, an ardent Protestant. In May 1538, a delegation of German ambassadors had finally travelled to England to explore the possibility of a political alliance. The German states, who had fully embraced Protestantism, still stood some way apart from an England under a monarch who, though tolerant of a degree

of religious reform, could only be moved so far from his traditional Catholic inclination, and the ambassadors had eventually left England disappointed. However, it had been during their stay that the Duke of Cleves was mentioned as having marriageable daughters. A seed had been planted.

The Dukedom of Cleves presented a tantalizing political compromise. It was situated in the Northern Rhineland, in what is now western Germany, and was overseen by Cleves' Duke John III. While independent from the Pope, nevertheless the Cleves family remained traditional Catholics and as such their views on religion were compatible with Henry's. However, usefully, the House of Cleves was allied with the Schmalkaldic League of German Princes, and one of Duke John's daughters was even married to John Frederick I of Saxony. In addition, a dispute over lands – the territory of Guelders – had put the Duke of Cleves at odds with Charles V. Given all these factors, by 1539 an allegiance with Cleves represented a political masterstroke. This was certainly the view of Cromwell.

In January 1539 letters from both Cromwell and the King were sent with three English diplomats to Cleves to test the water. Henry asked Sir Christopher Mont to confirm the religious orientation of the duke and his son. Cromwell's letters meanwhile suggested Mont should find out more about Anne of Cleves, and 'secretly inquire of the beautie and qualities of the lady else of booth doughters [...] as well what shape, stature, proportion and complexion she is of as of her lerning actyvitie, bihaviour and honest qualities'.[5]

John Frederick of Saxony was intrigued enough by the English delegation's enquiries to offer to send Henry a picture of his sister-in-law Anne of Cleves by his court painter, the renowned Lucas Cranach. Unfortunately, Cranach was sick, and so this would mean some delay in the delivery of a painting. However, Mont did relay the intelligence that Anne was beautiful.

Such information was at odds with much earlier descriptions of Anne that had been furnished by the King's ambassador in Brussels, Sir John Hutton. When asked very shortly after the death of the King's third wife, Jane Seymour, to suggest potential foreign brides, Hutton had noted rather cautiously that the 'Duke of Cleves hath a daughter but I hear no great praise of neither her personage nor her beauty'.[6] Nevertheless, Henry was not interested in listening to

negative accounts, nor was he keen to delay. Despite the fact that in February 1539 the old Duke of Cleves succumbed to mortality, Henry sent forth yet more ambassadors to Cleves with instructions to discover what they could about Anne's appearance and character, and even to request an audience with her that might afford a proper view of this young woman.

The envoys sent to the looming castle of Schwanenburg, seat of the Dukes of Cleves, were Nicholas Wotton and Richard Beard. They found John III's successor, his son William, much harder to pin down. Their attempts to get a portrait made of Anne were met with delaying tactics. In the absence of a forthcoming painting, the ambassadors tried to see the young woman themselves, but their efforts to get a sense of her were frustrated by a combination of the distance at which they were kept from Anne and her sister, and the clothing that the young noblewomen wore. The women of the English court often wore dresses with square, low-cut necklines that revealed their décolletage. English gabled hoods were designed to show their wearers' faces in full, and so-called French hoods, also worn in England, revealed not just the face but a good portion of the hair, too. By contrast, German women wore ornate, high-necked dresses, often with large, high collars. Their head-dresses could be concealing rather than revealing, their faces veiled.

Of course something of the delay was down to the new duke weighing up his options. Keen to resolve the lands he had in dispute with the emperor, he had begun to consider that rather than a marriage between his sister and the English king, a marriage between himself and the Hapsburg Christina of Denmark, the emperor's niece, might be more beneficial to Cleves.

Cleves' Deputy Chancellor Dr Henry Olisleger bought time for the duke with procrastination. He pointedly suggested to Henry's ambassadors that Anne's younger sister should be considered, despite the fact that her inferiority was less appealing to Henry. Meanwhile he also revealed Anne's childhood betrothal to Francis of Lorraine, son of Antoine, Duke of Lorraine. Though there were assurances this betrothal was no longer valid, nevertheless this was a complication that would take time to deal with, since the relevant documentation would have to be provided.

In spite of the apparent cooling of Cleves to the English proposition, and despite Lucas Cranach still being unavailable to paint, the English

ambassadors finally managed to extricate portraits of the princesses of Cleves. Cleves' court artist, Barthel Bruyn, was deployed to paint Anne and her sister Amelia. Bruyn's portraits were to be sent to Cologne from whence they were to be collected by the English ambassadors and transported to London.[7]

However, by June 1539 there was still no sign of Bruyn's paintings. Frustrated, Cromwell dispatched a new emissary, a Dr Peter, to try and hurry matters along. Peter was to liaise with Wotton, and together they were to appeal to the matriarch of the Cleves family, Anne's mother, the newly widowed duchess. They were to press upon her the advantages of a marriage into the English monarchy and the king's preference for Anne over Amelia. Once again the importance of the appearance of Henry's potential betrothed was emphasized by Cromwell, who reminded Peter that he and Wotton should 'then desire to see both ladies, since one of them is to be their Queen, and with all diligence thereupon signify their judgments'. If the portraits had still not been dispatched they were to view them if possible and send them, 'with their opinion of them as likenesses'.[8]

The matter of Anne's previous betrothal to Antoine of Lorraine's son was also to be scrutinized by the two emissaries, who were to ask to see documents relevant to the contract and its cancellation 'to clear up doubt and to accelerate the matter'. In fact the urgency of the king's interest in Cleves was so pressed that the ambassadors were to

> therefore require them, especially the mother, to open the bottom of their stomachs touching the matter, and, if they are inclined to the alliance, show the said writings. They shall tell the Duchess that the King has heard of her virtue and wisdom, and other things to her praise, as shall seem to the purpose.[9]

Where Wotton and Beard had failed, Dr Peter made headway. Within a month the probability of a marriage was rising. Edward Seymour, the late queen's brother, congratulated Cromwell on positive news emerging from Cleves. 'The King could not marry anywhere with less prejudice to his succession,' he wrote.[10]

However, when Barthel Bruyn's portraits of the Cleves girls finally arrived in London in the summer of 1539 with the return of Richard Beard, Henry was wholly disappointed. The King's eye had been spoiled, used by now to Holbein's persuasive verisimilitude. Bruyn's

work must have looked wooden by comparison. Today Bruyn's painting of Anne of Cleves is at St John's College in Oxford, and the difference between what Holbein could muster of a sitter and what Bruyn could deliver is clear. Shown in three-quarter profile Bruyn's Anne is revealed with her characteristic heavy eyelids, a long nose and a sharpish, defined chin. But it is clear that this is an approximation, as is her stiff body and the awkward gesture of a carnation (the symbol of love) in her right hand.

It is little wonder then that as the genuine possibility of a marriage strengthened, Henry felt compelled to turn to the magician in his midst, Hans Holbein, his own salaried painter, to give him a real sense of who he was dealing with. In August the painter was dispatched to Düren, a town sixty kilometres from Cologne. Here, in Burgau Castle, the Duke of Cleves' daughters were residing with their mother.

Holbein was not to just make drawings of these German women. Henry, fed up with waiting, did not want impressions. He wanted substantial portraits, highly finished, and he wanted them as quickly as possible. Holbein was duly paid £13 6s. 8d 'for the preparation of such things as he is appointed to carry with him'. In other words, enough to secure the porterage of studio equipment to complete a finished portrait on the spot.[11]

Castle Burgau is perhaps better imagined as a fortified manor house. Entirely surrounded by water and thus seeming as if it is afloat, it is reached across a long cobbled bridge that straddles its full moat. A large red tower rises to dominate a solid, undemonstrative building, wrapped around a courtyard and surmounted by a steep grey slate roof. Where others had failed, Holbein succeeded. Though ambassadors had been denied full sight of Anne, when the celebrated painter arrived at this austere residence with a mass of equipment, there was little to be done but acquiesce. Add to this Holbein's skill as a negotiator, whose diplomatic charm, honed through years of dealing with difficult clients, put people at their ease.

In contrast to Burgau's plain and austere façade, when Anne was finally presented to the King's Painter, she was decked out in the most ostentatious finery, indicative of the view that the House of Cleves considered itself a match for any monarch.

In fact she was wearing full wedding regalia, which she had also worn when sitting for Barthel Bruyn, though for Holbein her family

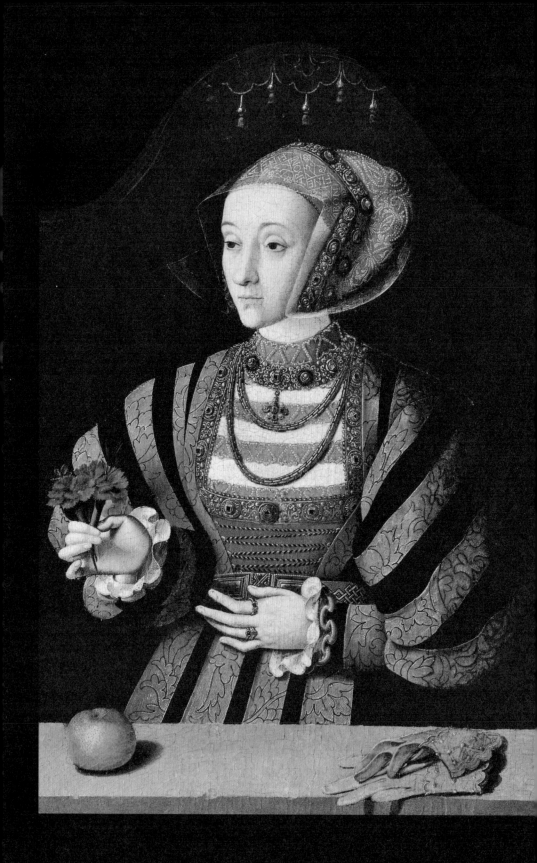

had added yet more adornment in the form of a weighty, expensive brooch to her costume. The message to Henry was clear: Anne was a prize.

Holbein took the point. But where Bruyn's depiction of the shimmering jewels that clad his sitter lacked the effect of real sheen and glitter, Holbein delivered fabric and gemstones so persuasive that they aroused the synaesthetic sense of the heavily wrought material in which this young woman was clad. He meticulously depicted Anne's headdress, a complex combination of a pearl-edged, russet-coloured silk cap embroidered in gold with the motto *A Bon Fine*,* and a bonnet or hood lavishly embellished with thousands of tiny swirling seed pearls, and a brocade embroidered with gemstones. The added brooch was noted: two golden jewelled busts, tiny miniature heads finely wrought, finished with gold tassels.

Anne's shirt and bodice are also a testament to wealth. Over a fine silk shirt decorated with more bands of intricately patterned seed pearls is a gold bodice worked with another band of pearls and jewelled flowers. The effect is to create a lower framing for her face as wrought and intricate as her headwear above it. Around her neck, a further strip of jewel-encrusted brocade supports a crucifix, and two heavy gold chains are added. Beyond this the girdle, sleeves and skirt convey heavy, expensive velvets and gold embroidery, all of which adds to a sense of weight and wealth.

Barthel Bruyn, *Anne of Cleves*, oil on panel, 1539.

Unusually Holbein chose to depict Anne squarely, face on. This full-frontal view was rarely used in secular work. This decision by the painter had the effect of making his portrait of Anne of Cleves quite distinct from the very great number of female portraits he had painted to date – an attribute that would have given the picture considerable impact and novelty value at the time.

What lay behind Holbein's compositional choice? Was it that he wanted to complement the three-quarter view that Bruyn had already delivered, giving the king a new perspective? Or was there a playful aspect to Holbein's choice of composition? Such had been the complaints of Henry's emissaries about their inability to properly see Anne beneath her bulky hats and veils, and such their difficulty in therefore confirming whether Bruyn's work was a reasonable likeness,

* 'To a Good End'

was Holbein now making a point? He had seen her. Up close. And here was her face in full!

Or was the full-face depiction designed to indicate something else? Holbein painted Anne's face with an almost total lack of expression on it. Her noticeably heavy-lidded eyes look directly out from resting brows, her lips are closed and still. It is unclear if the slight upward direction of each corner of her mouth hints at a smile, or simply suggests placidity. Positively, this might be construed as an embodiment of serenity, a woman prepared, calmly facing her future. A negative interpretation might be that she is vacuous, the compositional choice of the painter also indicating his impression that Anne lacked dimension or depth. Is the depiction of Anne suggesting she is blank canvas waiting to be moulded by her future husband, or is she instead just rather dull?

The clue is perhaps in Wotton's notes that accompanied his confirmation to his king that Holbein's portraits of both Anne and her younger sister 'expressyd theyr imaiges verye lyvelye'.[12] Wotton's additional words are a perfect complement to Holbein's visual description, equally diplomatic and skilful in providing a warning for those who chose to see one, wrapped up in an otherwise benign account of the young woman. He described a sheltered young woman, an entirely different creature from the worldly women at court who had previously caught Henry's eye. Anne had 'been brought up with the lady Duchess her mother [...] and in manner never from her elbow, the lady Duchess being a wise lady and one that very straitly looketh to her children'.[13] He went on to describe her humble demeanour, her lack of languages and the absence of musical accomplishment. And while he suggested optimistically that she would most likely learn quickly to speak the same language as the king, by implication he indicated that in the short term communications would be strained. Most ominously Wotton pointed out that this was not a young woman accustomed to having fun.

'All report her to be of very lowly and gentle conditions,' Wotton explained:

She occupieth her time most with the needle [...] she canne reede and wryte [...] Frenche, Latyn, or other langaige she [hath no] ne, nor yet she canne not synge nor pleye [upon] enye instrument, for they take it heere in Germanye for a rebuke and an occasion of lightenesse that great ladyes shuld be lernyd or have enye knowledge of musike [...] I could never hear that she is inclined to the good cheer of this country and marvel it were if she should, seeing that her brother, in whom yet it were somewhat more tolerable, doth so well abstain from it.[14]

For a man stuck between a rock and a hard place, Wotton did his best to warn the king that Anne's company might not be comparable to the vivacious, educated and lively women of the English court. However, it was not his position to judge Anne's suitability, and so he was also keen to point out that arrangements were moving forward as requested. The young Duke of Cleves and his powerful brother-in-law Frederick of Saxony had assembled ambassadors who were ready to make the journey to London and were empowered to sign all the relevant paperwork and treaties pertaining to the marriage. In addition, Wotton explained that the documentation relating to Anne's previous betrothal would also be provided, outlining her freedom to be married.

By 11 August Holbein's mission was complete. He had executed his portrait of Anne on parchment for expediency, so that it could be rolled for travel. Now he headed back to England at speed to deliver it and the ambassador's notes to the monarch in person. The fact that by the first day in September Holbein was already at Grafton suggests his ability not only as a painter, but as a horseman of considerable stamina. He must have ridden non-stop. But then, this was the king's business, and by 1539 Holbein knew well enough that Henry was not someone to disappoint.

Holbein's paintings were intended for discussion. Part of the event of their unveiling was a conversation about the meaning the painter had concealed within his work. He devised his work like a poem that one must return to in order to fully comprehend its layers. But in this instance, such was Henry's aversion to disappointment, he failed to heed the implicit warnings in Holbein's portrait, and the accompanying concerns noted by Wotton.

In fact, *so* instantly entranced was Henry by Holbein's latest endeavour that he commissioned a second portrait, a miniature that is now in the Victoria and Albert Museum in London. If the portrait Holbein had initially executed of Anne of Cleves was very much for public consumption and debate, this version of it was entirely private, for the king's personal contemplation.

To make this tiny work of art, Holbein took a piece of vellum and made a minute replica of his main painting, less than five centimetres wide. So accurate is it to the original that it is clear that he used equipment such as compasses and magnifying glasses to scale the image down without losing any of the original detail.

Holbein used expensive ultramarine blue as a background colour to accentuate Anne's pale face and rich clothing. Using real gold leaf, he recorded her costly jewellery and the goldwork on her headdress. The use of such expensive materials intentionally delivered a literal preciousness to the object, one to match the romantic sentiment this tiny work of art now also represented. The transformation of Anne from political bride into treasured precious gem is aided by Holbein's decision to give the miniature a discrete symmetry. Anne's chin marks the centre of the little round miniature. Her square neckline and square headdress mirror one another. The miniature was then set into a small, round ivory box, its lid in the form of a rose, the vellum now glued onto a court playing card for rigidity. Kept in Henry's pocket or at his side, she was now a delight he could enjoy at his leisure. With the warnings in his main painting overlooked, this miniature took on an entirely different complexion.

Hans Holbein, *Anne of Cleves* miniature, watercolour on vellum, stuck to a playing card and mounted in an ivory box, 1539.

Henry's response to the painting of Anne of Cleves chimes fully with the chivalric tradition of his era: that the heart is captured through the eye. Henry's reaction to what appeared to be a truly beautiful woman was instantly romantic. However, Henry's positive reception of Holbein's portrait may have also been stimulated by something else. Holbein, despite his ability to capture his sitters with what seemed like almost photographic realism, was also a master of visual manipulation. One of the layers of meaning that Holbein put down in his visual poem describing Anne of Cleves was a reference to one of the most sacred Catholic images. The fully frontal pose in which Anne is shown was one traditionally adopted by religious painters for

devotional depictions of the Virgin Mary. Did this subliminally appeal to the king at a moment of religious crisis and complexity in England?

In the autumn of 1539, as this portrait arrived, Henry had just reinforced a more traditional Catholic position for his Church of England, publishing a new edict, the 'Six Articles' that steered his subjects away from reformist views. Yet, in the very same year, the dissolution of England's monasteries and the removal of the trappings of Papal Catholicism reached a new level of intensity. Cromwell and his commissioners had moved from shutting smaller institutions to closing larger priories and abbeys. Statuary was torn down, paintings removed and burned, books destroyed and gold and silver treasures, many reliquaries, were removed. Meanwhile the churches up and down England were being transformed, their murals whitewashed, their icons removed. In the month of September, just at the moment that Holbein's portrait of Anne had so gratified the king, Cromwell's desk was newly laden with daily updates relating the dismantling of a

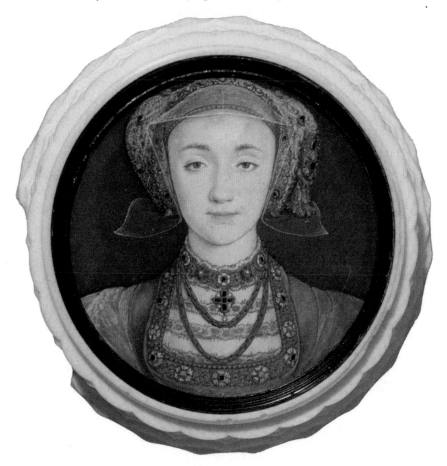

devotional visual culture that had been at the very centre of English daily life for hundreds of years.

As a younger man, Henry had avidly participated in Catholic devotional worship, just like his subjects. Like everyone else he had used the image of the mother of Christ as a focus for contemplation and worship. Twice he had made a pilgrimage to the much hallowed shrine of Our Lady at Walsingham in Norfolk, one of the most famous and potent devotional sites in the whole of the country. Here a statue of the Virgin had stood ever since Richeldis de Faverches had witnessed a Marian apparition in the eleventh century. The king had prayed in front of this most sacred shrine, and like every other pilgrim he had seen how the Virgin's holiness had been symbolized in the glittering gold and jewelled necklaces that had been placed around her neck.

The Walsingham Virgin was brought to London by Cromwell and burned in Chelsea in 1538. Though just one in so many destructive acts that would have felt like sacrilege to those who still held to the old ways, the warm fondness in which Our Lady of Walsingham was held in the national imagination must have made her desecration particularly horrifying.

Though Marian statuary and painting had been systematically removed across England and Wales during Cromwell's campaign, the image of the Virgin, heavily embellished and bejewelled, was seared into a shared memory at the heart of English culture. Similarly, the idea of the Virgin as the ultimate expression of motherhood was hardwired into the national psyche. Neither could be easily erased.

In his depiction of Anne of Cleves, Holbein references Marian iconography. It is not just his depiction of Anne full face, but Anne's serene expression is also resonant of that depicted in holy statuary as well as in paintings of the Virgin. In depicting Anne thus, Holbein transferred the potency of Marian iconography to a secular subject just when the much-loved Marian icon was vanishing in England.

Holbein had already used his kind of potent subliminal device in some of his depictions of the Tudors. His defining image of Henry, standing legs wide, his broad shoulders ready to bear the weight of leadership, suggested a new king or God on earth. His recent portrait of the young Prince Edward alluded to popular images of Christ as Salvator Mundi. The Tudors were now not just monarchs but the

spiritual leaders of the new church in England. In addition to all the other complex messages the portrait of Anne of Cleves potentially carries, it seems that Holbein may have used this final bold reference to the mother of Christ to suggest also that despite her shortcomings, nevertheless here was a virtuous virgin. Like Mary who faced mother-hood despite her virginity, Anne must play the role of mother to the king's young son.

Catching Henry just at the moment when he chose to reinforce his own traditional Catholicism despite Cromwell's reformist advances, this aspect of the painting may have proved its most persuasive and enthralling element for the king. To offer a painting with shades of a devotional image to a monarch who, despite his power and despotism, was also clearly ready to worship a woman, was wizardry indeed.

As the king succumbed to the painting, just as Pygmalion fell for Galatea, Henry agreed the marriage. This was a triumph for Crom-well, who embarked on the arrangements for Anne's conveyance from Cleves. Meanwhile Holbein was rewarded with more commissions in celebration of the forthcoming wedding. A marriage portrait of Henry was required, featuring the king clad in full golden wedding regalia.*

As the country began to celebrate news of a new era and a new queen, one wonders if the King's Painter harboured some concerns. He would have been right to. Holbein's painting of Anne of Cleves was indeed one of the most powerful pieces of art ever made, affecting the fate of a nation. But this diplomatic work of art had ramifications for all those associated with its commission. Rather than being a painting heralding a new period of marital bliss and political stability for England's king as intended, it would in fact sink England into further diplomatic turmoil and expose the king to yet more matrimonial disruption. It would cost men their lives and it would mark a moment of peril for the King's Painter from which, some claim, he would never recover.

* This is in the Palazzo Barberini, The National Gallery of Ancient Art in Rome.

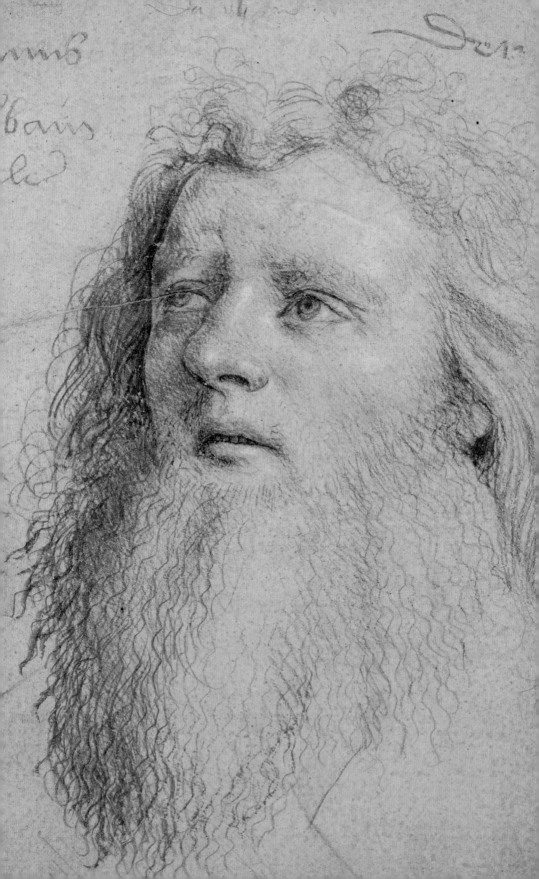

HOLBAIN

olbein learned how to harness the power of devotional art from his father. The supreme quality of the work by Hanns Holbain – for that is how his father's name appears in the contemporary documentation – had a formative influence on his more famous son.[1] Working in Bavaria, in the city of Augsburg, Holbain was one of the finest artists of his generation. Today father and son are distinguished from one another as Holbein the Elder, and the Younger.

Hans Holbein the Elder worked in an era when art and patronage were intrinsically linked. Never was art more entwined with the society in which it was created, nor of more service to the people who paid for it or observed it. Unlike his son, who saw the Reformation more often as an agent for the destruction of devotional art rather than its champion, Holbein the Elder belonged to the last generation of artists for whom the traditional Catholic Church was the patron *sans pareil*. Devotional art was the elder Holbein's métier at a time when that church's thirst for iconic imagery of not only Christ and the Virgin, but also myriad saints and martyrs, seemed unquenchable. Second only to patronage from the church itself was that from members of the laity keen to commission religious work for the sake of their own souls. Either way the product was a religious one.

previous page
Hans Holbein the Elder,
Self-portrait, silverpoint and red chalk on paper, *c.*1516.

Unknown goldsmith after a design by Hans Holbein the Elder, *Reliquary of St Sebastian*, 1497.

For an encounter with the brilliance of Hans Holbein the Elder's sacred work, go to the Victoria and Albert Museum in London. Here is an exquisite depiction of profound suffering: a statuette of the martyred St Sebastian, standing just fifty centimetres tall, the original design of which has been attributed to him.

Holbein the Elder's wounded Saint Sebastian hangs limply, tied to a tree, his body pierced by arrows. The face of the wounded man is one of resolution. His eyes, open and gazing downward, avoid his injuries and stare into a mid distance. His open mouth might suggest a sigh or a groan, or perhaps the panting of a man in agony. His furrowed brow is consistent with suffering. But there is no struggle. This body is at rest, and this man is one patiently awaiting his final moment.

But it is the statuette's depiction of this agony in silver and parcel-gilt that gives it its supranatural potency. Sebastian's curled hair, his cloak, loincloth and the arrows that pierce him, are all golden.

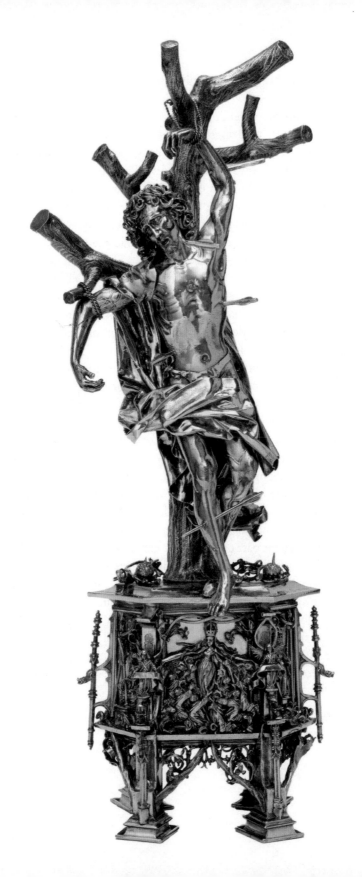

Meanwhile his body is in silver so highly polished it emits its own light.

The lustrous sheen, obvious preciousness and mesmerizing beauty of the statuette take one's breath away. The fifteenth-century eyes that were first set on this devotional image would have understood the intrinsic imaginative idea behind it. Preciousness was more than a mere signifier of holiness, but a visual mantra to allow the viewer to connect, through contemplation, with the divine. An artist who could harness precious material with decipherable imagery had the power to facilitate transmigration from this world to the next. The gleam from precious metal could, in the hands of an artist, become imaginatively transformed into the actual light of God. After all, this was a time when the veil between this world and another was easily lifted; the time of transubstantiation, the metamorphosis of bread and wine into the blood and body of Christ during the Catholic communion. It was also the time of magic, when witches and their familiars lived at the heart of communities and when candles blessed at Candlemass could deter devils and demons during the dark of night.

But the real frisson that this reliquary offered its original observers is the combination of otherworldliness with verisimilitude. In the same way that he has been careful to etch the patterns of bark into the silver branches of the tree to which Sebastian is bound, the goldsmith modelled bulging veins on the arms and legs of the dying man, as if to emphasize the blood pumping from his wounds. Arguably it amplifies the spiritual experience, by allowing the onlooker to more readily identify with the subject as real.

The figure is part of a reliquary containing fragments of the arrows that purportedly tortured the early Christian martyr. On its base are the names of the three powerful men who commissioned it in 1497. Abbot Kastner of Kaisheim was one. The double-chinned, long-nosed abbot governed the impressive, self-ruling Imperial Abbey of Kaisheim in Bavaria.* Such an abbey was not merely a group of buildings inhabited by Cistercian monks but a self-regulating community, with considerable lands. Kastner was an extremely active figure, using the

* He is immortalized in the altarpiece he commissioned in 1502 for the abbey. On the interior panels depicting the life of the Virgin, Hans Holbein the Elder features the abbot kneeling in the bottom left-hand corner, next to his own coat of arms.

abbey's wealth not only to build an impressive library during his tenure, but also to fund a substantial programme of new religious art for the community. At the time such a programme was arguably of even greater service to the community than a world-class collection of books. While a library might be considered a luxury for the here and now, religious art was harnessed in active service, improving life in the hereafter: those who prayed before devotional paintings and statuary were enhancing their chances of swiftly moving through purgatory towards salvation.

Northern Europeans were particularly ardent in their belief in the power of prayer as a route out of purgatory. The Germanic culture was apparently far more open to the concept of self-help when it came to the route to heaven, compared to the southern peoples who looked to their clerics for assistance and absolution.[2]

Within this Germanic culture of action and engagement, some were more able to act than others. The rich and powerful were in a position not only to save their own souls but to benefit the less privileged in their community. The St Sebastian reliquary is a case in point, since here Duke Frederick III, Elector of Saxony, is named as another of its commissioners. With the involvement of Frederick, uncle of John Frederick, to whom Anne of Cleves' sister would one day be married, the specific sacred purpose of the St Sebastian statuette comes more sharply into focus. The duke was a generous and interested commissioner of art whose heavy-set features, wiry sideburns and fulsome moustache would be immortalized by his court painter Lucas Cranach the Elder in due course. However, he was also a passionate collector of relics, driven by a profound belief in their actual power that was typical of the age.

For a Catholic Europe subject to an economy of salvation where good deeds and prayer could shorten inevitable purgatory, while bad deeds would lengthen it, both the collection of saintly relics and their veneration could advance one's trajectory to heaven. The duke's impressive purchasing power had already enabled him to acquire what was widely acknowledged as the world's greatest collection of relics. Housed in the Castle Church in Wittenberg he had thousands of items, including a tooth belonging to St Jerome, a branch from the burning bush, a thorn from the crown of Christ, bread from the Last Supper and even hair belonging to the Virgin Mary. His collection

had become a point of annual pilgrimage for the devout who trekked to see as many of the relics as they could on All Saints' Day, and in so doing provided a tidy revenue stream for the duke, since they paid to worship them. Cranach would go on to produce a souvenir catalogue to promote the collection with a sequence of woodcuts that took the pilgrims on a progress from relic to relic.

As it happened, in 1497 there was real need for the reliquary of Saint Sebastian, the patron saint of plague victims. The bubonic plague, and the terror that came with it, was once again sweeping Europe. In the previous century it had wiped out a third of the continent's population.

In the twilight of the fifteenth century, the return of pestilence was seen by many as a final scourge before a new age. In Florence the charismatic Dominican friar Girolamo Savonarola had taken heed and was busy building a New Jerusalem. In February 1497 he had encouraged the greatest bonfire of vanities that the city had ever witnessed, with penitent citizens purging their homes of secular luxuries and hurling their precious collections of classical antiques, priceless books and paintings by the most celebrated Florentine artists into the flames.

While apparently useless secular art was destroyed in Florence, the commission of the Sebastian reliquary in Kaisheim is an example of practical sacred art being deployed to engage with the evolving calamity. The arrows piercing Sebastian were seen as symbols of disease invading his body. That Sebastian had survived such an assault provided hope for those praying for their own survival. In the world where prayer and contemplation could invoke God's grace, the image of Sebastian could offer protection to those who knelt before it.

The Holy Roman Emperor Maximilian I is the third patron named on the Sebastian reliquary. The predecessor to Charles V, Maximilian's patronage signals the item's origin in Augsburg, a city that lay fifty kilometres from Kaisheim. Augsburg was one of the emperor's favourite haunts, where he spent much of his time and considerable wealth patronizing the artists who lived and worked in this city. Then Germany's cultural capital, it was home to the finest metalworkers, armourers, sculptors, printers and painters. Today that city no longer weighs as heavily in the popular imagination as its Italian counterparts such as Florence, Venice or Milan, but in the sixteenth century

Augsburg's credentials were considerable. It was here that Holbein the Elder was based.

An independent city that answered to no one but its own elected dignitaries and the emperor, Augsburg was founded 1,500 years earlier in the era of Augustus Caesar. Still bearing that Roman ruler's name, its wealth derived from its position on the old Roman Claudian Way that linked the Adriatic and the North seas. In the fifteenth century this well-trodden route continued to benefit the city. It was the main artery that circulated goods, money, ideas and news between Venice and Cologne.

But Augsburg was not just fortunate in its position at the centre of European traffic; it also enjoyed a combination of resources that defined power in fifteenth-century Europe. The Bavarian forests, mountains and rivers underpinned booming timber, metal and paper industries. What is more, the plague that had ravaged Europe's population in the previous century had miraculously missed Augsburg, and as a result that city, along with others in southern Germany, had stolen a march on a devastated Italy to dominate European textile production. By the time Holbein the Elder walked its bustling streets, Augsburg had a massive population of more than twenty thousand and bleaching racks covered with cloth were everywhere to be seen. It was a vibrant market where many of its merchant citizens had accrued massive wealth. It had also become one of the world's most significant centres of banking. Today the legacy of these wealthy residents is evident in the wide Maximilianstrasse that runs between the city's two most prestigious religious edifices, the copper-domed Basilica of Saints Ulrich and Afra to the south, and the cathedral to the north. Though described as 'Häuser', the generous four- or five-storey homes that line this wide medieval boulevard were in fact closer to palaces. Their flat, coloured façades, often highly decorated, concealed inner courtyards and ample buildings to the rear. Often operating as business premises as well as residences, their interiors were opulent.

When Maximilian rode into town, therefore, he entered an environment where not only would he be entertained by some of the richest men in Europe, where he could explore cultural projects with the finest available practitioners, but he also entered a city where he could get business done and secure loans for his political and military ambitions.

Holbein the Elder lived, like the other well-known Augsburg artists, in the quarter of the city around the canalized River Lech. Though just yards from the formal elegance of Maximilianstrasse, this area of the city enjoyed an entirely different aspect. Here the streets were narrow and winding. Today leather workshops, jewellers and little art galleries present a memory of the medieval ateliers that once defined the quarter. The Holbeins were in Vorderer Lech. Their home is still there, an ample three-storey building in front of which runs a fast-flowing canal, a metre wide. Like all the houses on the west side of Vorderer Lech, access to the wide, arched front door is across a little wooden bridge that spans this waterway.

Here Holbein the Elder, son of Michael Holbein, an Augsburg tanner, ran a workshop with his younger brother Sigmund that would become the training ground for Hans the Younger. Sigmund was an accomplished painter in his own right, his work – of which very little is known – stylistically different to his elder brother's. When working together under the guidance of Hans, the master of the workshop, Sigmund's personal manner is lost, but in the few extant pieces which he painted solo, it's clear that he liked a richer, darker palette and that his work is less subtle than his brother's, with a bolder, crisper, more graphic character. Yet his talent is obvious.

One imagines that the canal water running from the 'Holbeinhaus' often took on the colours of the work in progress within, as mixing bowls and brushes were washed. Typically, a busy workshop would employ fully trained journeymen, skilled artists yet to achieve the status of master, as well as apprentices. Among those who passed through Holbein's doors were talented painters such as Leonhard Beck and Hans Schäufelein, whom the young Holbein would have known well. Meanwhile, the Holbeins were related to the other prestigious artists in the city and further afield. The painter Thomas Burgkmair was Holbein Senior's father-in-law, and Burgkmair's son, another Hans, would go on to work extensively for the Emperor Maximilian. Meanwhile the Holbein family were also related to the Erharts, sculptors in Ulm, seventy kilometres to the west.

The choice of Holbein Senior to design the reliquary of St Sebastian acknowledged his experience of working closely with sculptors and goldsmiths. The distinctions between expertise in the arts was more fluid in the sixteenth century with artists, whatever their

initial training, often working across not only painting and sculpture but also decorative disciplines such as metalwork, jewellery design, illustration, stained glass work, the design and decoration of armour and weaponry, and even architecture.

However, it was also Holbein Senior's fast-rising stardom as a brilliant and inventive painter that recommended him as the man to design the figure of Sebastian. He had been busy with important commissions in and around Augsburg earlier in the decade. In 1490 he had delivered an altarpiece dedicated to St Afra for the modest Church of St Afra-im-Felde near Friedberg, just five miles outside the city. Three years later he added an impressive altarpiece for the town of Weingarten which lies to the west of Augsburg. Today the former work is split between Basel and Eichstätt.* Meanwhile, the wings to the Weingarten altarpiece now hang in Augsburg's cathedral, purchased by a foresighted nineteenth-century bishop and thus restored to the place of their origin.

The exquisite work of Holbein the Elder is much overlooked. The combination of intellectual depth and technical skill that defines his work would also define that of his son. Originality and a determination to experiment is also an attribute of both their work. Despite his late gothic style which offers stylized, often angular drapery, empirical perspective and references to the gothic architecture of the north, nevertheless Hans Holbein the Elder shares key motifs and instincts with his son. His use of geometric pattern in the foregrounds of works is a small detail that the son inherits, not least in his use of the patterned 'Holbein carpets' so often placed to the fore in his work. In the father's work, the juxtaposition of geometric interior decoration provides a dialogue with the brilliantly observed lacelike tracery and twisting forms of the gothic architecture within which his subjects are placed. It also offers a contrast to other minutely observed fabrics, their woven designs sometimes floral or vegetable, that the painter conveys so brilliantly. Hans Holbein the Elder is the master of golden brocade, and intricately woven damask. He also offers the most exquisite colouration defined by a balance of soft pinks and reds, vibrant blues and bright greens – again a palette that leaves its legacy in the work of the younger Hans.

* Basel's Kunstmuseum has the *Death of the Virgin,* while the *Coronation of the Virgin* and *Burial of St Afra* are in the Episcopal Palace in Eichstätt.

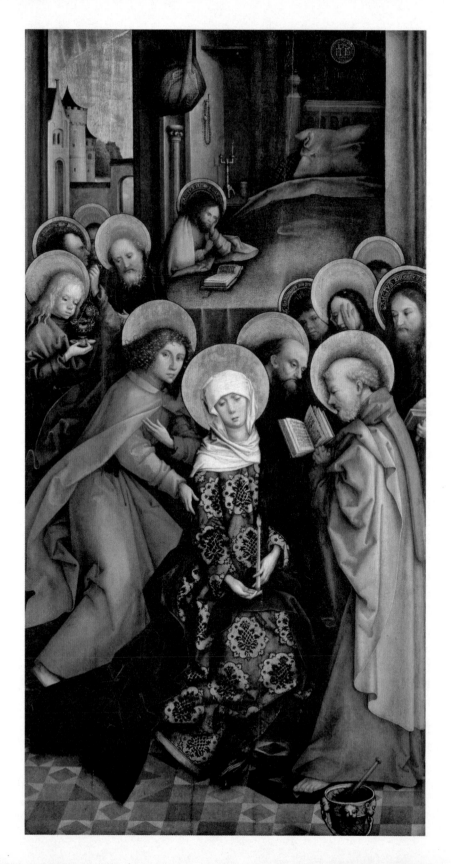

But far more significant is the father's sense of characterization and close observation in the realistic faces he depicts, the narrative he achieves in their interaction and the overall vivacity he realizes in his loving depiction of persuasive detail. By delivering credible faces and recognizable elements of the here and now in his religious painting, his work anchored its viewers in a tangible present through which they could imaginatively transport themselves to a long-lost biblical past.

For the St Afra altarpiece the elder Holbein painted two wings. The interior side of one depicted the *Death of the Virgin*, and the other her *Coronation in Heaven*. The wings closed to reveal a picture of the *Burial of St Afra* on their exterior. In the depictions of the Virgin, the geometric floors on which she is situated in both panels offset the rich golden fabric of her dress with its vegetable pomegranate pattern. The contemporary audience would understand the preciousness of such fabric, recognizing it as a velvet made in Spain or Italy, and known to be extremely costly. The traditional equation of preciousness with holiness meant that pomegranate velvets, often woven with gold and silver threads, were sometimes used in ecclesiastical ceremonial costume, and often banners of the cloth were hung behind images of the Virgin in church.

Hans Holbein the Elder, *Death of the Virgin*, Wing of the St Afra Altarpiece, mixed media on softwood, 1490.

The conceit, using contemporary fabric to clothe a Virgin depicted in her own time, is typical of Holbein's attempts to give devotional work an immediacy and accessibility for his audience, to overlay and compress the distance of time. In his representation of the Virgin's death, the individualization of each apostle achieves the same effect. Here are credible people rather than idealized representations. In the same panel, mundane artefacts are

overleaf
Hans Holbein the Elder, *The Birth of the Virgin* and *Joachim's Sacrifice*, Wings of the Weingarten Altarpiece, oil on wood, 1493.

drawn with convincing detail from the contemporary rather than biblical worlds: a brass candlestick in the background, a rosary hanging on a wall, a wooden bed, its pillow dented from a recent occupant. The loving depiction of the books Holbein the Elder places in the hands of some of the apostles is also typical of his work generally and his use of text to inform it. He paints the pages and bindings with care. He makes the words on the open pages legible. There is a sense of the artist's delight in his ability to combine realism with otherworldliness, when he creates a visual time-shifting paradox in which one apostle is reading a verse that relates to the scene of which he is part.

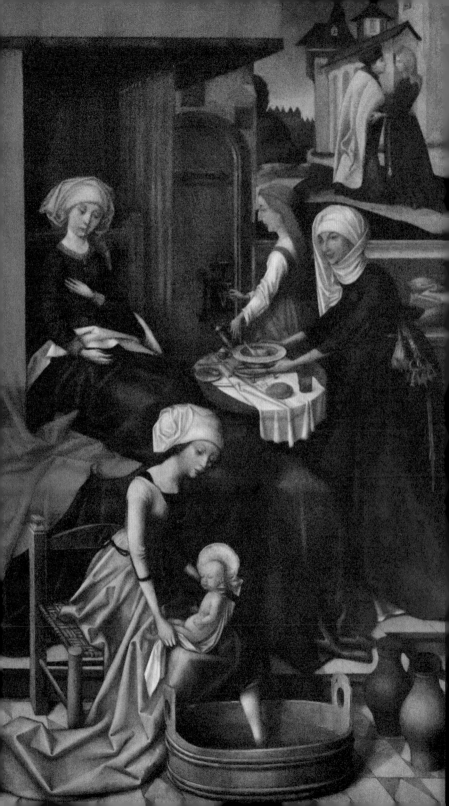

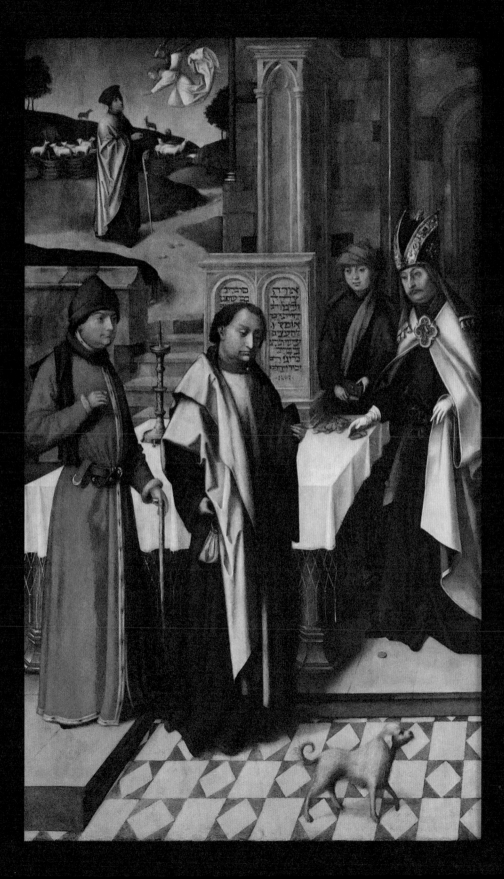

The wings Holbein painted for the Weingarten altarpiece featured the story of the Virgin's parents, *Joachim and Anne*, and the *Birth of the Virgin* on their exterior, and opened to reveal depictions of the *Presentation of Mary by her Parents at the Temple in Jerusalem* and then the *Circumcision of Christ*. Again, it is the intervention of observed details from a very real, domestic world that strikes one most in the story of Joachim and Anne, and the birth of their child.

The panel depicting the birth of the Virgin reveals her nursemaid sitting on a lovingly observed household chair, its seat a chequerboard of woven cord. She is about to bathe the baby in a wooden bathtub and is testing the water with her foot; a couple of earthenware ewers are on hand, with hot and cold water to moderate the temperature if necessary. Elsewhere the utensils of daily life are beautifully rendered. Mary's mother Anne is shown in bed, a serving woman offering her food from a pewter plate. She lifts this from a crumpled tablecloth, on which stand a drinking cup and bread roll.

The wing, which originally hung on the left of the altarpiece, features Joachim's sacrifice being rejected in the temple because of his childlessness. In the mid ground Holbein the Elder has attempted to give a sense of the depicted location – Jerusalem – by showing Hebrew letters carved into two arched stone panels.

Hebrew letters in arched stone panels, still in the walls of the former home of Conrad Peutinger.

It is surely no coincidence that just a stone's throw from the panel's current location two such ancient Hebrew panels are still on display, cemented into the walls of the former home of an Augbsurg lawyer and antiquarian, Conrad Peutinger (more of whom later), as they were in the 1490s. The fact that the artist chose to include the most immediate reference to ancient Judea he had to hand, again probably well known to the more erudite members of Augsburg society, also suggests a latent interest in authenticity that ultimately his son would explore explosively in his depiction of a dead Christ.

Holbein the Elder's reputation as a master of the altarpiece was consolidated on the cusp of the sixteenth century when, between 1494 and 1500, he painted yet another impressive and innovative work, this time wings for an altarpiece depicting the Passion of Christ. Known as *The Grey Passion*, its original situation is no longer known, but the Staatsgalerie Stuttgart purchased it in 2003 and restored it. The twelve panel paintings narrating Christ's story from his arrest to his

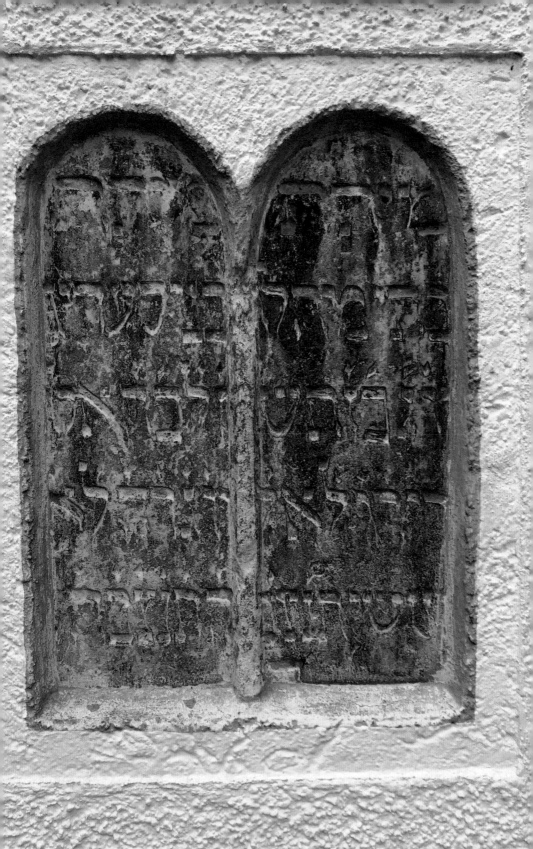

resurrection formed the folding wings of an altarpiece that, when opened, revealed a sculpture of the crucifixion by Gregor Erhart. Extremely unusually Holbein's paintings were in grisaille. Six panels were rendered almost entirely in grey and feature the journey of Christ from the Garden of Gethsemane to his presentation to Pilate. These grey panels were arranged on the exterior of the wings that opened to reveal the remaining interior panels in shades of white depicting the moment before the *Crucifixion*, as well as the *Deposition*, the *Entombment* and the *Resurrection*. In all the panels only Christ and the faces and hands of his tormentors are afforded flesh tone colouration.

The effect is intense. The careful rendering of the scenes in mono-chrome is suggestive of statuary or bas-relief, placing the events in an alternative realm. The glimpses of flesh and expression, however, provide a tension between this obvious artifice and an attempted realism. The statue at the heart of the altarpiece would have continued this tension. Erhart was a master of painted or polychrome statuary, where wooden carvings were coated with gesso and then painted to give a more realistic finish. The convincing flesh tones he would have applied to his Christ figure would have continued the interaction between attempted realism and obvious artifice.

Hans Holbein the Elder, detail of *The Resurrection of Christ, The Grey Passion*, oil-based mixed media on spruce wood, 1494–1500.

This exhilarating interplay is similar to that be-tween precious metal and verisimilitude delivered in the St Sebastian reliquary. And there is one more striking link between the two works. Sebastian's tilted head, his face with its slightly open mouth, downcast eyes and pain-pinched eyebrows are very like Holbein the Elder's depiction of Christ in his deposition in the Passion series.

overleaf
Hans Holbein the Elder, *The Grey Passion*, oil-based mixed media on spruce wood, 1494–1500.

The reference to statuary in the painting itself, and the intended interaction of the painted panels with a sculptural centrepiece, attests to Holbein's strong sense of three-dimensional form. The sense of dimension that the father found in working alongside sculptors would also be of fundamental importance to the son in due course.

The guild system that governed the working practice of artists demanded that young apprentices training under a master craftsman should travel for the sake of experience – becoming 'journeymen'. Hans Holbein the Elder, in his mid-thirties when he made the Sebastian,

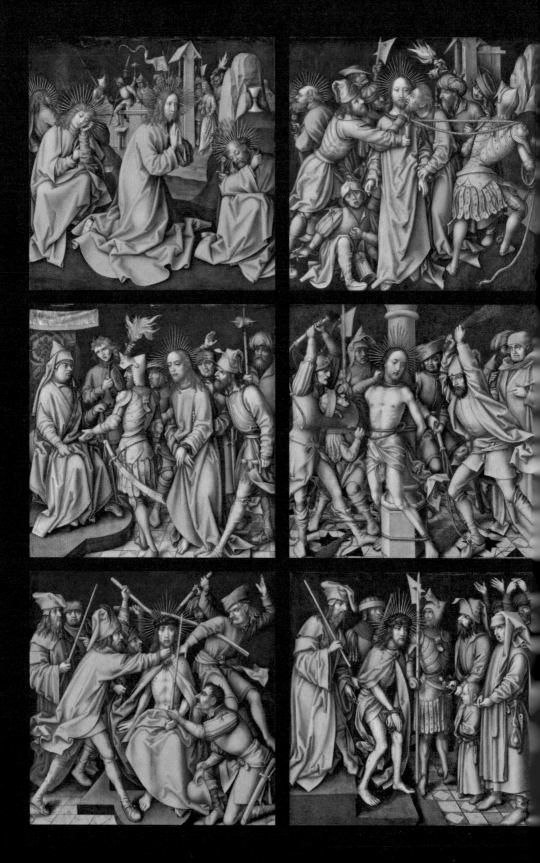

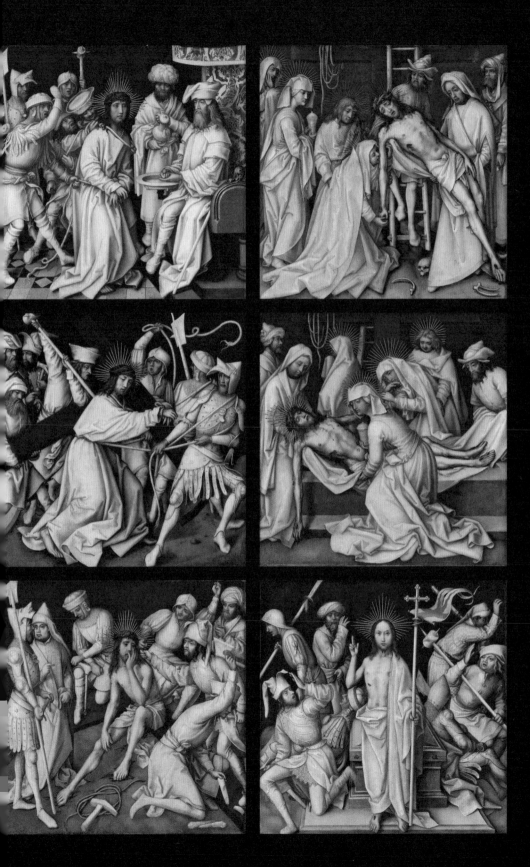

had returned to Augsburg only in 1494, having spent his journeyman years in Ulm where his relative Michel Erhart was a master sculptor. He had worked alongside Erhart and his sons Bernhard and Gregor, and when Holbein came home to Augsburg, Gregor returned with him, not least because, despite its many artists, Augsburg lacked a sculptor expert in polychrome wooden sculpture. It may well have been Gregor who worked up a wooden maquette of the San Sebastian from which a goldsmith – of which Augsburg boasted many – made his cast.

A drawing of the figurine by Holbein is held in the British Museum. The difference between this drawing and the finished item indicates its preparatory status. On the verso of Holbein the Elder's drawing of the Sebastian maquette, there is another sketch. This time the face of a middle-aged man, framed with long curly hair. Captured in three-quarter profile, the attention to the modelling of the sitter's prominent nose, the working to firmly capture his slight smile, and the strong, thick lines determining his profile and chin, suggest this is a preparatory study for a portrait. Hans Holbein was a skilled portrait artist, as the remnants of his sketchbooks suggest.[3] How to observe people was yet another crucial lesson that the father clearly passed on to the son.

Some two hundred drawings by Holbein the Elder survive, more than three quarters of which are portraits. It is highly unusual that these drawings have endured at all from an era when they were considered mere workshop ephemera rather than valued as works of art per se. The only other German artist from this time from whose hand more drawings exist is Dürer, a figure who will crop up again and again as a practitioner raising the bar and changing perceptions of art and artists. Dürer saw drawings as works of art in their own right and kept his. That the elder Holbein also valued his portrait drawings suggests that he too was at the vanguard of new thinking.[4]

Filled with faces of the citizens of Augsburg, his sketches serve several purposes. They depict the interesting physiognomies that would go on to populate his altarpieces and other religious works; they include images of folk that the artist chose to make for his own satisfaction, but they also provide studies for portrait commissions from the great and the good of the city. Portraiture was one of the secular art forms just beginning to get a foothold among the mercantile classes of the

city, and it was another source of income for the Holbein workshop.

The artist annotated many of his sketches, naming the sitters. Just as his son's work would provide a visual portal into Tudor England, and more specifically the Henrician court, the father's sketchbooks bring to life the bustling city of Augsburg through its long-lost citizens, from the loftiest to the lowest of its social ranks.

First and foremost one notices the number of powerful men included in the book, a mark of Holbein's level of access. These were faces of those that could open doors, provide work, offer recommendations, and generally make things happen. Some are captured opportunistically, such as Holbein's drawing of the 'great Kaiser Maximilian', cultural patron of Augsburg, riding through the city in a long travelling cape and brimmed, weather-protective hood.

Other portraits, however, have been captured during a formal sitting with the artist. In this category are members of Augsburg's dynastic banking families, who enjoyed wealth, power and fame on a scale that challenged Florence's Medicis, Milan's Sforzas or the Borgias. Augsburg's Fuggers and Welsers all had offices in those great Italian centres, but for them Italy was just part of trading, banking, mining and property empires that extended across the known world.

Jacob Fugger, referred to as Europe's banker, was arguably the richest man in the world when he was living in Augsburg, with businesses that reached into Africa, South America and India. Fugger's vast mansion still sits on Maximilianstrasse, and still houses the family merchant bank. Its ochre façade is today broken up by a grid of rectangular frames painted in a darker shade. The ornate frescoes that adorned it in Jacob's own time – once a monument to the achievements of a man who funded the Hapsburg dynasty, loaned to the Pope, and bankrolled many a war – are long gone.

But not far behind the Fuggers' business was that operated by the Welser family, whose own mansion lay just a little further south along the street. The Welser residence was converted in the eighteenth century into a baroque palace, a small-scale Versailles with a huge mirrored ballroom and enfilade of rooms rivalling any great house in Europe. This baroque grandeur nevertheless hints at the impressive original home of a family who claimed sea routes that extended to the Far East.

Albrecht Dürer's portrait of the rugged-featured Jacob Fugger,

painted in 1520, survives. But the possibility that Holbein the Elder also painted the banker earlier on is suggested by two extant drawings of him. In fact, Holbein's familiarity with the wider Fugger family is suggested by the fact that in addition to Jacob, Holbein also drew his nephews, Raymund, Ulrich and Anton; his nieces Anna and Veronika; Anna's husband Georg Thurzo, and their son Christoph.

These faces from Augsburg's distant past are all captured in silverpoint. It was Holbein Senior's preferred drawing technique, and one he taught his son. It involved using a thin silver rod or wire to draw on specially prepared paper. The preparation of Holbein Senior's sketchbooks may well have been one of the early duties that the younger Holbein performed for his father. This would have involved burning lead white and animal bone into ashes, which would then be ground into fine powder. This powder was then mixed with animal glue and water before being brushed over paper to create a slightly granular ground. A silverpoint pen, drawn across a surface prepared in this manner, produces a very delicate line, but it cannot be erased, so its use is a measure of an artist's skill.

Holbein certainly captures Fugger with a delicacy and precision that seems a little at odds with the impatient expression of his subject. In one of Holbein's sketches, the cloth-of-gold skullcap that was Fugger's signature item is covered by another larger velvet hat, its folds and dimples meticulously observed, as are the hairs on the thick fur collar that embraces Fugger's shoulders. The second drawing shows Fugger's famous gold skullcap revealed in full, edged with a rope braid; the cap has a latticework pattern woven into the cloth.

Hans Holbein the Elder, *Jacob Fugger*, silverpoint and ink on paper, *c.*1509.

Did a very young Holbein sit watching as his father drew this astonishing man? This would have offered the child his first real exposure to someone who truly embodied power and money. Fugger, surely the most imposing character in Augsburg during Holbein's childhood, certainly made a lasting impression on him. In due course the young Holbein would return to Fugger's skullcap and bold features, drawing on them as shorthand for men defined by money. One wonders to what extent the figure of Fugger also informed what would become Holbein's own complex relationship to wealth.

Alongside the bankers and politicians that trod Augsburg's colourful, busy streets, there were also monks and clergymen in great number.

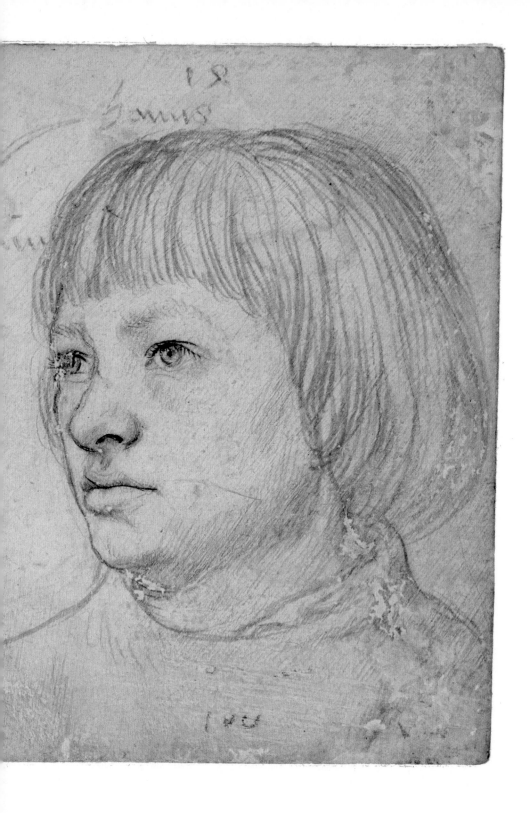

The city was replete with churches and monasteries, and one could observe Carmelite, Franciscan, Benedictine and Augustinian monks. And sure enough their visages with their tonsured hair also appear in the elder Holbein's sketches. The power of these figures should not be underestimated – not only did they have access to significant wealth, but the senior ecclesiastical figures could leverage significant political power at the time.

It's interesting then to see Leonhard Wagner among the drawings, a senior figure in the Abbey of St Ulrich and St Afra that extensively commissioned from the Holbein workshop. Also depicted are Abbotts Konrad Morlin and Johannes Schrott. From another religious institution, the Dominican Church, we see the face of Johann Faber, who was the vicar of the Dominican congregation in southern Germany and the Swiss territories and oversaw much work at the Dominican convent in the city alongside the prioresses there, of whom more later.

Another group of drawings by Holbein the Elder is dedicated to guildsmen. Captured with their workmanlike hats and conventional haircuts, they are named by the painter: Adolf Dischmacher, Hans Schlegal, Zimprech Rauner, Hans Aytenne and more. These must have been well-known characters in the workings of the city's daily life. Two of the most accomplished drawings in this group are sketches of Hans Schwarz, a young sculptor known for making the portrait medallions that were becoming extremely popular among the town's merchant classes. The drawings of him have a striking spontaneity. One catches him in three-quarter profile, gazing right at the artist, as if the young man has just turned his attention to him. Another reveals him glancing away, this time his wispy, unkempt hair more visible under a cap worn at a slight angle. Taken together these two sketches, with their psychological veracity and skilful verisimilitude, herald the work of the son and must have been an inspiration for him as he worked alongside his father.

previous pages
Hans Holbein the Elder,
Ambrosius and Hans Holbein,
silverpoint and ink on
paper, 1511.

It is hardly surprising that amid all these faces that tell a tale of a past community, Holbein captured his own family. In 1512, as he dates it, Holbein the Elder committed his brother and co-worker to paper. This drawing is in the British Museum. Long-haired and bearded Sigmund sits in profile for his sibling. His strong, sharp nose and full lips are again detailed with a tangible veracity, the angle of

the head and shoulders, just leaning forwards, suggesting he has sat momentarily to allow the likeness to be made.

A year earlier Holbein Senior also made three-quarter profile drawings of his two sons. Since he annotated the drawing with their ages, this sketch has been traditionally used to provide a birth date for the junior Hans Holbein and his elder brother, Ambrosius. Hans is shown at fourteen with his hair straight, cut in a fringe over his forehead and reaching down to his collar. His eyes slightly hooded, his cheekbones wide, the older man is already clearly visible in the child. With this age noted, it puts the younger Holbein's birth date at 1497, the year the Sebastian reliquary was made. There is little fraternal resemblance between the brothers. Ambrosius, whose name is shortened to Prosy, is widely considered to have been three years his brother's senior. His hair is wavy, his nose longer, and his face altogether narrower.

The father continued to chart the boys' progress towards adulthood in his sketchbooks. In the Hermitage Museum in St Petersburg is yet another drawing of Ambrosius and Hans, perhaps a copy, this time with a skyline sketched below them, and a caricature of their father with his long beard striding purposefully across the page. This is dated to around 1514 and not only suggests the continuing pride the father took in his sons, but gives a good account of them as young men. Ambrosius's face has become thinner and more angular, his curly hair cut shorter. The change in Hans is typical of an adolescent who has gone through puberty. The once smaller snub nose is gone and in its place a longer, more pronounced nose has emerged.

But these drawings of the young Hans and his brother are by no means the earliest images of Hans Holbein the Elder's sons. In fact, he painted depictions of them into his professional commissions. And if one looks closely enough at these deeply personal references, one finds vital clues about the childhood of Hans Holbein the Younger, a boy at the centre of a close-knit community, whose talents were evident early on, and who was marked out for greatness from the off.

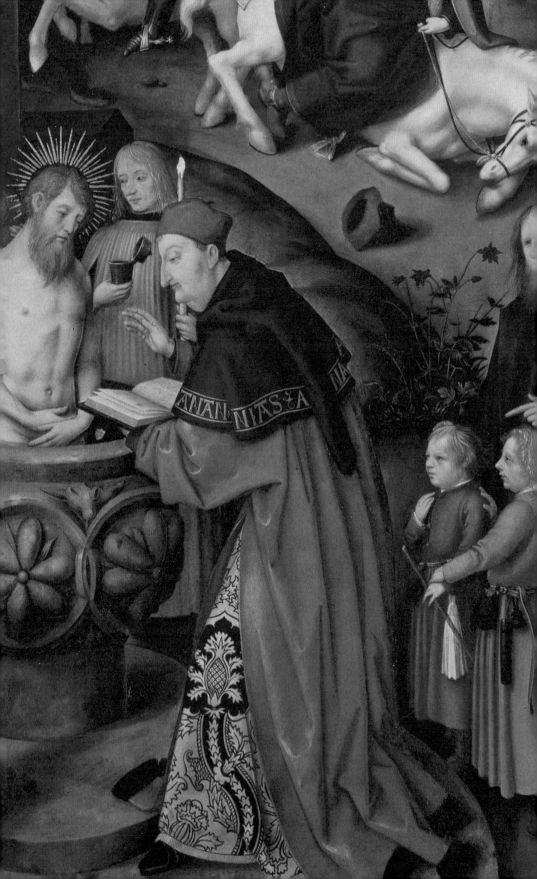

3

YOUNG HANS

Traditionally it is considered that the earliest painted portrait of Hans Holbein the Younger was made by his father, and shows him as a seven-year-old boy standing alongside his older brother. This often cited double portrait is described more fully below. However, there is an even earlier portrait of Holbein, also by his father, that has gone unnoticed. It forms part of a series of portraits and self-portraits that Holbein the Elder incorporated in works he executed for the same religious institution in the first two decades of the sixteenth century. This was the Dominican convent in the heart of Augsburg, and Holbein the Elder's extensive work for it provides a uniquely personal glimpse into his family life at the time.

In 1502 Holbein the Elder painted a memorial to the Walther family which was to be placed in the Katharinenkloster, St Catherine's Convent, in Augsburg. Ulrich Walther was yet another of Augsburg's high-ranking merchants, and part of the Welser family's extensive international trading empire. Two of his daughters held senior positions at the convent, which was populated by an elite group of women, and was conveniently situated just behind the Welsers' substantial residence and business premises on Maximilianstrasse. Anna Walther was the convent's prioress from 1498 to 1503 and her sister Maria its sexton. Together they oversaw the extensive remodelling of the main monastery building. Veronika Welser succeeded Anna and was responsible for an innovative redesign of the convent's church. This group of powerful nuns and their influential Augsburg families commissioned a series of art works associated with these renovations that provided consistent work for the Holbein and Burgkmair workshops in the late fifteenth and early sixteenth centuries.

Hans Holbein the Elder, detail of *The Miracle of the Loaves and Fishes*, The Walther Memorial, oil on softwood, 1502.

overleaf
Hans Holbein the Elder, The Walther Memorial, oil on softwood, 1502.

The Walther memorial, shaped to fit within one of the convent's gothic arches and to surmount a written epitaph, is tripartite, featuring the *Transfiguration of Christ* in its central panel, with the *Miracle of the Loaves and Fishes* on its left-hand panel, and the *Healing of the Demoniac* on the right. Ulrich Walther and his sons and grandsons are featured at the bottom of the left-hand panel, while his wife Barbara, her daughters (including Anna and Maria) and granddaughters are shown on the right.

It is in Holbein the Elder's rendition of the story of Jesus feeding

the multitude that Hans Holbein the Younger first emerges. In the Gospel according to St John, a very small boy presents Jesus with the two small fish and five loaves that the Messiah then shares with five thousand followers. Holbein the Elder features this small boy in the dead centre of his composition, and without a doubt his five-year-old son was the model.

Holbein the Elder draws particular attention to the young boy. While the characters in the scene are generally depicted in biblical robes, the small child is wearing contemporary dress: a red tunic, with a small toolbox, cloth and rosary attached to his belt. The only other characters depicted wearing contemporary dress are the Walther family. The location of these figures in the sixteenth-century world is an invitation to view them as portraits.

The other factor that identifies the boy as a portrait of a very young Holbein is the very specific facial features that are described. Here is a child with a characterful look. His darkish blonde hair is cut into a cruelly short 'pudding bowl', revealing a wide forehead, wide-spaced eyes, a pudgy retroussé nose and chubby cheeks. These are the distinguishing features, along with a very similar tunic and work belt, that Hans Holbein the Elder would repeat in later portraits of his youngest son. The likeness is irrefutable.[1]

It is not just the round face and specific clothing of the young child that closely resemble other, later, portraits of the young Holbein, but it is also the tenderness and pride that his father endows upon the image that signals the identity of the boy. Just above the child's head, Jesus hands a piece of bread to St Peter. The extended hand of Christ and the hand of the recipient form the shape of a heart. The junior member of the Holbein family was clearly cherished.

Hans Holbein the Elder does not forget his elder son. On the opposite side of the memorial, in the depiction of the *Healing of the Demoniac*, there is a portrait of another boy. He stands just behind Christ, to the right of the Saviour. He is also dressed in red. His face

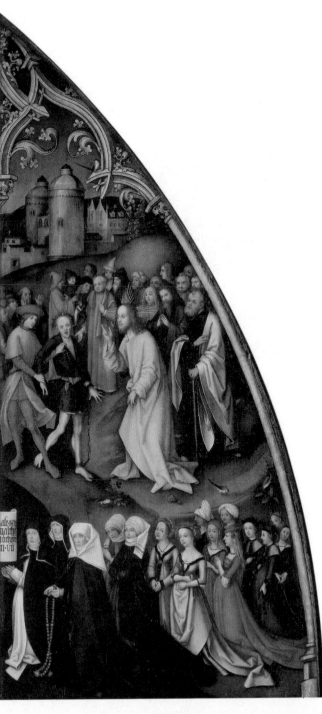

is longer, but it is his rather weak chin and the shape of the boy's lips that give away his identity. Here is Ambrosius.[2]

The question is whether the incorporation of portraits of his sons into this painting was a purely private reference for the enjoyment of Holbein's immediate family, or whether their inclusion in the panel suggests something more. The prominence given to young Hans is particularly intriguing.

The warmth towards the juvenile Holbein is also apparent in his next appearance in his father's work for St Catherine's, two years later. In 1504 Veronika Welser, newly appointed as prioress, made her contribution to a project that her fellow sisters had begun five years earlier.

The *Basilica Cycle* involved five nuns who commissioned six panel paintings depicting the seven basilicas of Rome for their newly built chapter hall. While Welser commissioned two of the six paintings, Anna and Barbara Riedler, related by marriage to the Walther family, commissioned one each. Dorothea Rehlinger, the daughter of another very rich Augsburg merchant, also commissioned one, as did Helena Rephonin, whose family, despite being part of a social class just below the patrician elite, were nevertheless rich landowners. The work was split mainly between the Holbein and Burgkmair workshops, with the latter responsible for three in the cycle, Holbein the Elder painting two, and an unidentified painter with the initials LF painting just one.

The paintings were endowed with genuine spiritual potency, as were other devotional works created in this era of traditional Catholicism. The nuns at St Catherine's were unable to undertake pilgrimage because of the restrictions of enclosure that kept them almost entirely within the walls of their convent.[3] However, thanks to the magical possibility whereby pigment on wood could become a version of the real thing through contemplation, the nuns had obtained a Papal bull which decreed that by praying in their chapter house in front of the painted depictions of Rome's places of worship, they would receive the same benefit and indulgences as those pilgrims who travelled and visited the actual basilicas in person.[4]

Holbein the Elder had already delivered an image of Santa Maria Maggiore to the project under the patronage of Dorothea Rehlinger in 1499, but now under the patronage of Prioress Welser, it was to the Basilica of San Paolo Fuori le Mura (the Papal Basilica of Saint Paul Outside the Walls) that he turned his attention. His panels depict the life of St Paul and feature a wealth of characterful people with individualized faces interacting with the saint, witnessing his conversion, baptism and subsequent beheading.

In a section of the panel featuring the conversion and baptism of St Paul stand a man and two boys as witnesses to events. This group is in fact a family portrait. A long-haired and bearded Hans Holbein the Elder presides over his two sons, while opposite the group a woman in green looks at them, her profile so similar to Ambrosius's that one wonders whether here also is Hans Holbein the Elder's wife.

There are some obvious motives for a painter to place himself and his family within his work. One, of course, is simply to secure a little life beyond death, a memorial in the form of a portrait. Another reason may well be to reap some spiritual benefit from the work. A degree of the indulgence that the contemplation of the saint's life might bestow on those who prayed before the painting might also be magically transferred to those depicted witnessing the saint's life within the painting itself.

Hans Holbein the Elder, detail of *The Healing of the Demoniac*, The Walther Memorial, oil on softwood, 1502.

However, neither of these motives for including himself and his family in this devotional work explains the attention Hans Holbein the Elder pays to Hans Holbein the Younger in the group. The older Ambrosius, long-haired and shown in profile, is protectively wrapping his arms around his round-faced younger brother. Young Hans, wearing incidentally the same items on his belt as in the *Loaves and Fishes* and sporting the same haircut, is clearly the focus of attention and affection not just of his brother, but also his father. Holbein the Elder places one hand lovingly on the child's head, and points to him with his other hand. This gesture ensures he catches the eye of anyone viewing the painting, incorporating their gaze and inviting them to share in the adoration of the painting's youngest subject.

Like the convent's church, where the Walther memorial was placed, the chapter hall in St Catherine's was one of the parts of the institution to which a limited public had access, allowing entry to

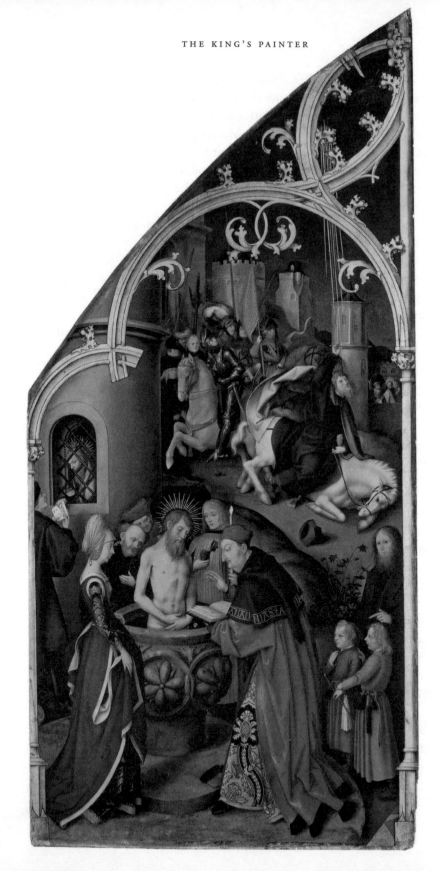

friends and benefactors. As such it was a space where paintings could offer an outward-facing message to a particular community above and beyond the very specific purpose they served for the nuns.

So in this semi-public context, what inspires this astonishing outpouring of affection towards such a young boy? Is Holbein the Elder suggesting that the future of his family rests with this young child? In the earlier painting the association of the young Holbein with bread and fish could be read as indicating someone linked with abundance. Could such intentional signalling reflect the fact that even before he had reached double figures, Hans Holbein the Younger was already exhibiting a prodigious talent that boded well for future patronage? Or was it a reference to the fact that within a specific social circle in Augsburg, a circle associated with St Catherine's, this young child had become something of a darling?

The erudite women at the convent and their associates were in the vanguard of the Northern Renaissance. That the young Holbein was within their orbit from a very early age is extremely significant. At the heart of those associated with St Catherine's was one influential tastemaker who may well have advised the Walther and Welser families on who to patronize from Augsburg's painters' guild. Conrad Peutinger, lawyer and antiquarian, was an influencer in Augsburg who advised the Emperor Maximilian on artistic matters from the early 1490s, including recruiting artists for imperial projects. Significantly, Peutinger was part of a newly established humanist community in the city, known as the Sodalitas Augustana.

Hans Holbein the Elder, Wing of *Basilica of San Paolo Fuori le Mura*, oil on softwood, *c*.1504.

Humanism, which in its most basic form was the interest in classical literature and the classical world, was a key aspect of the cultural Renaissance that originated in Italy and was now spreading more widely among Europe's intelligentsia. From its origins in the south, the renewed fascination with Europe's classical past had spread along that old Claudian Way to Augsburg, where its community of patrons, artists and craftsmen were the first in Germany to respond to it. Augsburg was effectively humanism's gateway to the north.

Peutinger had married Margarete Welser in 1498. As part of his embrace of some of the more liberal principles that became associated with humanism, he was not only open to, but positively encouraged, the intellectual contribution of women. He entered an unconventional

marriage with his well-educated and Latin-literate wife that saw him sharing his intellectual pursuits with her, building his world-class collection of books with her, and endorsing her continued education, along with that of their daughters.[5] He and his wife were unusual in that, rather than occupying the separate sections of their home traditionally associated with the male and female roles, they could often be found pursuing their studies in their library together.

The city's Roman past amplified the delight its culturally literate citizens, such as the Peutingers, found in classical texts and antique items. In 1491 – the year in which over in England Henry VII's Queen Elizabeth of York gave birth to her second son, Prince Henry – a Roman sarcophagus was unearthed at St Ulrich and St Afra. It served to remind Augsburgers that their church was founded on a Roman temple. Inspired, the Peutingers assembled a collection of remnants from ancient monuments found locally which they displayed in pride of place in the courtyard of their mansion house, right opposite the cathedral. The study of the inscriptions on these would inform a Roman typeface invented and popularized by one of Augsburg's printers. The Peutinger fascination with the antique extended beyond this to the commission of portrait medallions similar to those popularized in ancient Rome from Hans Schwartz, that metalworker so brilliantly depicted by Hans Holbein the Elder.

Peutinger was a fan of both the Burgkmair and Holbein establishments. Not only did he employ Burgkmair as an illustrator, but the inventory of his possessions made after his death reveals he owned paintings from both workshops.[6] Peutinger's likely advocacy would have been well heeded by members of his extended family, who would doubtless have enjoyed the cachet of sharing the patronage of specific local talent not only with their erudite relative, but also with the emperor.

It's fair to say that the influence of humanism and the Italian Renaissance, its fascination with classical artifacts and form, was yet to be felt in the work of Hans the Elder when his sons were very young. The *Basilica of St Paul* painting bears all the marks of northern, gothic art. The perspective is empirical, the composition essentially two-dimensional, the drapery of the figures still with stylized, angular folds, and there is no reference to classical ornamentation. Within a decade, however, this had changed.

In 1512, again working for the sisters at St Catherine's, Holbein the Elder delivered another altarpiece, 'Martyrs and Miracles', this time embellished with Italianate, classical decorative elements. Four panels are extant, two showing the martyrdoms of St Catherine and St Peter, another the Miracle of St Ulrich and St Conrad, and one depicting the Virgin and St Anne holding the hands of a baby Christ. Each panel is embellished with classical motifs in gold leaf in its upper portion. Trumpeting and dancing putti cavort across the top of the work, their chubby limbs entangled with vines. In the depictions of Saints Ulrich and Conrad, the painter dispenses with a gothic architectural setting and instead surmounts marble pillars with Corinthian capitals, decorated with curling acanthus leaves. Those pillars not supporting round Romanesque arches provide perches for chubby, kneeling putti.

Meanwhile in the panel featuring St Anne and Mary, the figure of a baby Christ is standing in typical contrapposto, the sinuous stance antique sculptors bestowed on their subjects, and one that any Augsburg painter could have researched by looking at a Roman figure of Mercury that had been excavated in the city and was a point of interest at the time.

The growing preference for a Renaissance style, featuring classical decorative elements, reflected more generally the changing tastes of the great and the good in Augsburg, who both adopted and consequently established what was deemed fashionable. With so many of Augsburg's major patrons travelling regularly to Venice and Italy it is hardly surprising that an appetite for the Renaissance aesthetic was growing.

The aesthetic choices of the Fugger dynasty were a case in point. In 1510 Jacob Fugger, along with his brother Ulrich, saw work begin on a family chapel at the Carmelite convent in Augsburg that is now widely acknowledged as being the first full Renaissance interior built in Germany. Fugger modelled his chapel, with its marble pilasters, rounded arches, balustrades and putti, on the Venetian churches he had grown familiar with – specifically Santa Maria dei Miracoli. The organ, equally Renaissance in style with golden putti and winding vegetable motifs, was decorated with wings by Jörg Breu, another Augsburg artist. Albrecht Dürer designed bas-relief epitaph slabs for it. Not only had the latter lived and worked in Venice, but he had already completed a painting of the *Feast of the Rosary* for Fugger in the city's German church.

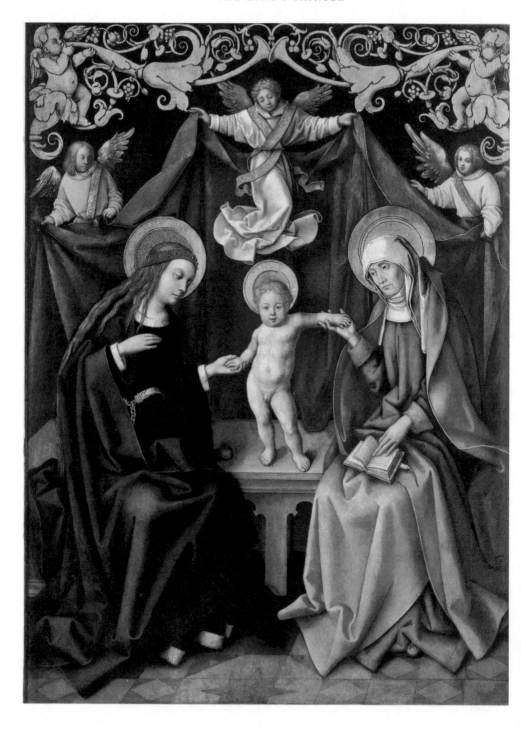

Fugger's Renaissance innovations did not end there. Once his chapel was finished in 1512, he demolished a series of houses along Maximilianstrasse and used the site to build himself the palace that still stands today. Once again he based it on drawings he had made himself in Venice. It was the biggest house in the whole city, with a footprint comparable to that of the cathedral, and in it Fugger housed his collection of Italian Renaissance paintings, including a portrait of him by Lorenzo Lotto.[7]

Fugger commissioned Hans Burgkmair to cover the façade of his new property with frescoes, replete with Italianate, classical detail. Burgkmair was well placed to find a visual language that would match the Renaissance references in the palace's architecture, since he, like Dürer, had also made an extended tour to Italy a handful of years previously, possibly under Fugger's encouragement.

But the Renaissance ideas achieved ultimate endorsement in Bavaria when the Emperor Maximilian also showed an interest in classically themed projects. The emperor had become fascinated by the idea of a legacy of power, handed down from Rome to his present German nation. Assisted by Conrad Peutinger, he determined to publish an illustrated ancestry, or *Genealogie*, that traced his roots back to Hector of Troy. Burgkmair was contracted to illustrate it. At the same time Burgkmair was also deployed to work on woodcuts of medallions to illustrate a *Kaiserbuch*, chronicling emperors from Caesar to Maximilian, which used the coins and medals in Peutinger's collection as sources. And as if these two projects were not enough, Maximillian's obsession with classical culture extended to commissions for woodcuts of a Triumphal Procession celebrating his rule which Burgkmair, along with Albrecht Dürer, was tasked with designing, while the latter was also commissioned to create a visual depiction of a Triumphal Arch. This last, completed in 1515, was one of the largest prints ever made, comprising 195 blocks.

It is little wonder that where Maximilian and Fugger went, others

opposite Hans Holbein the Elder, *The Virgin and Child with St Anne*, Martyrs and Miracles Altarpiece, oil on softwood, *c.*1512.

Roman figure of Mercury excavated in Augsburg.

followed. In 1513 Philipp Adler, another wealthy Augsburg merchant, asked Hans Holbein the Elder to make his portrait, and it comes as no surprise that he wanted something of the new Renaissance style applied to the work. Holbein's ability to comply with this demand was important for his commercial survival.

Adler was yet another Augsburger who had married into the Welser dynasty. He was also part of the circle associated with the convent of St Catherine and his face even crops up in the Martyrs and Miracles altarpiece painted for it. A sure indicator that Adler helped fund the altarpiece is that we see him in the background of the *Martyrdom of St Catherine*, wearing the item of expensive headgear that had come to define him about town – a large fur hat.

When it came to painting Adler's portrait, the same huge fur hat is once again featured. In fact, given the similarity of both depictions, Holbein probably used the same preparatory sketches. But whereas in his earlier portraits Holbein, like so many of his contemporaries, had presented his subjects in the most simple manner, against a plain background, in this portrait the use of Renaissance motifs is extensive. Adler is shown standing between classical pillars, surmounted by an architrave featuring decorative carved putti and acanthus vegetation. What is more, he is confined behind a sill, as if he is standing on a balcony, a framing device much favoured by Italian Renaissance artists such as Leonardo da Vinci.*

Hans Holbein the Elder, *The Martyrdom of St Catherine*, Martyrs and Miracles Altarpiece, oil on softwood, *c.*1512.

In 1515 Veronika Welser also moved to fully embrace the Renaissance style. She demolished the old church at the convent of St Catherine's, and commissioned Hans Hieber, who had built Fugger's Renaissance chapel, to erect a similarly fashionable structure for her establishment.

Gregor Erhart, who in the twilight of the fifteenth century had worked alongside Holbein the Elder in the production of the Sebastian reliquary, now produced a vision of Mary Magdalene for this new structure, so clearly classical in its references that even today it has a markedly powerful effect on the viewer.†

The mystic ascetic who, according to legend, lived in a cave clothed only by her hair, is celebrated in a near life-size depiction of a beautiful nude woman, which would have been suspended from the ceiling

* Now in the Kunstmuseum, Basel.
† She is now in the Louvre, Paris.

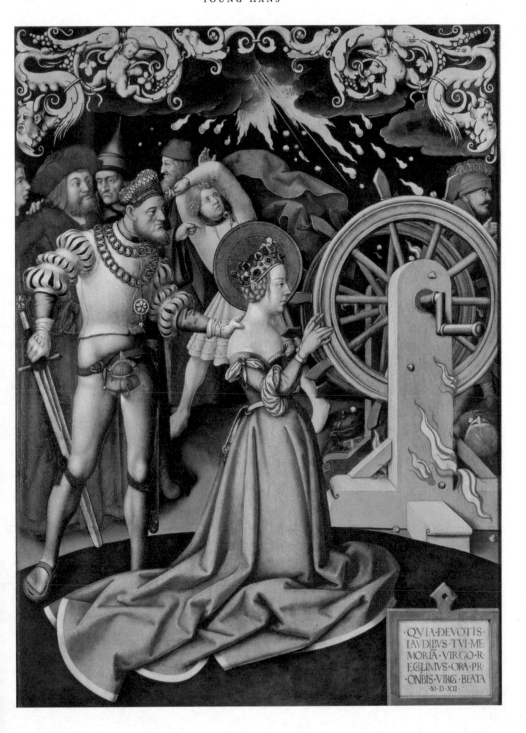

·QVIA·DEVOTIS·
LAVDIBVS·TVI·ME
MORIĀ·VIRGO·R·
ECLIMVS·ORA·PR·
·ONBIS·VIRG·BEATA·
·M·D·XII·

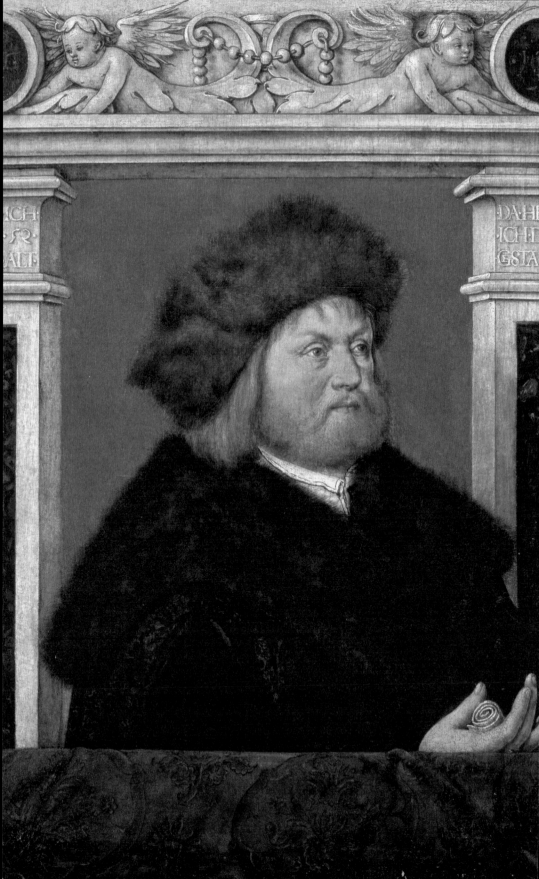

as if ascending to heaven. Mary Magdalene stands with a thrusting hip in the tradition of classical contrapposto, her long golden locks wrap around her body, though her breasts, part of her torso; hips and legs are fully revealed. This was far more reminiscent of classical nude statuary than the medieval versions of the saint which saw her fully concealed, top to toe, her hair forming something akin to a long robe. The allusion to Sandro Botticelli's *Birth of Venus*, painted more than thirty years earlier, seems clear, with the Magdalene's legs in almost exactly the same pose, suggesting that Erhart may have seen the painting, or one of its workshop versions. Whereas Botticelli's Venus wraps her arms around her body, Erhart's Mary Magdalene has her hands joined in prayer. This is also similar in composition to a woodcut of the same subject by Dürer circulating at the time. He too was also clearly exploring the potential of the classical nude in this context, and may have been an alternative reference for Erhart.

In 1516, Hans Holbein the Elder delivered a triptych featuring once again that ever-popular Saint Sebastian. The central panel was dedicated to the protector against plague, whereas the side panels depicted female saints, Elizabeth of Hungary and Barbara. The two side panels adopted fulsome references to Italian Renaissance style, which

Hans Holbein the Elder, *Philipp Adler*, oil on limewood, 1513.

suggests that the painting was very probably for Veronika Welser's new church, and intended to complement both the architecture and Erhart's statuary. The question is: how much of this Renaissance element in the output of the Holbein workshop was down to the father, or can it be attributed, at least in part, to his supremely talented son?

Today this St Sebastian altarpiece is in the Alte Pinakothek in Munich. The central panel features a wonderfully coloured depiction of the saint, whose tormentors and onlookers are delivered with an intensity of observation that is captivating and entirely typical of Hans Holbein the Elder's detailed eye and warmth of personality. He shows us one soldier in an elaborate striped costume with slashed sleeves, kneeling to calibrate his crossbow, the bolt gripped between his teeth as he does so. Another soldier, his back to the viewer, is a study in the exotic apparel of an Ottoman, his gold tunic heavily patterned and his pointed helmet wrapped with silk. The composition is sophisticated, with figures arranged so that there is a sense of movement across the surface of the work. The overall colouration is a careful balance of

blues, pinks, golds and greens. The perspective in the main painting is still essentially empirical rather than linear, with a sense of distance and a wider world delivered through glimpses of a town and its attendant turrets serving as a background to events, while misty blue mountains are portrayed even further away. The townscape is notably Northern European in terms of its architectural character, with gabled roofs, round towers and pointed turrets.

However, the two wings dedicated to female patron saints are entirely different. While their background settings continue details of the northern architecture featured in the main painting, the saints stand in the foreground, on a raised stage, surrounded by classical pillars and decorative classical friezes that speak of an entirely different culture. And in contrast to the empirical perspective of the main panel, these two women are standing on tiled floors, which in so much of the work by Holbein the Elder offer merely pattern, but now ground them within dimension and space. While the figure of St Barbara is depicted in three-quarter profile, her back arched and dress pushed forward in a more typical gothic stance, Elizabeth of Hungary stands face on with a contrapposto swagger consistent with classical statuary. The energy and dynamism of Elizabeth jumps out from the rest of the altarpiece.

Gregor Erhart, St Mary Magdelene, polychrome limewood, 1515–20.

It is not just the contrapposto stance that delivers an S-shaped sweep across the surface of the canvas; Elizabeth's gown is wrapped around her body to accentuate the effect. Even the veil around her head is twisted to give a sense of animation.

Looking at the work in reproduction it is tempting to conclude that here the virtuoso Holbein the Younger has been given the opportunity by his father to make a significant contribution to the altarpiece panel. In doing so he would be not only showing off his superior skills in figurative work, but placing himself in the vanguard of the latest thinking on beauty and form.

But looking at the work in the flesh, this conclusion is much harder to reach. The brushwork, colouring and even facial features of the two female saints are stylistically indistinguishable from one another. Nevertheless, the Elizabeth feels as if it springs from a different sensibility.

Looking back at the Martyrs and Miracles altarpiece for St Catherine's that Hans Holbein the Elder made four years earlier, a

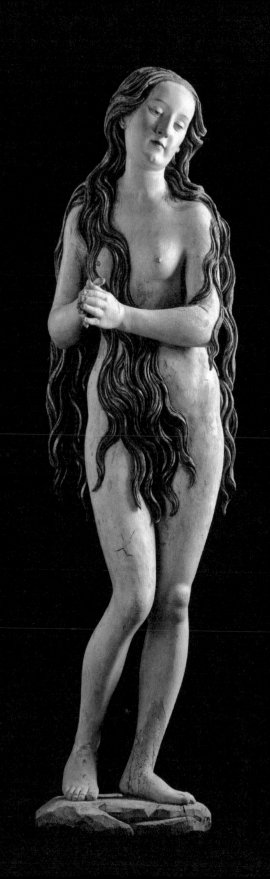

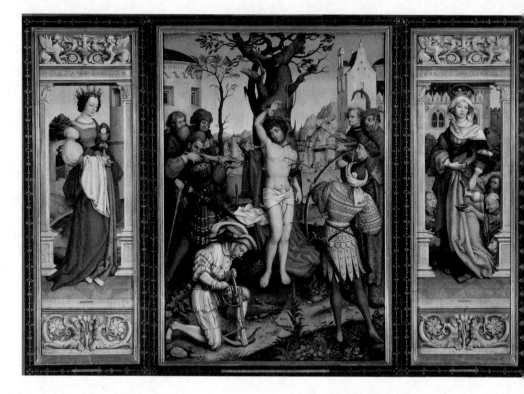

Hans Holbein the Elder, *St Sebastian Altarpiece*, oil on limewood, 1516.

similar tension is at play. The Renaissance decoration in gold leaf, the plump putti featured in it and even the figure of Christ offer a contrasting aesthetic to the gothic angels also presented. Hans Holbein the Elder has not delivered a piece entirely informed by Renaissance elements, rather he has delivered a generally gothic painting, with some Renaissance aspects. Could his namesake son have painted the golden Renaissance embellishments here and perhaps suggested the outline of Christ? Similarly, in the St Sebastian altarpiece, might Holbein the Younger have designed the Renaissance architectural motifs on the wings, and the figure of Elizabeth?

This is entirely feasible given the traditions of the family-run workshop. Although the Holbein business employed talented artists such as Leonhard Beck, there is no doubt it would also have served as a training ground for Hans and Ambrosius. Typically, junior assistants would have learned how to grind pigments, prepare materials and help with colouring while learning the craft of drawing by copying and

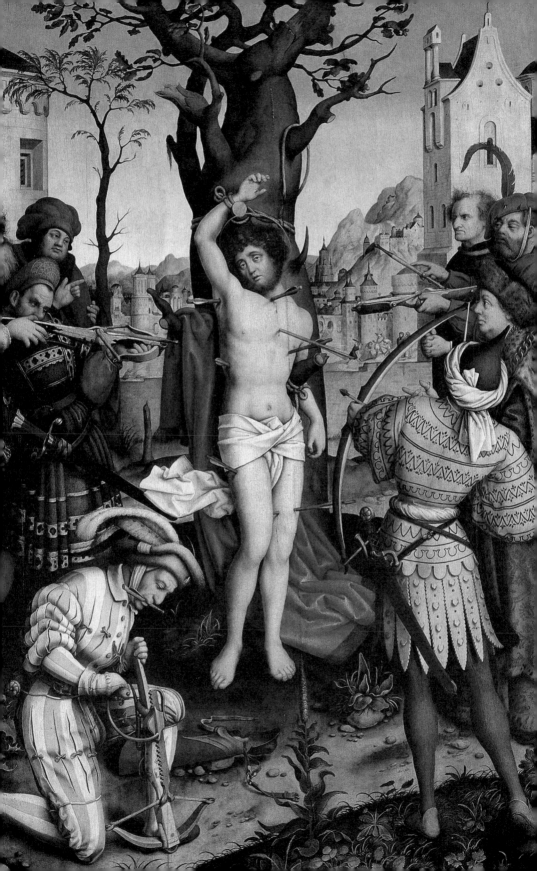

studying the work of their elders. Paperwork dated 1508 suggests that one of the boys was already assisting on a commission for an altarpiece delivered to the Church of St Moritz in Augsburg. The junior member of the workshop was tipped a guilder for his contribution when his father received his final payment.[8] It is normally assumed that this payment was to a teenage Ambrosius, for surely an eleven-year-old Hans was too young to be working alongside his father? One cannot be so sure.

For all its suggestions of the father giving the younger artist a step up in the world, the St Elizabeth panel in the St Sebastian altarpiece also delivers a tragic insight into the story of Holbein and his father.

Within this panel is the third in that series of family portraits Hans the Elder painted as part of his work for St Catherine's. The saint is featured pouring water into a beggar's bowl, held by one of three figures who are sitting or kneeling at her feet. Both the man holding the bowl and a young boy opposite him are clearly lepers, covered in the tell-tale lesions symptomatic of the disease. Their presence is expected in a dedication to the patron saint of leprosy. Some have suggested that the boy, his head shaved close, is yet another portrait of Hans the younger, and indeed the features are consistent with other images of him. The distinctive nose of the man holding the bowl suggest this figure might be based on Sigmund Holbein. Meanwhile the bearded figure who shows no signs of illness is another portrait of Hans Holbein the Elder, his drawing on which this painted portrait is based, is today in the collection of the Musée Condé. What rationale might possibly exist for placing a self-portrait at the feet of the saint who was the recognized patron of lepers? However, St Elizabeth of Hungary was not just the patron saint of lepers. She was also the patron saint of paupers. Once this is taken into consideration the inclusion of Hans the Elder at her feet sounds a poignant note in the composition. Hans Holbein the Elder was always running out of money. As the impoverished artist acknowledges his financial woes for all the public to see, is he making a self-deprecating joke or a plea for saintly assistance? In truth, it was probably both.

In 1516 life was changing for Hans Holbein the Elder and his namesake son. Money was at the heart of the matter. Or rather lack of it. The Sebastian triptych would be the last work the Holbein workshop delivered to St Catherine's, ending a relationship with the nuns there that had endured for twenty years. It was also probably the last piece of work Holbein the Elder made in the city of Augsburg.

The financial decline of Holbein the Elder stands in sharp contrast to the stories of those celebrated painters from the past that were being rediscovered by humanist scholars. One wonders when Holbein the Younger first heard the tales of the great painters of antiquity. Had Peutinger or other members of the Sodalitas Augustana shared them with him? The cult of the Ancient Greek painter Apelles of Cos had been growing in Italy throughout the fifteenth century. Drawing on accounts by Pliny and Lucian, Leon Battista Alberti had described Apelles' painting *Calumny* in his *Della Pittura* in the 1430s. By the time that Holbein's father was a rising star in Augsburg in the 1490s Sandro Botticelli had painted his own rendition of *The Calumny of Apelles*. And around 1500 the humanist Conrad Celtis had addressed Holbein the Elder's rival Albrecht Dürer as a second Apelles in a poem dedicated to the Nuremberg-based artist.

Hans Holbein the Elder, Detail of *St Sebastian Altarpiece*, 1516.

Pliny's accounts had revealed an idea of the painter in the classical world quite different from the subservient and often anonymous craftsman of medieval Europe. Apelles and his friend and rival Protogenes were famous individuals who enjoyed a creative and professional freedom. Their work was prized. Their talent eclipsed any inherited status. What their contemporaries most revered – indeed adored – in these two exceptional artists was their creativity and virtuosity. Pliny tells the story of Apelles calling one day at Protogenes' studio and, on finding his friend out, drawing a line on a blank panel. This line was so fine that Protogenes immediately recognized his friend's signature work and applied his own finer line over the first in a different colour. But when Apelles returned, he applied yet another, *finer* line over this. And this third line was the mark of ultimate virtuosity that Protogenes could not better. Pliny saw the work, first hand, displayed in the palace of Augustus on the Palatine.

In this version of the classical artist, where talent was liberated from a spiritual or moral harness, where it was subservient neither to

a higher otherworldly authority nor to the whim of a patron, great art bestowed prestige on those who acquired it and it was the patrons who battled for the services of the artist rather than vice versa.

For Hans Holbein the Elder and his contemporaries in Northern Europe, the experience of being an artist was still considerably different, however, despite the parallels that contemporary poets chose to draw. Holbein, like the rest of his extended family of painters, was part of a guild that regulated production within the city. The organization was essentially protectionist, controlling the number of masters, keeping foreign competition at bay and preventing underselling from the less skilled. Unfortunately, however, in terms of achieving good prices for its members' work, the power of the guilds within the wider socio-economic context of the medieval city had come under pressure from town councils who had intervened to set prices convenient for the powerful patrons who held sway. As such the protectionist aims of the guilds had also served to condemn their members to social and economic inferiority, and certainly by the early sixteenth century many guildsmen were slipping into poverty.[9] Hans Holbein the Elder was no exception. Despite the busy workshop that he ran with his brother Sigmund, and his evident success, his was a life dogged by debt.

Such was the economic pressure, Holbein the Elder often went beyond the bounds of the city to make ends meet. Despite the clear appetite for his work at home in Augsburg, he and Sigmund made extended visits elsewhere. In addition to Ulm where he spent much time, Holbein, Sigmund and their apprentice Leonhard Beck set off for Frankfurt where they stayed over a year, completing a major altarpiece for the Dominican church there in 1501. Where were Ambrosius and Hans while the family breadwinners were away? One can only speculate that their tender ages meant that they remained at home in Augsburg with their mother. It is notable that this pattern of paternal absence was one that Holbein the Younger would replicate with his own family in due course.

Despite his extensive commissions both in Augsburg and more widely in the region, records of his payments provide a sorry tale of Holbein the Elder's descent into hopeless debt. During extensive work for the Church of St Moritz around 1506 and 1507, when Hans Holbein the Younger would have been nine or ten, his father won a commission worth 100 guilders with a 10 per cent down payment.

However, the records suggest he made demands for several further advances long before he completed it, and there is evidence also of exceptional levels of borrowing on the elder Holbein's part – from all sorts of folk including, at one point, the wife of the church warden.[10] In 1508, after Holbein won another major commission, some of his creditors were paid in his stead, notably one Thoman Friehamer. Holbein was by no means exceptional in his inability to make ends meet from painting. Around 1511 his contemporary, Dürer, had given up painting altarpieces precisely because of their unprofitability.

Matters for Holbein Senior came to a head in 1516. In this year he faced creditors in court three times while trying to complete the St Sebastian altarpiece, and before the end of the year the bailiffs had been called in to dismantle his home. Hans Holbein the Elder, his business in disarray, packed up his brushes, pigments, and the other tools of his trade, and fled the family home in Vorderer Lech with a loan from Sigmund to help him on his way. But when even that had not been repaid by the following January, Sigmund also sued his brother for the 34 florins that he was owed.[11]

These were events from which the family could never recover. Although Hans' and Sigmund's four married sisters all continued their lives in Augsburg, the days of the Holbein workshop were truly over. Despite their considerable achievements there, the city had become such a toxic environment for the Holbein brothers that they were obliged to flee Augsburg. After two decades of success the brothers started over again, as far away from their original patrons as they possibly could, and far away from one another.

Sigmund moved to Bern in Switzerland, where he started a new business from scratch. He casts a solitary figure there. In a will made a quarter of a century later there is no mention of a wife or children, though he had acquired what he describes as 'small property' which he 'accumulated and hoarded [...] entirely by my works'. This small property was in fact a house with a courtyard and garden on the sunny side of the city's Brunnengasse, not far from 'Görg Zimmerman the tailor's house'. Sigmund's will suggests he had finally made a reasonable recovery from the financial disaster that forced him to the Swiss city. His house was comfortably furnished with a number of silver utensils, as well as the standard tools of the artist: 'colours, painter's gold and silver, implements for painting and other things'.[12]

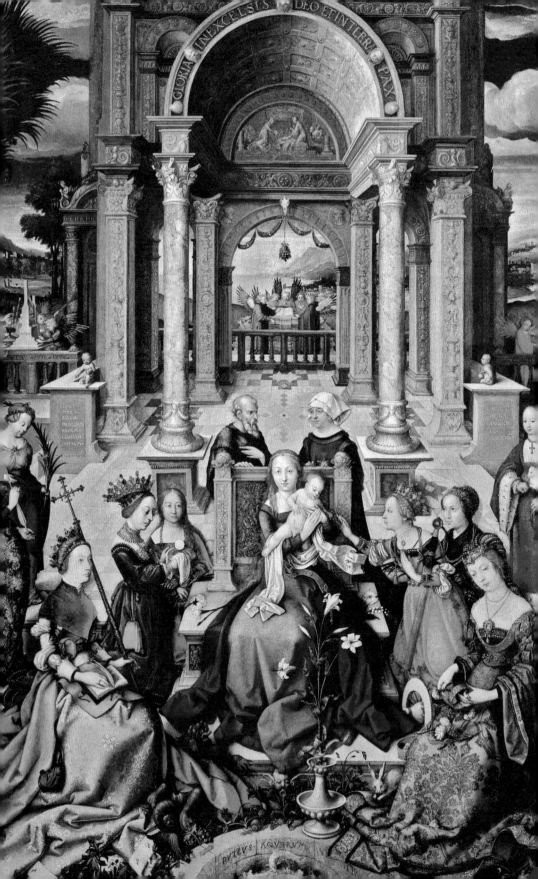

What this will also reveals is the complete dedication Sigmund retained to the star of the family, 'my dear nephew Hans Holbeyn, the painter'. He makes a point of noting in his will that the legacy he leaves his relative is not just because of their 'blood relation' but because of 'the especial love I bear him and [...] The affinity in which he stands to me'. Despite being written long after the tender portraits of Hans were included in the devotional paintings for St Catherine's, these words reinforce the sense that the boy was especially loved by those around him.

Some remnants of the Holbein workshop in Augsburg clearly remained, since Sigmund leaves 'whatever I have left belonging to me at Augsburg' to his three living sisters to divide between themselves. However, he goes on to warn them not to press any claim to his assets in Bern, nor to 'annoy my nephew Hans in any way'.

Hans Holbein the Elder meanwhile took off for Isenheim in Alsace. The talented painter Matthias Grünewald had just completed his astonishingly original altarpiece for the Monastery of St Anthony there. Here Hans Holbein the Elder began one of his last, great, works, *The Mystical Marriage of St Catherine*.* It is a painting typical of Holbein the Elder's work, with its sense of acute observation. Here the women surrounding St Catherine are depicted in exquisite detail: the brocade of their dresses, the books they hold, the sewing in their hands. Yet now Holbein the Elder dedicates half his work to the depiction of a massive, complex, classical arch rising above the figures. Perhaps once more this was based on a design that he worked on with his son? Whether this is the case or no, it was an important statement from a painter who could see his rivals such as Dürer excelling and wanted to say something about his own ability to move with time and taste. In the *Mystical Marriage* the painter acknowledges the new Renaissance world that is making itself felt in Northern Europe and beginning to dominate the old ways.

Hans Holbein the Elder, *The Mystical Marriage of St Catherine*, oil on wood, 1519.

So what had happened to the young, cherished Hans? What is clear is that while the senior Holbein brothers split after 1516, Hans' two sons stayed very much together.

Ambrosius, who would have been about twenty-one years old at that time, had probably already been travelling as a journeyman,

* Now in Portugal in Lisbon's National Museum of Ancient Art.

before enrolling in the workshop of Hans Herbster in Basel, in Switzerland. With family troubles in Augsburg there is little surprise that his younger brother joined him there at some stage in 1515.

Just as the members of the Holbein family settled into their new lives, the events that would change the complexion of European art had begun. Like Holbein the Elder's personal downfall, the momentous religious and political events that would shortly transform the continent owed something to money and Augsburg.

In 1514 Jacob Fugger, the Augsburg banker, patron of Dürer and Holbein the Elder, and passionate advocate for Renaissance style, loaned one Albrecht of Brandenburg an enormous sum of money to help him buy his way to becoming Archbishop of Mainz. The then Pope, Leo X, found Albrecht's preparedness to pay such a huge sum for the position too good to turn down and the position of Mainz was his. Albrecht suggested to the Pope that the loan he had taken out from Fugger might be repaid through an issue of indulgences – the Papal absolutions that lay people could buy to ease their passage in purgatory.

Leo was in the process of rebuilding St Peter's Basilica in Rome, and so he and Albrecht devised a scheme that would see indulgences sold ostensibly to fund this building scheme, but in reality see the money raised split between the project and the repayments owed Fugger.[13]

The responsibility for selling the St Peter's indulgences was given to a priest called Johann Tetzel, who was to concentrate his efforts in Germany, where the appetite for spiritual self-help was believed to deliver better results than in France or Spain. Though he was banned from entering Saxony by Duke Frederick, who saw the venture as a threat to the income that his relic collection generated, Tetzel began a trip in 1516 that would take him across the rest of Germany over the next two years. Carrying bibles, crosses and a large chest with a painting of Satan on it into which money was paid, he sold indulgences for 20 to 25 florins for the top tier of society, three for the merchant classes and a single florin for the rest. Fugger's accountants travelled with Tetzel's party.

Although Tetzel and his band of Papal commissioners were unable to enter Saxony, news of their progress naturally reached those within the region. On 31 October 1517, the same day that pilgrims were flocking into the city for the annual viewing of Frederick's relics, the

chair of theology at the University of Wittenberg, Martin Luther, decided to make a stand. He wrote in protest to Albrecht the Bishop of Mainz, including with his letter a *Disputation on the Power and Efficacy of Indulgences*, in which he questioned, among other things, how forgiveness could be purchased, and the propriety of a wealthy Pope building St Peter's with money from the poor. Some say that he also nailed this Disputation to the door of the All Saints' Church in the city. In doing so his voice joined those of others who were calling for change within the Catholic Church. In due course Luther's uncompromising and continued assault on Rome would encourage dedicated followers, and Lutheranism would evolve fast as an aggressive agent in the Protestant Reformation.

At the point Luther penned this protest against what he saw as corruption in the Catholic Church, Hans Holbein the Younger had been in Basel for over a year. His ambition to succeed must have surely been sharpened by his father's recent failure. Indeed, future events indicate Holbein's strong desire to acquire a level of wealth that had always eluded his father. Fortunately for Holbein, Basel was a crucible in which the ingredients for success in a new Renaissance world were already bubbling away.

Basel had nothing to match the grandeur and opulence of Augsburg, nor the wealth of the latter's banking dynasties. But Basel did have publishers of international repute and a formidable printing industry at a time when the power of the press was just beginning to be felt. As Dürer had already acknowledged, print offered artists a far higher return on their labour than paint.

Basel also had a European celebrity in its midst, a man whose wit, intellect and erudition had been noticed by Europe's kings and whose work was read widely by their subjects. In fact, it has been estimated that up to 20 per cent of all the books in circulation in Europe at this time bore his name. This man was the revolutionary thinker and embodiment of humanism, the Dutch scholar Desiderius Erasmus, or Erasmus of Rotterdam.

As it happened, the fame and influence of Erasmus would also prove a potent catalyst for the young painter's reputation, and propel his career more powerfully than the patronage of even the richest bankers in the world.

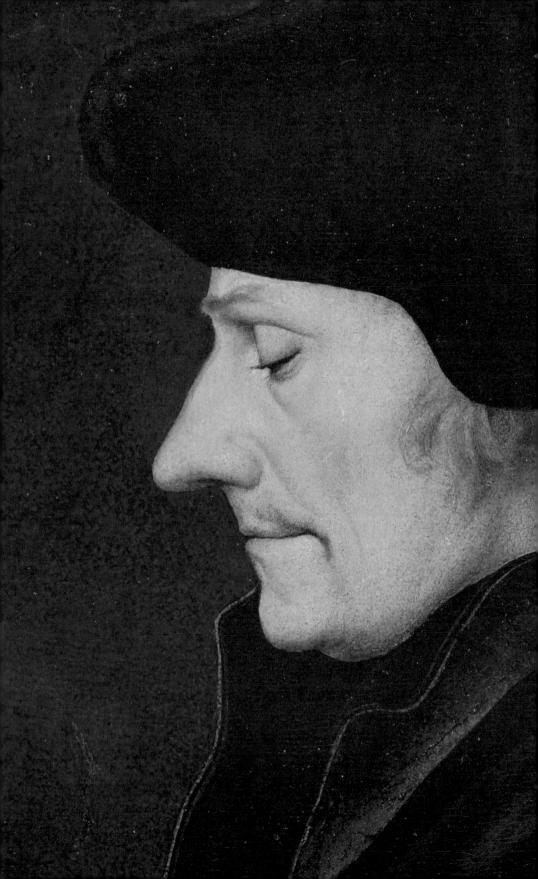

ERASMUS

In 1580, almost forty years after Hans Holbein the Younger died, Basilius Amerbach, an ardent collector of Holbein's work, noted that there were at least five portraits of Desiderius Erasmus by Holbein still hanging in the city of Basel.[1] During the course of Holbein's career two of his portraits of the humanist scholar and literary phenomenon had been taken to England, and the painter himself had also travelled to France with a third, so, unless some of these had made their way back to Basel, simple mathematics suggest that in the late sixteenth century there were eight original paintings of Erasmus by Holbein himself.[2] The probability is that he had made even more depictions of a man who, when Holbein encountered him, was not only hugely famous but whose writing was profoundly shifting the intellectual landscape of Europe. Add to these original portraits a small industry in copies from his workshop and the workshops of other artists, and a widely reproduced woodcut of the scholar by him, and one begins to get a sense that at the time when Erasmus's fame was at its apex, he was seen increasingly through Holbein's eyes.[*]

Hans Holbein, *Desiderius Erasmus*, mixed media on paper, mounted on fir wood, 1523.

Grateful though Erasmus may well have been to Holbein for so brilliantly capturing his likeness, the burden of debt that the painter owed the scholar was far greater. The name Erasmus was on the lips of Europe's intellectuals long before Holbein's own name gained recognition. Such was the influence of this luminary of humanist scholarship, the painter who could depict him in physical form for his vast readership was the real beneficiary of their relationship. The prestige of being associated with a man who sought to influence the kings of Europe was considerable.

Erasmus's influence on Holbein's life and work went beyond the promotional value of his endorsement, however. The Holbein we know today is unlikely to have emerged without the influence of Erasmian thinking. Holbein's work would become informed by Erasmus's new world view and reformist opinion. Importantly, the artist became woven into the creative circle that orbited around the scholar. In addition, it was Erasmus who would ultimately steer Holbein's career towards England. At a time when the arts on the continent were beginning to perish, Erasmus gave Holbein his passage to Tudor London,

[*] Albrecht Dürer also made a famous engraving of Erasmus, and Quentin Metsys had also depicted him.

the court of Henry VIII, and his subsequent stellar career there.

Given this unique connection between Erasmus and Holbein, it is no small wonder that a man determined to memorialize both of them would consider the portrait of Erasmus that Holbein himself owned as having particular value. When Holbein's Basel workshop was dismantled after his death in the 1540s, Basilius's father, Bonifacius Amerbach, went to Holbein's widow Elsbeth, to secure the portrait of Erasmus that Holbein had always kept for himself. Bonifacius had had close relationships with both men. He had been one of Holbein's earliest patrons, and became Erasmus's heir and executor. Now he added this particularly significant portrait to his own unique contribution to world culture, the 'Amerbach Cabinet'. This was Bonifacius Amerbach's collection of fine art, curiosities and antique items. Incorporating Erasmus's own collection of artefacts, Bonifacius and his son Basilius would continue to collect works by Holbein for the Cabinet throughout their lives.

Holbein's personal portrait of Erasmus, executed on paper and mounted on wood, may well have served as a master for those studio copies that remained in demand. It is the most simple of all his known versions of the humanist. Erasmus is seen in profile, writing with his signature reed pen, which he preferred to a quill. He is set against a plain green background that offers no distraction from the matter in hand: the words Erasmus is in the process of writing onto a piece of paper or parchment. It is his commentary on the Gospel of St Mark: 'Everything mortal is implanted with the striving towards happiness.' The quotation may well have been chosen by Holbein as a good-humoured reference to the subject, for Erasmus, despite his ecclesiastical background, was known to enjoy home comforts. Meanwhile, if happiness for Holbein rested in success, then Erasmus's contribution towards the painter's personal contentment in life was immeasurable.

Part of Erasmus's brilliance was his ability to grasp new opportunities. Since the goldsmith Johann Gutenberg had invented the printing press at some point in the 1540s, mass-produced literature had become a new kind of merchandise that was enjoying increasing popularity across Europe. Though essentially a luxury commodity, printed books could nevertheless have profound and explosive ramifications, since they made possible the dissemination of ideas both speedily and to a wide audience. Erasmus was a man who had

understood the potency of the printing press and whose profile was rising with the number of his publications. His output was varied. On the one hand he was a humourist and a populist, on the other an erudite classical and religious scholar.

Born in 1466 and a one-time monk, Erasmus had put cloistered life behind him and had instead sought a life of scholarship in various European cities including Paris, and the Belgian city of Louvain. A young English nobleman, William Blount, 4th Baron Mountjoy, whom Erasmus was tutoring in Paris, invited him to England in 1499 and here he pursued a successful career, initially at Oxford University and later at Cambridge, where he was a professor of divinity. Though he always grumbled about English weather, wine and beer, he enjoyed English company and became close friends with a number of reformist thinkers including the dean of St Paul's, John Colet, and John Fisher, the chancellor of Cambridge University. But the man to whom he grew closest was one who shared his combination of heightened wit, dry sense of humour, deep faith and erudition – the prominent lawyer and statesman Sir Thomas More.

It was during Erasmus's first stay in England, and while strolling at Eltham Palace with More, that they encountered the young Prince Henry, who was just eight at the time. More had come prepared for his encounter with Henry VII's second son and had produced a little verse to give to the precocious and well-educated boy. Erasmus had not, and when challenged by the young prince to write something, he rushed back to Mountjoy's home to write a poem. He offered it to the prince with a promise that in the fullness of time he would present more.

Erasmus's passion was classical literature and he had first found popular acclaim in 1500 when he published *Adagia*, or *Adages*, a collection of proverbs and sayings from the Greek and Latin canon, which his readership clearly enjoyed repurposing for a new era. With phrases like 'In the land of the blind, the one-eyed man is king', 'No sooner said than done' and 'A rolling stone gathers no moss', Erasmus's fame and popularity was secured.

Alongside this entertaining aspect to his literary endeavour was a far more serious one. Erasmus saw warmongering as the great problem of his time. He found it hard to reconcile Christian values with the cruelty, casualties and poverty that accompanied Europe's endless

conflicts. In 1503 he published his *Handbook of the Christian Soldier*, in which he offered advice to his readers on how to live better lives. Urging all Christians to follow the example of Christ and the saints, rather than merely worship them, this represented a move to seeing spirituality as rooted in the behaviour of the individual rather than the institution of the church. Though Erasmus could hardly have known it at the time, the massive take-up of this book would popularize a stance that would pave the way for Luther's revolution.

At the very heart of his work was a new scholastic approach to scripture that acknowledged the Bible as the literary output of men. As such Erasmus had realized that the Latin Bible, or Vulgate, used by the Catholic Church was subject to mistranslations from the original scripture written in Greek. Consequently he dedicated himself to learning Greek, and in doing so to correcting the Bible.

This study was highly controversial. A correction of a sacred text could, and did, lead to new interpretations of the scripture. For example, his discovery of what he believed was a mistranslation of the original Greek version of Corinthians 7:10 meant that according to Erasmus Paul did not talk about the need for 'penance' but of the need to feel 'remorse'.

For a Catholic Church that promoted penance as a central ritual, and the clergy as sanctified to oversee it, such a shift in perspective was going to be problematic. But it was a position that placed Erasmus in the vanguard of those who felt the church needed modernization.

His strong sense of humour and irony encouraged Erasmus's next major success *In Praise of Folly*, or the *Moriae Encomium*. This was a book conceived during a stay with Thomas More in England in 1509, the year that the young Prince Henry, whom Erasmus had met years earlier, was crowned king. Henry's elder brother Arthur, Prince of Wales, had died unexpectedly in 1502, leaving his younger brother with the burden of the crown. Erasmus and More, however, both had high hopes for England's new king. They saw a young man open to humanism and its values, a man who might set a new example for other European princes. More was so delighted he wrote a suite of poems for the new king's coronation.

Meanwhile, *Moriae Encomium* was a pun on More's name, which reminded Erasmus of the Greek word for folly. A reflection no doubt on conversations in which More and Erasmus had discussed the

wrongs of the world, both serious and not so, it was a satire in which Erasmus embodied Folly as a woman poking fun at human vanity and hypocrisy. Her attacks on religion, however, are harsh and reflect Erasmus's own frustrations with the church, its shallow materialism and double standards. Bawdy monks, greedy bishops and wealthy popes, with their indulgences and dispensations, all come under fire.

Peripatetic by nature, Erasmus arrived in Basel in 1514, a year before Holbein. He was a small, delicate man, humorous, sometimes acerbic, prone to sickness and approaching fifty years of age. Erasmus's decision to come to Basel had been hardly random. The city had become the most important centre for books and printing in Northern Europe, and in this regard it had become a rival to Venice – where Erasmus had also worked and been published some years earlier. The publishing establishments in Basel had built a reputation for supporting humanist work, and for offering classical texts in new translations and with new interpretations. As such the whole printing and publishing industry there depended on partnerships with scholars.[3] For a town such as Basel, Erasmus was a new resident to be prized.

Of the city's fifty or more printing houses, the most prominent was that run by Johann Froben, and it was to Froben that Erasmus immediately went. He announced himself with his typical sense of fun. 'To Johann Froben I delivered a letter sent by Erasmus,' Erasmus wrote to a friend, adding that

> I stood in closest friendship to him and that the whole business of publishing his Lucubrationes was entrusted to me by him so that whatever I might do would be just as valid as if done by Erasmus, and finally that I looked so much like him that whoever might see me would see Erasmus. Then he laughed, having caught on to the joke. Froben's father-in-law, who paid all we owed at the inn, moved us, along with our horses and baggage, into his house.[4]

Installed, and clearly happy with the generous hospitality of the Froben household, Erasmus began working on another version of his ever-popular *Adages*. Also in hand was a revised edition of the *Life and Works of St Jerome*, a saint whom Erasmus identified with since the latter was both a man of God and, as the first translator of the Bible into Latin and a commentator on the Gospels, one of the most authoritative early Christian scholars. A mark of Erasmus's ambition and intellectual confidence was that he saw his own *New Testament in*

Greek, which was also in production, as a task akin to Jerome's earlier one.

The Froben and Amerbach families were tight knit. Johann Amerbach, Bonifacius's father, Basilius's grandfather, had also been a leading light in the Basel publishing business, and an extraordinary force in the humanist movement. He had studied at the Sorbonne under the man who had set up the first printing press in France, the theologian Johann Heynlin. No doubt inspired by his pioneering tutor, Amerbach set up his own printing and publishing business in Basel in around 1478. It initially produced treatises, collections of letters and grammars for the study of Latin, before going on to provide editions of texts written by fathers of the church.[5]

Johann Amerbach had introduced a number of innovations into printing which today are taken totally for granted. He identified that the Roman typeface was easier to read than gothic script. Meanwhile Heynlin, who had moved to Basel and worked as a senior editor at the press, pointed out that ancient texts 'written without break and without any divisions placed between' would be more easily understood if they were 'divided into chapters and prefaced with summaries'.[6] This was a company that brought together the latest technology, innovation, aesthetics and intellectual output.

Johann Froben, twenty years younger than Amerbach, trained under the Basel master printer before setting up his own business. The two remained close and subsequently undertook a number of joint publishing ventures. When Johann Amerbach died at Christmas in 1513 he left his three sons, Bruno, Basilius (uncle of the aforementioned) and Bonifacius, enough money to invest with Froben and start a new iteration of the latter's company, effectively joining the two great publishing houses together.

Since 1507 the Froben Publishing House had occupied considerable premises in Basel, the Haus zum Sessel. Today the property is owned by the university and houses a Pharmacy Museum, but the original fabric and character of the building are completely intact. On the very narrow Totengässlein, a little stepped street which descends from St Peter's Church to the market square, the house is on the right. In the heart of the city, yet secluded in its little alley, it stands four storeys high, its plain façade punctuated by three double windows on each level. Froben's device, an adaptation of Mercury's caduceus,

two entwined serpents weaving around a staff surmounted by a dove, would have been here, over the wide arched door that leads through the broad-shouldered building into an ample cobbled courtyard with a little fountain. Here more two-storey buildings to the rear make sense of a property that was not just a residence, but also a shop, offices, and social club as well as housing the presses and attendant work force for Froben's impressive output of books, prints and pamphlets.

At four every morning the Haus zum Sessel sprang into life. A typecutter, a typefounder, a reader, a typesetter, two pressmen per press and a collator worked away under the watchful eye of Froben himself. Meanwhile, like Amerbach before him, Froben filled his premises with scholars who compiled appendices and indices, wrote prefaces, corrected proofs and provided afterwords and notes. Some edited works. There was also the task of obtaining new manuscripts for publication. All in all it was a hive of activity until seven in the evening, with everyone dedicated to creating a stable of luxurious, finely crafted, erudite books.

These scholars formed the basis of a humanist circle in Basel that would become referred to by Erasmus as the Sodalitas Basiliensis. It encompassed: the scholar and editor Beatus Rhenanus, who lived in the Froben house until 1519; Bruno and Bonifacius Amerbach; the university rector and canon of the nearby St Peter's Church Ludwig Baer; the cathedral preacher and theology professor Wolfgang Capito; the Franciscan and Hebrew specialist Conrad Pellicanus, and the scholar and musicologist Heinrich Glareanus. The bishop Christoph Von Utenheim could be counted as part of it, as could the clerical scholar Johannes Oecolampadius.[7]

There were three other men who also regularly walked through the broad archway to Froben's office. One of them, gruff and war-worn, was the artist and mercenary Urs Graf, who would have been in his late twenties when Erasmus arrived there. Two more young men would join the Froben production team shortly after: Hans and Ambrosius Holbein.

The Froben press had distinguished itself by producing particularly fine illustrations in its editions. The added value highly talented artists could provide to his output was not lost on Froben. It was not lost on the highly talented artists, either.

The printed image offered artists two crucial things: exposure and

reliable income. For those who traditionally toiled on paintings that would then only been seen by the congregation of certain churches or inhabitants of certain towns, the circulation that engravings enjoyed represented a huge breakthrough. Suddenly work was disseminated far and wide, viewed by potentially thousands of people, in a growing international print market. What is more, because this market was expanding, the work was regular and plentiful.

Hans Holbein the Elder, primarily a painter, had enjoyed neither the level of exposure print afforded, nor the cash flow. On the other hand, his contemporary Albrecht Dürer, from Nuremberg, had benefitted from both. Dürer's investment in engraving even in the previous century has reaped fine rewards. His illustrated edition of *The Apocalypse of St John, The Book of Revelation* secured his fame in the 1490s. Able to employ agents to market his finished work while he embarked on new projects, by 1508 it had dawned on him just how profitable the business of reproduction could be, pointing out to a patron that had he stuck to engraving alone, rather than also working on paintings, he would have been a far richer man. No wonder that Erasmus dubbed Dürer 'the Apelles of black lines'. It may well have been strategic thinking then that saw the young Holbein brothers leave behind the old-fashioned practices of their father and uncle in search of new opportunities and ways of working in a new land.

One wonders if the brothers arrived from Augsburg along the route still taken by today's regional train: across country to Ulm, then south-west to Lake Constance and west along the Rhine to Basel. Their father, who within the year would leave Augsburg for Isenheim, could have stopped to visit his sons and then continued his journey downstream.

Basel was and remains dominated by the Rhine, its broad, colourful houses with their painted shutters huddled along its shores. The fast-flowing waters carrying boats and little gondolas so swiftly downriver presented a struggle for those craft moving upstream. To cross such a powerful current, ferries were tied to ropes stretched between Grossbasel on the west bank and its smaller Kleinbasel to the east, while a single bridge also connected the city's two distinct quarters. The cobbled, well-appointed streets were punctuated by two hundred or so fountains, each vividly carved and colourfully decorated with the emblems of guilds, or statues of benefactors.

The Swiss city presented a considerable contrast from Augsburg. With barely ten thousand inhabitants, it was less than half the size of the Bavarian metropolis, and even Basel's most impressive houses, clustered in the winding streets close to its cathedral, were modest compared to the palatial mansions of Augsburg's merchant bankers. The purses available to sponsor major painted work were perhaps neither as numerous nor quite as ample as those in Augsburg. Nevertheless, for two young painters there was regular small-scale work in the publishing houses, and the opportunity to author work on the page.

Having said this, the accepted view is that Holbein and his elder brother Ambrosius began by following traditional protocol, and were installed as journeymen in the workshop of Hans Herbst. Certainly in September 1516 Ambrosius found himself testifying in Basel's court as a witness in a libel action brought by a sculptor, Bastian Lepzelter, against a local tailor who had verbally abused him while he was socializing with Ambrosius in Herbst's house.[8]

Herbst is remembered today only in a portrait by Ambrosius and a handful of large canvases preserved in the city's Kunstmuseum, scenes from *The Passion*. Basilius Amerbach collected two of these, *The Last Supper* and *The Flagellation of Christ*, for his Cabinet because he understood that Hans Holbein the Younger had worked on them. The museum has subsequently acquired a further three canvases, but *The Passion* remains incomplete, with the crucifixion scenes missing.

The series varies massively in execution, with some of the figures clumsily drawn and rendered, and the quality of the composition also inconsistent. As such it is hard to work out Hans' contributions. *The Flagellation*, however, with its forceful energy and sense of movement in the figures whipping Christ, does chime with Holbein's work and the facial expression of Christ here bears a strong resemblance to that conjured by Hans Holbein the Elder in both his *Saint Sebastian Reliquary* and the figure of Christ in his *Grey Passion*, suggesting the son was drawing on a repertoire of expression he had learned from the father.

A drawing that was also in the Amerbach Cabinet attributed to Holbein may offer a clue. A design for *Christ Carrying the Cross*, in white on black paper, not only seems stylistically consistent with *The Flagellation* in the Herbst Passion, the figure of Christ a remarkable match for the one depicted there, but it also represents one of the

scenes from the Herbst Passion that is missing. Might Holbein therefore have designed *The Flagellation* and *Christ Carrying the Cross*, absorbing elements of Herbst's style and characterization having seen canvases that had already been begun in the workshop? Did Hans therefore take on greater authorial responsibility for at least two of the works, rather than working merely as a technical assistant?

If Herbst had granted the young Holbein this level of autonomy, it is entirely consistent with the fact that both Hans and Ambrosius were sufficiently skilled to be also pursuing other projects, under their own steam. More importantly, though, it suggests that the young Holbein was already acknowledged as a prodigy, with a reputation that preceded him.

When they arrived in Basel, the boys were keen to improve their grasp of Latin, crucial for any young entrepreneur longing to engage with the humanist publishers in the city. To this end they enrolled themselves at classes with a follicularly challenged schoolmaster called Oswald Geisshüsler, who ran a school based at St Peter's Church, just a few steps away from Froben's premises on Totengässlein. Geisshüsler had joined other members of Basel's humanist circle who flocked to the Haus zum Sessel to make Erasmus's acquaintance. For his troubles Erasmus, with his penchant for a classical pun, had nicknamed the teacher Myconius, referring to the Ancient Greek geographer Strabo's observation that the men of Mykonos were bald. Next to the work they were doing with Herbst, Myconius would become the Holbein brothers' first patron in Basel.

As soon as Froben's 1515 edition of *In Praise of Folly* was released, Myconius acquired a copy and commissioned the talented young Holbein brothers to customize it for him with illustrations.

This instinct to personalize a book was not uncommon at this point in the history of print, a hangover from the tradition of the illustrated manuscript. Painters were often commissioned to provide highly coloured ornamentation or decorative vignettes to complement the text. The Holbein boys, in contrast, executed a series of marginal line drawings in ink, sometimes tucked away in a corner or squeezed at the bottom of the page, which, rather than adding regular form and pattern around the text, provided a surprise with each turn of the page.[9] In fact, to describe the work as having been carried out by both brothers is misleading. Ambrosius contributed just three vignettes to

the project, while Hans delivered seventy-nine.[10] The illustrations were completed in just a week and a half, indicating that the legendary speed with which Holbein worked was already apparent.

There may have been another motive behind the Myconius commission. After all, one of the very earliest and most successful books to be produced in Basel had been a satire by Sebastian Brandt, *The Ship of Fools*, published in the previous century, perhaps illustrated by the twenty-three-year-old Albrecht Dürer. By contrast, Erasmus's *In Praise of Folly* was for the moment without visual interpretation. Was Myconius gently advocating an illustrated version from another young talent, the eighteen-year-old Holbein? If so, the spontaneous marginal sketches, so intentionally graphic in their character, would serve as informal proposals for engraving a later edition.

Or perhaps it was an ambitious and precocious young Holbein who persuaded Myconius to allow him to illustrate the book with the same aim. That Holbein wanted to be compared to Dürer is evident because at the beginning of the book, he depicts Folly as a townswoman sporting a fool's cap, and preaching from a pulpit to a congregation of similarly clad fools. In doing so he instantly references Dürer's *Wisdom Preaching to the Fools*, which he conceived for Brandt's *Ship of Fools*.

The quality, wit, spontaneity and humanity of Hans' work goes far beyond mere illustration, however, and adds up to far more than an audition. Instead his little scenes create a dialogue with Erasmus's main text. It was this that delighted both Myconius, and importantly, Erasmus himself, who kept the illustrated copy for ten days to properly peruse and enjoy it.[11] Myconius's copy of *In Praise of Folly* must have taken on the status of a precious intellectual novelty or curiosity.

Faced with a text that drew stories from the classical and Christian worlds, Holbein found a common visual language for Erasmus's various themes by framing much of the action in his contemporary world. Whether Apelles or Julius Caesar, Holbein clad characters in contemporary dress. Despite their spontaneity, Holbein's sketches reveal a degree of empathy and humanity grounded in genuine observation that feels truly innovative. He rarely resorts to caricature or grotesque even when Erasmus's satire is at its harshest. Instead he creates a tension between the satire in the text and his more sympathetic depictions of ordinary people.

In the book Erasmus expresses some of his misgivings about the

church. The worship of saintly icons for self-preservation was something he strongly criticized, believing instead that a depiction of a saint should serve as a prompt to contemplate the deeds and sacrifices of the latter. Consequently, Erasmus does not suffer his fools gladly, singling out the 'people who've adopted the foolish but pleasurable belief that if they see some carving or painting of that towering Polyphemus, Christopher, they are sure not to die that day'.[12] Holbein, however, shows an ordinary man, belief and hope clearly etched on his carefully depicted face, while his hands are held up in prayer. The heel of his right foot is raised, giving a sense of imminent genuflection. This is no evil fool in Holbein's eyes, but an innocent led astray by a powerful institution, the Catholic Church.

One drawing in the book is particularly intriguing, suggesting a formidable intellect already at work, as well as a firm grasp of contemporary humanist debate. This is Holbein's drawing of Apelles painting Venus.

Holbein depicts the goddess with long wavy hair reaching down to her thighs like Botticelli's Venus, and Gregor Erhart's or Dürer's depictions of St Mary Magdelene. But he dispenses with any modesty whatsoever, exposing her in full nakedness in a manner that strikes a strange chord. What is stranger still is a lack of classical pose, nor any sinuous movement in the depiction that would allow the viewer to read the image as an antique 'nude'. Instead she stands still, her arms straight by her side, her legs pressed together. She is simply naked.*

Hans Holbein, illustration for *In Praise of Folly*, a fool praying before an image of St Christopher, ink on paper, 1515.

Reflecting on this, one grasps that this is a real woman, caught as if looking in a mirror, not a model posing for a painter. And with this realization the intellectual conceit contained in this tiny drawing unfurls. Here is Apelles, the master of verisimilitude, who knows the difference between idealization and a persuasive rendition of reality. To be truly convincing he must show the real woman, just as she looks at herself in a mirror, not the idealized one. And in depicting Venus looking at herself in a mirror, Holbein instantly taps into a long-established association between Venus and that particular accessory

* The difference between a naked form and a nude one is where the latter, posed consciously, seeks to comment on the aesthetic beauty of the human body generally. Being naked, on the other hand, is simply a state of undress.

libellus hic dica
elegantiſſime uer
i ſermonem lati
n.Hoc genus ho
um execratur &
is Hieronymus i
olis, qui pugnas
dæmōibus, atœ
ıſmodi portenta
ingunt. Sacrifi
& concionatori
.) Palam eſt, hic
reprehendi mira
, ſed conficta, &
ta ad quæſtum,
plus extorque
me credūt, œ ma
lamētis, maxime
Vider aūt taxare
circūferentes ſan
ıſmodi portenta
hriſtophorum.)
nagnitudine fin
ngreſſum undas
c deſcribit, Mon

Supſtitio
ſus imagi
nū cultus.

Apellus.

Zensis.

acipéfem mittite r
fas . Ambrofias
nent munera rara
pes . Apellis & Z
fidis .) Plinius li
tricefimoqnto, A
Impoftura lé dicit fuperaffe c
In gemmis nes añ fe genitos,
facticijs fteacɀ fequutos,
pe q pinxerit ea, c
alij pingere nõ po
rint, fulmia, tonit
brontẽ aftrapẽ Z
dis, itẽ meminit
nius, quem fumr
diuitias dicit arte
fibi cõparaffe, po
ɋ cẽfentem opa
maiora effe , ɋ c
precio poffent c
parari, cœpiffe ea
no dare. Plura de

which speaks of beauty, self-love and vanity. While these human foibles are all targets of Folly's criticisms, Erasmus nevertheless also encourages self-reflection, the examination of self that can also be symbolized by a mirror. The image is therefore paradoxical. Holbein gives us the embodiment of beauty and vanity, looking at her real self in the mirror. For an eighteen-year-old this was a sophisticated visual conceit that revealed not only a knowledge of the classics, but of the author of the book he was illustrating. And it is an early indicator that where Holbein is concerned there are likely to be layers of meaning concealed in his work.

Meanwhile Holbein's sketches also include plenty of autobiography. In one vignette Holbein illustrates Folly's statement that

> Great Princes eye men who are too clever with hostility and suspicion, as Julius Caesar did Brutus and Cassius, though he had no fear of drunken Anthony [...] In the same way Christ always loathes and condemns those 'wisacres' who put their trust in their own intelligence, as Paul bears witness in no uncertain words when he says 'God has chosen the foolish things of the world.'[13]

Alongside this text is a drawing of a bearded man. He stands slightly apart from two young men, one wearing a crown and the other a fool's hat. Is this the

Hans Holbein, illustration for *In Praise of Folly*, Apelles painting Venus, ink on paper, 1515.

drunkard Anthony, with Caesar and Brutus? Or is it St Paul, Christ and the fool? Holbein developed an image that could fit either interpretation, again the device of contemporary dress enabling multiple readings. But the old man is almost certainly based on Hans the Elder, depicted in much the same way as in the drawing in the Hermitage, somewhat comical to the modern eye in that his robe is belted so low it makes his legs appear short. And next to him are his two sons.

This integration of his own family into the narrative is not only a reminder of the close-knit relationship between the father and his sons, but also their complex feelings towards one another, often wrapped up in humour. Anthony was a drunk and Brutus and Caesar were ultimately rivals. Meanwhile in depicting Hans the Elder as Paul, Holbein is also acknowledging the ascendancy of the sons. The father is the apostle, not God's ultimate gift. Again, what at first glance appears to be a simple illustration, when considered closely, reveals complex layers of meaning.

The humanist circle in which Holbein now found himself, which so readily enjoyed and encouraged literary conceits, puns and layered meanings, would have been more than prepared to dig beneath the face value of the young artist's marginal illustrations. The detail with which he chose to execute these ink drawings is designed to hold the eye, encourage a longer, detailed analysis, and invite debate.[14]

Myconius wrote an inscription to his *In Praise of Folly* that notes some of the scholar's warm, humorous reactions to the book. One of Holbein's illustrations shows Erasmus himself at his writing desk. 'When Erasmus reached this point and saw himself thus represented, he exclaimed: "Oho, if Erasmus still looked like that, he would certainly take a wife."'[15] This self-effacing comment is revelatory. Holbein was already enough of a draftsman to make a decent portrait, and the fact that he drew Erasmus in such a way that the scholar barely recognized himself suggests that Holbein had not yet had sight of the great man in person.

Erasmus was not a man to stay in one place for long. His influence and connections reached across Europe, and soon after he saw Holbein's illustrations in the winter of 1515 he headed to Hapsburg-ruled Brabant (in what is now Belgium), where he would choose not Holbein, but the Antwerp-based artist Quentin Metsys for his first major portrait in oils. But the seed of admiration for Holbein had been sown, and it would bear fruit in due course.

Myconius too was on the move, heading for Zurich in 1516, where within two years he would become associated with the leading figure of the Swiss Reformation, Ulrich Zwingli. Before Myconius went, Ambrosius and Hans painted him a sign, perhaps as a leaving present. Painting a vignette each on either side, the work is full of charm, warmth and humour.

The sign has long been cut into two, its original sides framed as two separate works of art, one painted by Hans and the other by Ambrosius.* Its fine condition suggests that it never served its intended purpose, since it shows none of the weathering that an exterior sign would have suffered. Perhaps Myconius already understood the inherent value in the work of these two young men and determined to keep it safe? Or perhaps it was never intended to be practical, but

* The sign now hangs in the Kunstmuseum in Basel.

rather a novelty item thanking Myconius for his tutelage and support? Whatever its purpose, the teacher is depicted wearing a hat, his bald pate concealed in this instance.[16]

The script for both sides of the sign is the same; it points out jokingly to prospective clients that learning to read and write German is handy for anyone who wants to 'write down and read his debts'. It does however add that not only adults are welcome in this particular classroom, but also women and children of both sexes. This, unusual for the time, reflects the liberal attitude towards women among humanist circles in the city. What is more, the sign offers a money-back guarantee for those whom the master fails to teach.

The humorous tone of the work continues with the illustration. One depicts the schoolmaster struggling with his adult clients. In an interior that gives a detailed sense of the actual schoolroom, two men – in the dress of mercenaries of the time – are shown struggling at their work. Set against the crown glass window panes that look like bottle ends and defined Basel at the time, one man can barely sit on his folding chair, more interested in spinning or fiddling with his quill than getting down to writing. Meanwhile another is showing his work to Myconius, who is pointing, perhaps to some failing in the text. This panel has bold compositional elements that seem more typical of Hans than his brother. The legs of the soldiers make strong diagonals across the surface of the work and draw the eye to the schoolwork under discussion. The light from the window is well observed and dark shadows firmly secure the group in the room.

The other side of the sign shows the master, this time accompanied by his wife, instructing children. While the woman sits at a desk with a young girl, two small boys sit at a bench reading. Myconius himself, still wearing his red hat, stands over another boy who has written out the alphabet.

In his illustration of Erasmus's *In Praise of Folly* Holbein depicted a schoolmaster brutally beating the bare buttocks of a child in one of his marginal illustrations. Though holding a similar bundle of birch twigs to administer punishment, it is clear that in this instance Myconius is only delivering a gentle, encouraging tap rather than severe corporal punishment. The child has, however, made a mistake. His alphabet is complete except for the letter H.[17] Perhaps this deliberate mistake held some meaning for those associated in the work. Is the exclusion

of H a conscious reference, by omission, to Holbein the Younger, given this side of the panel is widely attributed to Ambrosius? Is the latter pointing out that the hand of his precocious and productive brother is, in this case, absent? Is there a self-deprecating conceit here too? As the artist responsible for the work, Ambrosius, as well as the boy he depicts, makes the error in the alphabet – is he alluding to his own failings as a poor student?

The narratives clearly delivered in these two charming domestic scenes are highly unusual for their era. Accounts of domestic life, though often incorporated in the detail of religious art, were not widely the subject of painting. In terms of the history of art it is not really until the seventeenth century that the domestic narratives depicted in what is known as genre paintings emerged. So in creating this novelty for Myconius, the Holbein boys were indeed being truly original.[19] Their love of storytelling, their humour, acute observation and reading of human nature, and their impetus to create a sense of event around work that operates at several levels is already evident.

Since Myconius was clearly part of the Froben circle, and his school so close to Froben's residence and company premises, it is not surprising that the Holbein brothers caught the latter's eye. What is impressive, however, is the speed with which they found themselves dominating the illustrative output at his company, an aspect of the publishing house that had been monopolized by Urs Graf to that point.

Graf was a goldsmith, painter and illustrator who had arrived in Basel some years earlier. A huge creative and innovative talent, he had designed woodcuts in the shape of border frames for Froben's title pages in Renaissance style, which the publisher had been reusing extensively across his publications. But Graf was a difficult character. He was part of Basel's mercenary force and his commitment to Froben was broken not only by his military service, but also by spells in jail. He was regularly in trouble with the authorities for wife-beating and consorting with prostitutes. Perhaps it's little surprise that Froben jumped at the opportunity to refresh his stock of borders with two ambitious young Augsburgers, who were also clearly well versed in classical motifs.

Ambrosius Holbein, *School Master's Signboard*, mixed media on spruce, 1516.

Despite Ambrosius being the elder, it was Hans whose work was published first by Froben, again a likely indicator that the elder brother worked in the shadow of his younger sibling. Across 1516 Hans Holbein designed three borders that the publisher would recycle considerably over the next few years. First published in October 1516 was Hans' design featuring the story of the Roman hero *Mucius Scaevola* (more of whom later) signed H H. A month later Froben published another woodcut designed by the young artist that is now known as *Triton Struggle*,[19] and then in December a third, *Salome*, depicting the beheading of John the Baptist.[20] All these borders are named after the narrative scenes placed at the bottom, but offer much more for a viewer to enjoy.

Triton Struggle is interesting for the fact it bears the near full signature of its creator. Holbein conceived a garlanded classical arch or niche, within which the title of the book hangs on an imagined banner. Several putti are arranged around the arch, some holding the banner, others holding Froben's own device displayed on an ornamental shield at the bottom of the page.

Holbein creates a sense of vigour, energy and originality by creating

a composition that at first glance appears symmetrical, but on closer inspection is in fact delightfully asymmetrical, thus holding the eye and attention of the reader. At the top of his page he has putti perched on capitals; on the left one looks down, but on the right the putto turns his back to the onlooker. The little angels grabbing the banner are also quite individualized. On the left-hand size the angel displays his arm and leg, using both limbs to hold the banner in place. His opposite, however, conceals his lower limbs behind the banner, while clinging to it with both arms. Two larger winged boys stand at the base of the pillars, each holding a spear. One looks up, the other down. And so on. This play on opposites, to and fro, back and forth, up and down, front and reverse, will become typical of Holbein's decorative work, providing it with a level of interest and narrative that goes beyond the merely ornamental.

What is significant about this title page that Holbein designed for Froben so quickly after his arrival in Basel is that he signs it 'Hans Holb'. This was an act of supreme self-confidence for a young man who, as a mere journeyman, was technically forbidden under guild rules to sign a work. Again this offers further evidence that just as Hans was seen as special in his hometown, he was acknowledged thus in Basel too. Rules were immediately bent in recognition of his considerable talents. It also suggests that Hans Holbein had already learned the lesson of Dürer's fame. Success might be accelerated with name recognition. Engraving was a means of advertising his skill.

Hans Holbein, design for a title frame, Triton Struggle, *for J. Froben, designed 1516.*

However, nothing speaks more fully of the exceptional impact Holbein made so quickly in Basel than the fact that within months of his arrival Hans secured one of the most prestigious private commissions going in the city.

In 1516 a thirty-four-year-old merchant and guild master called Jacob Meyer zum Hasen made local history. He was the first commoner to get himself elected as mayor of Basel, a role that had always been filled by aristocrats or high-ranking patricians known as Achtburger. The son of shopkeepers, Meyer's rise had been fast and impressive. Not only was his climb through the guilds swift, but he was a formidably successful businessman. He had established a money-changing business in a house just off the market square which proved

MARTINI

DORPII SACRAE THEO
logiæ professoris Oratio in
præelectionem episto-
larum diui Pauli.

De laudibus Pauli, de literis sa
cris ediscendis, de eloquētia,
de pernicie sophistices,
de sacrorū codicum
ad Græcos casti
gatione, &
lingua-
rum peritia.

Epistola ERASMI ad Dorpiū.

so successful that by the time he was just twenty-six he managed to buy Gundeldingen Castle, one of four impressive moated houses that had been built just outside the city in the previous century.

Meyer clearly had enough money to commission any of the leading, established painters of the region to paint a portrait to commemorate his mayoral election. But astonishingly, the most important man in Basel chose Hans Holbein, who was still a teenager.

The preparatory drawing for the Meyer portrait is preserved and it reveals much. For a start, just as his father had taught him, Hans secures Meyer's main features in silver point. He then gives the work a sense of life with a touch of red chalk, in this case on the nose, the lips and just under the eye. All attention is on the face, the characterization, with the clothing simply suggested. But one key aspect of the drawing differentiates it instantly from works by Hans Holbein the Elder. That is the shading. The diagonal hatching is largely drawn downwards, top left to right, whereas the shading in the work of Holbein's father is invariably the other way around, downwards from top right to left. The point being that Hans Holbein the Younger was left-handed.

The finished portrait of Meyer is the same size as the drawing, suggesting that Holbein transferred his sketch mechanically as a guide for the painting,

Hans Holbein, *Jacob Meyer zum Hasen*, silverpoint, with red chalk and pencil on paper, 1516.

which forms a diptych with a portrait of Meyer's wife, Dorothea Kannengiesser.*

Given this was the first portrait commission the young artist had secured, there is little wonder he turns to established prototypes as a guide. Holbein nods to the portraits he had seen executed in Augsburg by his father, and by Hans Burgkmair. Just as in his father's depiction of Philipp Adler, he pays great attention to classical decorative elements on the architecture that frames the work. And it is clear he had studied Burgkmair's chiaroscuro woodcut of an Augsburg banker, Hans Baumgartner, whom the painter had situated in front of a deep classical arch that suggested space and air behind him.

Despite the clear references to the artists who shaped his boyhood, Holbein's ambition to differentiate himself is immediately evident. He delivers a work that in its depiction of space, the complexity of

* Both the preparatory drawing of Meyer and finished portraits of him and his wife are in the Kunstmuseum in Basel.

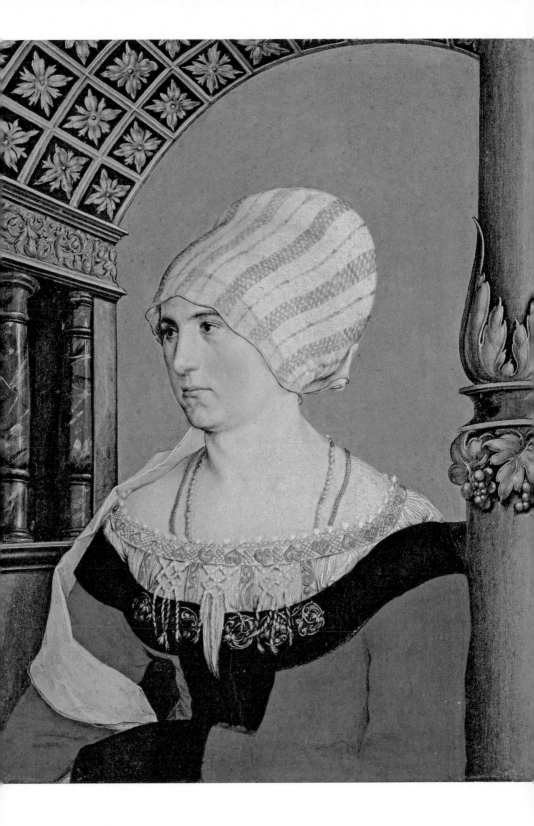

architecture and decorative elements, trumps both his father and Burgkmair. Despite its relatively modest size, each portrait measuring just 38.5 × 31 cm, Holbein has nevertheless designed a delight that is intended to excite the viewer not only as an impressively convincing representation of the sitters, but also as a virtuoso rendition of an imaginary, opulent architectural world.

And so he situates the pair in front of an arch within which four marble pillars are recessed. These are surmounted by an elaborate classical frieze, supporting a lavish coffered ceiling. The arch itself is framed within two further architectural features only partially evident: either pillars or large ornamental candelabras. The two sitters are immediately in front of these, with Dorothea gazing at her husband. Meyer, meanwhile, looks out of the picture. He is idly thumbing a gold coin in his left hand, a symbol both of his former business and perhaps the fact that as mayor he had overseen the moment when Basel began to mint its own money.

previous pages
Hans Holbein, *Jacob Meyer zum Hasen and his wife Dorothea Kannengiesser*, oil on wood, 1516.

Painted on limewood, this portrait diptych was designed to be folded and opened like a book.* The degree of ceremony this invited is significant, and worth considering. Stored in a library or a drawer perhaps, the special treasure would be brought out by Meyer. His guests would wait in anticipation as the work was then opened to reveal the delight within. Such a sense of event around the viewing of art added to its perceived preciousness.

Meanwhile, Ambrosius's career, though trailing his brother's, nevertheless mirrored it. Just as he had assisted to a small degree in illustrating Myconius's *In Praise of Folly*, and co-authored the schoolmaster's sign, he too began designing a selection of title page borders for Froben, with his work appearing a year after his brother's, in 1517.

Ambrosius was also securing some portraiture work. A commission for two portraits of young boys – their identity now lost – reveals the relative inferiority of the elder brother's painted work.† Though still admirably fine, Ambrosius Holbein's more delicate work remains less secure and convincing than that of his brother. The same device

* As suggested by a coat of arms painted on the rear of the painting of Jacob in 1520.
† These are in the Kunstmuseum in Basel.

of placing the boys within classical architecture does not deliver the spatial trompe l'oeil that Hans can conjure.

The other key difference in the brothers' work is the fact that Hans signed his, whereas Ambrosius did not. In his Meyer portrait Hans' initials are engraved into the fabric of the architecture – again in defiance of guild rules, which would normally not allow a young journeyman this privilege. The presumption in signing a painting is even greater than that of signing a design for a frontispiece.

A journeyman could use his master's signature on his work – and Hans Herbst shared the same initials as his precocious underling. This happy coincidence provides a degree of playful ambiguity around the signature, enough for Holbein to defend himself against accusations of a breach of guild rules. Ambiguity would become a recurring feature of Holbein's work, one which helped him negotiate the politics of his time.[21]

Holbein's determination to display his signature showed his resolve to have his name linked with great men for all to see: Erasmus, Froben and then Meyer. Between them and their circle these men would indeed shape the course of his career. Erasmus's fundamental influence on his fate has been described above. As for Meyer, Holbein would go on to benefit from further commissions, one being the so-called *Darmstadt Madonna*, the significance of which in the story of art was indicated rather forcefully when it was bought in 2011 by German billionaire Reinhold Würth for $70 million, making it at that time the most expensive work of art ever sold in Germany.[22] Meanwhile Holbein's patronage by Johann Froben would not only extend to a great many other commissions for that eminent publisher, but establish Holbein's reputation as one of the most sought after and prodigious illustrators of the sixteenth century.

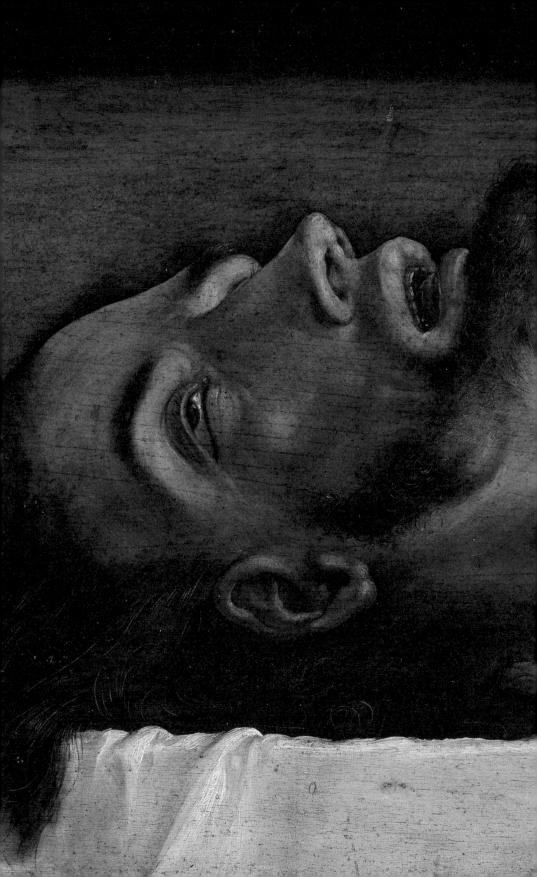

DEATH

5

In the height of summer 1805 one of Basel's medieval treasures was demolished. It took the municipal workforce just two days in August to dismantle an astonishing work of art, sixty metres in length, that had stood in the city for close to four centuries. The artwork in question was a *Dance of Death*, a long mural painted in tempera on plaster by the fifteenth-century painter Konrad Witz.*

Depicting a life-size Death in the form of a skeleton cavorting, jigging and taunting the citizens of the city, this large-scale memento mori adorned the walls of a cemetery adjacent to the Dominican monastery church of Predigerkirche. A stone's throw from the Rhine, Predigerkirche is still there today, at the easternmost end of St Johanns-Vorstadt, that same street where Holbein eventually bought a property that would house his workshop and become a family home. As St Johanns-Vorstadt extends to loop around the church the road actually becomes known as Totentanz – Dance of Death.

The nineteenth-century residents of Totentanz were increasingly fed up with their views of a neglected cemetery and its crumbling walls and lobbied the city to have the site levelled in favour of a park. The municipality duly obliged. Some horrified inhabitants with antiquarian sensibilities rushed out to save what they could of Witz's epic work. It featured thirty-nine figures each dancing with Death, as well as depictions of Adam and Eve, and a group of Dominicans surrounding a preacher. They salvaged just twenty-three partial figures. Today one can see some fragments of these figures on display in the Historisches Museum at Basel. Despite lacking their original context, their potency is intact: a reluctant emperor expresses terror and helplessness as he is dragged to purgatory; a coy duchess reaches out towards Death as if mesmerized; a young man is seemingly already lost to another world, his face expressionless, his head bent as if drugged, as he stumbles away.

Almost as soon as the city had lost this reminder of mortality, it succumbed to nostalgia. Quickly artists sought to recreate the work in memorial prints, books were published, and by 1823 a set of commemorative figurines were released that could be placed on mantle shelves and window sills. The people of nineteenth-century Basel were much attached to Death after all.

* A fifteenth-century artist otherwise credited with introducing the first ever landscape detail based on actual topography into a European painting.

In the sixteenth-century version of the city, Death felt closer still. It was not just the Catholic Church's determination to constantly remind its congregations of the need for salvation in order to pass as swiftly as possible into heaven, but the prospect of how one might meet one's death was more obviously present. Life expectancy at this time was just thirty-five years, an average figure informed not only by the huge numbers of infant deaths, but also the constant threat of a famine, plague or war that might quickly cull huge portions of the population.

Brushes with death were more common too. Sixteenth-century city life was precarious, not least because almost all men carried either a knife or a sword, which they were often provoked and prepared to use. Pub brawls, business rivalries or domestic arguments could quickly turn life-threatening. Meanwhile riots were common. Festivities, carnivals or celebrations often became violent rampages – a fact that the *Dance of Death* murals perhaps obliquely referenced. Students, apprentices and journeymen were known sources of trouble, often serving as the kindling where, with prejudice or poverty added to the mix, violence could suddenly ignite around particular grievances. In one instance in 1520, the threat of carrying knives and the problem of mob unrule spectacularly combined when students at Wittenberg rioted because the apprentices in Lucas Cranach's workshop there could bear weapons and they could not.

Another problem for Basel was the behaviour of its mercenaries. Switzerland – or the Old Swiss Confederacy, as it was then – was famous for its commercial soldiers, notorious for fighting with long halberds, spears and pikes. While those in the cities themselves apparently benefitted from the substantial income that the municipal and regional governments charged for supplying men, many of those living in the rural cantons who were summoned to fight felt less well rewarded.

When these war-weary men returned from campaign, they could be violent and aggressive, as Myconius, the very same schoolmaster who befriended the Holbein boys, discovered to his cost. He and his family were subject to a brutal assault by one such mercenary, who broke into the school, smashed it up and terrorized Myconius's wife and son, and then beat up Myconius when he gave chase. No wonder the schoolmaster took his family away from the city soon after.

Given this picture of lawlessness and violence bubbling under the surface of sixteenth-century life, it's hardly surprising that Hans Holbein got caught up in the odd scrap. In the summer of 1516 both he and Ambrosius found themselves in trouble with Basel's authorities when they were fined for brawling.

While this event does not indicate that the boys were particular troublemakers given the context of a generally aggressive world, nevertheless Holbein may have adopted an encoded signature at around this time that suggests, among other things, that he was a young man with substantial physical confidence and stamina, someone who saw himself able to stand up to the threat of death. This encoded signature may have been inspired by one of those frontispieces he designed for Froben in 1516 – the *Mucius Scaevola.*

Mucius Scaevola is a less familiar classical hero today, but in Holbein's time his story was popular and well known. He had been a Roman assassin, sent to kill Lars Porsena, an Etruscan king who had laid siege to Rome. Having crept into the Etruscan camp, Mucius encountered two men dressed as a king might be, and killed the wrong one. Captured by the Etruscans, Mucius determined to show his bravery in the face of death. Condemned to burn at the stake, he thrust his right hand into a fire and held it there, to show how little fear he had. His gesture so impressed his Roman captors that he was released.

In the Renaissance, this act of bravery and resilience had become associated with constancy, patience and self-sacrifice. The legend began to be seen as prefiguring Christ's own self-sacrifice. Such was the familiarity of the tale that those who witnessed Archbishop Cranmer thrust his right hand into the flames as he faced the stake in 1556 would have immediately understood the allusion to Mucius Scaevola, and by association Christ himself.

Mucius was also associated with something else in the popular culture of the time – left-handedness. After all, the self-inflicted wounds to his right hand had rendered it useless thereafter. Scaevola, a name given to Mucius after the episode, literally means left (scaevus) handed (vola). Given left-handed people were often seen by a largely superstitious society as being sinister, gauche and unlucky, Mucius offered a positive point of reference for them. Holbein, a sinistral himself, was obviously keen to capitalize on it.

His design for a frontispiece featuring the Roman hero was first

used by Froben in 1516 to illustrate a work by a humanist who adopted the name Aeneas Platonicus, and was writing on the immortality of the soul. Mucius' apparent disregard for his own mortality was a fitting illustration for a book whose subject was life beyond death. But one wonders if the classical legend suggested to Holbein a nickname or alternative signature for himself. Those in humanist circles were in the habit of finding classical monikers for themselves. More allusions to the left-handed Mucius Scaevola arose when in 1517 he moved to Lucerne.

The summer of 1517 was one of misery for many in Europe. 'If ever we were in trouble before, our distress and danger are at their greatest now,' Thomas More wrote to Erasmus that August, from London. The city was in the thrall of the sweating sickness, a particularly virulent and contagious yet mysterious disease that afflicted England with a series of epidemics until the mid sixteenth century. Rapid in its efficacy, it could kill across the course of just a day. Giddiness, headache, and severe pains in the neck, shoulders and limbs were part of a cold stage that lasted up to three hours and saw the victim shivering violently. After this the hot stage began, at which the characteristic sweat broke out. Death followed extremely fast.

overleaf
Hans Holbein, *Adam and Eve*, oil on paper, mounted on spruce wood, 1517.

More described 'many deaths on all sides and almost everyone in Oxford and Cambridge and London taking to their beds within a few days' and even suggested that 'one is safer on the battlefield than in the city'.[1] Little did More know that the sweating sickness would subside in December only to be replaced by a bout of traditional plague.

Basel too was having its share of mysterious afflictions. Here people were succumbing to another unidentified disease, the symptoms of which were headache, fever and loss of appetite. Erasmus, who was thinking of returning to the city the following year, was worried that this suggested the plague was about to rear its head there. Bruno Amerbach, Bonifacius's brother, wrote to reassure Erasmus. His optimism would prove misplaced.

During the course of this gloomy year, 1517, Holbein produced a particularly unusual interpretation of *Adam and Eve*. The painting is considerably original, departing from traditional ways of depicting the occupants of Eden. For a start the modestly sized painting

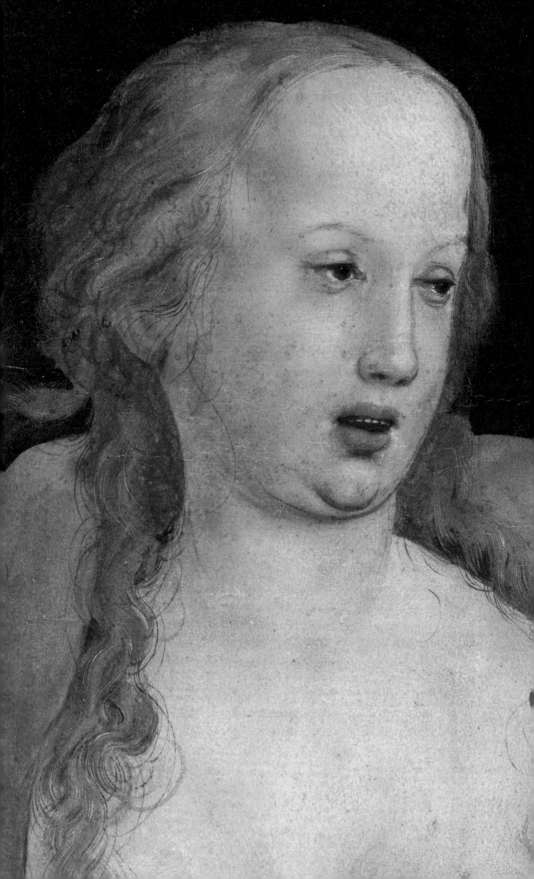

captures Adam and Eve from the chest upwards. They are set against a plain black background, also unusual. This inventive close framing of the couple avoids any depiction of nudity, and instead forces a contemplation of the expression and gestures they display.

But perhaps the most striking aspect of the depiction is the casual manner in which Adam drapes his right arm around Eve's shoulders. The gesture is intimate and nonchalant. On closer inspection of Adam's face, however, one begins to see an expression of resignation and sorrow. Eve meanwhile seems stunned, her lips slightly parted and her teeth clearly visible. This unusual detail is included as if to reinforce the bite Holbein shows has been taken out of an apple in Eve's hand. The apple, almost central in the composition, is held up in such a manner that the bite faces directly towards the viewer, a stark and blatant reminder of the couple's fall from grace and the subsequent price paid by those looking at the painting in the here and now.

In February 1517 Ambrosius succeeded in getting into the painters' guild in Basel, a landmark step that would allow him to work as a master in his own right and sign his work – something his brother was doing already, of course, despite it breaching convention. There was a fee attached to achieving this status, which was traditionally due within a month of taking the title. It took Ambrosius a year to pay it. Similarly, when he became a city burgher in June 1518 he could only find one of the 4 gulden required to cement this title and relied on a goldsmith, Jörg Schweiger, to underwrite the debt.[2] Schweiger was an Augsburger by birth and a contemporary of Holbein the Elder. As such he was an obvious person to turn to for help, not least because many goldsmiths were in the business of money lending.

Schweiger's benevolence towards Ambrosius extended to patronage.* In 1518 he commissioned Ambrosius to paint his portrait, possibly as part of the terms under which he had loaned the latter money. The portrait remains in Basel today. Modest in size, it is ambitious in its depiction of the curly-haired, middle-aged Schweiger, who is set against a landscape. Ambrosius's talents are obvious. His drawing is fine and extremely detailed. Yet his shading and sense of dimension

* Schweiger had worked in the workshop of the goldsmith Jörg Seld. He and Holbein the Elder had worked alongside one another between 1505 and 1507 in the Monastery of St Moritz in the city. After his work at St Moritz was complete, Schweiger moved to Basel and was well established when the younger members of the Holbein family turned up eight years later.

are less convincing than in the robust, confident work of his younger brother. In many ways Ambrosius worked more to achieve less than his sibling.

Whether Ambrosius's financial difficulties represented an unfortunate inability to manage money or were, more likely, just typical of the struggle any young artist faced when starting from scratch in a new city, by incurring debt the son was following in the father's footsteps. Struggling despite his talent, Ambrosius stood a better chance of profiting from his new professional status without competition from his more talented younger brother. This may well have been the impetus for Hans to leave Basel and head to Lucerne at some point in 1517, where his father was also exploring opportunities. In July 1517 Froben published a new title border from Hans Holbein the Younger, the *Children Triumph*; it is the last new border design from him until the summer of 1520.[3]

In many ways the city of Lucerne must have felt familiar to Hans Holbein. Like Augsburg and Basel its impressive merchant homes featured colourful façades and framed busy cobbled streets. And like Basel, the city was awash with mercenaries. Lucerne's Kaspar von Silenen had had the honour of becoming the very first commander of the Pontifical Swiss Guard a few years earlier, but when the Holbeins arrived in the city, Silenen and a number of his men had been killed in the War of Urbino, caught off guard after a night of heavy drinking. Boozing, it seems, was a significant pastime for Lucerne's citizens.

The account books of Lucerne's painters' Guild of St Luke reveal that Master Holbein – almost certainly the Elder – registered for the sum of a guilder, allowing him to take on work in the city. They also reveal that in October 1517 Hans the Younger was paid a florin and 9 shillings for stained glass designs. This paltry payment is a reminder that Hans, just like his brother, faced an ongoing battle to make ends meet regardless of his evident talent.

Perhaps stained glass seems like a marginal form of art today, confined to churches, and at the periphery of most artists' output. But in sixteenth-century France, Germany and Switzerland, stained glass was a booming industry that provided a significant income stream for artists who were asked to devise schemes not just for the church, but for civic buildings and even private homes.

In Augsburg Holbein would have grown up with the rare privi-

lege of seeing what today are the oldest stained glass windows still in situ. The Prophet Windows in the cathedral date from the late eleventh century – their luminosity, bright colouration and flat, two-dimensional figures, which no doubt signalled their medieval status then, seem strangely modern to the twenty-first-century eye. Meanwhile his own father's work on glass was also on display in the church of Saints Ulrich and Afra, alongside work by Jörg Schweiger. The discipline of designing for glass was very much shared by painters and goldsmiths.

Holbein would have also been aware of the innovation that Dürer, that ever-looming figure against whom any artist of the next generation was bound to be compared, had also brought to this discipline. Dürer had endowed his stained glass designs with the same dynamism, characterization and strong graphic qualities that he had explored in woodcuts. What is more, one of Dürer's followers and imitators, Hans Schäufelein, moved to Holbein the Elder's workshop in Augsburg from Dürer's in 1508.

In Switzerland in particular there was a tradition of friendship paintings on glass – smaller-scale works that normally contained heraldic motifs and meaningful emblems that individuals or civic groups gave to one another as expressions of allegiance or camaraderie. The frontispieces that Holbein had been designing for Froben that combined Renaissance architecture with various devices and shields provided a clear indication of what he might accomplish in this field.

Inevitably, hardly any trace of Holbein the Younger's designs for stained glass in Lucerne survives. However, some of his drawings suggest how very original and bold his approach to the long-established tradition of heraldic work was from the offset. In a drawing for one of Lucerne's prominent citizens, Hans Fleckenstein, Holbein, rather than designing a two-dimensional motif, places the Fleckenstein coat of arms in three-dimensional space, within monumental classical architecture. What is more, he depicts this from a low viewpoint, anticipating the raised position the resulting pane will occupy in a window. In this way the viewer looks up to see the underside of an archway and its architectural elements, including its supporting pillars. The perspective is enhanced further by the depiction of two confederate soldiers either side of the shield, the tips of their feet invisible from the low viewpoint.

Five years later Holbein would make another design for stained glass for the Abbey of Wettingen in Switzerland. The abbey had suffered a fire in 1507, and as part of a series of rebuilding initiatives *Standesscheiben* were commissioned – that is, a series of heraldic stained glass panels, each representing and donated by a Swiss canton. Back in Basel at this point, Holbein designed the stained glass offered by that city. But rather than a single panel, this time he created a diptych, where Basel's patron saint and the founder of its cathedral were depicted separately in each panel. These two figures were however unified by the architecture within which they were set. Two ornate triumphal arches framing the Virgin and child to the left and the Emperor Henry II (Heinrich II) to the right are in fact part of one grandiose architectural scheme that sees an arch and balustrade running between the two in a continuous space.[4] Today only the figure of Henry in its architectural setting survives on glass, but a drawing of the accompanying figure was preserved as part of the Amerbach Cabinet.[5] Some scholars have suggested that here Holbein uses the Mucius signature rather than his initials. Within the arch framing the Virgin is an antique-inspired medallion featuring the inscription MVCIVSFEZ.[6] The debate over the signature aside, this more complex architectural scheme suggests some of the dazzling and eye-catching imaginary spaces Holbein may have also conjured for the various stained glass commissions in Lucerne.

One man looking for architectural invention and spatial sleight of hand in 1517 was Jakob von Hertenstein. He was a senior figure in Lucerne, elected as its *Schultheiss*, or mayor, in 1515. Although he was attached to the prestigious Ravensburg trading company, the Humpisgesellschaft, he had little need to work. His old established family was asset rich and the income Jakob received from investments in bonds and lands was considerable. Jakob was also a seasoned military leader involved in the Italian Wars, a series of ongoing conflicts fought for control of Italy from the late fourteenth until the mid fifteenth century, in which Swiss mercenary forces played a significant role.

In 1515 Jakob had commanded the men of Lucerne in one of the defining battles of these conflicts, that at Marignano. When Francis I acceded to the Valois throne in that year, he had wanted to mark his reign with an instant triumph. He set his sights on Milan, which the French had most recently lost to their imperial adversaries. The

Swiss fought alongside the Milanese at Marignano but were no match for the French king, whose army was supplemented by Venetian reinforcements. It was a famously terrible battle, amid the carnage of which 12,000 men were lost. Jakob's son Benedikt, fighting alongside his father, was wounded in the field.

After the defeat of the Swiss, Hertenstein was one of those who negotiated with the French, securing what became known as the 'Eternal Peace', a treaty that saw the French pay a regular pension to the Swiss on condition that their mercenaries were not available to France's enemies going forward.

Two years after Marignano, and benefiting from French payments, Jakob von Hertenstein decided to have his house in Lucerne's Kapell-platz improved with an extensive programme of exterior decoration. Hertenstein was also looking for someone to paint a portrait of his son Benedikt, who, despite being only in his early twenties, had just been elected to the city council. It was the young Hans Holbein, just arrived in town, who secured both commissions.

Holbein's excellent designs for stained glass had clearly quickly established his unusual talent in the city. However, there was a web of connections that could have also brought him more fully to Hertenstein's attention. It may be no small coincidence that Myconius, recently departed for Zurich, had been born and bred in Lucerne, and would return there under the patronage of Hertenstein a few years later. Benedikt Hertenstein, meanwhile, had attended university at Basel, where Holbein's name was on the lips of an elite crowd. Hertenstein and Jacob Meyer, as officials of Swiss cities, were associates. It also remains a fact that Holbein the Elder was still one of the most prestigious artists of his time despite his recent troubles, and may have been already working on the interior of the house and so able to suggest his son as a candidate.

Hans Holbein, Benedikt von Hertenstein, oil on paper, mounted on wood, 1517.

Holbein painted Benedikt Hertenstein in oil on paper. Weak chinned and cherry lipped, today he looks out from the walls of the Metropolitan Museum of Art in New York City. His neat, reddish hair is under a large red and black beret. His wealth is signified by the gold embroidery on his shirt and the heavy gold chain around his neck. One voluminous pink sleeve of his doublet is visible beneath his black cloak. Its green lining picks up the green of his eyes, as do the emerald

and amethyst rings on his left hand, which is shown resting on the pommel of his sword. Here is a rich young man of action.

But if the meticulous rendering of his material existence and the ability to capture his likeness are every bit a match for Holbein's depiction of Meyer and his wife, the same cannot be said for the setting of this portrait. Meyer and his wife are settled within ornate, impressive architecture. By contrast Benedikt sits in plain, confined surroundings, just a dark corner behind him. Whereas Holbein created a sense of airiness and distance in the Meyer portrait, here space is tight, amplifying the bulk of his sitter, who, lit from the left, casts a shadow behind and to the right.

The point Holbein is making here is that Benedikt von Hertenstein is not in need of impressive architecture. *He* is monumental. Look again and one sees his left hand is huge, his left arm powerful. In fact Holbein made him more colossal as he worked up the painting, enlarging the width of his neck and increasing the height of his shoulders as he applied oil directly over his preparatory drawing.

These alterations, along with a modification to Benedikt's right eye, also create another painterly illusion. While adding to the sitter's bulk, when viewed straight on the proportions recede to more modest dimensions as one moves from left to right, until one reaches a point at forty-five degrees to the painting, when the sitter projects out from the canvas in a hyperreal three-dimensional manner. This kind of optical illusion was something Holbein would return to again in his career. But his experimentation with anamorphosis so early on suggests his strong drive to innovate, add novelty to, and secure visibility for, his work.[7] Meanwhile Holbein embeds his signature into the painting's narrative. To the left, he paints an engraved inscription. First, in German, we hear Benedikt's voice: 'Da ich het die gestalt was ich 22 jar alt' – or 'When I looked like this I was twenty-two years old'. Then in Latin, '1517 HH Pingebat'. Here Holbein's use of the Latin imperfect tense for painting ('was painting' rather than 'painted') makes reference to Pliny's *Natural History*, where the Roman writer relates that Apelles himself wrote his inscriptions in the imperfect tense. In doing so the painter not only makes himself an active if unseen presence, but with its implication of incompletion the suggestion is that the work had merely been interrupted and could be taken up again and improved if necessary. This kind of detail about tense was at the heart of many

a humanist debate on the subject of art and once again provides convincing evidence that Holbein was determinedly both part of that conversation, and keen to make the comparison with the most famous painter of antiquity.

The sad irony for those viewing this inscription today is the knowledge that when Holbein painted Benedikt Hertenstein they were both young men, and the reference to the latter's age from a distant future anticipated a much older version of the sitter confronting his younger self. But Benedikt von Hertenstein did not enjoy a distant future. Like so many men of his generation, his fate was governed by the ambition of Europe's superpowers. In 1519 Charles V succeeded Maximilian I as Holy Roman Emperor. His election revived hostilities and France and the Empire were soon at loggerheads yet again. The Italian Wars resumed once more and Benedikt Hertenstein died at the Battle of Bicocca in 1522.

There is one other detail in the Hertenstein portrait that is intriguing. This is a frieze of a classical triumphal procession that runs just above the sitter's head. It is significant because it provides a direct link to the larger Hertenstein commission that Holbein secured, the external decorations to the Hertenstein house. These featured a similar procession. It raises the question, which came first, the portrait or the decorations? Or were they concurrent? It is tempting to suggest that his designs for stained glass, and possibly interior work on the house with his father, when combined with the portrait, were in effect audition pieces that secured Holbein the extremely prominent external commission. The use of a triumphal procession in the portrait – which surely relates to Benedikt's recent military heroism as well as his political success – might have sparked the idea of a similar motif on the façade of the house.

Whatever the order of the commission, Holbein's ability to command such work at the age of just twenty did not go unnoticed by the city's resident artists. As in Basel, violence and resentment simmered under the surface of Lucerne's daily life. It did not take much to see it erupt. Particularly where foreigners were concerned.

If anything could ignite aggression towards a German journeyman in the Swiss Confederacy it was alcohol, and Lucerne had plenty of that. In 1517 Jakob von Hertenstein had control of the city's treasury. He was responsible for all payment from the civic coffers, and there is

some evidence that his tactic to keep those in the city's employ happy was the provision of a good amount of booze on paydays. Hertenstein patronized one particular inn, the Wild Man. Right in the centre of the city, it was used as a kind of municipal meeting place. Here those who had provided civic services went to get paid, and enjoyed the inn's hospitality at the expense of the city. Pay-day was always a raucous event, intended to foster goodwill, but inevitably also liable to generate trouble.

A local goldsmith from Schenkon called Kaspar came to pick up his wages on a regular basis from the Wild Man.[8] This is almost certainly the same Kaspar the goldsmith with whom Hans Holbein the Younger found himself in a potentially deadly knife fight on 10 December 1517. Both men were admonished with a heavy fine recorded in the city archives, a reflection on just how serious the fight got. While the cause of the brawl is unrecorded, it may well have been that Kaspar saw Holbein as unwelcome competition. Kaspar had probably already lost stained glass commissions to Holbein. The Hertenstein house was another prestigious piece of work that landed in the Holbeins' laps, the interior aspect of which was underway in 1517.[9]

Immigrants were blamed for much at a time when competition was strong and life precarious. This was a Europe-wide issue. In the same year that Holbein found himself targeted in Lucerne, antipathy was particularly forcefully expressed 1,000 kilometres away in London. Once again it was the case of a celebration turning into something more sinister. On Easter Tuesday a local preacher, Dr Bell, stood up near St Paul's Cathedral in London and denounced the influx of foreigners in the city. He encouraged 'Englishmen to cherish and defend themselves, and to hurt and grieve aliens for the common weal'.[10] The city had seen a great number of journeymen and master artisans coming over from the continent. European merchants were also highly visible and highly successful. Bell hit a nerve among the locals. Across the next two weeks attacks on foreigners increased on London's streets. Then the city's apprentices began to organize themselves. On May Day, a thousand young men gathered in Cheapside to protest. Erasmus's great friend Sir Thomas More, at that point the undersheriff of London, met the mob and did what he could to calm it, but as his pleas failed, it began to wreak havoc, smashing properties owned by foreign workers, creating terror and panic at the heart of the city. In

fact so violent was the rioting that the Duke of Norfolk was forced to muster an army of 1,300 soldiers to put down what was fast turning into an uprising. After rounding up about a third of the troublemakers, most were eventually released. But thirteen men, leaders of the mob, were charged with treason before being finally pardoned by the young King Henry VIII, at the behest of his then wife, Katherine of Aragon.

As plans crystallized for the exterior of the Hertenstein house, the notion emerged to copy Italian painter Andrea Mantegna's famous *Triumphs of Caesar*, a huge series of nine paintings he had executed for the Marchese Francesco Gonzaga and which had become very famous in reproduction. The series was so highly acclaimed that just over a century after Holbein reinterpreted it for Hertenstein, Charles I, the King of England and the English monarchy's greatest art collector, bought it from the Gonzaga estate. Today it is hanging in Hampton Court. It says something of Hertenstein's sense of self-importance that he wanted his own version of one of the most celebrated series of paintings in Europe on the front of his house.

Though no documentary evidence exists, there has been some speculation that in preparation for this gargantuan task Holbein took a trip to Mantua to see Mantegna's series in the flesh, probably as soon as weather permitted travel in 1518. It would have been a good year to travel generally. There had been a halt in the ongoing wars after Francis's defeat of the Swiss at Marignano and the Treaty of Eternal Peace. There are several instances in Holbein's work across the next two decades that reference that Italian master. However, Holbein also had at his disposal prints of Mantegna's work, some by Dürer, who, like Holbein, admired the painter and his formidable grasp of perspective.

Witz's *Dance of Death* was not the only victim of nineteenth-century enthusiasm for civic improvement. The magnificent Hertenstein house, entirely covered in Holbein's work, was demolished in 1825. The only record of it taken was a handful of pencil sketches by a local artist. Although almost all the preparatory work for this house is also lost, that for another house Holbein decorated in Basel a few years later survives and gives a sense of the stages of development he undertook in evolving the design with his client.

In the very initial stages Holbein broke the façade of the house down into sections, blocking out the actual architectural features such as doors and windows in grey. Around these he then executed a basic

schematic design featuring imaginary architecture in black ink. He then worked up more developed drawings – probably in discussion with the client, where further embellishments were added. Colour studies followed, suggesting the treatment of the imagined marble, stonework and so on. Finally, Holbein provided a highly finished, detailed presentation design. In full colour, with shading applied to best convey what the work would finally look like, this would be for his client's sign-off.[11]

In one of just two extant designs for the Hertenstein house, a section schematic for the ground floor can be seen featuring the main door and a wide, arched window. Around these actual features Holbein has woven an architectural and perspectival fantasy designed to deceive the eye and cheat the mind. He frames the door with imagined classical red marble columns, with ornate footings and garlanded capitals. The lintel is also red marble and supports an arch within which he imagines a bas-relief decorative antique frieze. Holbein makes the columns framing the door seem to project forward, by depicting a second set of ionic columns further back, bordering the double

previous pages
Hans Holbein, *Drawing for the Hertenstein House in Lucerne*, ink and watercolour, 1517–18.

window. These in turn frame a coffered arch through which we glimpse a further recessed space culminating in a staircase that leads up behind the formal façade of the building. These steps, climbing towards the first floor, create the entire conceit of the building. They suggest that the ornate classical work is part of an exterior masonry skin, wrapped around a smaller brick building, between which are hidden corridors, galleries and stairways. This provides Holbein with an imaginary depth of field of ten feet or so, where he can conjure the illusion of niches, and imagine balconies and loggia sufficiently spacious to place groups of people. Despite the classical decorative motifs that are deployed, the fantastical element of the design, the bizarre intricacy of these alcoves and balconettes, where people are perched and peeping, is entirely gothic in its sentiment, and makes one think of the peering gargoyles and layered aspects of the great gothic cathedrals in Northern Europe.

Between and above the first-floor windows, Holbein delivered a horizontal panel in grisaille intended to be read as pure decoration. Bursting through it in the centre of the building, however, he created a semicircular balcony seemingly projecting outwards, the extension

of a circular space in which a story from *Gesta Romanorum* plays out. This extremely popular book featured tales from Rome that would have been familiar to Lucerne's educated citizens. Depicted in full colour and with as much verisimilitude and perspectival accuracy as he could muster, Holbein tells the tale of the father who tests his three sons by suggesting they fire arrows into his body when he dies. Of course the one son who cannot bear to wound his father – even in death – is rewarded.

Above this scene and between the windows on the second storey, Holbein created trompe l'oeil niches framing Hertenstein's coat of arms and those of his wives (he had had four). Then above this was the splendid reinterpretation of Mantegna's *Triumph* marching across the house from right to left. The highest set of paintings once again deployed architectural trompe l'oeil, purporting to show that magical space between the building's façade and the brick building within. Five more stories from classical literature were depicted here, playing out beneath coffered ceilings that were tilted at just the right angle to seem convincing to viewers at street level.

Imagine this kind of spatial conceit writ large. The effect of such a dazzling confection, whipped up in the very latest Renaissance style, must have been profound. What is more, amid the uppermost series of five fables, and in central position, was the story of Mucius Scaevola. Whether he had had a hand in persuading his client to select this particular tale or not, the painter could nevertheless enjoy the personal symbolism this tale offered.

The Hertenstein house was completed by 1519. Lucerne had served Holbein well, but not well enough to persuade him to stay. Though work had been plentiful, the city as of yet lacked the intellectual engine of a university, or major publishing houses such as Froben's.

What is more, the effects of Martin Luther's assault on the traditional Catholic Church and its practice of indulgences were beginning to be felt. In the winter of 1517 Luther had nailed his theses to the door of All Saints' Church in Wittenberg, and now these, and other works by Luther and those sympathetic to him, were becoming extremely popular. A whole new era in protest publishing had been born, and with it yet more work for illustrators. Lucerne, home after all to the Pontifical Guard, was staunchly traditional and Catholic. Little of the new reformist material would make its way there. Basel,

on the other hand, placed itself as the publishing hub for the new debate. Its presses had never been busier.

Returning home Holbein found Basel transformed. Since he had left in 1517 a massive 2,000 people, one in five of the city's population, had died from either the mysterious headache disease or the bout of plague that had indeed followed it. Not surprisingly, Erasmus, who had returned to the city in May 1518, had decided to leave again by that September.

Against this backdrop of fear and illness, across 1518 Froben had prepared three hugely important texts for publication: a collection of Martin Luther's work including the *Ninety-Five Theses*, a second edition of Erasmus's *New Testament* and Sir Thomas More's *Utopia*. With Luther taking the church to task for its indulgences, Erasmus revisiting and reinterpreting the Bible, and More imagining an egalitarian society, each work was in its own way a commentary on the failings and flaws at the heart of the established world.*

A symptom of the troubles that these radical thinkers would ignite Europe-wide is suggested in microcosm in Basel in

Hans Holbein, woodcut by Hans Herman, *Luther as Hercules Germanicus*, 1519.

1519. As Holbein settled back in the city, Froben found himself the subject of a tantrum. He was planning to publish another text by Luther, his address to the Pope, *Ad Leonum X*. It was causing shock waves. Erasmus, sympathetic to many of Luther's arguments but ultimately wary of his extremism, correctly anticipated a backlash. Fearful of becoming associated with Luther, Erasmus gave Froben an ultimatum – either he or Luther could be part of the Froben stable, not both. Froben chose Erasmus.

Holbein, however, was by no means so sensitive. He could not afford to be. Rather than shy away from the Lutheran controversy, he embraced its opportunities. And so in Zurich's Zentralbibliothek today, pasted into a manuscript chronicling Luther's activities, is an extraordinary depiction of Luther as a Hercules Germanicus, a German Hercules, by Holbein.

In a way that would become typical of Holbein, the single-leaf woodcut invites more than one interpretation. At a first glance Luther

* Incidentally, Froben used an engraving of the *Calumny of Apelles* by Ambrosius Holbein to illustrate Erasmus's *New Testament*, and also deployed Ambrosius for *Utopia*, where he devised the alphabet letter illustrations within the text, as well as a map of the imaginary realm.

HERCVLES GERMANICVS

is triumphant and heroic, carrying the attributes of Hercules. He is shown valiantly battling corruption in the Catholic Church, just as Hercules defeated the Hydra. A lion skin over his cassock, he raises a spiked club to brutally dash his critics, many of whom are already defeated and underfoot in a crumpled heap. Luther is huge, twice the size of most of the figures he tramples. In comparison to the Pope, who is depicted like a tiny puppet dangling beneath Luther's nose, Luther is a gargantuan giant.

But look more closely and one suddenly wonders if the figure is less heroic and more ridiculous. There is something rather silly in a priest with a tonsured head standing in classical stance. In fact not just any classical stance but one which references the magnificent Laocoön, excavated in 1506 in Rome and instantly deemed a wonder of antiquity. The dissonance between these points of reference could be read as satire rather than praise. Further, that the Pope is dangling not just beneath, but *from* Luther's nose is bizarre. This is a pun on one of Erasmus's *Adages* which cites Horace's phrase '*suspendere naso*', literally *to hang by the nose* but used figuratively in the ancient world to mean *to sneer at or mock*.[12]

And here is Holbein's brilliance. In an era when one's allegiance to the wrong king or the wrong religious ideology could end a career, or worse, a life, Holbein delivers an image in which the audience can see what they want to see. It would be the same deft technique he would deploy twenty years later in his portrait of Anne of Cleves. Where Henry could perhaps see sanctity, motherhood and virtue in the portrait of Anne, others saw dullness and lack of dimension. In this instance those who were pro-Luther might choose to see a hero battling his adversaries, while his critics were offered a ridiculous priest foolishly pitting himself against the establishment.

The purpose of this engraving remains unclear. It may have been conceived as a standalone woodcut produced by Holbein and Hans Herman, a pattern-cutter (or *Formschneider*). There is one tantalizing suggestion that it originated in a discussion that involved Erasmus directly, and possibly places Holbein in the room as members of the Sodalitas Basiliensis chewed the intellectual cud together.

In 1522 Ulrich Hugwald, a scholar who worked alongside the printer and publisher Adam Petri, recounted in a letter the story of Erasmus joining in a group discussion on Luther and using Horace's

phrase '*suspendere naso*'. Someone in the room grasped the visual pun the phrase suggested and quickly produced a sketch of Luther literally hanging the Pope from his nose. The possibility remains that it was Holbein who drew that sketch, which he later worked up fully and reproduced.[13]

While Ambrosius no doubt welcomed his brother's return, his career had indeed benefitted from Hans' temporary absence. After Hans left for Lucerne, Ambrosius had taken over designing new title page borders for Froben, several of which would prove extremely popular with the publisher. In addition to the *Calumny of Apelles*, he had designed a frontispiece featuring *Lucretia and Tarquinius*, another *Imago Vitae Aulicae*, and several more.[14]

Ambrosius's *Imago* is worth brief consideration, since it highlights the lively intellectual dialogue that could underpin even illustration in the humanist circles for which it was intended. *Imago Vitae Aulicae* was the classical satirist Lucian's conclusion to *De Mercede conductis potentium familiaribus*, or *On Salaried Posts in Great Houses*. Its observations of underpaid scholars enthralled to the rich and powerful still felt relevant in the sixteenth century, and Erasmus, who was constantly seeking patronage from Europe's courts, had issued an edition of the work in 1506. In his conclusory picture of court life Lucian had noted that 'I would have glady required an Apelles or Parrhasius [...] to paint it, but since it is impossible nowadays to find someone so excellent and so thoroughly a master of his craft, I will show you the picture [...] in unembellished prose'. And with this he went on to describe a golden gateway leading to life at court, through which the hard-working scholar passes only to see personifications of Hope always leading him onwards – but Deceit and Servitude intervene, Toil works him, Old Age, Insolence and Despair embrace him, before Hope finally vanishes.[15]

Ambrosius shows a youthful scholar climbing the steps to court, enticed by a beautiful woman. He is then shown negotiating his way through the corridors of power before being dragged out naked and beaten by Despair. With the exception of Toil and Old Age, all those who take him by the hand are women: Servitude, Deceit and Contempt. The very fact that Froben asked Ambrosius to take on the task of finding a pictorial version of this tale submits a playful suggestion that the artistic resources available in sixteenth-century

Basel were on a par with those of the classical past.

Lucian's description of the life of a scholar was not only pertinent to men such as Erasmus. It was entirely applicable to the sixteenth-century artist, who, strive as he or she might, still found themselves poorly paid. It is no wonder then that Ambrosius was not exclusive to Froben. He could not afford to be. Like his brother he also worked extensively for Adam Petri and other publishers in the city. In 1519 he embarked on illustrations for Petri's edition of Thomas Murner's *Die Geuchmatt.* Murner had written a satirical piece focusing on women and their ability to lead men astray. It was the latest contribution to the popular genre of 'fool literature' that had begun with Brandt and been expanded by Erasmus. It was a considerable commission for some fifty illustrations across a 250-page book that firmly reinstated many prejudices held against women in the era.

The first illustration testifies the level of skill and charm Hans' elder brother could command in his work. He depicts Venus as a woman in contemporary Swiss dress, sitting enthroned on a raised dais underneath a classical scallop-shell niche. Around her stands a group of men, including a king and a Pope. One man kneels at her feet and Ambrosius depicts Venus stretching out her hand as if to bless him, her head gracefully inclined. In the second illustration he features Murner himself, writing at his desk. The work is typical of the son of Hans Holbein the Elder, with attention to detail such as a little cupboard built into the side of the desk and a bookshelf above laden with books and a glass vase.

In the third illustration Venus is seen chatting with a pious woman. The goddess is standing in elegant contrapposto, she is wearing a wide-brimmed hat adorned with plumage, and a balustrade is situated behind her, beyond which an exotic mountainscape is suggested. The fourth illustration is a repetition of the first. And then, quite suddenly, Ambrosius's pen is at rest. The woodcut that follows, clumsy and simple by comparison, simply cannot be by him, nor can the remaining forty-eight.

In March 1519 Froben also published a new title border from Ambrosius. It is a confection of boys and bearded men, the former winding up the left-hand side of the border and the latter the right, all entwined with curling vegetable forms and cornucopia. However, from this point on there is no more new work from Ambrosius for

Froben either. Every frontispiece by him the publisher uses after this is merely the reproduction of already existing designs. And it is not just his illustrative work that seems to terminate in 1519 – no more new work in any medium emerges from Hans Holbein's brother after this date.

There is no record of Ambrosius's death, but the abrupt cessation of his work in a year where so many were falling prey to sickness suggests that he either caught the disease that began with a headache, or the plague that came in its wake, and died. Another alternative is that his financial worries had pressed him into mercenary service, like Urs Graf, though with the Italian Wars in momentary pause, this seems unlikely. Whatever the cause of his demise, Ambrosius would have been only about twenty-five years old.

The loss of his brother may have forged a specific connection between Holbein and Bonifacius Amerbach. The two had likely met when the former first came to Basel and worked for Froben. Of all the three Amerbach brothers Bonifacius, the youngest, was the most talented. Erasmus took to him as soon as he first arrived in Basel and would grow to adore him in the fullness of time. A dedicated intellectual, passionate about the arts, he was embedded in Basel's humanist circle. His religious views were close to those of Erasmus, and like him he remained a traditional Catholic who was nevertheless sympathetic to reform. When Holbein probably first met him, Bonifacius would have been studying law at Freiburg im Breisgau but spending his holidays at home.

Across the summer of 1519, when Bonifacius was once again back in Basel, Holbein painted his portrait. It was intended to celebrate the former's twenty-fourth birthday, as well as his completion of studies. Holbein gives us Bonifacius almost in full profile. Long nosed, blue eyed, his auburn hair is short and he wears a full beard. His beret is black, as is his coat, beneath which a particularly fine pale blue damask jerkin is visible, fastened over a very fine, almost translucent shirt.

Some of Bonifacius's involvement in the conception of the portrait is revealed in a scrap of paper held in Basel's university library. Here the young scholar has written and rewritten different versions of the inscription for the portrait, reworking the words until they fit the available space.

In the end what appears on a board nailed to the tree in the picture

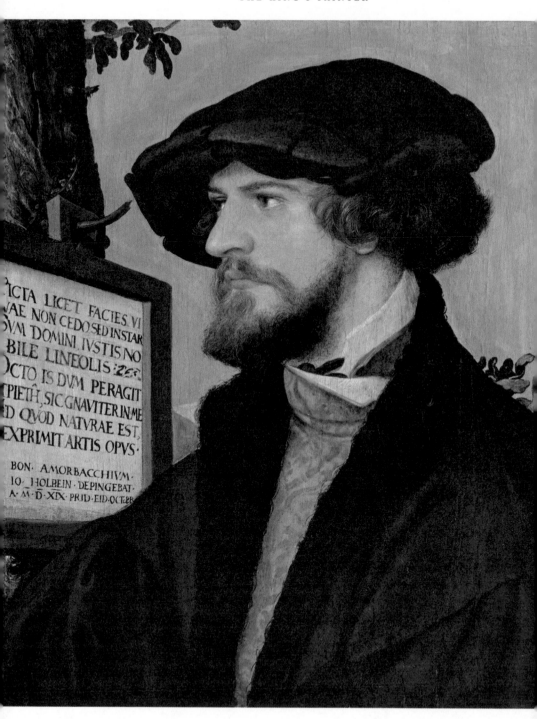

ICTA LICET FACIES VI
VAE NON CEDO SED INSTAR
VM DOMINI IVSTIS NO
BILE LINEOLIS 1520
CTO IS DVM PERAGIT
PIETH, SIC GNAVITER IN ME
D QVOD NATVRAE EST,
EXPRIMIT ARTIS OPVS.

BON. AMORBACCHIVM.
IO. HOLBEIN. DEPINGEBAT.
A. M. D. XIX. PRID. EID. OCTEB

is the following: 'Although only a painted likeness I am not inferior to the living face; I am instead the counterpart of my master, and distinguished by accurate lines. Just as he completes three intervals each lasting eight years this work of art diligently renders his true character. Hans Holbein painted Bonifacius Amerbach on 14th October 1519.' The inscription is at once a compliment to Holbein's skills of verisimilitude and a playful acknowledgement of the distinction between art and the real thing.

Whatever celebrations accompanied the unveiling of Bonifacius's portrait, any sense of joy quickly evaporated in the Amerbach household. It was just a week after Bonifacius's birthday that his elder brother Bruno died, aged just thirty-five. Tragically, the plague took Bruno's young wife too.

Bruno, who had been so dismissive of the threat of contagion when encouraging Erasmus to return to Basel, was known to be a reckless character. All the warnings had been there for him. Wolfgang Capito had written to Bruno in the autumn of 1518 deterring him from paying a visit on account of a servant who was suffering headaches and may have had the plague. A year later and Bruno himself had fallen ill.

Hans Holbein, *Bonifacius Amerbach*, mixed media on fir wood, 1519.

It was not until March 1520 that Bonifacius wrote to Erasmus about his loss:

> What can I tell about our own affairs? If I am not mistaken, you know that we have had a miserable year. The loss of my brother Bruno, mowed by the plague, has immersed us in deep mourning. I have no doubt that his passing has wounded you, for he was as closely connected to us by the blood as to you by his boundless dedication; He has always admired and honored you with awe. Now he is dead, while we would love to see him stay alive; [...] he has fallen asleep, which means a huge loss to us. Because of my brother's death, I have stayed in Basel so far. However, this spring I will be leaving for Avignon.[16]

Was it during this bleak winter to which Bonifacius refers, the drab five-month period of mourning between the end of October 1519 and March 1520, when Bonifacius and Holbein were united in grief for their respective brothers, that one of the greatest works in the history of Western art was first discussed by them?

The Dead Christ in the Tomb is a painting by Holbein that has

caused ripples down the centuries. Christ is painted full size, dead and emaciated, flat on his back, in a shallow tomb. The limewood Holbein has painted on has been cut into a shallow rectangle, the same length and height as the imagined space containing the Messiah. Christ's body is viewed side on, the interior sides of cold stone slabs the only other subject of the work. There is hardly any space in this narrow resting place. Jesus' ribcage is just centimetres from the roof of his grave. His head lolls to one side to reveal a gaping, hollow mouth. His eyes, partially open, are unseeing.

When the Russian novelist Fyodor Dostoevsky saw the painting in 1867 he was so mesmerized and troubled by the work that his wife had to drag him away from it, fearing he was about to suffer an epileptic fit. He subsequently wrote the painting into his novel *The Idiot*, where one of his characters, Prince Myshkin, points out that 'some people may lose their faith by looking at that picture'. In the twentieth century the psychoanalyst, author and academic Julia Kristeva considered the work as the 'unadorned representation of human death'. She suggests that in depicting the lonely and isolated figure of Christ, Holbein 'endows the painting with its major melancholy burden' before going on to suggest the painter was a 'disenchanted verist'.

The ability of a painting to speak to an audience in the language of its own time is indicative of its brilliance. That the *Dead Christ* could speak to the insecure Christianity of a nineteenth century fractured by Darwin's *Origin of Species*, as well as to the post-Freudian twentieth-century psychoanalyst, does nothing but recommend Holbein's supreme gift. The question remains, however: how was it intended to speak to those looking at it in sixteenth-century Basel?

The Amerbach family home was in Kleinbasel, or Little Basel, the part of the city to the east of the river. Situated at 23 Rheingasse, the so-called Haus zum Kaiserstuhl had been bought by Johann in the 1480s. Looking out over the busy, fast-flowing waterway, it was just a short walk along the shore of the Rhine to the Carthusian monastery of Margarethental.* Boy and man Bonifacius would have made endless trips back and forth between his home and the monastery. It was the natural resting place for Johann when he died in 1513, and now, just six

* Johann Amerbach's old university professor, collaborator and great friend Johann Heynlin had given up on public life and installed himself in the monastery in the late fifteenth century.

years later, Bruno was laid to rest there too. In 1519 Bonifacius and his surviving brother Basilius decided it would become the site of a family tomb, complete with epitaph.[17]

It comes as little surprise that the combined inventive minds of Bonifacius Amerbach and Holbein would come up with a unique idea for a memorial painting to accompany this epitaph. It also comes as little surprise that, given Bonifacius's views so closely mirrored Erasmus's own, any devotional image for the tomb would have to circumvent the issues that the latter had with traditional devotional art. Together the two young men sought to find a new way of depicting Christ in the new era of Erasmian humanism.

It was clear from *In Praise of Folly* that Erasmus took issue with those who prayed in front of devotional images as part of ingrained ritual, without fully appreciating the Christian significance of the holy figure they knelt before. For Erasmus devotional religious work was only of value in conjunction with properly informed contemplation. Key for Erasmus was the idea of holy figures as actual people who had thought, taught, written and demonstrated the essence of Christianity. In his *Handbook of the Christian Soldier*, he explained this opinion with specific reference to Christ.

> You give homage to an image of Christ's countenance represented in stone or wood, or depicted in colour. With how much more religious feeling should you render homage to the image of his mind, which has been reproduced in the Gospels, through the artistry of the Holy Spirit. No Apelles has ever portrayed with his brush the shape and features of the body in the way that speech reveals each person's mind and thought. This is especially so with Christ, for as he was the essence of simplicity and truth, there could be no dissimilarity between the archetype of the divine mind and the form of speech that issued from it. [...] You gaze with awe at what is purported to be the tunic or shroud of Christ, and you read the oracles of Christ apathetically. You think it an immense privilege to have a tiny particle of the cross in your home. But that is nothing compared to carrying about in your heart the mystery of the cross.

Consider this paragraph a gauntlet thrown down to Holbein. If he could deliver what Apelles could not – a depiction of Christ that could reveal the mind, thought and essential spiritual message of the saviour – that would be something indeed. And this, surely, is what he attempted.

In his painting of Christ Holbein takes verisimilitude in devotional art to a new level. The fact that the figure is full size is just the first indicator that the artist intends this work to be as convincing as possible, a genuine counterfeit – or counterpart – to the real thing, that is Christ the man who died for mankind.

The legend is that to best give a sense of the reality of Christ post-mortem Holbein observed a corpse he had dragged from the Rhine. Whether this is true or not, there is no doubt of his attempt to be totally convincing. Christ's hair is painted with astonishing detail, with individual strands clearly visible. This minute detail is continued around the eyes, where each single eyelash is noted. The parted lips are desiccated and swollen, the gums and teeth exposed. There is bruising on the side of the face. The anatomy and musculature of the body are persuasive. There is no idealized frame here, but the thin remnants of a man who has been starved during crucifixion, the sinews and muscles perished, his ribs visible, the skin suffering from that strange sagging that death brings when blood stops pumping.

Hans Holbein, *The Dead Christ in the Tomb*, oil on limewood, 1521–2.

As is traditional, Christ wears nothing but a piece of white cloth, perhaps a foot wide, tied around the top of his legs. This too is brilliantly observed: its fastening knots and the raw, torn edge of the surplus fabric. The winding sheet beneath him is also as convincing as can be. Like a white tablecloth in a Dutch still life from a future era, it ruffles and creases beneath its offering.

The only detail Holbein takes from existing devotional art rather than real-world observation is the greenish colour he paints the

discolouration around Christ's wounds on his hands and feet, and in his side. This seems to be a reference to the work of his father. Hans Holbein the Elder also depicted Christ's hands and feet using this very same haunting hue in his own vision of *The Entombment*, painted around 1500, and now hanging as part of a triptych also featuring the *Crucifixion and Deposition* in Augsburg's Staatsgalerie.

Today, when there is the technology to look through opaque material, and one is used to the effects of film and computer graphics, it's tempting to think that Holbein has allowed us to see into the kind of fully sealed stone box sarcophagus that was regularly described in traditional entombment scenes. If this is the case Holbein has given us an imagined cross section of the tomb, revealing the figure within. Julia Kristeva certainly interpreted the image in this manner, describing Christ as being in a 'closed-in coffin' where the 'tombstone weighs down on the upper portion of the painting'.[18]

However, it is unlikely that the original viewers of the painting would make this imaginative leap. With painting of such virtuoso realism an exhilarating rarity at this time, the impact of the painting was just that – its verisimilitude. As such the instinct of the sixteenth-century viewer would be to take the painting more literally than those of us looking at it today. This is not Christ imagined inside a tomb with four walls, a base and a tombstone on top. This is Christ slid into a horizontal niche, three sided, with one side exposed.

Holbein reinforces this illusion. He is careful to show the edges of one of the stone slabs lining the niche, cracked and chipped. Meanwhile the pall on which Christ lies is falling over the edge of

the slab it covers, as is Christ's hair. His right hand marks the niche's boundary: rigid in death, its extended middle finger marks the limit of the tomb, while his bent fourth and fifth fingers protrude beyond it. Given the heel of Christ's right foot is also placed on the very edge of the recess, and the foot is leaning over further to the right, his toes must also be extending beyond the confines of the cavity in which the body is held. This bold perspectival illusion which places parts of Christ's body outside his tomb, by implication extends his presence into the same space as the viewer.

Putting this trompe l'oeil to one side for a moment, one has to ask what elements of this description of a dead Christ might reference funerary or devotional monuments familiar to Holbein's contemporaries. For a start the depiction of a dead Christ that avoids any idealization and acknowledges the process of post-mortem deterioration makes some allusion to cadaver tombs. These carved memorials show the interred occupant of the tomb depicted in emaciated or skeletal form lying on top of the stone sarcophagus, thus serving as a memento mori.

It is also the case that in some parts of Northern Europe, particularly Germany[19] and England, Holy Sepulchre niches were made in the walls of churches to hold either the host or an image of Christ during Easter. Christ, a wooden statue, or a panel painting, could be temporarily placed in the niche before being removed again to celebrate resurrection. In cases of patronage these niches were sometimes made above the tomb of the patron in question, enabling it to take on the symbolism for Christ's tomb at Easter, particularly if it were adorned with depictions of the soldiers sleeping or other images of crucifixion, deposition, burial and resurrection.[20]

Despite its reference to cadaver tombs and Easter sepulchres, however, recent research has revealed the more likely reason that Holbein painted a cadaverous Christ in a horizontal niche. And that relates once again to the ambition of that painter to create work of seeming reality, and genuine authenticity.

While Holbein had been working on his commission, Amerbach had been continuing his studies in Avignon, but in September 1521 he returned to escape the plague which had taken hold in the French city. On 16 December 1521 Bonifacius Amerbach borrowed a book from the library of the Carthusian monastery where his father and

brother were buried.[21] The book he took out was an account of a
trip to the Holy Land written in the previous century, Bernhard von
Breidenbach's 1486 *Peregrinatio in terram sanctam*. It suggests that as
Holbein's painting was evolving Bonifacius was researching details
of the tomb of Christ in Jerusalem. Breidenbach must have disap-
pointed him, since his account of his visit was brief. But even had he
delivered something more detailed, its usefulness was limited. Some
of Bonifacius's contemporaries who had more recently undertaken
pilgrimage to the site of the burial of Christ had observed that the
tomb could not be original, but must be a later monument constructed
on the original site.

Today's archaeology substantiates this observation, and suggests
buildings over the site have included a temple to Venus by Emperor
Hadrian, a domed mausoleum constructed by Constantin and an
eleventh-century monument that was then further embellished in the
twelfth century. What current thinking suggests is that most likely
Christ was placed in a niche grave in a Roman catacomb, examples of
which were known across the Mediterranean as well as in Rome itself.
Bonifacius's research seems to have led him to a similar conclusion.

X-rays reveal that Holbein reworked the internal space of the
niche, changing a rounded, arched back wall to one with rectangular
corners. The alteration allowed Holbein to move his signature and
the inscription of the date of the work, which was originally rather
squeezed next to Christ's right foot, into the space it currently
occupies in this 'corner' above Christ's left foot. Both barrel vault and
rectangular niche catacombs existed in the Roman period. Whether
this alteration was made purely for pragmatic reasons or whether
it was attendant on Bonifacius's investigations we will never know.
Nevertheless the suggestion is that the conceit Holbein and Bonifacius
had conceived was to portray Christ with as much archaeological
accuracy as possible, in a *catacomb*. At first the assumption was that the
catacomb had a rounded back wall, until Bonifacius discovered that
rectangular versions also existed, this being Holbein's preference.[22]

The original title of the painting which Basilius Amerbach recorded
in the inventory of his Cabinet also has strong archaeological overtones:
Iesus Nazarus rex J(udaeorum).[23] Imagine then the experience Holbein
had planned for those originally intended to see the work. They would
walk along the cloister, encountering the painting first from its left

side. It would be hanging over the Amerbach family epitaph, above eye level. Holbein's perspective, which shows just the right corner of the tomb and its ceiling but not its floor, accommodates this view. Here they would stop and contemplate the image of a dead Christ in his catacomb rendered as persuasively and historically *accurately* as possible. The lack of ornamentation and the tight framing of the tomb around the body, itself simple and naked in death, would focus the contemplation of that body. In looking closely viewers would perceive the agony shown in the face of this dead man, the torture suggested in his hands, gnarled and curled with pain, the rot set in around the wounds, and the suffering of terrible emaciation. Here Holbein mustered all his skill to meet that Erasmian challenge: to paint a body that could convey the mind of Christ, a body that could communicate his ultimate sacrifice.

The verisimilitude better enables the viewer to empathize with Christ – bridging the tension between artifice and truth. This lesson had of course been taught Holbein by his father. And in *Iesus Nazarus rex J(udaeorum)*, Holbein deploys another device his father experimented with. He compresses time.

By giving the impression that parts of Christ's body overhang the catacomb niche, he places Christ and the viewer of the painting momentarily in the same dimension. Christ is at once present in the here and now, a dead man, a memento mori to remind the viewer of his own fate. But the viewer is also momentarily in the Holy Land, in a distant past, in a time when Jesus was mockingly crowned 'King of the Jews' by Pontius Pilate and Christianity was yet to be properly born. In time-shifting the viewer back to Palestine, the painting invites him or her to become part of the theatre of the Messiah's death. Suddenly one is a witness to the entombment, a character in a story that will ultimately lead to Christ's resurrection. Though for Dostoevsky this was a painting that challenged faith, and for Kristeva it was a painting that spoke to the depths of the human psyche, for its original audience it was conceived as a painting that could reinforce the faith of those who saw it, by immersing them in the moment of Christ's sacrifice.

Erasmus had returned to Basel in 1521, in November. He must surely have seen Holbein's astonishing image of Christ. It would have still been incomplete in those first winter months the scholar was back in the city. X-ray investigation of the painting has revealed that

Holbein had written 1521 in the first stage of his composition, when he had placed Christ in a vaulted tomb. At the point he repainted the tomb in its current rectangular form he added a new date, MDXXII, or 1522. He then revised his inscription once more, overpainting the last I to revert the date to 1521, perhaps reflecting that the work had been majorly completed in this year.[24]

Holbein's *Dead Christ* represented a considerable development from the ink sketches Erasmus had enjoyed half a decade earlier in the margins of *In Praise of Folly*. The painting could have done nothing other than reinforce Holbein's talent in his eyes, and remind the scholar of his own fragile mortality. No wonder Erasmus would shortly turn to Holbein for his own portrait.

Erasmus discovered Froben, now in his sixties, much changed from just a few years earlier. The publisher had taken a bad tumble down some stairs in the previous month, and was left partially paralysed. He worked on in spite of this new infirmity. In December Froben, his wealth boosted by legacies from relatives who had died in the most recent bout of plague, purchased a grand new house at No. 17 Nadelberg. This ample new accommodation was very close to the Haus zum Sessel, with the rear of both properties adjacent to one another. In a gesture of enormous generosity and considerable business acumen, Froben immediately lent it to Erasmus for the latter to live in comfort – and continue to work with the Froben press.

Froben also followed Erasmus in commissioning a likeness from Basel's young star. Holbein's simple, unadorned portrait of his occasional employer, revealing his strong jaw and underbite, his lined no-nonsense face and thinning hair, is an honest memento for the family of a man whose health issues signalled his time was running out.*

Holbein by contrast was still young. By the time his profoundly powerful image of *The Dead Christ in the Tomb* was finally handed over to its patron in 1522 he could claim to have dodged death himself more than once. The epidemics, wars and street brawls that had taken so many of his contemporaries had left him unscathed. The Grim Reaper would continue to be a menacing presence in what was to come, but in the meantime Holbein embraced life. He was climbing that slippery slope, with hope leading him forward. He had also embarked on a new adventure – married life.

* Holbein's portrait of Froben now hangs in The King's Closet at Windsor Castle.

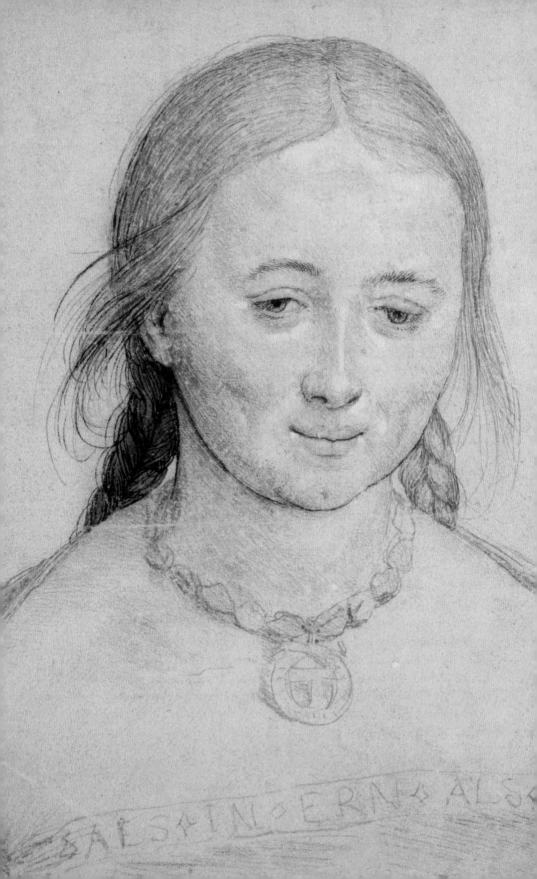

ELSBETH

As a young journeyman or *Wandergeselle*, Holbein was immersed in a strongly defined fraternity. Fully trained, and in Hans' case with a talent that already surpassed his elders, yet not equipped to become acknowledged masters of their craft in guild terms, journeymen formed a rather specific social group in early modern culture, with its own attendant rites of passage and occasional bad behaviour. Basel's civic records remind us of this. On several occasions in the fifteenth century the city was forced to legislate against their antics, forbidding journeymen from forcing their fellow journeymen or guildsmen to drink with them on Ash Wednesday, or from throwing anyone in fountains. Nothing much changed over the course of a century. In 1516 the authorities were still trying to discourage the journeymen's high jinks, this time banning them from hitting each other with bags of ashes, and getting covered in the contents.[1]

Typically, the *Wandergesellen* lived either in the homestead of the master to whom they were attached or in a local journeyman's hostel. As a group they socialized together and whored together in the pre-Reformation era of greater sexual freedom. In Germany in particular they became organized rather like a modern-day union, which could attempt to force the hand of guilds by direct action. In Switzerland journeymen's organizations were effectively emasculated at the end of the fifteenth century; nevertheless the cultural traditions associated with them persisted.

previous page
Hans Holbein, *Elsbeth Schmidt/Holbein,* metalpoint, ink, red chalk and white gouache, on paper, *c.*1520.

Among these was the expectation for a journeyman to be single.

This separation from the opposite sex amplified the prejudice journeymen held towards women within guild society. Journeymen tended to put up strong objections to most women becoming part of a workshop, even family members. In the same way sailors resented women on board ships, they often considered that having to work alongside a women tainted the honour of the journeyman code – be that formal or not. This sense of hostility to working women was symptomatic of the culture more generally, where elsewhere roles between the sexes were strictly defined, where the authority of women was usually confined to domestic environments and child rearing, and where married women's obedience to their husband was expected and their participation in public life was extremely restricted.

Grating with this, however, was economics, and the usefulness of

women within the guild and workshop system – particularly within crafts guilds. Daughters and sisters could perform some of the tasks that lay at the heart of workshop practice. Historically they had done just this, with earlier medieval society seeing women working in artists' workshops and even in exceptional circumstances taking on the role of 'master', particularly when widowed. However, by the time Holbein was born, the guilds had generally clamped down on the liberty of the so-called fairer sex. Some of them even restricted the amount of time a woman could run her husband's workshop after his death.[2]

All this said, the wife of a master benefitted from an entirely different status. Whereas there was debate about whether daughters and sisters should be working, the expectation was for a master's wife to be part of his business. She was an accepted asset to a workshop, responsible for feeding and caring for its members. She could also keep business ticking over were the master away, or even work alongside him. Dürer's wife, Agnes, had been an extremely active business partner. What is more, in what seems to be an ironic response to the journeymen's resentment of women, it was generally a necessity for them to take a wife to acquire the title of master, with some guilds often granting the status only on condition that a marriage was contracted within a year of enrolment in the guild. On the one hand working women were distasteful, tainted and socially problematic; on the other they were the ticket to success.

For Holbein this ticket took the form of a young widow, Elsbeth Schmidt, née Binzenstock. She was born between 1492 and 1495 in Ehrenstetten, a small village not too far from Freiburg, but moved to Basel to live with her childless aunt Sibille von Kilchen who lived at 24 Gerbergasse in the town.[3] She was, therefore, like Holbein, German in origin.

Elsbeth's first husband Ulrich Schmidt was also a resident of Gerbergasse, a street that took its name from the tanneries that lined it. The Schmidts had been tanners in Basel for at least four generations, and Ulrich's branch of the family lived at a house known as 'Little Venice'. Gerbergasse was a long thoroughfare running parallel to the river and extending across half of Grossbasel, until it reached the main market square. It must have stunk. The huge vats at the rear of the properties, which contained the dung and urine in which hides soaked, made for a pungent and toxic atmosphere.

Mercenary work took Ulrich away from his young wife regularly. In 1509 he was making war *in alliance with* the French against the Italians at Pistoja. Then in the following year he was one of 400 guildsmen from Basel who followed Jacob Meyer – whom Holbein would paint in due course – into battle *against* the French. But it was the campaign against the French that the men of Basel joined in 1515, culminating in the terrible battle at Marignano, that proved a disaster for Ulrich Schmidt.

In that year, three waves of militia set out from Basel led by the city's senior men. In May Henmann Offenburg led 200 men from the city, a month later Hans Trutmann led a larger force of 600 men, and then finally in August, Offenburg's father-in-law and a fellow councillor, Heinrich Meltinger, took 800 men – including Schmidt – to the war. On 13 and 14 September the Battle of Marignano raged and, as Jakob von Hertenstein and his son fighting with the men of Lucerne also discovered, turned into a victory for the French under their new King Francis I. Schmidt, like a huge number of Swiss, lost his life.

Holbein had become an official member of Basel's painters' guild – the Zunft zum Himmel – in late September 1519. However, to be wholly made up into a master, he needed a wife. Elsbeth Schmidt would have been widowed for four years at this point, and was the single mother to a young son, Franz, born in 1514. It is hardly surprising that when Hans Holbein made overtures to her, they were welcomed. The benefits were mutual, of course. Holbein had promise but Elsbeth had premises, money and the experience of running a workshop alongside her former husband. The two tied the knot at some point in 1519 or 1520. By July 1520 Holbein was acknowledged as a citizen of Basel, almost certainly because he was already married to one, and thus not required to pay the 4 gulden fee that his brother had been subject to.[4] This must have been a welcome exemption. A month later Holbein found himself in court on account of debts owed to the wife of his fellow painter Michel Schuman.[5] One gets a sense of the difficulty he had had in making ends meet up to this point. His marriage to a woman of some means came not a moment too soon.

As a master, Holbein was able to display his family coat of arms in the guild hall on Freiestrasse, another long street that ran parallel to the tanners' Gerbergasse. The Holbein family coat of arms was an

ox head, and is recorded as early as the mid fourteenth century, in an association with an Abbot Burckhardt Holbein.[6] It had come to prominence in the following century when the Holbeins had been one of the founding families of the Ravensburg Trading Company, the Humpisgesellschaft.

The Holbeins of Ravensburg had been at the forefront of paper making at the dawn of the previous century. In 1393 Hans and Frik Holbein built one of the first paper mills north of the Alps. From this landmark enterprise, known as the Hammer, they produced an extremely high-quality linen-based paper, before anything similar was made in Italy. Their rise was consequently swift. Not only did they make vast sums of money, but they ascended through the ranks of Ravensburg's officials. Frik and his son of the same name both became city commanders. However, the family fell from grace during a political scandal when they were accused of conspiracy. Relieved of their civic titles, the Ravensburg Holbeins were forced to sell up. At which point they moved away, very possibly to Ulm or to Augsburg.

The watermark of Holbein paper from Ravensburg was once again the ox's head. This symbol provided several useful references. First, of course, the strength and durability of such an animal was a comment on the resilience of their paper. An ox head was also part of a grading system widely used by traders. Quality controllers checking goods would stamp the finest quality goods with this motif, second-rate goods with a lion, and third-rate with a grape. Although the system of stamps varied a little between cities, Basel used the ox stamp to signify the very finest products. And finally the ox head was the symbol of St Luke, that literary and artistic saint who was both author of one of the Gospels and who according to tradition painted the Virgin Mary, creating the very first icons in the Eastern Orthodox Church.

The symbol acquired a slightly different significance when applied to this latest member of the Holbein family. For sure, the associations with strength and durability persisted. But when it came to St Luke, his forbears would have surely benefitted from this association with regard to the intended literary use of their product. For Hans Holbein the Younger, perhaps he considered the allusion to St Luke the painter as more apposite. Over the course of the 1520s Holbein would embark on a series of depictions of the Virgin and motherhood. In one of those moments when art can coincide with life with uncanny proximity,

these commissions came just as he was discovering his own wife and the first of his children was born.

In the Louvre there is a silverpoint drawing of Elsbeth made around the time of their marriage. It is an intimate, honest portrayal. Elsbeth is no conventional beauty. Her husband had not shied from showing a peculiarity in her eyes, both of which seem a little lazy, with slightly swollen lids – possibly symptoms of the dry eye disease that tanners often suffered from their terrible working environments. Elsbeth is depicted wearing the insignia of St Anthony on her necklace, another saint who offered protection from the plague. Elsbeth is self-conscious, her downward gaze and tight smile suggesting a slight unease at being the subject of a drawing. Her cheeks, a little rosy, also suggest their exposure to a working environment. She is a far cry from the confident, aristocratic, porcelain-skinned women that Holbein would draw in England some years later.

Elsbeth could not have avoided being subject to the attitudes working women had to put up with as a fact of life at that time. Despite their accepted role, masters' wives could still find themselves subject to the scorn of men who enjoyed their own social superiority. It is telling that even Erasmus, a supporter of the education of women, nevertheless found it frustrating dealing with a woman when she strayed into territories that were normally the domain of men.

When he had to work with Johann Froben's well-educated wife in business matters, Erasmus could slip into caustic unpleasantness. In 1518, for example, he criticized Froben's wife Gertrud for 'petticoat government', warning Froben against handing 'the reins' of his business over to 'the home-bred slaves'.[7]

It is equally telling, however, that despite his grumblings Froben's wife dealt with Erasmus nonetheless – testimony to the importance of her role in the family enterprise. Gertrud and her sisters, who also lived with her at the Haus zum Sessel, did more than get involved with the management of the business. They helped finance it. In 1516 Gertrud had personally paid the production costs for Henricius Glareanus's treatise on music theory, and two years later she was part of a family consortium that included her sisters and mother who backed the publication of legal opinions by Ulrich Zasius.[8]

The only testimony we have of Holbein's own attitude to women is his depiction of them, and in this Elsbeth played her part. In 1864,

more than three hundred years after Holbein captured his wife in silverpoint, another likeness of her was rediscovered when an art collector called Franz Anton Zetter took an interest in a dilapidated and blackened old painting of a Madonna in the small Allerheiligen, or All Saints Church, in the Swiss town of Grenchen.

The painting was hanging high up in the choir, worm-eaten and frameless. To add insult to injury two holes had been bored into the limewood, through which a piece of string had been passed to support the work.

Nevertheless, Zetter bought the work and had it restored to discover, perhaps as he had always suspected, that it was by Holbein. The face of the Madonna bears a striking resemblance to that silverpoint drawing of Elsbeth in the Louvre, and the date of the work to 1522, revealed as part of the cleaning, adds credence to the supposition. Just a year after Holbein had sought the utmost authenticity in finding a corpse on which to base his image of the dead Christ, now he sought a real-life young mother to portray a Madonna.

Today the painting hangs in the museum at nearby Solothurn, and is consequently referred to as the *Solothurn Madonna*. It features the Virgin and child seated on a dais, beneath a barrel vault. The vault is notable for its plainness. After so many instances of Holbein displaying complex architectural space, luxurious materials and intense decoration, the simplicity of the setting he now describes seems all the more striking. Decorated with nothing but a grey plaster, the vault even has the iron tie rods securing the structure, visible and unadorned. Short of any other explanation for this aspect of the work, the most obvious reason is that Holbein adopted these architectural aspects to reflect the genuine architectural features of the church in which it was originally intended to hang. His ability to trick his audience into momentarily mistaking his painting for a continuation of a series of vaulted windows would create an imaginative space in which devotional icons could, during a suspension of disbelief, interact with the real world.

The Madonna is clad in a voluminous blue cloak worn over a pink dress. The baby on her lap, his right arm foreshortened and appearing to reach out of the frame in a blessing to anyone looking up at the painting, may well have been modelled on Holbein and Elsbeth's baby son Philipp. The Virgin is flanked by two saints, one clad like

a bishop, the other in gleaming armour. A green Turkish carpet is spread on the dais, an accessory that Holbein would grow so fond of in due course that the term 'Holbein carpet' slipped into common usage. The edge of the carpet has been cut off at the bottom of the painting, suggesting the possibility that it may have continued to spill out over the original frame to further enhance the trompe l'oeil effect. Meanwhile the escutcheons of the painting's patrons are woven into the carpet design: Johannes Gerster and Maria Barbara Guldinknopf.

What is astonishing about the depiction of the Virgin is her imperfection. In using his own wife Elsbeth as his model, Holbein also chose to depict those strange eyes, with the same slightly drooping lids. In doing so he makes an obvious and conscious move away from the idealized facial features usually used to portray the mother of Christ. One has to ask: why?

At the simplest level the choice must be to humanize the figure of the mother of God, making her relatable and convincing. His decision to use suggested rays of sunshine behind her rather than a traditional halo contributes to the naturalism. But there are other treatments of the figure which suggest that Holbein intended to convey a yet more subtle message. Mary is after all dominated by her huge, voluminous cloak which, rather than sitting easily on her shoulders, seems to dwarf her. There is also that hint of self-consciousness or shyness in her expression which is consistent with the Louvre drawing. In effect Holbein offers a unique, flawed person rather than an idealized, perfect one. He offers a woman for whom the mantle of power does not properly fit. She is at once ordinary and yet special, the incongruity between these two qualities noted in her slight discomfort and the burden of her clothing. In the same way that his *Dead Christ* suggested that the mystery of Christ lies in his all too human suffering and death, here he suggests that Mary is a similarly fallible mortal who must nevertheless carry the weight of being the mother of Christ.

Hans Holbein,
The Solothurn Madonna,
oil on limewood, 1522.

Holbein scholars have long debated the wider iconography of this painting, as well as its original location. The key is undoubtedly in its patronage. Johann Gerster was Basel's town archivist, town clerk, and most importantly provisor of the Church of St Martin. This has encouraged the most recent scholarship to identify the saint on the left as St Martin. St Ursus of Solothurn is more easily identified on the

right with his tell-tale armour and flag. The depiction of St Martin has also suggested that the painting was intended to hang in the church of the same name. Meanwhile the presence of St Ursus is explained by the fact that the Church of St Martin in Basel had a reliquary of St Ursus, and after a discovery of this Roman saint's sarcophagus under the church at Solothurn in 1519 and its opening in 1521, the cult of the saint had particular purchase at the time across Switzerland.[9]

However, the fate of the painting was to be affected by the burgeoning Protestant movement. Typical of those who formed part of the city council, Gerster was a traditional Catholic. He, like the members of the rich merchant class and the cathedral chapter, was finding himself increasingly at odds with a group of preachers, guildsmen, tradesmen and artisans who were sympathetic to the new Protestant ideas.

When Gerster had originally commissioned his Madonna, possibly as early as 1519, St Martin's would have still been a traditional Catholic church. However, by 1522 its congregation had moved to the vanguard of the religious revolution in Basel. The strong reformist attitude expressed by those worshipping at St Martin's was soon fed further by the return to Basel of the man who would ultimately be known as its principal reformer – Johannes Oecolampadius. Once part of the Sodalitas Basiliensis, where he had enjoyed Erasmus's esteem and had worked with him and Froben, Oecolampadius had left Basel for a few years only to come back a changed man in November 1522. In 1521 he had published two treatises that made clear his breach with the traditional Catholic Church, and by default Erasmus. As such on his return to the city, rather than reclaim his role as a corrector with Froben's press, where Erasmus was effectively editor in chief, he joined the rival printer Andreas Crantander, who was associated with publishing evangelical material. Within a couple of months he had been offered a position not only to teach theology at the university where his views could be disseminated, but also to preach at St Martin's.

It seems highly likely then that as the Protestant temperature rose Gerster's commission either never hung at all in St Martin's, or was moved after a few years. At this point the presence of St Ursus in the painting would have easily suggested the church at Solothurn, dedicated to that very saint, as a safe haven for it. Solothurn remained staunchly Catholic as the cities of the Swiss Confederacy split along the lines of the old and new religions.

It seems that Holbein's *Dead Christ*, completed around the same time, may have suffered the same fate. The Church of St Theodor, which in Kleinbasel sat right next to the monastery for which the *Dead Christ* was destined, had also become a reformist hot spot. It was all too easy for the newly Protestant congregation there to express their frustration with the Catholic Church by an assault on the neighbouring institution. It is very likely that if the *Dead Christ* ever hung in the cloisters in the Carthusian monastery of Margarethental, it was not for long, and was soon taken down and kept safely at the nearby Amerbach homestead.

Despite the mounting tensions in Basel between followers of the old church and the new, few could yet have had a sense of the full impact that the Protestant revolution would have on the story of art. Holbein's sketches from this era suggest that devotional art was still uppermost in his practice. Marian imagery had of course always been a popular subject for Catholic churches and a major part of an artist's repertoire pre-Reformation. It would be second nature for Holbein to turn over in his mind how he might approach the subject, particularly given his instinct to innovate. However, the novelty of fatherhood and marriage provided Holbein with an opportunity to closely observe the way young mothers actually handled and taught their children. It is these observations that become key to a set of highly inventive drawings on the Marian theme.

overleaf
Hans Holbein, *Madonna and Child*, pen and grey wash, white highlights, on grey prepared paper, 1519.

Hans Holbein, *The Holy Family*, pen and grey wash, white highlights, on red-brown primed paper, 1519.

Holbein's sketches were not always silverpoint on a white ground. Far from it. He could also reverse the process, taking a dark grey or red paper from which he would work from dark to light using ink and white highlighter. Among such drawings, dating to 1519, is a depiction of a seated young woman in contemporary dress; her hair is loose and caught in a breeze, and she is holding a child who is trying to walk. She has the baby under its arms, bouncing it on feet which practise steps but cannot take them. As she looks down, her child looks up. The two are held in each other's gaze. It is hard not to see this as a study of Elsbeth, caught up in this particular moment in the development of her child, one that is familiar to any parent. If this is Holbein's wife, then the child would be his son Philipp, since Franz Schmidt would have been around five

years old in 1519. So the drawing may suggest not only a marriage in 1519 but potentially one that was convenient in another sense, in that a child was already either on its way or arrived.

Holbein adapted this domestic moment into a depiction of the Virgin and child by using hatched lines to imply a halo over the mother's head. He also increased the volume of the mother's clothing to provide a weight and monumentality to the figure. However, these details to one side, the drawing is otherwise a tender study of the way in which a mother dotes on and cares for a child, and the devotion that the child returns to its mother.

One detail of the drawing is Holbein's signature and date, an attribute that indicates this formed part of a formal presentation to a client. This along with the fact that the Virgin is sitting on a rectangular seat, in much the same way as she is shown in the Solothurn piece, also raises the possibility that this could have formed part of an early dialogue with Gerster regarding his commission.

A desire to inject convincing verisimilitude and recognizable human character into religious subject matter is seen again in a drawing of the holy family from around the same time. Here Holbein again experiments with a combination of the monumental and naturalistic, and the tension between the extraordinary and ordinary.

The drawing in question has been made on paper that has been dyed reddish brown. Depicted in grey wash with white highlights, Mary and her mother Anne are featured sitting in front of a complex classical arch, replete with all the decorative elements that Holbein could amass. Baby Jesus is positioned between then. Yet despite this grand setting, Anne and Mary are focused entirely on another tiny moment in a child's development. Anne holds the baby under his right arm, while Mary, lightly holding his left hand with hers for balance, uses her right hand to encourage his leg to move. Here are a grandmother and a mother urging their baby to take a step between them. The baby looks back at his mother for reassurance as his grandmother patiently waits for him to complete the action. And although he has provided a grandiose architectural scheme as a backdrop for this simple, mundane event, Holbein has captured the scene from an unusually oblique angle that undermines its formality.

In this way, Holbein shows us not solely Anne and Mary, but also two women wrapped up in their maternal craft, displaying their

unique understanding of how to help children achieve key stages in the growing-up process. As if to emphasize the women's authority in this matter, Holbein excludes men from the process. Two male figures, Joseph and Joachim, are peeping from behind pillars, careful not to interrupt an activity in which they know they are inexpert.

Holbein has provided an exposition of the unique value of ordinary women for which men should be thankful: their ability to raise children. In doing so he unsurprisingly reveals himself as a creature of his time. Nevertheless, his communication of female worth to his contemporaries takes on a new level of meaning when applied to the holy family. The womanly gift of child rearing, applied to the mother and grandmother of Christ, becomes all the more precious to the Christian onlooker.

The pure observational brilliance of depicting a mother and child in these drawings is perhaps not matched again in Holbein's work until 1525, when he was commissioned to paint the shutters for Basel's cathedral organ. When closed these huge shutters served as dust covers for the organ's pipes; when opened they offered a pictorial opportunity on a vast scale, thirty feet above eye level. Holbein designed a monochromatic scheme in shades of brown, probably to complement the decorative wooden casing that housed the organ. On the shutter to the left he conceived a monumental version of the cathedral's founder, Heinrich II, and to the right he delivered a huge Madonna looking down on the congregation below, a child in her arms. The brilliance of his female figure derives from the combination of Holbein's perspectival genius, delivering a real sense of the huge Virgin peering down from her position of height, and her stance, so typical of mothers who take some of the weight of the baby on their hip as well as in their arms. But the essential difference between this Madonna and those based on Elsbeth is that here the Virgin is the embodiment of beauty. Her face is exquisite, its features even, and instead of a figure ill at ease with ornaments and the burden of majesty, this Virgin wears her crown effortlessly. The effect therefore is uncanny. If in the *Solothurn Madonna* Holbein was attempting to depict a real human Mary, here the converse applies: it is as if he has brought a monumental idealization of her, a superhuman, to life.

overleaf
Hans Holbein, Wings of the Organ of Basel Cathedral, distemper on canvas, *c.*1525.

The tenderness with which Holbein depicted Mary around the time of his marriage is surely a reflection of his own initial delight in Elsbeth and her abilities as a mother. It is perhaps telling then that she apparently ceased to be his model fairly quickly. When he returns to Elsbeth as a subject later in the decade, the delight he once found in her has been replaced by a more complex emotional response to his spouse. In his portrait of Elsbeth and their two eldest children, probably painted in 1528, her eyes seem downturned less through self-consciousness and more in inner contemplation. She has aged, of course. Her smile has gone. In its place is an expression of quiet resignation. It is a melancholy work.

Life evidently intervened in the Holbein marriage. Extant works on paper reveal the story of a growing workshop in the first half of the 1520s, with a full range of output. There is the continuation of work for stained glass, commissions for devotional pieces from important city burghers and also decorative projects for the interior and exterior of buildings. Holbein continues his illustrative work for Basel's publishing houses. He paints devices and branches out into metalwork design with proposals for scabbards and cups. He carries on with his portraiture, of course, this period being key in his work for Erasmus. None of this could have been achieved alone. Alongside Elsbeth and junior assistants, he must have had at the very least one journeyman. Evidence of this emerges, by coincidence, in the portrayal of another woman.

Hans Holbein, *Laïs of Corinth*, mixed media on limewood, 1526.

Lais of Corinth was, according to tradition, the lover of Apelles and an extremely beautiful courtesan who charged handsomely for her company. In 1526 Holbein executed a painting that is notably stylistically different from much of his other work and is evidently an exercise, or an experiment, in Italian Renaissance figurative style. He entitled it *Lais of Corinth*, referring by implication to himself as Apelles. The figure shares some of the characteristics associated with the work of Leonardo da Vinci and his followers, notably Andrea Solario,[10] as well as Raphael, and it is probably the result of Holbein viewing Francis I's collection at the chateau at Amboise around this time — of which more later.

Holbein shows Lais seated behind a stone parapet. Her right hand extends outwards over the parapet, asking the onlooker to place some

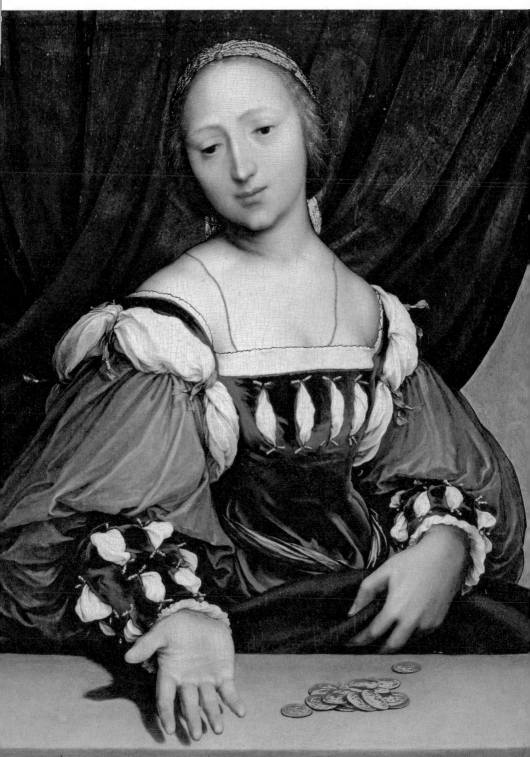

LAIS · CORINTHIACA · 1526

coins in it. Her body is slightly angled and her head is inclined. She grasps a blue cloth in her left hand, which is spread across her lap. She herself is clad in a red velvet dress with slashed bodice and sleeves. Behind her is a lush green curtain.

As if Holbein wants to combine the best of all three artists in a pastiche of contemporary Italian work, he achieves, in the articulation of the body, an elegant, floating gracefulness that is typical of Raphael and that he could have witnessed in a version of the holy family that the French king had in his chateau at Amboise. But some scholars have noted that the orientation of the body, turned one way, with the head inclined in the opposite direction, combined with a downward glance of the eyes, is really reminiscent of Andrea Solario's *Salome*, which was also part of Francis's collection.

All in all, the work is a very long way from that other embodiment of beauty, Venus, who, Holbein showed as a woman reflecting on herself in a mirror, as a comment to Erasmus's *In Praise of Folly*. Instead, by moulding a completely idealized visage, he offers not a reflection on beauty, but an attempt to describe a particular concept of beauty – in this instance, that promoted by Italian painters. In the oblique reference to the viewer being asked to pay for the privilege of this beauty, Holbein is also noting that patrons will pay handsomely for the idealized work that Italian masters are able to deliver. In a way, therefore, the subject of the painting is painting itself. And perhaps implicit in it is a mild criticism of those who resort to idealism for a patron's coin, rather than deliver a work founded in observation.

Unknown member of Holbein workshop, *Venus with Cupid*, oil on limewood, 1526–8.

This small painting – at 34.5 × 27 cm it is only just a little bigger than the size of a sheet of A4 paper – did however serve a specific purpose in the master's workshop, as suggested by the existence of another version of it. The second version is almost the same size, just a centimetre less wide, and shares a great many similarities. Here again is a woman in a red velvet dress, slashed at the bodice, sitting behind a stone parapet and in front of a green curtain. At first glance she looks almost identical to Lais, though her head is held in a different position and her eyes engage the viewer rather than look down. And crucially, in this picture the figure of Lais has been transformed into a figure of Venus, with Cupid standing between her legs, his arrow resting on the parapet.

However, on closer inspection further differences, not just in composition, but in execution, emerge. Venus' face is narrower, her mouth a little wider, and her cheeks and neck more heavily shaded. Venus' right hand is extended to the side rather than the front, in an apparent move to avoid having to attempt the challenge of subtle perspectival foreshortening. Her body is almost entirely square to the viewer, and as such the careful modelling of the chest and cleavage that is evident in the Lais, where the torso is slightly twisted, is avoided. But it is Venus' left arm that is the giveaway. Rather than extending to Cupid's shoulder as it should, it ends out of vision behind his over-accentuated forehead. There is, in short, a profound mistake in the painting.

This is the work not of Holbein, but of his journeyman. Unnamed, forgotten, a man who clearly had a good sense of the Italian Renaissance style. He may have come from Milan, or perhaps from the circle of painters feeding the French court at Amboise. The Venus painting is an exercise in imitating his master's work, and may have been a kind of audition piece.[11]

The Lais worked its way into the Amerbach collection, acquired from the Holbein studio after his death. Bonifacius's son Basilius noted in his inventory that the work was a portrait of 'ein *Offenburgerin*', that is a member of the Offenburg family, whose wealth came from their apothecary business and whose latest patriarch, Henmann, is mentioned above as one of the councillors who led the mercenaries of Basel in campaigns in Italy in 1515.

Basilius's decision to catalogue the picture as if it were a portrait has created an art historical red herring, encouraging scholars to speculate that it is a depiction of either Magdalena Offenburg or her daughter Dorothea. However, it is more likely that Basilius, aware of Lais' relation to Apelles, was prompted by the painting's title to reference an historic rumour that Holbein had had a liaison with an *Offenburgerin*, and made the assumption therefore that this was her portrait. The fact that the level of idealization in the painting stands in strong contrast to the apparent honesty of Holbein's other portraiture was entirely overlooked.

Holbein's earliest biographer suggested that Elsbeth had a terrible temper that had eroded the Holbein marriage. Though it is tempting to see this as a rather stereotypical characterization of a married woman as a scold, nevertheless, van Mander insisted, 'He had a wife

who was rather cranky, and who had so bad a disposition that he never could expect any peace or rest with her'.[12] In 1524 Holbein left Basel for some months and travelled abroad. There were several reasons why it was a good moment for him to leave – a furious wife might just have been one of them.

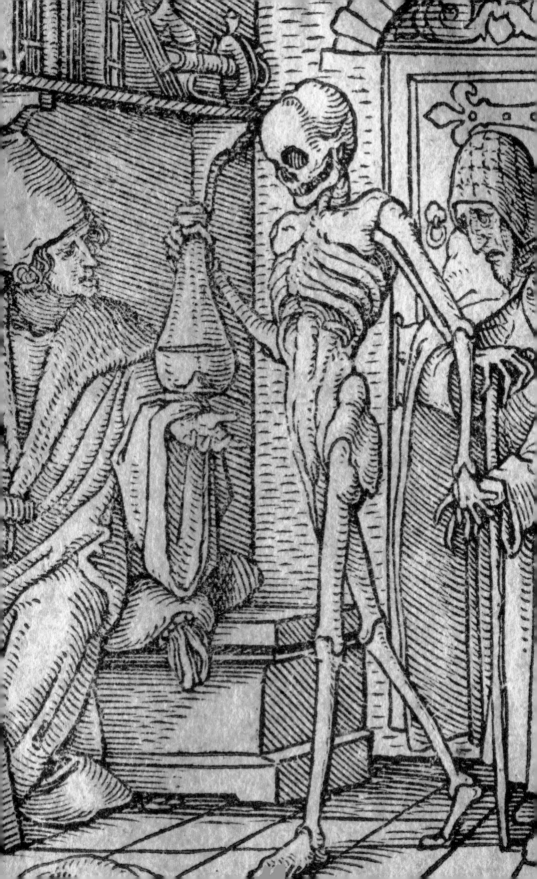

THE DANCE

7

J ohann Gerster, who had commissioned what is now known as the *Solothurn Madonna*, had a very wealthy brother-in-law rather fabulously named Balthasar Angelroth. Angelroth was also related by marriage to Jörg Schweiger, the Augsburg-trained goldsmith who had underwritten Ambrosius's debts and had once worked with Holbein the Elder. Schweiger was married to Angelroth's sister, Elsbeth. Like Schweiger, Angelroth was a goldsmith.

Given this web of social connections it is hardly surprising that when Angelroth decided it was time for him to display his wealth for the entire city to see, it was to Holbein he turned for a magnificent scheme for the exterior of his substantial property, which sat on the corner of Basel's Eisengasse and Tanzgasslein, close to the city's central marketplace and town hall. Perhaps he would have turned to the city's new master painter anyway – after all, Holbein was clearly Basel's star.

Angelroth and his wife Dorothea had lived in the house on the corner of these two streets since at least 1507. Since it flanked Tanzgasslein – Dance Alley – it was already known as 'Zem Vordern Tanz' – 'At the top of the Dance Alley'. Though Tanzgasslein originally derived its name from a person, a thirteenth-century citizen called Heinrich Tanz who had once owned property there, nevertheless, the allusion to dancing provided Holbein with a ready-made subject for the façade painting.

What would become known as Holbein's Haus zum Tanz, or 'House of Dance', was demolished in 1909. The only records of it are copies of preparatory drawings in Basel's Kunstmuseum. These are enough, however to reveal that Holbein's scheme could not have been more different from the majestic depiction of a triumphal procession that he had delivered for the battle-worn Hertenstein in Lucerne. For Angelroth, Holbein whipped up a confection of worldly delight.

His design featured dancing figures, wrapping themselves around the property, cavorting, singing, playing instruments and wearing garlands in their hair. With wanton merriment, chubby townsfolk gambol hand in hand along a relatively narrow ledge at first-floor level, perhaps twelve feet or so from the ground. Some are cautious, others bold. One woman in red seems to have momentarily stumbled, but is steadied by her partner's grip. The precariousness of their situation is subjugated to the compelling spirit of the dance, which pulls them around with abandon.

These figures would have suggested much to the residents of Basel in the 1520s. Stocky and short, they could be dwarves who, according to Swiss folklore, were skilled blacksmiths living in the mountains, where they also stored up huge piles of gold and treasure. How pertinent to the Angelroth household, who had members in both the blacksmith and goldsmith guilds. Meanwhile the fact that the figures are generally dressed as peasants also draws on the traditional association of rural workers with the cycles of the year, the inevitable fertility of spring and abundance of summer. Finally the scene would also speak to Basel's residents of their annual carnival, which the city celebrated in the period before Lent, Shrovetide. At this time people's inhibitions were put aside and dancing in the streets was part of the fun. The city's gentry would often dress as peasants, a fair bit of cross-dressing went on, and the city's women, normally so constrained in public, could for once take to the streets and let their hair down. Holbein's mural alludes to all this, and perhaps also to the fact that at carnival things can go too far. Some years after the completion of the Haus zum Tanz, for example, fifteen members of the grocers' and blacksmiths' guild were arrested and imprisoned for dancing naked accompanied by a piper.[1]

Rising up above this band of raucous stompers, Holbein created an architectural frivolity, a folly in honour of earthly pleasure. Once again he imagines complex layers of arches, niches and pillars, with corridors and terraces, balconies and windows, all covered in classical ornamentation.

Figures drawn from classical mythology inhabit this elaborate façade. Bacchus, corpulent and semi-clad, stands cup in hand, next to a barrel, a drunken woman lying at his feet. Venus is there too, bare breasted, with Cupid gazing up at her. The figures are less partially nude and more half naked, a condition enhanced by Holbein's decision to give their limbs a flesh tone, rather than depict them in grisaille as if they were sculpted stone. In effect he creates a fictional space where the distinction between painted figures, statuary and real people becomes blurred. To make his point further, one figure in classical military dress, with cuirass, and a quiver of arrows on his back, is disturbed from his architectural task of holding a shield medallion by the lively rearing of the animate monumental horse and rider above him.

This figure on horseback has widely been identified as the legendary

Hans Holbein (copy after),
Designs for the Haus zum Tanz,
pen in black, watercoloured,
composed of four sheets, laid
down on thin paper, *c.*1521.

Roman Marcus Curtius. The story goes that when a chasm opened in the Forum it was believed that the only means to close it was for Rome's most precious items to be thrown into it. Curtius argued that nothing was more precious than a brave citizen, and in throwing himself into the void, the citizens of Rome were able to keep their gold. It is an appropriate and witty story for the façade of a goldsmith's house, and with an animated Curtius available, the treasures within were secure.

In 1709 this identification of the Roman hero 'throwing himself headlong into the chasm in the Forum at Rome for the safety of the Commonwealth' was in circulation, along with the additional information that 'for doing this Holbein had a reward of sixty florins'.[2]

The house also represented Holbein's most ambitious perspectival conceit to date. Boldly, he decided to try and give the impression that the house was not triangulated on a corner. He devised a scheme to give the illusion that, instead of having two façades, one either side of the corner, the house presented one continuous horizontal façade facing anyone approaching it along Tanzgasslein, from Basel's bridge. This interactive aspect to the work added to its playfulness. After all, this huge optical trick would be most persuasive from one specific spot, and presumably visitors would walk back and forth until they found the very best point from which to view this sleight of hand. An illusion on such a scale made the house a talking point. It became an attraction for anyone visiting the city, and of course helped raise Holbein's profile yet further. In keeping with a time of discovery of new worlds, new learning, and the revival of ancient knowledge, Holbein made even house decoration an event, an exciting experience, and, significantly, a demonstration of visual science.

But was there more to the Haus zum Tanz than fun and spectacle? Though records of Balthasar's personal reputation are not forthcoming, the very size of the property and Angelroth's ability to decorate it so luxuriously speak for themselves. A description of the property in Angelroth's will reveals a house full of splendour. It also reveals the extent of his practice, with a huge shop and atelier at ground level seen through two shop windows on Eisengasse and one window on Tanzgasslein, and a further large workshop immediately above on the first floor.[3]

There is circumstantial evidence that the Angelroth family was very

good at spending money on food and wine but could be rather lazy when it came to repaying borrowings. Balthasar's brother Caspar, also a goldsmith and twice head of the blacksmiths' guild in Basel, was eventually exiled from the city for leading an errant life. His property in the Fish Market had to be confiscated to pay creditors, and when the bailiffs went in they discovered not only plenty of gold in his workshop, but a kitchen inventory that evidenced his penchant for fine dining. His and Balthasar's father Nikiaus also fell foul of the authorities, and had some of his clothing seized from the house in Eisengasse in 1520 in order to pay debts. So was Holbein also making a joke at the expense of his clients, alluding to their indulgent and sometimes wayward lifestyle?

Normally in a work of this period that so clearly embraces festivity and pleasure, one would also expect the inclusion of a memento mori, some reminder of the transience of life and the inevitability of death. At first glance this seems entirely lacking in what appears to be a full endorsement of hedonism. But typically in the work of an artist who enjoyed making layers of sometimes contradictory meaning available to his audience, Holbein does in fact offer a reminder of mortality and vanity in the work.

The position of Angelroth's house was just four hundred metres, or a five-minute walk, from Totentanz, where Witz's mural of the *Dance of Death* reminded the citizens of Basel of their ultimate fate. Amid Holbein's group of dancing townspeople, he paints a few who are types that also appear in Witz's macabre mural. A young woman with a head garland made from cereal crops appears in both, while a woman whose headdress is a crown of flowers is a reminder of the queen in the other deathly procession.

Meanwhile the citizens of Basel in the 1520s would also be familiar with the phenomena of Dance Mania or the Dancing Plague, an affliction that swept across early modern Europe several times, and had occurred most recently in its most famous outbreak in Strasbourg in 1518. Here, in a city that lay just a day's travel downstream along the Rhine, a woman began a dance that swept the city up in a mass hysteria with ultimately some four hundred people joining in. Many of the hysterical dancers would not stop until they dropped from exhaustion or their failing hearts. Holbein's deeply engrossed dancers seem to capture an air of demented mania.

The other reminder of transience is in Holbein's imaginary structure. At the uppermost level the building is either still under construction, unfinished, or ruined, an incomplete brick structure visible behind the ornate façade. This detail suggests some debt Holbein might owe to Donato Bramante, the Italian Renaissance architect whose depiction of a *Ruined Temple* was engraved by Bernardo Prevedari and much circulated at the time. Either way it speaks of impermanence and lack of substance.

The Haus zum Tanz's message of communal frivolity and worldly excess, no matter how spiked with more sinister associations, may have struck a peculiar chord in the early 1520s in Basel. The economic gap between the city's wealthy residents and its ordinary townsfolk felt uncomfortably wide. After all, though he was painting Bacchus happily imbibing from a huge barrel of wine, this was the period when Holbein himself, for all his success, could not even afford a *bottle* of wine but was forced to buy it by the glass.[4]

There had long been a schism between the city's council members and the ordinary working people they were apparently supposed to represent. Now the rift between the privileged and those who saw themselves as underdogs was once again causing serious concern. Several issues conspired to turn a place once celebrated for its liberal atmosphere into a fractious, nervous and disgruntled conurbation on the point of eruption. Basel's marketplace transformed from a centre of commercial activity to a place where various factions sought to disrupt and demonstrate, often on a daily basis.

In 1521 tensions rose to a point that the council felt compelled to invite the artisan guilds, disgruntled because they saw the elite merchant guilds using their influence on the council to feather their own nests, to state their complaints. A long list of grievances was forthcoming. The wool weavers, cabinetmakers, coopers, masons and carpenters objected to the monopolies that merchants had, and to competition from foreigners, as well as from the monasteries whose craft output was not subject to the same guild rules and could therefore undercut their offer in the marketplace.

And then there was the explosive issue of pensions. The efficacy of Swiss mercenaries had made Swiss cities such as Basel much sought after by foreign parties who were prepared to offer substantial payments to secure their services. However, this apparently commercial transaction

was the cause of much resentment, because not only would powerful foreign leaders offer a pension to go into the municipal coffers of a particular city, but they were perfectly capable of offering pensions to eminent and influential *individuals* within a city too.

Jacob Meyer zum Hasen, who, Holbein had painted in 1516 on his appointment as Basel's mayor, became the focus of a pension controversy. Like Elsbeth's former husband Ulrich, Meyer had found himself fighting both for and against the French across the years. In 1507 he led Basel's mercenaries in support of the French during a campaign in Genoa, but in 1510 and 1512 he was leading his fellow townsmen alongside Milanese troops against the French. Consequently Meyer found himself in receipt of an offer of a personal annual pension from the Duke of Milan. Basel's council looked dimly on the transaction and after Meyer declared it, they passed a ruling that no other personal pensions could be accepted and henceforth all personal pensions should be paid into the public purse.[5] A year later, however, Meyer negotiated a pension from Milan for the city as a whole, to be paid into its civic treasury. He dutifully paid his own pension into the treasury, but then the treasury gifted him the same amount back by way of thanks for securing the civic grant, in what today might be called a 'backhander'.

This kind of practice was causing problems elsewhere in the Swiss Confederacy. Riots were breaking out in Lucerne, Solothurn and Bern with peasants and townsfolk marching against, and destroying the property of, those town councillors whom they considered corrupt.

Alarmed, Basel's council once again declared its policy of not allowing personal pensions, and Meyer returned his gift to the city – only to receive it again in 1515 when the popular unrest elsewhere had died down. It makes one look again at the coin Holbein paints Meyer holding in his portrait of 1516. For Meyer this would have been indicative of his early career as a money lender and the fact that in 1516 the city gained the right to mint its own coins. In hindsight, however, one cannot help but see an ironic allusion to Meyer's tendency to take the coin for his own personal enrichment.[6]

In 1521, around the time the Angelroth murals were most likely unveiled, it was Francis I of France offering pensions for the right to draw on Swiss mercenaries to face his adversaries. After the Battle of Marignano the Treaty of Eternal Peace had simply seen the French

pay the Swiss as a guarantee that the latter would not fight *against them*. But now Francis wanted to update this agreement and actually draw the Swiss to his side. In the spring all the Swiss cantons, with the exception only of Zurich, agreed to take the French king's payments in return for their famed soldiers, even though many Swiss cantons, including Basel, were also still taking money from the Pope and Holy Roman Empire.

In Basel, France not only agreed a pension payment into the public treasury, but also substantial private pensions to certain powerful council members. The city began to rumble. Though they had fought alongside them in 1507 many of the mercenaries, including Holbein's colleague Urs Graf, were vehemently anti-French and determined to fight for the Pope and Empire regardless. For these mercenaries, a determination to defy the French deal and fight for the other side not only pitted them against their own countrymen, but put them in breach of the law. The rumours of the substantial sums that had persuaded council men to create such a scenario only further added to the fury of many Baselers. The square outside the town hall once again filled up with protestors.

In August the personal greed of council members was further laid bare when, despite the protests, it voted to award all its members a further portion of its growing annual pension income that was pouring in from the rest of Europe.

In mid October the riots in Basel began. After weeks of street fighting between supporters of the French and Papal parties the 'outcry over secret money and pensions' came to a head, according to Fridolin Ryff, a weaver in the city who sat on the council.[7] With the council on the verge of being stormed it had no choice but to backtrack. Men who days earlier had been laying down the law were quickly thrown under the proverbial bus. Holbein's patron Jacob Meyer was arrested and slung into jail along with a handful of other councillors. Basel's government ate humble pie and once again banned personal pensions provided by foreign powers, this time in perpetuity.

It is perhaps no coincidence that another preparatory drawing for a town house façade that Holbein made around this time was never executed. The scheme features an emperor sitting on a throne. This may have been for the Amerbachs' house in Kleinbasel, 'Zum Kaisersthul', or perhaps for the Haus zum Kaiser on Nadelberg.[8] In

any case, the project was surely discarded because the clients deemed it rather incendiary to execute in a city ravaged by anti-elite sentiment.

Holbein himself was in a difficult position. In the early years of his workshop, he and Elsbeth built a business based on commissions from men like Meyer, Angelroth and Gerster – wealthy merchants, privileged councillors, and by and large traditional Catholics. Of course they had no choice. Patronage of the arts had always been the exclusive privilege of the powerful, and the demand in the Catholic Church for devotional pieces remained. But there was no question that his reliance on this elite group of men would begin to affect the working life of Hans Holbein in a deeply negative manner.

In June 1521, the very month that Basel's blinkered councillors signed up for that French pension, Holbein had embarked on a major piece of civic art that must have initially seemed an exciting prospect for a young master. The council had completed the building of a new town hall and Jacob Meyer zum Hasen commissioned Holbein to execute a series of murals in the new Great Council Chamber, on the second floor. He was to be paid 120 gulden for a series of wall paintings that would cover three walls of the room, the fourth wall being mainly windows. Beginning work immediately, he would have done so with the noise of the demonstrations immediately outside in the market square ringing in his ears.

Like so much of Holbein's work the murals combined architectural trompe l'oeil with figurative work. He described a series of historical scenes framed by pilasters, interspersed with allegorical Virtues positioned in niches. Each historical episode was supposed to show an example of good governance. The irony of the subject matter Holbein was dealing with while his townsfolk protested against the corruption of his clients cannot be avoided. This may well have been why Holbein stopped work in mid September, though the short winter days and low sun may have also encouraged the painter to pause. According to records of his payments there was a hiatus between September 1521 and April 1522. He received his final payment at the end of November 1522 despite having only completed two walls of the chamber. Evidence of his persuasive abilities lies in the fact that despite having finished only two thirds of the job in hand, Holbein was able to convince his commissioners that the work was of such fine quality he deserved full payment nevertheless.

The murals from Basel's town hall only exist today in the most fragmentary form. But drawings of one, his depiction of *Manius Curius Dentatus Rejects the Gifts of the Samnites*, featuring a Roman general rejecting foreign bribes, feels uncomfortably close to the issue that had prompted such vociferous protest in Basel. The subject matter was probably not chosen by Holbein himself but proposed by a member of Basel's scholastic community – Beatus Rhenanus is often cited as a candidate – and would have been negotiated some time before the pension storm erupted.

Below the depiction of Manius Holbein painted a life-size portrait of the city's head town guard, touching his hat in greeting to the gathered councillors.[9] The man Holbein painted was the intermediary who actually delivered gifts from foreign envoys. This was a role typical of the system of middlemen in early modern society. Gatekeepers, town guards, and other officers enjoyed their own shadowy practice of accepting gifts to ease the speed with which doors were opened, or lapses overlooked. They were cogs in the civic wheel that everyone knew needed oiling.

Hans Holbein, fragment from the mural from the east wall of the Meeting Hall of the Great Council in Basel Townhall, Manius Curius Dentatus Rejects the Gifts of the Samnites: Three Heads of Envoys, 1521–2.

The inclusion of a real-life, contemporary figure in the mural, builds a bridge between the past and present. Holbein, as he does elsewhere, creates an imaginative space where historical and contemporary worlds are collapsed in order to engage his audience with his subject matter in an interactive manner. As Basel's councillors looked at the story of Manius Holbein invited them to consider how they might instruct their own town guard in such a situation.

One hugely important aspect of Holbein's work is present in both the Angelroth house and his work for the council chamber. Though dulled to the modern eye, his work can have a satirical edge. And why not? Basel was the home of satire at the time, with the fool literature of Brandt, Erasmus and more recently Murner proving extremely popular.

There are almost certainly some sardonic jibes in the mural that time has eroded, but at least one can still be deciphered. In the drawing of *Manius and the Samnites*, while the general is in antique Roman costume, the Samnites are all in contemporary merchant dress. The leading figure bears a strong resemblance to Augsburg's Jacob Fugger

in his signature gold cap. Surely this reference to Fugger cheekily alludes to a recent international controversy?

After the death of Maximilian I the title of Holy Roman Emperor was once more available. Henry VIII had been positioning himself for the role. Francis I was also keen, as was Frederick III, Elector of Saxony. But Charles V was able to leverage his relationship with Jacob Fugger, who raised an exceptional 850,000 guilders to pay off the election committee and buy Charles the title.

Outside his sharper political satire, there is anecdotal evidence that Holbein had a good sense of simple fun, too. According to Basel legend, at about this time Holbein was in debt at the local inn 'Zur Blume' and agreed to decorate the façade of that establishment as a means of settling bills. However, as the work went very slowly, with Holbein often absent, the innkeeper threatened the painter unless his attendance on site improved. Consequently, Holbein painted a pair of legs that appeared to dangle from the scaffold which was apparently so convincing the landlord was satisfied that the artist was working away.[10]

In November 1521, just as Holbein was taking a break from the work to the council chamber, Erasmus, now in his mid fifties, returned to Basel. Indeed, 1521 had been a pivotal year in the story of the Reformation, in which Erasmus played such a part. Martin Luther had been excommunicated in the January before being summoned to the Diet at Worms in the spring. After refusing to discredit his own writings, Luther had been declared a heretic and outlawed.

Duke Frederick of Saxony had proved Luther's guardian angel. Staging his fake kidnap on Luther's departure from Worms, Frederick had subsequently spirited Luther away to a safe house – his castle at Wartburg.

As Luther's controversial profile continued to rise and as Protestantism in its various forms took hold, Erasmus felt embattled. On the one hand he was keeping the company of those who saw Lutheranism as a blight. In August 1521 he had been in Bruges where Charles's emissaries were meeting Cardinal Wolsey, Henry's leading politician at that time. Despite recent gestures of friendship to France, Wolsey was in fact negotiating an allegiance with Charles V and his Empire, which would commit Henry to an invasion of France in 1523.

Erasmus took the opportunity to catch up with his old friend Sir

Thomas More, who was part of Wolsey's entourage. More complained about the spreading of Lutheranism in England and discussed how Wolsey had ordered a bonfire of Luther's books and had banned their import.

However, many orthodox Catholics considered Erasmus *as responsible* for Luther, having begun the arguments against the church that Luther had so effectively evolved. When Pope Adrian VI succeeded Pope Leo in 1522 he called for Erasmus to denounce Luther, which Erasmus failed to do. Yet Erasmus equally failed to offer Luther his support. For Luther's supporters this silence was perplexing and frustrating. Dürer, who had embraced Lutheranism, gives a sense of it in his diary of 1521 when, on hearing Luther had been kidnapped, he believed he might be dead.

'O God, if Luther be dead, who will henceforth expound the Holy Gospel so clearly to us!' Dürer asked himself:

> Oh, all ye pious Christian men, help me to lament this
> God-inspired man and pray to Him that He will send us
> another enlightened man.
> Oh, Erasmus of Rotterdam, where wilt thou stay?
> Dost thou see how the unjust tyranny of worldly power and the
> might of darkness prevail? Hear, thou knight of Christ, ride on
> beside the Lord Jesus; guard the truth, win the martyrs crown! [11]

With Erasmus back in Basel and installed in the comfortable accommodation provided by Johann Froben, one of the first letters to arrive for him was from London. William Tate, a vicar in service of the English king, sent him Henry VIII's latest publication, *Assertio Septem Sacramentorum*, inscribed by Henry himself. This was the king's treatise against Luther, dedicated to the Pope, Leo X. Leo, who would die in December 1521, rewarded the English king with the title of Defender of the Faith. This was another signal that Erasmus must show his hand.

Erasmus became more and more concerned by the violence and vitriol he saw associated with the Protestant revolution. And he saw the creeping influence of the new thinking slowly engulf Basel. In September 1523, he finally wrote to Henry VIII and conceded that after years of refusing to be drawn into battle, he was preparing something. But Erasmus was aware that he was not in tune with his

compatriots in Switzerland and Germany. Here the appeal of Luther's doctrine was clear. 'I have something on the stocks against the new doctrines,' Erasmus conceded to England's still staunchly Catholic king, 'but would not dare publish it unless I have left Germany first, for fear I prove a casualty before I enter the arena.'[12]

In the short term Erasmus's health was keeping him in Basel. He had kidney stones, an affliction he put down to eating too many dried pears. Despite his temporary incapacity, he was not short of offers for a new home. Henry VIII would have welcomed Erasmus in the Tudor court. But Erasmus, ever conscious of his personal comfort, had not got on with the English weather when he was there as a younger man.

Francis I, who had after all enticed Leonardo da Vinci to live at the Château du Clos Luce, close to Francis's own palace at Amboise, was also keen to lure Erasmus to France, and had even written to him personally. 'I have already had frequent invitations from the King of France,' Erasmus explained to his friend Willibald Pirckheimer, 'But it will look like deserting to the enemy, and was so represented to the emperor by my opponents; but he is still pretty well disposed towards me.'[13]

It was not just Europe's monarchs courting the scholar; Basel's elite were also keen to keep Erasmus as long as they could. He was feted. On his arrival in Basel in November 1521, the city had welcomed him with barrels of wine. He soon found himself in receipt of other expressions of admiration, much to Holbein's benefit also.

As the Holbein workshop grew, it diversified. Extant works on paper reveal that the young master was working up schemes for fine metalwork including highly decorated weaponry. Despite the growing status of the painter in Renaissance culture, the fact remained that fine metalwork was still generally considered more luxurious than fine painting. Goldsmiths were busier, richer, and frankly grander than

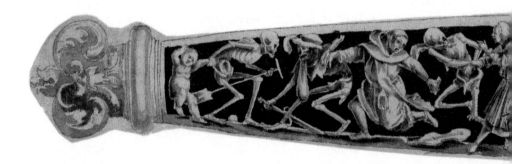

their brother painters. At least designing for them gave Holbein some share in their lucrative market.

In Basel the dagger of choice was the 'baselard'; with an 'I'-shaped hilt this was a relatively long dagger, traditionally carried in a near-horizontal position at the waist. Holbein's colleague at Froben's Haus zum Sessel, Urs Graf, is sometimes credited as being the first to design a particular type of decorative scabbard for the baselard, where intricate decoration or figurative scenes could be expressed through open relief work in silver or brass, often gilded, and then mounted on leather. Graf's earliest known designs date from around 1510, when Holbein was still a boy in Augsburg, but once his own workshop was established it is evident that Holbein saw this kind of scabbard decoration as an important and profitable aspect of his output.[14] In fact daggers designed in the Holbein workshop drew such demand that his contemporaries coined the term 'Holbein dagger' for this particularly aspirational and highly decorated accessory.

Today, if one takes a break from the bustle of London's Oxford Street and diverts to the Wallace Collection in Manchester Square, one can see examples of 'Holbein daggers'. Holbein took advantage of how the baselard was worn to create narrative scenes along the length of the scabbard. In the Wallace, one Holbein dagger features the story of *William Tell*, another the story of *Virginia and Appius Claudius*. But it is the dagger depicting the *Dance of Death* that brings this aspect of Holbein's output back to Erasmus.

Designed in 1523, Holbein's scheme for a scabbard featuring the *Dance of Death* is thought to have been conceived as a gift for Erasmus.[15] In fact Erasmus was building up something of a personal armoury – though purely decorative – with several of his acquaintances choosing

Hans Holbein (copy after), *Design for dagger sheath featuring a Dance of Death*, pen and brown ink, grey wash against black background, *c*.1523.

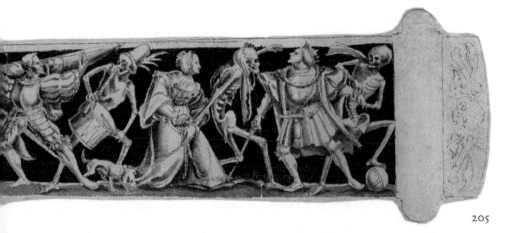

the dagger as a pertinent and witty gift for the author of *The Christian Soldier*. The design, which features members of the clergy as well as knights, noblemen and women all being dragged off by cavorting skeletons, marks a significant narrative leap from Witz's mural in the city. The latter was a series of vignettes, each distinct from the other. But not so long after painting his own wild and arguably unsettling dance around the Angelroth house, Holbein is keen to also overlap his figures here, weaving them into one continuous motif which, though not a conga line per se, nevertheless sees all the dancers linked together in their inevitable demise.

Such a dagger design not only afforded Holbein diversification, but it also allowed him to experiment in the realm of miniature. In a culture where art, luxury, event and delight could be aligned, the miniature ticked all the boxes. The ability of an artist to exercise his skill on a very small scale was considered particularly virtuoso and thus added to the perceived preciousness of any miniature object. The contrast between the large-scale mural by Witz and this tiny rein-terpretation of it on a dagger would have been a talking point.

Gift giving was a crucial part of an informal but extensive economy in the early modern period. Outside the pensions that were controversial even then, there was also a fully accepted established protocol of giving that was indicative of duty, loyalty, the expectation of reciprocity and also a means of establishing or reinforcing status. Erasmus was no exception. While the happy recipient of many items, he made sure his patrons were gifted copies of his latest writing. And despite Erasmus's firm belief that the written word would always convey a better sense of the true character of the writer than a visual portrait of the sitter, nevertheless he also saw the potential of portraits as presents. In this respect the fact that the teenage boy he had known in 1515 had, by 1521, become Basel's most exciting artist, was very handy indeed. That he shared a rather sharp satirical sense of humour with Erasmus stood him in good stead too.

Erasmus had already explored using portraits as gifts. In 1517 he and his friend Pieter Gillis had sat for Quentin Metsys in Antwerp for a pair of portraits that were sent to their mutual friend Sir Thomas More. Erasmus then commissioned a portrait medallion from the Dutch artist featuring his profile on one side, and his personal emblem, a bust of the god Terminus, on the back. By 1523 Erasmus

had run out of these portrait medals and was looking to have more cast. In the meantime he had nothing to hand to send out. He needed to commission a new tranche of personal mementos.* He turned to Holbein.

Since his earlier residency in Basel in 1514, Erasmus had been building on his reputation as the advisor and philosopher in chief to the kings of Europe. He had written another handbook, *The Education of a Christian Prince*, for the young Charles V in 1516, and had also begun commentaries on the Gospels with the ambition to dedicate each one to Europe's rulers: Matthew to Charles V, Mark to Francis I, Luke to Henry VIII and John to Charles V's brother, Ferdinand. It is not insignificant therefore that a man who saw himself as the intellectual light of Europe was prepared to entrust his image to this young painter.

The Holbein workshop embraced the creation of 'Erasmia' as part of what in today's terms was a visual marketing campaign for the scholar. As part of this Holbein set about updating Erasmus's personal device and generating a new series of portraits.

The Metsys medallion had depicted Erasmus in profile on one side and the head of Terminus, the Roman god of boundaries, on the reverse. Holbein now evolved the depiction of Terminus, enlarging it to include the god's nude torso. This extended representation, rising from the ground, intentionally took on the same dimension as a tombstone, and thus alluded to Terminus' association with death. But Holbein took his conceit further, also merging Erasmus's features with those of the classical deity. Once designed, this device was available to Erasmus to adapt across different media, and indeed a modification of it appears in Holbein's design for a frontispiece that Froben would use in forthcoming publications. Meanwhile Holbein also produced a large painted version that hung on the chimney breast in Erasmus's rooms in Froben's house.[16] Given a smaller painted version of the device also exists in the Cleveland Museum of Art, it may have been that Erasmus also commissioned a range of smaller paintings on wood to send to friends. Holbein also adapted the device in a design for a

* In the summer of 1520 Erasmus had met and sat for Dürer in Brussels, presumably with the idea of creating a portrait that could be engraved and more widely disseminated, but Dürer had become ill and the work had remained incomplete.

stained glass window Erasmus gifted to the University of Basel.*

In terms of the series of portraits that Erasmus commissioned from Holbein, two were sent off to England in 1523. One was for the then Archbishop of Canterbury William Warham, and today it hangs in the National Gallery in London. Warham was a patron of Erasmus who provided him with a pension – one he had recently increased. The work was intended to recommend Erasmus to his patron as being worthy of this investment. Holbein, perhaps audaciously, took the opportunity to also promote himself to the English statesman. In fact this may be the earliest indication that Holbein had already recognized that England might be a potential market for his work.

He depicts Erasmus in three-quarter profile. The thin, rather frail scholar is wrapped up well against Basel's cold winter in a voluminous, dark, fur-lined coat. Erasmus's hands are at rest on a book entitled the *Labours of Hercules* that represents his literary career. For those aware that Luther was being ascribed the title of Hercules Germanicus in some quarters, this title may have also proposed a correction, contrasting the considered study and calm scholastic approach of Erasmus with the violent outbursts of the other. The ribbons that seal the book are undone, implying the work remains unfinished and the scholar is merely at rest. He stands next to a pilaster with Renaissance motifs, a reminder of his classical scholarship. Behind him a green curtain is drawn back to reveal a shelf

Hans Holbein, *Cartoon for a stained-glass window with Terminus*, pen in black, brush in grey, over pre-drawing chalk, washed in grey, with watercolours in places, 1525.

on which a glass bottle is placed, alongside a couple of books. The glass bottle was often used in depictions of St Jerome, the translator of the Bible, and this allusion is clearly intended to draw the parallels Erasmus enjoyed making between himself and his predecessor. At a time when the religious debate was so intense, this bottle would also have carried a message of reassurance to Warham regarding Erasmus's continuing loyalty to the traditional Catholic Church. It was a Marian symbol, a reminder of the Virgin as the vessel that bore Christ. For Holbein, his ability to depict glass with such persuasiveness also served as further promotion of his abilities.

One notable characteristic of this portrait is revealed in the preparatory drawings that are in Basel's Kunstmuseum today. Most

* The preparatory drawing for which is in the Kunstmuseum in Basel. The actual window was still in place in the eighteenth century.

of Holbein's extant preparatory work suggests that he usually focused his efforts on capturing details of faces, and sometimes clothing where the sitter might want the expense and quality of a particular aspect of their costume recorded. He would normally not bother making sketches of a sitter's hands and instead presumably relied on generic hand studies that would have been part of a library of images kept in the workshop. However, in the Basel museum there are sketches by Holbein of Erasmus's hands. This may have been a detail that the sitter insisted on being properly observed, part of a conceit shared between him and his painter. Erasmus's stated belief was that written work, obviously achieved via the hand, offered the real portrait of a person since it provided insight into his or her mind. There was a special need therefore to correctly portray Erasmus's own hands in this instance.

Holbein made sure that his own signature would also be noticeable for Warham's consideration. The cover of one of the books sitting on the shelf behind Erasmus features roman numerals giving the painting's date of 1523. Across the pages of the same book Holbein

Hans Holbein, *Erasmus*, oil on wood, 1523.

signs his painting and adds: 'whom it is easier to denigrate than to emulate'. Warham should have picked up the reference to the classical painter Zeuxis who according to classical literature wrote beneath one of his works that it was 'easier to envy than to copy'. Priming his viewer that the painter was comparing himself with the great painters of the antique era, Warham may well have then been tempted to see the partially drawn curtain that Holbein had also depicted as referring to that famous competition between Zeuxis and Parrhasius in which the latter's painting of drapery fooled even his greatest rival. That Holbein made the impression he intended with this potential client is evidenced by the fact that Warham became one of his very first clients when he did eventually set foot in England.

Holbein's persuasive portraits of Erasmus clearly had a considerable impact on those who had the chance to see them in the flesh. Beatus Rhenanus made a point of citing them when he wrote a commentary on Pliny's *Natural History*, just a year after their completion. In this commentary he reflected on the high quality of classical portraiture in which painters depicted 'things by following the actual model to represent every feature':

There were a great number of such painters among the Ancients

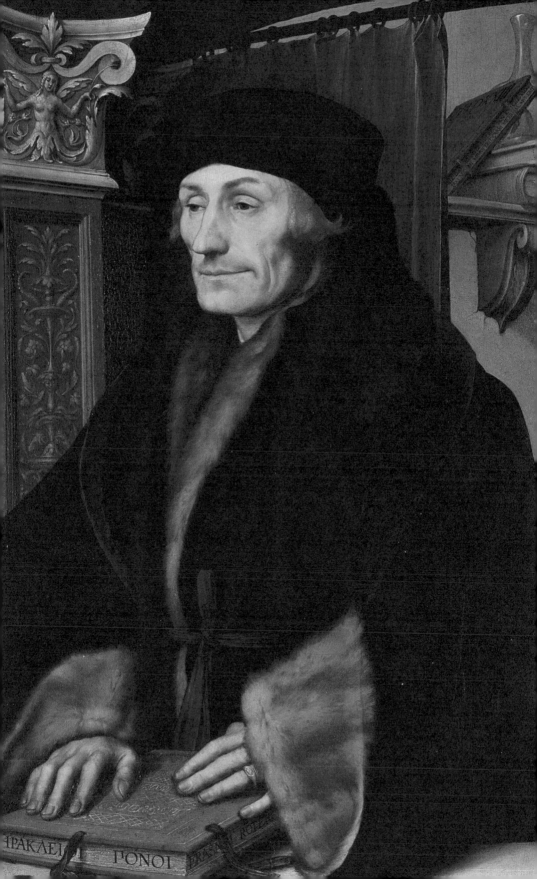

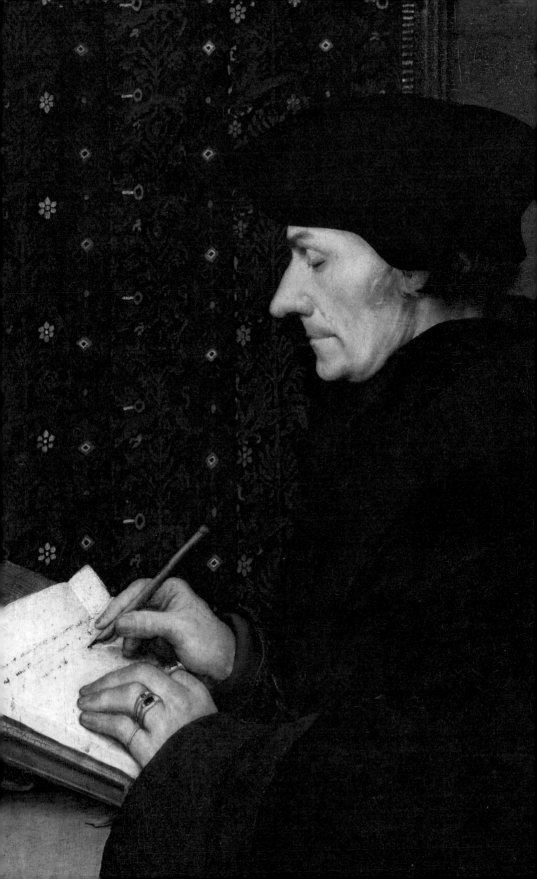

...Among the foremost painters in Germany today are reputed Albert Dürer in Nuremberg [...] and Hans Holbein in the upper Rhine area. Last year he painted our Erasmus of Rotterdam twice, on two separate paintings. He painted a very striking likeness with much grace. Both paintings were later sent to England. If only our contemporaries valued painting as highly as the Greeks and Romans once did, I would not doubt that painters, in hope of gaining fame and acceptance, would with careful practice, easily attain great accomplishment. The saying 'Honour feeds the Arts' is absolutely true.[17]

It remains unclear whether the portrait of Erasmus by Holbein now in the Louvre was the second portrait sent into England alongside that for Warham. A simpler portrayal, similar to Holbein's own workshop portrait of Erasmus that ended up in the Amerbach Cabinet, the Louvre picture shows Erasmus in profile, sitting in front of a patterned curtain, writing his commentary on St Mark's Gospel.*

It also remains a mystery for whom this second portrait was intended. Though much speculation has formed around the idea that it was for Thomas More, this would seem strange given he already had a painting of Erasmus by Metsys.

Hans Holbein, *Erasmus*, oil on panel, *c*.1523.

However, More's daughter, Margaret Roper, is an interesting candidate. Roper was the subject of Erasmus's praise in letters of 1523, and she went on to translate his *Precatio Dominica* into English – a landmark event since she was the first woman, outside royalty, to publish a translation. A copy of the original book from which to work, along with a painting of its author, would have been a pertinent gift for a young woman whom Erasmus greatly admired. Another candidate is Cardinal Wolsey, or the man who would shortly join his household, Thomas Cromwell, a measure of whose genius was the fact that he knew Erasmus's translation of the *New Testament* by heart. Holbein's first biographer, van Mander, notes that in the early seventeenth century 'another of Holbein's portraits was in the house of old Lord Cromwell; it was about a foot and a half square, painted most cleverly and perfectly as a fine portrait of the highly learned and widely famous Erasmus of Rotterdam'.[18]

Erasmus's letters of the mid 1520s suggest that Holbein had become

* The fact Erasmus is writing his commentary to St Mark, however, also makes it a candidate for a version sent to France, since Francis I was the dedicatee of the work featured.

considered a friend by the scholar. In November 1523 Erasmus writes to a colleague, Johann Faber, a vicar general in Constance, warmly citing Olpeius – his latinized name for Holbein. 'The good wishes you sent me by Olpeius were a great encouragement,' Erasmus wrote, 'for they were elegantly expressed, and they came from one friend and were brought by another.'[19]

Given the few direct accounts of Holbein, it is worth considering this one forensically. It reveals Holbein as trusted and articulate, both key attributes to professional survival in the period. Moreover, given that Erasmus insisted on speaking Latin – a habit that greatly annoyed Sir Thomas More's wife, incidentally – the clear implication here is that Holbein was conversing in that language with a level of fluency that pleased his patron.

While a degree of intimacy could well have been born from their intense collaboration around this time, it is also worth considering Erasmus's concept of friendship in 1523. This was a year when his sense of being under siege from all sides is evident. So could 'friend' suggest an apparent supporter who purported to share the scholar's opinion in the wider religious debate? Though quite how Erasmus would square this with Holbein's work for Adam Petri in 1522, when he provided decoration for Luther's version of the *New Testament,* is unclear. Having said this, despite his dismay at the violence that Lutheranism incited, Erasmus admired Luther's scholarship, and thus may have forgiven Holbein his role in ongoing debate.

There was currency in opinion. Erasmus signs off his letter to Faber with a telling anecdote: 'Murner has been sent back from England with his pockets full.' Murner, the satirist whose work Ambrosius Holbein could not complete, had travelled to Henry VIII's court at the invitation of Sir Thomas More. His anti-Lutheran views were of great interest to both More and the king and earned him £100. As Erasmus rather sourly points out, 'How many men are made rich by that penniless Luther!'

Erasmus's advice to the princes of Europe to take up Christian values and stop warmongering had fallen on deaf ears. Despite Henry and Francis pledging friendship in 1520 the English king had gone on to form that allegiance with Charles V and across the next six years Europe was once again in the throes of war.

Erasmus did not want to take sides. Despite his well-established

links to Charles V, the Pope and Henry VIII he continued to seek favour from Francis. In 1523 his commentary on the Gospel of Mark was complete and dedicated to the French monarch. The question was how a copy of the work might be conveyed to the dedicatee in such difficult times.

Circumstances were definitely bleak. It was not just bandits and poor roads that might waylay a traveller between Basel and the French court. There was also the possibility of skirmishes from the various armies on the march. However, in the spring of 1524 there was the opportunity to deliver Erasmus's book, along with another portrait of its author, to Lyons where Francis was gathering troops. This opportunity came in the form of Jacob Meyer zum Hasen. Following his disgrace and imprisonment during the pension storm of 1521, Basel's former major was now, literally, back in the saddle. In April he led a group of 200 Basel mercenaries to Lyons as part of that notorious contract to supply troops to Francis's army.

Holbein joined the convoy, clearly at Erasmus's behest, since the latter writes to his friend Willibald Pirckheimer in June that not only had he 'lately sent two pictures of myself to England, done by a very elegant artist', but that also 'he took a picture of me to France'.[20]

For Holbein, the prospect of being able to impress Europe's most cultured monarch was presumably too hard to resist. He would take Erasmus's gifts himself and see if he too might benefit from the king who had patronized Leonardo da Vinci.

Though Lyons was on a war footing Francis was not there when Holbein most likely arrived in late April 1524. In fact Francis had left Lyons the previous summer and was now in the Loire Valley. Fortunately, Holbein had other business to pursue in Lyons, and it was probably this that had also encouraged him to take the journey.

In 1520 a particularly talented *Formschneider* – that is, a wood cutter who translates designs into wood blocks for reproduction – had arrived in Basel. Hans Lützelburger's background mirrored Holbein's own. He was born in Augsburg just two years before Holbein; the two could have been childhood friends. Now the Lyons-based publisher and printer Melchior Trechsel was funding the pair to make a new series of luxury prints, reinterpreting *The Dance of Death*.

The Trechsel family had moved to Lyons from Germany and had a family printing and publishing business much like the Amerbachs'. In

fact correspondence between the two families is indicative of a long-standing professional relationship between the two publishing houses, and suggests how Holbein's commission may have occurred, with a recommendation from one of the Amerbach brothers, or Froben.

Meanwhile images of the Dance of Death were popular in France. Even earlier than Witz's mural in Basel, another had been painted in Paris's cemetery of Saints-Innocents. Paris was the largest city in the whole of Europe at this time. With a massive population of over 200,000, it was around three times the size of London. Saintes-Innocents was right in its centre. If ever a place spoke of mortality it was this, for so oversubscribed had this cemetery become, the soil of the surrounding parish had become contaminated, and the whole *quartier* suffered from the smell of putrification. In order to relieve the subterranean overcrowding, many graves had been exhumed and the skeletal remains therein placed in ossuaries, or charnel houses which framed the cemetery walls. Beneath these mass tombs ran extensive arcades, and here the very first mural of the *Dance of Death* had been conceived. It had been popularized in the 1480s by engravings of it by Guy Marchant, which were in constant reproduction and which Holbein would have known.

Lyons, second only to Paris as a centre for printing in France, had made sure to capitalize on the appetite for morbid imagery. On the cusp of the sixteenth century Matthias Huss, another Lyons-based printer of German origin, had produced *La Grant Danse Macabres des Hommes et des Femmes* in response to Marchant's engravings. A good twenty years on, at a time when printing and illustration had made such technical leaps, it was not surprising that the Trechsels felt there was room in the market for a new version.

The miniature scheme that Holbein originated for a dagger perhaps suggested the scale of this new *Dance of Death* series. The agreement with Trechsel was for Holbein to design fifty-one vignettes in miniature, each contained in a tiny rectangle, measuring just 6.5 cm × 4.8 cm. This format was utterly original, and would have given the series a considerable novelty value, as well as serving to highlight Holbein's versatility.

Unlike his dagger design, where characters were linked, the printed series reverted to hermetic scenes. Death – shown as a skeleton – is depicted leading different social types, from Pope and emperor to

peasant, to their respective graves. These encounters between Death and his prey were contextualized with a *mise-en-scène*. Intended to be issued initially as single sheets, these scenes could be purchased by collectors as the next in the series became available, creating an ongoing interest and sense of anticipation. Ultimately of course the series could be bound into an edition.

Though the 'types' he portrayed dancing with Death were ostensibly generic, Holbein's sharp sense of satire is fully expressed in this series. All his wry observations about bribery, social inequality and hypocrisy are expressed here. And as a truly authored series, where the artist had a genuinely free rein over the narrative, this undertaking perhaps gives us the clearest clue to Holbein's personal views. It is also a testament to Holbein's considerable ambition that, after Erasmus had so clearly offered his satirical comment on society in *In Praise of Folly*, now Holbein dared to make his own. Perhaps he had hoped that the fame and income that had been secured by Folly for Erasmus, Death might now bestow on him.

Holbein laced the whole series with satirical references for those who chose to see them. In his depiction of *The Emperor* there is a passing resemblance to the Holy Roman Emperor Charles V, or perhaps his predecessor Maximilian, whose focus on his broken sword (his Empire) is detracting his attention from the starving peasant at his feet. The fleur de lys banner framing *The King* identifies him as Francis I. He is shown at a vast banquet at which he is the sole attendee. It was indeed part of Francis's daily ritual to eat alone, watched by his (presumably hungry) staff. In *The Miser* Holbein cannot resist Jacob Fugger, once again identified by that cap. Perhaps the darkest joke in the series comes in the depiction of *The Queen*. Surely here is Queen Claude of France who died at the chateau of Blois in the summer of 1524. That chateau had its own mural of the Dance of Death, painted in 1500, running under the castle's arcades, around the central courtyard. This arcade is shown in Holbein's image and, as if figures from its mural have sprung to life, Death is seen leading a couple out of the arcade, scooping up a reluctant Claude in the process.

In addition to these specific references to Europe's famous rulers and influencers, Holbein makes more general jibes. While taken as a whole the book is clearly a reminder that Death is the leveller that affects everyone regardless of rank, nevertheless Holbein is keen to

point out that the living were suffering plenty of social injustices.[21] As he travelled across France in 1524 the unhappiness of a peasantry that would soon rise up in full revolution across the continent must have been apparent to Holbein. And as the recent protests in Basel had shown, unrest was not confined to the rural poor – city folk had their grievances too. In his *Dance of Death*, it is not just the emperor and the king who cannot see the plight of their least privileged subjects. In Holbein's series *The Cardinal* is too busy selling indulgences to care; *The Bishop* has allowed his flock to wander; *The Duke* can't bear the sight of the poor let alone address them, and *The Senator* has his back firmly turned on them.

The hot topic of bribery is something Holbein raises again and again. Both *The Judge* and *The Attorney* are shown, in quite separate scenes, extending their hands for a sweetener. More black humour comes with the picture of *The Physician*. It is not he, but the patient to whom he is dispensing medicine, that Death has by the hand. All in all there is a narrative that weaves through the series that speaks of self-interest above compassion, duty or professional conduct.

Woodcuts for *The Dance of Death*: Hans Holbein (design), Hans Lützelburger (block cut by): *The Doctor* (opposite); *The Rich Man/Miser*, and *The Ploughman* (overleaf), c.1526.

Holbein's treatment of women is broadly sympathetic. *The Empress* is seen as a solitary figure, who though surrounded by courtiers steps into her grave unnoticed by them. Again this is consistent with tales of Bianca Maria Sforza, Maximilian's wife, in whom he lost all interest and effectively deserted. Meanwhile *The Countess* is seen giving away her clothes to her maidservant as Death places a necklace of bones around her neck. Perhaps one of the most empathetic images is that of *The Duchess*, startled by Death in her bed in the night, a common human fear. It is only *The Nun* who is distracted from her worship by a young man playing the lute that draws Holbein's mild, playful censure.

The most vulnerable in society are portrayed with the greatest empathy. Holbein shows the overladen *Pedlar* desperate to keep on selling what he can before Death takes him; meanwhile *The Ploughman*'s own hard work speeds him to his grave, and the hunched *Old Man* is led gently into his tomb.

Holbein had his own experience of Death in 1524 when he lost his father to the Grim Reaper. Despite his huge talent as a painter,

Holbein the Elder had consistently failed to make ends meet. The demise of the father must have emphasized the frustration the son had with his own financial health and status, despite his apparent successes. It was this, along with the wider plight of those engaged in the crafts, that must have sharpened Holbein's ambitions. The successes of his Italian contemporaries, and indeed Dürer, showed that there were new opportunities and rewards for some artists. Art could now be a means of social leverage, financial security, even fame for those with sufficient talent, enterprise, and above all connections. As he planned his *Dance of Death*, Holbein must have felt keenly the need to grasp every opportunity he could in a dangerous and corrupt world. Despite the warnings of Lucian, the lure of Europe's courts was strong.

With Francis noticeably absent in Lyons, Holbein travelled to the Loire Valley to continue his mission to secure the French king's patronage.*

In 1524 the French court was still mobile, but the two chateaux of Amboise and Blois in the Loire were its beating hearts. Amboise was the king's childhood home, the palace where he had entertained Leonardo da Vinci, and the showcase for a painting collection that had been begun by his predecessors Charles VIII and Louis XII. Francis's queen, Claude, was traditionally at the chateau of Blois nearby. Meanwhile the king's erudite sister the Duchess of Berry, Marguerite of Angoulême, was at Bourges.

In the late spring of 1524 Francis was at Blois because his wife,

* There is also some suggestion he visited Avignon during this trip to see Bonifacius Amerbach, who was at university there.

Der Ackerman.

Claude, was ill. In fact he did not leave Blois until 12 July, when he finally returned to Lyons to fight his adversaries in a war that would end in humiliating defeat, when he was taken prisoner at the Battle of Pavia in the following year.

Since he had become king in 1515, Francis had built a reputation as a very generous patron of the arts. Word of his munificence, as well as the comfort he afforded those artists who stayed in his court, had spread through Europe's cultural community. For a painter who legend has it had had to conjure up a pair of legs on a wall to stop an innkeeper from berating him, the notion of working for Francis must have been extremely appealing. That Francis gave Holbein some access to his court and his collection of paintings at Blois and Amboise seems certain. That Holbein actually incorporated some of the details of Blois's architecture into his *Dance of Death* seems to be evidence of his sojourn. What is more, the influence of Francis's collection becomes visible in Holbein's work thereafter.

Francis was a painting enthusiast. His taste for Italian Renaissance work in particular had been reinforced after his success at the Battle of Marignano, when, while briefly resident in Milan, he had explored exporting Leonardo's mural of *The Last Supper* from Santa Maria delle Grazie. When unable so to do he had copies commissioned, including a Brussels tapestry which he displayed at Blois as well as a painting which may well have been at Amboise. These were mere complements to a considerable collection of da Vinci's work that was on show at Amboise by 1524. Francis had inherited *La Belle Ferronier*, *The Virgin of the Rocks* and the *Young Christ as Salvator Mundi*. To this he had added the *Mona Lisa*, *The Virgin and Child on the Lap of St Anne* and *St John the Baptist* and possibly a further portrait of a woman.[22]

It was not just Leonardos that Francis had on show in the Loire chateaux. Works by Raphael were represented by *La Belle Jardinière*, which had been in the collection of Louis XII, as well as his portrait of Lorenzo de Medici, while *Noli me Tangere* and the *Incarnation of Christ* by Fra Bartolomeo were also on display.

Close to both Amboise and Blois was the city of Tours, and here Jean Clouet, France's most prestigious artist, lived and worked under the patronage of the French court. Around fifteen years Holbein's senior, Clouet had been in service to Francis since 1516. He was primarily a portrait painter.

Such was Francis's dedication to the painter, he had made Clouet a Valet of the King's Chamber the year before Holbein's visit. It was a title that reflected that the social prestige of the artist was indeed being acknowledged and valued. More importantly this position gave Clouet a salary, a defined status in court, and freedoms to operate without the regulation of a guild. But above all it gave Clouet direct access to key rooms in the court and to the king himself. As such he could benefit from the various gifts and payments many were prepared to make for a good word in the king's ear, or to pass on some form or message or request. The proximity to an all-powerful monarch gave Clouet an influence and authority that far outweighed his salary, and raised his significance in the life of the court beyond the apparent remit of being a painter.

Holbein's exposure to Clouet and the French court had an immediate impact on his work. For a start, with access to Francis's extraordinary collection he could see in the flesh work from the greatest Italian painters of the day: an extremely rare privilege.

Further, in meeting and spending time with Clouet, Holbein had the opportunity to witness how another painter worked. Of course Holbein would be familiar with the techniques of the masters in his vicinity, but the ability to study those further afield seldom arose.

Several aspects of Clouet's work clearly fascinated Holbein. First, Clouet was not just painting portraits – he was also innovating in this genre. Clouet was behind the invention of the detached portrait miniature, a type of painting that would delight consumers for the next three hundred years.

An example of Clouet's small-scale work that was probably a catalyst in his development of the independent portrait miniature is his tiny depiction of Francis in a manuscript known as *Les Commentaires de la Guerre Gallique*. Clouet illustrated this around 1519 for the monarch, depicting him in grisaille against a blue background, within a gold roundel. In a second edition of the *Commentaires* Clouet also depicted the seven military commanders who had helped Francis to his victory at the Battle of Marignano in 1515. Executed in the margins, these little portraits were also placed in small roundels and were painted in watercolour and gouache, again against a blue background. These compositions, so similar in size to the portrait medallions cast in bronze and other metals that were proving so popular among the elite, must

have suggested to Clouet how he might be able to get in on this new market for small-scale portraiture, and offer exquisite colour where sculptors could not. The painted miniature had a different kind of cachet to the medallion. Once cut out and mounted (often on playing cards) this exquisitely detailed and colourful work had a preciousness more akin to jewellery, particularly when set into tiny gold frames, placed within a locket or concealed within an ornate box.

The painted portrait miniature also arguably offered a greater degree of appeal and verisimilitude than the cast portrait medallion. A painted likeness was of course coloured in convincing flesh tones, and could offer details such as strands of hair and intricate aspects of costume. Its evolution fed into an ongoing debate at the time as to whether painting or sculpture was superior. The debate, encapsulated in the term *Paragone*, was one entertained by Leonardo and his views on the subject came to light posthumously when his *Treatise on Painting* was published in the seventeenth century. His argument for the superiority of painting, which he considered a science, is one that Holbein, with his constant display of perspectival ingenuity, would have embraced.

The commercial potential of the portrait miniature was not lost on Holbein, because in the fullness of time he and his workshop would be producing a considerable number of them. In the meantime viewing Clouet's work could only have reinforced the idea to execute his own forthcoming series of engravings of the *Dance of Death* in miniature format.

Clouet's technical approach to drawing was also eye-opening to Holbein. Before his French adventure Holbein made his preparatory drawings for portraits in silverpoint, as had his father, using chalk as a means of colouration. But after 1524 he used chalk to describe the outlines of his sitters, like Clouet. While silverpoint offered a line that would not interact with paint applied over it, chalk allowed execution on a far greater scale, and it also delivered a softer finish.

On his return home, Holbein painted a series of works that open a dialogue with the work of the Italian Renaissance painters that he had seen in France.

Lais of Corinth, painted after this trip to France, is a pastiche of Italian work, as discussed previously. Meanwhile the Holbein workshop went into production of an altarpiece featuring *The Last*

Supper which clearly alludes to the copies of Leonardo's Milanese mural that Holbein would have seen at Amboise and Blois. *Noli Me Tangere*, which Holbein painted shortly after the trip to France, also seems to reference Bartolomeo's depiction of the same subject, consciously offering a mirror reworking of the composition (that is, all elements in Bartolomeo's painting on the left appear in the right in Holbein's) and a colour scheme in reverse (where the Italian shows Christ in a long red gown and Mary in a red cape, Holbein shows Christ in a red cape and Mary in a red gown). Finally, an altarpiece depicting the Passion from this period also references some of the work witnessed in the Loire, including perhaps a Crucifixion by Andrea Solario.[23] Drawing on both the work of his own father, who had explored the Passion so fully, with new ideas taken from recent travels, it suggests an artist exploring possibilities.

The effect of both Clouet and Francis's collection continued to echo throughout Holbein's career, and suggests perhaps that Holbein's relationship with the French master and his patron was not confined to this particular visit.

As Francis left Blois on 12 July 1524 and headed for Lyons, and beyond that war in Italy, his entourage would have offered Holbein safety once again on his route home. If anything the journey back to Basel had become more dangerous across the summer. June 1524 was the breaking point, when what had begun as strike action by a group of land workers in Germany turned into open revolt, with organized uprisings from peasant armies stretching initially from the Black Forest along the Rhine to Lake Constance. Tensions in the countryside were high. Although not directly related to the new reformed faith that had spread widely into rural areas, Protestantism, with its pronouncement of the failings of the Catholic Church, had intensified a long-standing sense of economic discomfort and social injustice among the peasantry. Such was the force of their armed rebellion that Europe's aristocrats were forced into bloody combat.

Meanwhile the French populace was also generally in black mood. Francis had imposed huge taxes on his people to finance his latest war in Italy, and in the summer of 1524 this combined with an outbreak of plague in and around the Loire, which alongside a series of earthquakes had considerably unsettled people.

One of the stops that Francis's train would have made during

this journey east would have been at Bourges, where his sister was resident in the Ducal Palace. There is clear evidence that Holbein was not only in Bourges at around this time, but also that he had privileged access to the palace chapel there. Here one could see two magnificent monuments to the fifteenth-century Duc de Berry and his wife Jeanne of Boulogne. These polychrome statues of the duc and his wife kneeling before a Madonna caught Holbein's interest, and he drew them.

Created in the fifteenth century by the French artist Jean de Cambrai, they are astonishing for the level of characterization in their faces. But perhaps with the issue of Paragone in mind, Holbein is careful to enhance his portrayals of the duc and duchesse, giving the latter the eyelashes that the sculptor could not deliver.

Although Holbein's foray into the Loire was successful from a research point of view, he was not successful in securing a position with the French court. By attempting such a thing in 1524, his timing was poor. Francis, prosecuting a war while his queen was in the process of dying at Blois, had largely put a halt to his artistic patronage in 1523 and would not turn his mind back to cultural pursuits until after his release from captivity in the spring of 1526. But also it is hard to see what, at this stage in his career, Holbein could offer Francis. The monarch's taste was predominantly for Italian painters, while he was committed to Clouet as the painter of his own image and that of his immediate family. It must have become quickly evident to Holbein that a court position was exactly what he wanted, but that he had to look elsewhere for the kind of patronage Clouet enjoyed. England was the obvious alternative.

Hans Holbein, *Jean de France, Duc de Berry*, black and coloured chalk on paper, 1523–4.

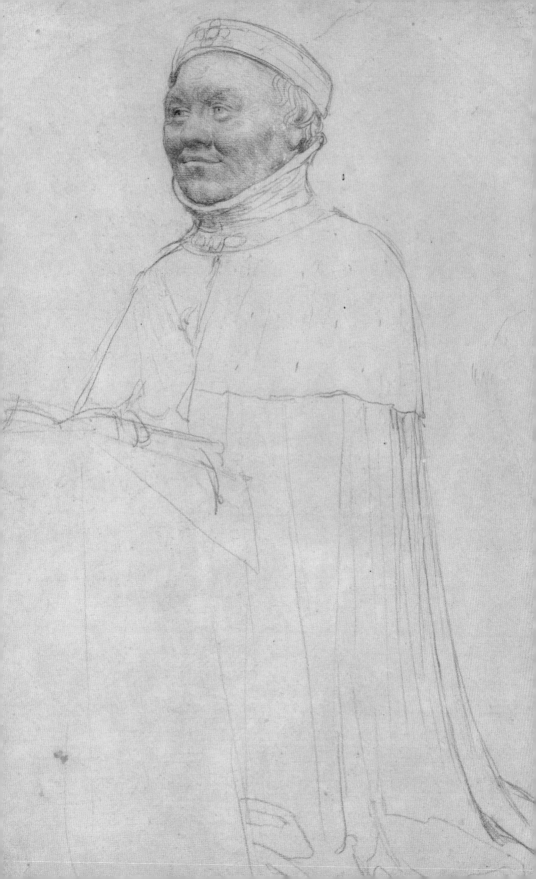

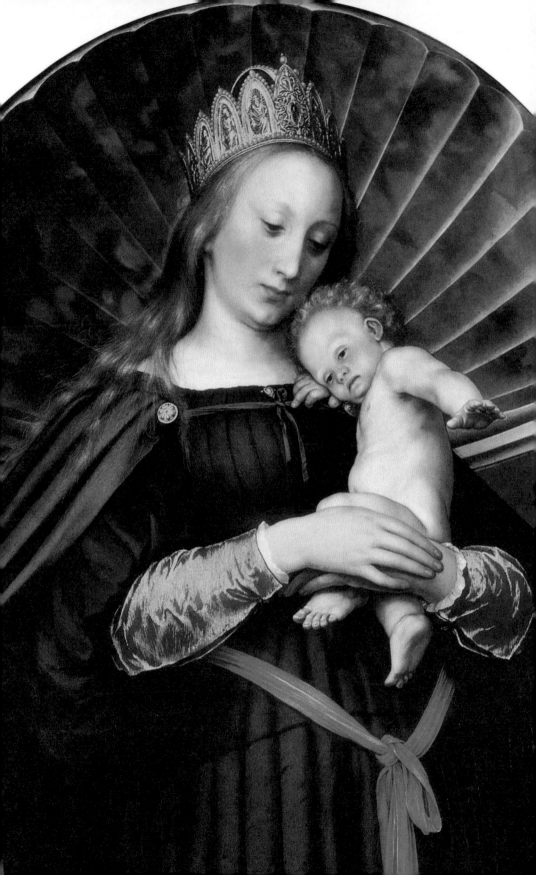

MEYER'S
MADONNA

By 1526 Holbein had made the decision to leave Basel, his workshop, his wife, and two young children and travel to London. In the end it was a decision made as much out of necessity as ambition. The economics of his profession were undergoing a transformation – for the worse. Painting in Basel was in crisis. But this only reflected the wider crisis engulfing Europe as a whole.

Across the twenty-nine years of Holbein's life so far, wars had been raging. Europe had always been defined by a group of superpowers constantly reconfiguring into different alliances. Between the Empire, France, German principalities, the Italian city states, and the Pope, there was continuing friction where peace was at best a brief truce and violence apparently unending.

The most recent wars played out in Italy had come to an astonishing conclusion. Francis I, whom Holbein had sought out in the Loire, had returned to the battlefield only to suffer a crushing defeat. Charles V had managed to wrest Milan and Lombardy back from the French in 1522. Francis, determined to regain the Italian territory, marched onwards from the Loire in 1524, crossing the Alps, and descending on Milan where he retook the city. Holbein, who, as suggested earlier, may well have left the Loire with Francis's men, conceivably stayed with the army for a while – after all, the French were now supported by thousands of Swiss mercenaries. Among them were Jacob Meyer and the men of Basel. Could Holbein have even joined them, as so many of his fellow artists did?

In Basel there is a drawing of a battle scene, drawn on French paper, that dates from this period and suggests the artist's relationship with the mercenary forces of his Swiss compatriots. A copy in Vienna reveals what was once the full scale of Holbein's depiction, a long line of soldiers, stretching as far as the eye can see, engaged in battle. Men, woven together in conflict, appear like a single prickly beast, the pikes that defined the Swiss mercenary troops like porcupine spikes raised high above the action. It is a partisan piece, one that focuses on and perhaps even celebrates the Swiss tradition of brutal hand-to-hand fighting. Cavalry and artillery have no place in this version of engagement.

After his success at Milan Francis went on to lay siege to Pavia, part of the Duchy of Milan. But in February 1525 Charles's troops broke the siege and laid waste to the French and their mercenaries.

Francis was taken captive before being removed to Spain, where he was incarcerated. It was not until the following year, when on signing the Treaty of Madrid he ceded important territories, that the French king was released. Even then, Charles only let Francis go on condition that his two eldest sons became hostages in Spain.

Despite these endless and exhausting conflicts there had been one thing that had bound Europeans together in the early sixteenth century, and that had been their shared religion under the authority of the Pope. This ancient institution was in need of an overhaul, and yet there was hope. Erasmus was not alone in recognising the need for reform within the church. He and others saw a new way forward for European society, one where pity and kindness were valued. They had even mooted the possibility of a new kind of Christian monarch who might eschew war. There was an opportunity to cast away superstition, corruption and injustice in favour of genuine piety, self-knowledge and good governance. Perhaps there might even be a way to end war.

However, by the early 1520s these exciting ideas had also begun to sow widespread factionalism and discord. Instead of seeing an improvement in the lot of the European, Holbein and his contemporaries were witness to a new religious crisis that plunged the continent into yet deeper discord. Luther in particular had unleashed the idea of the Antichrist and a significant portion of Europe's population had consequently developed a vehement hatred of the established Papal Church. Wars once fought along lines of national or regional interest were now intensified by religious ideology. What had begun as debate about the state of the church had turned into dissent and division. Protest was turning into fully fledged violence.

overleaf
Hans Holbein, *Battle Scene*, pen and some brush in black, washed in grey, on paper, c.1524.

By 1526 the painters of Basel were reeling from the severe economic consequences of half a decade of strife. The art market had become blighted by paralysis and uncertainty. Patronage was subdued either by new ideology or by fear of reprisal. Holbein was not exempt. His paintings of both the *Dead Christ* for the Amerbachs and the *Solothurn Madonna* for Johann Gerster had most likely failed to be positioned in their intended locations because of religious tensions in the city. The execution of a mural for the façade of a house had been cancelled for the same reason. The desire for lavish decoration, in which Holbein was so very expert, was generally fading. He had

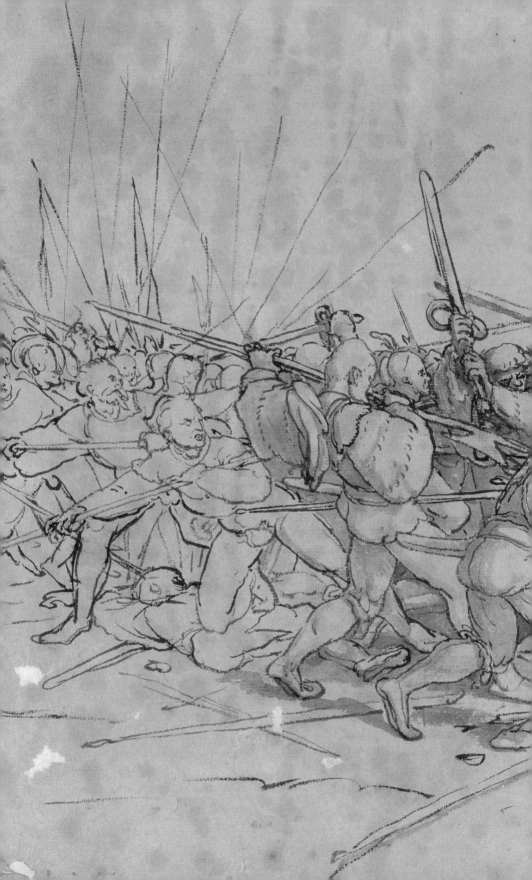

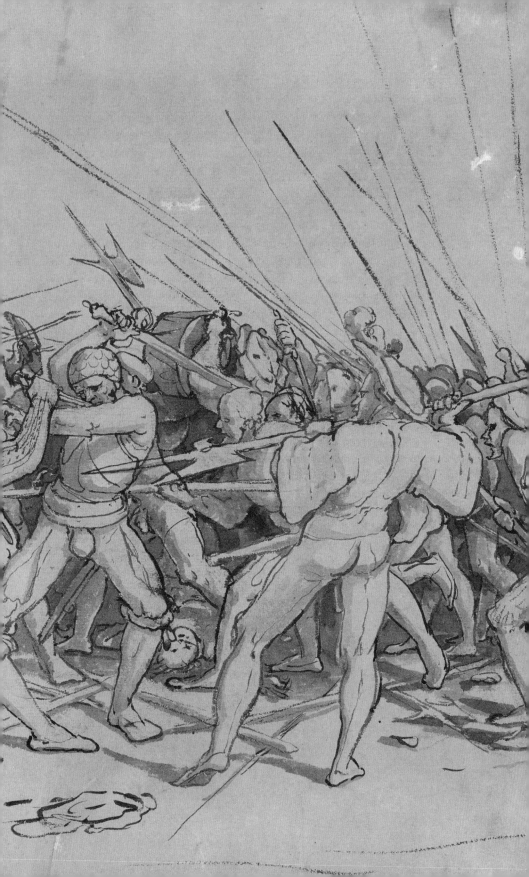

failed to complete the full commission for the town hall murals by the end of 1522, and though paid in full for the incomplete scheme, there was then no evidence of the council stumping up more money to allow him to finish the project. Similarly an appetite for lavish illustration in published material had also waned with the rise of an ascetic Protestant palette, and so work with Froben had also ground to a halt around 1523. This may well have been one of the reasons why Holbein embraced the commission for the *Dance of Death* series from the Trechsels in Lyons. How heartbreaking, then, when it became evident that this would be another venture to end in disappointment.

In 1526 the plague hit Basel yet again. This time the Reaper danced off with Hans' colleague, the *Formschneider* Hans Lützelburger. He had completed just forty-one of the *Death* series and so it was unfinished. Trechsel seized the plates and had them shipped back to Lyons where he subsequently failed to publish them for more than a decade.

Holbein would have been forgiven for panicking. In fact many other painters in the city did just that. It was only Holbein's exceptionally high level of skill that was keeping him economically afloat. While other artists were drowning, he had his commissions from Erasmus. Meanwhile his workshop was effectively hoovering up what small pickings were left of the market. In March 1526 Holbein is recorded as receiving some money for painting coats of arms, small-scale work for such a virtuoso artist.

For some, work had already dried up completely. Two months earlier, in January 1526, utter desperation led Basel's painters' guild to petition the city council for assistance, since so many of its members could no longer feed their families.[1] Against this backdrop the decision by Jacob Meyer to order a major religious work from Holbein was nothing short of extraordinary. Little could Holbein have known that it would be the last large-scale devotional work he would execute; for him it must have felt like a genuine godsend, keeping the family coffers supplied for a few months longer.

It was most likely when travelling together to Lyons, or perhaps later in Lombardy, that the now rather controversial former mayor and Holbein discussed a Marian-themed painting, destined perhaps for St Martin's in Basel, the church where Meyer's first wife was buried.[2]

There were already devotional pieces executed by Holbein in Basel for the two men to discuss. One had been commissioned by another

member of the town's council, Hans Oberried, around 1520. This was a typical devotional piece where, below scenes of *The Birth of Christ* and *The Adoration of the Magi*, Holbein had depicted members of the Oberried family.* In true tradition the family were shown in an entirely different scale from the events depicted and even separated from them by a low wall. In making these distinctions the realms occupied by the holy figures portrayed and those expressing their devotion to them were quite different.

That Meyer had also seen Gerster's Madonna, the *Solothurn Madonna*, and wanted something comparable, is suggested only by the almost identical format and size of both works. Destined for the same location, St Martin's Church, the duplication of size and format may have related to their situation within the church.[3] Perhaps they were to hang opposite one another?

Beyond this they could not be more different, because while Gerster's Madonna is the embodiment of simplicity and humanist Christianity, her ordinary face and burdensome gown presented under a plainly rendered arch, the picture for Meyer presents an entirely different version of the Virgin.

Today Meyer's commission is known as the *Darmstadt Madonna*. It features a Madonna with a baby Jesus in her arms, at whose feet six figures are assembled in a semicircle. She is serene rather than humble, standing tall and crowned, in simple but luxuriant clothing. The Christ child in her arms is twisting and reaching out with his left hand. The entire group is positioned on a richly patterned carpet, rucked up to indicate that it is falling over an edge. The Madonna and child are framed in a niche, the arch of which is in the form of a huge scallop shell carved into rich red marble. Two ornate brackets project from either side of the niche, decorated with carved leaves. These provide a comment on artifice, a reflection of 'real' fig leaves and branches which Holbein depicts winding across the background of the painting.

The Madonna's cloak is wide open and envelops the kneeling figure of Meyer on her right, while to her left are the female members of his family: his first and second wives, and his daughter Anna. Also to the Virgin's right is a boy, crouching, who is steadying another baby who

* The execution of some of the figures in the patron's group is of poor quality and cannot be by Holbein, but perhaps by a workshop member.

stands on insecure legs and seems as if he might topple over the edge of the dais on which the group is arranged. The figures and faces of the Virgin, boy and babies are idealized and arranged in a triangular composition in a manner reminiscent of Raphael or Leonardo. As such one is invited to perhaps interpret them as otherworldly. The boy and baby may be a presentation of Meyer's two deceased sons, their faces idealized not only because Holbein was unable to draw them from life, but also because they had become part of the spiritual domain.[4]

There are some similarities between the *Darmstadt Madonna* and Andrea Mantegna's *Madonna della Vittoria*, or *Virgin of Victory*, which the Italian painter made to celebrate Francesco II Gonzaga's conquest at the Battle of Fornovo at the end of the fifteenth century.

Though Mantegna's Madonna is seated, she too is framed in a niche, which features a scallop shell. She holds a baby Jesus whose hand is extended, as is the Madonna's own hand. Meanwhile at her feet stands a baby John the Baptist accompanied by his mother St Elizabeth. To her right kneels Francesco II Gonzaga, enveloped by her cloak – the implication being of course that the Virgin had offered him her divine protection during his recent battle. Unlike Holbein's depiction of Meyer, Mantegna's Gonzaga is gazing up at his protector. But most significantly, it is the perspectival approach of both Holbein's and Mantegna's paintings that is almost identical. Clearly intended to be positioned slightly above eye level so that one looks up at the figures, the underside of Meyer's and Gonzaga's respective chins are visible, as are the downward-facing palms of Christ in Holbein's piece and the Madonna in Mantegna's. Equally, it must have been with Meyer's commission and Mantegna's masterpiece in mind that Holbein sat in the chapel in the Palace of Bourges on his return from Blois, studying the beautifully executed kneeling figures of the Duc de Berry and his wife by Jean de Cambria. Those statues were also positioned at the foot of a seated Madonna and reconstructions of their original arrangement suggest that they occupied a slightly elevated position. As such, and as Holbein's sketches reveal, they provided him with the convenient opportunity to rehearse a view of kneeling figures seen from below, as well as to contemplate a triangular composition with a Madonna at its apex and kneeling figures at the base.

In the absence of a victory to celebrate after the French defeat in

Hans Holbein, The Darmstadt Madonna, oil on wood, 1526–8.

1525, today the piece is considered less a *Madonna della Vittoria*, and is instead interpreted as a *Schutzmantelbild*, or a *Virgin of Mercy*. This was a familiar, traditional Catholic icon in which the Madonna opens her cloak, encompassing and protecting those praying at her feet. Certainly a *Schutzmantelbild* suited the staunchly traditional Catholic Meyer. By 1526 in Basel, the production of such an icon would have been considered a provocative gesture, signalling Meyer's loyalty to the traditional church in the light of the ongoing growth of what would eventually be called Protestantism. Meyer was pinning his colours to a mast in no uncertain terms.

The painting has an awkward yet compelling lack of resolution. It is not just their angelic and unblemished faces that give the group of spiritual figures suprahuman qualities; Holbein also achieves an otherworldliness in the description of their limbs: their hands seem to float, their touch is soft. From the static Madonna, the children provide sinuous movement cascading down and across the surface of the painting as they twist, reach and grasp. They perch and balance in a way indicative of imminent movement – yet one imagines that any gesture would be delivered as if choreographed in slow, dreamlike articulation.

Hans Holbein, *Jeanne de Boulogne, Duchesse de Berry*, black and coloured chalk on paper, *c.*1524.

In contrast to these balletic creatures, the rest of the Meyer family, packed tightly around them, seem to be the epitome of the mundane world. Meyer, his wife and daughter, are rooted firmly to the ground, their clothes falling in heavy folds. Meyer has ruddy, well-fed cheeks and the shadow of stubble under his double chin. His age is felt in the bags under his eyes, and his thinning hair. His considerable, robust presence is amplified though his large head and hands. His expression is one of mild supplication, a request perhaps for his past misdemeanours to be forgiven. His second wife's thin lips are shut tight, her jaw a little tense, and her cheekbones sharp and visible. Her expression hints at retained worries. Yet despite these brilliant facial characterizations, there is stiffness in the attitude of the figures that is reminiscent of those statues of the kneeling Duc de Berry and his wife at Bourges on his return from Blois.

In spite of the contrasting execution of the figures – the ethereal Italianate figures versus the mundane and statuesque ones – Holbein unites his subjects within the same dimensions. Unlike the Oberrieds,

who were painted smaller than the holy figures they worship, here the Meyers, the Virgin and child and deceased children, all share the same human scale. And whereas the Oberrieds were separated from the realm of the ancient and holy past, here the Meyers share the same credible space as the Virgin and child. The idols and those idolizing them are brought together in a common imaginative realm.

Holbein goes further still. He projects the painting into the space of the real chapel in which it originally hung. The acanthus brackets appear to extend over the heads of Meyer and his family and in doing so break the painting's fourth wall. The carpet, folded over the dais on which the group is placed, also impinges on the real world: Holbein probably also painted it spilling out over the picture's frame. The hands of baby Jesus and Meyer's deceased baby son reach 'outside' the painting. As in his *Dead Christ* this creates an arena that also incorporates the viewer standing below the painting, a momentary compression of different realms into one single experience. It has been suggested that the painting, an epitaph, would have hung above the Meyer family tomb at St Martin's, and so those figures reaching outside the painting are also reaching out over the tomb below, drawing attention to it.[5]

In this way, this painting explores the same tension and porosity Holbein had interrogated again and again in his work to date: between the real and the imagined, between statuary and paint, between this world and the next. In the *Darmstadt Madonna* it is as if he taunts his viewer. The Meyers look real, just like the fig leaves in their background that are so more full of life than their sculpted counterparts. Yet like the painted foliage, the Meyers are no more real than statuary; they only seem so because of the supremacy of the science of painting over sculpture. And as the viewer joins the circle of devotees surrounding the Madonna, Holbein's conceit is complete. Ultimately it is only the imaginative contribution of the onlooker that can resolve and accept the contradictions the painting presents.

It was probably Meyer's own specific request for his Madonna to be more icon and less real woman, according to Catholic tradition. Such a demand could have forced a lesser artist to seem retrograde, but in the hands of Holbein, he uses the opportunity to make a persuasive

and profound argument for the potential of painting.*

However, with the completion of Meyer's Madonna by the summer of 1526 Holbein knew his luck had finally run dry. Basel, now so changed from the city he had come to in 1515, could no longer offer him the career he had hoped for. If he was to avoid begging the guild for alms like his fellow painters, he had to move away.

He began to tidy up his affairs in preparation for leaving. One matter was in connection with his father's estate – such as it was. The old man's painting equipment was still at the abbey in Isenheim where he had last worked, with the abbot there either reluctant or too lazy to return his possessions. Holbein leveraged his connections to press the abbot, with Basel's mayor Heinrich Meltinger writing on his behalf in July.

This was not the only literary favour Holbein now pulled in. The one man who he knew had access to all the courts of Europe was, of course, Erasmus. Holbein clearly felt a request for letters of introduction for him might be seen as presumptuous. Ever the politician, he called on the services of his good friend Bonifacius Amerbach to approach Erasmus on his behalf. A few years later Erasmus would remember the moment when Amerbach made the request, pointing out to the latter that Holbein knew well 'you are the only person that I cannot ever refuse'.

Once his arm had been twisted, Erasmus was in fact generous in the arrangements he made on Holbein's behalf. Such was his web of connection that he produced helpful introductory notes for those who could accommodate Holbein's journey en route to the port of Antwerp, where he would cross to London. In truth, Holbein's trip provided Erasmus, a former citizen of Louvain, with a useful opportunity to courier letters and messages to his friends and associates en route. Holbein surely sailed north up the Rhine to Cologne, before heading west to Louvain and ultimately Antwerp.

* The tensions in the piece may well have been further exaggerated by what was clearly its long period of creative gestation. It is a brilliant example of how Holbein worked with his clients, adapting his work at their request. Meyer evidently kept changing his mind. X-ray analysis of the painting reveals how Holbein 'aged' Anna, Meyer's daughter, painting over hair he had initially shown long and loose and tidying it up under a hat as appropriate for a girl of marriageable age. He also added the figure of Meyer's first wife, who had died in 1511. In doing so the work moves again from being the intended Madonna of Mercy, to an epitaph for the Meyer family. Meyer must have had a premonition – by 1531 he was dead, aged just forty-nine.

One of Erasmus's colleagues based in Louvain was his friend and financial agent, Conrad Wackers, also known as Goclenius. He would write in due course that he was 'so friendly with Holbein that I can get anything I want from him',[6] suggesting that the two must have met and spent time together – quite possibly in this instance.

Meanwhile, Holbein's letter of introduction from Erasmus to his friend Pieter Gillis still exists. Known as Petrus Aegidius, Gillis lived in Antwerp, where he was a well-heeled town clerk and editor for the esteemed publisher Dirk Martens. He had also acted as an agent for Erasmus over the years. Erasmus's tone in his letter is conscious of his imposition on his friend. Gillis had only just lost his wife of twelve years and was left as the sole parent to eight young children; no wonder Erasmus was keen to persuade Gillis that Holbein's stay need not be inconvenient. 'The bearer of this letter is the man who painted my portrait. I don't want to bother you with a recital of his merits, but he is a distinguished artist.'[7] He suggested that if Holbein should want to 'see Quentin and you are too busy to take him, a servant can easily show him the way to his [Quentin's] house'.

'The fine arts are perishing here,' Erasmus continued, 'he's going to England to gather up some "angels": he'll take any letters you want (sent there).'

The reference to 'angels' was another Erasmus pun. On the one hand it refers to potential benefactors, on the other it alludes to the English currency, where an angel was the name for a 10 shilling piece. Meanwhile, the allusion to 'Quentin' is of course to Quentin Metsys, who had painted Erasmus and Gillis in that double portrait that was sent to their mutual friend Sir Thomas More in England a decade earlier.

Metsys, now turning sixty, was the most celebrated artist in Antwerp, known for his stunning portraits, satirical scenes and devotional work. Dürer had paid homage to him in 1520 and Holbein was clearly keen to follow suit.

Metsys was one of that new breed of artist who had managed to achieve an elevated social position in Antwerp society, despite his background as a crafts guild member, and being the son of a blacksmith. He now lived in considerable splendour in 'St Quentin's house', a property that was considered an Antwerp landmark on Schuttershofstraat, a street today packed with luxury fashion boutiques. St

Quentin's house had an impressive gate surmounted by the saint and namesake of the occupant. Inside his prestige property Metsys had commissioned Italianate decorative friezes in grisaille replete with grotesques, festoons and prancing putti.[8] This was a far cry from the house Holbein had grown up in in Augsburg.

On the day Holbein visited, he might just have been lucky enough to see an *Adoration of the Magi* in the workshop that Metsys shared with two of his sons (he had a total of thirteen children!). One such is dated to 1526 in Metsys's own hand. If Holbein's patrons in Basel were becoming nervous of showing their Catholic sympathies or displaying their abundant wealth, the same could not be said for Metsys's patrons in Antwerp, as this deeply Catholic and extremely indulgent painting suggests.

The city was one huge commercial nexus, the biggest port in Europe, a celebration of trade in exotic spices, fine quality fabrics, tapestries, ceramics, art, jewellery, diamonds and books. A vast number of its 100,000 residents were wealthy merchants and ostentation was de rigueur. This was a city of excess, money and business where the wave of Protestantism, with its scorn for show, was firmly held at bay.

Metsys's depiction of the Magi mirrored his clients' taste for opulence; his ancient kings are clothed in sumptuous embroidered garments, carrying exquisitely worked golden vessels. Even the humble stable in which they discover Mary is embellished with lavish Renaissance motif.

Beneath this splendour, Antwerp was also a city of secrets. It enjoyed a level of tolerance for freedom of expression and new thinking that Basel had just lost. The busy port had become a haven for underground literature; the merchant ships docking there regularly used to smuggle evangelical literature across to England, either hidden within the unbound pages of books in barrels, or slid inside bales of cloth. In the very year Holbein passed through the port, William Tyndale, an English scholar and preacher who had begun a mission to translate the Bible from the Greek and Hebrew version into English, an act at this stage punishable by death in England, had found refuge in Antwerp in the home of a sympathetic merchant, Thomas Poyntz, who lived at the appropriately named English House in the city.

Holbein clearly loved Antwerp. No wonder. It was not just Metsys's house that would have encouraged an artist fleeing from imminent

poverty. The Gillis house, De Spiegel, also spoke of opportunity. It too was extremely large and comfortable. Both Erasmus and Sir Thomas More had enjoyed Gillis's hospitality here, and it was his conversations with Pieter in the garden at De Spiegel that had encouraged More to write *Utopia*. The house still stands, just on the city's main square, close to the city hall and main guild halls. Gillis's father, on buying the house, had constructed a panorama tower – an octagonal lookout that pierced the roof and gave a view over the city and port. From here the bustle of expensively clad merchants and busy daily markets would have provided Holbein with plenty of food for thought. Here was a ready clientele. Holbein would have been able to see money everywhere.

Meanwhile, news coming across from London was that a violent bout of bubonic plague that had hit the city in 1525 was still lingering. Consequently Holbein stayed longer than anticipated in Antwerp, a fact that Erasmus would grumble about in due course: 'He delayed more than a month in Antwerp and would have stayed longer if he had found fools there.'[9] The implication is that rather than moving quickly to England as anticipated, Holbein began to look for patronage among Antwerp's wealthy populace (referred to by Erasmus as fools). A Holbein sketch in the Royal Collection at Windsor Castle dated to around 1526 depicts a woman wearing a headdress identical to those depicted by Quentin Metsys and other Antwerp-based painters such as Joos van Cleve in their portraits of their townswomen. This drawing alone suggests that Holbein did indeed find some 'fools' in the city. In fact the woman in question bears some resemblance to van Cleve's portrait of Margaretha Boghe.[10] Both have blonde hair, the fullness and shape of the lower lip is consistent, the outline of the nose, long and straight with a squarish end, is similar, as is a slight double chin.

Hans Holbein, Portrait of an Unidentified Woman, black and coloured chalk on paper, c.1526.

Boghe was married to the one-time goldsmith, dealer in tapestries and luxury goods, and art collector Joris (or Georges) Vezeleer. Vezeleer would soon become a major supplier of fine tapestry to Francis I. Whether Boghe or not, the woman must have nevertheless belonged to a wealthy mercantile community that Holbein was keen to seek out.

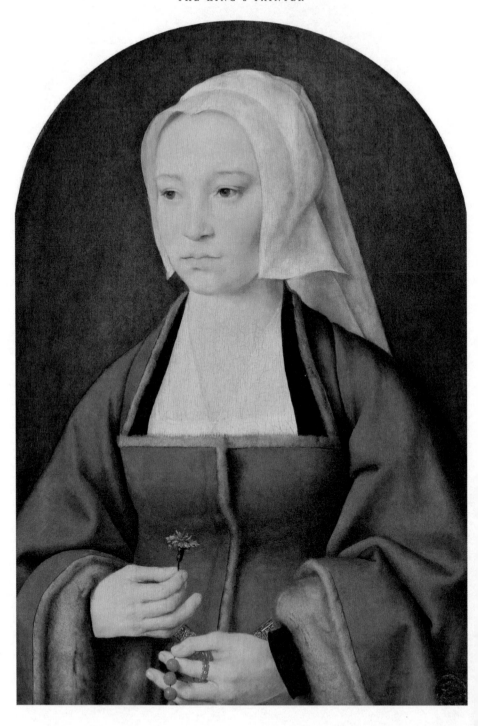

But despite its attractive clientele, Antwerp had no court. London did. Finally Holbein put to sea as originally planned. He arrived in the English capital in the late autumn.

London was a city of about 70,000 at this time; not quite as big as Antwerp. It had a reputation for being crammed, busy and damp, a fast-growing population still largely contained within the ancient city walls. With just one bridge linking the north and south banks of the Thames, the river itself was a busy thoroughfare, though the penny wherry was still relatively costly for the average man. Meanwhile London Bridge, teetering with houses and shops, was rammed with vehicular and pedestrian traffic slowly pushing its way under the overhead timbered jetties.

The city was more colourful and decorated than at any other time in its history. Still traditionally Catholic, its narrow winding streets were adorned with little niches where polychrome devotional statuary drew attention from passersby. Among those who would pay their respects as they made their daily route were the 'London wives who [...] pray before the image of the Virgin Mother of God which stands near the Tower.'[11]

Meanwhile the churches and chapels benefitted from yet more colourful statuary, often adorned with trinkets. The pillars and ceilings of London's religious buildings, sometimes ornately carved, were also painted and frequently gilded – while the walls offered murals of saints and scenes from the Bible. The city was one of symbols and devices. Brightly painted wooden signs creaked over doorways and alleyways, directing the majority illiterate to their destination. Guild halls and public chambers were also adorned. Even taverns benefitted from painted and stained cloths hung on their walls, while banners and flags flapped in streets and squares. Meanwhile the London homes of England's aristocracy displayed coats of arms and heraldic devices, were decorated with murals or hung with tapestries, and made sure their considerable households sported their bright liveries.

Despite this riot of creative energy and such a rich visual environment, England was still considered culturally backward by its European counterparts, who also tended to characterize the English as boorish. The goldsmith and sculptor Benvenuto Cellini famously refused to cross the Channel, wary of 'such beasts as the English',[12] who were

Joos van Cleve,
Margarethe Boghe,
oil on panel, *c*.1518.

also characterized as having an unpleasant insularity, and a general antipathy for foreigners.[13]

When Henry VIII came to the throne he had been determined to alter this perception of his country. He had been acutely aware of the superior grandeur of the French and imperial courts and was keen to develop his court's cultural credentials, and offer a display of magnificence that could match his counterparts. To do so he had to import talent that was not evident at home.

The Tudor court placed huge value on material objects to express magnificence. It was the cumulative effect of overtly precious property that created the grandeur Henry craved. And the utility of already precious objects added to their value. In this way finely wrought tableware, weaponry, clothes and textiles, and items such as clocks, had far greater 'artistic' worth than today.

Not surprisingly, given this system of value, Henry's initial investment was less in painting and more in other luxury goods. He became an avid importer of beautiful objects – particularly textiles, expanding his father's collection of 400 tapestries to 2,000. But crucially he also set up royal workshops where foreigners – or 'strangers', as they were known – could work exempt from London's rigid guild rules. In his book on 'Limning' or 'Painting' Nicholas Hilliard, the English painter who would succeed Holbein as the darling of the Tudor court, remembered that Henry was 'a Prince of exquisite Jugement: and Royall bounty, soe that of cuning Stranger even the best resorted unto him, and removed from other courts to his'.[14]

One of the first such workshops Henry established produced armour. Obsessed with chivalry and courtly tradition, Henry had been raised on the idea of the Noble Knight, an heroic figure with a specific code of behaviour. In this respect he was much akin to the older Emperor Maximilian, who had also enjoyed being seen through this chivalric lens. Henry had long admired the beautiful tournament armour that Maximilian had invested in to achieve the best possible spectacle for his subjects. When Henry acceded to the throne in 1509 and married Katherine of Aragon, the emperor sent the new king and husband a magnificent set of gilded horse armour. This astonishing piece of work was covered with ornately curling leaves and pomegranate fruits (the pomegranate was the device of Henry's new queen) embossed in high relief. Small details were added

by engraving and then the whole piece had been silvered, with some elements highlighted in gilt.

Henry was so inspired by the workmanship and literal brilliance of this gift that in 1511 he set up his own armoury at his palace in Greenwich, which he hoped would quickly match the skill and invention of the imperial workshops. Maximilian used German metalworkers, with his favourite city, Augsburg, a key supplier. By the time Holbein arrived in London, Henry's Greenwich armoury had such a significant number of German metalworkers, it was known as his Almain workshop.

Another crown workshop, based at Richmond, produced illumination – high-quality miniature illustration to manuscripts and books. Meanwhile the king also employed foreign glaziers to produce decorative glass for his many homes and palaces, under the supervision of the wonderfully named Dutchman, Galyon Hone.

But in terms of what today would be termed fine arts, Henry's initial interest was in sculpture rather than painting. The very first commissions Henry oversaw after the death of both his father Henry VII and his grandmother Lady Margaret Beaufort in 1509 were tombs. For these he sourced, probably with the help of the art aficionado Cardinal Wolsey, the Italian Pietro Torrigiano.

If many other celebrated sculptors turned their noses up at working in England, there was good reason why Torrigiano might welcome the opportunity to step outside the continent. A Florentine contemporary of Michelangelo, he was known for both his talent and his atrocious behaviour. In fact it was Torrigiano who punched Michelangelo and delivered the broken nose that would come to define the artist.

Torrigiano had had to resort to becoming a mercenary before Henry's scouts encouraged him to England. What he brought as early as 1509 – the same moment when Jacob Fugger was planning his Renaissance chapel in Augsburg – was a keen interest in verisimilitude in portraiture and a strong sense of classical decoration and design. With Torrigiano, the Renaissance of England's visual arts began.

The tomb portraits of both Beaufort and her son were based on their death masks, thus assuring a persuasive likeness. But it is the design around the compelling image of Henry VII in which Torrigiano also makes his mark. He depicts four angels at each corner of the tomb, a delightful playfulness in their feet dangling from its edge. The

sarcophagus itself is decorated with putti, Renaissance pilasters and medallions featuring patron saints.

Not to be left out, Cardinal Wolsey secured Florentine sculptors for his own commissions. At Wolsey's residence, Hampton Court, Giovanni da Maiano, an expert in polychrome terracotta work, delivered eight beautifully coloured and gilded classical medallions featuring the heads of Roman emperors that were set into the palace walls. Da Maiano was also teamed with another Florentine sculptor, Benedetto da Rovezzano, to design Wolsey's mausoleum. Holbein could easily have seen the four crouching bronze angels that da Rovezzano realized as magnificent candelabra for the tomb.

As for those expert in *painting*, the field was fairly wide open for Holbein. The king did have court painters, and the position of Serjeant Painter was created by Henry not long after his accession to the throne and awarded to the Englishman John Browne. But what is clear is that Browne's job was to provide the visual material for Henrician diplomatic theatre, rather than make what were known as 'tables' – standalone paintings on wood or canvas to hang in rooms or picture galleries. John Browne was responsible for overseeing decorative work at Henry's various palaces, the production of banners and heraldic devices and importantly the visual material for pageantry at diplomatic events. In fact it was Browne who had been in part responsible for Henry's most famous piece of diplomatic theatre, the Field of the Cloth of Gold, in 1520 (more of which later). He also painted the flags for Henry's battleship *The Great Harry* and standards that the English would carry to war on the continent in 1523.

Yet again, however, it was immigrant artists who worked alongside Browne, and their familiarity with 'antique' motifs that had been deployed in Italy long before they had become fashionable in England was no doubt extremely useful. Vincenzo Volpe, originally from Naples, was part of Browne's team, also tasked with painting targets, streamers, maps and heraldry.[15] But these men were a long stretch from displaying the ingenuity that Holbein did in his interpretation of Renaissance motif. John Browne and his team were following fashion, while Holbein had been setting it in his delightful designs for Froben and the other Basel publishers, in his stained glass work and impressive murals.

What is more, Browne and his team were not portrait painters.* It wasn't until 1525, just months before Holbein arrived in England, that Henry employed a painter for this specific requirement. Lucas Horenbout, a Flemish painter of portrait miniatures, was hired as 'pictor maker' in what was a response to the work that Jean Clouet was making for Francis in France.

Ever since 1513, when Henry had waged war with France alongside Maximilian I whom he so admired, he had developed a passion for French style. Henry and his imperial ally had laid siege to the French town of Therouanne and routed the French at the Battle of the Spurs. Henry's exposure to France during this period inspired a new admiration for French fashion and culture, and also a desire to keep up with it. So when in 1526 Marguerite of Angoulême sent Henry portrait miniatures of Francis I's hostage sons painted by Jean Clouet, Henry was able to return the gesture and send her his own portrait miniature by Horenbout.

Despite their king's enthusiasm, Londoners' attitudes towards incomers such as Holbein remained potentially hostile. Every May Day after the riots of 1517, foreigners in the capital would remain indoors, just in case. But despite the resentment of some, others understood the value of their continental counterparts. Nicholas Hilliard was clear in his opinion. Among those seeking fortune in England 'came the most excellent painter and limner Haunce Holbean, the greatest Master truly in both these arts afer the liffe that ever was, so cuning in both to gether, and the neatest, and theerwithall a good inventor soe compleat for all three, as I never hard of any better than hee'.[16]

It is testimony to his stand-out brilliance that, much as he had done in Basel and Lucerne, Holbein made an immediate impact on his arrival in London. This was an artist whose work was so unusually impressive, of such novelty and quality, that he could not fail to get noticed. However, he was still particularly fortunate to find his very first port of call was with a man who had by now become one of England's most cultured and influential men – Sir Thomas More.

* Though there is evidence that Volpe did paint portraits later, providing a portrait of a duke for Henry as a New Year's gift.

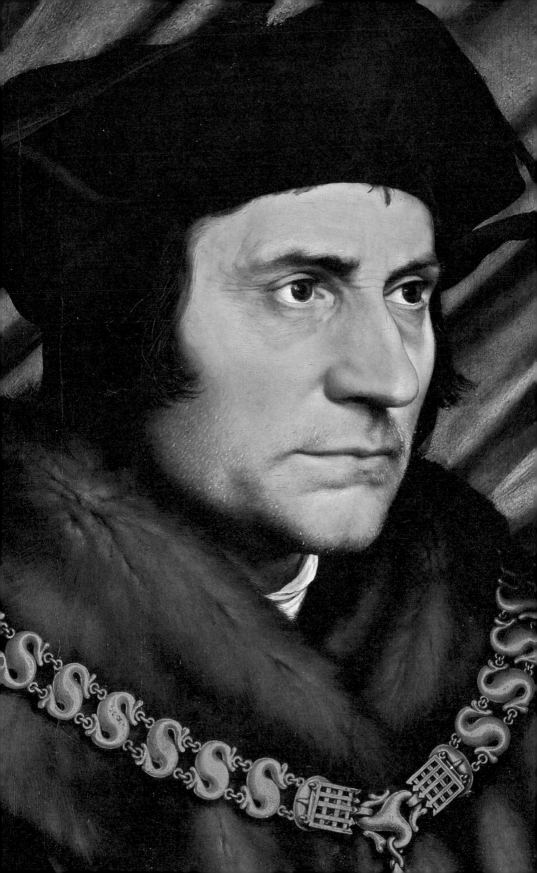

THOMAS

9

On 18 December 1526 Sir Thomas More, who by now had risen to become one of Henry VIII's most trusted advisors on the Royal Council, was at the king's palace at Greenwich. Amid his duties he found time to write to Erasmus and inform him that Holbein had finally landed safely in his colourful and complex land. 'Your painter friend, my dear Erasmus, is a wonderful artist,' he declared.[1]

It was not so far from Greenwich where, at the smaller palace at Eltham, More and Erasmus had cemented their friendship a quarter of a century earlier. More was then a mere law student at Lincoln's Inn. Erasmus was a tutor based in Paris, and they had encountered a young Prince Henry. From this moment a strong and intimate friendship began between the two older men, along with a shared affection for Henry, who would unexpectedly become his father's heir.

Since this meeting Erasmus had enjoyed a spectacular rise, but in some ways More was his complement in England. He shared Erasmus's dry and persistent wit and sense of humour. Like Erasmus he was a leading humanist author, with his *Utopia* in wide circulation. But whereas Erasmus had never veered from writing and study, More had combined literary pursuits and his academic interests with a legal career, then a parliamentary one. A former undersheriff of London (who had to deal with those May Day riots); a member of Parliament, the Speaker thereof, a diplomat and ambassador, and now part of the King's Council, he had become an extremely high-profile politician.

Hans Holbein,
Sir Thomas More,
oil on oak, 1527.

Whereas Erasmus had been careful in his response to Lutheranism, More was not so squeamish. As his public duties had grown, so too had his belief in the necessity to protect the Catholic faith at any cost. That meant stemming the influx of Lutheran material from the continent and making example of those distributing it.

More could display a real degree of cruelty as part of his public duty that seems at odds with other descriptions of him as gentle and kind in private. In 1525 More had the Steelyard in London raided on suspicion that its inhabitants were harbouring Lutheran literature. The Steelyard was a gated community where German merchants, members of the Hanseatic League, lived and worked. To the horror of the league's members, several of them were arrested, and though they

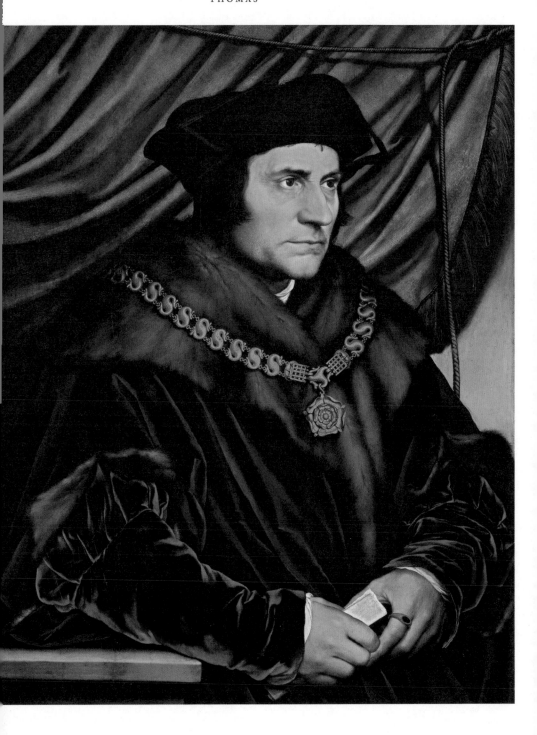

were spared from being burned as heretics, they were eventually led through London sitting backwards on donkeys, faggots strapped to their backs, in a humiliating warning. It was a measure that did little to improve the city's continuing resentment of foreigners working there.

Not surprisingly then, despite his German origins, Holbein seems to have given the Hanseatic community a wide berth on his first arrival in London in October or November 1526. Instead he went straight to More, who immediately gave him lodgings in his own household.

Sir Thomas and his family had only relatively recently moved to a huge estate at Chelsea, on the banks of the Thames, where there was plenty of room, and where, with work still going on around them, there was some perspicacity in having an artist join the already large household. Only two years earlier More had bought up parcels of land and existing buildings that combined to create substantial grounds with a riverfront. Initially using one of the existing properties close to the Thames as a main house, More began work on what the family would call the 'New Building', a classically inspired mansion set back from the river, which included in its eastern wing More's extensive library, a fashionable long gallery where pictures could be hung, and also a private chapel. The devout Catholic, who was known to wear a hair shirt, also invested in a family chapel in the nearby local church, which still stands today and is known as Chelsea Old Church.

More created magical gardens around his new property. A large, formal walled knot garden to the north led into orchards and meadows stretching towards the distant hills, where the outline of the village of Kensington could just be made out. In what would become recognized as one of the most beautiful gardens in England's Renaissance era, More's intellectual and physical worlds aligned. A menagerie of animals that included birds, a monkey, a fox, a weasel, and a ferret was housed there, providing not only entertainment but also a reminder of a wider animal kingdom. The vast array of flora, which included irises, lilies, gillyflowers and sweet cabbage roses, took on a personal symbolism. A mulberry tree was planted because its Latin name is Morus. Rosemary was allowed to grow wild along the paths because More enjoyed the herb's symbolic association with friendship and remembrance.

More's friendship would serve Holbein particularly well. Asked to paint a portrait of More in words in 1519, Erasmus was very clear in his

view of More's sense of responsibility to others. 'Friendship he seems born and designed for; no one is more open-hearted in making friends or more tenacious in keeping them,' Erasmus wrote.

> Besides which, though somewhat negligent in his own affairs, no one could take more trouble in furthering the business of his friends. In a word, whoever desires a perfect example of true friendship, will seek it nowehere to better purpose than in More [...]
>
> In fact his household seems to enjoy a sort of natural felicity, for no one has ever been a member of it without bettering his fortune later [...] Whatever power his station gives him, whatever his influence can do with so powerful a king, is all devoted to the good of the commonwealth and of his friends. His disposition was always most ready to do good unto all men [...] Some men he helps with money, to some he gives the protection of his authority, others he advances in life by his recommendation. Those whom he cannot help in any other way, he aids with good advice.[2]

While some, in particular members of the Steelyard who had been punished by More, may not have recognized such a generous description of him, those in his immediate circle benefitted from his enthusiasm for learning and debate. The More house was more than just a building, it was a way of life, and its patriarch gathered around him not just immediate family, but an extended one in a kind of humanist 'academy'. More had made a point of educating his daughters and female wards to an exceptional degree. They would become acknowledged as pioneering translators, physicians and mathematicians. Their erudition, exceptional at the time, was already well acknowledged by Erasmus, who had a particular admiration for Thomas's eldest daughter Margaret Roper, to whom he wrote warmly.

When Holbein set foot in the More household he would have therefore encountered a constant to and fro of the 'academy' members. First, More's three married daughters, Margaret Roper, Cecily Heron and Elizabeth Dauncey and their respective husbands. Then his son John, who would marry More's ward Anne Cresacre only months after Holbein's arrival. Another ward, Margaret Giggs, had just married the family classics tutor, John Clement. Meanwhile another young woman who had been educated in the household, Margaret à Barrow, had married Sir Thomas Elyot. Then there was More's sister Elizabeth and her husband John Rastell. There was More's secretary John Harris,

and his professional fool Henry Paterson. Finally Nicolaus Kratzer, a mathematician, astronomer, map maker and horologist who tutored the family while also serving as the king's astronomer. Kratzer came from Munich – not so far from Augsburg – and as a compatriot must have been a helpful German speaker for Holbein, should his Latin fail him and as he got to grips with English. The two would become firm friends.

As Ellis Heywood, More's great nephew, would record in due course, this group of erudite, modern-thinking folk 'took delight in subtle discussions of the essential concerns of human life, and, since all participants were intelligent and well educated, each derived great benefit and satisfaction.'[3]

More was already enthusiastic about painting by the standards of the day. His friends Erasmus and Pieter Gillis, who in 1517 sent him their portraits by Quentin Metsys, would scarcely have wasted such a gesture. There were clearly other works in his home and chapels. In the early 1520s correspondence with the Bruges-based humanist Frans van Cranevelt reveals that More exploited his ambassadorial trips overseas to acquire art, in this instance a *Madonna* from a Bruges-based artist.[4] And by the time More was imprisoned in the Tower of London his collection included an *Adoration of the Magi* and a *St John the Baptist*, which he sent to his friend and fellow prisoner Bishop Fisher for contemplation.[5]

However, More was aware that he was the exception rather than the rule, and that the appreciation of painting was less developed in England than elsewhere.

Of course among the intellectual elite there were men and women for whom painting was an interest. Nevertheless, in 1531 the writer and intellectual Sir Thomas Elyot, the very same married to More's ward Margaret à Barrow, still felt the need to encourage England's power brokers to look to art, when he wrote a handbook for men of state, *The Boke named the Governour*. Bemoaning the lack of interest in the visual arts in England, Elyot stated that the appreciation of painting and drawing should be prerequisite for any gentleman. Importing continental ideas and citing classical precedent, he even suggests the potential superiority of visual art over the written or spoken word, suggesting, 'And where the lively spirite, and that whiche is called the grace of the thynge, is perfectly expressed, that thinge more

persuadeth and stereth the beholder, and soner instructeth hym, than the declaration in writynge or speakynge doth the reader or hearer'.[6]

If Elyot's readers found themselves wondering how they might possibly follow his recommendations, Hans Holbein's arrival in London changed everything. Suddenly there was an artist available to the country's elite who could claim a level of accomplishment in perspective and observation that was not just on a par with the most celebrated artists on the continent, but superior to them. In fact seeing Holbein at work in the More household could not have failed to inform Elyot's views. Hardly surprising then that Elyot secured portraits of both himself and his wife from Holbein. In a moment when science and art were yet to suffer their separation, Holbein was a human lens.

Nevertheless, five years before the publication of Elyot's book, More worried that London's streets might not be paved with the gold that Holbein so badly craved. 'I fear he will not find England the rich and fertile land he hoped,' he told Erasmus, 'however, lest he find it quite barren, I shall do what I can.'[7]

True to his word to do what he could, More set Holbein to work on a portrait of himself. For the first time ever Holbein would find himself preparing English oak for the task – having always worked on fir or limewood in Basel. His painting of More is in the Frick Collection in New York, and shows a statesman wearing his gold chain of office, the links in the shape of an S, from which hangs a golden Tudor rose. The chain was a mark of loyalty and bondage to the sovereign, its esses standing for 'souvent me souvien' or 'remember me often'.

The work is an essay in simultaneous simplicity and detail, of understatement and yet penetrating observation. More sits in front of a green curtain; a plain wall is glimpsed behind; his arm rests on a plain wooden table and in his hand he holds a folded piece of paper. Yet Holbein delivers this modest arrangement with a new level of executional skill. The curtain has fold upon fold, brilliantly depicted, while its tassels and the ropes that tie it to one side are visible and all rendered with minute definition. The satin of More's gown gleams and the red velvet of his creased sleeves only need to be looked at to be felt, as does the fur of his collar.

Fur would become a hallmark of Holbein's portraits. In an era when the type of fur one could wear was governed by sumptuary law,

the importance of being able to convincingly convey sable, ermine or lynx was of particular importance. And in his portrait of More, Holbein shows the politician wearing a huge sable collar, the varying shades of colour ranging from pale caramel to deep toffee brown, and the length of the hairs indicated by the manner in which they part as the pelt is folded.

Further details are delivered in the grain of the wooden table, the stubble of More's beard, which is a mix of grey and dark hair; even the few strands of hair that he has failed to conceal under his black hat and which creep onto his forehead.

It is likely that More envisaged commissioning a series of portraits from Holbein, just as Erasmus had done. Like Erasmus, More could present his image as a gift to friends, family and to those with whom he wanted to cement his status. A later inventory of the home of John and Margaret Clement revealed that in the study they kept 'a table of Sir Thomas More's Face' which could well have been one in such a series. Its attribution to Holbein is suggested by the exceptional value of £40 ascribed to it.[8]

The other swift commission that More bestowed on his new lodger was a religious piece: that *Noli Me Tangere*, informed stylistically by those works Holbein had seen in Francis I's collection in the Loire. The evidence that this was painted for More rests in part in the fact that by 1540 it was in Henry VIII's collection, and it is widely presumed that it was seized by the king at the point of More's attainder. Given its scale – 77 × 95 cm – it would have sat well in More's private chapel in the New Building.

Holbein's *Noli Me Tangere* is untypical, once again evidencing the painter's instinct to innovate, but also suggesting a client with sufficient intellectual independence to commission a deviation from the norm. The scene is based on a passage in the Gospel of St John where the text describes Mary Magdalene visiting Jesus' tomb to anoint his body, and instead finding two angels sitting inside it next to his empty shroud. As Mary, distressed, asks where the body of Christ has gone, she turns and sees a man whom she does not recognize and supposes to be a gardener. This figure is in fact Christ, who, on uttering her name, she recognizes. About to reach out to touch him, he urges her not to do so since he has not yet ascended to his Father, but instead he urges her to go and tell the disciples what she has seen.

Depictions of this scene had been popular across Europe since the medieval period and traditionally featured Mary Magdalene kneeling at Christ's feet with Jesus standing, spade or hoe in hand. Certainly both these elements feature in the composition by Fra Bartolomeo that was in the collection of Francis I.

However, in Holbein's version Mary is standing, not kneeling, and Christ is not carrying a spade. Meanwhile, whereas Fra Bartolomeo described Jesus' tomb with the earlier event of two sleeping soldiers by it, thus presenting different time periods as one reads the painting from left to right, Holbein shows two angelic figures bathed in light inside the tomb.

Mary is not kneeling in Holbein's version, since there is nothing in the actual text to suggest she did. Nor is there need for Christ to carry a spade – after all, the text says Mary mistook him for a gardener, not that he was dressed as one. Such close adherence to the text in John's Gospel not only suggests a scholarly client with particular views, but provides the painting with dynamic energy. In framing a single moment in time and place, Holbein delivers a narrative drama. Mary is shown in the moment after she has realized she has encountered a risen Christ, with Christ stepping backward to avoid her touch, his hands raised in a gesture of prevention.[9]

More had other opportunities to offer Holbein. With so much building work underway, the artist could design decorative elements in both the New Building and also in the family chapel at Chelsea Old Church. While the home More built is long gone, and descriptions of it slight, *The London Survey* notes that a pair of capitals in Chelsea Old Church may have been designed by Holbein during his stay. Still visible, they are much damaged. Nevertheless they display an abundant invention. Each capital is five sided and the visual conceit is that objects relating to the More family are nailed to each side with a ribbon. On the easternmost capital winged cherub heads look down on dangling secular objects, such as the More family coat of arms. To the west are trappings of religion: a bundle of tapers, a pair of candlesticks, a pail of holy water and a prayer book are all secured with curling ribbons tied in bows. These are surmounted by human heads. The objects are framed by intense, curling acanthus leaves, which spill out beyond the confines of the capital and stretch out across the chapel wall at each extremity. All the heads are twisting in different

directions, with beards and hair blowing in imaginary winds to give the composition a vital dynamic energy.[10]

But the most significant commission by far that Sir Thomas More bestowed on his new German visitor was that large-scale portrait of himself and his family, undoubtedly envisaged as a talking point for his new home, as well as, perhaps, a celebration for his fiftieth birthday – which fell on 7 February 1528. Where the idea came from we can never know, but it is worth remembering Holbein's admiration and frequent reference to Mantegna. The fact that the latter had painted a mural in the Ducal Palace in Mantua depicting Ludovico Gonzaga and his family may well have served as inspiration for the project.

The scale of Holbein's conception was huge, and apart from his vast murals on the exterior of houses, and those in the council chamber at Basel, at an estimated 249 × 343 cm[11] it is the largest known freestanding painting he had attempted to date. Indeed its size informed Holbein's need to paint on canvas rather than wood. It was intended as a massive trompe l'oeil that would give the illusion of

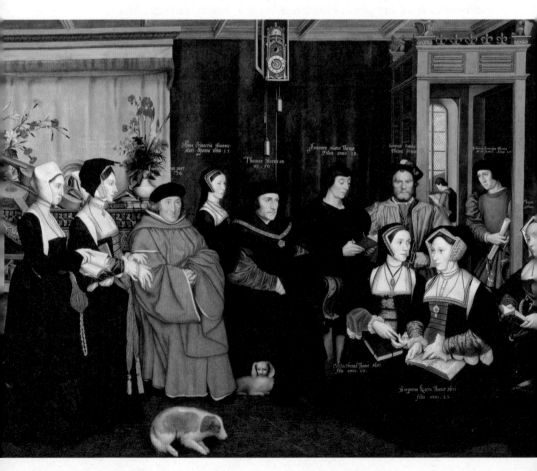

extending the room in which it was hung, in order to present the family, life size, to visitors.

In a world where portraiture was such a novelty, one has to ask: what version of his family did More want to present? Like Erasmus, More's levity was so ingrained in his character that the Tudor chronicler Edward Hall wrote that 'I know not if I should call him a foolishe wyseman or a wyse foolishman, for undoubtedly he beside his learnyng had a great witte, but it was so mingled with taunting and mocking that it semed to them that best knew him that he thought nothing to be wel spoken except he had ministered some mock in communication.'[12] Erasmus also noted of More, how 'in his youth he wrote brief comedies and acted in them. Any remark with more wit in it than ordinary always gave him pleasure [...] In fact, there is nothing in human life to which he cannot look for entertainment, even in most serious moments.'[13]

With this description of More's character, there can be little doubt that within this large group portrait some doublespeak and foolery was intended.

Since the original portrait was destroyed in the eighteenth century an extant preparatory drawing, along with a version commissioned by More's grandson Thomas Roper from the painter Rowland Lockey more than half a century later, are the keys to imagining the original. Holbein's drawing reveals the family, and key members of the 'academy', gathered for one of those conversations described by Heywood. They are about to talk about literature, and books are to hand. Reading the drawing from left to right, Holbein shows Elizabeth Dauncey, just arrived, her book slipped under her arm while she removes her gloves. Next to her stands Margaret Giggs, leaning over, book in hand, to discuss a passage with a seated John More. This is Sir Thomas's elderly father, who resolutely fails to pay attention to the woman at his shoulder. Sir Thomas sits next to his father, in the centre of the composition, and he too seems disengaged from the group, his eyes looking off into a mid distance. Holbein portrays More once again wearing his gold chain of office and his father is in his red lawyers' robes. Between the family patriarchs the head and shoulders of Anne Cresacre can be seen. Anne's fiancée John More

Rowland Lockey, copy/ adaptation of *Sir Thomas More and his Family* by Hans Holbein, oil on canvas, 1592.

overleaf
Hans Holbein, *The Family of Sir Thomas More*, ink over a chalk sketch, on paper, 1527.

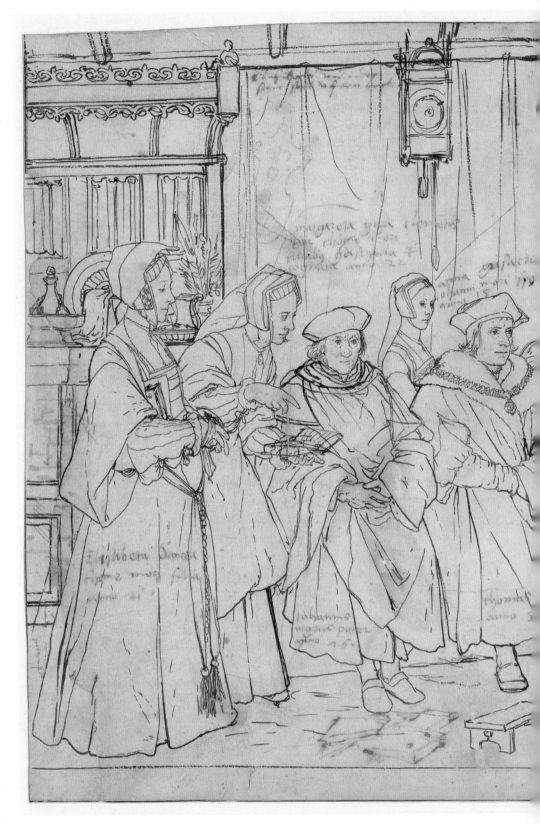

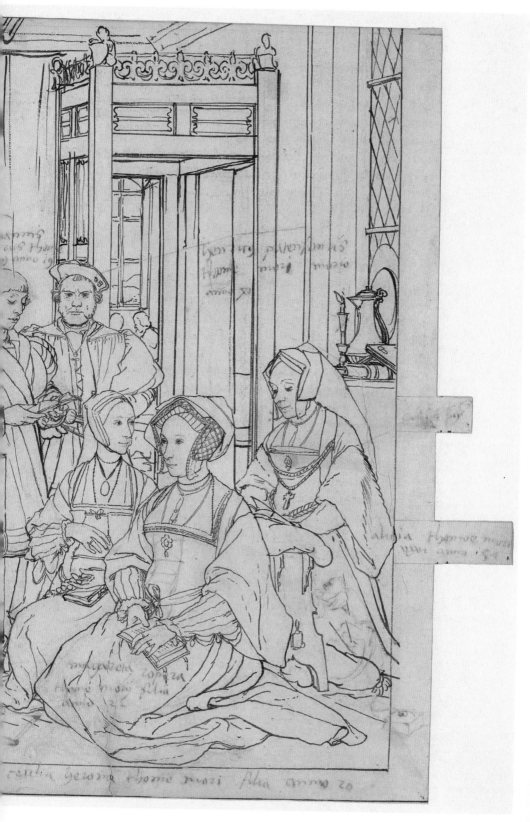

(the younger) with his distinctive drooping eye is next, absorbed in his book. More's fool Henry Paterson stands next to young John, the only figure positioned face on and staring out of the painting, directly engaging the viewer. Kneeling on the floor are Cecily Heron, Margaret Roper and finally Thomas More's second wife Alice Middleton. Cecily and Margaret have their books too, the former distracted and turning from the group, possibly to attract the attention of Alice, who kneels at a lectern and is already too absorbed in her literature to notice. Margaret Roper's book is open, her hands resting on the text, paused as if she is waiting for the group to settle down.

Behind the group is a domestic interior, a buffet on the left on which there is a large plate, some jugs and food. Then a curtain covers a large portion of the back wall, in front of which hangs a clock. To the right, carved panelling frames two doorways, one into an office where two figures can be seen hunched over their work. Also to the right is a leaded window, on the sill of which stand a candle, jug and some books.

There are some notes on the drawing which indicate changes to be made to the final work. Musical instruments need to be included on the buffet, reflecting the family's love of music. The candle to the right is not needed. But a monkey on a chain should be inserted next to Alice, who should sit rather than kneel. A pile of books is suggested on the floor – these are surely for Sir Thomas and his father, neither of whom have a book in hand yet.

The Lockey copy reflects these changes, but has other differences. Now two little dogs are at More's feet, vases of cut flowers are abundant on the window sill and buffet, and the latter has been concealed beneath a 'Holbein carpet', though this is rucked up by an open cupboard door, which reveals some items inside. More's secretary John Harris has been included to the right, coming through a doorway. Margaret Giggs and Elizabeth Dauncey have swapped places. The rosary around Cecily Heron's wrist has vanished.* And the reading material has been identified as Seneca's *Oedipus*, whereas in the drawing

* The removal of the rosary may have been an amendment made in the Lockey era, by which time England had become determinedly Protestant and the Catholic More and Roper families may not have wanted to draw further attention to their religious orientation. Frank Mitjens has also suggested that what appeared as prayer books in the original were modified into Seneca.

the family were holding what were probably intended to be understood as prayer books.

The group portrait of Sir Thomas More and his family, like so much of Holbein's work, is an exercise in tension. In this instance it explores the conflict between public and private life, with a dose of irony and wit appropriate to its patron.

In Erasmus's description of him, it was well noted that More found the chains of his public office unnecessarily ostentatious. 'Simple clothes please him best,' Erasmus explained,

> and he never wears silk or scarlet or a gold chain, except when it
> is not open to him to lay it aside. He sets surprisingly little store
> by the ceremonies which ordinary men regard as a touchstone of
> good breeding; these he neither demands from other people nore
> tenders meticulously himself either in public assemblies or in private
> parties...[14]

For More, the formalities which accompanied public life were consistent with his idea that life was like a play in which one was required to wear a mask, dress up and adopt a role – particularly when associated with the court, where the regular deployment of pageant, ritual and chivalric codes meant that much of the daily life had a strong fictional element. This view is reflected in one of More's scholarly achievements, a *History of King Richard III*, written in the decade before Holbein arrived in London. Here More notes that

> If thou sholdest perceue that one wer earnestly proud of the wering
> of a gay golden gown, while the lorel playth the lord in a stage playe,
> woldest thou not laugh at his foly, considering that though art very
> sure, that whan the play is done, he shal go walke a knaue in his old
> cote? Now though thinkest thy selfe wyse ynough whyle thou art
> proude in thy players garment, and forgettest that whan thy play is
> done, thou shalt go forth as pore as he.[15]

Why then, if More was so dismissive of pomp and ceremony, would he want to be shown in his official garb in his portrait? One amusing idea might be that More's counterfeit wears his robes of state so that the real More does not have to; in this way More might be able to excuse his informality to his visitors. But there is a more fully developed conceit that he and Holbein devised in the work, one which draws on the idea that in the same way that public life is theatre, so too is a group portrait. As they sit for their likenesses the More

family adopt a pose, creating a *tableau vivant* from which the finished painting can be made. Despite the fact that they are in the privacy of their own home, Holbein portrays More in his grand robes of office, since this is the accepted attire of portraiture. He has had More dress up for the theatrical, staged version of his domestic family life.

Holbein draws attention to this playful idea of painting not the family, but the family in the act of posing, by making it clear that the group is not yet in final position. The patriarchs are both sat in stiff posture, their faces solemn. They have not yet settled on their proposed attitude; their books are still on the floor. Margaret Giggs has already begun enacting her part in the scene, and is pointing out a passage to John More. But the elderly gentleman is slow on the uptake and has yet to turn to her to pretend to be in conversation with her. Meanwhile Elizabeth Dauncey has arrived late and is still removing her gloves, her prop – a book – under her arm, and not yet deployed.

The device of the glove is something that, should Holbein indeed have painted Margaretha Boghe and her husband Joris Vezeleer in Antwerp, he may have borrowed from their earlier portraits by van Cleve. The latter's portrait of Vezeleer from 1518 features the merchant pulling on a glove, as if about to step out of the portrait and go about his business. Given such a feature in portraiture was extremely rare, this may have impressed Holbein sufficiently to encourage him to use the device for his own ends.

The other device Holbein perhaps borrowed was the incorporation of a fool in the group scene. Mantegna's mural of the Gonzaga family also features their fool, a dwarf, who stares out with the same blank expression Holbein gives Paterson. It has been suggested that the incorporation of Paterson heightens the reference to theatre and role playing in the portrait.[16] After all, he is a professional player whose role is to remind his superiors of their fallibility. He, like that garrulous old woman in Erasmus's *In Praise of Folly*, becomes a choric figure, providing a commentary both on the portrait in which he is included, and on life in general.

The monkey at Alice More's feet, a golden chain around its neck, is at one level a reflection of the actual menagerie that More kept. At another level it refers to the Tudor association of apes with foolery and surely invites comparison with More himself, the only other member of the group wearing a chain. The monkey may have also been a

prompt for viewers to recall one of Erasmus's much-cited adages: 'An ape is an Ape though clad in gold', or the popular English rhyme: 'An ape is an ape, a varlet a varlet though clad in silk and scarlet'.

If More's pet monkey was intended as a reminder of human folly, it may have also served to remind members of Henry VIII's court of their status vis à vis the king. Despite his high office, More, like all courtiers of the time, was ultimately a mere pet or puppet, subject to the whim of the king, and set to be pulled hither or thither as the monarch wished.

That the profound message of the painting might be the inability to control one's own destiny is suggested further in the Lockey version. Here the actual text in the book being read by Margaret Roper is legible. Her finger points to a line from Seneca's *Oedipus*: 'Were it mine to fashion fate at my will, I would trim my sails to gentle winds, lest my yards tremble, bent 'neath a heavy blast a gentle, moderate breeze that does not heel the side would guide my untroubled boat.' Who wouldn't want an easy ride in life if one could choose? However, as implicit in the lines, people are in fact powerless to direct their fate. For the More family their futures were in the hands of the king, and ultimately God. For the deeply devout family their solace in a world over which they had so little control is their religion. The trappings of their traditional Catholic faith are clearly visible: a rosary hangs at Margaret Giggs's belt, a crucifix around Alice More's neck.

In a world full of uncertainty, the only reliable fact is that death is inevitable. As a reminder of this Holbein paints a clock hanging ominously over More's head. While passing time is of course applicable to everyone represented, the clock's specific alignment with More, right in the centre of the composition, cannot be avoided. The dog at More's feet, also in line with the timepiece, references the traditional funerary sculpture where men were often shown with their feet resting on a canine companion. In retrospect, the symbolism of the group portrait is rather haunting. It would prove horribly apposite. After all, More's fate was indeed in another's hands, and death was far closer than he could have imagined.

However, for the moment the king displayed particular devotion to More. Henry, whose love of pomp and palaces was always counterpointed with an equal delight in domesticity, was in the habit of visiting More's Chelsea home to enjoy what Erasmus described as

his 'country-house which is dignified and adequate without being so magnificent as to excite envy'.[17] The king and his councillor would walk the grounds together, arm in arm.

Of course no clear record of such a visit from Henry in the winter of 1526 survives. However, what records do reveal is that on 3 January 1527 Holbein most certainly could have glimpsed the monarch from the jetty at More's house. Having jousted during the day, Henry and other members of the court had disguised themselves as shepherds and, wearing beautiful beards made of silver or gold thread, had taken the Royal Barge from Greenwich to Hampton Court, passing Chelsea en route. At Hampton Court, then still the impressive residence of Henry's chief advisor Cardinal Wolsey, an extravagant banquet and entertainment was being staged to welcome the new year. All the most senior diplomats in London were there, with ambassadors from the continental courts.[18] Thomas More would likely have attended.

After a lavish feast Wolsey provided entertainment. Into the dining hall came a woman dressed as Venus, then young, naked boys styled as cupids. They held a silver rope and pulled into the room a cart on which the 'shepherds' now sat. Venus summoned her 'nymphs' to entertain the men and thus began the dancing between the women and men of the court.

The orchestration of such a piece of theatre to ease diplomatic relations was merely the latest in a long tradition of pageant that defined the Henrician court. Today permanence is part of value. One might be prepared to invest in a painting with the expectation that it will remain in one's possession for some considerable time. For Henry, however, the value of splendid events, though transient, was a significant means of conveying his magnificence. As such, pageantry was at the real heart of much of his cultural interest. His love of lavish, novel theatre was both part of court entertainment and diplomatic negotiation.

The latest piece of fancy dress for Wolsey's New Year's celebration was nothing compared to the most lavish spectacle that Henry had staged some seven years earlier. In the spring of 1520 6,000 men had found themselves hard at work in fields between the French town of Ardres and the English town of Guines (part of the English territory of the Pale of Calais). They were constructing what some contemporary commentators would claim was the eighth wonder of the world: the Field of the Cloth of Gold.

After Henry's aggressive campaign against France's Louis XII which had culminated in that battle at Therouanne, Henry had forged a peace with France and had arranged a marriage between his own sister, Mary Tudor, and the defeated French king. In 1520 Henry wanted to display his friendship with Louis's successor Francis I, who had been on the French throne for half a decade by this point, and whose own reputation for magnificence in his palaces in the Loire was causing Henry a degree of envy. Given the castle at Guines was far too modest to sufficiently impress Francis, Henry had decided to construct a temporary palace next to the extant one, of such beauty that it became a legend in its own era.

This temporary palace sat on a huge quadrangular site; a mix of wood, canvas, paint, gold and luxuriant fabrics, it rose up in just three months flat. Only its foundations were brick, with walls, towers and roof made of temporary material. Painters bent over canvas panels to create the illusion of bricks, masonry and slate. There was a gatehouse that appeared to have been constructed in the very latest Renaissance style. It had a decorative scallop-shell pediment in which sat the royal coat of arms. Below this, the tower sported more ornate 'carvings' of festoons and Tudor roses. A golden cupid perched above the gate, peering down on those entering. Meanwhile the palace walls were crenellated and punctuated with pilasters and towers. These were surmounted by statues of men in defensive mode, rocks raised over their heads, ready to be hurled down at those below. Underneath the battlements a gilded classical frieze wrapped the building. Below this, huge arched windows with glazing by Henry's glassmaker Galyon Hone illuminated the interior, while more lights were inserted into a faux roof painted to look like real slate.

The palace was square, and based around a central courtyard. Each of its four sides measured 100 metres in length. One side was dedicated to the king, another to Queen Katherine of Aragon, another housed Mary Tudor, the king's sister, and the last section of the palace held accommodation for Cardinal Wolsey. There was a chapel and a dining hall. The interiors were fitted out with the most luxurious fabrics imaginable, and were painted in the most expensive colours. The chapel, for example, was all blue and gold, its altar laden with a huge gold crucifix, gold statues of the apostles, and some of Henry's exquisite reliquaries. Meanwhile other rooms enjoyed gilded ceilings

and cornices, walls hung with tapestries woven in silver and gold, and floors covered in silks and damasks overlaid with oriental carpets.

Directly in front of the palace two further 'monuments' were erected. At a glance permanent stone structures, these too were in fact artifices that would be swiftly dismantled. One was a column on which stood a golden Bacchus, the other an octagonal fountain flowing with three different types of wine.

Meanwhile at a short distance was a tiltyard, as well as an array of grand marquees in gold and bright colours for further banqueting and entertainment. Nearby at Balinghem 3,000 colourful tents housed part of Henry's entourage. There were kitchens and ovens on site. Somewhere amid the melee, live monkeys painted with gold darted between the crowds, providing entertainment for the players in this astonishing theatre.

The festivities began proper on 7 June and for days there were feasts, musical performances, jousting, wrestling, archery and more. Everyone was wearing the most opulent costume and Henry and Francis engaged in direct one-on-one competition in events, each keen to show off their prowess. Henry, it has to be said, was a genuinely gifted and robust sportsman with considerable stamina. This was deemed an important measure of his qualities as a man and king, along with his erudition and musical abilities.

His close male entourage, the 'king's minions', were a reflection of the king's own priorities. As a group they were bound by their love of chivalric sport and entertainments. They included Henry's boyhood friend Sir Nicholas Carew, whose skills in the tiltyard were legendary; the hell-raiser Sir Francis Bryan, who lost an eye jousting, and Charles Brandon, Duke of Suffolk, over whose good looks women swooned, and who married Henry's sister Mary Tudor after the death of Louis XII of France. Then there was Sir Thomas Boleyn and Sir Henry Guildford, who would join the king in little theatrical pranks or 'masking', dressing up to delight members of the royal household.

All these minions were in attendance at the Field of the Cloth of Gold. The names of some of the painters who helped create their arena are known. Vincenzo Volpe was there, working alongside the King's Painter John Browne. So too was John Rastell, Sir Thomas More's brother-in-law.

Rastell was a creative entrepreneur – a lawyer, an author, a printer/

publisher, a painter/designer, a cultural broker and conceiver of pageant. He had a workshop close to St Paul's Cathedral identified by the sign of a mermaid. Today he would probably use the term 'producer' to describe much of his occupation. In 1527, just months after Holbein arrived in London, Guildford, the comptroller of Henry's household, turned to Rastell for a new fantasy. This time he, along with Nicolaus Kratzer, the king's astronomer and a member of Sir Thomas More's entourage, were to help devise some theatre to impress French ambassadors. In the ever-revolving roundabout of relations with France, the king was hoping to sign yet another treaty of friendship despite recently warring with the Empire against the French. At the heart of this new friendship was another proposed marriage – this time of Henry's daughter Mary into French royalty, either to Francis himself or his son Henri, Duc D'Orleans.

And this is how Holbein got his first royal commission. His residence in the More household had put him straight in the sights of More's brother-in-law Rastell, and his paymaster Sir Henry Guildford. Guildford, a correspondent of Erasmus, may well have also been the recipient of a letter of recommendation from the scholar regarding Holbein. Though his portrait of More could have barely been completed (the single portrait is dated 1527 and the group portrait is almost certainly later) Rastell and Guildford must have seen a portfolio of work that Holbein had brought with him of such outstanding quality that the king's own pageant masters were left with little doubt of his exceptional ability. That the breadth of Holbein's talents was instantly grasped and deployed speaks volumes not only about the work he was able to show, but the character of a man who could instil instant confidence. He had done this again and again. As a boy he had signed his work in defiance of the guild system, as a young man he had secured the most prestigious commissions that established masters would have been eager to secure, he had shown Erasmus to the scholar's vast following, and even if he had not secured work there, he had sweet-talked himself into the French court.

Now he was handed not just any work, but crucial commissions from the English court. By 8 February 1527 Hans Holbein was on site at the palace at Greenwich, where the construction of a new wonder had begun.

NICOLAUS

The weather in the winter of 1526 and 1527 was atrocious. According to the chronicler Edward Hall, the first few months Holbein spent in England were dismal: November and December suffered 'aboundans of rayne'. If nothing else the country was living up to Erasmus's description of it as damp. There was no let-up in the new year, with a daily deluge of bitter wet, and 16 January was notable for 'such a grete rayne that there ensued great fluddes which destroyed corne, feldes, and pastures'.[1]

Despite the elements, and the attendant misery they visited on the rural population who faced a new bout of poverty, the court continued, immune to such worldly trouble. The proposed revels in honour of the French ambassadors were to go ahead and take place in temporary structures built at Henry's Palace of Placentia in Greenwich. Greenwich was one of Henry's favourite residences that reflected his passion for jousting and display. Here the clang and thump of the royal armoury would have been heard from the palace grounds, and here Henry had designed his own tiltyard. Flanked by the river on one side and ample parklands on the other, it offered an impressive, accessible and adaptable site for diplomatic entertainment in theory, though in practice it must have been a cold, miserable, muddy quagmire in the early months of the year.

With the French ambassadors due to arrive just before Lent, Sir Henry Guildford and Sir Henry Wyatt, who between them were responsible for the overall organization of the festivities, must have summoned producers such as John Rastell almost immediately in the new year. Certainly sufficient plans had been approved by the king to allow construction to begin on site by mid January 1527.

Two adjoined buildings were to be built close to the tiltyard at Greenwich, one a banqueting hall and the other a theatre. Rastell was in charge of the latter. He probably wrote the interlude, called 'Love and Riches', that was performed there as entertainment, and it is likely he conceived the overall themes for the decoration of the building itself, as well as the sets. As part of this he hired the two extremely talented Germans, both of whom were members of his brother-in-law's household: Holbein and Kratzer. They were to devise and paint a huge planetary ceiling, of such scale and complexity that a company of nineteen assistant painters were made available to work under them. There is also some evidence that other 'cloths' were painted by

Master Hans and his team, and these may have been a background cloth, and a curtain for Rastell's interlude, as well as wall decorations for the auditorium.

This work with Kratzer was the beginning of a friendship and series of professional collaborations that would last for the rest of Holbein's life. Kratzer had a larger than life personality and sense of fun. A good decade older than Holbein, he had made his way to England in 1516, and after finding work with Sir Thomas More was noticed by the king and became the official court astronomer by 1519. He had met Erasmus and was a friend of Dürer's, who had painted his portrait around 1520 – a fact that could not have been lost on Holbein. In an era of new discovery and investigation, Holbein and Kratzer became partners in the design of astronomical instruments and clocks. At a time when such delight was taken in masks and disguise, they would also work together devising complex messages hidden within Holbein's visual motifs.

However, as far as Holbein's contributions to Henry's diplomatic revels in 1527 went, they did not end with his project with Kratzer. Again, in evidence that clearly suggests that he was instantly perceived as a stellar talent, Holbein was also hired to produce work for the adjacent banqueting hall, largely under the supervision of the Italian Vincent Volpe and the King's Painter John Browne. Here he was to create a huge standalone work on canvas, off site. For this he was paid £4 and 10 shillings, a sum that other skilled workers would have to graft for several months to achieve.[2] It seems likely that he embarked properly on this once the ceiling in the theatre was complete, since records reveal that the latter was delivered to Greenwich by boat on 4 April.

It was not just for the painting for the banqueting house that Holbein was able to command an exceptional sum. Details of the payments associated with the theatre also reveal that Holbein was considered superior from the off. For their contribution to the theatre, for example, both he and Kratzer were singled out and paid more than any other practitioner on site, at 4 shillings a day, between 8 February and 3 March, 'granted at the King's pleasure'.[3] This was around six times the average wage for a skilled worker. And while Volpe came close to this amount, others were looking at considerably less. The respected sculptor Giovanni da Maiano, who had worked for

Cardinal Wolsey at Hampton Court, could command wages of just 16 pennies a day while one of the more senior English painters, Robert Wrythoke, secured only 12 pennies per day.[4] What is also fascinating is that in addition to the money given to Holbein, he also was paid in 'black collars'. These were fine linen collars embroidered in silk black thread known as 'blackwork'. Very much the preserve of the rich, in due course Holbein would adorn his portraits of England's noblemen with these collars. He was clearly extremely keen to acquire such a status symbol for himself.

That Holbein quickly chose to indicate his status with demands for fine clothing is consistent with the descriptions of him in later life, wearing velvet. For a man whose father had been run out of town as a debtor, a display of wealth and achievement was clearly of some importance to Holbein at this time. In a society where clothing spoke of one's position within it, it was also an important statement about the social mobility that the Renaissance had delivered its artists. However, fine clothing was also portable wealth, and, mindful that the account of Holbein wearing velvet alludes to his return to Basel some years later, Holbein may have also wanted be sure of his ability to take some of his earnings out of the country, when often the amount of coinage one could carry abroad was limited.

With so little time to create Henry's latest lavish fantasy, teams of smiths, joiners, moulders, plumbers, sculptors and painters worked around the clock, day and night, Sundays and holidays to realize the plans. Again, the court account books give a rare insight into the materials and techniques deployed by 'Master Hans' on site at the theatre.

Struggling against the daily downpours the teams managed to get the outer roof of the theatre in place and watertight by early February, enabling them to begin work undercover. First, before Holbein arrived on site, he had his canvas prepped. On 4 February 330 ells of cloth (that is about 377 metres) were wetted with size in preparation. Then the tools of the painter's trade arrived. These included 'quills and tails', 'fine hers for pensilles', and fine brushes. 'A grete fox taile' was also part of the equipment.[5]

Huge quantities of gum arabic at 4 pennies per pound were 'spent by Master Hans on the mayn clothe'. This was to be used as the medium with which to apply the colour to the canvas. When painting

on wood, painters would use oil as the main medium to transfer colour. But the slow drying qualities of oil were problematic when working at speed, and so for canvas work pigments were mixed with water and gum arabic.

In terms of those pigments, the requirements were extensive and costly. Hans asked for several different types of reds. Senaper lake, a dark red, was required at twelvepence an ounce, while bright vermillion was acquired at 16 pennies a pound and 'sanders to temper roosset' at a penny an ounce. There was pink at 16 pennies a gallon for the roof. This was in fact a yellow used in the making of green and brought in as a liquid. Other brighter green was provided in the form of verdigris. In terms of yellows he had 'spreus oker' as well as golden yellow 'orpiment'. Blues were 'bice', an azure blue, and 'dry florry', a kind of indigo. Loads of lead white was made available, as well as black and Spanish brown. In addition aprons of guilding cloth were ordered, and 'party gold', that is a gold leaf made of a mixture of gold and silver, for 'the lines, the regements, the stars'.

By mid March the paintings were ready and were inspected by the king himself, who attended the site for a viewing.

Meanwhile, there was yet more demand for Holbein's skills. The king traditionally enjoyed jousting at Greenwich on Shrove Tuesday, and in this particular year it was anticipated that the French ambassadors would attend the event on 5 March. Therefore Henry's armourers were also burning the midnight oil preparing a new suit of armour for the king.

Perhaps it was examples of his designs for daggers that he had brought with him that suggested Holbein as a collaborator on this project too? Whatever brought him to the attention of Henry's Almain workshop at Greenwich, it was sufficient to secure him the exceptional honour of designing a decorative scheme for the king's new armour.

On 26 February the French party arrived at Dover. They included Gabriel de Grammont, the Bishop of Tarbe; Francis, the Vicomte de Turenne, and Antoine le Viste, President of Paris and Bretagne. On Shrove Tuesday the group were invited to the annual joust at Greenwich where the king appeared

> in a new harness all of gilt of a strange fashion that had not been seen, and with him eight gentlemen all in cloth of gold of one suite, embroidered with knots of silver, and the Marques of Exeter

and eight with him in blue velvet and white satin, like waves of the sea, these men of armes came to the tilte and there ran many fresh courses till cclxxxvi speres were broken...[6]

Made in steel, the whole suit had been gilded prior to engraving and so it enshrined the king in shimmering golden metal. This had then been entirely and intricately decorated, with no piece of armour left plain.

After seeing Henry in this extraordinary garniture, a week later the French ambassadors were invited to view the 'king's furniture and riches'. This was a close inspection of choice pieces in the king's collection, during which the suit of armour was produced. It was at this point that Henry commissioned an identical copy as a gift for Turenne.[7] This copy survives today and is held in the Metropolitan Museum in New York. Its entire decorative design is by Holbein. What is unknown is whether Henry's original piece was also engraved with the same designs, or whether this was a bespoke deviation as part of the diplomatic gift. Whichever, there is little doubt that Holbein's work was now deemed ultimately aspirational.

Hans Holbein (design for decoration), Royal Almain Armoury at Greenwich Palace (execution), armour garniture for Henry VIII and detail of breastplate, c.1527.

So intricate and extensive is the decoration on the armour that it is impossible to do it justice in words. But a description of the breastplate alone gives a sense of how this piece of martial kit, in the hands of the Almain metalworkers and a designer of Holbein's calibre, allowed its wearer to quite literally embody chivalric values of beauty, strength and courtly love.

Like all of Holbein's decorative work, what appears as symmetrical at first glance is revealed to be pleasingly asymmetric on closer inspection. And the playfulness seen elsewhere in his work is evident here. For example, he creates a border around the edge of the breastplate, within which sit cherubs apparently holding up

the protective shield at key points. With typical Holbein wit, the breastplate offers a picture of a piece of armour – within a piece of armour. The decorated shield the cherubs show to their audience has a tree of life growing up the centre, its branches curling outwards to the left and right to frame vignettes of elephants, each carrying a fortress on their back. These branches have putti climbing along them, dangling and peeping through the rich foliage. To the left, one cherub has lost his footing and fallen, only to be rolled up in the elephant's trunk. To the right, however, the elephant's trunk rummages through the vegetable undergrowth uninhibited. The elephant and castle was a sign of strength and fortitude, and this is counterpoised with soft vegetation, flowers, birds and of course the playful winged putti. In each tower more putti lurk, playing trumpets and other musical instruments. Then, as the tree climbs further, its branches part again into a heart shape where an armoured merman is featured sword in hand, opposite a bare-breasted mermaid.

The annual Shrovetide joust of 1527 may have been remarkable for this unusual armour worn by Henry, but it was the joust of 1526 that was deemed notable by many other members of the court. In the previous year Henry had jousted wearing a motto 'Declare je nos' and a heart engulfed by flames. This is roughly translated as 'I dare not declare' and Henry's courtiers on the contrary immediately understood this as an indication of the king's recent infatuation with Sir Thomas Boleyn's daughter, Anne.

Sir Thomas Boleyn was a star diplomat who had been part of the king's entourage at the Field of the Cloth of Gold. The Boleyns were close relatives of the extremely powerful Thomas Howard, Duke of Norfolk. A measure of Norfolk's superiority is that he was one of only three dukes in the entire realm.* Both the Boleyns and the Howards had benefitted from an earlier affair Henry had enjoyed with Anne's sister, Mary Boleyn. It is perhaps no small coincidence that Sir Thomas gave the king a ship in 1526 called the *Anne Boleyn*.

In 1527 the king's obsession with Anne had not abated. Anne was dark and slender, though not exceptionally beautiful by accounts. But it was her sex appeal, her intellectual vivacity and her deftness on the

* Henry made Charles Brandon Duke of Suffolk on his marriage to Henry's sister, Mary Tudor. Henry's illegitimate son Henry FitzRoy was made Duke of Richmond and Somerset.

dance floor that had won Anne several admirers alongside Henry, not least the son of Sir Henry Wyatt, the poet Thomas Wyatt.

At this point the prospect of a marriage between Henry and Anne Boleyn was a complete fantasy. The king was already married to Katherine of Aragon and had been for nearly two decades. There was a general acceptance that kings had mistresses, and Henry had already enjoyed other extramarital liaisons without them challenging the security of the queen. One of his mistresses, Elizabeth Blount, had given him a son known as Henry FitzRoy, who was now a recognized member of the aristocracy, and had been given the title of the Duke of Richmond and Somerset. Nevertheless, in 1527, during the negotiations with the French, a seed was sown that would ultimately lead to Henry annulling his marriage with Katherine and taking Anne as his queen.

On 28 April 1527, when incidentally the heavy rain was still ongoing, a treaty was signed. It included an agreement that the Princess Mary would marry either the French king or his second son Henri; that Henry VIII would receive a pension from France; that England would join in league with France against the Empire, and assist in the recovery of Francis's two sons who remained in Spain as the Emperor Charles's hostages. But during the negotiations, according to one account at least, Antoine le Viste, the President of Paris, had suggested that Mary was an unsuitable match with a member of the French royal family because he 'doubted whether the marriage between the Kyng & her mother, being his brothers wife, were good or no'.[8] Despite Henry's officials being able to reassure the French on this point, as Hall observed, 'of this first mocion grewe much business'.

With the treaty at last signed, all the work that Holbein had been preparing to impress the French could finally be revealed. The revels in the making since January were to go ahead. There was a small delay at the beginning of May when the ambassadors 'kept at home, for fear of the London artizans, who go in arms "querir le May",' and 'sometimes attack foreigners.' On 6 May, however, the French were once again ferried from their lodgings in London to Greenwich and here they were led through a carefully planned narrative.

On arrival, they went straight into the banqueting hall. This was 100 feet long and 30 feet wide, its ceiling hung with purple cloth decorated with roses and pomegranates – the respective devices of Henry and his queen, Katherine. There was the requisite Renaissance

decoration with classical corbels supporting bespoke candlesticks 'of antyke work […] polished like Aumbre'. And the feast was sumptuous with a cupboard, thirteen feet long, seven shelves high, and stacked with ostentatious tableware made from gold and studded with jewels. At the far end of the banqueting room were, according to Hall, two large arches supported by 'three antike pillars of gold, burnished, swaged and graven full of gargills and serpents'. The arches themselves were decorated with 'Armorie' all in blue and gold and further classical motifs.[9]

After their dinner, the king led the party through these two arches into a lobby that ultimately led to the exit. If the banquet was the first event of the evening, then the second event occurred here. It involved a degree of theatre. When the party had passed under the arches, the 'Kyng caused them to turn back and look […a]nd there they saw how Tyrwyn was besieged and the very manner of every man's camp, very connyingly wrought, which work more plese them than the remembering of the thing indeed'.[10]

This was Holbein's surprise. On the rear of the arch was his huge painting of Henry's victory of 1513 at Therouanne. Quite how Henry explained a depiction of French defeat in diplomatic terms remains a mystery. Perhaps he pointed out that this victory over the French had led to the marriage of Henry's sister to Louis XII and a new peace. A quarter of a century later, and the two nations were once again celebrating together, with another marriage between their respective royal houses on the table.

Despite this rather one-sided view of Anglo-French relations, what is clear from Hall's account is that it was the visual ingenuity of the painting that managed to create genuine pleasure and surprise for the French onlookers. This was a wonder almost certainly delivered with the perspectival wizardry for which Holbein had become known at home in Basel.

After this the party was led into the adjoining theatre. Here the seating was raked around a proscenium arch painted with heads of Roman emperors and other classical heroes such as Hercules, executed by Giovanni da Maiano. Azure-coloured pillars decorated with stars and flowers framed the room, and above everything was the magnificent ceiling that Holbein had made in conjunction with Nicolaus Kratzer. It featured the

earth surrounded by sea, like a mappe, and by a connying making of another cloth the zodiac with the XII signes and the fine circles or girdelles and the two poles apered on the earth and water compassing the same, and in the zodiac were the 12 signes curiously made and above this were made seven planets as Mars, Jupiter, Sol, Mercurus, Venus, Saturnus and Luna, every one in their proper houses made according to their properties, that it was a connying things and a pleasant sight to behold…[11]

Clearly Holbein and Kratzer had devised a system where cloths of differing opacity were layered over one another to create different fields of vision.

Underneath this an interlude was played out. First a figure clad in cloth of gold and blue silk, wearing a golden cap and a crown of golden laurel leaves, gave a speech in Latin about the value of love and friendship. Then there was singing from the choristers of the Chapel Royal before two more actors, once again clad in cloth of gold and blue silk, performed a debate on which was superior, love or riches? Unable to agree, a battle was necessary. A 'bar all gilt' was lowered from the proscenium arch and over this three knights representing riches on one side fought three knights representing love on the other side. After failing to defeat one another the knights exited and an old man with a silver beard took the stage to declare that 'love and riches both be necessarie for princes… by love to be obeyed and served, and with riches to reward his lovers and friends'.[12]

This was by no means the end of the entertainment. Now for the finale. The curtain that had served as a backdrop to the oration and mock battle fell to the ground to reveal a huge fortified rock made from a kind of papier mâché. This was painted to appear as if it was inset with crystal and rubies, while faux roses and pomegranate vines appeared to grow all over it. On top of the rock, in a fortress, were members of the court 'appareled in cloth of Tissue & silver cut in quarter foyles, the gold engrailed with silver, and the silver with gold, all loose on white satin'.[13] These men, who also wore black velvet caps embroidered with pearls and sported black cloaks, climbed down from the rock and sought out ladies in the audience and began a dance.

When this was done, more was yet to come. From a cave set within the rock, Mary, Henry's eleven-year-old daughter, emerged accompanied by seven ladies in waiting. They were also elaborately

costumed, in classical garb made from cloth of gold and 'crimosin tinsel bendy'. They wore crimson velvet bejewelled bonnets and performed a dance with the 'Lordes of the Mount'. After this *yet* more, as dancers costumed in cloth of silver and back tinsel in the 'fashion of Iseland' emerged, wearing visors with bears over their heads so they were entirely masked. And then the royal party and the ambassadors were conveyed out of the theatre only to re-emerge also in disguise, this time in Venetian clothing made of cloth of gold with purple tinsel, their faces covered with 'beardes of gold'. When this 'masking' was finished, and before the parties returned to the banqueting hall for a *second feast*, the king gave the Vicomte de Turenne yet another gift – his own masking apparel, as well as that worn by the Vicomte himself.

After the event the king opened the palace grounds to the public for three or four days so that they could 'see & behold y riches and costely devices'.[14] It was a hugely popular novelty, which a great number of people did indeed make the effort to visit, and there can be little doubt that Holbein's name began to circulate more widely.

As to Holbein's fabulous paintings for the event, their fate is unclear. Rastell, not just a printer/publisher, was also a commercial theatre producer with a stage at Finsbury Circus. There is plenty of evidence that some of the costumes from the Greenwich Revels, and possibly some of the curtains, were recycled by him in his own commercial productions there.[15] With this in mind, one might not be entirely surprised if he had also taken the huge map of the world that Holbein had designed and painted with Nicolaus Kratzer. Rastell's son, William, would eventually marry Margaret Clement's (née Giggs) daughter, Winifred. When, in the late 1540s, the Clement/Rastell household was forced to flee England because of their persistent Catholicism, an inventory of the possessions in one of their properties was made. Their manor house at Bucklersbury in the City of London certainly had the tell-tale signs of their religious persuasion, with 'a gret crucyfyx and dyvers images' in its chapel. But elsewhere the tone was decisively theatrical, with descriptions of 'a serpent hanging in the chamber next the gallery' and 'a part of a hanging of paynted cloth of a chamber'. Most intriguing, however, is the description of a 'gret map of all the world' that was in the great hall, and was valued at the considerable sum of 20 s.[16]

While the Greenwich Revels had been proceeding in celebration of

peace, war was still raging on the continent. Not long after the French ambassadors had returned to their accommodation, news reached London that Rome had been sacked.

This atrocity was a direct product of the latest wars in Italy, in which the Empire had mounted an attack on French territories there. Though Emperor Charles V defeated the French at Pavia, incarcerating Francis I until he could be swapped for his hostaged sons, Charles had been unable to properly pay his victorious armies. By 1527 his largely mercenary forces were in mutinous mode and in the spring forced their commander to march on Rome. German mercenary *Landsknechts*, who made up nearly half the imperial army, had embraced Lutheranism and were particularly antagonistic towards the Papal city. On 6 May, the very same day that Henry so delightfully entertained his French guests, the imperial forces invaded the ancient city, massacring the Swiss Guard which defended the Vatican and looting Rome's churches, monasteries and palaces. The Pope, by now Clement VII, fled to the Castel Sant'Angelo where he was effectively a prisoner.

Had Holbein still been in Basel he would have witnessed the reception of this dreadful news. Many of the town's mercenaries, including perhaps Urs Graf, had faced the German soldiers. It did nothing but aggravate the divisions in the city between its traditionalists and Lutherans. At the end of May Erasmus wrote to his English patron, Archbishop William Warham, in despairing terms.

> Here everything seems to point towards revolution, and I fear
> bloody uprisings, so extensively do these uprisings send out their
> roots; you must see it to believe it. I have had the ill fortune of
> growing old in these times. From the church I cannot withdraw.
> And the opposing party has a following with whom I would not
> wish to be allied. The rampaging monks, to their own detriment,
> make this melodrama worse [...] In Rome everything is in turmoil,
> and letters cannot get through. [...] I fear the world will never be at
> peace... I fear I shall not be able to reside here long.[17]

Compared to the city he had made his home, London was still holding Lutheransim at bay. As such Holbein must have felt remote from the troubles Erasmus described. In contrast to the sterile economic situation in Switzerland, and despite Sir Thomas More's scepticism, London was in fact delivering everything he had hoped for.

It is little wonder that after such a major public endorsement as the Greenwich Revels, Holbein suddenly found himself in immediate demand. His work for the rest of 1527 was taken up with a flurry of portrait requests – not least from Erasmus's correspondent, Warham, who commissioned two, one for himself and one for his friend Erasmus.

In his biography of Warham, the archbishop's successor, Matthew Parker, makes a specific note about Holbein's portrait of Warham and its reciprocal relationship with that of Erasmus. 'Erasmus, […] was so greatly loved by him (Warham) on account of his learning,' Parker notes, 'that when he (Erasmus) was dealing with Basel he saw to it that his own portrait painted by […] the most accurate and ingenious painter […] was copied as realistically as possible by the same painter and sent to Warham in Anglia. And he (Warham) in turn sent, along with other diplomatic papers, (a portrait of) himself to Erasmus, a vivid likeness that captured his expression and profile.'[18]

What Parker's account impresses yet again, is the impact but also the appeal of the verisimilitude of Holbein's work. Today we prize deviation in portraits – particularly where colour or form may express some emotional insight into the sitter, or express a particular aesthetic. But again and again in this moment, when the search for truth was so crucial, be it the true meaning of the Bible, the true nature of the physical world or the universe beyond, being able to make a portrait 'realistic' was both rare and enormously valued.

Hans Holbein, *William Warham, Archbishop of Canterbury*, oil on oak, 1527.

The picture destined for Erasmus was likely almost identical to that which hangs in the Louvre today.* What is noticeable in his portrait of the archbishop is its new decorative energy, a greater delight in intricate fabric and precious items, as if the brilliance of Henry's court had given the painter a new fascination with glitter. A direct response to Holbein's portrait of Erasmus, Warham, looking old and drawn, adopts almost exactly the same pose as his friend, and items are arranged around him in a similar composition. But the ornamental elements in the painting are enhanced. Whereas Erasmus's hands rest on a book, Warham's rest on a costly damask cushion. While the green curtain behind Erasmus is plain, that behind the English clergyman is highly patterned. An intricate Turkish 'Holbein' carpet covers the

* The Louvre painting is most likely that originally kept by Warham himself and hung at Lambeth Palace.

table behind him on which his heavily jewelled mitre is adorned with pearls, gold and sapphires. His golden cross, bearing the figure of Jesus, is elaborate with fine metalwork and studded with gemstones.

Interestingly, one of Holbein's visual jokes is played in the painting. The date of the painting and the age of its sitter are written on what appears to be a piece of parchment, known as a cartellino. Normally the cartellino would be designed as part of the painting, as if it were stuck on a wall within the imagined space of the work of art. Holbein, however, made his cartellino appear as if it had been stuck to the physical painting, by placing it where the curtain appears in the pictorial space, the soft folds of which would be unsuitable as a support for the paper. As an afterthought the label is secured with sealing wax, perhaps underlining the authenticity of the information like a seal.

Holbein must have been particularly pleased with his little trompe l'oeil trick of painting what appeared to be a sliver of parchment annotating the portraits, since he repeats its use widely in 1527. It is a gimmick that he was clearly exploring as one of the signature elements of his work for his new English clientele.

Hans Holbein, *Lady Guildford,* black and coloured chalk on paper, 1527.

overleaf
Hans Holbein, *Sir Henry Guildford* (l); *Mary, Lady Guildford* (r), both oil on panel, 1527.

A preparatory drawing of Warham reveals something of Holbein's technique. The drawing held in the Royal Collection at Windsor exactly matches the painting in terms of size and outline, and suggests that it was traced by Holbein onto the primed oak panel, providing key guidelines. This technique was not only time saving for a painter, but it also meant that any diversion from reality was restricted to a single degree. Had Holbein had to copy his drawing, there would have been some risk of yet further deviation, creating a second degree of separation from the original subject.

Some of his commissions came from those directly involved in the diplomatic festivities. One of Henry's minions, the celebrated jouster Sir Nicholas Carew, commissioned a painting of himself, glorious in his tournament armour. Meanwhile Sir Henry Guildford commissioned portraits of himself and his wife.

The preparatory drawing of a slightly plump Lady Guildford is particularly touching since it shows her with an enticing smile, glancing sideways, the experience of having her likeness made one of self-conscious delight. Holbein may have asked her to glance to her

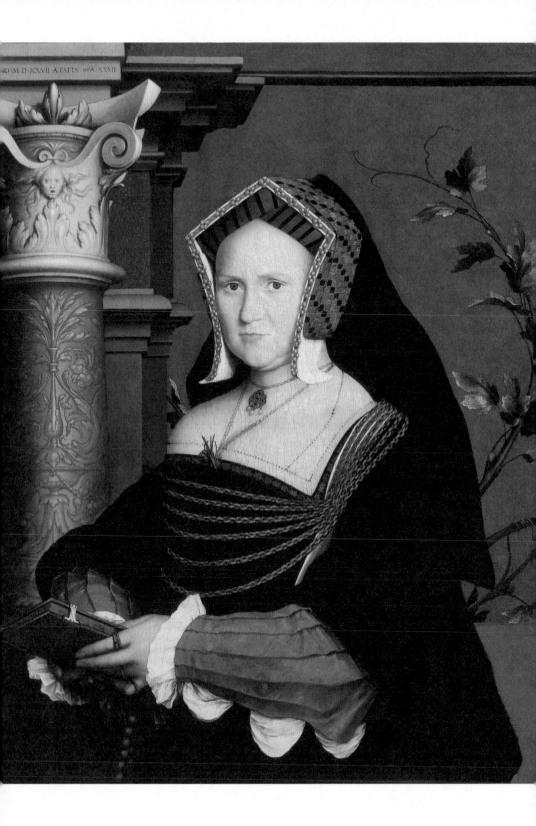

right so that she would appear to be looking at her husband when the finished works were hung together. However, in the final portrait this idea has been dropped, as has Lady Guildford's smile.

This change reveals more about Holbein's working practice. Again key elements of the preparatory drawing of Lady Guildford match the finished painting and suggest that Holbein traced his drawing onto his prepared wood. But then he worked to achieve the alteration, this time deploying memory and imagination to alter the sitter's eyes so that they gaze forwards, and modifying the smile appropriately.

It is worth remembering that Holbein would have portrayed the victorious King Henry in his painting of the Battle of Therouanne, a painting which the king subsequently showed to the public. While Holbein is today known for the portraits of Henry he made in the 1530s, it is tantalizing to think that this very first depiction of the monarch, now lost, was almost certainly a significant catalyst in making Holbein immediately fashionable.

There was a second depiction of the king. The National Archives at Kew holds a gold seal fabricated for a further treaty signed with the French in August 1527. Made by French goldsmiths, the design is likely Holbein's. It shows Henry, clean shaven, enthroned in Renaissance style. His robes fall in complex, heavy folds and he holds an orb and sceptre. He is framed by classical pilasters and a shell niche; his feet rest on a Tudor rose held by two putti, delivered with the asymmetrical deviance typical of Holbein. More putti, urns and garlands creep around the perimeter.

The aspirational appeal of having one's portrait painted by Holbein extended beyond London very quickly indeed. Norwich, grown rich on its wool trade, was England's second city at this time, and Norfolk society quickly recognized the value of Holbein's work. One young aristocrat, Sir Francis Lovell, had found himself the beneficiary of his extremely wealthy uncle's will in 1524. Sir Thomas Lovell had been a significant courtier and politician during the reign of Henry VII and had amassed vast estates across the country. When he died without issue, he left Francis his ample manor house Harling Hall, in the village of East Harling in Norfolk.

Just three miles from Kenninghall, the seat of the powerful Duke of Norfolk, Harling was a prestigious acquisition for Lovell. It bore all the marks of his uncle's successful career and fashionable taste,

not least a bronze portrait medallion of Sir Thomas by Torrigiano, which was positioned in the gatehouse. Here was evidence of a man of culture, who understood the power of cultural currency and had commissioned the king's sculptor for his own commemoration.

As Lovell and his young wife moved to Harling Hall around 1526, they must have considered portraits by the new star painter not only a pertinent statement of their new-found status, but an appropriate complement to the work by Torrigiano.[19] If the latter was associated with the last wave of continental talent to impress the English, Holbein was clearly seen as the latest.

The Lovell badge was a red squirrel cracking a nut, and the Church of St Peter and St Paul in East Harling still remembers its Lovell benefactors with the depiction of red squirrels in its stained glass windows. No wonder then that when Holbein and his client planned the Lovell portraits, a squirrel was included.

Today only the portrait of Anne Lovell survives. Like the Guildfords, she is depicted against a bright blue background, perhaps a sky, across which creep curling fig branches. But this is the only point of comparison. The Guildfords occupy larger works, with their expensive attire depicted in costly materials – Sir Henry's goldwork doublet is represented in shell gold and real gold leaf, the value of which added a layer of worth to the painting. Anne Lovell, by contrast, is a study in black and white, only her fashionable white fur hat signalling her comfortable financial position. Otherwise plainly dressed, in her hands she loosely holds a chain, on the end of which is tethered a squirrel cracking its nut. The allusion to the family device to one side, this is surely a warm reference to the marital bond, the love that tethers her husband to her. And to her right, balancing on a fig branch and chirping in her ear, is a starling – probably a pun on East Harling.[20]

The Lovell portrait is an early exposition of Holbein's determination to add dimension to his painting. As his work develops he devises a language of symbols that, when deciphered, add another layer of meaning. Often a visual cue referencing sound, such as a bird or a musical instrument, suggests that there is an aural pun in the work and that one should sound out some of the visual images provided to decipher it.

Holbein was clearly prepared to embrace a wide circle of clients, with varying abilities to pay. If the Lovell portrait, in size and the

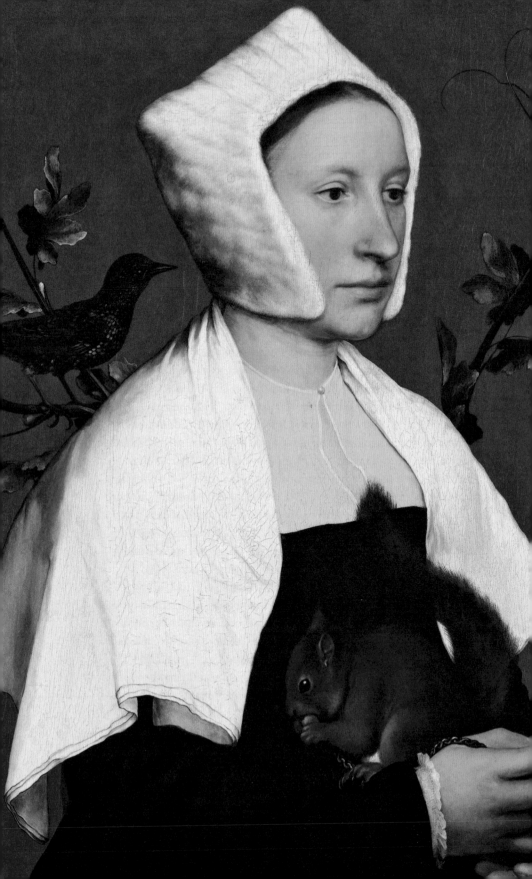

extent of its materials, represented a cheaper price point than the Guildford work, then Holbein's painting of another Norfolk-based family reveals work at an even more accessible level.

Sir Thomas Godsalve lived at Buckenham Ferry Manor – just outside Norwich. Godsalve was a wealthy landowner, and as registrar of the consistory court at Norwich he could well have known Lovell, who served as the sheriff of Norfolk around 1527. Holbein made a very small painting, on oak, of Godsalve and his son John. At only 35 × 36 cm, and thus almost square, it is an unusual format. Equally unusual is the cramped, rather unsuccessful, composition which sees John sitting close behind his father, and both sitters looking out of frame right. One wonders whether it was designed as an accompaniment to another portrait of the Godsalve women, intended to be folded together, much like Holbein's first ever Meyer portraits? In any case, Holbein's far-sighted approach to networking paid off. The Godsalve family, part of Thomas Cromwell's circle, would only grow in importance and John Godsalve would prove a useful contact for Holbein in due course.

As to more commissions from the king, it seems odd that after the success at Greenwich Holbein should continue to live and work for at least another year in England without apparently finding more court assignments. But none are acknowledged. Lucas Horenbout had been executing a number of miniatures of the king and it may have been that Henry was satisfied with these for the time being. However, there is a work on paper by Holbein in Basel's Kunstmuseum that might suggest there was a royal commission after all, in the afterglow of the Greenwich success.

Hans Holbein, *A Lady with a Squirrel and a Starling* (Anne Lovell?), oil on oak, *c.*1527.

In August 1527 the agreement that Henry had struck with Francis of France was refined. Whereas back in April of that year the two monarchs had agreed that Princess Mary might be married to either the king or his second son, Henri, by the late summer it was determined that it was the French prince who would be her husband. However, with Henri still very much hostaged in Spain, there was an issue with securing a betrothal portrait of the young prince for Mary.

The work on paper in Basel is a coloured drawing of an unidentified boy, sitting behind a parapet holding a marmoset or small monkey. Could this drawing be of Henri?

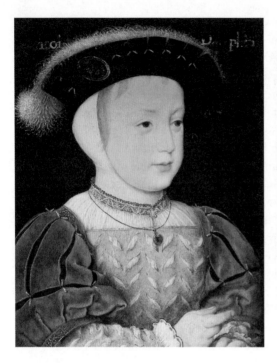 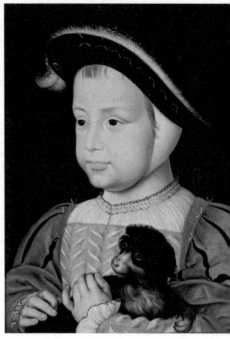

Above left Jean Clouet, *The Dauphin*, oil on panel, 1524.

Above right Jean Clouet, *Prince Henri*, oil on panel, 1524.

Jean Clouet, *Francis, Dauphin of France* miniature, watercolour on vellum, 1526.

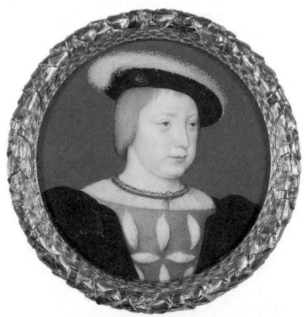

The drawing becomes more intriguing when one realizes it references a group of drawings and paintings of Henri and his elder brother the Dauphin that Jean Clouet executed for the French king in 1524. The preparatory sketches for these are now in the Musée Condé at Chantilly, with the finished painting of Henri also in that location, and the completed oil of the Dauphin in the Royal Museum of Fine Arts in Antwerp. In both of Clouet's portraits the boys are shown wearing extremely similar dress: velvet plumed hats, with a bonnet underneath, and red velvet, slashed sleeves over a golden-coloured doublet, also slashed to reveal the shirt beneath. The boys face in opposite directions, as if looking towards one another, with the Dauphin looking out of frame right and Henri out of frame left. While the Dauphin sits in a formal pose, little Henri is depicted clasping his small lap dog to his chest.

Two years later, in 1526, Clouet painted miniatures of both Henri and the Dauphin that were sent to Henry VIII. Since the boys were hostaged the little portraits were intended to appeal to the king at an emotional level and encourage him to intercede on their behalf, which he did. Clouet's 1526 miniature of the Dauphin exists today in the Royal Collection at Windsor, and seems to be based on the foundation drawing at Chantilly, though the child appears older and his hair is shown rather than concealed beneath a bonnet. In this later work the Dauphin has been given a new costume, differentiating it from the earlier portrait, and contributing to the presentation of an older child who now is shown wearing black velvet sleeves over a golden doublet. As in the earlier portrait, the Dauphin looks out of the miniature from frame right.

However, Clouet's miniature of Henri that accompanied this one of the Dauphin has been lost. Could Holbein's *Boy with a Marmoset* be a copy or interpretation of it, scaled up into a larger size? Assuming that just as in their 1524 portraits, the 1526 miniatures would have seen the boys once more dressed in near-identical costume, this would explain why Holbein's boy with a marmoset and Clouet's miniature of the Dauphin of 1526 are apparently wearing matching outfits. Like Clouet's Dauphin Holbein's boy also wears his hair long beneath his hat, without a bonnet. There is also a strong facial similarity between the two boys, suggesting they could be brothers, and both are featured against a bright blue background. Holbein's *Boy with a Marmoset* shares a noticeably large forehead with Clouet's Henri. The inclusion of

the monkey or marmoset in Holbein's portrait is evocative of Clouet's earlier portraits of Henri holding his pet dog and is thus perhaps intended to distinguish the younger brother from the Dauphin.*

The *Boy with a Marmoset* seems to be an example of Holbein looking at Clouet's work and responding to it in an imaginative exercise. It is tempting to suggest that this is a work by Holbein's based on the lost miniature of Henri by Clouet, enlarged and refined, and possibly a preparatory drawing for a fuller painting of the French prince, possibly to mark his betrothal to Mary.

In the end the match between Mary and Henri was not realized, not least because Henry himself began to doubt his daughter's legitimacy. While on the one hand appearing with his queen in public and promoting their daughter, Henry was already exploring how he might annul his marriage to Katherine of Aragon. As early as May in that year William Warham, whom Holbein had portrayed with his long-jowled face and weary expression, had been ordered to meet Henry's chief advisor Cardinal Wolsey to discuss the king's doubts. By the end of June Henry shared his intention to seek an annulment with the queen herself, news that was met with genuine distress by a woman who had sat on the English throne for two decades and who was much loved by her people. Thus began what became known as the 'King's Great Matter'.

Hans Holbein, *Boy with a Marmoset*, black and red chalk, black pen and watercolours in places, *c.*1527?

Despite his having no other known major royal commissions, Holbein remained within the king's sights. Nicolaus Kratzer had written a short manual for the use of astronomical instruments, which he presented to the king in January 1529. In order to give his book the very latest sheen of luxury, he turned to his new associate to design the illuminated lettering of the title page – a beautiful golden E set in a bright blue rectangle. The letter is three-dimensional in appearance, designed to look like intricate metalwork.†

Not shy of self-promotion, Kratzer also made sure his own image was captured by his German compatriot. In painting Kratzer's portrait

* Thanks to Clouet, however, it is known that Francis's children also kept pet monkeys, since one is shown with them in a much later miniature of Francis and his family, also in the Musée Condé.

† And indeed Holbein would return to and borrow the design for initial jewellery depicting the same letter a few years later.

in 1528, at just the same moment he illustrated Kratzer's book for him, Holbein got the opportunity to display highly valued scientific equipment in the process of being made – something that must have been of particular interest to a man who likely saw himself as a fellow scientist.

In his painting of his German friend, the tools of Kratzer's craft hang on the wall behind him: a pair of long iron dividers and a wooden vice. Meanwhile on his workbench are other implements such as a bradawl and scissors. On a shelf behind Kratzer are two completed instruments – a star quadrant and a shepherd's dial. Meanwhile the astronomer is shown in the process of making a ten-sided sundial.

Holbein uses the portrait of this eminent scientist to draw attention to his own science – perspectival illusion. The point of the bradawl and the corner of a sheet of paper poke over the edge of the bench on which Kratzer leans and in doing so extend beyond the boundary of the painting, into 'real' space. And as if to emphasize this, Holbein depicts the star quadrant on the shelf behind Kratzer also projecting over its edge, in doing so giving the painting an enhanced sense of dimensional space.

Hans Holbein, *Nicolaus Kratzer*, oil on oak, 1528.

The science of time and place with which Kratzer occupies himself is reflected in the particular inscription Holbein provides in Latin on the letter resting on Kratzer's workbench. This translates as 'Nicolaus Kratzer from Munich, a Bavarian who is reaching the end of his forty-first year'. Kratzer clearly composed this inscription himself, since he had written something similar on a large sundial he had made in Oxford in the churchyard of St Mary's Church.

This particular monumental sundial had been made in 1520 and was in the form of a stone pillar, with dials on its four sides, and a pyramid with a ball and cross. Kratzer recalled the inscription he made on the sundial in a manuscript 'De Horologis':

> To one thousand five hundred and three years add twice ten, and you will discover the time at which I was placed here. Thomas Mosgrave (then) professed medicine at Oxford, and was skilled therein. William Aest the stone cutter set me up fairly with his own hands, and placed me in this spot. Nicolas Kratzer, the Bavarian who was of Munich, caused me to tell all the hours. He also at that time lectured to his pupils on astronomy, and much learning he handed

down. He was then the astronomer of King Henry, of that name the eighth, who held him very dear. The stone cutter was English, the other German, at the time when I was the admiration of the whole age. Both men drank ever in the German fashion, and could swallow all the liquor that there was.[21]

The sundial was evidently much viewed and visited by the people of Oxford. Kratzer used it as a noticeboard of sorts when there was important news to convey; he mentions how 'At that time Luther was condemned by the University, a testimony of which I Nicolaus Kratzer wrote and placed with my own hand upon the column.'

So Kratzer had a sense of humour and loved beer. No wonder he and Holbein became so friendly, since according to tradition, Holbein had a penchant for drink. But, as the Oxford inscription revealed, Kratzer also loved a narrative that would precisely locate an object in its time and within a specific context. That he saw responses to Luther as significant in establishing episodic time is also a fascinating revelation. Was Kratzer a Lutheran? Certainly his correspondence with Dürer suggests this may be the case. Did he see his contemporary world in terms of before and after Luther, in the way Christian time had to date been measured in terms of BC and AD, and in terms of the duration of monarchs' reigns?

The partnership between Kratzer and Holbein would in just a few years produce one of the most astonishing pieces of art ever made. However, as the summer of 1528 progressed, Holbein's first visit to England came to an end. Such were the strictures of Basel's guild rules, Holbein risked forfeiting his status at home if he did not return within a period of two years. He clearly left London at the last possible minute, extending his stay overseas as long as he could.

For close to two years he had lived in Chelsea as part of the More household, no doubt counting his blessings. In 1532 he would return to England and make it his home, by which time the country he had encountered and the fortunes of many of the friends he had made would have changed considerably. The young woman that he had perhaps already encountered, Anne Boleyn, would have become the most powerful woman of her generation and the formerly loyal Catholic King of England would have cast off Rome to head his own brand new Church of England. As for Thomas More, the next painting Holbein would make of the man who gave him his introduction to

English life would be a tiny miniature, showing the man in the Tower of London where he was imprisoned.

11

EASTERLINGS

The first real warning of the revolution in Basel that Erasmus had predicted came while Holbein was probably still in London. On 10 April 1528 the Protestant-leaning congregation at the Church of St Martin's, located right in the centre of the city, rioted. The new religion was largely contemptuous of devotional imagery. After all, it encouraged the idolatry that Protestants saw as one of the main failings of Catholicism. And so St Martin's altar pictures were torn down and discarded into a great pile. Holbein's *Solothurn Madonna* and perhaps the one he painted for Jacob Meyer may well have been among the treasures heaped up ready for destruction, before their respective patrons extracted them and spirited them away.

But the anger and violence directed at these works of art was driven by more than just new thinking. It was mainly members of Basel's crafts guild who had turned to Protestantism, not least as an indication of their wider dissatisfaction with an unfair society. The city's craftsmen were poor, subject to the whims and prejudices of the council. The costly paintings and statuary that filled the churches were symptomatic of the social divide between these folk and the rich guildsmen, the merchants and noblemen who were members of the town's council and who were effectively their masters. Commissioned by a wealthy church or by the most privileged families in the city, a group which continued to adhere to the old church, the paintings of beautiful madonnas and saints, worshipped by a kneeling elite, had become as much symbols of oppression and social injustice as of religious practice.

The minister at St Martin's was the reformer Johannes Oecolampadius, once part of Erasmus's golden circle, but now too hard line a figure for the scholar's continuing friendship. Like a good politician Oecolampadius distanced himself from the violence, but despite this it continued. On the following Easter Monday thirty men broke into the Augustinian monastery and ransacked it too. The town council sent in its guards and arrested the mob.

Basel's council had a history of giving in to its people. Aware perhaps that the majority of the populace sympathized with the rioters, the council let the rioters go, and, to prevent more trouble, began a process of authorized iconoclasm. In response to public rage devotional works of art were removed from both St Martin's and St Leonard's churches, as well as the 'Barfusserkirche' Franciscan church and the Augustinian

monastery. Some of the ornamentation in the side chapels in both St Leonard's and in the Franciscan church was permitted to remain to allow traditionalist members of the congregation to pursue their devotional worship, but these side chapels were to be closed during sermons. With this compromise, the council could barely claim to have preserved Basel's reputation for tolerance.

So Holbein returned to a tense and febrile city in the summer of 1528. Despite this, the considerable sums he had earned in England were instantly expended – on a house. On 29 August he put down 100 florins cash on a house in St Johanns-Vorstadt, a street that runs parallel to the riverfront. This was a prime piece of real estate just a few minutes' walk from the cathedral and the important and elegant residences of civic dignitaries. Today the houses on St Johanns-Vorstadt are separated from the river, backing onto dwellings with views over a waterfront path. However, some sixteenth-century maps suggest that the original properties had grounds that reached right to the Rhine, and would have provided ample space for a busy workshop with direct access to the river.[1]

For a man who wanted to be seen wearing blackwork collars, property acquisition was another important statement about status. Holbein also set about decorating his new property, and, taking a cue from his work with Sir Thomas More, devised a family portrait, perhaps based on a similar conceit of 'posing'.

Only a remnant of the painting exists. Made of the largest sheets of paper available, and glued together, it is part of what was once a much larger-scale work featuring the Holbein family, almost life size. What remains however is just the depiction of Elsbeth and Holbein's two eldest children, Philipp and Katherine, in a triangular arrangement. The figures have been cut from the original and pasted onto wood. Elsbeth is seen seated, in three-quarter length; her daughter is almost full length on her lap and Philipp's head and shoulders occupy the bottom left section of the canvas. The composition is resonant of the arrangements Leonardo and Raphael were exploring for holy families.

With the eyelines of the children veering to the right and Elsbeth's gaze contemplative and inward, the painting as it exists today has a strange sense of dislocation. But it is thought that originally Holbein included himself in the picture, to the right, in the process of composing a painting of the family. As such not only would the whole

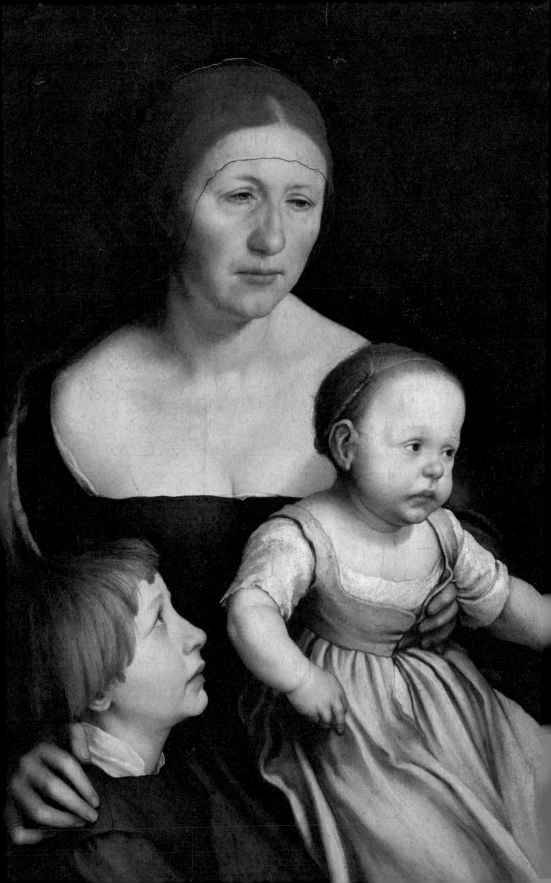

painting be considerably larger, but the figures we see today would have been complete. Philipp would have been seen kneeling; the lower section of his mother's dress would have been visible, as would his little baby sister's feet. Holbein, standing at an easel, would have rationalized the viewpoints of his sitters. And the date of the work and an inscription would have been complete. Today it is incomplete, with just '152' visible; the final digit revealing the actual year in which the painting was made is missing. Most scholars assume that the missing number is '8', but it could be '9'.

In portraying his family, Holbein, the master of innovation, delivers a deeply unconventional type of portrait. If he painted the More family in the process of adopting their poses and public masks, here he shows a family at once posed and yet completely unmasked. There is no ornamentation on Elsbeth's clothes; no jewellery around her neck nor rings on her fingers. Her clothing is simplicity itself, as is that of the children, who are seen in plain linen garments. In reproduction, Elsbeth seems world weary, with her ruddy complexion and downcast eyes. But if one visits the Kunstmuseum in Basel to see the painting in the flesh, it is actually more sympathetic. It is executed with such exquisite finesse, and the colouration and texture of Elsbeth's skin so carefully achieved, that there is a palpable tenderness towards this middle-aged, working woman. When this depiction of bare and straightforward humanity is combined with a composition associated with devotional painting, the effect becomes profound. Set against the politics of the moment in which it was painted, it identifies the family as poor. Despite his request for blackwork collars, it places Holbein as a man who remains united with his brother painters, his family posing for a work destined for a far richer clientele.

Hans Holbein, *The Artist's Wife and Two Elder Children*, mixed media on paper, mounted on limewood, *c*.1528.

By 1542 the painting had ended up in the possession of Hans Asper, a Zurich-based portrait artist and goldsmith who may well have trained with the Holbein workshop and whose portrait Holbein painted in 1532.[2] It is not known who cut the painting up, but it could have been Asper himself.

So does the painting that hangs in Basel today reveal Elsbeth the bad-tempered and long-suffering wife, or is it the loyal, hard-working Elsbeth who for the moment remained her husband's business partner as well as his lover? The two versions are not mutually exclusive. What

is clear is that the marriage between Holbein and Elsbeth was warm enough in 1528 to see two more children conceived in quick succession. Jacob was born at some point in 1529, and Kungold probably in the following year. What is more, the enlargement of their home in 1531, when, in the March, he bought another small adjoining building, indicates Holbein's dedication to his family and hometown during this period.

Holbein's determination to continue to invest in a life in Basel was set against the city's most violent and terrifying era. What became known as the *Bildersturm* or 'image storm' finally ripped through the city in February 1529. It began once again during that annual carnival that led up to Lent and had so often unleashed misrule. This time the misrule was on an unprecedented scale, and informed by deep-felt religious zeal.

In the very early morning of the Monday before Lent, 8 February, a mob gathered outside the Franciscan church. The church was still promoting the old religion, and the townspeople did not approve. A number of citizens marched on the town hall and lobbied the council to ban traditional Catholicism entirely. Their demands also included a request for a number of old guard, old religion, town councillors to resign and for a new voting system that would see councillors elected not just by senior guildsmen but by all guild members, thus giving the Protestant populace, who dominated the inferior ranks of the guilds, a proper voice.

Though presented as requests, these were really non-negotiable demands and the consequence of not delivering them was clearly dire. The mob had managed to seize control of the city's arsenal in Petersplatz and now had professional weaponry rolled out into the main market and trained on the town hall. They had also locked the city gates. No one was leaving, by road at least.

'When a miscellaneous mob was assembling in the town square, armed and with artillery in position, everyone who had anything he would not want to lose was afraid. For some time it looked like war,' Erasmus, witness to events, later explained. 'The better part favoured the church side, but they were outnumbered. The others were a mixed lot, many of them outsiders, many ruined men, many notorious scoundrels.'[3]

There was a stand-off. The councillors, effectively imprisoned,

ruminated in the town hall. The townsfolk lit bonfires in the main square and stood guard all night. Some of the main civic dignitaries actually took the opportunity to take flight under the cover of night – including the then mayor, Heinrich Meltinger. This man, who had written on Holbein's behalf to recover his father's effects, was the same man who had led Basel's mercenaries at Marignano. Far from a coward, he must have understood the resolve of the men who had once served under him. He slipped away by river.

Then, in the early afternoon of Shrove Tuesday, 9 February, the destruction of Basel's art began proper when one of the protestors stormed into the cathedral and hurled his halberd at one of the altarpieces. Panicked, the chaplains locked the cathedral's doors, only for a larger crowd of more armed men to break down what barriers the clergymen could erect and begin a frenzied destruction of anything they could get their hands on. In one afternoon hundreds of years of art and devotion was completely obliterated. After they had trashed the cathedral, the mob moved through the other churches smashing the statues, stripping the reliquaries and treasures and burning and breaking the paintings that they could remove from the walls. The murals painted onto the fabric of the buildings had whitewash hurled at them.

The rioting and destruction continued until a great bonfire of Catholic treasure was finally set alight in the main square on Ash Wednesday. There can be little doubt that some of Holbein's work would have gone up in flames as part of it, and probably some of his brother's, too.

'When they decided to vent their wrath against the saints, both male and female, they assembled in the marketplace, with their brass crossbows in position, and spent several nights in the open air, having built a huge fire, and causing widespread panic... No statues were left in the churches, or in the vestibules, or in the cloisters, or in the monasteries,' Erasmus remembered. 'All painted images were covered over with a whitewash. Anything that would burn was thrown on the fire, what would not burn was torn into shreds. Neither value nor artistic merit ensured that an object could be spared.'[4]

Kleinbasel, over the river, had some time to put up a resistance. The small enclave, home to the Amerbachs, was strongly traditional and prepared to defend itself. On hearing the riots on the other side

of the Rhine, the residents of Kleinbasel barricaded the bridge and set up artillery positions. It took several days before, on 14 February, the iconoclasts broke through. However, as they marched on St Theodore's Church, which was opposite the Carthusian monastery of Margarethental where the Amerbachs had their family burial place, the mob met a counter force led by a local blacksmith. It was enough to stop another ransack. Agreements were made and the residents of Kleinbasel were given time to remove their treasures from St Theodore's and the adjacent monastery. If it had ever been there, this was surely when Holbein's *Dead Christ* would have been removed to the Amerbach residence, where it remained.*

On 1 April 1529 the council finally caved in to the will of the people and printed an order of reform. From this point Basel was officially a Protestant city. The members of the old religious orders quite literally packed their bags and left. The monastic community in the city dispersed and the cathedral canons headed for Freiburg im Breisgau, in Germany.

For Holbein this was a remarkable moment. If his sympathies essentially lay with the people, his income was dependent on the privileged. Over the next few days the men and women who had patronized him for over a decade crept away, fearful for their lives. Hans Oberried, who had commissioned his altarpiece from Holbein, went to Freiburg. Not surprisingly Jacob Meyer, for whom the artist had painted not just the *Darmstadt Madonna* but to whom he owed his earliest commissions, sought sanctuary there too. When Erasmus also left the city for the same destination there must have been no question that Basel would never be the same again.

'Everyone is aware of the storms that have for some time now been battering the city of Basel,' Erasmus wrote to Jean de Lorraine later

* In 1632 an English vicar called Sir William Petty was on the continent acquiring old master art for Thomas Howard, the Earl of Arundel, who was an avid collector of Holbein's work. Petty took instruction from Arundel's son Henry Frederick, Lord Maltravers, who in one letter wrote 'my Lord desires that you should endeavor in and about Bassill to gette things of Holben especially in a house which belonged to Amor Bacchus there being a rare dead Christ at length in oyle, with diverse heads and drawings of Holben and of other masters all now to bee sould, my Lord desires that you would buy them'. Though Maltravers fails to remember Basilius Amerbach's name, and instead offers an approximate classical title, there can be no doubt that he is referring to the Amerbach Cabinet and the house on the Rheingasse in Kleinbasel, where clearly the *Dead Christ* had remained safe but largely forgotten since the Reformation.

in 1529.[5] 'One convulsion follows after another. That was the reason why so many of its distinguished citizens left and imposed a sort of voluntary exile upon themselves, preferring to lose their material possessions rather than forego the pious observance of their beliefs.'

With the departure of the old guard, the entire character of the city changed. What civil liberties had once existed were removed. The populace found themselves in an authoritarian regime where observance of the decrees of the new Protestantism were policed.

When Holbein had returned home he had brought a memento of the More family with him – the preparatory drawing for his portrait of them. Kratzer had annotated it with all the sitters' names. It was not until September 1529 that Holbein made the trip to Freiburg to see Erasmus, taking the drawing with him. He discovered the scholar living in a grand property called the Haus zum Walfisch, or the Whale House, that the city had put at his disposal. Formerly owned by one of Maximilian I's advisors it had been graced by the emperor in times past. Amid these sumptuous surroundings, Erasmus remained as frail and as sensitive to change as ever, and complained about the costs that leaving Basel in haste had incurred. The wine was different, his feet were playing up, he needed more wood for the fire…

It was a thoughtful gesture by Holbein to bring the drawing of the More family for Erasmus to see. He may have even given the drawing to the scholar, since there is a suggestion in the latter's note to Margaret Roper that the work had been left in his possession. Erasmus was utterly delighted by the drawing's truth to life.

'I only wish that while I am alive I could see the friends who are so dear to me!' he wrote to More.[6] 'I have seen them in a manner of speaking in a picture Holbein showed me, which gave me very great pleasure.'

Erasmus was even more effusive in his letter to Margaret Roper.

I could scarcely find the words, dear Margaret Roper, […] to express the delight I felt in my heart when the painter Holbein brought your whole family before my eyes so felicitously that I would not have enjoyed a better view if I had been among you… Often a great longing comes over me that once more before my final hour I may have the good fortune to look upon that little society that is so dear to me… The painter's skillful hand has answered a considerable part of my prayer. I recognized everyone, no one more clearly than you. I imagined I was looking beyond the lovely exterior into the

brilliant and even lovelier mind within... Please give greetings to your mother, the estimable Dame Alice, [...] I give her portrait a kiss since I cannot embrace her in person.[7]

Holbein's visit to his old patron bore fruit. Holbein made drawings of the older man, his face more drawn, his hair more grey. These served for a series of new, small, painted portraits to be executed in two formats – one in a traditional rectangular cabinet format (that is, small enough to be enclosed by doors like a book or incorporated into a cabinet) and one in a more innovative medallion, or roundel, format.

The introduction of a painted medallion, or roundel, of Erasmus, would prove a very useful and marketable option for the Holbein workshop. A roundel of Erasmus that is in Basel's Kunstmuseum today is just over fourteen centimetres in diameter and therefore substantially smaller than Holbein's traditional portraits. However, it is still considerably larger than the smallest miniatures of just a few centimetres width, which were costly because they necessitated time-consuming work, using the finest brushes and magnifying glasses, and typically used expensive materials. This kind of roundel was therefore a compact, portable and less expensive purchase than a traditional large-format painting, and also cheaper than a tiny miniature. It could, however, still benefit from some of the novelty aspects of the miniature, such as a screw-on lid that might bear a device, coat of arms or an inscription.

Erasmus's friends and followers could commission these direct from the Holbein workshop. Certainly it seems that this is what one of Erasmus's friends, Conrad Goclenius, the theology professor at Louvain, did in 1531. When a correspondent of his, Johannes Dantiscus, Bishop of Culm, enquired about a portrait of Erasmus, Goclenius sent him his own painting of the scholar. The bishop returned the portrait, saying he had heard that there were more recent versions available. It seems an odd response to such a generous gesture, but scholarship has interpreted Dantiscus's actions kindly, suggesting that the bishop was embarrassed by his friend's generosity and was looking for an excuse to return the painting. However, Goclenius had the last laugh. A friend of Holbein's, he simply ordered one of the new versions as a gift instead, direct from Basel.

This new round of Erasmia must have kept the proverbial wolf

from the Holbein door, but there is no question that opportunity in Basel was even leaner than it had been before he left for London in 1526.

In 1529, under the new reformed regime, the council changed its complexion. Twelve members from the old guard had been fired and now a Protestant team prevailed. They appointed *Bannherren* – enforcement officers who were tasked with making sure that the citizens of Basel adhered to the new reformed religion and its required behaviours. Although these men had the power to excommunicate 'sinners', their initial work was to identify all those not attending the newly authorized communion. In fact these refuseniks were not just the city's traditional Catholics but also the orthodox Lutherans who diverged from the particular interpretation of the sacrament that Basel had adopted.

Basel had embraced a version of Swiss Protestantism based on the preaching of Ulrich Zwingli, who suggested that communion, taking bread and wine, was merely a sign or a remembrance of Christ. In contrast the traditional Catholics upheld the idea of transubstantiation, that the bread and wine actually became the body and blood of Christ during communion, and as such the bread and wine themselves were worthy of adoration. Luther meanwhile offered a paradoxical view that on the one hand insisted that transubstantiation did not mean that bread and wine transformed into the body and blood of Christ, but nevertheless suggested Christ was present in them.

In the summer of 1530 Holbein had been reported by the *Bannherren* for not taking communion. He was not alone. Many of the Erasmian circle still resident in the city, including Bonifacius Amerbach, had also been reported. In the notes taken in Holbein's case on 18 June it was recorded that, when asked why he was not attending, the painter explained: 'we must be better informed about the (holy) table before approaching it'.[8] Whether this was a genuine case of not fully comprehending the Zwinglian interpretation of communion or a convenient excuse designed to delay is unclear. By 26 June, when Holbein was called before the council to explain himself further, he clearly agreed to attend the reformed church, since his name appears on a list of those who 'have no serious objections and wish to go along with other Christians'.[9] It took the council another four years to persuade Amerbach to agree to the same.

This sparsely recorded incident raises the question of Holbein's religious orientation once again, and once again delivers little clarity. Was his initial reluctance a sign of him essentially sharing a similar stance to Erasmus, Amerbach and More – pro reform but still traditionally Catholic? Could he have already turned towards Lutheranism, as had the famous Dürer and his new friend Nicolaus Kratzer? Or was he purely pragmatic, bending with the political wind? Holbein had been massively influenced by Erasmus and his circle and had not long returned from the More household, and so it is tempting to think that at this stage he probably continued to share something of their approach to religion, that is a Catholicism in need of reform. However, he was also a pragmatist who had just invested in real estate in the city. Many of his patrons may well have fled, but Holbein needed to find a way of keeping his workshop open and so 'going along with other Christians' was a reasonable stance. However, there is much to suggest that Holbein would embrace a version of Protestantism in due course.

Certainly his concession to participate in the new Protestant communion in Basel immediately opened the door to more work. Suddenly the newly constituted council felt able to commission him to finish the murals in the town hall council chamber. On 6 July 1530 Holbein received the first payment for a mural that would include *Rehoboam Rebuking the Elders of Israel*, *The Meeting of Samuel and Saul* and *Hezekiah Ordering the Idols to be Broken into Pieces*. The relevance of these Old Testament tales in a reformed city was of course intentional, particularly the reference to iconoclasm.

The work took until November of 1530, when Holbein received his final payment. Other work recorded around this time includes his restoration of the town's clock face. The pickings were slim.

It is little wonder then that for Holbein a return to England, where work had been so forthcoming, was inevitable. Why it took him another year before he headed there is unclear. There is some evidence that the council was encouraging him to stay, since not long after he arrived back in England a letter followed from the new mayor Jacob Meyer zum Hirschen (not to be confused with the former controversial Jacob Meyer zum Hasen) offering him 'thirty pieces of money, until we are able to take care of you better'.

Another factor delaying his return to London may have been a

particularly severe epidemic of sweating sickness followed by plague there, news of which had certainly reached Basel. A virulent outbreak of sweating sickness had begun in the summer of 1528. Anne Boleyn had been affected but survived – unlike many. Erasmus's letters to Bonifacius Amerbach in late 1529 reveal a growing panic about the English disease, which had apparently spread to Germany at this point.

Then in 1531 news broke that the bubonic plague had also taken hold in London. Henry VIII had fled to Hampton Court, which he had acquired from the recently deceased Cardinal Wolsey.

However, by 1532 Holbein was back in England's capital. He hit the ground running, and in an entirely different vein from his first, exploratory visit. Whether by intent or circumstance he set up shop, secure in the knowledge that there was a new market for portraiture, as well as for Renaissance motif, or antique work, in which he also specialized.

However, the Mores' New Building was not to be his home this time around. That household had drastically altered from the one he had portrayed in 1527. In May 1532 Sir Thomas More resigned his position of power and with it the king's favour. He was no longer the fixer who could affect introductions at court or whose recommendations carried weight. The house that had hosted More's academy had become a place of tension and worry. This was all because of the king's 'Great Matter' – his desire to annul his marriage to Katherine of Aragon, and marry Anne Boleyn.

Since Holbein had left England, some slow progress in this matter had been made. The king had failed to secure the Papal dispensation required to declare his marriage to Katherine null and void, a failure that he laid squarely at the door of the man who had once been the most powerful figure in England bar the king himself, Cardinal Wolsey. However, Henry had found another way to achieve what he wanted by sidestepping established canonical procedure. With the aid of legal insight from a rising star, Thomas Cromwell, in 1531 Henry had declared himself the head of a new Church of England. Thus the foundations were laid for the English church to formally separate from Rome, approve the king's divorce and his marriage to Anne. For More, who remained a loyal Catholic, there was no future in this regime. He stepped away from power and prayed for a peaceful life.

He had lived life to the full during his moment in the sun, spending vast amounts of his wealth not only on the New Building and gardens at Chelsea, but also in looking after friends. Now More was reduced to modest means that would no longer stretch to the generous patronage afforded beforehand.

Holbein's other useful contacts were also waning. Archbishop Warham, whom Holbein had painted, would die on 23 August. John Browne, the King's Painter, alongside whom Holbein had worked in Greenwich, would be dead on 24 September 1532, handing over the ample home in Little Trinity Lane to the guild of which he was the head. Sir Henry Guildford would also shuffle off his mortal coil in the same year.

Technically London's Peynters and Steyners Guild forbad foreign artists to set up shop within the limits of the City of London; neither could 'straungers' join the guild, which was restricted to those with citizenship. Those artists working for the court were afforded some protection from these restrictions. When Holbein had been living with Sir Thomas More in Chelsea and on royal business at Greenwich he was working well within the parameters his English colleagues had established to protect their own livelihoods. Now, however, things were different. He needed to find a location for a workshop that would not breach guild regulations.

There are accounts of Holbein living initially in Mayden Lane, one of the old streets just south of the old St Paul's Cathedral.[10] This street was only known as such because of a sign for an inn or shop there. It was close to John Rastell's workshop at St Paul's Gate, but also to John Browne's home, and either could have shared their knowledge of available lodgings in the area. Significantly, however, it was very close indeed to the Steelyard – and the latter was an ideal location for a work premises.

The Steelyard was the Hanseatic enclave in London, just west of London Bridge. It was an area around what is today Cannon Street Station, that stretched down from what was then known as Roperestrete to the Hansa's docks – known as Easterlyngeshalle Key.[11] It was bounded by Dowgate on the west and All Hallows Lane on the east. It was effectively a unique gated community, one of London's long-lost wonders.

The Hanseatic League, established in medieval times, was a con-

federacy of Germanic merchant guilds that had grown to monopolize maritime trade in the Baltic and North seas. The Hansa had huge armed fleets of such a scale that they were capable of waging war, and had done so successfully against England in earlier times. As a result the league's London trading post had secured unique privileges, had a very particular character, and was a liberty, outside the city jurisdiction.

The Steelyard was surrounded by extremely high walls protecting the precious stuff in its warehouses from London merchants who resented the massive share of the city's import and export trade that the Hansa's members, or 'Easterlings' as they were known, had secured.

Once through the Steelyard's fortified gates England was left behind and one entered what was effectively a German colony. Self-governing, it was a tax haven exempt from the standard tariffs and custom duties applied to others. The language in the Steelyard was largely German, and here 'Easterlings' were busy applying their metal seals of certification to the bundles of cloth, fur, wood and whatever else that had just come off their ships. Unlike the ostentatious merchants that one might see elsewhere in Europe, the Hansa chose to dress in modest luxury; simple clothing made of the finest plain material. This, they considered, was a sign of their reliability and sensible wealth management.

For Holbein the Steelyard was a reminder of home. In addition to its substantial warehouses and counting houses, there were German wine cellars selling Rhenish wine, and inns with familiar beers, German pastries and smoked meats. There was a guild hall, a German chapel and residential accommodation for four hundred or so men. The Steelyard even had a small garden planted with fruit trees and vines, and a summer house looking onto the river.

The Steelyard was also a terrific informal brokerage for business, particularly in precious goods and high-quality design. Some Easterlings supplied armour and weaponry to the court, while the German and Netherlandish goldsmiths popular with the king and his entourage were also in touch with those importing fine metals and jewels from Antwerp and elsewhere.

Holbein's German nationality would have recommended him as someone who might hire premises in the Steelyard. Holbein's friend Nicolaus Kratzer was a member of the Company of German

Merchants based there.[12] It also happened that Holbein's contact John Godsalve had just been appointed to the Office of the Common Meter of Precious Tissues – an establishment that had sight over the valuable fabrics such as cloth of gold imported into the Steelyard. Godsalve would have been regularly at the Steelyard, and once again able to help ease Holbein into the community there.

This is perhaps why in the Royal Collection there is a very thorough, coloured drawing of Godsalve, dating from this moment. It was perhaps a preparatory piece for a more substantial portrait in oil that has since been lost. It is a striking piece not only because of the extent of its finish, but also because although Godsalve is seen in three-quarter profile, he offers a sharp and direct look from the corner of his eyes, straight at the viewer.

The question is, why did Holbein work up a preparatory drawing of Godsalve to the extent of colouring the background, block colouring Godsalve's clothing and even providing detailing on his hands? In most preparatory work Holbein only records detail on the face, providing

Hans Holbein, John Godsalve, black and red chalk, ink, bodycolour, and white heightening, on pale pink prepared paper, c.1532.

the merest hint of colour to the facial features and barely indicating other aspects of the sitter's clothing and hands. So it seems likely that Holbein worked up this preparatory drawing so it could be included in a catalogue or portfolio he could then show to potential clients as evidence of the quality of his work.

Holbein set to work designing a new version of his coat of arms too, possibly to hang on a sign outside his workshop. Tiny but well-evolved sketches today in the British Museum show him trying different decorative settings for the ox head and a star.

The merchants of the Hansa quickly took advantage of the Holbein workshop. There is a distinct group of portraits of them that Holbein painted across 1532 and 1533 that reveal how fast the appetite for his work spread among this particular expatriate community. Recent scholarship has convincingly suggested that a significant motive was a desire to send their portrait back home to be remembered to their families overseas.[13]

It is worth reflecting again on the effect these portraits would have had on the loved ones receiving them. The sixteenth-century people viewing Holbein's work would have likely experienced it in a much more substantial and intense manner than those looking at portraiture

today. Then, the novelty of portraiture was huge, and Holbein's exceptional ability to convey the image of a loved one with what is today recognized as near-photographic accuracy was nothing short of miraculous. No wonder Erasmus revealed how he kissed Holbein's portrait of Alice, Lady More, since he could not kiss her in the flesh. For a culture that had been raised on the practice of contemplating devotional imagery as a means of growing closer to holy figures, there would perhaps be an instinct to contemplate a portrait with a similar sense of communion.

Many of the portraits Holbein made of the Hansa merchants share something with the portrait he made of Godsalve, again suggesting that the latter may have provided a prototype for this group of work. The sitters look straight out at the viewer, making a direct and profound connection, some adopting the same sideways glance that Godsalve modelled.

The most elaborate of the Hansa portraits to survive is that of Georg Gisze, made by Holbein very shortly after he set up shop, at a moment when he was keen to show the full range of his abilities to encourage business. The picture also shares some similarities with the portrait of Nicolaus Kratzer that Holbein made a few years earlier, in that it displays Gisze surrounded by items that are indicative of his trade.

Hans Holbein, *Georg Gisze*, oil on oak, 1532.

For Holbein both the Kratzer and Gisze portraits mark a developmental step. His portraits to date were characterized by their decorative framing, achieved through either architecture or curling foliage, or both. The references to the sitter's identity were slight – a ring, an inscription, and in the case of Anne Lovell, decipherable symbols. But now Holbein placed his sitter surrounded by objects, each one providing a layer in a rich narrative description.

It is not just the influence of the Kratzer portrait, but the man himself that is felt in the manner in which the items surrounding Gisze define, contextualize and, if you like, locate the sitter. In Kratzer's inscription on his sundial in Oxford he uses a number of coordinates or points of reference to memorialize himself. One coordinate is his own origin – from Munich. Another is the year in which he made the sundial at Oxford, and just in case a numerical definition of a year does not jog the memory clearly enough, he characterizes the year by citing his contemporaries in the city. In this way the reader of

the inscription has a number of references by which to plot or locate Kratzer in the map of human history. Taken all together Kratzer is providing a kind of mnemonic to aid his memorial. That there are shades of astrology, astronomy and map making in this mnemonic system is hardly surprising given Kratzer's profession.

The portrait of Gisze employs exactly the same kind of coordinates, though these are a mixture of visual, written and aural devices. The man is shown in his office, letter in hand, seated at a table covered with a 'Holbein carpet'. Gisze is beautifully dressed, wearing ample, pink silk sleeves and a low-necked black coat. His thick, wavy hair is neatly cut below his ears, but still barely contained beneath his velvet hat. On the index finger of his left hand he has two thick gold rings, and he is opening a letter with a silver coin held between the thumb and index finger of his right hand. The wall of his office is panelled and painted green, and behind him are well-stocked shelves, as well as strips of wood pinned to the wall and used as letter racks. On the shelves are books and boxes. Hanging from them are scales, weights and measures as well as signet rings and keys on hooks. An ornate, spherical string dispenser hangs from the shelf to his left. On the table in front of him is a fine glass vase filled with flowers, a small clock, writing equipment, another signet ring and a pewter stand with sealing wax and seals.

Holbein provides plenty of written material in the first instance to help identify and locate the sitter. A cartellino tells the viewer that here is 'Georg Gisze [...] showing his features; how lively his eye is, this is how his cheeks are shaped. In his 34th year anno Domini 1532'. This rather playful note about his good looks suggests that the portrait is perhaps being painted for Gisze's betrothed. Just three years later Gisze was back home in his native Danzig and married to Christine Kruger. Perhaps these rather sentimental observations about his features are Kruger's own, expressed in a letter that can be seen barely concealed inside the breast of his coat? As if to emphasize the romantic aspect of the painting, in the glass vase in front of Georg are three pink carnations, the flowers symbolically associated with lovers. A sprig of rosemary is included alongside, a herb associated with remembrance. Holbein has also included a stem of a flower commonly known as 'Good King Henry', thus providing a second reference to the period when Gisze was in London.[14] In his hand is a letter from his brother

conveniently addressed to him in London. So more coordinates are forthcoming. This is Georg Gisze, resident at London, in the reign of King Henry, in 1532. Given that the spellings of people's names at the time would vary, Holbein has also been careful to reveal several different versions of Gisze's name in the correspondence on the letter racks. He is also Ghyszen, Gyssze and Ghyszin. So here we have him, described and located by place, time and by the variants of his name.

Next Holbein tells us more about the sitter by using symbolic objects. Once again there is a clue in the flowers held in the vase. Included here is some thale cress which is perhaps intended to evoke an aural clue – the German silver coin was known as a 'thaler'.[15] Georg is a merchant banker.

The hand of Kratzer is perhaps strongest felt in the inscription on the spherical string dispenser in the right-hand side of the painting. Apparently made from metal and enamelled, it bears the inscription EN HEER EN. A heer was the medieval measurement for yarn, and as such it seems an apposite label for an instrument that dispenses it. However, the unravelling of yarn next to the sitter, much like the clock on his table, is surely a reference to passing time and mortality. Perhaps the medicinal properties of the plants in Georg's vase are a response to this? After all, alongside their symbolic associations, in the practical world they were all considered efficacious in warding off plague, which was, of course, once again a threat to those living in London in 1532.

The inscription on the dispenser may also have a playful aspect, and reference other words, some written, others spoken. The written word '*Heer*' in German refers to a band of men, an army, and in this respect could indicate the Hanseatic League of which Gisze was a part. When spoken 'heer' invites us to 'hear' its aural variations. One of those is 'here', which may position Gisze in England (En). Gisze also has a notable amount of wavy *hair*, and again this may be intended. It also sounds like the German word for gentleman, *Herr*.*[16]

Finally 'heer' is also related to the number nine in Pythagorean numerology. It sounds like a pronunciation of the two letters I and

* One can go on and on. Some have suggested that one might read 'in here', as 'in the painting', or as 'inherent', that is the essence of the subject contained within the painting. Above all, it is a partial sentence that Holbein invokes the viewer to complete.

R (ir) that Pythagoras associated with nine – a number to which he ascribed both positive and negative values. People whose numerological number is nine are on the one hand inspired by wealth but on the positive side can be generous and philanthropic.

The yarn dispenser which appears on the right of the painting is balanced on the left with scales, and Georg's own personal inscription 'Nulla Sine Memore Voluptas', or 'No joy without sorrow'. As such there seem to be visual prompts inviting us to remember that in life one must expect a balance of ups and downs.

The success of the Gisze portrait was clear. Other members of the Hansa quickly put their hands in their pockets, though notably other extant portraits are much simpler, more often than not featuring the sitter against a plain backdrop and with perhaps just one or two associated items in view. Hermann von Wedigh, framed against a rich blue, glances out at his family from the corners of his eyes, much like John Godsalve; another member of his family is depicted fully frontal, face on, with penetrating gaze, as is Cyriacus Kale. Kale, like the von Wedigh men, has his gloves in one hand, that device Holbein had experimented with in the More family portrait. The portrait of Dirk Tybis has some of the elements of the Gisze picture: letters that locate the sitter, writing implements, sealing wax and a box of seals. One portrait that diverges a little is the portrait of Derich Born, who is offered a more Italianate composition, leaning on a stone parapet and framed by fig leaves in the background, decorative elements that Holbein had also used in his earlier portraits of the lady with the squirrel and the Guildfords. This all supports further the idea that Holbein had a catalogue, or portfolio, based on past works that was not just used to provide evidence of the quality of his work, but also offered a kit of parts to his clients. Would his sitter like to be holding gloves? Would he prefer the plain background or perhaps the fig leaves? Would the sitter like the king's astronomer to work with Master Hans to provide a more complex arrangement of conceits in the work? Inevitably different elements of the portrait came with a sliding scale of prices, based on the amount of work involved. Holbein would go on to make up books with his designs for metalwork, weaponry and jewellery for exactly the same reason.

Holbein's work for the Hansa did not end with portraits. We must

Hans Holbein, *Hermann von Wedigh*, oil on oak, 1532.

ANNO.1532. ÆTATIS.SVÆ.29.

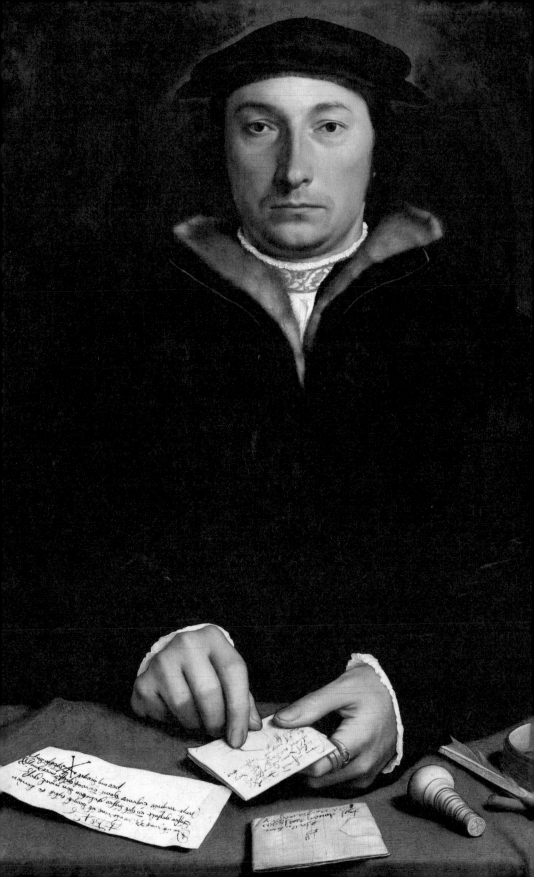

imagine a slew of work now lost. Among it were decorations for the dinning hall in the Steelyard, depicting a *Triumph of Riches* and *The Triumph of Poverty*. Today only Holbein's preparatory work for the mural exists. The moral of the triumph was that money is the root of all unhappiness, whether for the rich or the poor. That it was clearly painted in the costliest shimmering silver and gold against blue may have been an intentional layer of irony.

In addition to building up a presentation portfolio on arrival in England, and delivering murals that could advertise his services to the widest possible audience, Holbein would have also brought work with him. The fact that one of his latest cabinet portraits of Erasmus ended up in the possession of a courtier, Sir John Norris, suggests that Holbein selected items not just because they were portable, but because they would be quickly *saleable*. Erasmus remained a European superstar, an intellectual celebrity, whose face people wanted on their walls.

If Norris was buying from Holbein soon after the latter's return to England, other members of the Henrician court were quick to *commission* him, fuelling a fashion for his work that had not had time to properly establish during his first stay in London. With each new patron selecting a different format and composition one gets a sense of how Holbein served a reasonably broad market, with a combination of 'off the peg' and bespoke solutions.

Hans Holbein, *Dirk Tybis*, oil on oak, 1533.

At the most affordable end of his output are roundels. Typically with a diameter of just under thirteen centimetres they take off immediately, as the features of a young court official wearing red livery embroidered with H R (Henricus Rex) and dated 1532 testifies. In the same year Sir Robert Cheseman, a more senior member of the court and the king's representative in Middlesex, has himself committed to posterity holding a magnificent gyrfalcon, an incredibly valuable bird of prey. This work would have been a far more expensive commission. It is a piece that reveals Holbein's virtuoso ability to capture the texture of feathers by dragging his brush through the paint. In using this brilliant technique the quality of the painter's skill is a good match for such a fine subject. The result is the sophisticated realization that few men could own such a bird, but even fewer could paint it so convincingly.

Hans Holbein, *Portrait of a Man in a
Red Cap*, oil on parchment, mounted
on limewood, 1532–5.

Hans Holbein, *Robert Cheseman*, oil
on wood, 1533.

The ability to manage his work and direct his patrons' choices with a range of 'off the peg' options was imperative when demand for Holbein's work began to swell. The artist used other techniques too that not only speeded up output but also guaranteed that expectations raised by preparatory drawings were met. Many of Holbein's extant drawings are of exactly the same size as the finished portrait, revealing that he would transfer the outlines of his preparatory work onto canvas or wood to make up the finished painting, in the same way as he did in his paintings of William Wareham or Lady Guildford. And although there are modifications in some instances, such as removing Lady Guildford's cheeky smile, in others the finished work remains remarkably close to the drawing.

It is also clear Holbein used stencils to help him render decorative backgrounds quickly. The pattern of damasks on curtains and walls, the repeats in his carpets and even perhaps the curling fig leaves he liked to use may have been built up and modified from stencils.

One member of Henry's court who lived not too far from the

ROBERTVS . CHESEMAN

ANNO . D M̃

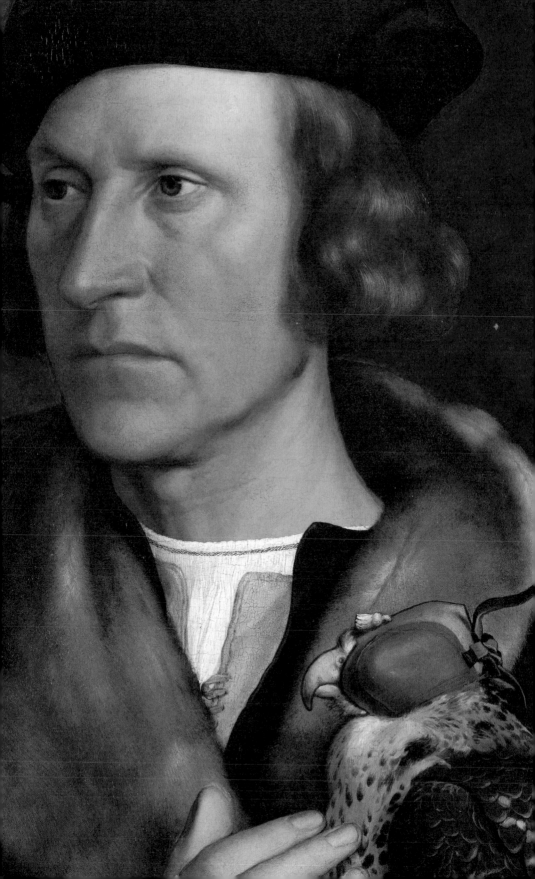

Steelyard was its rising star Thomas Cromwell. Just as the Renaissance was proving a moment when art could deliver social leverage to artists, the law was providing a similar means of social mobility for its most talented students. Cromwell, like Holbein, had a humble background. His father, a blacksmith, was not so far removed from Holbein's own family, routed in the crafts guilds. Cromwell's legal brilliance had made him highly valued by the king. Soon Holbein's artistic ingenuity would draw him close to the monarch. Both men were very much on the up.

Cromwell's home was Austin Friars, a ten-minute walk as the crow flies from London Bridge, less perhaps from the Steelyard. The precinct of the Augustinian monastery was a pleasant place to live. The monks tended large gardens stocked with vegetables and medicinal plants and herbs, and enjoyed considerable orchards. They had built comfortable housing on site too. Erasmus had lived there briefly in 1513, though characteristically complained about the home comforts – the wine was not up to scratch.

Hans Holbein, *Sir Thomas Cromwell*, oil on oak, 1532.

1532 was Cromwell's year – no wonder then that when Holbein arrived, almost on his doorstep, it was time to have his portrait painted by this new talent.

Perhaps he envisaged a work that friends would want to have copied for their own walls, in the same way Holbein's portraits of Erasmus and Sir Thomas More became reproduced among family and supporters.

Cromwell had been instrumental in securing the submission of the church in England to Henry's supremacy in mid May of that year, thus supplanting the Pope's authority. This submission, which had proved too much for Holbein's first major English patron, Sir Thomas More, would be the making of the man who would become his next one.

For Cromwell's role in this achievement the king awarded him the position of Master of the Jewel House in July 1532, and it is this event that is specifically alluded to in Holbein's painting. His portrait of Cromwell offers a fabulous insight into the man who has been widely considered the orchestrator of the English Reformation.

In terms of size the work is almost identical to that Holbein made of Sir Thomas More, a painting that Cromwell would have known well. This may be no coincidence. One can easily imagine a conversation

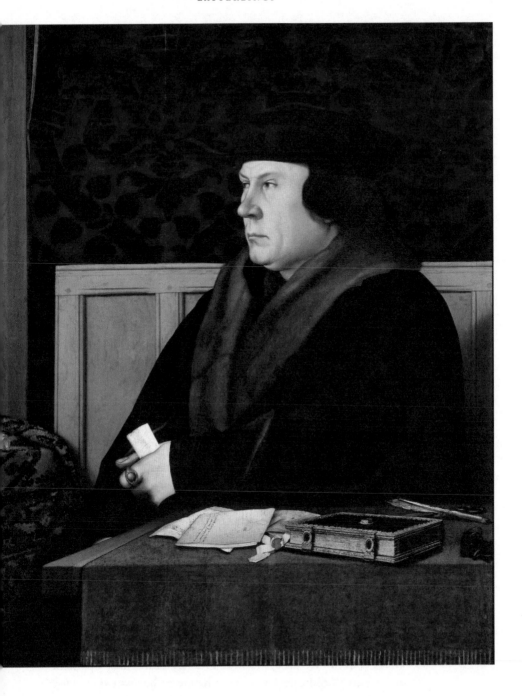

in which the artist asks what size Cromwell would like his image and the gruff response.

In other aspects the painting could not be more different from that of More. Cromwell is portrayed in three-quarter profile, and in contrast to the plastic, open-faced More, his is almost a caricature, the epitome of rigidity, his thin lips shut tight. His eyes, looking into a mid distance away from the viewer, feel all the more small since they are set in a solid, fleshy face, with a heavy double chin. The bridge of his nose is furrowed with wrinkles.

Although the three-quarter orientation of the sitter is indicative of some spatial depth, the painting feels very flat. The depiction of Cromwell seems to lack the verisimilitude of Holbein's other portraits, and this lack of dimension or vivacity in the work is enhanced by the huge swathe of damask stretched taut across the wall behind the sitter, offering a two-dimensional proposition to the viewer. Strong horizontal lines in the composition also compete with the painting's illusion of space. One horizontal is created by the table at which Cromwell sits. Covered in a plain green cloth which hangs over its edge, like the damask wall it offers the viewer a block of colour in the same plane as the painting. Another horizontal is created by the back of the rather plain wooden bench seat on which Cromwell sits. The overall effect is one of severity.

Cromwell makes sure that evidence of his new-found power is in full view. The green cloth on the table is indicative of his belonging to the king's inner sanctum, since 'The Board of Green Cloth' was a term applied to those senior court officials who met to discuss the royal finances. But far more important is the letter on it, addressed 'To our trusty and right well beloved Councillor Thomas Cromwell, Master of the Jewel House', apparently from the king himself.[17]

The plain tablecloth; the simple bench; the stern face. The severity of Holbein's portrait of Cromwell seems to suggest a man who wants to convey his success and means without resorting to ostentation, despite the fact that at this moment Cromwell had already begun to enlarge his 'home' at Austin Friars towards the 'palace' it would become in due course. Similarly the lack of any mitigating expression to soften, enliven or endear the sitter's frankly rather unsympathetic features seems to indicate a man very happy in his own skin. Here is someone who had found his way to the top of English society by

hard work, intelligence and a good measure of ruthlessness. This is the portrait of a man who does not care what he looks like and who is not much impressed by finery. He wishes to be measured not by what appears to be the case, but by what is actually the case. Despite his humble background and odd demeanour, he has the king's regard.

Does Holbein *like* Cromwell? It is only when one again draws comparison with his portrait of Sir Thomas More that one perhaps gets a sense of the painter's opinion here. More's portrait is a study in generosity. The open face, though with a rather serious expression, the ample curtains rich with tassels, the fulsome sleeves, all give an overall sense of bounty and liberality. In contrast the portrait of Cromwell is a study of meanness – or at the very least, economy. The meterage of the damask wall covering is not sufficient, and the material is stretched and pinned so tight it can be seen pulling from its frame. The bench could not be more basic. Cromwell's clothes have nothing to recommend them; they are the very minimum expected of his position. And yet, despite the tone of this painting, there is much evidence that in time Cromwell and Holbein would become very close indeed, professionally at the very least.

The work had its desired effect – for both parties. The existence of roundel versions at around eleven centimetres in width indicate that Cromwell commissioned more portraits based on this master portrait and handed them out to his loyal associates – his assistant Ralph Sadler, for example, or his equally faithful cousin Richard Cromwell. Or perhaps these members of the Cromwell camp had wanted to show their allegiance and appreciation by commissioning portraits of Cromwell themselves, directly from the Holbein workshop. Either way Holbein was the beneficiary in financial terms.

Cromwell had been for years part of Cardinal Wolsey's household. As one of Wolsey's men the younger version of Cromwell had used his excellent Italian to broker many of the deals with the Italian artists Wolsey promoted. Cromwell understood cultural currency. Now, he commissioned one of the new 'miniatures' from Holbein, probably at the same time as his main portrait. Now in the National Portrait Gallery in London, at just four centimetres in diameter it is probably the very first example of a portrait miniature on the same scale as those produced by Clouet and Horenbout by Holbein.

Examine a magnified version of this tiny depiction of Cromwell

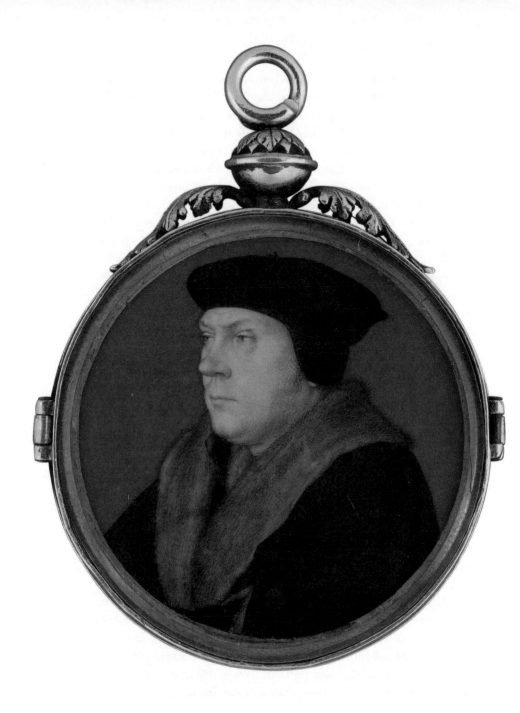

and one sees the individual hairs on Cromwell's fur collar; the greying stubble on his chin, his eyebrows and even eyelashes are delineated with astonishing care. The work has a brightness and vivacity that stands in contrast to the larger work in oil. Painted on vellum, the work is provided with rigidity by being mounted on a playing card. It is interesting that given all the options a deck of cards might offer, Holbein selected the ace of spades to back his little Cromwell. This may be a joke between the artist and sitter. Of all the men who would play a significant role in Holbein's life and career, it is unlikely anyone would match Thomas Cromwell for his ability to call a spade a spade. That Erasmus had coined that very phrase might not have been lost on either of the men.

Hans Holbein, *Sir Thomas Cromwell* miniature, watercolour and bodycolour on vellum, mounted on a playing card, 1532.

12

THE
AMBASSADORS

At the end of 1533, a very large item of personal luggage was manhandled onto a ship from one of London's docks, headed for France. It was a huge panel made of Baltic oak measuring more than two metres high and the same again in length, carefully padded, wrapped, tied, and marked up for the chateau of Polisy in the Champagne region of France. This mysterious cargo was the property of Jean de Dinteville, a young French aristocrat in the service of Francis I who had spent close to a whole year in London as the king's ambassador. Those handling this extremely large and heavy item may well have surmised it was a painting – though standalone 'easel' paintings were still relatively rare luxury items and scarcely known on this scale. But even if they had guessed that this was an exceptionally novel work of art, how could they have possibly known then what we know now, that Holbein's *Ambassadors* – because that was indeed the cargo – would become one of the world's most famous, mysterious, contested and beguiling paintings?

Today, after centuries lying forgotten at Polisy, *The Ambassadors* has made its way back to London, where it was originally painted in 1533, as the signature and date in Holbein's own hand testifies. It is a painting as famous for its oddity as for its genius. The huge work features two young ambassadors standing together, yet apart, at either end of a buffet. An enormous green damask curtain hangs behind them. On the upper level of the buffet, on a 'Holbein carpet', lie a number of astronomical and astrological items. At the lower level there is a lute, a globe and books. There is something awkward about the composition. It is as if the subjects (standers, not sitters, in this instance) have also been 'arranged' around these objects, their direct gaze challenging the onlooker to decipher what this strange collection of stuff might possibly mean. What is also peculiar is the fact that these two men are in the painting together in the first place. What kind of bond between them could justify commemoration in a painting of this scale and expense? It is perhaps why some have been determined to read the work as a barely concealed admission that the friendship between the two men was more than just that.

And then of course there is the weird *thing* that hovers between them. What looks like a huge baguette or some kind of fish bone (according to one curator of the painting) slants across the panel

Hans Holbein, *The Ambassadors*, oil on oak, 1533.

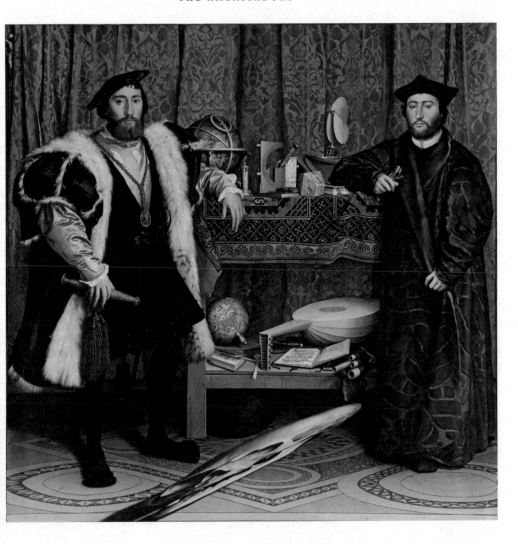

in a totally different plane of vision, floating in an imaginary space between the ambassadors and the onlooker. For years the purpose of this intervention in the painting had been lost, until its function was rediscovered. Here is a memento mori, a reminder of death and mortality, but one that is only understood when one views the painting from the extreme right-hand side. Only when looking intently from this position at the object does the ovoid brown sludge snap into proper perspective and reveal itself as hard, dead bone in the form of a human skull.

The ambassadors in question were both French. Of course de Dinteville was one, the other his friend and fellow diplomat Georges de Selve.[1] Jean de Dinteville, Seigneur de Polisy, was part of a successful family at the heart of Francis's court. Jean, along with his father and brothers, had the rare privilege of being the guardians of the king's children, his father and then his brother Guillaume responsible for the Dauphin, his other brother Gaucher responsible for Henri, and Jean responsible for the youngest son Charles. As such there is a strong possibility that de Dinteville knew Anne Boleyn, who had been part of the French court in her younger days.

Born in 1501, daughter of Sir Thomas Boleyn and niece of the powerful Duke of Norfolk, Anne had been sent abroad at the age of just twelve in service to Margaret of Austria, Regent of Belgium. When Henry VIII married his sister Mary Tudor to Louis XII of France, Anne was then sent to be part of Mary's household as she had already acquired good French. After the death of Louis, rather than returning to England Anne was retained by the French court and became part of the circle of Francis I's wife, Claude. She was close in age to the French queen and there is much speculation that the two became very good friends. She lived in those chateaux in the Loire that Holbein would visit in 1524, and was certainly there at the point that Leonardo da Vinci was enjoying Francis's patronage. In fact by the time she was twenty-one years old Anne Boleyn had spent nearly half her life on the continent and was to all intents and purposes French. Certainly she was culturally French, and certainly she was perceived as such, bringing French fashions back with her when she eventually returned to the English court in 1521.

There was a significant reformist circle in Francis's court, led not least by his sister Marguerite of Angoulême. Jean de Dinteville was part of this, along with the prominent biblical humanist Jacques Lefevre d'Étaples, whom de Dinteville appointed as tutor to the young prince Charles. Other members of a group who remained loyal Catholics but nevertheless saw reform in a positive light included Jean's brother the Bishop of Auxerre, and a rising star in French politics, Georges de Selves, the young Bishop of Lavaur, to whose father d'Étaples had dedicated his *Psalterium David* in 1524.

That Anne Boleyn may have adopted some of the views of this group during her residence in the French court is suggested by the fact

that she possessed a Bible in French, in a translation by d'Étaples, and would in due course work with de Dinteville to secure the release from a French jail of the humanist poet and reformist sympathizer Nicholas Bourbon, to whom she offered safety in England. Meanwhile there remains much debate to what extent she exerted influence over Henry, who, during his marriage to her, became more open to reformist thinking.

In 1531 de Dinteville would have re-encountered Anne Boleyn when he served his first tour of duty as one of Francis's ambassadors in England. By this point Henry was parading Anne as his beloved and would finally retire Katherine of Aragon to his palace in Rickmansworth, the More, that winter.

It is also likely that de Dinteville met Anne yet again the following year at Calais. In October 1532, during a period when France and England were once again seeking to strengthen their relations, Henry crossed the Channel with the apparent intent of discussing with Francis Turkish ambitions in Europe. Francis brought his sons and their de Dinteville supervisors to the meeting. Henry was godfather to Francis's second son Henri, and having helped secure the release of both Henri and the Dauphin from their hostage with Charles V, the English monarch was keen to see the young men in the flesh. However, when he took Anne Boleyn with him to these diplomatic talks, it was clear to the French that Henry was as interested in discussing Francis's support for his next marriage as anything else.

The trip proved unexpectedly eventful. When the royal party was delayed from returning to English shores by bad weather Anne and Henry had time on their hands. If Anne Boleyn had resisted Henry's sexual advances to this point, she certainly gave in to them now. By the new year she was evidently pregnant. On 25 January 1533 Henry married her in a ceremony so low-key that few members of the court were aware of it. Almost immediately after the event Jean de Dinteville was dispatched by Francis to London. Whether this was mere coincidence or not, by February he was installed in some comfort and at Henry's expense at Bridewell Palace, flanked by the Thames and the Fleet rivers just west of St Paul's.

French support was much desired by Henry, since he saw Francis as the man to lobby the Pope, whose approval he continued to seek despite his moves to remove Papal authority from the church in

England. Henry was worried about a popular rebellion on English soil if the Pope excommunicated him as he had threatened, and he could not have failed to notice Anne's lack of popularity. In a twist of fate de Dinteville's brother François, Bishop of Auxerre, was at that moment Francis's ambassador in Rome and would be the diplomat on the ground providing advocacy for the English king at Francis's behest. No wonder Henry, and Anne for that matter, would want de Dinteville well looked after.

Francis meanwhile wanted to keep Henry on side as relationships with his traditional enemy Emperor Charles remained hostile. The French king must have been sensitive to the fact that Anne was a useful Francophile who might be able to exert influence over the king in France's favour – a marked change from Katherine of Aragon, who was Charles's aunt.

In March 1533 Henry sent Anne's brother George Boleyn over to France to formally tell Francis about the king's marriage to his sister. Shortly after this Francis sent a special envoy in the form of Georges de Selve back to London, doubtless carrying a private message that could only be relayed by de Selve himself and could not be committed to paper. The message may well have offered some encouragement, because on 11 April, Good Friday, Henry told his parliament that he was married and that a coronation would proceed in due course. The following day Anne Boleyn appeared in all her majesty at mass at Greenwich. Decked out in an extraordinarily expensive cloth of tissue, dripping with diamonds and accompanied by a cohort of ladies in waiting, she was without doubt intended to be seen as a queen in waiting. And she was referred to as such during the prayers in the service.

From this point onwards, the court was thrown into preparations for a coronation of such ostentation and scale that it was clearly designed to force the message home to Henry's common subjects that, regardless of their twenty-year loyalty to Katherine of Aragon, and in spite of a general mistrust towards Anne Boleyn, the latter was now their queen. Thomas Cromwell was placed in charge of the arrangements. And much to Jean de Dinteville's dismay he too was required to play a significant role in the proposed pomp and ceremony, delivering a symbol of French approval as well as signalling Anne as a crucial hinge in Anglo-French relations.

De Dinteville's concern regarding this role he was required to play was twofold. First, he was terribly anxious about the cost of France's involvement in what promised to be one of the most lavish pageants ever staged. This was a cost that in the short term he would have to shoulder himself. He could only hope that Francis would reimburse him appropriately. Second, there was a genuine tension between France's covert encouragement of the wedding and Francis not wanting to be seen to overtly support rash actions on Henry's part. De Dinteville was executing a diplomatic balancing act. Expectations of him were high on both sides and he clearly fretted about how he was to meet them. But anxieties to one side, meet them he did.

On 30 May 1533 Anne, wearing cloth of gold and accompanied by the great men of state of the country, was conveyed along the River Thames from Greenwich to the Tower of London, with huge spectacle. The Lord Mayor of London, along with fifty barges all decorated with banners and bells, and with 'mynstrelsie', accompanied her own magnificently adorned vessel. Ahead of this flotilla, there was a brigantine kitted out as a dragon shooting fireworks from its mouth, with fire-eaters, monsters and 'wylde men' on board. Another boat had been turned into a great enthroned and crowned white falcon, surrounded by red and white roses. This realization of the queen's personal device carried young women singing and making music.

But it was on the next day that Jean de Dinteville played his part in public. On Saturday 31 May Anne was conveyed from the Tower through London to Westminster in an unprecedented street pageant. The narrow medieval streets had been covered in gravel lest any of the horses slip and rails had been put up behind which all the tradesmen of the city guilds were lined up. At the very head of the parade 'were xii frenchmen which were belongying to the French Ambassador clothed in coates of blue velvet with sleves of yellowe and bleue velvet and their horses trapped with close trappers of bleue sarcenet poudered with white crosses'.[2] De Dinteville himself came a little later on.

Following the French vanguard, the whole structure of English society was laid out. There were gentlemen, squires and knights riding two by two; the Knights of Bath in violet gowns; abbots, barons, bishops, earls and marquesses. Sir Thomas Audley the Lord Chancellor followed, with Edward Lee the Archbishop of York, and the Venetian ambassador. The Archbishop of Canterbury, then Thomas Cranmer,

accompanied the ambassador of France. All the English lords and ladies in the parade were clad in scarlet. Anne herself, her pregnancy well advanced, was dressed in the French style, in white cloth of tissue with a white ermine cloak over her shoulders. Her dark hair worn long, she was crowned with a bejewelled circlet of gold. Her open litter was covered in cloth of gold and the white palfreys bearing it had white damask coats that reached the ground. Knights held a canopy of cloth of silver, covered with tiny bells, over her head. Chariots containing the noblewomen of the land took up the rear. No wonder Edward Hall commented that the people of London had never seen the like.

However, things were not over. The coronation itself occurred on the following day, Sunday, in Westminster Abbey, and a huge feast followed. Then on Monday there was jousting and celebrations. For four days the most astonishing display of wealth, magnificence and English society cemented the king's equally astonishing creation of a new world order, one that enabled him to marry the woman he loved.

De Selve was back in France by the time the coronation was over. His visit to London, short though it was, had been much welcomed by de Dinteville, who mentions in his letters his delight in the former's company. Much to de Dinteville's dismay, however, he was ordered to stay in London at least until the new prince or princess was born. Effectively until close to the year's end.

De Dinteville expressed constant discomfort in London. His pre-coronation anxieties evolved as the year went on. Despite the apparent show of friendship embodied in those twelve Frenchmen riding at the head of the coronation parade, this visible endorsement of Henry's regime was putting a huge strain on Franco-Papal relations. Meanwhile Henry still had high expectations of Francis's ability to act as an advocate of the marriage. Shortly after the coronation, Anne's uncle, the Duke of Norfolk, travelled to France with the aim of joining Francis in a meeting with the Pope, Clement VII. However, before any meeting was secured, the Pope censured the Boleyn marriage and demanded Henry take back his first wife. Norfolk consequently returned home.

When in October Francis was once again due to meet the Pope, the English had become so wary of Francis's real intentions that Henry sent another envoy, Edmund Bonner, to intervene in the meeting and make sure the king's message was conveyed. Bonner managed

to threaten the Pope rather than persuade him, with results that led to genuine acrimony between Francis and Henry. Amid all this de Dinteville was attempting to rebuild trust and maintain relations between the parties.

It was not just the professional challenges of his job that weighed heavily on Jean de Dinteville. He was also ill for much of his stay in London with a kind of malarial fever. And he was failing to find entertainment to cheer him up.

In one letter to his brother he complained that his archery was not good, whereas falconry, which he clearly enjoyed, was not much offered him as an alternative. Against this background of stress, illness and a degree of boredom, the opportunity to work with Holbein to conceive a complex work of art must have provided a welcome distraction.

Holbein's portrait featuring de Dinteville and his fellow diplomat de Selve must have been planned in some rudimentary form at least in the few weeks the latter was in England, in April or May 1533, during which time Holbein could have made preparatory drawings of the bishop. It represents a considerable expansion of the model served by the portrait of Georg Gisze, that is one enhanced by items and symbolic references that locate the subject and elements of his biography in a specific time and place. There is little doubt Nicolaus Kratzer was involved in its conception, circumstantial evidence for which is the inclusion of astronomical items that belonged to him and also appeared in his own portrait by Holbein.

Like so much of Holbein's work, *The Ambassadors* operates on several levels, with ambiguities that offer different readings. But what is truly exceptional about the painting is the number of apparent interpretations of the work, and the consensus that it is a painting with messages that are still to be unlocked. What is evident is that it was intended as a conceit from the off, one that demanded an unusual level of involvement from the viewer. This was more than a portrait per se, it was a discussion point, a debate or a game that de Dinteville could initiate when introducing people to the work.

Having said this, there is one level at which the portrait can be fairly easily read, in just the same way that the Gisze portrait can be. Holbein offers a constellation of references that identify and contextualize his subjects. If you like, his painting offers a map that, properly followed,

tells you all you need to know about who he is painting, their status and the political climate when they were being commemorated. These coordinates position his subjects not only in a specific moment in their own biographies, but also in the wider history of events.

On the left stands de Dinteville. He is magnificent in a slashed pink satin doublet and sleeves. Over this he wears a tunic of black velvet, and a silk coat, lined with highly sought-after lynx fur. The neck of his white shirt is exquisitely depicted, with finely detailed white on white 'whitework' embroidery. Around his neck is the gold medal of the Order of St Michael, a chivalric badge of loyalty awarded him by Francis in 1531. On his black cap he sports a fashionable hat badge, within it a Vanitas – that is, a reminder of the futility of pleasure against the backdrop of human mortality – the depiction of a skull. Contemporaries may well have recognized this outfit as that worn by him to Anne's coronation. But there are more clues to help nail this man and the moment when he was captured for posterity. In his right hand is an ornate Holbein-type dagger, decorated with abundant Renaissance motifs and 'engraved' with an age: AET SUAE 29. This indeed corresponds with de Dinteville's age in 1533. A heavy gold tassel hangs from the dagger, which Holbein depicted using real gold leaf.[3]

To locate de Dinteville further, Holbein makes sure to give his origin. He is from Polisy, and this is legibly marked on the globe that Holbein depicts on the lower shelf of the buffet, just to the right of de Dinteville. There is surely some wordplay in the spelling of the place name as 'Policy' – after all, what do ambassadors do all day if not deal with just that? Certain other French cities are highlighted too: Paris and Lyons. The French court was still largely based at Lyons at this moment in time, while of course Paris also remained an important centre for court and state.

The globe has been customized further by Holbein to emphasize certain characteristics of the world in which his subject was living. Despite the globe lying upside down in the painting – a symbolic orientation, perhaps – the names of certain cities have been made legible: Jerusalem, Rome and Nuremberg, along with Paris and Lyons. Meanwhile red lines cross the map, dividing the world into geographic segments. Taken all together, the globe in an unusual orientation, certain cities coming to prominence and certain areas of the world being marked up, Holbein is describing a moment when maps, be

they intellectual, geographic or religious, are being redrawn. This globe suggests not only the intellectual Renaissance that characterized the age into which de Dinteville had been born, but also an era of discovery, exploration, and religious reform.

The intellectual map of Europe in 1533 is specific. Nuremberg is singled out, the intellectual heart of liberal Germany. Then Lyons, its French equivalent. The religious complexion of the world is also alluded to in these centres, since both had significant associations with Lutheranism. Meanwhile Rome marks the centre of the Catholic Church and Jerusalem is a symbol of Islamic puissance since it had been under the control of the Ottoman Empire since 1517.

Then there are those red lines, representing the redrawing of the world from a territorial point of view, in the era of discovery. One, which runs through Brazil and divides the Atlantic, reminds the viewer that the Treaty of Tordesillas in 1494 divided the Americas between Spain and Portugal. Another line cites the Treaty of Saragossa in 1529, which divided the map in the other direction between the same two super-explorers.[4]

If there is a suggestion that Germany and France are in the vanguard of intellectual developments, there is also an acknowledgement that in terms of the exploration of the physical world, the Spanish and Portuguese remain dominant. However, other elements of the composition serve to remind the viewer of the French and German attempts to chip away at this Spanish and Portuguese dominance of the New World and the associated trade and riches to be derived from commercial colonization. The globe that Holbein depicts is based on one produced in Nuremberg, made in the 1520s to assist German seafaring merchants wanting to open their own trade routes.[5] Similarly Holbein's globe singles out Brazil, marking it 'Brisilici R', a territory that France had attempted to make claims on since the 1520s.

So this is the complexion of a world that ambassadors, who deal in international affairs, must navigate as part of their daily political discussions. The rivalries and divisions they had to negotiate, be they the politics of religion, trade, or territorial claims, are perhaps suggested further in the book featured just below the globe. This is a book on arithmetic, written by Peter Apian and entitled *A New and Well Grounded Instruction in All Merchant Arithmetic*. It is held open by a set square at a page dedicated to division.

In a world defined by division, the ambassador must try to achieve harmony. And his attempts and struggles in this endeavour are indicated by the lute which lies close to de Selve on the lower shelf, a symbol of accord. The fact that the instrument in the picture has a broken string is therefore a sign of discord. In fact, in popular literature of the time the lute with the broken string had become an established symbol of the difficulties associated with political alliances. One man who really popularized this was Alciati, a humanist based in France who had published an *Emblematum*, or an emblem book, in 1531. In some ways a complement to Erasmus's *Adages*, Alciati's bestseller featured little woodcuts illustrating Latin phrases. The tenth emblem was the lute, and the accompanying text outlines its relevance to diplomatic alliances where if just one party to a treaty breaks away, the whole pact is ruined.* [6]

The lute was also a well-understood symbol of heavenly harmony, as its diagonal relationship with the heavenly globe on the shelf above serves to reinforce. And here Holbein, just as he asked us to 'heer' what he was saying in his depiction of a string dispenser in the portrait of Georg Gisze, is asking us to listen to the sound of the lute in this painting. Because when spoken out loud the English word 'lute', or the French word 'luth', both sound like the German pronunciation of 'Luther'. Martin Luther was strongly associated with the instrument; a trained musician, he was known to have played both the lute and the flute (a bag of flutes is also featured in the painting) and claimed that music was second only to theology for its ability to drive away the devil, melancholy and evil thoughts. The lute in this picture offers both a symbol of discord, *and* the balm to soothe it. It references the discord Lutheranism has visited upon the state of Christianity, but suggests that accord might also be achieved.

As if to hammer this point home, next to the lute a hymnal lies open with two of Luther's hymns clearly legible. Again, writing music was a passion of Luther's and he published hymns widely as

* 'Take, O Duke, this lute whose form is said to come from a fishing boat, and which the Latin Muse claims as her own. May our gift be pleasing to you at this time, as you prepare to undertake new treaties with your allies. It is difficult, unless the man is skilled, to tune so many strings, and if one string is not well stretched, or breaks (which happens easily), all the pleasure of the shell is lost, and the splendid song becomes absurd. So the princes of Italy join together in alliances: there is nothing for you to fear if your love remains harmonious. But if anyone withdraws, then, as we often see, all that harmony diminishes into nothing.'

well as some of the music for them. Of these Holbein has selected *Kom Heiliger Geyst Herre Goot*, based on the old Catholic *Veni Sancti Spiritus* traditionally sung at Whitsun, and both an expression of church unity but also a tribute to the Holy Spirit. The second hymn, *Mensch wiltu leben seliglich und bei Gott bleiben ewiglich*, incorporates the Ten Commandments.

The lute also has another role in this painting, one that specifically references Holbein himself. It is an allusion to his own success in advancing the science of drawing. Dürer had made an earlier drawing of the instrument in a manual on how to achieve perspective. He made a series of woodcut illustrations showing tools useful in the process of making art. One shows an artist using a wooden frame, or window, to render a foreshortened lute in a very similar position to that depicted by Holbein. It can be no coincidence that below his perfect rendition of a lute that sits so convincingly in the imagined space of the *Ambassadors*, Holbein presents his own exercise in perspectival anamorphosis – that skull that emerges only when viewed from an oblique angle. Whereas Dürer offered a means of portraying an object within the imaginative space of the painting, Holbein's skull projects beyond the painting in an entirely different plane of vision. In doing so Holbein goes beyond anything achieved before in the realm of perspectival art.

Doubtless still keen to recommend himself in France, Holbein would have been aware that Leonardo da Vinci had also illustrated anamorphic perspective to Francis I. Holbein was keen to be seen as the successor of both Dürer and Leonardo, and the reference to Dürer's hometown Nuremberg and the spelling of Lyon as LEON might also have been Holbein's way of suggesting that he had as much claim to the title of the modern Apelles as both of these artists.

And yet there is still more. Because perspective is not merely a science, it is also a point of view, or a cognitive realization. As Holbein forces the onlooker to participate in and interact with the painting to discover the skull concealed within it, the inevitable outcome is that as it emerges the figures of de Dinteville and de Selve diminish. As the skull comes into focus, the rest of the painting becomes peripheral. Apart from the shock that unsuspecting onlookers might experience as the skeletal form suddenly presents itself, Holbein is also suggesting that worldly attainments should be put into perspective, against a

wider universal scheme. Fine objects, grandeur and achievement, all fade when the reality of death emerges. In a major amplification of the vanitas de Dinteville wears on his hat, Holbein's strange anamorphic skull is an intentionally shocking reminder that human life is peripheral to the greater certainties of the universe, of which death is one.*[7]

As to de Selve, he is shown standing on the right, clad in a floor-length, fur-lined coat made from expensive damask. His age is also indicated as being twenty-five, inscribed on the closed pages of a book on which he leans. Of the two envoys de Selve is closest to the lute and its reference to Luther, and this seems apposite for a man known to have strong Lutheran sympathies, who sought to find a means of bringing the old and new Christian faiths towards reconciliation. In fact he had a track record in this area, having written a particularly conciliatory speech for the Diet – or ecclesiastic conference – held at Speyer in 1529.

Mindful of the personal coordinates Kratzer had inscribed on his sundial in Oxford, one wonders to what extent de Selve's inclusion in the portrait is as a further contextualization for de Dinteville. Kratzer referenced his contemporaries in Oxford as a means of locating the moment when he too was resident there. Does de Selve serve a similar purpose? Is his portrait a means of whittling down the moment the portrait depicts to that point in the spring of 1533 when both men were together in London? Given *The Ambassadors* ended up in de Dinteville's chateau in Polisy, one must assume that the focus of the painting would have always been more on Jean than his friend and colleague Georges. And it is true that Georges feels secondary in the painting. He is set back a little more than Jean de Dinteville; he is slightly smaller, and his position to de Dinteville's left is that traditionally associated with a wife in portraits. In heraldry, to the left is also the lesser side. Hence in the page known as Death's Coat of Arms in Holbein's *Dance of Death* a man and woman are featured in the same orientation as de Dinteville and de Selve, with the woman to the man's left. Between them is a skull.

If de Selve serves in part at least as a coordinate to locate the portrait of de Dinteville to the spring of 1533, then there are other devices to pinpoint time with yet more accuracy. On the top shelf of

* There is also the possibility that this image was intended as a pun on Holbein's own name, 'Hollow Bone'.

the sideboard is an array of astrological and astronomical instruments, all of which serve to tell time. From right to left are a celestial globe, a shepherd's cylindrical sundial, a quadrant, a polyhedral dial and a torquetum. The cylindrical sundial is clearly set to a specific day, 11 April 1533. Some scholars suggest that the other instruments are also indicating this date and a time around four in the afternoon.[8]

11 April 1533 was Good Friday, and this Easter date which commemorates the crucifixion of Christ is also alluded to in a crucifix hanging on the wall in the upper left-hand corner of the painting, only partially visible from behind the green damask curtain. Taken together with the anamorphic skull there is a clear message here about the inevitability of death, but equally salvation through Christ's sacrifice. So, working in an entirely different plane to the depiction of the ambassadors and their mundane concerns, is a spiritual or metaphysical message hinging on Christian faith.

One wonders how de Dinteville could afford such painting at a time when he was so anxious about his expenditure in London. It is tempting to suggest that the painting was therefore a gift. From whom? The identity of the person who commissioned the painting for de Dinteville is perhaps also indicated in the complex web of symbols that defines the work.

11 April 1533 was not only Good Friday, it was also the day that Henry VIII revealed his marriage to Anne Boleyn to his court. Anne's subsequent coronation at Whitsun is also indicated in the Lutheran hymn often sung at that time. The beautiful floor on which the ambassadors stand is widely considered to be based on the magnificent 'Cosmati' pavement in Westminster Abbey. This is a medieval floor, laid down by Roman craftsmen in the thirteenth century, who deployed a specific mosaic technique called Cosmati work, so named after one of the families who specialized in it. It was on this medieval mosaic floor that Anne was crowned. Another reference to Henry's second queen might be the lute, since she was known to play the instrument particularly well, and share Lutheran sympathies. Meanwhile one of the devices she used in her correspondence was a sphere, and again there are two in the painting.[9]

If commissioned by Anne, then the painting is an outright gesture of gratitude not only to de Dinteville and de Selve for their contributions to her coronation, but to France more generally for its apparent

support. It may well acknowledge her sympathetic ear to French matters. In 1532 the imperial ambassador in London, Eustace Chapuys, had moaned that Anne represented the French king's interests better than anyone else and the warmth of Anglo-French relations was largely down to her influence. The Easter message entwined with references to Anne therefore might suggest a moment of hope and rebirth for England from a French perspective, and from de Dinteville's and de Selve's personal perspectives a hope that Anne's reformist sympathies might be useful in their quest to find resolution between Catholic and Lutheran factions.

This author is not going to crack all the coded messages inherent in *The Ambassadors*. It remains one of the most complex metaphysical conceits ever wrought. Other students of the work have identified messages concealed in the painting's geometry, numerological codes hidden within it and even occult symbolism. Nevertheless, these mysteries aside, it still remains a portrait of two diplomats, the challenges of their roles in the complex and divided world of their time, and a celebration of their very latest mission in England. It acknowledges a world in transition, where there is nevertheless always hope for accord. It places the efforts of these two men against a broader cosmological or universal context, one which ultimately renders the lives of even powerful men relatively meaningless in the greater scheme of things, and in the face of inevitable death. And yet it offers hope through Christian belief.

If Anne did pay for the work, one has to ask how she may have become aware of Holbein's work. But this is not hard to fathom. She would have seen Holbein's pieces for the Greenwich festivities of 1527, of course. Cromwell, the other man who proved so efficacious in her cause, had been painted by Holbein a year earlier. There is also the distinct possibility that Anne had already availed herself of Holbein's services, of which more later.

Whether Anne commissioned *The Ambassadors*, and whether she had already had her likeness painted by Holbein, what is known is that in the spring of 1533 the painter was hard at work on another work of art directly related to her. It was a piece of public art that would be remembered as one of the wonders of Anne's coronation parade. This was the pageant paid for by the Hanseatic League.

Hall describes it quite clearly:

She rode to Gracious Church Corner where was a costly and marvelous cunnying pageant made by the marchauntes of the Styllyarde, for there was Mount Parnassus with the fountain of Helycon which was of white marble and iiii streams w'out pype did rise a ell hye and mette together in a little cuppe above the fountain [...] Which fountain ranne aboundantly Racked Rhenish wyne till night.[10]

'Cunning' is a word Hall has used before in relation to Holbein, and it is clearly a reference to a work of art that delivers an illusion, or visual trickery. Of course this is Holbein's hallmark, his deployment of sleight of hand to marvellous effect. Hall continues with a fuller description:

On the mountain sat Apollo and at his feete satte Calliope and on every side of the mountain satte iiii muses playing several instruments and at their feet epigrammes and poyses were written in gold letters, in which every muse according to her properties praised the Quene[11]

A preparatory drawing for the Parnassus pageant still exists in Berlin's Staatliche Museum. It draws on Holbein's love of Mantegna once again, since it uses the Italian artist's Madonna della Vittoria as a model for Apollo sitting on a throne, underneath an arched canopy, reaching out with his left hand. Apollo is sitting in a valley on Parnassus, with two steep slopes rising behind him on either side. Around him are gathered a group of women, muses, playing instruments. The group sits on a stage supported by three arches. Two heraldic shields are indicated on either side of the group and a fountain in the foreground.

The similarities with Hall's description and the preparatory piece suggest that Holbein's scheme presented life-size, or larger than life figures raised above the level of Anne's litter on a massive canvas curtain, or frame, that would have stretched the width of Gracechurch Street, and would have been on Anne's left as her procession turned right into the street from Fenchurch Street. It most likely enjoyed some actual depth as well as painted perspectival illusion, with a stage projecting forward on which a real wine fountain could operate, but with faux architecture details then painted on the cloth covering the stage. Certainly Holbein's sketch suggests the impression of coffered arches and ornate decorative elements around this structure.

A view down Gracechurch Street towards the river would provide a real vista and it is worth considering whether mountain scenery was set back to cover the view of the street's buildings, but nevertheless deliver a real sky. If so the depiction of Apollo and the Muses may have been on a fine semi-transparent cloth through which the mountains to the rear could be seen (certainly some kind of effect was achieved in this way with the ceiling at Greenwich). Or perhaps the figures were cut out and mounted in front of the mountains. These are all akin to matte painting techniques once used on film sets where paintings on glass, inserted in front of a camera's lens, block out certain elements of a location, and allow staged features to be swapped in. Holbein's drawing does suggest something like this since he had omitted to detail a sky and has provided a very hard, definite edge around the valley.

The Hansa had showcased Holbein's work from the moment he returned to English shores. The French ambassadors had seen what they liked and patronized him further, in doing so enabling one of the most astonishing expressions of a Renaissance point of view. With the aid of expatriates living and working in a diverse, cosmopolitan city, Holbein devised some of the most vivacious depictions of young men of his era. But with a new, fashionable queen on the throne, under whose beady eye Holbein had already been fixed, it was to the opposite sex that Holbein turned next.

Hans Holbein, *Apollo and the Muses on Parnassus*, black ink and watercolour on brown paper, 1533.

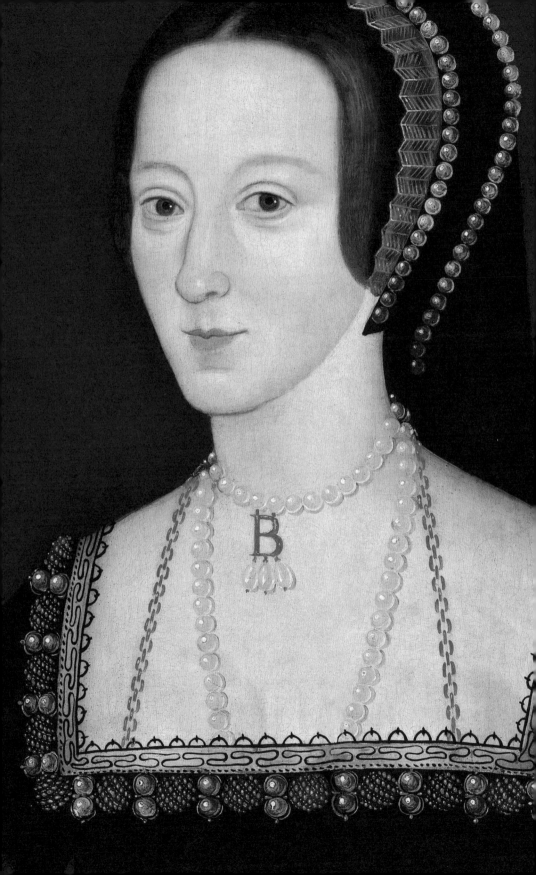

ANNA
BOLINA
REGINA

H olbein draws Anne Gainsford in a French hood. You would expect this of a woman who had been with Anne Boleyn for so long – to have adopted her signature headgear. The French hood is rounded, a crescent that sits towards the back of the head and reveals the scraped back hair. It is lighter and more revealing that the English or gabled hood, which sits on top of the forehead and rises like a little pointed roof to frame the face.

Since his return to England Holbein had devised a new approach to drawing, preparing his paper with a pink tint to provide a ready-made base flesh tone. On this specially prepared paper, Anne is depicted straight on. This relatively unusual presentation suggests perhaps that she is sitting for a miniature, a technique of which Holbein was now master. For the man who holds her tiny image in the palm of his hand, this fully frontal aspect makes sense. He can gaze directly at this reduced version of his true love and she can gaze straight back. But Holbein, ever the innovator, captures her in a moment of thought, her eyes sinking down in inward reflection, or perhaps deflecting the full force of her lover's ardour.

previous page
Unknown artist, *Anne Boleyn,*
oil on panel, based on a work
*c.*1533–6.

Hans Holbein, *Anne Gainsford,*
black and coloured chalks, and
pen and ink on pale pink
prepared paper, *c.*1533.

Her hair is vivid, a vibrant strawberry blonde that comes close to pure orange. Her lips are the colour of peaches. Her eyes are a slate blue. She is really quite beautiful. She was wearing black velvet when she sat for Holbein – he notes the costly material. Her waist is taut and small, contained in a conical-shaped bodice, part of her kirtle, or gown. The neckline she wears is square and exposes her décolletage. An ornate gold chain is wrapped around her neck. On her bodice is a large oval brooch decorated with a figure, probably classical, just hinted at in the sketch. This was the fashion among Anne Boleyn's ladies in waiting. So many of them are very similarly clad, with a large brooch placed in the same position.

Anne, or Nan as she was affectionately nicknamed, was with Anne Boleyn from about 1528. The two were close. So close that Anne felt she could lend Nan *The Obedience of a Christian Man* by William Tyndale, hot off the press from Antwerp. This book, published in 1528, could only have been smuggled into the country, probably through the Steelyard. That Anne Boleyn had a copy suggests either her reformist sympathies or her sense of intellectual inquiry, or both. It also suggests

a level of bravery, some might say recklessness, in acquiring books that could be seen as heretical. Indeed, for those seeking to dent the growing power of a woman who had captured the king's heart, her possession of such texts was most useful. For a man like Sir Thomas More, ever the scourge of Protestants, this book was barely short of heresy. Within a year he had published his own repost to it, a *Dialogue Concerning Heresies.*

However, it was not More who discovered Anne's copy, it was Cardinal Wolsey. Somehow between Nan Gainsford and Sir George Zouche, the man who would become Nan's husband, the book found its way to the then Archbishop of York. Wolsey was set to use the book against the king's sweetheart, but in a move that signals her own strategic and political nous, Anne Boleyn took it to the king herself and suggested he read it. Could Anne already have sensed that its contents would prove useful? After all, one of the ideas in the book was that rather than the Pope, the king of a country should be the head of its church. This surely influenced Henry's own Act of Supremacy, finally brought in in 1534? This Act confirmed him as the Supreme Leader of the Church of England, a status he had essentially acquired a couple of years earlier with the Submission of the English Clergy to royal assent.

The Act however went further than establishing Henry as the head of the English church, since it also required his subjects to take an oath recognizing the validity of his marriage to Anne Boleyn.

Sir Thomas More had failed to attend Anne's lavish coronation, a fact which had of course been noticed. When he refused to take the oath that the 1534 act required he was arrested and imprisoned in the Tower of London. More was subsequently tried. Despite his brilliant defence, it was the evidence of the solicitor general and Cromwell's ally Sir Richard Rich, almost certainly fabricated, that determined a verdict of treason and More's subsequent execution in July 1535.

More apparently never lost that wry sense of humour that he shared with Erasmus. His very own sense of folly. Even in the moment of death, the condemned man summoned his gallows humour. He moved his long beard carefully to one side when he placed his head on the block, explaining that it was not his beard that had offended the king. The lovely house and gardens at Chelsea were impounded and given to Sir William Paulet, a man who presided at More's trial.

Holbein must have watched on in horror at the fate of the man

who had shown him such kindness. Since Holbein's arrival in London there had been constant burnings of heretics (Protestants), and the hanging, drawing and quarterings of those who were deemed to have committed treason (those who refused to take the King's Oath or acknowledge his Act of Supremacy). A glance at the chronicle of a contemporary observer, Charles Wriothesley, across the early 1530s seems less an account of the times and more a list of those executed by the king. In 1534 and 1535, for example, Wriothesley draws attention to the prominent executions of: the popular nun Elizabeth Barton – the 'Holy Maid of Kent' – and the group of priests and laypeople who formed an entourage around her, all hanged at Tyburn for denouncing the king's divorce of Katherine of Aragon; John Houghton, Robert Lawrence and Richard Reynolds, three priests hung, drawn and quartered for refusing the King's Oath; and then in 1535 twenty-two 'diverse dutchmen and women' of whom half were burned and half exiled for heresy.

Of course, Wriothesley's list was far from complete. In fact Houghton, Lawrence and Reynolds were leading Carthusian monks, Houghton from London's Charterhouse, Lawrence of Beauvale Priory and Reynolds from Syon Abbey. They were accompanied to their horrible deaths by Augustine Webster, the prior of Axholme, and a secular priest called John Haile in May 1535. A month later three more London-based Carthusians were bound upright in chains for a fortnight before meeting their grim end. One, Sebastian Newdigate, a former courtier and member of Henry's privy chamber, had been a personal friend of the king. And these were just the tip of the proverbial iceberg.

A former friendship with the king was not a guarantee of pardon, as More and many others in due course would discover. If anything those closest to the king were most under scrutiny. The persecution of the Carthusians was deplored in Catholic Europe. But the execution of More was considered particularly shocking at home and abroad. Surely Holbein sensed the irony that the success he was enjoying in the era of Anne Boleyn was in no small part down to More's initial good offices. Yet for a man who had seen his fellow painters on the point of starvation in Basel, who had seen many guild members turn their hands to mercenary warfare to top up their poor incomes, Holbein still sat down to paint Sir Richard Rich, the man whose testimony had

The Lady Rich.

sent More to his death. Art was a business, after all.

If there are clues to Holbein's view of his sitters one has to look hard. The economy apparent in the portrait of Cromwell compared to the generosity in that of More is one of the rare instances when one senses the painter's personal sympathies. In his preparatory drawing of Rich one cannot quite sense dislike. The drawing is simple and to the point, an open, clean-shaven face, a mouth shut, his outline captured in single ink line. The most one can say is that it conveys a solemnity that could verge on pomposity. However, it is in the preparatory sketch of Rich's wife where Holbein relishes a small detail in a manner that could certainly be deemed unkind.

Elizabeth Jenks married Sir Richard Rich in 1535, the year in which Sir Thomas More died, and the pendant portraits Holbein made of the couple were most likely to celebrate this union. Holbein's drawing of the new Lady Rich reveals she was a large woman, but unlike the equally ample Lady Guildford who is so evidently lovely in her plumpness, Holbein does not see any positives in the bloated features of this sitter. In fact he goes out of his way to draw a mole on her chin from which protrude a number of thick, dark, wiry, curling hairs. The original portraits of the Riches no longer exist, but two workshop copies of the depiction of Lady Rich are extant – both of which reveal that the offending hairy mole was not in Holbein's finished work. It is as if its inclusion in the study was an indulgence for Holbein himself – a reminder of just how unattractive this woman really was compared to what would today be considered the final 'airbrushed' version.

Hans Holbein, *Elizabeth, Lady Rich*, black and coloured chalks, pen and ink, and metalpoint on pale pink prepared paper, *c.*1535.

As to More, did Holbein see his old friend again? The evidence suggests that despite his work for the faction in court responsible for More's downfall, Holbein nevertheless maintained his relationship with the latter's family. In the Metropolitan Museum of Art in New York two exquisite miniatures of More's daughter Margaret Roper and her husband William are dated to 1536, the year after Margaret had herself taken down the head of her decapitated father from its traitor's spike on London Bridge. The two Margarets, Roper and Giggs, are most closely associated with the final days of Sir Thomas More. Giggs, his one-time ward, visited him shortly before his execution. Both Margarets were waiting for him on Tower Wharf as he was walked to

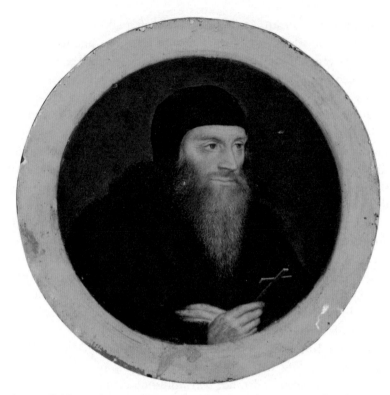

the scaffold, so they could embrace him one last time before he went to his death.

Some years later Giggs shared with the Catholic theologian Thomas Stapleton an image of More as he had been in prison, with a long beard and a pale face. It was a work executed with great skill, according to Stapleton's recollection. The question is, who had painted it? Had Holbein gone into the Tower to make a final portrait of a man who was quickly seen as a Catholic martyr and was ultimately canonized?

A miniature of Thomas More with a long beard and a face aged by imprisonment was auctioned at Christie's in 2018. Just over seven centimetres wide, it was in oil on baltic oak, a similar wood to that Holbein often used, probably sourced at the Steelyard. The work has exquisite detail, with individual grey hairs from More's head creeping out from under a simple black skullcap, and his beard depicted with equally fine observation. His lined face wears an expression of benign acceptance. Christie's attributed it to Holbein's circle.[1] It is of particularly fine quality. It is tempting to consider it based on an

original produced by Holbein himself during one final sitting with his friend.

One other circumstantial matter suggests that Holbein may have visited the Tower. More was not the only person locked up there. John Fisher, Bishop of Rochester and Chancellor of Cambridge University, had also been condemned for treason for the same refusal to take the oath demanded in the Act of Supremacy. Fisher was a friend and correspondent of Erasmus. He was close to More, too. For his contemporaries, his death was as shocking as that of More's, since not only was he widely acknowledged as a devoted Catholic, but he was also a senior figure in royal circles, whom the king had known since he was a boy. Fisher, as the chancellor of Cambridge University, had worked closely with Henry VIII's grandmother in establishing colleges, and he had given the sermon at Henry VII's funeral. In spite of this, Henry was so determined to secure the full endorsement of all his subjects in the matter of his supremacy that he made an example of the sixty-six-year-old bishop in death. After his execution – in June 1535 – Fisher's body was left on the scaffold, before being stripped and unceremoniously put in its grave. His head was also placed on a spike on London Bridge.

Hans Holbein (school of), *Sir Thomas More*, oil on panel, *c*.1535.

Holbein made a fine drawing of Fisher, in three-quarter profile, his face gaunt, his cheeks hollow, his coat collar pulled up high against the cold. Was this done in the Tower? There are of course other possibilities. It is just feasible that Holbein drew Fisher before his arrest in March 1533. It is also conceivable that he drew Fisher from an extant bust of the man made by the brilliant Italian sculptor Pietro Torrigiano, which is thought to have been housed in the Palace of Whitehall. Certainly Holbein produced a drawing of another clerical star – John Colet, the former dean of St Paul's Cathedral – from a Torrigiano bust around this time.[2] Whereas Holbein's drawing is faithful to the bust of Colet, his drawing of Fisher diverges, not only in the clothing which is arranged differently, but in the face itself, which is older and more harrowed. An adaptation to imaginatively age a subject would not have been beyond Holbein, of course. Similarly, if he did produce a new miniature portrait of More, rather than visiting the Tower he could have simply taken Margaret Giggs's verbal description to provide an adjusted image of a man's face he already knew well.

However they were achieved, Holbein's images of both More and Fisher became much sought after by Catholics who chose to remember, even venerate, the men after their 'martyrdom'. The National Portrait Gallery holds a pattern clearly taken from Holbein's original drawing of Fisher, used to reproduce the image. This pattern has been created by pouncing – a technique that Holbein and his contemporaries regularly used to transfer a master image, or preparatory drawing, onto canvas or wood. Tracing paper would be placed over the original image and small holes pricked along the key lines, often using a small instrument called a pounce wheel. The tracing paper would then be placed on the new surface and ground charcoal or chalk blown or blotted through the holes, leaving a series of guide dots for the artist. Though none of the finished portraits based on this pattern have been found it suggests the circulation of portraits of the deceased Fisher, presumably supplied by the Holbein workshop in London. To what extent the production of such a portrait would have been clandestine is unclear.

Hans Holbein, John Fisher, Bishop of Rochester, black and coloured chalks, brown wash, pen and ink, brush and ink on pale pink prepared paper, c.1532–4.

Similarly paintings of More became valued by England's Catholics, as is evidenced by a later, probably seventeenth-century, tiny devotional diptych comprising a copy of the miniature of More in the Tower placed alongside a miniature copy of Holbein's 1527 portrait of the man.[3]

While More, Fisher, and so many more perished under the new regime, others tied themselves to Anne's coat-tails and enjoyed heightened influence and privilege. Nan Gainsford, far from punished for her negligence with that controversial book, retained her proximity to the new queen as her portrait, probably drawn in 1533, suggests. In the drawing there is a faint outline of a carnation, a traditional symbol of love. She married Zouche around this time.

There is no extant painted portrait of Anne Boleyn by Holbein, a fact which seems extraordinary given the extent to which he portrayed her contemporaries. But then there are very few portraits of Anne Boleyn full stop. Such was the fury of Henry at the point of the collapse of their marriage, and her arrest and execution for treason, that evidence of his second wife was rather quickly removed. All those devices featuring white falcons or the initials of the king and queen entwined were hastily removed from the homes of England's

aristocrats, and Henry's palaces. It is no surprise that her portrait vanished too.

Two of Holbein's sketches have been identified in the past as preparatory drawings for a portrait of Anne Boleyn, but the identification is problematic in both. One, in the British Museum, shows a woman in an English hood in three-quarter profile. She has a longish nose, fulsome lips and pale blue eyes. Her hair, only just apparent, is dark. The identification of the picture as being Anne however dates only back as far as the mid seventeenth century, and descriptions of Anne suggest she had very dark eyes.

The other drawing is in the Royal Collection and features a woman in informal garments, wearing an under cap tied tight under her chin, and a fur-lined gown, which could be a nightgown. The identification of the portrait as being of Anne was made by Sir John Cheke, the tutor to Edward VI, who had known Anne, and his commentary has been taken as important evidence. The unusual intimacy of the drawing has also been accounted for by the fact that Anne could be rather liberal in the manner in which she received people. In addition, the king had given her a black satin nightgown during their courtship. While her full lips are reminiscent of the British Museum drawing, the woman in this image is clearly blonde, and Anne was by all accounts dark haired, which is genuinely problematic.

Hans Holbein, *An Unknown Woman,* possibly Anne Boleyn, black and red chalk, black ink, yellow wash, on pale pink prepared paper, 1532–5.

Some copies of a lost master portrait of Anne have survived, however, one in the National Portrait Gallery, another at Hever Castle. Both are inscribed with Anne's name 'Anna Bolina', and the Hever version additionally identifies her as 'Anna Bolina Regina'. Both portraits also reveal a woman wearing a pendant with the initial 'B' and the rounded French hood which Anne was credited as making fashionable in England. This depiction of Anne is different from a commemorative medal cast of Anne after she was queen featuring her wearing an English hood, a cross around her neck and the inscription AR (Anna Regina). These key differences between the painted portraits and the medal suggest that Anne had her portrait painted before her coronation, and probably before her marriage.

In September 1532 Anne was made Marquess of Pembroke by the king. Only once before in his reign had Henry created a peerage for a woman, when twenty years earlier he had made Margaret Pole Countess

of Salisbury, a gesture that sought to mollify his Plantagenet rivals. By making Anne a marquess, and endowing her with considerable property and incomes, Henry created the most powerful woman in the realm, a woman who was at that stage single, and still known by her own maiden name – Boleyn. It was a good moment to have a portrait painted and her jewellery bearing the initial B was fitting at this stage, whereas once married and crowned a pendant AR or AH would have been far more appropriate jewellery.

There is no evidence that the Hever or National Gallery depictions of Anne relate to a long-lost Holbein, and yet the gaze that looks straight out at the onlooker in both works has something of the directness of Holbein's Steelyard portraits of the same year. And of all the available artists in 1532 or thereafter, Anne is unlikely to have commissioned anyone other than Holbein.

Holbein drew a lot of the women who surrounded Anne. This in itself adds fuel to the notion that he had already made a portrait of the most powerful woman in England. The women in her entourage well understood the influence the new queen had, and their desire to be seen to follow her tastes and practices is obvious. These drawings, most of which are part of the Royal Collection at Windsor, were almost certainly preparatory sketches not just for roundels or miniatures, but some for full-size portraits, which have been long lost. Nevertheless one gets a sense of the finished works from the annotations Holbein made to remind himself of the materials and colours in which these women were clad, and the jewels which adorned them – all marks of status.

Hans Holbein, Anne Boleyn, black and coloured chalks on pale pink prepared paper, 1533–6.

What is clear from the portraits when considered as a group is the web of power Anne weaves in the court, rewarding her own family and thus securing her own influence. Holbein's drawings (More and Fisher excepted, of course) generally provide a commentary on people 'on the up' at the moment he drew them. Mary Shelton, later Lady Heveningham, is a case in point. She is Anne's cousin, and is depicted by Holbein in much the same attire as Nan Gainsford, though she wears the traditional gable hood. Like Nan she has a large, expensive medallion brooch fixed to her chest; again Holbein offers just the hint that this brooch is classical in character.

Mary's mother was Thomas Boleyn's sister. In the era of Katherine

Anna Bollein Queen.

The Lady Heuegham.

of Aragon Mary's parents, Sir John and Lady Anne, were doing well enough as local dignitaries. Based in Norfolk, Sir John Shelton was Justice of the Peace. But with the coronation of Anne, their rise is meteoric, and at the expense of the king's previous family.

In September 1533 Anne Boleyn gave birth to a daughter. The king had fully expected a son, to the extent that letters announcing the birth of a prince had already been written. These were now changed to announce a princess. For a man who saw through the lens of his religious beliefs, or at least purported to, the failure of Anne to provide a son must have felt like a reprimand from God. Nevertheless Henry suggested a male heir would arrive next. In the meantime the arrival of the Princess Elizabeth was celebrated across the realm.

Except in the Palace of Beaulieu, where Henry's first-born daughter by Katherine of Aragon, the Princess Mary, resided. When asked by her father to renounce her title as princess in favour of the downgraded style lady, she refused. As a result her father turned her out of her luxurious residence, removed her staff and incorporated her into her new sister's household. Doubtless at Anne Boleyn's suggestion, the Sheltons became her new wardens. Sir John Shelton was appointed comptroller of the house looking after the king's daughters, and his wife the Princess Mary's governess. It was a way for the Boleyn faction to keep an eye on a woman who many in the country still considered the first Princess of England and heir to the throne. Anne Shelton was not, by accounts, sympathetic to her ward.

Hans Holbein, *Mary Shelton*, black and coloured chalks, white bodycolour, ink, on pale pink prepared paper, *c.*1532–43.

More of Anne's immediate relatives benefitted from the demise of Princess Mary too. A portrait by Holbein would have been just the icing on the cake for Anne's brother Sir George Boleyn, Viscount Rochford, and his wife Jane Parker. They were gifted Beaulieu after Mary was moved from it and lived there amid ostentatious splendour. There is a Holbein drawing that is sometimes attributed as being of Jane Parker, who of course became one of Anne's ladies.* He draws a tiny waif, her features almost caprine, with pale eyes, wide set. There is a preparatory drawing at Windsor of a young man in a magnificent beret with a plume, gold aglets and badges, and a coat with a huge fur

* The drawing might equally be of Grace Parker, wife of Sir Henry Parker, who was ten years younger than Jane Parker.

collar that some have speculated might be George Boleyn. He wears a sparse beard, and Holbein makes a point of noting his chestnut-coloured eyes.

If the Boleyns saw their status inflate quickly with Anne's rise, the power of her mother's family, the Howards, was never in doubt. But Anne Boleyn's relationship with her uncle Thomas Howard, the 3rd Duke of Norfolk, was problematic. Norfolk was a staunch old-school Catholic and disliked Anne's reformist leanings and French ways. Unable to move her uncle, Anne made sure that she drew the younger members of the Howard family close around her – not least those among them who had enjoyed exposure to the French court and its culture, and as such had greater sympathy for her.

The teenage Henry Howard, Earl of Surrey, Norfolk's son and Anne's cousin, had been taken under the wing of the French king in 1532 and had enjoyed a whole year at his court before returning home. He had arrived in France as part of Henry and Anne's entourage for that important dialogue at Calais. Surrey was not alone in France.

Hans Holbein, *Grace, Lady Parker*, black and coloured chalks on pale pink prepared paper, 1532–43.

He spent his year there in the company of Henry VIII's illegitimate son Henry FitzRoy, the Duke of Richmond and Somerset. FitzRoy and Howard had been brought up together, were practically the same age, and great friends.

Surrey, a fiery character, was both a reformist and a keen intellectual. He was a fine poet, his vanity and strong sense of his own aristocracy meant he would sit for Holbein several times across his life, and the two may well have become friends. He had married a teenage bride, Frances de Vere, just before his French interlude and it is likely that the portraits Holbein made of the newlyweds were on his return in 1533. Again the fact they are full face suggests they may have been preparatory drawings for more intimate miniatures. Lady Surrey, again like so many of Anne's other female companions, wears a classical medallion pinned to her breast.

Anne succeeded in getting Henry Howard's sister, her fourteen-year-old cousin Mary Howard, married to FitzRoy shortly after his return from France, in November 1533. Serving as part of Anne's household she was also a noted reformer, despite her tender age. Holbein draws the new Duchess of Richmond and Somerset wearing a plumed black velvet cap rather than a 'hood'. As part of his drawing

The Lady Parker.

The Lady of Richmond.

of the new duchess's hat, Holbein explores alternative designs for how a monogram might be incorporated into it. He suggests a capital R made from pearls in one sketch, in another he toys with aglets or little gold ornaments all in the form of Rs sewn all over the cap.

Holbein's working designs for the new duchess's hat ornamentation suggests that he went on to design this bespoke jewellery for her. Might it have been delivered along with the painting? If so, Holbein created another delightful conceit for his clients, one which reversed the idea that art is nothing more than an imitation of life. In being handed her new portrait showing her not in her plain velvet hat but in one decorated with her new monogram R, and simultaneously receiving the very jewellery to adorn her cap, the duchess would *become like her portrait*, rather than vice versa.

The importance of jewellery in Holbein's portraits of both women and men should not be underestimated. Though of course jewellery remains admired and impressive today, it bears nothing of the significance it did in the sixteenth century, where it was a form of portable wealth, a badge of status, and a public projection of self.

Hans Holbein, *Mary, Duchess of Richmond and Somerset*, black and coloured chalks, and ink on pale pink prepared paper, 1532–3.

And jewellery was not restricted to necklaces, rings, bracelets and brooches – the opportunity to make practical buttons and fastenings from precious materials was fully exploited. This is reflected in the inventories of people's possessions at the time, where individual buttons, buckles, aglets and hat badges are noted and valued.

Henry, a man defined by his inability to do anything by halves, built up the largest and most splendid collection of jewellery of any monarch. As part of his magnificence he covered himself in precious stones and shimmering metals. Similarly he bestowed vast quantities of jewellery on Anne Boleyn, and her appetite for the new Renaissance style was clearly copied. As part of the solidarity of the women surrounding Anne, many of them appear to be wearing jewellery either designed by Holbein or in the new Renaissance style he made fashionable.

A book that was in the possession of Henry VIII on his death, known not surprisingly as the 'Jewellery Book', reveals the full range of Holbein's repertoire as a designer of fine Renaissance-style metalwork. Designs from the book, now in the British Museum, feature

Holbein's drawings for ornate tableware, clocks, dagger handles and sheaths, book covers, enamel work, chains and bracelets, lockets and monogram necklaces, pendants, tassels, sundials, rings, brooches, buckles and yes, even buttons. The book may well have been a record of specific royal commissions. Among them are designs for jewelled monograms entwining the letters H and A, probably indicating some of the many gifts Henry showered upon Anne Boleyn. With such royal endorsement, it is clear that Holbein quickly benefitted from a rush of commissions from other court members who wanted to be seen wearing what was considered *the* most exclusive jewellery.

What might the women that surrounded Anne be wearing in terms of the large enamelled or chased Holbein medallions on their bodices? Between the British Museum's 'Jewellery Book' designs and those Holbein took back to Basel during a trip in 1538, there are drawings for medallions featuring classical images such as the *Death of Dido*, and religious scenes such as *Lot Fleeing Sodom* or *The Penitent Magdalene*. All feature exquisite detail and animation. Then there are schemes for courtly vignettes; for example, one shows two kneeling lovers, a cup adorned with a heart held up between them.

Opposite and below left
Hans Holbein, designs from the 'Jewellery Book', 1532–43.

Hans Holbein, *Courtly Couple*, from the 'English Sketchbook', black ink over a chalk sketch, 1533–6.

Many of the women in Holbein portraiture wear ornate pendants around their necks, and once again these may well have been also conceived by the artist. Although German jewellers were already exporting Renaissance-style items to England, Holbein's variants

Hans Holbein, *Table ornament* from the 'English Sketchbook', black ink, over a preliminary drawing of chalk, on paper, 1533–6.

Hans Holbein, *Table ornament with caryatids* from the 'English Sketchbook', black ink, over a chalk sketch, on paper, 1533–6.

defined the fashion, leading to the coining of the term 'Holbein jewellery'. This enjoyed a revival in the nineteenth century, when the 'Holbein' style was once again in currency.

Holbein often delivered strongly symmetrical designs for gem settings, ornamented with foliate classical decoration. But when he embellished his design with figures or half figures it is their asymmetry that enchants. One pendant features a woman in contemporary dress and a French hood holding a large gem; another features a half figure of a naked woman, her arms encircling gems on either side, her lower torso dissolving into another central stone. Her head is inclined slightly, her hair flowing to one side as if caught in the wind. As in all his designs, it is the vigour, energy and dynamism and hint of narrative that gives his work such a vivacious character.

Anne Boleyn herself also invested in Holbein, not least for her gifts to the king. Just a couple of months after the birth of Princess Elizabeth, Anne Boleyn was pregnant again. The king was overcome with joy and had a medal minted with his wife's face on it in celebration. As if to toast her own fecundity, as part of the New Year's rituals of 1534 Anne is recorded as having given the king

> A goodly gilt bason, having a rail or board of gold in the midst
> of the brim, garnished with rubies and pearls, wherein standeth
> a fountain, also having a rail of gold about it garnished with
> diamonds, out whereof issueth water at the teats of three naked
> women standing about a foot of same fountain.[4]

Two drawings now at Basel could relate to this. One shows the design for an extremely elaborate five-tiered table ornament or fountain. An apparently wide basin or dish sits as the lowest tier, on a shallow base supported by caryatids formed by mythical half figures. Then the main fountain forms the second tier. Around its base are naked women and along its rim sit four women with complex headdresses, one apparently a ship, another a bowl of fruit. Other ornamental heads project just below the rim. Crouching figures and more caryatids lead to a third tier, then a fourth has more figures looking up at the summit, upon which sits Jupiter, thunderbolt in hand.

The drawing is merely a half design, on the left-hand side of a page. It is very loose, and clearly represents an early stage in the design process. Elements of it are redrawn and explored around its edges.

As part of his design process, Holbein would often fold his paper vertically down its middle so that when he was happy with his half design he could trace over his work and while the ink was still wet fold the paper to make a symmetrical imprint as a basis for the fuller drawing. In this particular instance, the idea of naked women at the foot of the fountain suggests it might have been a very early scheme for Anne Boleyn's gift, but it might equally relate to the fountain made for the Hanseatic merchants' coronation pageant.

Another drawing at Basel is closer to the description of Anne's New Year's gift. This time the drawing is more finished. It had been developed in full, is executed in ink and has careful, rudimentary hatching to suggest shading. Other drawings suggest that this preparatory state would precede a further presentation version where Holbein applied grey wash and other colours to give the drawing not only an even greater sense of dimension but also an indication of its ultimate materials and colours.

This drawing shows naked women holding their breasts at the foot of the fountain. If the water were to emit from their nipples as described in the court papers, then this would have been designed to sit within another receptacle. The body of the fountain features satyrs holding an ornate lid, and Anne's falcon emblem chased on its body.

Holbein's many drawings of ornate jewellery and metal ware suggests that this aspect of his output may well have become quickly extensive, possibly even superseding his considerable output in paint. There is clear evidence that Holbein formed close partnerships with the leading goldsmiths in London such as Cornelius Hayes and John of Antwerp. The fact that his two eldest sons were trained as goldsmiths may also have been part of a family plan for them to take on this particularly lucrative aspect of the Holbein business.

One of the earliest noted collaborations with Cornelius Hayes is where Hayes pays Holbein for the provision of Adam and Eve figures for the cradle intended for the king and Anne Boleyn's second child. As the birth of this child drew closer in 1534, Anne was moved to Eltham Palace, where Henry himself had been brought up as a boy. A lavish nursery was installed and the splendid jewelled cradle commissioned from Hayes, decorated with silverwork and Holbein's figures.

But Anne never produced the son Henry had hoped for. She miscarried her second child, very late since she was described as being

visibly very pregnant by Eustace Chapuys, the Spanish ambassador. In doing so she had twice failed to deliver the male heir that Henry had become so fixed upon. And perhaps it was at this stage that the allure of this woman who had so long influenced the king began to fade. What is more, during both her pregnancies Henry took one of her ladies in waiting to his bed. In 1534 it was probably either Mary Shelton or her sister Margaret. Despite Anne's generosity to her cousins, it could not have been lost on her that even her own family bent to the king's will over hers.

Anne understood the extent to which the reform of the English church had facilitated her own marriage with Henry VIII and subsequent coronation as queen. It is likely that it was Anne then who commissioned a small painting of Solomon and the Queen of Sheba from Holbein, again as a gift for the king, and that it was intended to encourage Henry's continuing sympathy towards reform in his new role as head of the church in England.[5] The painting, just 23 × 18 cm, may have been intended as part of a book. It is executed on vellum in the most precious materials and incorporates minute, delightful detail.

Hans Holbein, detail of *Solomon and the Queen of Sheba*, brown and grey wash, blue, red and green bodycolour, white heightening, gold, black ink over metalpoint on vellum, *c*.1534.

Holbein depicts Solomon enthroned on a raised dais, framed by Renaissance pillars against the backdrop of a magnificent tapestry. At his foot is the Queen of Sheba, facing him, her entourage encircling the pair. All the figures and architectural aspects are rendered with a grisaille effect, where silverpoint and black ink outlines are filled with brown and grey wash. Over this, however, Holbein highlights certain detail in gold and silver to produce the effect of fine metalwork tracery, while the background has been coloured the traditional blue associated with miniature painting. In a thoroughly charming detail Holbein has also added minute drops of colour in just one area of the painting. The fruit being held up to the king, apparently strawberries in a basket, is coloured vivid red and green. Meanwhile each figure is described with incredible attention: the folds of drapery are meticulously rendered, turbans and headgear are carefully drawn, hands and feet are all individualized, and every single face offers a different characterization. It is a picture that invites constant revisiting and re-interrogation, and with each new study of it another detail emerges.

SIT·DOMINVS·DEVS·TVVS·BENEDICTVS·
CVI·COMPLACIT·IN·TE·VT·PONERET·TE·
SVPER·THRONVM·SVVM·VT·ESSES·REX·
CONSTITVTVS·DOMINO·DEO·TVO·

VICISTI·FAMAM·
VIRTVTIBVS·TVIS·

REGINA·SABA·

The symbolic intention of the painting is highlighted by text included within it. In the foreground the inscription *REGINA SABA* identifies the painting as being of the Queen of Sheba. On each side of Solomon's throne biblical inscriptions declare 'Happy are thy men, and happy are these thy servants, who stand continually before thee, and hear thy wisdom'. On the tapestry behind Solomon is written 'Blessed be the Lord thy God, who delighted in thee, to set thee upon his throne to be King elected by the Lord thy God'. Finally, on the steps leading up to the king's throne is written 'By your virtues you have exceeded your reputation'.

At a time when comparisons between Henry and Solomon were being encouraged, it is clear the miniature is a celebration of Henry's new role as spiritual leader. The reference to the Old Testament king who had a deep spiritual link with God is intended to redefine and reinforce Henry in his new role as the head of England's church, which Sheba represents. If from Anne then, the picture may also be an encouragement to the king, making an alignment between Solomon's wisdom and the new reformist thinking by which his new church should be guided.

Also, if from Anne, it is more than likely to contain symbolic messages of a more personal nature for the king. This is surely why the box of fruit being held up to the king is painted in red and green, drawing specific attention to it in an otherwise monochrome setting. Strawberries were linked to Venus because of their heart shape.* Is the painting therefore also inviting a second reading of the work? Is this also Venus paying homage to the king? Anne expressing her love for Henry? And could the inscription REGINA SABA in fact stand for Regina Salomonem Anna Boleyn Amat (Anne Boleyn loves Solomon)?[6]

Anne's devotion to a reformation in England continued in 1535. Cromwell, now newly appointed vicegerent, began an assessment of English monasteries, ahead of their proposed dissolution. It was in May 1535 that, with the aid of Jean de Dinteville, the French poet and reformist sympathizer Nicholas Bourbon was finally released from jail on the continent and was provided a haven in London by the English queen. The new arrival at court was quick to have his portrait executed by Holbein.

* Apocryphal accounts also suggest Anne had a strawberry birthmark on her neck.

Bourbon, a correspondent of Erasmus, could not have failed to be aware of the role Holbein had played in disseminating the latter's portrait. No wonder he swiftly sought out Holbein to make a profile drawing of himself, to be used in woodcut form. This would make its appearance the following year in an edition of his poems, *Paidagogeion*.

The preface of *Paidagogeion* provides a glimpse into Bourbon's life in England. The poet reveals he lodged with none other than the goldsmith Cornelius Hayes, and refers to friends he made at court including Nicolaus Kratzer, Thomas Cranmer, Thomas Cromwell, Francis Bryan, and William Butts. This places the poet in the same circle as the king's goldsmith, the king's astronomer, his vicegerent, the king's physician (Butts), the Archbishop of Canterbury and Francis Bryan, who alongside his reputation as a rake and one of the king's 'minions' was also a poet and man of letters. This was a cultural super club, and as Bourbon also mentioned, his friend Holbein was part of it.

If Erasmus had been useful to Holbein simply by association, Bourbon went an important step further. He actively promoted the painter. Since Holbein was a teenager he had been aware of the great painter of antiquity, Apelles, with whom he had been drawing his own comparison, but of the Northern European artists it was Dürer who had been crowned the 'Apelles of the North' by his contemporaries. In 1536, however, in this preface to his *Paidagogeion*, Bourbon paid the same compliment to Holbein, referring to him as the 'Apelles of his age'. Bourbon also began to include him in a repertoire of Latin, humanist poetry designed to commend his genius to posterity. In 1539 Boubon would publish *Tabellae*, featuring a woodcut of Holbein's portrait of him. 'Those who know the poet Bourbon by sight recognize this true image of him,' Bourbon wrote in his commentary. 'The painter erred in this alone, that he forgot to crown the honoured head of the prophet with sacred leaf. But the painter, Hans, who recently fashioned the same wearing laurels, on that account lives more greatly renowned than Apelles.' He also dedicated a poem to Holbein, 'On the peerless painter Hans Holbein'. 'While your divine hand gave expression to my features, Hans, and your skilled hand hurried over the canvas, I painted you thus meanwhile in a single line of poetry: Hans, as he did my portrait, was greater than Apelles.'[7]

If wealth and security had always been part of Holbein's ambition, so too had this kind of recognition.

Bourbon was not the only poet to take up his pen to praise Holbein. The English humanist poet John Leland,[8] also at the heart of Henry's court, did so too, writing, for example, on Holbein's portrait of Erasmus:

> On the image of Desiderius Erasmus:
> This is the wondrous image of the immortal Erasmus,
> to whom the Teuton lands owe their gracious Muses.
> No other painter was more celebrated than Holbein,
> who produced this work of rare mastery.[9]

And with this praise from the important poets of his day, Holbein became the embodiment of a crucial shift in how the value of art was perceived in Tudor England. If Leonardo and Michelangelo had managed to shift the perception of the artist in Italy from artisan to intellectual, and art from mere craftsmanship to a form of expression of similar value to poetry or music, then Holbein had finally achieved this in England. As such no wonder his friendship group could genuinely include not just goldsmiths – who were being afforded a similar level of endorsement – but poets, men of state and leading mathematicians.

One can expand Holbein's circle further. Certainly the goldsmith, John of Antwerp, was a close friend. He would become the executor of Holbein's will. But assuming Leland was also an acquaintance then one begins to consider some other mutual connections. Leland lodged with the printer/publisher Reyner Wolf, who was resident in St Paul's churchyard. Holbein designed his printer's device in due course. Leland was also an acquaintance of Sir Brian Tuke, a collector of paintings whom Holbein painted as early as 1533, and whose collection Leland also memorialized in verse. And Leland also mentions in his poetry a number of the circle of Sir Thomas More whom Holbein clearly knew well, not least Nicolaus Kratzer (again), Sir Thomas Elyot and his wife Margaret Clement.[10]

What did this group have in common? Kratzer, like Holbein, was German, and Cranmer had a German wife. Hayes, John of Antwerp and Wolf were, like Holbein and Kratzer, immigrants from Northern Europe. Wolf, Cranmer, Cromwell, Bourbon, Kratzer and Leland had strong Protestant sympathies. And yet there were figures with more traditional beliefs in the mix too: Elyot and Clement, Bryan and Tuke.

The one aspect that defines all in the group, however, is their interest in humanism.

At about the same time that Holbein and Bourbon were forging their friendship, the former made a painting of the *Allegory of the Old and New Law* depicting a sinner being encouraged to look towards the New Testament rather than back towards the Old. On the painting's left, against a tempestuous sky, images from the Old Testament allude to a vengeful and punishing Old Testament God. On the painting's right, however, lies a green and verdant land where Christ is seen dying on the cross to effect man's salvation and resurrecting from his tomb to demonstrate victory over death. In the climate of the 1530s, this emphasis on the redemptive power of faith rather than the inevitability of sin spoke to the Lutheran position of 'justification by faith', that is God's ability to absolve the sinner and admit him into heaven by fact of the sinner's faith alone.

For whom this painting was made is not known. Cromwell is a possibility. Perhaps Anne Boleyn herself. Such a painting would have appealed to Philip Melanchthon, a leading figure in the German Reformation. Melanchthon was a Lutheran supporter who wrote an exposition of Lutheran doctrine, *Loci Communes*, and in an ambitious gesture of hope and encouragement sent Henry an English edition publicly dedicated to the king the year after the Act of Supremacy. The dedication was not entirely out of the blue. As Henry faced cooling relations with the continent's Catholic superpowers he had been encouraged by Cromwell to look to Germany's Protestant rulers for political support, and as part of this had begun to explore the new religion in an exchange of letters with Melanchthon.

Cromwell had a hand in the production of this English edition of the *Loci Communes*. Holbein was commissioned to design the title page. Holbein also made a miniature portrait of Melanchthon, based on prints in circulation, that sat in the base of a little round box, the interior of the lid of which featured Renaissance decoration and lines of poetry by Leland. It is entirely plausible that this deeply personal gift accompanied the presentation copy of the book as a supplementary gift for the king from Cromwell.

The frontispiece of Melanchthon's work was by no means the only piece of publishing work Holbein undertook at the dawn of the Church of England. Cromwell had rather boldly begun to exploit the press as

part of his own personal evangelism, and had drawn Holbein into a network of radical printers and publishers, scholars and theologians. In doing so Holbein was drawn further and further into England's Protestant community. And it is his exposure and commitment to this group that encourages the notion that he too began to embrace a Protestant position.

Though unauthorized Bible translations were still banned in England, after the Act of Supremacy both Cromwell and Cranmer felt sufficiently confident that the religious sands had shifted enough for them to patronize a group of Protestant theologians who had been exiled. One such was Miles Coverdale, who had been working on the production of a Bible in English in Antwerp. After the execution of that scourge of Protestants Sir Thomas More, Coverdale slunk back to England under Cromwell's protection. Now Cromwell teamed Coverdale with Holbein, who made a title page for what became known as the Coverdale Bible. Anticipating Henry's approval, Holbein depicted the king on this title page, handing the Bible to his bishops.

And, just as in his painting of the same, Holbein depicted the Old and New Laws, with Old Testament scenes on the left and New Testament on the right.

Hans Holbein, *Title page of the Coverdale Bible*, 1535.

Under Cromwell's encouragement, in 1536 a Southwark-based printer called James Nicholson produced literature by another exile – William Tyndale. Tyndale had incensed the king years earlier when he openly opposed Henry's divorce, and as a result Henry had developed a hatred for this dissenter as strong as the one he held for Luther. Nevertheless, now Nicholson's presses on the southern banks of the Thames turned out Tyndale's *Parable of the Wicked Mammon*. Once again the title page was designed by Holbein. This work, which includes a translation of a sermon by Luther, was an extended defence of the fundamental Lutheran belief in justification by faith.

Some of Holbein's earliest contacts in England, who had been devoted, traditional Catholics on his departure from England in 1528, had embraced Protestantism by the time of his return in the 1530s. A case in point was John Rastell, Thomas More's brother-in-law, the producer of pageants, who had worked with Holbein on the Greenwich festivities. By the time Holbein returned to England, Rastell had become part of the reformist movement that was not

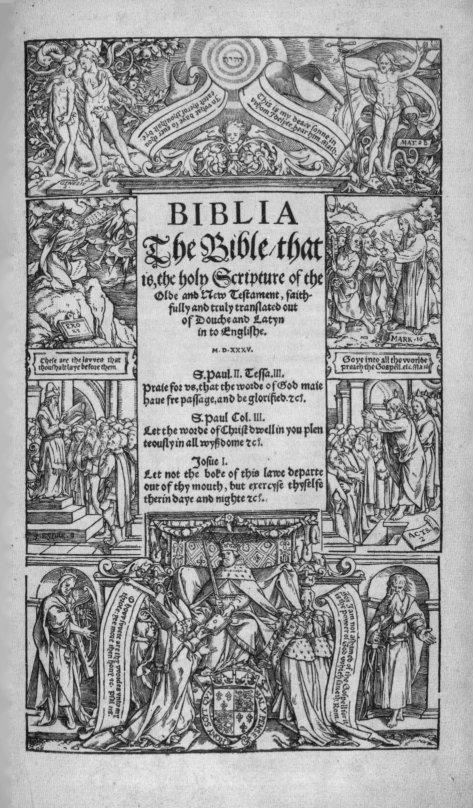

BIBLIA

The Bible, that

is, the holy Scripture of the
Olde and New Testament, faith-
fully and truly translated out
of Douche and Latyn
in to Englishe.

M.D.XXXV.

S. Paul. II. Tessa. III.
Praie for vs, that the worde of God maie
haue fre passage, and be glorified. zc̄.

S. Paul Col. III.
Let the worde of Christ dwell in you plen
teously in all wyßdome zc̄.

Josue I.
Let not the boke of this lawe departe
out of thy mouth, but exercyse thyselfe
therin daye and nighte zc̄.

just being reflected in the publication of Lutheran material but was also being acted out on London's stages in the work of a Protestant playwright called John Bale, a friend of Rastell's. The imagery created by agitators such as Bale included the depiction of monks as Pharisees, devils or wolves.[11] Three woodcuts by Holbein, made in England and bearing his signature, also take up this imagery and must have been intended for the radical press that Cromwell encouraged. One shows *Christ Casting out the Devil*, another *The Hireling Shepherd*, and a third *The Pharisee and the Publican*. In the latter Christ is shown in discussion with a robed man in the right of frame; to the left a monk is depicted kneeling at an altar, a publican standing more centrally. In *The Hireling Shepherd* Christ is seen pointing towards a flock of sheep running wildly astray; a wolf has taken one and a monk runs to recapture the strays. Finally *Christ Casting out the Devil* shows the saviour administering to a man from whose mouth a demon escapes, while a group of monks look on. All can be read easily through a Protestant lens. The publican is being encouraged by Christ to turn away from corrupt Catholicism represented by the monk/Pharisee at the altar. The monks/Pharisees standing around the possessed man are his equivalent. The hireling shepherd is the errant Catholic monk who has allowed his flock to stray and become preyed upon. But as in so much of Holbein's work he leaves just enough ambiguity to allow a different reading if one were determined. In *The Pharisee and the Publican*, the Pharisee could be the man standing with Christ, from whom he ushers the publican towards the altar of the Catholic Church. Equally, Christ's exorcism leaves the formerly possessed man to be re-embraced by the group of Catholic monks, and finally the Catholic monk in *The Hireling Shepherd* might – just – be seen as someone calling the flock back, his arms open in welcome.

The ambiguity of Holbein's work may be a reflection of his professional caution. No equivalent caution seemed to be observed by his regular paymaster, Cromwell. The fragility of Henry's flirtation with Protestantism might have been better heeded by the latter, who in the fullness of time would pay a heavy price for his determination to promote that cause. Ironically, just as Tyndale's *Parable* went into circulation Henry's tolerance of its author snapped. He had Tyndale arrested in Antwerp, executed by strangulation and then burned. Cromwell's attempts to save Tyndale were in vain.

In the meantime Jean de Dinteville's replacement had arrived from France in April 1534 in the form of Charles de Solier, Sieur de Morette, a seasoned ambassador to England who had served in London on and off for close to a decade. De Solier could not have been more different from his young, melancholy, sickly predecessor. In his fifties, a former soldier, de Solier was a hugely robust figure, striking looking with a strong, handsome face and a beard streaked with grey in distinct and distinguished stripes.

De Solier must surely have seen *The Ambassadors*, because almost as soon as his feet touched English soil he sought out Holbein to make his own commission. The result is one of Holbein's very finest portraits, breathtaking not only in its splendour and verisimilitude, but in its characterization of fearlessness.

Holbein fills his entire frame with a depiction of de Solier face on, square, his eyes looking directly at the viewer. This is a man standing his ground, impassable, with his shoulders as wide as the painting, his formidable arms extending even beyond the panel and his left hand clasped around his dagger. De Solier does not need the klaxon of bright damasks or coloured jewels to signal his status and wealth. His black, slashed doublet is richly embroidered black on black, his costly gold buttons and pendant half concealed as if there were no need to display them more fully. The huge fur collar that sits across his shoulder serves less as a show of wealth, and more of formidable strength, like the lion skin Hercules wore across his back. In short, this is a man for whom adornment is not necessary, because his huge presence speaks for itself. As does his firm, unmoving, stare.

The painting draws on much of Holbein's previous work. As early as 1517, when he drew the young soldier Benedikt Hertenstein in Lucerne, Holbein had experimented with using the breadth of his sitter in a confined space to give a sense of muscular power. But whereas Hertenstein was cast in a corner, de Solier is practically bursting out of his frame. And as if to enhance a sense of potential violence, the jade-coloured silk curtain against which he is poses is slashed.

Though not a king, de Solier is unquestionably regal. It may well have been the qualities of this veteran that suggested the pose that Holbein would borrow from his portrait and use to define a man who was a king. There seems little doubt his portrait of Charles de Solier is a prototype for his next major cycle of work – his portraits

of Henry VIII. And if in 1534 when he made the portrait of de Solier an intimate sitting with that king was still just beyond his reach, by 1535 this was no longer the case. In his preface to his *Paidagogeion* Bourbon revealed something else. He referred to his friend Holbein not just as the 'huius aevi Apelli' – the 'Apelles of his age' – but also as 'pictori Regio' – 'the King's Painter'.

Hans Holbein, *Charles de Solier*, oil on oak, 1534–5.

THE
KING'S
PAINTER

B ecoming a formal employee of the court brought with it several practical advantages for Hans Holbein. The restrictions on foreign artists practising in the City of London would have been eased for the King's Painter, and if one goes by the privileges bestowed on the miniaturist Lucas Horenbout, who shared the same title, Holbein would have been allowed not only to operate a workshop but to do so with a number of assistants also drawn from overseas. Any protection afforded Holbein by the Steelyard was no longer necessary and London was now a place where he could operate with ease.

The situation of Holbein's workshop after the Steelyard years has long been sought, but to date any record of it remains to be found. Two legends prevail. First, that at some point he was operating on London Bridge. This has in part been promoted by the story related by descendants of Sir Edward Harley. In the late summer of 1666, family tradition has it, Harley was crossing London Bridge when he was caught in a rainstorm. It was heavy, and rather than plough on, the member of Parliament took the opportunity to shelter in the premises of 'one of the divers smiths and other artificers selling their wares' along the course of the great thoroughfare.

At this point in London's long history, London Bridge was still the only fixed link providing passage across the Thames – but it was by no means merely a means of getting from the bustle of the City to the wharves of Southwark and the Manor of Lambeth. Just as in Holbein's time a century earlier London Bridge was a destination in its own right: a magnificent medieval structure that straddled the river, upheld by nineteen gothic arches with houses and shops on both its east and west flanks, some of which overhung the Thames by seven or eight feet, and soared seven storeys high. The huge golden signs strung up across the bridge (a notorious nuisance in rainstorms for their tendency to collect and then dump water on those below) beckoned those in the market for high-end books and luxury goods.

On that particular day, Sir Edward took shelter in a goldsmith's emporium. Here, much to his delight, he came across a portrait by Holbein *of himself and his family*. Sir Edward found out that the goldsmith in question had come across the painting within the house. Holbein had lived and worked at that very property in the previous century, according to the seventeenth-century occupant. And so with the portrait's provenance so conveniently established,

Harley offered £100 for the work and the pair shook hands. It was a lifelong regret of the nobleman that instead of taking the painting with him then and there, he left it to be collected at a later date. On 2 September, as the Great Fire of London crackled and boomed across the bridge, destroying everything in its path, this particular painting was consumed by flames.

This account is far from reliable, of course, and has much of the urban myth about it. But the description of a painting of the artist and his family, extant in London, certainly close to where Holbein first settled on his return in the 1530s, is tantalizing. The London Bridge records do indeed reveal rents paid by John Holbyne from 1532 but this particular Holbein was still paying his rent in the 1550s, long after our Holbein had died.[1]

Holbein's formalized association with the king has also led to speculation that he was given work premises on royal territory. The king's palace at Whitehall has been suggested as a location where Holbein was afforded space, and the fact that one of the gates to that palace became known as the Holbein Gate offers some support to this, as does Holbein's drawing of the bust of Colet, since Torrigiano's original was also located in rooms above the 'Holbein Gate'.

But far more important than the provision of workshop space was the cachet of access to the monarch that the status of King's Painter afforded Holbein. For a society that revolved around a king, access to his person offered a level of prestige hard to quantify today. Apart from enhancing the desirability of Holbein's work, this title would make the painter a focus for information and also for requests.

That the king had a form of friendship with Holbein, and held him in genuine, personal affection, is suggested by van Mander, who states that 'King Henry VIII appreciated Holbein, esteemed him highly and was glad to have the great artist with him [...] the King's affection for Holbein increased and he favoured him more and more, as the artist served him well'.[2] More telling than this account, however, are Henry's official court documents, where his fondness for the artist is expressly noted for the record. Of course with such acclaim came the potential for a great fall, and Holbein must have been keenly aware that any failure in the eyes of the king was not an option.

In 1537 Holbein's virtuosity was put to the ultimate test when he secured the most prestigious project Henry had on offer for a painter.

It was a large mural celebrating the Tudor dynasty. What is more, it was to be painted in the very inner sanctum of the palace at Whitehall in the king's newly fitted-out privy chamber, a space where the king would meet the most privileged guests. A work on this scale, at the heart of Henry's court, was of immense importance. It was the culmination of Holbein's career and a work that would deliver the most famous and defining depiction of Henry VIII ever made.

The work was also the culmination of Henry's own ambition for Whitehall, which had been his major building project of the 1530s. He had embarked on a massive programme of enlargement and refurbishment of what had once been Cardinal Wolsey's York Place. His plan was to create a new palace, which was to surpass all others as well as become his main base in London. Here Henry had intended to govern with Anne Boleyn, who pored over the designs for the palace with him long before she was able to claim the title of queen. Henry's sense of magnificence, already so visible in his bejewelled person and lavish pageantry, naturally extended to this building project, which was exceptional in not just its scale, but in its execution. Whitehall should rival, in fact surpass, the great palaces of Europe, and for those without access to its interiors, its exterior was designed to convey the treasure within, as it was decorated in complex black and white antique work featuring Renaissance motifs, the design of some of which may well have been part of Holbein's remit.

As part of Henry's building project at Whitehall, the king expanded across a public road, King Street, building a new gatehouse that straddled the thoroughfare and linked the eastern part of the palace where the king's privy chambers were located with his leisure facilities, including his cockpit, tennis court, bowling alley and of course a tiltyard, to the west. This gatehouse became something of a notorious landmark. After all, it was in one of the upper rooms here that Henry secretly married Anne Boleyn in January 1533.

Years after the king's demise it was this huge three-storey gate that had become known as the 'Holbein Gate'. Some said the painter had designed it. This is extremely unlikely, given it was erected at a time when Holbein was back in Basel around 1531, and one would imagine that any design by the painter might have incorporated more Renaissance elements than the four roundels by da Maiano that it featured. However, Holbein must have passed through this gate many

times in his role as the King's Painter, not least in 1537, when he embarked on that mural designed to assert the authority and pedigree of a man who was not only king but head of the church in England. And as suggested above, Holbein may well have occupied rooms in the gatehouse where the preparatory work for the mural was executed, along with other royal commissions. After all, Holbein needed a secure location to study Henry's splendid and deeply costly outfits, transported from the royal wardrobe.

The Whitehall mural was to depict Henry, his parents Henry VII and Elizabeth of York, and his queen. However, the queen in question was not the woman who had helped Henry design his latest palace, Anne Boleyn. As Holbein found himself pouncing his large cartoon for his monumental mural and carefully marking up the walls, Anne had been dead for some months.

A frost had begun to set in for Anne only a year after her coronation in 1533. In another turn of the roundabout of Anglo-French relations, the English court suddenly experienced a cooling from its counterpart over the Channel. As the winter of 1534 set in, Francis I sent a special envoy over to propose a marriage between the Tudor and Valois houses. It was not at all what Anne and Henry envisaged. The envoy in question, Philippe Chabot de Brion, the admiral of France, rather than proposing that the Dauphin might marry the newly arrived Princess Elizabeth, the only heir Henry now acknowledged as legitimate, suggested instead an engagement with the king's daughter by Katherine of Aragon, now known plainly as Lady Mary.

It was not just this proposal that was a clear snub from the French to Henry's new family; the entire composure and attitude of the French envoy could not have been more different from the friendliness of de Dinteville and de Selve only months earlier. The admiral broke with the tradition followed by his predecessors and refused to send the queen a courtesy greeting, nor did he engage with the lavish hospitality she laid on for him. If Anne had once been seen as the key for Anglo-French friendliness, all of a sudden she appeared to be its barrier.

Meanwhile the group of women whom Anne had surrounded herself with began to deteriorate. Not only was her cousin sleeping with her husband, but her sister-in-law, Lady Rochford, had been banished from court by the king for getting involved in the matter.

The discombobulation experienced by Henry and Anne during the

French admiral's visit began a downward spiral in diplomatic relations. When a new French ambassador came to replace Charles de Solier in the summer of 1535 the king refused him Bridewell Palace, a grace and favour lodging that had been bestowed on previous ambassadors. Relations soured further as Cromwell continued to seek political alliances with the German Princes, a group of Protestant rulers that France regarded with immense caution.

Anne's personal affairs meanwhile continued to get worse. Her own family were apparently beginning to turn on her, with Lady Rochford returned to court but now presenting herself as a supporter of the Katherine of Aragon faction. Meanwhile King Henry's straying hands were reaching out for another of Anne's ladies in waiting, a young woman called Jane Seymour.

In spite of so many disappointments, the summer of 1535 saw Henry and Anne progress in the West Country. Holbein's association with this tour came in the form of Nicholas Poyntz. Poyntz was a young, ambitious man who discovered early in 1535 that the royal household planned to stay at his manor house Acton Court, not far from the Gloucestershire village of Iron Acton. With just nine months before the arrival of his royal guests and their entourage Poyntz made extensive preparations.

Poyntz was part of Thomas Cromwell's circle, friendly with the latter's nephew Richard Cromwell and Cromwell's colleague Sir Richard Rich. The Poyntz family were also related to the Guildfords through marriage. Unlike the senior members of his family, who had been most loyal to the old queen and the old religion, the young Sir Nicholas was a reformist, and it may well have been this, along with the other connections, that singled him out as a host for part of this particular progress. The 1535 tour was, after all, much about promoting Henry as the new head of the Church of England. As the prospect of hosting the king and queen approached Poyntz demolished part of his manor house in order to build a magnificent new east wing with special royal reception rooms, no expense spared.

On the basis that imitation is the most sincere form of flattery, Poyntz's new build took much from the Whitehall palace, offering as best he could a home from home for the king and queen. He made a huge new window in his extension which was very similar indeed to the main window in the Holbein Gate, unusually set within the

thickness of the wall. The exterior of the new wing was rendered and so may have enjoyed antique work decoration outside, in the same way as Whitehall.[3]

In terms of furnishing the new rooms Poyntz set the bar high. He purchased the very finest glassware from Venice and exotic tableware from Italy and Spain for his guests;[4] meanwhile the allusion to Henry's new Whitehall Palace was continued inside, where wall friezes in three-dimensional antique work were commissioned. Craftsmanship and design of this quality could have only been executed by the very finest painters in England, those otherwise employed by the royal works.[5] The question is whether Poyntz was so keen to impress that he even went as far as getting Holbein involved in this scheme.

One section of extant frieze at Acton Court comprises three panels, separated from one another by trompe l'oeil balusters and contained within trompe l'oeil frames. Executed in grisaille with some highlighting in red and ochre, the easternmost panel has decoration in the form of two half torsos with beaked heads dissolving into acanthus scroll tails holding a cartouche. The central panel features a roundel formed of a green wreath in which there is an Italianate bust of a blonde woman, captured in three-quarter profile, rendered with great detail and apparently wearing classical robes, with one shoulder bare. She is flanked by dolphin motifs. Meanwhile to the west there is an urn on a pedestal flanked by cockatrices or griffins with beaked heads and acanthus scroll tails.

Only a handful of master designers available in England at the time could have designed these friezes, Holbein of course being one of them. Holbein drew Poyntz in 1535, wearing the chain of his newly awarded knighthood, an honour the king bestowed on Poyntz during his stay at Acton Court. Holbein makes the drawing in sharp profile so that it could be incorporated into a medallion, and possibily into a roundel within the interior scheme. What is more, there is a strong similarity between Acton Court's roundel featuring the Italianate, semi-clad woman, and a design for a similar cameo in a heavily ornamented and bejewelled cup that Holbein would conceive within the next few months.[6]

The cup in question was for Henry's next queen, Jane Seymour. As Anne enjoyed the hospitality of the newly knighted Sir Nicholas Poyntz in August 1535 in the splendour of his new building, surely no

N Pomes Knight.

one, not least she, could have anticipated her fall would be so rapid.

By the end of 1535 and with cool winds blowing from France, Henry began courting the friendship of the Emperor Charles V. Meanwhile, as 1536 dawned, Henry's attention to Jane Seymour became more intense. This was a double blow to everything Anne Boleyn stood for. Jane Seymour's brothers and their circle, which included minions such as Sir Nicholas Carew, Lord Montague and his brother the Marquess of Exeter, were all traditional Catholics and, quietly, supporters of the old Queen Katherine and her daughter Mary.

On 7 January 1536 Katherine of Aragon died. She was buried on 29 January and on the very same day Anne Boleyn miscarried her third child. Rather than showing sympathy for his wife and lost child, Henry began to interpret his wife's miscarriages as ominous signs of God's displeasure, and began to mutter that he had been bewitched by Anne. The latter must have shuddered when in March 1536 Henry promoted Sir Edward Seymour to his Privy Council.

Meanwhile Sir Thomas Cromwell had formed the opinion that an alliance with the emperor would be a positive move for England, and in an astonishingly bold maneouvre he plotted with the Seymour circle to have Anne Boleyn removed as queen, since she was an obvious impediment to the alliance. Anne had always been flirtatious, and now Cromwell and the Seymour contingent began to investigate whether there might be grounds for a charge of adultery. What perhaps they did not know as they made their enquiries across that spring was that Anne was once again pregnant, with a fourth child.

Hans Holbein, *Sir Nicholas Poyntz*, black and coloured chalks, ink on pale pink prepared paper, 1535.

For a painter now at the heart of court life, to whom top courtiers were sitting, it is obvious that Holbein was careful not to be seen as partisan. Just as he delivered portraits of Sir Richard Rich after the latter condemned his patron Sir Thomas More, so too Holbein drew the faction determined to destroy Anne Boleyn, as well as producing work to her commission. Holbein's universal appeal was vital to his success, and this must have been achieved through a mixture of charm, discretion, and diplomacy as well as professional reputation. In an era where information was key, Holbein was also a useful source of it. His conversations during sittings, the people he had seen in various locations – all this would have been interesting currency. His

astonishing access to the most powerful men and women of the age must have made him popular among those who craved news.

The fact that Holbein was so very dispassionate in his work, that he painted people with different political allegiances and religious inclinations, provides a fascinating insight into the deeply complex state of court politics, and reveals an England coloured by many shades of conviction. For example, there is the difference between generations. Sir Nicholas Poyntz is a case in hand. The extremely young, devil-may-care Poyntz, with a wispy beard and a white plume placed jauntily in his hat, is nothing if not an embodiment of the new ways: his likeness intended for a fashionable humanist medallion, his religious attitudes reformist. The drawing of his uncle made by Holbein could not be more different. When Sir John Poyntz sat for Holbein he did so in a dour black cap and unadorned robe. He and his brother, Nicholas's father Sir Anthony Poyntz, were traditional men. Sir John had overseen his brother's estate when the latter died, and made an inventory of its traditional Catholic adornments: tapestries of the passion, altar cloths, and vestments.*[7] He steadfastly refused to accept the validity of the new queen, whom he witnessed visit the lavishly expanded home of his childhood in 1535.

Hans Holbein, *Sir John Poyntz*, black and coloured chalks, ink, on pale pink prepared paper, 1532–43.

Might Holbein have met Katherine of Aragon in these difficult times? He certainly met the young man who to all intents and purposes was her gaoler. In 1534, after the coronation of his new queen, Henry had his old queen moved to Kimbolton Castle in Cambridgeshire, the seat of the very young Sir Charles Wingfield. Charles was almost certainly part of the Boleyn faction at court, and Katherine had probably been put under his custodianship for this reason. His mother, Bridget Wingfield, was a long-time friend of Anne Boleyn, and a lady in waiting to her. Meanwhile in 1535 Charles married Joan Knollys, sister-in-law to Mary Boleyn's daughter Catherine.

It was probably in anticipation of his marriage to Joan Knollys in 1535 that Holbein made a drawing of Charles Wingfield. It is unique in the painter's work for depicting one of his sitters bare chested. The

* The unusual attitude of Poyntz in the sketch, looking upwards, is reminiscent of Holbein's sketch of Jacob Meyer for the *Darmstadt Madonna*, and perhaps indicates it was made with a devotional scheme in mind?

Charles Winhfield Knight.

young man is shown semi-clad, with a pendant hung from a ribbon on his neck. Most likely the drawing was intended for a miniature, with the young lover perhaps consumed by the flames of love. Certainly Nicholas Hilliard, that 'limner' who so admired the work of Holbein, would paint a miniature of a bare-breasted man, holding a locket and consumed by the flames of love, in due course.*

Yet despite the ties of the younger Wingfields to the Boleyns, the older Wingfield generation had ties to the old queen and the old ways. They were part of a humanist circle, encompassing the senior Guildfords and Wyatts, who had connections with Erasmus and shared something of his outlook. Holbein may well have been introduced to Queen Katherine, whom Erasmus noted was particularly learned, through his association with this group during his first stay in England.

As it turned out the Wingfields may well have contributed to Anne Boleyn's downfall. Sir Charles's mother Bridget is alleged to have turned against the queen in 1536 and offered a testimony against her.[8] What is more certain is that Jane, Lady Rochford did indeed assist in the condemnation of her sister-in-law.

On 30 April 1536 Cromwell shared with the king his investigations into Anne's adultery and her plans to put one of her lovers on the throne. The king was ready to hear what Cromwell had to say, since by this time he was passionately in love with Jane Seymour.

Hans Holbein, *Sir Charles Wingfield*, black and coloured chalks, ink, on pale pink prepared paper, 1532–43.

By mid May six noblemen and a servant had been arrested and questioned along with the queen herself. The musician Mark Smeaton confessed adultery with the queen, while Sir Henry Norris, Sir Francis Weston, Sir William Brereton and Anne's own brother George Boleyn, Viscount Rochford, denied it. Of these five Holbein likely knew at least two, Rochford and Norris; meanwhile it was Norris's brother who had bought the little roundel of Erasmus from him when he first arrived back in England. All five were tried and found guilty.

Anne, whom again Holbein had almost certainly met and painted, was tried and condemned by a court presided over by her own uncle the Duke of Norfolk. The poet Sir Thomas Wyatt, who if not already a friend of Holbein's would become part of his circle, was held in the

* Hilliard's miniature of an unknown man, his shirt unbuttoned revealing his chest, a locket in his hand, set against flames, is in the Victoria and Albert Museum in London.

Tower, as was Sir Richard Page, but both were eventually released. Jean de Dinteville made a plea for the release and pardon of Sir Francis Weston, but was unsuccessful. The five condemned men were all beheaded on 17 May. On the very same day Archbishop Cranmer announced the marriage between the king and Anne Boleyn null and void, and as such this left the former Princess Elizabeth as a bastard. Two days later Anne Boleyn also climbed the scaffold and was executed by decapitation. Cromwell attended the event. The king married Jane Seymour on 30 May.

Holbein must have picked up his brush to describe Henry's third queen very soon indeed after the abrupt demise of the second. In his portrait of her Holbein records Jane Seymour's skin as porcelain white. This is consistent with the description of her by the Spanish ambassador Eustace Chapuys, who noted that she was of 'middle stature and no great beauty, so fair that one would call her rather pale than otherwise'.

Holbein did not flatter. Jane has a weak chin, small lips and little dark blue eyes, one of which seems to be slightly squint. She was the antithesis to her dark, sexy predecessor in looks, and apparently in temperament.

Hans Holbein, *Jane Seymour*, oil on oak, 1536–7.

Anne, forthright and voluble, had gone too far in her tendency to breach the normal etiquettes afforded the king. Her outspokenness had begun to annoy him. Jane, in contrast, was quiet. And Holbein indicates this restraint in his depiction of her mouth, clamped shut, tight lipped.

Holbein made a workshop drawing of Jane that was put to various uses.* He captured her in three-quarter length, so that unusually he could draw her hands. His preparatory sketch reveals that so important was it for Holbein to feature them, he extended the length of his paper, sticking another sheet to the bottom of it. This invites a close interrogation of what Holbein wanted to capture – the manner in which her hands are folded together. One placed on top of the other in a slightly contrived way, the hands add to the overall sense of propriety and restraint conveyed in the painting. There may be a message: each hand is under the thumb of the other, and for those who considered Boleyn had run rings around their monarch, this may

* Part of the Royal Collection.

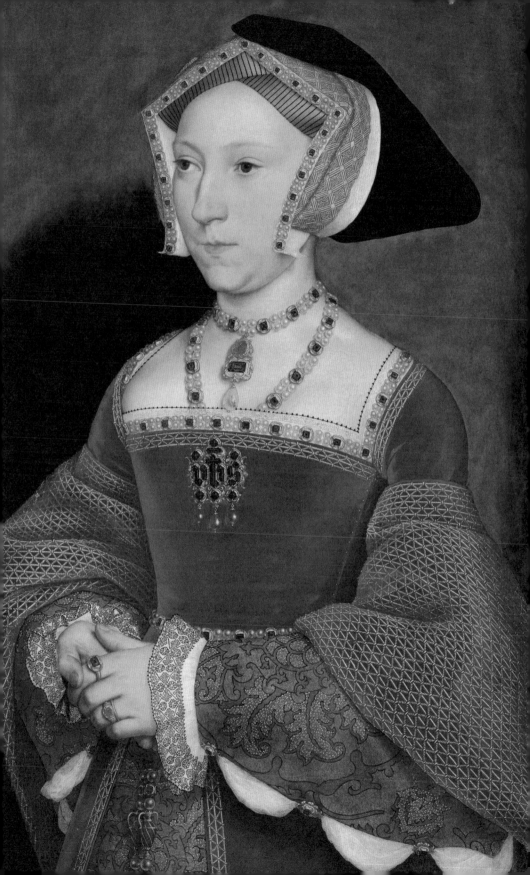

have been a gentle suggestion that this queen was in sharp contrast under the thumb of her king, as indeed her motto 'Bound to Obey' also indicates.

The drawing Holbein made was used as a workshop template for several other painted portraits, some of which exist. A formal three-quarter portrait in oil on oak now hangs in Vienna's Kunsthistorisches Museum. In it Jane is shown wearing luxurious slashed cloth of silver sleeves, achieved with the use of a real silver base on top of which the painter adds further detailing. She wears oversleeves of velvet heavily embroidered with gold thread, and her kirtle bodice is smooth, made from stiffened red velvet, the neckline heavily bejewelled with stones set in gold and punctuated with pearls. Around her neck she wears a chain made from the same, from which hangs a huge pendant. This is probably a gift from the king, designed by Holbein. A drawing in the British Museum 'Jewellery Book' shows a very similar arrangement of two stones from which hangs a pearl drop. On her breast she wears black gemstones set in gold, with drop pearls, which form the initials IHS, the monogram for Christ. This too was a gift from the king. Lucas Horenbout made a miniature of a clearly ageing and overweight Queen Katherine of Aragon in which the very same jewel is featured. That Henry passed this item on to his third wife is not only an indication of the huge importance placed on jewellery, but also the total sense of ownership the king had over his spouses and the gifts he bestowed on them.

In addition to the Vienna painting of Seymour, there is a workshop copy of obvious inferiority at the Mauritshuis in the Hague. Another was acquired by the National Portrait Gallery in 2019. It has some similarities to the Vienna painting but in contrast to the plain blue background on the former, this has an elaborate gold embroidered, twisted curtain framing Jane. However, this portrait is unfinished. The detailing of Jane's sleeves and jewellery is missing, and one wonders whether this represents a client defaulting his payment. More portraits of the queen from Holbein's source drawing of her continued to be commissioned long after she died, not least because she was the mother of the heir apparent. In 1542 her brother is still commissioning 'Hance' to make 'quene Janes Pycture'.[9]

As Holbein found himself painting a new English queen he must have looked back on events of the last decade with a degree of

amazement. Leaving a tolerant, liberal Basel in 1526 he had discovered an England in which religious art was in demand, and where the humanism that had shaped Basel's culture was newly taking root. On his return to Basel he had seen a city ransacked by reformers and witnessed the rage of iconoclasts. Fleeing back to England in 1532 he found its Catholicism newly compromised by a split from Rome, and the creation of a Church of England that had opened the door for certain parties to push for reform. With the triple agency of Boleyn as his queen, Cromwell as his key advisor, and Cranmer as his Archbishop in Canterbury, Henry had indeed absorbed some of the new Protestant thinking. In 1536 the king endorsed the Ten Articles: 'Articles devised by the King's Highness' Majesty to establish Christian quietness and unity among us.'[10] The articles were informed by reformist thinking, not least the statement that the body and blood of Christ are present in the elements of the Eucharist, a vague line taken by Luther that avoided endorsing the idea of transubstantiation. Further, the articles pointed out that images are useful as remembrances, but should not be objects of worship. And the decree reminded the people of England that things they had formerly relied on – such as Papal pardons, and soul-masses offered at certain localities – were no longer efficacious.

In the same year, Henry and Cromwell began a programme of dissolving the monasteries, subsuming their treasures into the royal coffers, and destroying the images of the Virign Mary and saints that were the focus of worship. This iconoclasm may have been in the name of reform as far as Cromwell was concerned, but it was also a scheme to give Henry all the funds he needed.

All these events formed the backdrop to the Whitehall mural. Commissioned by a king, from his painter, for the inner sanctum of the palace, and as a permanent fixture there, it was the most prestigious piece of patronage Holbein had ever secured. It represented the climax of his career. Tragically, it burned to the ground with the Palace of Whitehall in 1698. However, part of the preparatory cartoon for it remains, as does a painted record of it from 1667 by the artist Remigius van Leemput. With so few accounts of it, it appears a problematic piece of work viewed from the distance of the future.

The preparatory drawing, which relates to the left-hand portion of the composition and features Henry, indicates that this enormous mural was over two and a half metres high and probably close to three

metres wide.* According to van Leemput's copy a huge, plain, stone monument with a lengthy inscription was central to the work. To the left of this monument stands Henry VIII, not quite its equal in height, and behind him, raised, stands his father Henry VII, who leans his elbow on the monument. Both kings look directly out at the viewer, although Henry VII does so from the corner of his eye. Opposite Henry VII stands Elizabeth of York, also on a raised step, and below her stands Jane Seymour. The gaze of both the women is oblique, their heads turned slightly towards their respective husbands, but their eyes staring into an unspecified mid distance. The stance of all four is formal, statuesque, and there is nothing of the interaction that Holbein achieved in his depiction of the More family (even if it was knowingly posed). Instead the formality is more akin to that presented stiffly by de Dinteville and de Selve in *The Ambassadors*, their public personas standing to attention. There is also something of the static quality Holbein achieved in his kneeling figures in his *Darmstadt Madonna*. Some have noted that the composition, with such attention to a central inscription, is similar to the formats Holbein used for title pages in books, where figures were often arranged either side of the inscription.[11]

Hans Holbein, *Cartoon for the Whitehall Mural,* ink and watercolour on paper, 1536–7.

Though all the figures were doubtless brilliantly rendered, it was Holbein's astonishing depiction of the king that stood out. It was reportedly capable of instilling fear in those who encountered it, for, as one contemporary notes, 'it seems as if it is alive and that one might see the head and all the limbs moving and functioning naturally.'[12] Intended to prepare the attendee for his encounter with the monarch, Henry's looming full-size portrait took pictorial intimidation to a new level. In a development from the cartoon where Henry's face is in three-quarter profile, in the finished mural Holbein turned the king full face, and in doing so he becomes the only figure in the group looking straight out. The effect is to draw the viewer's eye left, always to the king. Showing the king standing with his legs spread wide and his shoulders matching the width of his gait, Holbein took full length the composition he had already explored for de Solier in three-quarter size. In doing so he generated

* Holbein's original cartoon forms part of the National Portrait Gallery's collection, while van Leemput's copy is part of the Royal Collection, and is in the Great Watching Chamber at Hampton Court Palace.

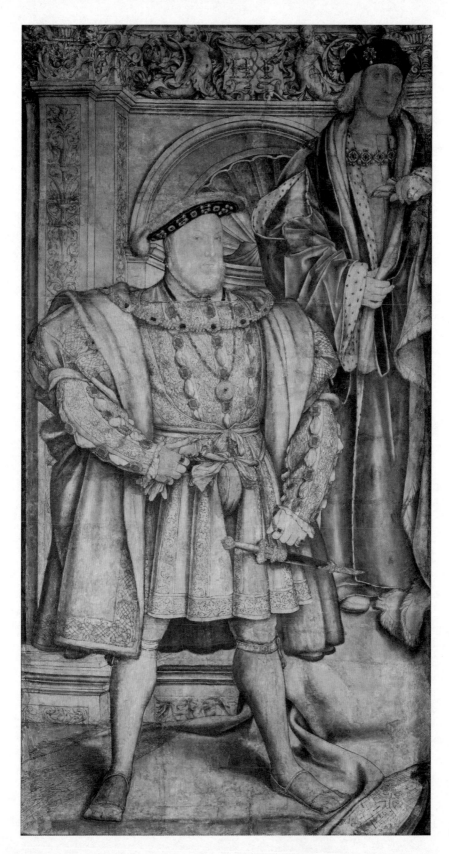

SI IVVAT HEROVM CLARAS VIDISSE FIGV
SPECTA HAS, MAIORES NVLLA TABELLA T
CERTAMEN MAGNVM LIS, QVESTIO MAGNA PAT
FILIVS AN VINCAT VICIT VTERQVE QVID
ISTE SVOS HOSTES PATRIÆQVE INCENDIA S
SVSTVLIT, ET PACEM CIVIBVS VSQVE DE

FILIVS AD MAIORA QVIDEM PROGNATVS AB
SVBMOVET INDIGNOS SVBSTITVITQVE P
CERTÆ VIRTVTI, PAPARVM AVDACIA CESS
HENRICO OCTAVO SCEPTRA GERENTE
REDDITA RELIGIO EST 1510 REGNANTE D
DOGMATA CEPERVNT ESSE IN HONORE

PROTOTYPVM ISTE MAGNITVDINIS IPSO O
FECIT HOLBENIVS IVBENTE HENRICO

ECTYPVM A REMIGIO VAN LEEMPVT BRE
DESCRIBI VOLVIT CAROLVS II M B
Aᵒ DNI MDCLXVII

Remigius van Leemput,
Copy of the Whitehall Mural,
oil on canvas, 1667.

the defining image of the Tudor king that his subjects and cronies quickly sought to disseminate, buying their own copies of the figure from the Holbein workshop. Today several exist of varying quality, including copies at the Walker Gallery in Liverpool, Petworth House, Chatsworth House and Trinity College Cambridge.

What all the versions show is, at first glance, an embodiment of raw, terrifying power. In its fuller form this stance summoned a version of the classical Colossus of Rhodes described by Pliny the Elder, that had once straddled that island's port. Here Henry straddled his own realm, the implicit classical reference not only fitting for a true Renaissance king, but a conscious inversion of traditional Christian imagery.

Unlike Christ on the cross, whose legs were nailed together, his arms spread wide and head bowed, Henry stood with legs wide, arms bent in defiant pose and head held high. Far from pinned down, this version of a lord and saviour was ready to leap forth. Like so much of Holbein's work, the meaning of such a depiction lies in the eye of the beholder. Henry would have doubtless only seen the depiction of power he sought. For others, the inversion of Christian imagery might hint at the Antichrist – the very label Lutherans were pinning on the Pope at that time.

Hans Holbein (school of), *Henry VIII* based on the Whitehall Mural, oil on panel, 1443–7.

overleaf
(l) Hans Holbein (school of), *Henry VIII* based on the Whitehall Mural, oil on panel, *c.*1537; (r) Hans Holbein (school of), *Henry VIII* based on the Whitehall Mural, oil on panel, after 1557.

There are other subtleties in the depiction of Henry that, on closer study, deliver some of the tensions that make Holbein's work so rich. For a start Holbein makes a strong vertical line that takes the eye downwards from the centre of Henry's face, through his magnificent jewelled gold pendant at his chest, down his oversized codpiece, through the pommel of his dagger, to the image of a classical warrior with a spear raised over his head (possibly Mars, the god of war) that can be spied between Henry's feet, a bas-relief carving at the foot of the panelling behind him. The intention is to align Henry's vast wealth and magnificence with his equally vast endowment contained in the codpiece. The size of the codpiece of course indicated virility, a quality that was widely equated with military prowess and strength, hence the line through the dagger and ultimately to the martial motif at his feet.

But one thing to note is that unlike the portrait of de Solier Henry's hand is not on his dagger; instead this thumb holds the cord which

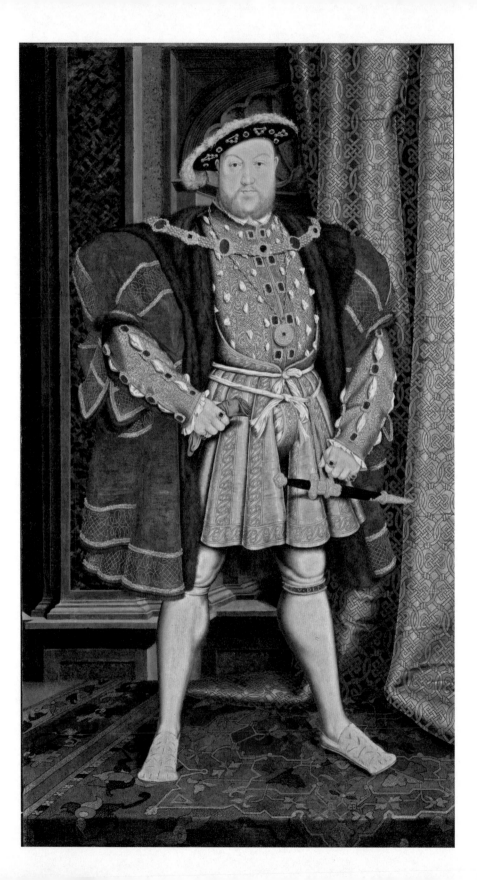

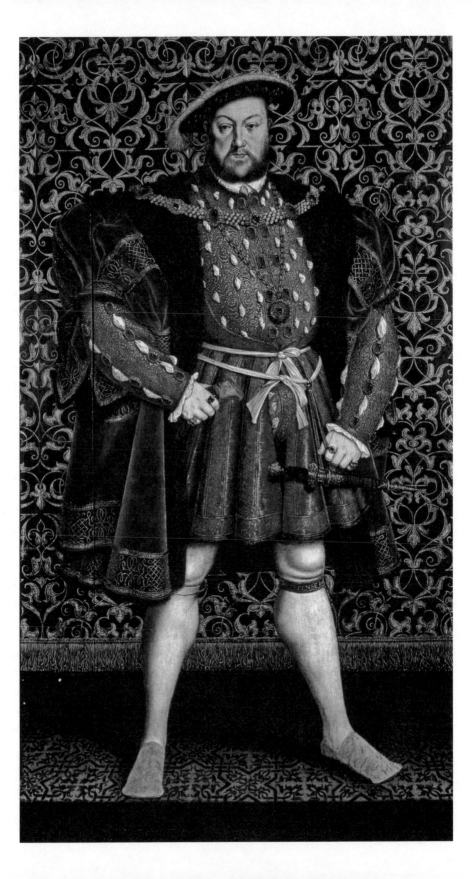

attaches it to his person. Meanwhile the figure of Mars is emasculated, in that the lower portion of the warrior's body is cut off, covered up by a carpet. These small details, which on the one hand add to the verisimilitude of the painting by slightly undermining its formality, on the other hand might offer Henry's critics the suggestion that this man is less virile than he would like to suggest. Consider also that in the only other group portrait that Holbein had made on this scale, that for Sir Thomas More, the only person looking straight out to engage the viewer was More's fool, Henry Paterson. Was there a little private joke here for Holbein? Henry Paterson could be read as Henry father and son... fools and players like all men in the greater scheme of the universe.

Under the feet of the group is a magnificent signature 'Holbein carpet'. It is draped over the step and, interrupted by the monument, is rucked up and folded around it. Close examination reveals that Henry VII and his wife Elizabeth of York are standing on two blocks, also covered by the carpet. The monument itself is draped with a red velvet cloth, lined with satin, and on it lie two cushions made from shimmering embroidered fabric.

In contrast to the grey monochrome monument around which the figures are arranged, the space within which they stand is highly decorated and architecturally complex, the unravelling of which is key to comprehending the conceit Holbein and the king intended – and there can be little doubt that a conceit is embedded in the work.

Holbein shows the group and the monument standing on a low, stepped dais that has been butted up against a wall. This wall is replete with classical decoration and Italianate architectural features and forms part of a permanent structure, while the dais is clearly a new, arguably temporary, addition. Should there be any doubt, Holbein draws the viewer's attention to the status of the platform by showing that it conceals the lowermost part of the extant wall, concealing the base of an elaborately decorated pilaster in the left-hand corner.

The rear wall is punctuated by a recess in the form of a coffered arch, which frames an open roundel with an inset bust. The bust, however, is only viewed from the rear. Shell niches also punctuate the wall, above which half figures frame cartouches inscribed with the year – 1537. Highly wrought antique pilasters mark the left and right extremity of the mural.

These architectural details are clearly inspired, yet again, by Bramante's fantastical *Ruined Temple*, which Holbein had of course referred to in his earlier large-scale murals on houses in Basel. But the quotation is close in this instance, the roundel with the outward-looking bust a very specific reference, as is the coffered ceiling in the arch that frames the monument. Is this reference to a ruined temple an oblique reminder of Henry's own dissolution of monasteries? By the time the mural had been completed Henry had already seen an uprising in the north of England, and a massive march, known as the Pilgrimage of Grace, in protest at what many saw as a desecration of their religious life.

What Holbein adds to his architectural confection, a feature not in the Bramante, is a series of overhead ornamental corbels in the form of half figures, projecting outwards and over the heads of the group. As such they frame the dais or stage below. To make it quite clear that his figures are standing within a set of sorts, Holbein reveals the 'real' architecture of a much larger room above the corbels, and a much higher ceiling can be seen with high-level arches and roundels.

The spatial conceit, then, is that within the palace, Holbein has created a theatre, a new imaginative space, which accommodates not just the imagined physical entities of the king, his queen and parents, but where momentarily the past and present coexist.

Here, however, the first problem occurs. In van Leemput's copy, the success of the illusion of real space is spoiled by the fact that the elaborate carpet that Holbein painted is cut off at each corner. It seems unconscionable that Holbein would have failed to resolve this element of his design. However, this does invite speculation that he had continued the carpet into the real space of the privy chamber.

Might Holbein's carpet and the outermost corbels have been continued onto the actual wainscoting in the chamber, giving the impression that the group was standing in a recessed bay within the room? If so, this would indicate that the mural was placed at just above floor level, accounting for the dais on which the life-size figures stood. This is consistent with the perspective views offered in the painting, where the ledge of lowest order of the monument is visible since it is below eye level, but the top of the monument cannot be viewed since it is above eye level.

The next problem the mural poses is: why dedicate so much space

to a monument at the centre of the work? The key is in its Latin inscription, which translates:

> If it pleases you to see the illustrious images of heroes, look on
> these: no picture ever bore greater. The great debate, competition
> and great question is whether father or son is the victor. For both
> indeed were supreme. The former often overcame his enemies and
> the conflagrations, and finally brought peace to its citizens. The
> son, born indeed for greater things, removed the unworthy from
> their altars and replaced them by upright men. The arrogance of the
> Popes has yielded to unerring virtue, and while Henry VIII holds
> the sceptre in his hand religion is restored and during his reign the
> doctrines of God have begun to be held in his honour.[13]

With this inscription contextualizing the mural, one immediately understands that the monument is in fact a pedestal for a statue... one which will bear either Henry VIII or his father. It is up to the viewer to debate the qualities of both and to then use their imagination to place the rightful 'victor' on his plinth – and conveniently Holbein has provided sufficient space above it for the figure to rise up, between the corbels.

The reference to 'altars' in the text also invites one to see the monument simultaneously as this – an altar – the devotional space that the Pope once commanded, from which he has been toppled. With Henry's dissolution of the monasteries well underway, the smaller houses already stripped and disassembled, the empty plinth was perhaps also intended as a reminder of the huge number of Marian and saintly icons that had recently been removed and broken up. The figure who will take the place of Pope and Catholic icons alike on this altar – and surely the implicit invitation is to place Henry VIII in the position of victory – is indeed the upright man standing on the left. Henry is the new embodiment of God on earth.

What is known about this huge mural suggests a work that, like so much from Holbein, can sustain several interpretations. For its client, the king, here was a depiction of England's new Colossus, a new God on earth, the man who had destroyed the temple of an old religion and deserved therefore to take his place at the centre of a new form of worship. From the safety of the future, the painting also offers a different reading. Here is Henry the Antichrist, destroyer of the Catholic tradition, a man's whose virility was questionable and

who despite his kingly status was no more than a fool, playing out his role in life's theatre.

For a work of art that deals with the topic of worship, the painting is noticeably godless. Unlike *The Ambassadors*, where the figure of Christ is half concealed by the green curtain that frames the two Frenchmen, there is no comparable Christian imagery here. However, what the mural shares with *The Ambassadors* is a reminder of mortality, fully central to the composition. No anamorphic skull, but a huge tomb. For surely the addition of two cushions on top of the monument aligns it with the traditional tombs where those interred lie recumbent on top, their heads resting on stone pillows, their feet often on their pet dogs. A little dog is painted at Jane Seymour's feet – a pet she is recorded as having doted on. Its inclusion in an otherwise formal group portrait suggests perhaps that at the point the mural was completed Henry's third queen was already dead. She had been queen for less than eighteen months. Holbein could scarcely have imagined that the next queen he would paint for Henry would reign for an even shorter period.

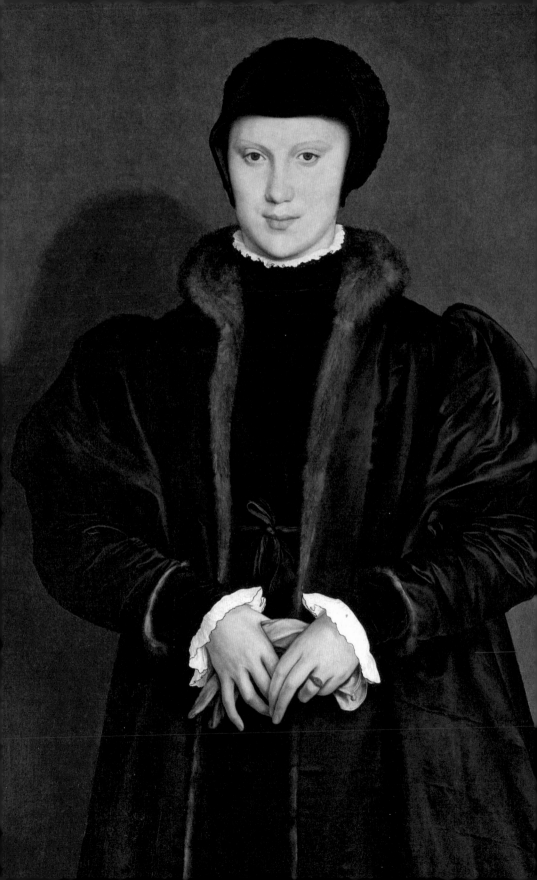

CHRISTINA

At eight o'clock in the evening of 24 October 1537, the Duke of Norfolk sat down in his lodging at Hampton Court and wrote to Cromwell. Norfolk profoundly disliked Cromwell, the upstart lawyer who had risen to the rank of principal secretary, chief minister, Lord Privy Seal and had been recently appointed Knight Companion, as part of the exclusive Order of the Garter. It must have been a further affront to Norfolk's keen sense of the proper order of society that Cromwell had even managed to marry his son Gregory to Queen Jane Seymour's sister, Elizabeth. In doing so Cromwell had practically become part of the king's family. However, this strategic move by Cromwell was soon to be rather weakened. The queen was dying.

'My good lord,' he wrote, 'I pray you to be here tomorrow early to comfort our good master, for as for our mistress there is no likelihood of her life, the more pity, and I fear she shall not be on lyve at the time ye shall read this. At viij at night, with the hand of [your] sorrowful friend, T. Norffolk.'[1]

Less than a fortnight earlier Jane Seymour had fulfilled King Henry VIII's greatest desire, and had delivered him a legitimate male heir, Prince Edward. Henry's joy was supreme. All his hopes for the Tudor dynasty were bound up in this child now, not least because the Duke of Richmond and Somerset, the illegitimate son whom Henry may well have recognized in the absence of another, had died very suddenly in July 1536.

The new heir, so anticipated and so welcomed, was destined to be almost instantly motherless. Jane Seymour clung on to life for just another four hours after Norfolk wrote his sad note to Cromwell. Around midnight, that most deadly of hours, she died. She was only twenty-eight.

Jane Seymour's body lay in state for a week, women from her household kneeling beside it at all times. One of those who officially mourned her in this manner was the twenty-one-year-old Lady Mary, daughter of the king and Katherine of Aragon. Mary is noticeable by her absence in Holbein's finished portraits. When his career as a portrait artist to the court took off after 1532, the princess and her mother were already ostracized. Yet there is one slight drawing of her by Holbein that almost certainly dates to the few months Seymour became her stepmother. Faint, an almost cursory description, one can

just make out Mary's ice-blue eyes. She looks to her right, a necklace of large pearls around her neck. Her expression is inscrutable. It is the sole testimony in Holbein's oeuvre to Jane Seymour's influence on her husband – which was to effect a reconciliation of sorts between Henry and his eldest daughter, and return her to court. The young Elizabeth was also brought to see her father at Seymour's suggestion. Behind Seymour's stiff exterior there was clearly a woman with her own agenda, built apparently on kindness and a desire to unite a family that had been torn apart. If the painting, or miniature, for which this drawing was intended was ever completed, it has not yet come to light. Perhaps it was to be a gift from Seymour to the king. But then again, perhaps the commission died with the queen.

Henry lost little time in his search for his next spouse. Exceptionally for a monarch of this period, ever since his initial marriage with the Spanish princess Katherine, Henry had turned away from the great dynasties of Europe and allowed flirtation and physical attraction to take precedence over diplomatic gain. Europe's rulers had watched bemused as Henry had sought out first Anne Boleyn, and after her execution Jane Seymour.

Times, however, were changing. Both the king and Cromwell acknowledged that a traditional marriage into one of the continent's ruling families might be prudent to divert potential hostilities, to add a balm to the wound caused by Henry's rupture from Rome. Nevertheless, having married twice already for love, this most sensitive of kings felt the need for some reassurance that beneath a marriage of political convenience some sexual chemistry might still be achieved.

Within days of Jane Seymour's demise Cromwell pressed his fleshy fingers around his quill to instruct the English ambassadors in France to begin to search for a new queen there. Lord William Howard, Norfolk's brother, and Bishop of London Stephen Gardiner were to engage in some mild duplicity. Cromwell recommended that they depict a king not necessarily keen to once again tie the knot, yet to nevertheless secretly enquire about two attractive possibilities.

'Announce to Francis that though the Prince is well and "sucketh like a child of his puissance," the Queen, by the neglect of those about her who suffered her to take cold and eat such things as her fantasy in sickness called for, is dead,' Cromwell suggested, before continuing that they should say that

The King, though he takes this chance reasonably, is little disposed to marry again, but some of his Council have thought it meet for us to urge him to it for the sake of his realm, and he has 'framed his mind, both to be indifferent to the thing and to the election of any person from any part that with deliberation shall be thought meet.' Two persons in France might be thought on, viz., the French king's daughter (said to be not the meetest) and Madame de Longueville, of whose qualities you are to inquire, and also on what terms the King of Scots stands with either of them. Lord William must not return without ascertaining this, but the inquiry must be kept secret.[2]

Henry's nephew James V of Scotland, the son of his sister Margaret Tudor, had also just lost his wife Madeleine of Valois. Cromwell's suspicion that the Scottish king may have begun an approach for a potential replacement from the French court was well placed. With an alacrity that was comparable to Henry's own, James already had his sights on Mary of Guise, Madame de Longueville, the daughter of the Duke of Guise. In what is clearly further commentary on the fragility of life at this time, she herself had been recently widowed after just three years of marriage.

However, Henry was undeterred by his nephew's rivalry and put Mary of Guise on *his* list of candidates too. By December 1537, he was citing Sir John Wallop, an English ambassador in Paris who was familiar with the young French aristocrat, and had been 'so loud in her praises as nothing could exceed them'.[3] While Henry's enthusiasm may well have been in part informed by a desire to derail a marriage that would perpetuate Franco-Scottish relations, nevertheless descriptions of the woman had lit the taper of his easily fired romantic imagination.

Roused by the description of Mary of Guise, Henry was determined to see her. It would be to Holbein that he most likely turned. Holbein's portrait of Mary of Guise no longer exists. All we have is a record of two courtiers, dispatched separately in February 1538 to secure her likeness. Peter Meutas was one, sent on 1 February, Philip Hoby the other, sent later. Across the next two years, Hoby would become Holbein's regular travelling companion on missions to secure portraits of marriageable women for Henry. It is a reasonable assumption that Holbein accompanied him on this very first one.

One can well imagine his travelling companions making use of their time together to secure their own commissions.[4] By 1538 such

was Holbein's prowess that the balance between the prestige conferred on the sitter by the painter or vice versa had tilted in Holbein's favour. Hoby would have doubtless felt some real kudos in acquiring a likeness of himself, along with a companion depiction of his young wife. A Holbein portrait of Peter Meutas's wife suggests something to commemorate their marriage at around this time. Mistress Meutas had been part of Jane Seymour's entourage.

In his assessment of Hoby, Holbein captured sharp features, close-cut hair, a wispy moustache and beard, and pale blue eyes. But what is striking in even this preparatory sketch is the astonishing detail that Holbein could see. The unique contours of Hoby's face indicated by shading across the cheek, nose, and forehead suggest a very specific physiognomy. The ear, far from a generic formula, is an acutely observed complication of folds and lobe. The face is relaxed and open, the mouth just lightly closed, the brow unfurrowed. All combine to deliver the portrait of a workmanlike, uncomplicated civil servant. From this piece of paper we see young Philip Hoby as a man without agenda – other than the task in hand. Something fairly remarkable in the Tudor court.

The drawings of the Hobys and Joan Meutas are typical of Holbein in this period, made on that pre-tinted pink paper. It would have been exactly this kind of work that Holbein would have also made of Henry's prospective brides, the hour or two taken for fine and pertinent observations just about tolerable for his aristocratic sitters. Though one imagines Holbein might have worked up a drawing with more colour to show his monarch – as in his depiction of John Godsalve.

Ultimately, James V's head start in his courtship, along with an established rapport with France, played their part in securing Mary of Guise for Scotland. Henry's reputation after having divorced his first wife and beheaded his second had not helped in his suit. If Holbein, with either Meutas or Hoby, had managed to deliver a likeness of the French noblewoman, it may have been diplomatic to remove it from the king's possessions after Mary and James tied the knot in May 1538. It would not have been the first time that Holbein's portraits suffered destruction to spare the king's blushes.

However, in March 1538, Holbein was dispatched to record another potential spouse. This time the mission was part of a wider ambition by

the king to rekindle a relationship with Emperor Charles V. Christina, the sixteen-year-old widowed Duchess of Milan, was Charles's niece and a marriage with her would have gone far to heal wounds left by Henry's divorce of Katherine of Aragon – Charles's aunt. Cromwell dutifully sent Holbein to Brussels where Christina was living under the guardianship of Charles's sister, Mary of Hungary. Philip Hoby was at his side.

Cromwell was clear in what he wanted Hoby to achieve. He and Holbein were to

> repair to Mr. Hutton [Henry's ambassador to the Low Countries] and tarry secretly at his lodging until he shall have been with the Regent. Then upon Hutton's advertisement to go to the Duchess, present Cromwell's commendations and say that no doubt she has heard from the Lady Regent and by the relation of the King's ambassador there, the cause of his coming and Cromwell's inclination to the advancement of the same as is declared in the letter. He shall then beg her to take the pain to sit that a servant of the King, who is come thither for that purpose, may take her physiognomy; and shall ask when Mr. Hanns shall come to her to do so. The said Philip shall as of himself express a wish that both for my Lord's reports of her virtues and for his own view of them, it might please the King, being now without a wife, to advance her to the honour of a queen of England. And he shall well note her answers, her gesture and countenance with her inclination, that he may at his return declare the same to the King's Majesty. Her picture taken, he and Hanns shall return immediately...[5]

Holbein and Hoby arrived in Hutton's lodgings on 10 March 1538. Hutton had already dispatched a portrait of Christina to London, but with the greatest painter in Northern Europe now sitting in his parlour, Hutton felt it wise to recall it, sending his man to intercept the package, as he described in a subsequent letter to Cromwell four days later on 14 March.

> Pleasithe your good Lordshipe [...] that the 10th of this present monthe in the evening arivid here your Lordshipis sarvand Phillip Hobbie, accompanied with a sarvand of the Kynges Majisties namyd Mr. Haunce, by which Phillip I recyved your Lorshippis letter [...] the effect whereof apercevyd, having the day before sent wone of my sarvandes towards your Lordshipe with a picture of the Duches of Myllain, I thought it very nessisarie to stey the same, for that in my

opinion it was not soo perffight as the cawsse requiryd, neyther as the said Mr Haunce could make it...[6]

Hutton was by accounts jovial and good company, though not necessarily the best diplomatic aid Henry had in his service. Nevertheless the evident urgency of the matter was such that on 13 March Holbein had his audience with Christina, when at 'wone of the cloke in the afternoon' a gentleman from the court came and fetched Holbein, 'whoo, havyng but three owers space, hathe shoid himself to be master of that sience, for it is very perfect. The other is but sloberid to it, as by the sight of bothe your Lordshipe shall well aperceve.'[7]

The inadequate portrait deemed 'sloberid' by Hutton depicted Christina in full courtly attire. However, Holbein had encountered the young duchess in her plain widow's weeds and determined to depict her as he found her. It was a stroke of brilliance for, as one of the women of her court pointed out, in full regal dress 'You should have only seen her so'.[8] In showing Christina simply attired, Holbein rightly gauged that the viewer would not be distracted by the depiction of rich clothing, and instead he ensured the personality of his sitter would be the focal point of the work.

The portrait, still just a drawing, found its way to Henry by 18 March. This in itself was a marvellous achievement given the challenges presented by travel at the time. Hoby and Holbein took their instructions quite literally and left Brussels the afternoon Holbein had completed his drawing, riding home at speed.

Henry's response to the depiction was exceptional. Intelligence from the Spanish ambassador in the English court, Eustace Chapuys, revealed that on 'the 18th, the painter returned with the duchess' likeness, which has pleased the King much, and put him in much better humour. He has been masking and visiting the duchess of Suffolk, &c.'[9]

It is easy to assume that Henry's well-documented adulation on seeing Holbein's drawing of Christina was solely a personal response to the beautiful woman he saw before him, and yet more evidence of a man whose infatuations were easily stoked. However, it is also clear that his hugely positive reaction also marked his growing appreciation of Holbein's exceptional work.

Around the same time that he transposed Henry's image onto the walls of his privy chamber in Whitehall, Holbein had also used his

master drawing to produce a small portrait of the king. Measuring just 28 × 20 cm, its size in no means diminished its quality.* Set against a dark blue background the king is wearing the same magnificent outfit as in the master drawing, though Holbein has altered the colours from those depicted at Whitehall. Whereas the mural shows Henry enveloped in a cloth of gold doublet, with a red velvet coat and a dark sable collar, in the small portrait Henry is in cloth of silver, his gown a fantastic golden silk. The portrait is also consistent with Holbein's drawing, in that the position of Henry's head has not been modified, and remains in three-quarter profile, rather than face on as in the mural. It is significant that this picture, probably a diplomatic gift for Francis I, came from Holbein's hand rather than his fellow court painter Lucas Horenbout, who had made such diplomatic gifts to date. Horenbout, who may well have instructed Holbein in the necessary techniques for painting in miniature, was finding that his good friend and rival was indeed now very much the latter.

Henry was a monarch determined to expand his cultural trove.

Hans Holbein, *Henry VIII* based on the Whitehall cartoon, oil on panel, *c.*1537.

To date, his collecting activities had been focused on textiles and jewellery, but with Holbein in his service there was a real opportunity for him to build an art collection that might match those already assembled by his rival European monarchs. As such Henry saw an opportunity above and beyond the practical role that a drawing of a prospective bride offered.

On sight of the drawing of Christina, Henry requested a fully finished oil painting to be made up. The drawing that Holbein had presented was less than half-length.[10] Now he embarked on a full-length depiction, a format unique in his output outside his large-scale group portraits and murals. The question is whether the king suggested an enlarged full-length version of Christina as a prelude to her joining the Whitehall mural as his new spouse, or whether Holbein, reading the king's immediate enthusiasm, sought to suggest this possibility? Either way, the painter set about the task with a similar level of urgency as that pursued in the matter since the start. Within two months the 'great table'† was delivered to the king.

* Now in the Thyssen-Bornemisza National Museum in Madrid.
† The term for a large-scale painting on wood.

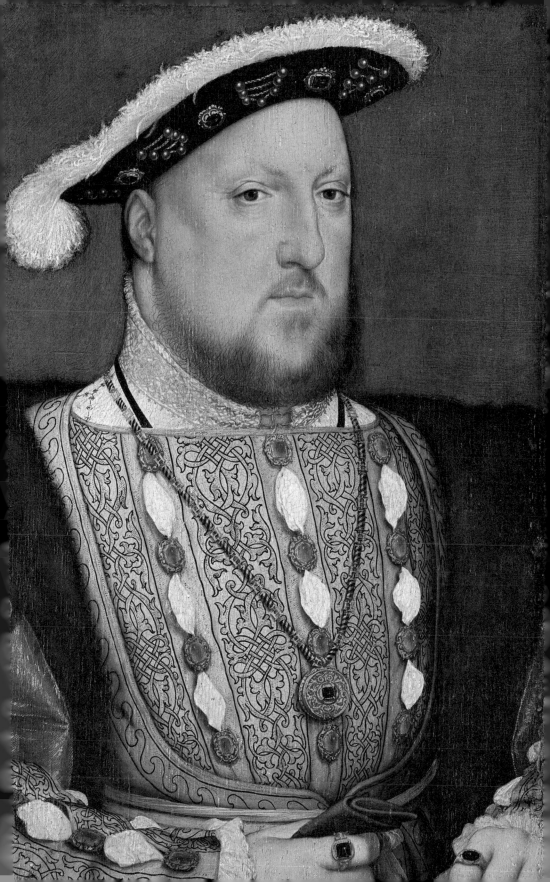

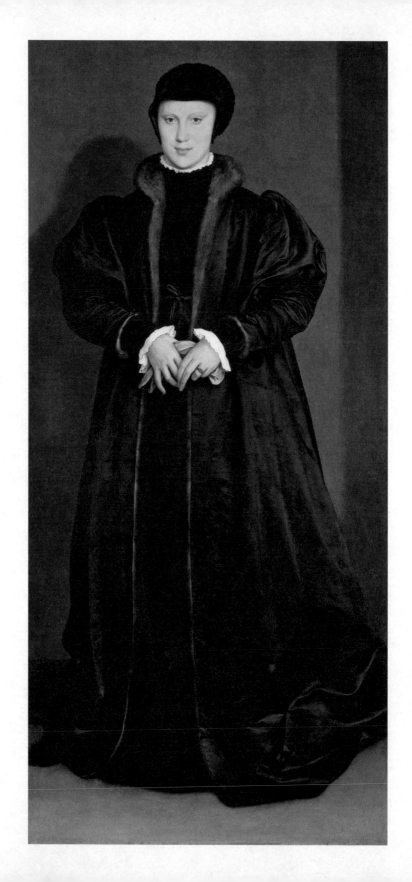

Today Christina stands in the National Gallery, London, oil on oak, an essay in understatement. Entirely clad in black as befitting a widow, the implication of luxury and wealth that colour also conveyed is lost on modern viewers for whom hue no longer has value. Now perhaps only the fur lining of her silk robe suggests her status. Her dark dress serves to amplify her pale face and hands and their slightest detail. Her lips seem all the more pink and heart shaped, their colour accentuated by the ruby ring she wears on the finger of her left hand, and their shape mirrored in the position of her hands.

Holbein depicts Christina in a moment of pause. She is standing still, but the slight orientation of her body to her left, and the drag of her clothing on the floor behind her, serves to suggest she has just walked into frame. In the same way her mouth is captured mid smile, in the process of reaction. This, along with her white gloves, twisted in her fingers, gives the portrait, at once so simple and still, a sense of vitality and animation.

Holbein is careful to include details from the sitting that most painters would have surely chosen to exclude or amend. Christina's gown has strong horizontal fold marks across it, a reminder of the most basic domestic aspect of a life where clothes are taken off, folded and stored at the end of each wearing. It serves to make the woman in the painting all the more human and plausible.

Hans Holbein, *Christina of Denmark, Duchess of Milan*, oil on oak, 1538.

There was a place for Christina ready and waiting. Cardinal Wolsey, well attuned to the power of art even before Elyot's *Boke*, had introduced the architectural innovation of a long gallery in his plush palace at Hampton Court, a space specifically designed for the exhibition of tapestries or paintings. After Wolsey's fall from grace, Hampton had passed into the king's hands, and here, in that long gallery, Henry now hung his 'great table' of Christina.

This was a watershed moment. The hanging of his Christina in the king's gallery not only cemented the new-found enthusiasm on Henry's part for painting, but it also indicated that Holbein's esteem was doing nothing but rising in the king's eyes. Many records from this period have not survived; however, those that have reveal that on Lady Day 1538 (25 March) Holbein had an annual salary of £30, 'paid quarterly, and continued yearly until his death'. This was a considerable sum – far more income than a landed gentleman might expect annually from

property, or the £20 a year a country gentleman needed to qualify him to become a justice of the peace. Within the court itself Holbein's earnings were ahead of those of the court astronomer and surgeon, as well as the high-profile Italian artists Antonio Toto and Bartolommeo Penni, whom Henry had inherited from Wolsey and who had the advantage of being in court since the late 1520s. Even if by court standards, Holbein's salary was modest, by national standards it put him in the league of the wealthy.

One fascinating possibility is that the portrait of Christina gave Henry the idea of using the search for a wife as an opportunity to collect a *series* of paintings of European beauties by Holbein that he could exhibit in his long gallery, thus aligning further the ambitions of the prospective spouse and aspirant art collector.

By June it was becoming clear that a marriage to Christina was frustrated, not least by Mary of Hungary's lack of enthusiasm for it. The latter had known Anne Boleyn when both were part of the court of Margaret of Austria. She, like many, had been astounded by Anne's fate, believing that she had faced fabricated charges on the basis that Henry had tired of her. Even Eustace Chapuys, who loathed Anne Boleyn, wrote to his master that the accused were condemned without valid proof.

With resistance from the imperial camp, Henry turned his attention back to the French aristocratic Guise family, and to Mary's eighteen-year-old sister, Louise. The French king himself had encouraged this option, pointing out that 'He approves the project of marriage and the king of England will not lose by the change of one sister for the other.'[11] This somewhat tradesman-like approach to the fate of the women involved was translated by his latest ambassador in England, Louis de Perreau, Sieur de Castillon, in more eloquent terms. Mary 'had a sister as beautiful and as graceful, clever and well-fitted to please and obey and any other'.[12]

So at the beginning of June 1538 Hoby and Holbein were now directed to Le Havre with an audacious instruction. Mary of Guise, who had been initially married by proxy to James V, was en route to Scotland to finally join her husband, and would be sailing from the French port. Louise was part of her sister's retinue, and here, amid the nuptial progress, Holbein and Hoby were to intercept the younger sister and take her likeness.

When Holbein's drawing of Louise of Guise arrived at court it created sufficient stir to find mention in a letter between Castillon and Francis I. The ambassador recorded Henry's reaction to the depiction of Louise, whom 'the King does not think ugly, as I know by his face'. And with this report, Castillon and his peers saw a new way to win the king's ear.

'If you wish to entertain this king,' explained Castillon, 'urge always marriages; for he only waits for them to be presented and pictures must be sent immediately. He has heard Mons. de Guise has a daughter still more beautiful than the second!'[13]

And so now Henry decided he wanted *another* finished portrait in oils, not just of the beautiful Louise, but also the other Guise sister Renée. Even though at the time of Henry's interest her life had already been dedicated to the church, the king was not deterred. In fact, so fascinated by the Guise sisters was Henry that he suggested to the King of France that they, along with two other potential brides, their cousin Anne of Lorraine, and the daughter of Madame de Vendôme, might be brought to Calais for his inspection.

This was a suggestion too far. Though Francis had been more than happy to discuss French noblewomen as easily traded one for another, he considered the English king's desire to inspect them an insult. The French accused Henry of assessing their female aristocracy like horses. Further, Francis now reminded Henry that the House of Lorraine was an independent duchy, and in the complicated political landscape of the time, it was under the protectorate of neither France nor the Empire. As such marriage into this particular dynasty was not in the gift of Francis, and even the King of England would have to seek the permission of the Duke of Lorraine for his daughter's hand.

Henry was undeterred. In fact he was motivated. More portraits of beautiful women were envisaged: a diptych of the available Guise sisters, and a portrait of their cousin Anne too. Holbein was issued three quarters of his annual salary in advance at the end of June, and by August 1538 he and Hoby were back in the saddle on another European mission. This time they were sent 'into the parties of high Burgony', specifically first to Joinville in the Haut Marne, where they were tasked with obtaining the portrait of Renée of Guise, and then on to Nancy, a day's further ride, where Renée's cousin Anne of Lorraine resided.

Cromwell's instructions regarding the Guise sisters were clear. Hoby was to 'repair with diligence' to

> where he shall find the two daughters of Mons. de Guyse, whom he shall salute, declaring that having business in these parts he could not omit to visit the one of them 'of whom he hath by his late being there some acquaintance'. And therewith he shall view well the younger sister, and shall require the Duchess, her mother, or whoever has the government of them, that he may take the physiognomy of her, that he may join her sister and her in a fair table.[14]

The pair, reaching Joinville on 30 August, discovered themselves in a realm of profound cultural sophistication and connoisseurship. The seat of Claude de Lorraine, 1st Duke of Guise, was in a state of transformation. The old medieval fortified castle, perched high above the Marne river, was being updated with the addition of an annexed pleasure palace. This impressive architectural adventure was however the fruit of the turmoil and division that continued to plague Europe. Claude de Lorraine had been richly rewarded by the French king for his assistance against the Swiss at Marignano, and then Charles V's Holy Roman Empire at Neufchâteau. More recently Claude and his elder brother Antoine de Lorraine had joined forces in putting down an army of revolutionary Anabaptist peasants.

The Duke of Guise's new Château du Grand Jardin combined traditional French style with Italianate Renaissance motifs and was essentially a cultural space where the duke could entertain and where the court artists popularized by their work for Francis I, such as Jean Clouet and Leonard Limousin, were invited to work.

Holbein may well have felt rather disappointed therefore that he was dispatched to lodgings in the town and told to keep a low profile. Hoby meanwhile faced his own disappointment on discovering that the primary object of their visit, the beautiful Renée, was not at home and was probably already at St Pierre in Reims where she had been abbess elect since 1536 despite her tender age of just sixteen. Hoby extemporized and insisted that the sole point of his visit was in fact to call on Louise. However, the Duchess of Guise was no fool, and her own account of the meeting shines light on the unconvincing performance of the young English diplomat, whom she had met already at Le Havre, and now saw straight through.

'It is but two days since the gentleman of the King of England who

was at Havre and the painter were here,' she related to her daughter Mary, now in Scotland,

> The gentleman came to me pretending he was going to the Emperor, and having heard Louise was ill would not go without seeing her [...] He saw her and talked with her [...] he then told me he wished to go to Nancy to see the country. 'Je me doubte in contynent il y allet voir la deymoyselle [i.e. Anne of Lorraine] pour la tirer comes les autres'; for which reason I sent to their lodgings to see who was there and found the said painter.[15]

Hoby and Holbein must have been surprised when with a knock on their door the real purpose for their visit was so deftly uncovered by the inquisitive lady of the chateau. Guessing that Henry was still throwing his net the duchess followed their progress and acquired a fulsome account of their trip to Nancy, where cousin Anne was ensconced in the ducal palace.

'In fact they have been at Nency,' she recounted. 'Vella se que jen ay encore seu; au pis alle sy navyes pour voysine vstre seur se pouret ester vostre cousine.'[16] Madame de Guise's conclusion was simple: as she had guessed, if Henry was not going to proceed with Louise or Renée, it looked as if he might take a fancy to Anne of Lorraine, their cousin. Either way Mary would soon have a member of her family as company on the other side of the Channel.

Nancy was the ancestral home of the Lorraine family. Here the Duke of Guise's elder brother, the aforementioned Antoine de Lorraine, lived in a palace that once again spoke to the family's cultural credentials. A sensibility for Renaissance taste was expressed in renovations begun by the brothers' father, Duke René II, in 1502 and completed by Antoine a decade later. The family's determination to exploit the potential of art for self-promotion and aggrandizement was clear in the huge equestrian statue of himself Antoine had commissioned from the local artist Mansuy Gauvin as part of an ornate gateway into the palace. This grand 'porterie' was adorned with Renaissance emblems such as putti and classical ornamentation, as well as depictions of antique cuirasses, military musical instruments, quivers and arrows, and bas-relief heads of warriors wearing fanciful Italianate helmets.

Whether Hoby and Holbein entered through the gate wide enough for carriages and horsemen, or though the narrower doorway provided for pedestrians, both entrances carried the Lorraine coat of arms,

and both signified a passage from a mundane world into a place of power, intellect and wonder. And once inside the delights continued. In a huge reception room on the first floor of the palace Lorraine had commissioned Hugues de la Faye, a local painter, to present the life of Christ interwoven with hunting scenes in a series of vast and impressive murals on a massive scale. The two narratives combined in one concluding fresco where the death of the hunted stag and the crucifixion of Christ were offered in metaphorical juxtaposition. No wonder this great hall became known as the Galerie des Cerfs in the century before Henry IV made his own *galerie* with the same name at Fontainebleau.

De la Faye had also executed a portrait of Antoine a good decade earlier, and perhaps it was in looking at this that Holbein secured his own commission to paint the head of the House of Lorraine. He would not execute or deliver this painting for another five years; nevertheless the comparison of his portrait with that of la Faye's is startling. The three-quarter angle in which Antoine is posed by Holbein is identical to the la Faye portrait. Both depictions feature Antoine's large, long, straight nose at exactly the same angle as it leads the eye down to his thin lips, almost concealed beneath a huge, thick beard. Both show a velvet cap adorned with golden beads, pulled down to Antoine's left, though there the comparison ends. De la Faye made a painting of a man in rich robes, where the eye of the viewer is constantly torn between assessing a face and the depiction of a finely embroidered shirt, a huge brown fur collar and different items of gold jewellery from a chain and medallion around the duke's neck to golden beads sewn into his sleeves. Yet the onlooker is convinced by nothing. In viewing it one knows that the painting is at one level no more than an approximation, and at another a careful catalogue of status and wealth. In contrast, Holbein's pared down view of the man in plain, though plush, robes delivers a fully three-dimensional person, so convincingly real that there is no need to impress the eye with more decorative dress. In fact in his depiction, Antoine's great fur overcoat has some threads breaking loose at the neck, this detail serving to increase the illusion of reality. Only in real life would such a grand man have some stray threads visible on his clothing. For a portrait surely they would have been tidied up!

Hans Holbein, *Antoine, Duke of Lorraine*, oil on oak, c.1543.

· AT IS · · SVÆ · 54 ·

Although Holbein always captured his sitters with meticulous detail, this loose thread, rather like the fold creases in Christina's gown, was more evident now. Holbein's approach to portraiture was shifting a little. From this period onwards his portraits tend to enjoy simple, dark backgrounds, often inscribed with the age of the sitter, and such mundane aspects are given greater attention. It is as if Holbein had neither the time nor the inclination for the complex symbolism of his earlier portraits.

The only splash of colour in Holbein's portrait of Antoine of Lorraine comes from the crumpled pink sleeves of his raw silk shirt, complementing the flush of pink in the duke's cheeks. It is the same technique he had used in his otherwise sombre palette for Christina of Denmark, where her ruby ring chimes with her lips. The duke is solemn, caught in thought, his eyes downcast, a streak of grey in his beard indicating his fifty-four years. A sense of burden exudes from this depiction of Antoine, who, unlike his brother who had thrown himself in with the French, found himself endlessly as a piggy in the middle between the interests of France and the rival Holy Roman Empire. This was the image of a man who had successfully maintained the sovereignty of his duchy against the odds, retaining a neutrality in the fast-shifting sands of sixteenth-century politics; friend of all, enemy of none. As such this is a man whose portrait needed no adornment. Instead Holbein focuses his efforts to give a psychologically convincing version of the man under his scrutiny. It is not pomp but presence that Holbein is trying to evoke in the painting.

It's tempting to imagine Holbein, his status and confidence riding so high, offering to make a drawing from the same angle as de la Faye's, quickly as always, just as an exercise in revealing the superiority of his talent. It is likely that Antoine de Lorraine was keen to entertain Holbein given they shared an important acquaintance. As the subsequent portrait suggests, Antoine de Lorraine understood the reputation of his guest.

The main connection between the two men was Erasmus, who was a regular correspondent with Antoine and his brothers. Some of the constellation of scholars, artists, writers, and philosophers that had surrounded the writer had found its way to Lorraine's court. One was Claudius Cantiuncula, a lawyer and scholar from Metz who had dropped his family name, Chansonette, and like so many humanist

scholars of his day restyled himself with a classical moniker. Another was Johann Egli Offenburg, the son of a Basel dignitary. Erasmus himself had recommended Offenburg to the duke. Holbein shared close mutual friends with both men, including Bonifacius Amerbach.[17] Offenburg was also a relative of the *Offenburgerin* woman rumoured to be Holbein's one-time mistress. Like Holbein, both Cantiuncula and Offenburg had left Basel amid the tensions of the Reformation. Their stories of Basel, Erasmus and the circle he had cultivated there must have reached Antoine's ears.

The reception at Nancy was therefore significantly different from that at Joinville. No longer hidden in lodgings, here Hoby and Holbein were honoured guests. As the Duchess of Guise recounted to her daughter Mary, they 'were well entertained and at every meal the maître de hôtel came to eat with them, with plenty of presents'.[18]

It was not just Holbein's reputation that preceded him at Nancy, but also news that he had just painted Christina of Denmark. And here one gets the sense of Holbein – not quite the spy – but the broker of information. The duke would have been keen to hear about this young woman that Holbein had spoken with and studied, though briefly, with such intensity.

Antoine, who was secure in his friendship with Francis I, had been seeking a way of protecting Lorraine from the Empire as well as his Protestant German neighbours. In an attempt to ally the latter he had initially matched his son Francis to the daughter of the German Duke of Cleves, Anne. This childhood betrothal had not been followed up, however, and now the notion of marrying Francis with Christina, and hence securing some protection against her uncle Charles V's Empire, seemed more attractive. It may be no coincidence that after Hoby and Holbein completed their mission in Nancy, Hoby was sent back to reignite talks between Henry and Christina's representatives, all too aware perhaps that there was serious competition for her hand.

There is some irony that the woman that Lorraine let go, Anne of Cleves, would become the King of England's next object of desire. Hans Holbein's role in forging Henry VIII's next marriage with this Rhenish princess was significant, to say the least. But for the moment Holbein needed to complete his own personal mission – to return to Basel. He had not seen his own wife and family for more than half a decade, and he needed to take matters in hand.

EDWARD

Basel was just two to three days' ride from Nancy. His mission to Lorraine had presented Holbein with the first real opportunity to return home in years, and so as Philip Hoby headed back to England, Holbein headed further into the interior of the continent.

Holbein had planned this return home from the moment he was given his latest mission by the king. He arrived laden with money for his wife, instruction manuals for his sons, and consciously dressed in the finery of the Henrician court so he could make a very noticeable entrance.

The city had changed yet again since Holbein had last been there. It was finally finding a new equilibrium. Sure enough, the red sandstone cathedral, mounted on its hill and overlooking the Rhine, was no longer adorned with the vibrant devotional handiwork of the city's painters and sculptors. Its altars were stripped and the huge organ doors he himself had painted were now covered up with a plain curtain. Nevertheless the city's university had managed to continue, and its one-time reputation for relative tolerance, debate and creative discourse was slowly returning. Recent evidence of this was the red marble epitaph lavishly inscribed in gold, erected in the cathedral to none other than Erasmus. Holbein's old patron had died in Basel just two years earlier, in 1536. Now Holbein could view this memorial to a man who had remained loyal to the Pope in spite of his criticism of the church, and was now embraced by the city from which he had once fled in fear for his life.

Far more significant than the epitaph of a dead friend, Holbein had not seen his wife and family in Basel since 1532. Elsbeth and his four children, Catherine, Philipp, Jacob and Kungold, were waiting for him. In his absence his eldest children had become young adults; meanwhile his youngest had grown up barely knowing him.

Travelling under His Majesty's order he was uniquely placed to avoid the legal restrictions that prevented most travellers taking more than £5 out of England, and thus he would have been able to bring substantial funds for his family. Holbein had even been exploiting his recent foreign missions to pursue extra-curricular business ventures so that he could arrive home with plenty of money to hand over.

One small detail that exists about his trip to Le Havre earlier in the year provides surprising insight into these commercial ambitions, as well as the entrepreneurial time in which he lived. In an era when

travel was difficult and regulated, it was not unusual for the privileged members of court to exploit their official business trips to undertake personal business ventures, some more successfully than others. For example, in the early 1530s Cromwell had lost his shirt trying to export spermaceti, whale oil used to make a wax. Meanwhile both Philip Hoby and John Hutton had indulged in a little buying and selling of tapestry during the former's stay in Brussels in the spring. Before his trip to Le Havre to draw Louise of Guise, Holbein had embarked on his own enterprise. Exploiting his contacts he had turned once again to John Godsalve, who now had a prestigious position in court as one of the king's Clerks of the Signet.[1] The combination of Godsalve's and Holbein's visibility at court secured the painter a royal licence to export 600 tons of beer. The level of favour he had achieved is revealed in the king's grant, to his 'well beloved' Holbein.[2]

There is no record as to whether Holbein was more successful as an exporter of ale than Cromwell was of whale oil, but there is no doubt he made a spectacular entrance in Basel. Holbein turned up there wearing a velvet cloak, and a damask doublet with satin sleeves. For once he was the subject of theatre, rather than being one of its unseen producers. Certainly the lawyer Johann Iselin noted that the man who had once been unable to afford a pitcher of wine and had been obliged to 'buy wine at the tap [i.e. by the glass from the cask]' was now 'attired in silk and velvet'.[3]

The full significance of this description of Holbein's clothing is easy to overlook today, but in sixteenth-century England there was a strict hierarchy attached to outfits, reinforced by sumptuary laws that restricted the wearing of certain fabrics or details of dress by rank. In 1533 the use of velvet had been limited to the aristocracy or those whose annual earnings exceeded £200, for example.[4]

The people of Basel bought into the Holbein show. On 10 September 1538, just days after his arrival, the residents of Johanns-Vorstadt threw a street party in his honour. It was as much a gesture of reconciliation as a homecoming celebration. Holbein had been an errant son. He had been defying the strict regulations under which Basel society operated ever since he left the city's walls in 1532 to return to London.

Guild members were expected to seek consent for extended leaves of absence. Despite the guild authorities offering Holbein a pension to

return home sooner, its appeal had paled at a moment when he found his services so readily taken up in London and when he knew pickings were still slim at home. Twice he had ignored further calls to return, and to make matters worse he had also apparently failed to seek the permission from the city council that was considered mandatory before any citizen could accept work from a foreign master. The same ambition, self-importance, and vision for the status of the artist that had encouraged him to sign his work as a boy, and motivated Holbein to hurl that English earl down a staircase, was perhaps behind his consistent refusal to conform to Basel's protocols. It was a tactic that had paid off.

Now Basel's burgomasters were keenly sensitive to Holbein's clearly visible success. Much like the English courtiers who had grasped the cultural esteem associated with a man of such huge talent, the man who had left as Master Holbein and had returned as the King's Painter was wooed by the civic dignitaries for whom he had once worked under different circumstances. After the street party, Holbein made a point of continuing his parade. He revisited some of the prominent works he had completed in the early 1520s, making suggestions for enhancements he could undertake on his agreed return at the end of 1540. The murals he had painted in the council chamber of the town hall could be improved on. 'His intention was [...] to paint many of his pictures again at his own expense, as well as the apartment in the Town Hall', Iselin remembered. However, he added that the murals of cavorting peasants he had provided for Balthasar Angelroth were still, even by his latest standards, 'rather good'.[5]

Holbein's performance had its desired effect. By early October the city elders struck a new deal with him. As the burgomaster wrote in a public letter:

> From the special and favourable will which we bear to the honourable Hans Holbein, the painter, our dear citizen, since he is famous beyond other painters on account of the wealth of his art; weighing further that in matters belonging to our city respecting building affairs and other things which he understands, he can aid us with his counsel, and that in case we had to execute painting work on any occasion, he should undertake the same, for suitable rewards, we have therefore consented, arranged and pledged to give and to present to the above named Hans Holbein a free and right pension for our treasury of 50 gulden.

It was not just a handsome pension the city offered, but flexibility in terms of absence. The burgomaster conceded:

> As however the said Hans Holbein has now sojourned for some time with the King's Majesty in England, and according to his declaration it is to be feared that he can scarcely quit the Court for the next two years, we have allowed him under these circumstances to remain in England, following this date, in order to merit a gracious discharge, and to receive a salary, and have consented during these two years to pay his wife residing among us forty gulden yearly... And, as we can well imagine that the said Holbein, with his art and work being of so far more value than that they should be expended on old walls and houses, cannot with us alone reap much advantage we have therefore allowed the said Holbein, that, unimpeded by our agreement, for the sake of his art and trade, and for no other unlawful and craft matters, as we have also impressed upon him, he may gain, accept and receive service money from foreign kings, princes, nobles and cities; that moreover he may sell the works of art which he may execute here once, twice or thrice a year, each time with our special permission, and not without our knowledge, to foreign gentlemen in France, England, Milan and the Netherlands.[6]

The city was, however, keen to give an impression of jurisdiction. 'Yet on such journeys, he may not remain craftily abroad,' the charter warned, 'but on each occasion he shall do his business in the speediest manner, and repair home without delay and be serviceable to use, as we have before said, and as he has promised.'[7] Even with this final clause, the contract was a huge achievement.

The countries cited in the permission are worth brief consideration. Little evidence remains of Holbein's patrons outside of England and Switzerland. His ambition to work for Francis I and Antoine of Lorraine may well account for the reference to France, while the permission to work in the Netherlands could potentially secure him imperial commissions, as could permission to work in Milan, still under imperial control. But the very specific mention of Milan does perhaps suggest a relationship with that place, and patronage based there, and also perhaps adds weight to the view of some scholars that Holbein may have travelled to Italy, though documentary evidence of this does not exist.

With business thus concluded, Holbein did not delay long in Basel. If there is evidence of the seriousness of his commitment to the

English court, it is that he had left Basel by the end of October and was back in London by December.

However, one thing he had achieved was financial security for Elsbeth and the children, and he made another important gesture in this respect. He left behind his expensive wardrobe. His velvet-trimmed cape, and doublets of silk, damask and satin were handed over to Elsbeth, who packed them away for safekeeping.[8] Like so much in Holbein's life and work, the gesture can be read in two entirely different ways: either as a promise of return, or, as would prove the case, an important gift to help secure Elsbeth's financial comfort in light of his failure to come home.

Although he left Elsbeth again, Holbein was mindful of his sons' careers. Both would become goldsmiths in due course and it is clear that this choice of career was one fully encouraged by Holbein. As suggested earlier, designs for fine metalwork had become a particularly successful aspect of his own workshop and he may well have imagined the boys overseeing this side of the business later on. He was clearly determined to assist their progress in this field by sharing some of his own decorative designs for metalwork.

Holbein's determination that his sons should be goldsmiths, not painters, is another example of the absent father nevertheless doing his best for his children. It had become evident to Holbein that the acquisition of wealth, and the attendant social mobility that went with it, was far easier for a goldsmith than it was for a painter. It speaks once again to a man who had seen his father and brother struggle, his fellow guildsmen starve, and who, in spite of his own exceptional situation, still saw that the lot of the painter was an unnecessarily thankless one. Goldsmiths on the other hand dealt in precious metals and stones, not just working with these luxurious materials, but trading in them too. Revisiting the Angelroth house in Basel, its sumptuous façade and ample footprint would have done nothing but reinforce this fact of life. Precious items allowed those who handled them social mobility, their access to treasure opening the doors not just of the bourgeoisie, but the aristocracy and even royalty.[9]

Holbein had even come with some of his own metalwork designs for his boys to study. The ample collection of Holbein's technical drawings and decorative motifs in the Basel Kunstmuseum today, originally part of an 'English Sketchbook', suggests that Holbein

brought back with him from London material that his sons would find instructive in their own proposed careers.[10] In what must have been a thick portfolio transported across Europe, there are a mass of ideas and information for the young men, including Holbein's own guide to how to achieve a sense of dimension and proportion in the depiction of figures; drawings of urns and goblets; ideas for Italianate decoration such as that of a man with an arched back that might serve as an adornment or handle; spectacular conceits such as a jug in the form of a peacock; references to classical motifs, such as a sketch for a depiction of Ceres; proposals for classical picture frames and dagger sheaths; and more.

It was in fact a starter pack and reference guide that would provide a leg up for an aspirant apprentice. Back in London there were expert goldsmiths such as Cornelius Hayes or Hans of Antwerp with whom Holbein could have apprenticed his eldest son Philipp. Sure enough, when he left Basel, the teenage Philipp went with him. But instead of London, Holbein took him to Paris to be apprenticed to a goldsmith called Jakob David, who like Holbein had once lived and worked in Basel. Such a move was made under the official jurisdiction of the Basel guild, who not only gave their permission, but retained the right to summon Philipp's return in due course.

The route Holbein took back to London is unrecorded, and yet the few details regarding his departure suggest the complex religious and political landscape he was traversing in his journey back to the Tudor court. If a decade earlier Holbein had fled to London to escape the freeze continental art was suffering under the new Protestantism, by contrast in 1538, working under the patronage of Thomas Cromwell, Holbein's services were being fully harnessed to the latter's Protestant agenda.

If Holbein's own religious beliefs had once been closest to those shared by Bonifacius Amerbach, Erasmus and Sir Thomas More, it is blatantly clear that he had pursued a pragmatic approach when it came to business. He navigated the religious debates and divisions of his time in much the same way he navigated the equally volatile politics of his day – with a mixture of diplomacy and opportunism. In terms of opportunity, that brought by Cromwell's programme of reform in England was considerable.

However, his dedication to Cromwell's often extremely controversial

religious propaganda also suggests a level of complicity. He would have been far from the first to become more and more convinced by reformist thinking. Many of his friends had turned to Luther and his followers.

Shortly after arriving in Basel Holbein met up with a young Protestant scholar, Rudolf Gwalther, whom he had most likely encountered the previous year when Gwalther was in England. The two clearly had a fulsome and friendly chat about life in England, because the latter's subsequent correspondence with Henrich Bullinger, an influential Swiss Protestant theologian based in Zurich, reveals how Holbein had been extolling 'the happy state of things in that Kingdom'. Gwalther explained to Bullinger that 'After some weeks he will return there again. If you therefore have anything which you may have forgotten eight days ago in the whirlpool of business, send it to me and I will see it is taken care of.'[11]

At first glance Gwalther's note seems little more than an account of Holbein's personal good fortune in England, but on reflection it could well suggest that the scholar was referring less to Holbein's own prosperity at court and more to his role in promoting the Protestant religion in Henry's realm. Given Cromwell was in the process of overseeing the publication of an English translation of Bullinger's commentary on the *Second Epistle to the Thessalonians* at Nicholson's presses in London, Holbein's sudden appearance in Basel presented an ideal opportunity to courier home further communications relating to this or future projects.

Bullinger's text took a shot at some of the Catholic shrines in England that Cromwell had closed during the course of the year, and as such amounted to a justification for his dissolutions.[12] The book was eventually published with a title page of Holbein's design. With this, the Coverdale Bible and Tyndale text all now benefitting from Holbein's illustration, a clear link was evolving between the artist and the English reformist presses.

With his illustrative work and courier services supporting the Protestant cause in London, his paintings serving the king's most pressing diplomatic and personal business, and perhaps even the profit from 600 tons of beer sales in his pocket, it's hard to imagine room for much more success for Holbein in 1538. Yet this golden year had still more to give. Elsewhere on the continent, in Lyons in France, a

printer was busy at work finally producing two groundbreaking series of illustrations by Holbein that had been languishing unpublished since the 1520s.

After lying dormant for over a decade, the printing blocks for *The Dance of Death* were finally in service. Holbein's macabre series was at last to be published by Melchior Trechsel and his brother Gaspar in Lyons. The Trechsels were also making up Holbein's series of illustrations to the Old Testament, his *Icones*. Happily for Holbein, these were now being prepared and distributed from the bookshop of two other brothers, Francis and Johan Frellon, in Lyons' main mercantile thoroughfare, the Rue Mercières. The Frellons had even secured an introductory poem in praise of Holbein in the *Icones* by none other than Nicholas Bourbon. Unhappily for Holbein, however, his name had been omitted from the *Dance of Death* series by the man who wrote its dedication, Jean de Vauzelles.

Why did Vauzelles fail to credit Holbein? Over the forthcoming years the series was used in the service of both Catholic and Protestant agendas, a fact that reinforces the inherent ambiguity in Holbein's work. So was it that the painter himself had become a recognized part of a Protestant propaganda machine? Had the name Holbein strove so hard to make famous become a shorthand for the evangelical press at this particular moment in time? If so was there a degree of risk in attributing his work in Catholic France? Certainly when there was a Protestant uprising in 1542 the Frellon brothers did issue a version with Holbein's named attached.[13]

When Holbein was once again travelling across France in 1538 it is tempting to imagine that he revisited the Loire and Francis's collection, which at this point had been moved to the chateau at Fontainebleau. Here he would have once again seen Leonardo's *Young Christ as Salvator Mundi*, and Clouet's portraits of the young French princes. Or perhaps it was just his memory and long-lost sketches that finally served their purpose as and when. Nevertheless Holbein certainly seemed to have all these works in mind when, on his return to England, he set to work on another project for the king.

It was a portrait of the king's baby son and heir, Prince Edward. This was a painting Holbein intended as a formal, public gift to the king from his painter. It would be presented to his benefactor as part of the New Year's ceremony, the most important annual gift-giving

ritual at Henry's court. Conducted in public in the king's Presence Chamber with Sir Brian Tuke, the king's treasurer and secretary of the royal household formally recording all the gifts in writing, it served to remind the court who was in favour and who sought it. In fact the right to present a gift as part of this ceremony would have been carefully negotiated, and for those who misjudged their place, the public rejection of a gift could be devastating. However, having a gift accepted was a feather in the cap. As far as can be ascertained, this was the first time Holbein made such a gesture.[14]

Holbein's portrait of the young prince may well have been underway before he left for the continent. The 'English Sketchbook' that he had taken with him to Basel already contained a design for a miniature of Edward, suggesting that Holbein had made a series of preparatory drawings of the baby earlier in the summer. The design for the round miniature, executed in ink, shows the latest member of the Tudor dynasty sitting on a cushion. The curve of a hat worn on top of a bonnet follows the curve of the circle framing the subject. Edward's arms are outstretched, his left hand grasping some of the ornamental foliage that helps fill the composition, while a little dog looks adoringly up at him.

Hans Holbein, *Edward VI as a Child*, oil on panel, 1538.

The miniature, if executed, may have been an accompaniment to the formal portrait that Holbein presented. This is in oil, on wood. The child was set against a bright blue background.* In bold contrast to the azure backdrop, Edward is clothed in red, gold and silver.† The influence of Cromwell is felt in the inscription that accompanies the painting, composed by Richard Morrison, a reformist who was part of a stable of authors Cromwell used for propaganda. The sentiment takes its cue from that already expressed in the Whitehall mural. Intended to flatter, it suggests that though barely possible to surpass the glory of the father, the hope is that the young prince might nevertheless inherit his virtue.

This young prince, who had only celebrated his first birthday in October 1538, is shown face on, though his body is slightly angled. He is upright, poised, in control of his movements, the man to come

* The background today is discoloured and appears grey. The painting is in the collection of the National Gallery of Art in Washington, Andrew W. Mellon Collection.
† The silver leaf work on the child's cap is now also discoloured and grey.

PARVVLE PATRISSA, PATRIÆ VIRTVTIS ET HÆRES
 ESTO, NIHIL MAIVS MAXIMVS ORBIS HABET.
GNATVM VIX POSSVNT COELVM ET NATVRA DEDISSE,
 HVIVS QVEM PATRIS, VICTVS HONORET HONOS.
ÆQVATO TANTVM, TANTI TV FACTA PARENTIS,
 VOTA HOMINVM, VIX QVO PROGREDIANTVR, HABENT
VINCITO, VICISTI, QVOT REGES PRISCVS ADORAT
 ORBIS, NEC TE QVI VINCERE POSSIT, ERIT.

already implied in the child. The frontal aspect of the portrait imme-diately associates it with religious imagery, where traditionally holy figures were shown full face. Holbein's conscious referencing of reli-gious painting is also indicated in his depiction of the young prince extending his right hand. At first glance this is a simple wave from a child, but a degree of control in the hand is also reminiscent of the gesture for blessing. Meanwhile, the child grasps a golden rattle in his left hand, but rather than shake it, again the gesture is restrained, allowing one to imagine for a second that this is a glimpse of the sceptre the prince will one day wield. Holbein endows his image with a sense of spiri-tuality as a nod to the fact that this child will take his father's place as leader of not just a nation but a new English church. Typically, Holbein provides imagery that operates across several meanings. For those who chose to see it thus, the painting was merely of a child. For others here was a king in the making. The reformists in the room may have chosen to see a reference to the future of the Church of England and an expression of hope that it would follow the path of reformation.

The scale of the yearly gift-giving ceremony should not be underestimated. As early as November each year a massive construction of trestle tables and platforms began in anticipation of a great display of these New Year's gifts. In January 1539 nearly two hundred gifts were given and displayed. For a painter like Holbein this theatrical presentation amounted to an important showcase for his work, as well as the endorsement of his hard-won status. And in this year the fact that his gift was the *only* painting, amid an array of money (in purses), clothing, silver- and gold-plated vessels, and food (including a large Parmesan cheese) could only work to draw attention to it.

For all those members of the aristocracy and gentry who had their gifts accepted by the king, a gift was given in return. In Holbein's case he was awarded a 'gilte cruse with couer' weighing 10 ¼ ounces – in other words a small gold-plated jar or vessel, with a lid. It was designed by his colleague Cornelius Hayes.

The gift was very much at the lower end of the royal generosity, which was measured in ounces. Members of the aristocracy and those who held positions of state could expect far more, with the Duke of Suffolk and Thomas Cromwell enjoying some of the king's largest gifts that year, at a weight of a 84 ½ ounces of plate and 74 ¼ respectively. The smallest gift of all was to a Mistress Morris, whose token was just 7 ⅛ ounces.[15]

John Godsalve, Holbein's business partner in matters relating to beer and part of the court's most senior clerical staff, got a gilt bowl and lid weighing 18 ounces in exchange for two games tables he offered the king. This serves as a reminder that, despite the praise from scholars, poets and indeed the people of Basel which placed Holbein on a pedestal, Henry's court, in terms of gifts at least, still defaulted to a rather medieval footing when it came to recognizing artistic genius. So Holbein found himself ranked alongside the king's polisher of stones Richard Atsell, and his fruitier, also called Hans, who were both given comparable gifts, while Lucas Horenbout, the other painter at court, got a slightly lighter one.

Hans Holbein, *Roundel portrait of Prince Edward*, ink on paper, 1538.

Nevertheless, despite the relative modesty of his gift, this was significant recognition for Holbein. He was one of just a very few whom the king knew, recognized, and would hear speak. It placed him in an elite milieu that most men and women in England could only dream of occupying. The portrait also had the promotional impact that Holbein had hoped. John Leland was moved to put his pen to paper, writing a poem inspired by the portrait that elevated Holbein's status to the divine:

> As often as I direct my eyes to look at your delightful face and appearance,
> So I seem to see the form of
> Your magnanimous father shining forth in your face.
> The immortal hand of Holbein painted this pleasing picture with rare dexterity.[16]

As the new year of 1539 progressed the king continued to look to Holbein in the matter of most profound importance to him – his remarriage. Christina of Denmark's formal rejection of Henry had arrived the previous October when Holbein was still overseas, and as January progressed it became evident that a union with one of the French aristocrats Holbein had drawn would not prove fruitful either. It would only be a matter of time before Holbein would once again be sent to make another painting. But this time Henry's search for a queen would have to be made outside France or the Holy Roman Empire. It narrowed the field somewhat.

Europe's political sands had been shifting again across 1538. Most worrying for Henry was a new alliance between Europe's two Catholic superpowers and former rivals, France and the Holy Roman Empire. Though Francis I had once been held captive by Charles V the enemies had, across the course of the year, been discussing a new treaty of friendship that would not only unite Catholic Europe, but would also alienate England. On 12 January 1539, just days after the ceremony of New Year's gifts, these Catholic superpowers signed the Treaty of Toledo, an agreement of cooperation that also ruled out any alliances with England and put paid to a political marriage with a princess drawn from either of these camps.

Henry's court was thrown into turmoil at the news. It was not just the threat from foreign superpowers that cast a sense of dread; Henry feared that there were those close to home also plotting to oust him. As the frost covered London's streets and the Thames froze, so the atmosphere at court plummeted.

One of the omissions from the 1539 New Year's gift ceremony had been Henry's great boyhood friend, minion and confidante, Sir Nicholas Carew. This was the brilliant jouster and tournament hero whom Henry had once honoured with his own tiltyard at Greenwich, and whom Holbein had depicted in his gleaming armour.

But that January Carew's gift to Henry and the reciprocal one from the king were glaring by their omission. Only Carew's wife Elizabeth, a relative of Anne Boleyn and one-time mistress of the king, was remembered with a modest 12-ounce cup. In retrospect this was perhaps a sign that she would not be entirely condemned for the king's displeasure in her husband, yet its very modesty also spoke of the king's disappointment in a woman who, as part of a formerly

golden couple, he had once showered with gifts of precious jewellery.

Carew's friendship with the king had provided him with the misplaced confidence that he could speak his mind regarding the king's affairs. He had been vociferous in his sympathy for Henry's first wife Katherine, and in his support for her daughter Mary. He had been a favourite of Francis I, something which now must have been a considerable irritant for Henry. And, according to anecdote, he had made a serious misjudgement when, over a game of bowls with the king, he was too fulsome in his response to an insult from the monarch. While the king had overlooked all this, in the final months of 1538 Carew's name had become linked to a plot to usurp Henry and place a descendant of the Plantagenet kings, Reginald Pole, on the throne. Henry's indulgence of his boyhood friend finally ended and Carew was arrested and charged with treason.

Pole, another one-time companion of the king, had defected to the continent after Henry's marriage to Anne Boleyn, and most recently had been portraying Henry as a tyrant to the Pope. Unable to punish Pole himself, Henry's fury had turned on Pole's family in England. Again these were people who were once considered close to Henry. He had Pole's mother, the Countess of Salisbury, arrested. This was a woman in her late sixties, who had in happier times been the Princess Mary's nursemaid. Far more significant, however, was the fact that she was the only entitled woman in her own right in the country, and a cousin of Henry's mother. Pole's brother Henry, Baron Montagu, Montagu's brother-in-law Edward Neville, and their cousin Henry Courteney, Marquess of Exeter had, like Carew, all been part of the Seymour circle, and associated with the demise of Anne Boleyn. This however did not prevent their arrest on charges of treason as 1538 drew to its close.

The Exeter Conspiracy, as it is known, throws into relief the harsh reality of the Henrician court. It is not just the fact the accused were arrested on the flimsiest of evidence, as Boleyn and the men in her circle had been, nor that Cromwell used the king's paranoia to eradicate a family, but that other members of the accused family helped to condemn them – perhaps to spare themselves from scrutiny.

Edward Neville's younger brother Sir Thomas Neville was part of Henry's inner circle at court at the time, and from this position of privilege observed the destruction not only of his sibling, but of his

niece, who was married to the unfortunate Montagu.

Similarly, Elizabeth Carew's brother, Sir Francis Bryan, watched his brother-in-law's fate unravel from a position of rare intimacy with the king. Another rake like Carew, Bryan's reputation for debauchery had not prevented him becoming the king's Chief Gentleman of the Privy Chamber, a position that continued to give him the most intimate access to the monarch.

Despite the Carew and Neville relatives who had the king's ear, no one stepped forward to save the condemned. The extended Pole family, with the exception of Lady Salisbury, were all beheaded between December 1538 and early January 1539. Carew survived only until early March, when chillingly Francis Bryan sat as part of the jury that condemned him.

In addition to Nicholas Carew, Holbein had known some other members of this circle. In the early 1530s he had drawn the solid, jowly features of Edward Neville's elder brother George, 5th Baron Bergavenny, from which he had made an exquisite miniature for him. These men and women who lost their heads now joined the long list of executed people the painter had known. By now the English court must have felt a very dangerous place indeed.

Across the next few weeks the political crisis deepened. In Europe news of the Pole killings was received with horror and provided nothing but fuel for Reginald Pole, who in February visited Charles V and actually suggested the emperor mount an invasion of England. Charles demurred, neither agreeing to the invasion nor acquiescing to a furious Henry's request to extradite Pole. Fearing the worst, England prepared for war. The king dispatched commissioners to England's coastal counties to survey their vulnerability and draw up plans for fortification.

Against this backdrop, the question for England going forward was whether it should form an alliance with Europe's northern Protestant states, which had aligned with one another under the cumbersome title of the Schmalkaldic League.*

The man still most in favour with the king was Cromwell. Good news for Holbein, who was now bound fast to the latter. As

* Established in February 1531 at Schmalkalden, Germany, it was a defensive league formed to respond to any attempt to enforce the recess of the Diet of Augsburg in 1530, which gave the Protestant territories a deadline by which to return to the Catholic Church.

1539 dawned, Cromwell's patronage of Holbein was reinforced by a substantial payment of 40 shillings to the painter. Meanwhile the Lord Privy Seal's mission to reform the English church and to take the king with him continued apace. In one of the recently dissolved monasteries in London, Greyfriars, he had removed the Papal trappings of that establishment and instead set up a group of French printers at presses that were now busy producing 9,000 copies of the Coverdale Bible in English, one for each of the churches in England and Wales.

In the face of this onward march of religious reform, there were however conservative forces in the Tudor court set on fighting back. At some point in 1539 the hugely powerful Duke of Norfolk, the same who had summoned Cromwell to the king's side the day Jane Seymour died, decided that Holbein should commit his image to posterity. Norfolk was Cromwell's nemesis. If ever a painting anticipated a political move, it is Holbein's depiction of him.

Holbein knew the duke's son, Henry Howard, the Earl of Surrey. There seems little in common between the young poet and his father. The duke was a small, wiry man, his face and nose long, and his eyes small and hooded. However, his sense of self-importance was great. It is perhaps no coincidence that at roughly 80 × 61 cm his portrait is just larger than the one Holbein made of Cromwell, which measures close to 76 × 61 cm.†

While the man lacked genuine physical stature, Holbein provides it by adopting a low point of view in the portrait so Howard appears to loom. The painter also allows Howard's huge, meticulously depicted lynx fur collar to fill almost the entire width of the frame, impressive immediately for both its bulk and costliness. The importance of Howard's status is indicated in the careful and detailed depiction of the chain of the exclusive Order of the Garter which is draped around his shoulders, while the white staff indicating his position as Lord High Treasurer is gripped firmly by the bony fingers of Howard's left hand. In his right hand, he holds up the golden truncheon of his office of Earl Marshal.

Holbein chose to depict Howard in three-quarter profile, his gaze apparently directed to the left of the onlooker, his face at rest, without an immediately evident expression. In fact at first glance

† The painting, part of the Royal Collection, hangs in the Queen's Drawing Room at Windsor Castle.

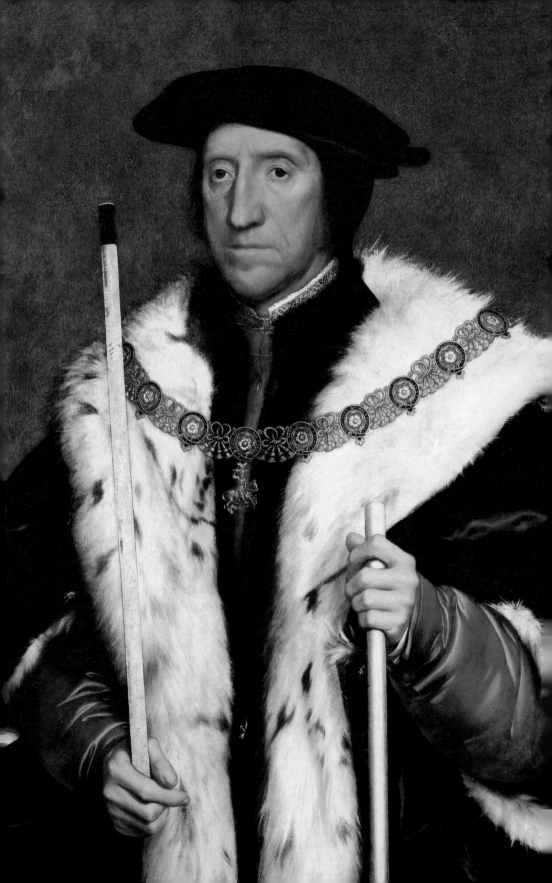

Howard's face is inscrutable. It offers none of the humour or warmth that Holbein sometimes conveys in his portraits, nor by contrast the confident masculinity that can be felt in other depictions of powerful men. Only on closer and prolonged inspection does Holbein's work reveal itself. The more one stares at the face of the sixty-six-year-old duke, rendered with such detail that every contour and crease of age is seen, one notices his left eye. It is not quite in line with the right. While the right eye stares beyond the viewer into a mid distance, the left is perhaps focused. The effect is one of unsettling movement, a quick surreptitious glance from a watchful power player. This illusion of a darting eye is in sharp contrast with an otherwise depiction of utter stillness, emphasized by the strong vertical lines of his two staffs that frame him. In addition, the impressive volume of Norfolk's cloak and the padded sleeves of his doublet give a sense of impenetrability. The painter's subtle message thus emerges. Here is Norfolk, the real man shielded and concealed beneath the trappings of power. Here is a man held back, steady and waiting. But here also is a man who is ever watchful, ready to pounce. And that he most certainly was. Norfolk was determined to halt the dismantling of traditional Catholicism in his country, and unseat his rival Cromwell. He was simply awaiting his opportunity.

Hans Holbein, Thomas Howard, 3rd Duke of Norfolk, oil on panel, 1539.

It came in the spring of 1539. Suddenly Cromwell fell sick. While he was confined to his bed and too unwell to attend court, Norfolk found his room to manoeuvre. Henry's ordinary subjects, the men and women in the streets and fields, were rightly confused by what the Church of England stood for. The Ten Articles Henry had launched, during the Boleyn era, under the influence of Cranmer and Cromwell, had opened the door to what felt to some like a form of Protestantism. The Pope was no longer the head of their church, his authority gone. The Bible in English was on its way, transubstantiation was not necessarily part of the sacrament and priests could marry. The monasteries were being dissolved and the icons of traditional faith had been smashed. Nevertheless the king was still the man whom the Pope had once celebrated as the Defender of the Faith. It was time that the head of the church in England should clarify its position.

While Cromwell was indisposed, Norfolk took the opportunity to suggest a push back against the religious reform. In early May the

House of Lords set up a committee to consider questions of doctrine, and within a fortnight Howard had presented six conservative articles for consideration. Many of these represented a walk back on reforms that the king had apparently endorsed earlier, and Cromwell and the Archbishop of Canterbury Thomas Cranmer had already embraced. Importantly the six articles re-established a traditional interpretation of the sacrament as a literal ingestion of the blood and body of Christ, and reinstated the Catholic ban on the marriage of priests. While Cromwell sweated in bed at home, Norfolk worked his influence with parliament and the king and by the end of June the Act of Six Articles had been passed into law and received royal assent. Of particular embarrassment for the Archbishop of Canterbury was the article on priestly matrimony, as a consequence of which his German wife was quietly returned to her homeland.

Though Cranmer's marriage was compromised, the king, by contrast, was still eager to embark on his own adventure into wedlock with a fourth wife. Whether it was the magic of Holbein's Christina that had enthused him, the king was noticeably embracing the persona of a Renaissance monarch for whom culture was a potent currency. This was not lost on the new French ambassador, Charles de Marillac, who noted with some apparent astonishment in early June 1539 that

> The King, who in some former years has been solitary and pensive,
> now gives himself up to amusement, going to play every night
> upon the Thames, with harps, chanters, and all kinds of music and
> pastime. He evidently delights now in painting and embroidery,
> (having sent men to France, Flanders, Italy, and elsewhere for
> masters of this art, and also for musicians and other ministers of
> pastime). All his people think this a sign of his desire to marry if he
> should find an agreeable match.[17]

By September 1539 the king's appetite looked as if it would be finally sated. Holbein had been to Cleves and back, and now a portrait of Anne of Cleves had been delivered. Henry was at his leisure in his manor at Grafton in Northamptonshire, Anne's miniature in his pocket. The marriage between England and Cleves was in train, and with it an alliance with the German Princes.

As the king's enthusiasm for this young Rhenish woman was witnessed by the foreign ambassadors in England, a degree of genuine panic set in abroad. Henry, who just months earlier had feared invasion,

could not help but be delighted at the deft political manoeuvre that was apparently being achieved. The arrival of Holbein's portrait of Anne of Cleves had turned the tables. What might an alliance with the German Princes bode? On the one hand the French were now asking if Henry might be considering an invasion of France, to which Henry must have enjoyed answering with a degree of false humility that 'he was content with his fortune, and desired to keep within his own island, ready to defend himself and not to invade his neighbours, whose grandeur he envied not, provided they left him the little he had, which, however, was enough to guarantee him against such as would hurt him.'[18]

Meanwhile the Emperor Charles was also worrying that a union with Cleves would lead to trouble for him. Marillac was quick to point out that the Spanish ambassador, who was sick in bed in London rather than on the road with the court, feared that Cleves, reinforced by an English army, might finally attempt to stamp his claim on that disputed territory of Guelders. 'I hear,' wrote Marillac, 'with those who are coming from the Duke of Cleves, […] he thinks plots are being made against his master, for the quarrel which is between the Duke and him'.[19]

With Anne's portrait in his pocket Henry was suddenly enjoying a leverage on the international stage he had not had for some time, and this could only have served to strengthen the appeal of the marriage. And this is perhaps another reason why the warning signs provided by both Holbein in paint and Wotton in ink were ignored.

In his depiction of Anne of Cleves Holbein had delivered the antithesis of the painting of Christina of Denmark that Henry so adored. In his *Christina*, Holbein's entire focus was to convey personality and he removed the distracting detail of an elaborate costume in order to emphasize his sitter's delightful presence. In his painting of Anne the opposite is true. The painting depicts Anne's opulent clothing with the fullest attention, and in doing so the importance of personality is majorly downgraded. The key question is whether this was because there was little perceptible personality for the painter to explore. Nevertheless, if Anne's blandness was spotted by the king, so too was the stir her portrait created. With the arrival of Holbein's picture of Anne of Cleves, the whole timbre of diplomatic relations immediately shifted.

Days after the painter had unfurled his parchment to the apparent delight of the king, and as the ambassadors from Cleves were well on their way to England to finalize the marriage, Duke Count Palatine Frederick II of the Rhine announced he was at Calais seeking an urgent audience with the English monarch.

Duke Frederick was Christina, the Duchess of Milan's brother-in-law, and loyal to Charles V. Observers in court were quick to speculate that he was on a mission to stop the Cleves alliance. 'The embassy of Cleves has not yet arrived,' Marillac informed his French superiors,

> and there seems some coolness on this side, because of the coming of Duke Frederic, brother of the Count Palatine, who was lately at Paris, who lately certified here that he was at Calais intending to cross hither; as this King has told me, who sent some of his chief ministers, knights of his Order, to meet him, and wrote to the mayor and burgesses of London to receive him honorably, who are making great preparations to do so. There are divers conjectures about the cause of his coming, the most likely being that it is to resume the marriage negotiations formerly commenced between this King and the Duchess of Milan.[20]

When the duke arrived in mid September, secretly, 'with four horses and two carriages only', Henry's delight in the changing political landscape became more evident. The extended conversations around Christina's availability that had culminated in nothing had been a painful snub for Henry, particularly in light of his explicit and well-reported adoration of Holbein's portrait of her. Henry now hinted to Marillac the short shrift he would enjoy delivering to the duke. 'The King himself said he did not know the motive of his coming, unless it were for old acquaintance' sake,' Marillac related, 'adding that if the said Duke spoke of what was formerly in question he knew what to answer; and that he was not to be put to sleep by fine promises, of which there is such a market that everyone may be rich and poor – rich in hope and poor in effect'.[21]

The king's relish in the sudden turn of events was also relayed to Cromwell by William Fitzwilliam, the Earl of Southampton, who had discussed the matter with Henry. 'As to the matter concerning the duchess of Milan,' Southampton wrote, 'he paused a good while and then said, smiling, "Have they remembered themselves now?"'[22]

1539 was thus ending well for all. Henry VIII saw his rivals rattled,

and a young German bride was soon to be his. Cromwell had seen his political strategy realized, and Holbein had had another year of adventure and supreme success. However, like so often in the Tudor court, those who felt secure in their ascendancy were in fact far from safe. With the dawning of the new decade Cromwell was set for a terrible fall. The question would be whether he would drag his man Holbein down with him.

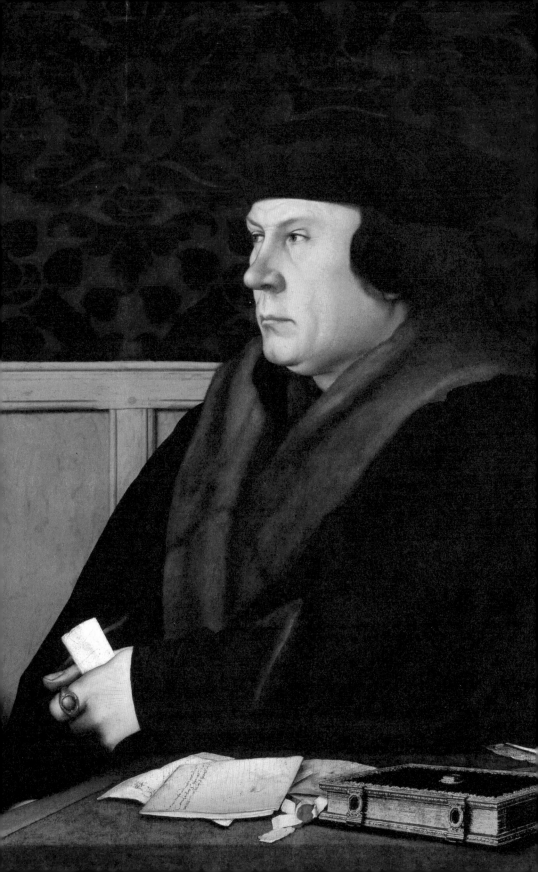

17

THE
EARL
OF
ESSEX

I f the Duke of Norfolk's portrait by Holbein marked what the latter saw as his triumph in getting the king to sanction the Six Articles and steer England back towards traditional Catholicism, Thomas Cromwell was far from cowed. Though Norfolk may have assessed that he was ascendant, the steely Lord Privy Seal carried on with his own agenda regardless. Cromwell remained equally persistent in his programme of reformist messaging, for which he continued to treat Holbein as his artist in residence.

Despite the traditional Catholicism of the Cleves family, because of its political allegiances with German Protestant states, there were many who thought Anne of Cleves was a reformist. Consequently, many in England saw the forthcoming marriage as most likely heralding another period of reform akin to the Boleyn era. If the Six Articles had been issued on the basis that the English people were confused at what direction the new church under Henry was taking, the rumours that Anne was of Lutheran sympathies, along with the literature that Cromwell continued to encourage, could have done nothing but continue its bewilderment.

Towards the end of 1539 Cromwell turned to a new publisher to help encourage religious reform in England. John Mayler had recently set up business in Botolphe Lane, east of London Bridge, at the sign of the White Bear. As his future publications would go on to suggest, he was a Lutheran sympathizer* and the opportunity to work for a man as powerful as Cromwell must have emboldened him to publish a piece of work that was very controversial indeed in light of the Six Articles. It was a piece of anti-Papal propaganda that while on the one hand chimed with Henry's rejection of Rome's jurisdiction (Pope Paul III had after all excommunicated Henry in 1538), nevertheless featured Martin Luther, whom Henry continued to loathe. The commission was a broadside, a Holbein woodcut showing Martin Luther waving his theses in the face of a Pope, coupled with a lengthy ballad extolling the evils of the Catholic Church.[1]

Anticipating a phrase popularized much later, 'the pen is mightier than the sword', the woodcut shows a youthful Luther waving his pen and paper at the Pope, who struggles to lift a sword in defence. The scene is given real dynamism in the form of a peasant who stands

* He would be put under arrest in the mid 1540s.

behind Luther, hoe raised in hand, ready to reap corn – his stance very similar to that Holbein gave Luther himself in his depiction of *Hercules Germanicus*. Behind the Pope, Albrecht of Mainz stands with indulgences for sale, bent and intimidated. The verses beneath reflect the views of the figures. Luther warns the Pope that only the word of God, that is to say the Bible, is the supreme authority for the Christian faith, not Papal decrees. Meanwhile the peasant complains about the injustices of church taxes and compares greedy churchmen to wolves.[2]

The woodcut dates from the early 1520s and was made by Holbein in Basel, possibly for either Adam Petri or Andreas Cratander, both of whom produced Lutheran material when Froben declined. How it made its way to England, one can only speculate. That Holbein himself had returned at the end of 1538 seems a convenient coincidence.

Once in England Cromwell had the German ballad that originally accompanied it translated into English – probably by Miles Coverdale – and then the woodcut went to press. This piece of advocacy for reform would then be circulated, its English poetry accessible to anyone who could read or be read to, its depiction of a peasant an appeal to the populace. If Norfolk sought to influence from on high, Cromwell was using Holbein's imagery to speak to the common man.

overleaf
Hans Holbein, design for woodcut, *Luther and the Pope*, published 1539.

Cromwell's optimism continued as the arrangements for Anne of Cleves' arrival in England proceeded. It seems extremely likely that he had a hand in the conception of the ceiling that Holbein reputedly designed for the Chapel Royal at St James's Palace, part of a wider set of refurbishments commissioned around the country in celebration of the nuptials. Drawing inspiration once again from the architect Bramante whom he so admired, he designed a jigsaw of stucco compartments, gilded and then decorated within.

Holbein had a busy and well-established workshop now. Who was part of it? Certainly some younger English painters who, painting in his style after Holbein's death, probably learned their trade as his apprentices. One was called Master John, another John Bettes, Harry Maynert a third. Holbein's status as the King's Painter also allowed him to hire other foreigners and he may well have deployed those already associated with royal work. That the goldsmiths Cornelius Hayes and John of Antwerp were collaborators seems clear. Holbein's

¶ The husbandman.

¶ Let vs lyft vp our hartes all
And prayse the lordes magnificence.
whiche hath geuen the wolues a fall
And is become our stronge defence
For they thorowe a falle pretens
From Christes bloude dyd all vs leade
Gettynge from euery man his pence
As satisfactours for the deade.

¶ For what we w our flayes coulde get
To kepe our house and seruauntes
That dyd the freers from vs fet
And w our soules played the marchauntes
And thus they with they false warantes
Of our sweate haue easelye lyued
That for fatnesse they belpes pantes
So greatlye haue they vs deceaued

¶ They spared not the fatherlesse
w he carefull, nor the pore wydowe
They wolde haue somewhat more or lesse
If it aboue the ground dyd growe
But now we husbandmen do knowe
Al their subteltye and their false caste
For the lorde hath them ouerthrowe
with his swete word nowe at the laste

Doctor Martin

¶ Thou Antichrist w th
Hast vsurped kynges po
As hauig power ouer re
whom thou oughtest to le
¶ Thou thinkest by thy iug
thou maist lykewise God
As do the deceatfull foul
Whan they they nettes

¶ Thou flatterest euery
Threatening pore men
All those that do folowe
To make them cleue to t
They bokes thou burne
Cursynge with boke bell
suche as to reade them
Or with them are wyll

¶ Thy false power wyl
Thou shalt not raygne
I shall dryue the from
Euen with this pen cha
thou fyghtest with swer
But I wyll fyght with
which is now so open a
That it shall brynge the

The Pope.

...ought neuer so many to hel
dampnacion
...yne ensample and consel
...abhomination
...lawe excurse my fashion
...ther arte accursed
...me and my condicion
...es haue the condempned

...nest against my purgatory
...findest it not in scripture
...by myne auctorite
...ake one for myne honoure
...not that I haue power
...mar in heuen and hell
...uery creature
...do it must be well.

...pture I am aboue it
...es hye vicare
...bounde to folowe it
...nter his ruler
...rithes peace
...t obey my auctorite
...de I wyll declare
...al accursed be

The cardinall

I am a Cardinall of Rome
sent from christes hye vicary
To graunt pardon to more and sume
That wil Luther resist strongly
He is a greate heretyke truely
And regardeth to much the scripture
For he thinketh onely therby
To subdue the Popes hye honoure

Receiue ye this pardon deuoutely
And loke that ye agaynst hym fight
Plucke vp youre hertes and be manlye
For the pope sayth ye do but ryght
And this be sure that at one flyghte
All though ye be ouercome by chaunce
Ye shall to heauen go with great myghte
god can make you no resistaunce

But these heretikes for theyr medlynge
shall go downe to hel euery one
For they haue not the popes blessynge
Nor regarde his holy pardon
They thinke from all destruction
By christes bloud, to be saued
Fearynge not our excommunicacion
Therfore shall they al be dampned

younger son Jacob would also come and join him and would pursue a career as a goldsmith in London.[3] For the ceiling Holbein may well have pulled in the services of Italian Antonio di Nunziato d'Antonio, known as Anthony Toto, since the latter was expert in stucco work, and the execution is resonant of Toto's work. Toto had been in the employ of Wolsey before being transferred to the royal works. He had been in England for twenty-odd years now and had taken an English wife.[4]

The ceiling is joyous: light, airy, its pale base and bright colours conveying a delicacy that feels like a development from the heavy opulence of so much Tudor finery. But within this confection came a message. At the very centre of the ceiling are the initials H and A interwoven, and the territories of the Duke of Cleves are alluded to: 'Berg', 'Gulick' and 'Cleve'. But also imprinted on the ceiling, four times, is the inscription VERBUM DEI – 'The Word of God' – an evangelical reference to the supremacy of the Bible over the Pope that, perhaps lost today, would not have been then.

Holbein also found himself deployed on other work that was indicative of Cromwell's general optimism. One of the most striking portraits of a woman Holbein ever delivered was of Cromwell's daughter-in-law, painted probably in 1539 as she turned twenty-one. Elizabeth Seymour was the late queen's sister. Apart from a nose that seems indistinguishable from that Holbein observed on Jane Seymour, the two women are not much alike. Elizabeth has nothing of Jane's pinched expression, nor her weak chin. Elizabeth does not even seem to have inherited the porcelain white complexion that Henry so adored in his third wife.

Hans Holbein, *Elizabeth Seymour*, oil on wood, 1535–40.

There is a tenderness in Holbein's handling of this subject that is noticeably lacking in his depiction of the deceased queen. Elizabeth Seymour, set against the plain, dark blue background that is typical now of Holbein's latest work, is shown with a soft, inward and contemplative gaze. There is something reminiscent of the treatment Holbein gave the portrait of his own wife. Like his depiction of Elsbeth, Elizabeth's skin has been treated with such sensitivity that a sense of intimacy or empathy is achieved. However, unlike the depiction of his wife in her simple clothes, in this painting Holbein shows a woman entirely clad in sumptuous black velvet, her sleeves occupying the

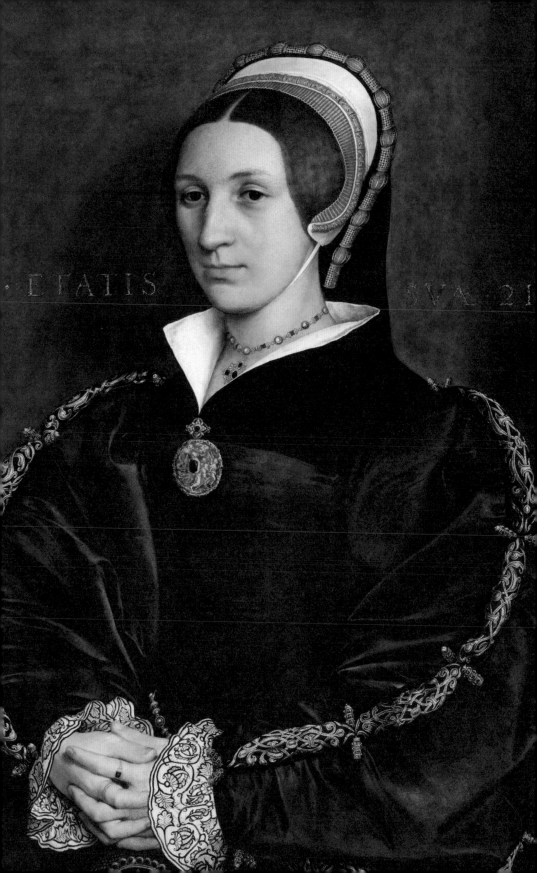

ETATIS SVÆ 21

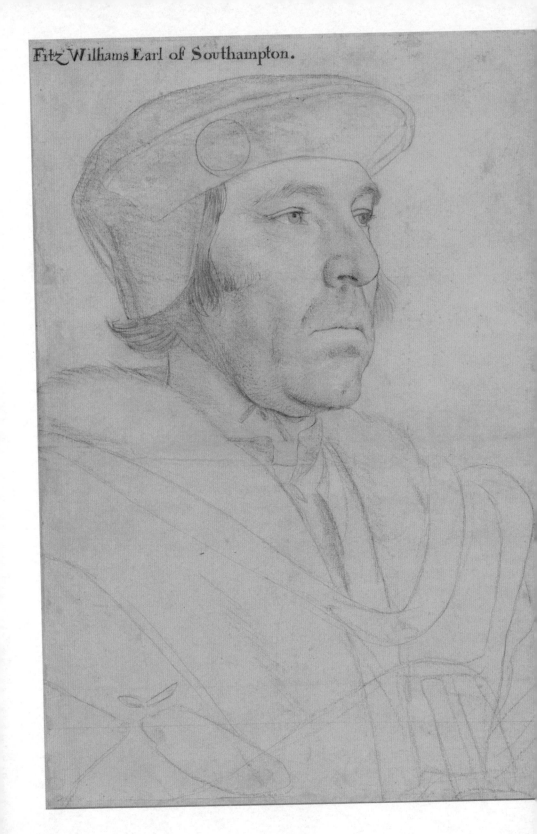

Fitz Williams Earl of Southampton.

width of the painting, their volume suggesting a power and authority that provides an intriguing tension with the tender features of their wearer. The impact the painting delivers is amplified by its restrained palette. Just as in the painting of de Solier, black and gold are the predominant colours, with just a touch of white and brown elsewhere. Elizabeth's slashed sleeves, held by gold aglets, reveal gold work on black beneath. On her bodice is a golden Holbein brooch, a black gem at its centre; around her neck a Holbein pendant hanging from a chain embellished with pearls; the French hood she wears is decorated with golden embroidery. This is a regal painting of a woman who was not in fact a queen. Yet it would not have been lost on Holbein that the children she and Gregory Cromwell would bear would be the cousins of the future King of England.

In the autumn of 1539 Nicholas Wotton and a considerable group of courtiers set out for Cleves to bring back the woman who was to be the young prince's new stepmother, and Henry's fourth bride. Joining Anne's own entourage, the enormous caravan was on its return journey to England by November, aiming for a marriage at Greenwich at Christmas. With a massive retinue of 300 horses, progress was slow. The territory Holbein had managed to cover in days now took weeks.

Anne went via Antwerp, a route which of course Holbein knew well. Her progress was extremely public and characterized by the pageantry for which Henry was famous. Fifty English merchants in velvet coats and sporting their finest gold chains met her four miles outside Antwerp and escorted her to the famous English House there, the very same where William Tyndale had been hidden. The following day the English merchants presented her with a gift before seeing her on her way.

In early December Henry's welcoming committee arrived in Calais, where Anne would cross the Channel. Among them were a number of Holbein's clients. The young Sir Nicholas Poyntz from Acton Court was there, as was Gregory Cromwell, and Sir Thomas Seymour, who had sat for Holbein, probably when his sister became queen.* Also in attendance was William Fitzwilliam, the Earl of Southampton. Holbein painted Southampton in a bold full-length portrait that only

Hans Holbein, *William Fitzwilliam, Earl of Southampton*, black and coloured chalks, and metalpoint on pale pink prepared paper, 1536–40.

* A drawing likely to be Seymour is in the Victoria and Albert Museum, London.

survives in an eighteenth-century copy.* The earl is shown standing on an elevated terrace, a seascape behind him with tall ships – a work that had it survived would have stood out in Holbein's repertoire for its inclusion of these elements. Southampton had become the Lord High Admiral in 1536 on the death of Henry's son, the Duke of Richmond and Somerset, and the allusion to this appointment is obvious. The drawing Holbein made for it is extant, in the Royal Collection at Windsor. The earl's face is one of the most striking recorded in Holbein's career – a huge beaked nose, hollow cheeks, the loose skin under his chin bound tight by the straps of his hat. A hirsute man: Holbein records his rough afternoon shadow of stubble and the sharp mark of the razor across his cheekbone from his earlier shave. Southampton's eyes are a piercing pale green; his chin is cleft. His presence is formidable. Gregory Cromwell, however, pointed out that Fitzwilliam was 'very friendly'.[5]

The Cleves entourage finally managed to reach Calais by mid December. Just as with her arrival at Antwerp Anne was met by a welcoming party outside the town which then led her with considerable ceremony to her lodgings. The group of three hundred or so men greeting their new queen had been instructed to wear specific costume. The noblemen welcoming Anne, including the Lord Admiral and Geoffrey Cromwell, all sported 'three collars of cloth of gold and purple velvet and chains of gold', a further eighty gentlemen wore 'coats of satin damask and velvet', while 200 yeomen were in the 'King's colours, red and blue cloth'. As Anne approached Calais, the king's ships loosed their cannons and then the town's let go. At the Lantern Gate, Fitzwilliam showed Anne *The Lion* and *The Sweepstake* – two of the king's ships, decked with 100 banners of silk and gold, wherein were 200 master gunners and mariners and 31 trumpets, 'and a double drum that was never seen in England before'.

Once inside the walls of Calais, another 500 soldiers in king's livery lined the streets, along with the mayor and merchants. Anne was presented with a gift of gold sovereigns, and the following day enjoyed 'a gun shot, justing and all other royalty that could be devised in the King's garrison'.[6]

However, things now went awry. Anne and her massive train

* In the Fitzwilliam Museum in Cambridge.

became hemmed in at Calais by unfavourable weather. It was not until 27 December, after the proposed wedding date, that England's new queen finally landed on English soil. She was met by the Duke of Suffolk, Charles Brandon, the handsome boyhood friend of Henry who had once been married to Henry's sister, Mary Tudor.† The conditions were atrocious, with wind and hail battering the party, but despite such unpleasant weather Suffolk reported that 'her Grace was so […] desirous to make hast to the King['s Highness] that her Grace forced for no other, which [we] perceyvyng were very gladde to set her G[race] furthwarde'.⁷

In London, Holbein was preparing a wedding portrait of the king based on the Whitehall mural. Showing Henry predominantly in gold, it provided a complement to the portrait Holbein had already delivered of Anne of Cleves. The king would not have required a supplementary sitting for this and only the new clothes from the royal wardrobe would have been needed by the painter, delivered to his rooms above the gatehouse at Whitehall.

Holbein's attention to their detail is as meticulous as anything he had done to date. Set against a plain, dark blue background, Henry wears a slashed doublet of red velvet, heavily embroidered with gold. The buttons on both the doublet and his sleeves are black jewels set in gold. The huge chain around his neck has pearls and dark stones, perhaps rubies, set in ornate Renaissance gold work. His coat is golden damask with a huge sable collar. One is drawn to Henry's face, not least because Holbein had now evolved a formula of writing the age of his sitter in an inscription aligned with his or her eyes. Thus, despite the competition from his sumptuous clothing, the viewer is still drawn to Henry's face.

The magnetism of the king's own gaze is amplified by the fully frontal aspect in which he is shown. His mouth is small in a head swollen with indulgence. His beard, shorn to expose the chin, reveals the roll of fat behind. His little eyes, dark and piercing, have grey shadows beneath them. Henry's skin is pale and bears hardly any lines; his hair is fine, light reddish brown, his eyebrows remarkably thin for a man. As a result the impression is a man at once considerable and insubstantial.‡

† Mary Tudor died in 1533.
‡ This portrait is in the collection of The National Gallery of Ancient Art, in the Barberini Palace, Rome.

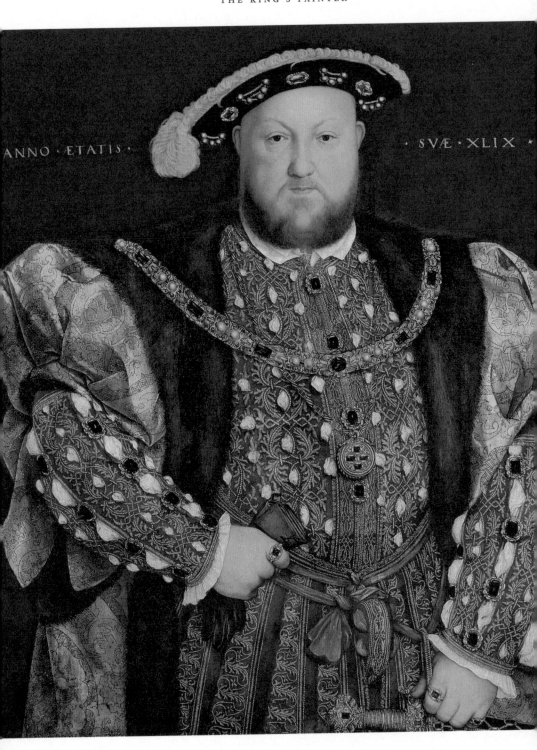

ANNO · ÆTATIS · · SVÆ · XLIX ·

Of course insubstantial is exactly the phrase one might apply to Holbein's depiction of Anne of Cleves, a woman who, depending on how one chose to interpret Holbein's portrait of her, seemed either malleable or vacuous. Suffolk's account of a young woman, compliant and eager to please, is entirely consistent with the notes also provided by Southampton from Calais, who relayed how Anne was keen to learn card games that the king enjoyed so she could play them with him. These accounts therefore must have encouraged Henry in the expectation of an acquiescent companion.

It was only when Anne finally reached Rochester on New Year's Eve that the first sense of concern set in. Lady Browne, the wife of Sir Anthony Browne, Master of the King's Horse, welcomed Anne to the Bishop's Palace there and was instantly worried that this woman was of 'such fashion and manner of bringing up so gross and far discrepant from the King's Highness' appetite'.[8] Lady Browne would have clearly subscribed to the alternative reading of Holbein's portrait of Anne of Cleves – that she was dull.

Lady Browne's instincts were spot on. On New Year's Day 1540, Henry decided to surprise his new bride, and turned up quite unexpectedly at Rochester in disguise. He and a selection of five companions were all clad in grey 'marbled' cloaks and hoods. This was of course a continuation of the elaborate theatre in which Anne had been a participant since November, if only she had known it. But Anne, not remotely educated in the games of chivalry and courtly love, completely failed to understand this episode of masking that the king was providing for her delight. She did not understand how to react to the uninvited men before her, and the king had to awkwardly reveal his game and identity to her. It was a meeting during which the king formed an instant prejudice against this young woman. Henry continued the courtship with his betrothed and dined with her at Rochester before returning to London, but he was dismayed.

Hans Holbein, *Henry VIII*, oil on panel, 1540.

Cromwell had not travelled to Calais. Records show that he spent the months after Holbein's return from Cleves deep in business relating to the dissolution of the larger monasteries. A cloud of dread must have crept over him then, when on asking the king's opinion of his new bride he was told in no uncertain terms that 'Nothing so well as she is spoken of. If I had known as much before as I know

now, she would never have come into this realm.'[9] Nevertheless, the marriage was in motion, and for the moment there was little to be done. Cromwell took Southampton to one side and berated him as if a lack of warning on his part from Calais was to blame. Southampton, despite the friendliness Gregory Cromwell had detected, did not take kindly to Cromwell's attempts to shift blame. It would be a move Cromwell would regret in due course.

On 2 January the pomp continued with Anne's progress to Greenwich where the marriage was to take place. Given her Germanic background, it had been decreed that all the Easterlings from the Steelyard were to be on horseback, lining the route to Greenwich Park, so that the king and his new queen would pass through them. Some of those Holbein had portrayed for their loved ones now looked on at Henry's latest companion as she made her way to Greenwich on a cold winter day. Philip Hoby and Peter Meutas, who had been part of the long search for Henry's fourth bride, were also there. It is likely the painter himself formed part of that stage of the welcome.

What stands out in the descriptions of Anne from those who encountered her on this strange journey is just how truly bizarre the German clothing she wore appeared to the English eye. Even to the worldly gaze of Marillac, the French ambassador, her garments were noted for appearing odd. For a culture where outward appearance was so important, where clothing was used as an instant measure of the wearer, and where the brooches and jewellery one wore spoke of one's heart, taste or religion, it's hard not to speculate that something of Henry's immediate dislike of Anne had been the shock of her attire. Bulky, heavy, and concealing, it must have made Anne seem impenetrable.

'She looks about 30 years of age,' Marillac reported home on 5 January,

> tall and thin, of medium beauty, and of very assured and resolute countenance. She brought 12 or 15 ladies of honour clothed like herself – a thing which looks strange to many. An ambassador of Saxony is in her company, probably to conclude treaties between his master and this King; for now the affairs of Cleves and Saxony, with all their League, and of this King will be one.[10]

The king married Anne of Cleves in January after it was decided by his advisors that there was no legal escape. Things had simply gone too far for an about turn. For the sake of appearances, Henry made a point of sleeping with his new wife, but sleeping was all he did. He told his close counsel he found her unattractive, she had an odd smell and her body was not to his liking. As for Anne, so naïve, she was unaware that matters in the royal bedroom were not as they should be.

Despite attempts to conceal it in public, the king's aversion to Anne soon became the subject of rumour at home and outright ribaldry in diplomatic circles on the continent. There was considerable pleasure taken among Cromwell's enemies at the apparent failure of the Lord Privy Seal's latest manoeuvre. Among the traditionalists at court moves began to unseat the king's most powerful councillor. With the king out of sorts, the Duke of Norfolk was also quick to promote a young niece of his, Catherine Howard, who was one of Anne's maids of honour and who had managed to catch Henry's eye.

There is a miniature by Holbein that for years was passed down as being of an unknown woman until, in the eighteenth century, it was identified as Catherine Howard, who would indeed become the king's fifth queen. Certainly this is a miniature that could well be of a queen. The rich dress she wears is indicative of her high status, but even more telling is the necklace she wears that formerly belonged to Jane Seymour, and is memorialized in Holbein's portraits of the latter. In addition both the necklace of rubies and pearls she also wears and the jewels crowning her French hood are noted in an inventory of the jewels given to Catherine Howard by the king.[11]

But when placed next to Holbein's miniature of Anne of Cleves, the faces of the sitters are so similar one wonders whether this is not Catherine at all, but Anne? Both women have a wide forehead and far-set eyes. They share the same chestnut brown eye colour. The nose is long, the mouth very similarly shaped and enjoying that slight upturn in each corner. The expression on both faces is benign and calm. Even the chin shares the same notable prominence. But it is the unusually heavy eyelids in both, such a key feature of Holbein's depictions of Anne of Cleves, that are particularly noticeable. In addition the sitter in the miniature wears a ring featuring a square black diamond similar to that worn by Anne in Holbein's portrait of her.

When compared to Barthel Bruyn's portraits of Anne, which show

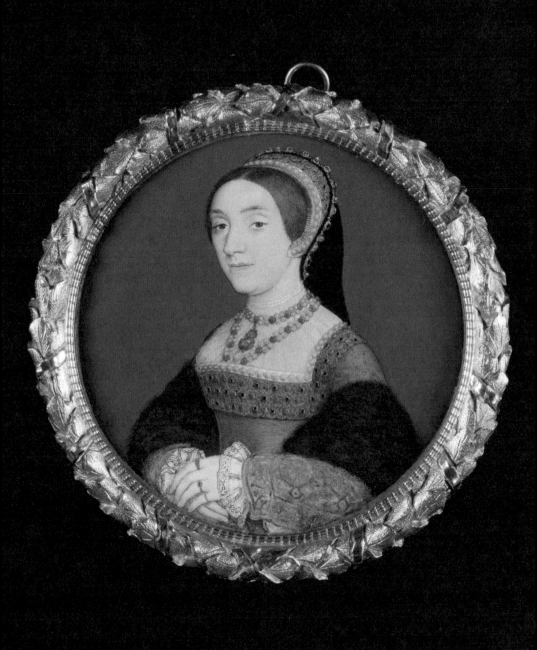

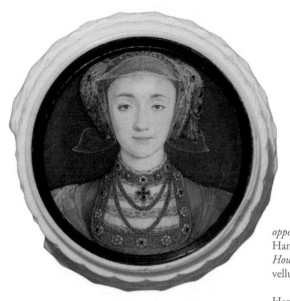

opposite
Hans Holbein, *Catherine Howard?*, watercolour on vellum, 1540.

Hans Holbein, *Anne of Cleves*, watercolour on vellum, 1539.

Barthel Bruyn, *Anne of Cleves*, 1539.

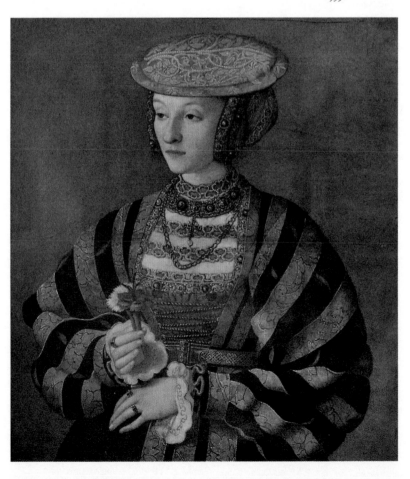

her in three-quarter profile, the likeness continues. Placed next to a portrait of Anne held in the Rosenbach collection in Philadelphia, it improves.[12] What is more, when placed next to all these portraits of Anne from around 1539, the woman in the miniature appears of comparable age, whereas Catherine Howard was at least ten years younger than Anne. Finally, the miniature is mounted on a playing card, the four of diamonds. Did the artist choose this card because here he had the fourth queen?

Is this is a miniature Anne of Cleves had commissioned in her attempts to please the king – now wearing clothes he found more palatable? In contemporary correspondence between Cardinal Farnese and Pope Paul III, it was mentioned that when Henry saw Anne 'he was not pleased with her in that German dress, and made her dress in the French fashion'.[13] Certainly on 11 January 1540, days after their marriage, Anne attended a celebratory joust in full English dress with a French hood.[14] Rather than evidence then of his *next* love, perhaps here is yet another example of Anne's well-documented attempts to please her spouse.

The presence of the jewellery in the Howard inventory does nothing to dismiss this theory. It is merely a reflection of the fact Henry retrieved the Seymour jewellery he had bestowed on Anne of Cleves and passed it to Catherine Howard. It would not have been the first time he did this – after all, much of Katherine of Aragon's jewellery was passed to both Anne Boleyn and Jane Seymour.

The fly in the ointment is the description by Hall of Anne of Cleves on her wedding day as wearing her long fair hair loose. The miniature shows a woman with light brown hair, not blonde hair. But Hall remains an unreliable witness, and the extent to which Anne was blonde rather than a light brunette must be questioned by the darkness of her eyebrows in all the portraits of her. Furthermore, the term 'fair' could equally apply to light brown as well as blonde hair.

If this miniature was a move by Anne of Cleves to encourage her husband to see her anew, Cromwell may well have suggested the initiative. Momentarily it seemed as if things were improving for the Lord Privy Seal when in April 1540 the king bestowed upon Cromwell the title of the Earl of Essex.

However, Norfolk had wind his sails now. By May it had become clear that the king was fully infatuated with his teenage niece Catherine

Howard. Despite this Henry was at least attempting sexual congress with his queen, rather than merely sleeping in the same bed with her. Nevertheless, whether it was a combination of his continuing lack of chemistry with Anne, her lack of experience or his new-found predilection for Howard, in June Henry confessed to Cromwell that his attempts had failed and that he was completely impotent when it came to his latest wife.

With Henry's admission to Cromwell, the brilliance of Holbein's portraits of Henry comes back into focus. Here was a man who wanted to be seen as a colossus, a virile warrior king. Yet the Colossus of Rhodes was no more than a fabrication, and Holbein's own work can claim no more. The portraits Holbein painted describe a king assuming the posture of power, clothed in magnificence, wearing the codpiece of virility – but the balloon face of the man himself is in complete contradiction. Unlike his portrait of de Solier, where the strength and formidable character of the man are present in both his impressive face and his swagger, in contrast Holbein shows us Henry as a man *adopting* a pose, playing a role. This is as much of Henry's sense of theatre as the extravagant pageants and lavish masks which he so loved.

However, Henry's problem was that he desperately *needed* to live up to the image Holbein had conjured of him. Henry's brother had died a young man, as had Henry's first, illegitimate son, the Duke of Richmond and Somerset. He was terrified the same fate would befall the baby Prince Edward. Despite approaching his half-century, Henry felt strongly he needed to produce yet more sons to secure the Tudor throne. With Anne of Cleves he found himself unable to perform his role.

When the mask slipped too far in Henry's theatre, there was real danger for those around him. In revealing his impotence, Henry laid his failure at Cromwell's feet. The latter's oversight was to under-estimate the full jeopardy of the moment. Cromwell understood this latest situation was a 'great matter', reminiscent of the king's first such. However, perhaps blinded by his recent elevation to Earl of Essex, Cromwell could not properly see his own peril.

Henry allowed Cromwell to share the issue of his impotence with just one other of his closest followers. Cromwell duly discussed the matter with William Fitzwilliam, the Earl of Southampton. There can

be little doubt that an annulment of the marriage was once again on the king's mind, but the political advantages of the Cleves allegiance remained.

Then Cromwell made his fatal error. He *also* shared the intelligence with Thomas Wriothesley, a man who had been in his service for some time.

Holbein's drawing of Wriothesley is in the Louvre. It shows a jutting-jawed, handsome man with a bushy reddish beard and pale eyes. For Holbein the drawing is a little more complete than usual, with Wriothesley's clothing fully drawn rather than just suggested – something the artist does perhaps when it is one of his workshop who is to complete the work and needs more guidance. A miniature based on the drawing is indeed often attributed to Holbein's workshop. It is

revealing in the rather jaunty use of spotted ermine or lynx fur that is seen lining Wriothesley's coat. This rather dandyish attire, technically above his rank according to sumptuary regulations, says something of Wriothesley's reputation for being vain and egotistic. He also had a reputation for being completely ruthless.

Despite owing so much to Cromwell, Wriothesley now changed camps. And with Wriothesley turned witness, the traditionalists led by Norfolk were suddenly empowered. On 10 June Cromwell was arrested as he attended a parliamentary meeting. Norfolk, who had always resented Cromwell's rise, ripped off the collar of St George he was wearing. Southampton, less friendly now, removed his Garter decoration.

Marillac was quick to write to France that he had just 'heard that Thomas Cramvel, keeper of the Privy Seal and Vicar-General of the Spiritualty, who, since the Cardinal's death, had the principal management of the affairs of this kingdom, and had been newly made Grand Chamberlain, was, an hour ago, led prisoner to the Tower and all his goods attained'.[15]

Before Marillac even had a chance to seal his letter a courtier appeared in his apartments with a message from the king to explain events. The French ambassador should 'not be astonished because Cromwell was sent to the Tower', the courtier relayed, because

Hans Holbein (workshop?), *Thomas Wriothesley*, watercolour on vellum, on card, *c.*1534–40.

> the King, wishing by all possible means to lead back religion to the way of truth, Cromwell, as attached to the German Lutherans, had always favoured the doctors who preached such erroneous opinions and hindered those who preached the contrary, and that recently, warned by some of his principal servants to reflect that he was working against the intention of the King and of the Acts of Parliament, he had betrayed himself and said he hoped to suppress the old preachers and have only the new, adding that the affair would soon be brought to such a pass that the King with all his power could not prevent it, but rather his own party would be so strong that he would make the King descend to the new doctrines even if he had to take arms against him.[16]

Cromwell may have been arrested for his promotion of religious reformation, but few could doubt that Henry was also punishing Cromwell for the humiliation of his latest marriage. Cromwell's

removal conveniently paved the way for the king to dispose of his fourth wife. No one would put up opposition. By the end of June the charges of treason and heresy were formally brought against the former Earl of Essex, and a week later, on 5 July, moves were set in motion to annul the Cleves marriage.

Anne was completely taken aback by news the king wished to declare their marriage void. However, whether it was a mixture of good advice or her own good sense she agreed to Henry's proposals to make her 'his sister', provide her with an ample pension, an English household, and to even retain the political allegiance with Cleves. For a woman who had always been under a thumb, this perhaps felt like an unexpected freedom.

In the evening sunshine of 28 July 1540 Marillac once again sent news to France. This time he was able to report 'Mr. Thomas Cromwell, heretofore condemned by Parliament, this morning was beheaded in the usual place for such executions. Grace was made to him upon the method of his death, for his condemnation was to a more painful and ignominious penalty.'[16]

Hans Holbein, *Symbol of the Incarnation of Christ* from the 'English Sketchbook', black ink, after 1532.

Cromwell's property passed to the king. Among the papers of the Tudor court is a brief summary of his 'goods', evidently in the hand of a member of his household. For those interested in Holbein one line jumps out. In the 'furniture of a chamber' there is 'a cloth stayned with a table of the taking of the French King'. Might this be Holbein's picture of Therouanne, from the festivities of 1527? Also there is a note of '2 tables of my master his [vis]namy painted'; again likely these are by Holbein.

For a man with his beliefs, it is interesting to see that Cromwell had not, like some of the most radical Protestants, taken against devotional paintings, but clearly believed that it was the manner in which they were approached that was crucial. As such he held a number of religious paintings in an otherwise very impressive and therefore by its very existence avant-garde art collection. Cromwell's religious paintings included 'a great table of misery of Italy, painted; a table of the Passion of our Lord, painted; a table of the Pity of Our Lady [...] tables of the Salutation of our Lady [...] And an image puerile of our Lord set in a box'. The latter could well relate to a design for a miniature that appears in Holbein's 'English Sketchbook'

in Basel, in which the infant Christ is featured in a design with a lion and a sheep.

Cromwell's execution horrified Europe. His sympathizers, such as Melanchthon, now referred to Henry as the 'English Nero'. And though Cromwell's removal was welcomed in Catholic Europe, the swiftness of his arrest and the death sentence delivered to him nevertheless added to a growing sense of alarm that the King of England had become a reckless, mercurial tyrant. Marillac wrote with horror about the continuing slaughter of those who chose to disagree with the English king. Two days after Cromwell was beheaded, three doctors were 'hanged as traitors for speaking in favour of the Pope', while another three were burned as heretics for speaking against the Pope.[18]

Marillac also wrote with concern about a new Act of Parliament, which allowed that 'if two witnesses swear before the King's council to have heard anyone speak against the King's edicts touching obedience and the articles determined upon religion, he shall, without further process, suffer death. Everyone is dismayed by the encouragement thus given to false witnesses.' The country was in complete confusion, Marillac relayed, not understanding quite what the English church

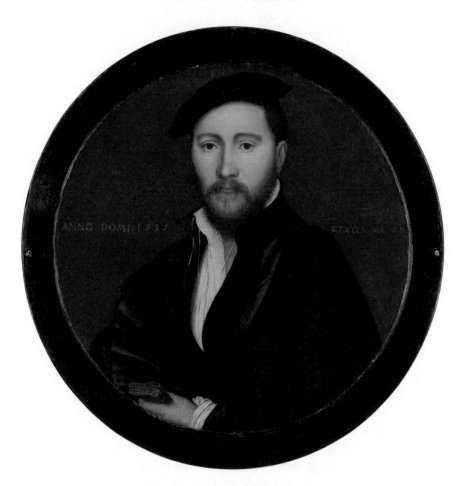

stood for, and where 'what is commanded [...] is so often altered that it is difficult to understand what it is'.[19]

Holbein was undoubtedly in very great danger now. In the wake of Cromwell's execution many of his Protestant circle, men and women with whom Holbein was associated, feared for their safety. One of Cromwell's entourage, the merchant Richard Hilles, fled to the continent under the pretext of making a business trip. Writing fearfully to Holbein's acquaintance, the Zurich-based Heinrich Bullinger, Hilles expressed what many of Cromwell's circle must have felt. He explained he 'left England when he saw there was no place for him there unless he became a traitor both to God and man, on the pretext of carrying on his trade in this place. His true motive is known to his

friends, and suspected by his enemies. His property, however, is at present safe, as he has not been indicted for heresy.'[20]

In court circles, a campaign of vengeance against the former Cromwell camp was launched. In January 1541 two of the latter's staunchest allies were suddenly frogmarched to the Tower of London: Sir Ralph Sadler and Sir Thomas Wyatt. Holbein's record of Sadler dates from Cromwell's heyday in 1535, when his henchman had his portrait painted. While the main drawing of the twenty-eight-year-old in the Royal Collection is clearly by Holbein, a roundel now in the Metropolitan Museum of Art in New York is based on the drawing, but has been executed by one of Holbein's workshop. Both show a fresh-faced man with an auburn beard, pale piercing blue eyes, a noticeably straight, thin mouth.

Wyatt, too, had sat for Holbein. The poet and statesman had accompanied Cromwell to his execution, and is described watching on with tears. This very public show of affection and support for the condemned man would have been considered by many a fool's bravery, not least after Wyatt's former run-in with the monarch and imprisonment over the Boleyn affair. But Wyatt – uncharacteristic perhaps in a court where most sought to be pragmatic – did not desert the memory of a man who had been his protector.

Workshop of Hans Holbein, *Portrait of a Man (Sir Ralph Sadler?)*, oil and gold on oak, 1535.

Both Sadler and Wyatt were released, as were various others in the Cromwell circle after interview. Holbein's recorded work for 1540 is notable by its absence. With the exception of the portrait of the king he made at the beginning of the year there is almost nothing else. It is more than likely that this hiatus in a formerly prodigious output was not only because of a sudden toxicity associated with the artist but also because Holbein may have been one of those held and questioned. And unlike many of those being arrested, Holbein was the only person who truly shared what the king saw as Cromwell's double betrayal. Holbein was not just a collaborator in Cromwell's Protestant propaganda machine. His role had also been crucial in securing the Cleves marriage. Was he to be blamed for misleading the king?

The flurry of testaments from Henry and his courtiers that were issued in connection with the Cleves annulment offer some indication on where Henry actually laid the blame. It was the reports from his

ambassadors that he considered to have been at fault. As Anthony Denny, a Gentleman of the King's Chamber, testified, the king felt Anne

> was no such as she was praised for', and afterwards upon continual praisings the King told him, as a confidential servant, that he could not induce himself to have affection for her, for she was not as reported and had her breasts so slack and other parts of her body in such sort, that he suspected her virginity, and that he could never consummate the marriage.[21]

So by his own account, it was the words of those who served him that failed Henry, not the vision his painter had delivered. Perhaps now Henry could finally appreciate the warnings that Holbein had actually seeded in the work.

It must be a reflection of Henry's genuine admiration for and fondness of Holbein that he chose not to punish the painter. However, that his work fell away from him was chastisement enough. If ever there was an apt time to return to Basel, it was surely now. Not only were Holbein's two years of approved absence up, there were family matters to attend to in Switzerland. His uncle Sigmund had died that year and left his estate to him, a matter that clearly could have summoned Holbein home. However, Holbein stayed in England, and like so many courtiers who found themselves on the wrong side of the king, he laid low. As such it was Elsbeth who saw to the hearings regarding Sigmund's will in Basel, and it was she who ultimately benefitted from it.

Had Holbein been reassured by some of his other influential clients that flight was not necessary? One of those to whom Holbein may well have turned for self-preservation was Sir Thomas Audley, Lord Chancellor.

Audley had been a close associate of Cromwell and a man who had always worked alongside him to deliver the king's will. He had walked in lock step with Cromwell through many of the major events of the previous decade. He had supported Henry's desire to marry Anne Boleyn and had assisted in the preparation of the Act of Supremacy. He had presided over the trials of Sir Thomas More and Bishop Fisher, of Anne Boleyn, as well the Exeter Conspirators. When it was Cromwell's time to fall, Audley had prepared the attainder and

then helped oversee the undoing of the Cleves marriage. He was a pragmatist, and a survivor.

The major oil painting Holbein made of Audley is long gone. However, later versions exist, not least in Audley End House, the property that the chancellor built when the king granted him the dissolved Walden Abbey in 1539.

Audley sits in huge wooden chair, wearing a black robe. It is the texture of the coat's wide sable collar, the fascination with the creases in the pelts creating a pattern that is almost chequered, that points instantly to Holbein's eye. That and a gaze that one knows instinctively in the original would have been compelling.

Holbein's depictions of Audley's second wife, Elizabeth, are however preserved in the original – again in the Royal Collection at Windsor. Here there is both a preparatory drawing and a miniature, indicating once again that Holbein scaled down from his drawing.

Elizabeth married Audley in 1538, and so the drawing of her likely

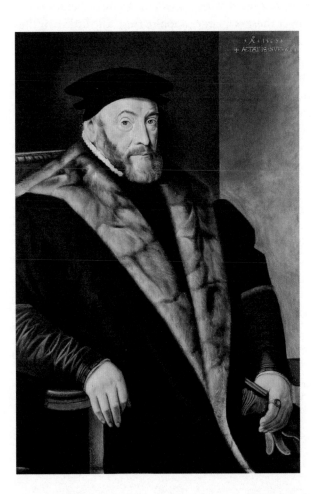

Biagio Rebecca (after Hans Holbein?), *Thomas Audley, Lord Audley*, oil on canvas, 1774.

dates from around this time. This is not only the wife of one of England's most powerful men, but the daughter of the Marchioness of Dorset, whom Holbein had portrayed a few years earlier. The daughter bears little resemblance to her mother, bar an unusually prominent procheilon (that little bump in the centre of the upper lip). However, like her mother, who was ultimately portrayed in ermine and velvet, Elizabeth is dressed as sumptuously as a queen. This fact is not lost on Holbein, who notes the details of her jewellery and clothing as he draws. After close to a decade in England, he still makes some of these observations in German. She is in 'rot damast' or red damask, her cuffs are 'samet' or velvet, her brooch has green, white and red jewels embedded in it. In the miniature, the watercolour paint used, applied to vellum, has a jewel-like brightness and luminosity. Holbein had transformed damask into sumptuous red velvet, with heavily embroidered sleeves. It is likely he did this to better show off her impressive pearl and gold necklaces and that bejewelled brooch. Her French hood is decorated with pearls and goldwork and on her finger there is a large sapphire ring. The little painting has been mounted yet again on a playing card, and yet again Holbein chooses this with care. Elizabeth sits on the Ace of Hearts, as she should as a new bride.*

Hans Holbein, *Elizabeth, Lady Audley* miniature, watercolour on vellum, 1538.

Holbein's connection with Audley was not merely as the painter of his portrait. In the troubled years after 1540 it seems that Audley offered Holbein a haven. One he much needed as he faced a new fight for survival.

* There is much debate about the significance of the choice of playing card onto which miniatures were mounted. It has been pointed out to me that other miniaturists would pre-prepare vellum with a range of differing flesh tones, ready mounted onto cards, and choose the right tone for their subject regardless of the mount. Holbein's own practice in this respect is unrecorded, though he clearly pre-prepared his larger-scale drawing paper. However, Holbein layered so much of his work with discrete symbols and conceits that it remains a possibility that he may haven chosen his cards to convey some commentary on his subject.

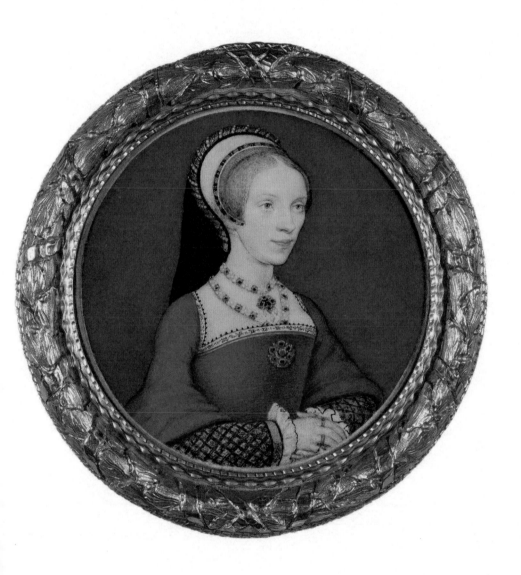

DEV ET MON DROIT

NONSUCH

I n 1533, while Cromwell was making his extensive urban palace at Austin Friars, Sir Thomas Audley had managed to get his hands on his own piece of impressive real estate, Holy Trinity Priory, just a fifteen-minute walk away in Aldgate. He proceeded to demolish much of the old priory buildings and convert the extensive grounds into a substantial property, which was initially known as Cree-Church Mansion, before ultimately becoming known as Duke's Place when the property passed to Audley's son-in-law, a later Duke of Norfolk.

In 1541 Holbein is recorded as living in Aldgate, in the parish of St Andrew Undershaft, a church so called because of a huge maypole that stood just next to it. It was an area popular with the German community. The parish represented a small, well-heeled area of London incorporating the then westernmost end of 'Algatestrete'; the easternmost stretch of 'Cornhull'; the northernmost aspect of 'Lymestreet' and the southernmost stretch of 'St Marie Strete'. Here the painter is recorded as living and paying a not inconsiderable £30 in taxes.

Later accounts locate Holbein living in Cree-Church Mansion itself.[1] Though this initially sounds odd, it is in fact feasible, since the mansion was really closer to a gated community, with a series of buildings around courtyards, accessed through a wide stone archway.*

Hans Holbein, *Design for a fireplace*, black and brown ink, with grey, blue and red wash, on paper, 1537–43.

Here there were tenements, some dwellings, other businesses, and some substantial leasehold houses. What is more, Cree-Church Mansion was a liberty, outside the jurisdiction of the City of London, and as such a good place for a foreigner – or 'straunger', as they are recorded in the contemporary documentation – to reside or work without contravening the guild rules affecting aliens. The portion of the Cree-Church complex that fell into the parish of St Andrew Undershaft was that on the eastern side of 'Berye' (Berry) Street. So here, then, was likely Holbein's London home, where he retreated in the second half of 1540, if not before.†

* This had formed part of the original priory and survived until the nineteenth century.
† The engraver George Vertue, who studied so much of Holbein's work, believed Holbein had lived at 'the Duke of Norfolk's house'. This was dismissed in nineteenth-century scholarship and has not been considered properly since. However, disregard of Vertue's claim was on the basis of an incorrect assumption, that since Duke's Place was so named after Holbein's death, the painter could not have lived there. However, although by Vertue's time the complex was known as Duke's Place, it would have been available to Holbein in its former incarnation as Cree-Church Mansion.

Little remains of the Cree-Church complex. However, one item found in excavation relates to the artist. A rectangular stove tile discovered on the site is moulded with the female allegorical figure of Logic. Set within a Renaissance arch, it is based on one of Holbein's woodcuts.[2] The tiles based on these were produced in Cologne in the 1560s and imported into England two decades after Holbein's tenure at the property.[3] But these are a firm reminder of the huge popularization of his work and the extent of his influence in the years after Holbein himself had died.

The Aldgate area was lively, and convenient for Holbein. A stone's throw from his door was the busy market at Leadenhall. There were coaching inns, the Pewter Pot and Pembridge's, and ale-houses. Three handsome guild halls were just to hand, and a fair few splendid homes. There was that of 'Mistress Cornewallies', a widow, who along with Audley, benefitted from the dissolution of the priory and was gifted by Henry VIII 'a fair house with diverse tenements near adjoining' in gratitude for the fine puddings she made the king as his confectioner. Cromwell – in his heyday – was a stroll away. There were other manor houses in sight, built by the Neville and Scrope families, as well as a beautiful old medieval house known as the Green Gate. All these impressive establishments were set amid large gardens and orchards. It was an area also defined by foreigners working as publishers, merchants and goldsmiths. According to the parish accounts the population was close to 50 per cent European, with a great many immigrants working as servants.

Yet even the protection of a man as powerful as Audley could not shield Holbein from general legislation. London's discomfort with its foreigners was ongoing. In the spring parliament of 1540 foreigners were put on notice. In addition to his other worries this was a blow for Holbein. Under new Acts of Parliament, according to Marillac, 'the harshest ever heard of, especially for craftsmen', they would be forced to leave the country by Michaelmas without taking drastic and costly measures.[4] All leases held by aliens would be voided and further leases banned unless 'straungers' had become 'denizens', that is a permanent resident, for which there was a fee. In the end such was the rush of London's not inconsiderable European community to register, and so overwhelmed were those dealing with applications, that the deadline was extended until the summer of 1541.

The king might have afforded Holbein an exemption to these rules in better times. But 1540 was not the year for him to seek favours. Even living in a liberty, the effect of this legislation could not be avoided. Yet although this was another incentive to leave England, Holbein chose to stay and signed up for residency. One has to wonder why?

By March 1541, just eight months after the event, Henry began to regret his rash decision to execute Thomas Cromwell, and complained to his advisors as such. After twelve months at a standstill, slowly Holbein's work began to flow again. Court records indicate that by May 1541 his salary had been paid in full. In 1542 his name appears again as a salaried employee of the king, in the account books of Sir Brian Tuke, 'Treasorer of the Kynges Chamber and of the Courte of Generall Surveyors of the Kynges landes'.[5] In short, he had survived.

The preparedness of the king to forgive his painter any perceived misdemeanours would of course have come as a huge relief for anyone, but for Holbein in 1541 it solved a problem. The fact is, Holbein had not only invested considerably in building a livelihood in England, but by this time he also had another family in London. And this is surely why flight had not been an option.

In 1543 Holbein is recorded as having two children living with him in Aldgate.[6] His youngest son Jacob had joined him in London and was apprenticed as a goldsmith, quite probably with Hans of Antwerp, who had become a close friend and work colleague.[7] But Jacob, in his early teens, would not be counted as one of these two children, who were clearly much younger and 'at nurse'. The names of these latest additions to the Holbein family, along with the identity of their mother, are lost.

Gradually, commissions from the king picked up again. A Holbein drawing for another portrait of the young Prince Edward, showing a child aged perhaps five, must date to after the Cromwell saga. There was also work to be done at the king's latest building project – the palace of Nonsuch at Ewell. Conceived shortly after the birth of Prince Edward, this was to be more lavish than anything the king had yet built, and decorated in a Renaissance style on both the exterior and interior. The overall conception of the exterior has been attributed to Nicholas Bellin of Modena, a stucco expert, who was to design some seven or eight hundred stucco panels, each about a metre square, featuring classical themes.[8]

The palace was destroyed in the seventeenth century. Accounts of it are few and far between, and no plans for it exist; as such the level of Holbein's involvement is not fully understood. However, a design for a huge, lavish fireplace by Holbein is widely considered to have been for this destination. The drawing proposes a realization of the fanciful architecture Holbein typically paints: two classical orders or storeys comprise double fluted doric columns on ample pediments, surmounted by smaller ionic columns. In the upper tier are three roundels, one featuring the figure of Blind Justice, another the figure of Charity as a mother, and finally one featuring the king's crest. In the lower tier, immediately above the fire itself, is another roundel, featuring Esther and Ahasuerus. All this is set within an arch, with miniature roundels framing classical heads on each side, and all round intricate strapwork and Renaissance motif.

This fireplace, though it looked like stone, was likely to have been carved in oak and then painted to appear like marble. Archaeology at the site of the palace has suggested this mode of construction across much of the palace, which allowed the king to build faster and more cheaply.

Among the papers of Sir Thomas Cawarden, who became the keeper of the house and gardens of Nonsuch Palace in 1543, is the fragment of a bill 'for a peynted boke of Mr Hannsse Holby making – £6',[9] once again suggesting the delivery of items from the Holbein workshop to the palace for royal consumption.

Did Henry also invite Holbein to make a portrait of the new queen, Catherine Howard? In the Metropolitan Museum of Art is a workshop painting of a very young woman. Though described by one scholar as a Holbein pastiche, the museum's own technical investigations reveal that its execution is consistent with Holbein's workshop practices. The woman is set against that darker blue, plain background favoured by Holbein at this time. With her age written in roman numerals just below her eyeline, the sitter is noted as being seventeen. Yet this young woman is dressed in regal attire, wearing the very latest fashion of the moment, her sleeves slashed like those worn by Elizabeth Cromwell.

Howard was sixteen or seventeen when she married Henry in July 1540, and she was described as small, slight, auburn haired and both as 'the most beautiful woman of her time' and as a 'beautie freshe and pure' in contemporary records.[10] The portrait pays particular

ETATIS · SVÆ ·

attention to conveying not only a translucent sense of youthfulness with her perfect pink, blushed cheeks and wide-eyed expression, but also the most ravishing cupid mouth. Perhaps, then, by 1541 Holbein was sufficiently forgiven to commit the next queen to Henry's gallery of beauties.

That this portrait, if it is indeed the queen, only survives in the form of a copy is not surprising. Just as in the case of Anne Boleyn, portraits of Howard are all but non-existent. Such was the fury of the king when he discovered her betrayal, pictures of her were quickly removed and destroyed, especially in the homes of her own family.

The betrayal in question was twofold. In their rush to promote this young member of the Howard family, the Duke of Norfolk and his followers had either overlooked or not properly interrogated her reputation. Howard, who had been brought up in the household of the Dowager Duchess of Norfolk, had in fact been exploited by the men around her from an early age. At thirteen she was sexually involved with a music master in the house, and by the time she was fifteen she was having an affair with a young courtier, Francis Dereham. The Dereham affair was an open secret.

Workshop of Hans Holbein, Portrait of a Young Woman, oil on oak, c.1540–5.

On becoming queen, Howard made the unwise choice of admitting Dereham into her own household. Inevitably rumours about their former intimacy grew and were finally brought to the attention of Archbishop Cranmer – a man who was still smarting from the traditionalist backlash in court, and the loss of his friend and ally Cromwell. Dereham was interrogated, at which point he brought up the name of one of Henry's favourite young courtiers, Thomas Culpepper, as a man with whom Catherine had been involved since becoming queen. It transpired that none other than Jane Boleyn, Lady Rochford, the wife of executed George Boleyn and one-time sister-in-law of Anne Boleyn, had been facilitating Catherine's meetings with Culpepper. On 10 December both Culpepper and Dereham were executed and their heads spiked on London Bridge. Catherine, meanwhile, had been under arrest since November 1541. She and Jane Rochford were finally executed in February 1542; both had been reduced to mental wrecks during the period of their captivity.

It has been claimed by some of those who have studied Holbein's life

that the King's Painter did nothing of particular note after Cromwell's demise. True enough, Cromwell's patronage of Holbein was such that it enabled him to create the visual propaganda for the Henrician court that continues to define that era. Apart from delivering the image of a king that has persisted, Holbein's portraits for the royal household, and his large-scale mural, broke new ground in English art. But even in the post-Cromwellian period there is evidence of Holbein pushing forward with yet more new ideas, evolving his work, and continuing the trajectory of innovation, experimentation and brilliance that had always defined him. The tragedy is that he would not live long enough to fully develop some of these new ideas, and much of his vision for his very last work was compromised by events beyond his control.

In 1541, as Holbein's output cranked up and the king's favour was somewhat restored, new clients presented themselves, and old ones returned. Portraits of merchants, probably with associations with the Steelyard, re-emerge in 1541, though it's fair to say they reflect a house style entirely consistent with what Holbein had produced before. One sitter wears a ring that identifies him as Roelof de Vos van Steenwijk, a member of Dutch nobility. Another portrait of an unnamed, twenty-eight-year-old man has all the hallmarks of Holbein's earlier Steelyard paintings, with the sitter looking straight out.

Hans Holbein, miniatures of Charles and Henry Brandon, watercolour on vellum, 1541.

Nevertheless, though Holbein and his workshop were on the one hand delivering a now standard portrait type for a market still hungry for it, there is also evidence that the painter sought to innovate in some other areas – perhaps surprisingly in miniatures.

1541 was the year in which Holbein painted two touching miniatures of Charles and Henry Brandon, the Duke of Suffolk's two young sons. Brandon, formerly married to Henry's sister, had remarried to a young woman who was his legal ward, Catherine Willoughby, after Mary Tudor's death. Suffolk had turned to Holbein in the year of their marriage for her portrait, and a drawing of Willoughby exists. Now their two sons, Henry and Charles, were five and three respectively, and Suffolk wanted their likenesses made.

It's no wonder that Holbein, himself once again a father, imbued the two tiny portraits with so much warmth. What he also does is incorporate information about the sitter into the narrative of the painting, rather than applying it as a separate inscription. Of course

this is a technique Holbein had used in larger-scale portraiture, but his decision to do it in this miniature format is a genuine new step, and in this instance enhances the psychological depth and characterization that Holbein also achieves in the minute works.

Charles Brandon was Suffolk's youngest child, and Holbein paints a little blonde, wide-eyed boy wearing his hair long with a fringe cut high on his forehead. He sports a velvet cap and a striped jacket. In his hands he holds a piece of paper on which someone has written his age – after all, he is too young to know his own age, let alone write it. Slightly clumsily Charles holds the paper for the viewer to see, obscuring part of its message with his little, chubby hands. It says 'ANN(O) 1541. ETATIS SUA 3. 10 MARCI'. It is unclear if the date in March is the child's birthday when he turned three, or the date of the painting, or both.

The second miniature shows Henry Brandon, Charles's older brother. With a similar fair complexion and the same blonde hair as his brother, Henry wears the expression of feigned boredom that precocious children sometimes adopt. He leans nonchalantly with his elbow on the arm of a bench. His clothing is a little more adult, his hat has a plume, a signal of course of his status as the son of only one of two dukes in the kingdom at the time.* He also wears noticeably costly clothing, a doublet with iridescent sleeves made of shot silk, which glimmer green and red. This is a child who, unlike his brother, knows his own age and can write it. In fact like a naughty schoolboy he has scratched it on the side of the bench: 'ETATIS. SUA 5. 6.SEPDEM. ANNO 1535'. One can hear him telling the painter his age when asked. He is five, but like so many young children is keen to be older – so he makes the point that he will be six in September. He was born in 1535.

Holbein would not have travelled far if the boys were in London. Suffolk's home in the capital, Suffolk Place, was in Southwark, just south of London Bridge. With the two miniatures taken together one can place Holbein there on a day between March and September 1541.

Another major commission came his way in the same year from the Company of Barbers and Guild of Surgeons. The two associations had been unified in the previous year. Its members included Dr Butts and

* The death of the Duke of Richmond and Somerset left only the dukes of Norfolk and Suffolk.

Dr Chambers, the king's personal physicians, and so not surprisingly there was a desire to celebrate the guild's association with the king, and show him handing over its charter or letters patent. Chambers and Butts would have been familiar with Holbein's Whitehall mural and it is clear that this commission was intended as a response to it – not only in terms of scale, but also in answer to the question the mural posed its viewers.

The painting is huge, taking up eleven oak panels, and measuring nearly two metres high and over three in length. Like the Whitehall mural, then, it depicts its subjects life size and, as in the Whitehall mural and the painting of Thomas More and his family, was intended to create the impression that the figures were occupying an imagined extension of the hall in which the painting was hung.

In the Whitehall mural, the inscription that accompanied the painting asked which of Henry VIII and his father Henry VII 'is the victor', able to take up his place upon the empty pediment around which they stood. In a testament to their loyalty to the king, the Barber Surgeons answer the question. Henry is shown statuesque, guild members kneeling in adoration.

overleaf
Hans Holbein and workshop, *Henry VIII handing over a charter to Thomas Vicary, commemorating the joining of the Barbers and Surgeons Guilds*, oil on panel, 1541.

Despite its scale and importance, the Barber Surgeons painting is problematic. At a glance it seems clumsy compared to Holbein's other work: the figures of Henry and those kneeling at his feet are stiff, the composition awkward, the technique lacking. There is good reason. The painting was saved from the Great Fire of London in 1666, but not before its paint had bubbled and charred and it had to be repainted. Before that, it had also been altered by other painters, who added subsequent masters of the company in the 1550s. Even before these additions by different hands, Holbein's workshop had contributed significantly to the work, probably because Holbein himself died before it was complete.

So one has to look beyond the unsatisfactory surface of this work, to excavate Holbein's original conceit for it. His hand is still felt in elements of the composition despite all the other hands who have worked on it. Meanwhile the cartoon for the work, extant but also much overpainted by later hands, is a reminder that Henry's face and many of the portraits of the kneeling figures were based on Holbein's original drawings, pounced and transferred onto the wood.

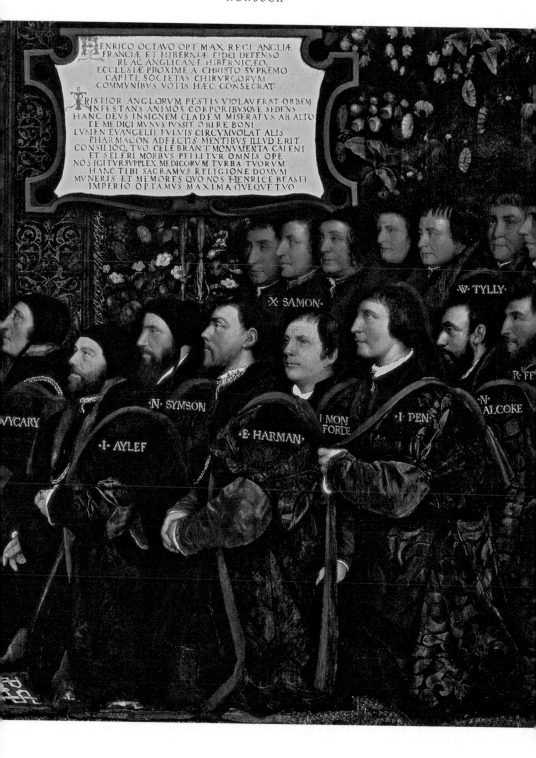

HENRICO OCTAVO OPT MAX REGI ANGLIÆ
FRANCIÆ ET HIBERNÆ EIDEI DEFENSO
RI AC ANGLICANÆ HIBERNICÆO,
ECCLESIÆ PROXIME A CHRISTO SVPREMO
CAPITI, SOCIETAS CHIRVRGORVM
COMMVNIBVS VOTIS HÆC CONSECRAT

TRISTIOR ANGLORVM PESTIS VIOLAVERAT ORBEM
INFESTANS ANIMOS CORPORIBVSQVE SEDENS
HANC DEVS INSIGNEM CLADEM MISERATVS AB ALTO
TE MEDICI MVNVS IVSSIT OBIRE BONI
LVMEN EVANGELII FVLVIS CIRCVMVOLAT ALIS
PHARMACON ADFECTIS MENTIBVS ILLVD ERIT
CONSILIOQ TVO CELEBRANT MONVMENTA GALENI
ET SELFRI MORBVS PELLITVR OMNIS OPE
NOS IGITVRSVPPLEX MEDICORVM TVRBA TVORVM
HANC TIBI SACRAMVS RELIGIONE DOMVM
MVNERIS ET MEMORES QVO NOS HENRICE BEASTI
IMPERIO OPTAMVS MAXIMA QVEQVE TVO

X · SAMON ·

W · TYLLY ·

R · FF

VYCARY

· N · SYMSON ·

· I · AYLEF ·

· E · HARMAN ·

I · MON
FORDE

· I · PEN ·

N ·
ALCOKE

To this end, it's worth returning to the *Darmstadt Madonna*, painted all those years previously, where Holbein explored the tension between statuary and painting, icon and real life, spiritual and mundane worlds. All those tensions in that work re-emerge here.

Henry is in a formal, seated posture, similar to that in which he is depicted on his Great Seal. As on the Great Seal he wears his crown, he carries the sword of state upright in his left hand, and with his right he hands out the charter. But Henry is disengaged from the proceedings, looking straight ahead rather than bestowing his gaze on those receiving the charter, and so he appears to belong to a different dimension from those around him. The dissonance created by Henry's lack of human communication with his beneficiaries is what delivers the reference to Catholic statuary and icons. Although Henry is enthroned as any king might be, the decision to show the guild members genuflecting in adoration echoes those devotional works of art, such as the Darmstadt Madonna, where patrons are depicted kneeling around the image of their holy protector. Here then is the image of not just a king, but a God on earth. As such this work completes the propaganda campaign Cromwell began, his ghostly influence implicit in the work.

The tension between the real person and his emblem that Holbein delivers in his depiction of Henry was not a purely imaginative proposition. It has more documentary foundation than one might credit, and mirrored a state of affairs that some looked on with horror, not least the French ambassador Marillac. Writing home in August 1540 he had vented his dismay at the tightening grip Henry had on his country's religious and political bodies, and the increasing adulation of the all-powerful king. '[T]he Estates have entirely transferred their authority to the King, whose sole opinion will henceforth have the force of an act of Parliament,' Marillac moaned:

> Although formerly everyone condescended to his wishes, still there
> was some form of justice, but now will be only the King's pleasure.
> Thus Parliament, so often prorogued and re-assembled in years
> past, has now been closed [...] (I) Will not speak of the pamphlets
> (cayers) and books which... bishops print daily, in which, [...] they
> permit their King to interpret, add to, take away, and make, more
> divine law than the apostles or their vicars and successors ever dared
> to attempt. They make of him not only a King to be obeyed, but an
> idol to be worshipped.[11]

As with so much of Holbein's work, inbuilt is a fascinating ambiguity allowing people to see just what they wish. The Barber Surgeons painting could be seen through Marillac's eyes as implicitly critical. Yet for anyone entering the space, visiting the hall in which the huge painting was hanging, all one had to do was to kneel before it, joining the guild members already represented, and in doing so not only commune with the imaginary space of the work, but become complicit in the adoration of England's king and spiritual leader.

One of the next areas of experimentation that Holbein embarked upon was to further evolve the classical references in his work. He did this in conjunction with Cromwell's great friend, Sir Thomas Wyatt. The statesman and celebrated poet Wyatt was a sometime neighbour of Holbein's in Aldgate where he owned land and property. But Holbein's relationship with the Wyatt family was not only a product of coincidence of geography and the mutual friendship of Cromwell, it was far more established. Sir Henry Wyatt, Sir Thomas's father, has been in charge of the Greenwich festivities along with Sir Henry Guildford over a decade earlier, and he had sat for Holbein.

When Holbein made his portrait of the patriarch of the Wyatt family in the 1530s he recorded an old man, his face lined and cheeks hollow with age. Like Guildford, and their mutual friend Sir John Poyntz, Sir Henry Wyatt had quietly stuck to the old Catholic religion, and this is acknowledged in the fact he clasps a gold cross in Holbein's depiction of him. Otherwise Holbein paints a figure full of worry, his brow furrowed and lips slightly apart as if he were short of breath. No wonder. His son Thomas was errant. The latter's marriage was broken and he had embarked on another relationship with a woman he could never marry. It is as if the old man sensed the troubles that lay ahead for his brilliant but rash son. Perhaps the painting was made after the latter had already had his first brush with the Tower, when he had been imprisoned under suspicion of impropriety with Anne Boleyn?

The errant Sir Thomas Wyatt also sat for Holbein, and the impressive drawing recording that sitting survives. Wyatt bears little resemblance to his father. In contrast to the large nose and worried face of the elder Wyatt, Thomas has fine features, the bridge of his

overleaf
Hans Holbein, *Sir Henry Wyatt*, oil on oak, 1537.

Hans Holbein, *Sir Thomas Wyatt*, black and coloured chalks, and pen and ink on pale pink prepared paper, *c.*1535–7.

Tho: Wiatt Knight.

nose thin, his eyes almond shaped and sharp. His beard is particularly long and his hair is curled, though visibly thinning on top, beneath his hat. There is no concern or lack of confidence in the sideways glance of this man, whose tightly shut lips speak of composure.

Sir Thomas's son by his estranged wife shared his name. He was brought up by his worried grandfather. It was perhaps Sir Henry then who commissioned Holbein to make a wedding present when the younger Thomas married Jane Haute in 1537. Among Holbein's drawings are ornate designs for two metalwork book covers, each with a small fastening to allow it to be attached to a girdle. Conceived to be made in gold and enamelled in black, and to cover a small book for Jane to hang from her person and read at her leisure, they bear the initials TWI and commemorate her inclusion in the Wyatt house.

Sometime later Holbein worked again with Sir Thomas Wyatt the elder, making another portrait of him, just head and shoulders in slight three-quarter profile, almost certainly in the form of a roundel. The portrait is lost and recorded only in copies and in a woodcut version that John Leland used when he published a tribute to his friend in 1542. But what is deeply unusual about the work is that it depicts Wyatt, now quite bald, in classical dress, his neck and shoulder bare, a toga tied around him.

Hans Holbein (copy), *Sir Thomas Wyatt in toga*, based on original, *c.*1540.

Wyatt's poetry was not published during his lifetime, but of course it was known and widely circulated among his circle. Significantly, Wyatt is credited as introducing the sonnet into English literature, a form he encountered during his travels abroad, when he discovered the work of Petrarch. Holbein's classical reinterpretation of Wyatt is a direct reference to a print published by Rome-based Antonio Salamanca, which features Wyatt's hero Petrarch in the same classical attitude, the toga tied in similar manner. The literal classicization of Wyatt suggests that he, like his Italian hero, deserves to stand alongside the celebrated poets of the antique period. It is a means of at once immortalizing Wyatt, crediting him as England's version of Petrarch, comparing him favourably with the great poets of the classical world and thus securing his legacy in the history of verse.

As if to reinforce the contextualization of Wyatt in the classical past, Leland, in a dedication that accompanied the woodcut, alludes once again to Holbein as Apelles. The reference to two important

cultural figures, the poet and painter, as comparable to those of the antique period adds weight to Leland's more general celebration of a moment of Renaissance in England, which he considers now very much arrived.

Leland takes the opportunity, however, to engage in the ongoing humanist debate about whether art or poetry could best convey the spirit of a person. Leland, a poet himself, naturally suggests that the poet and his wit remain elusive even to the great Holbein/Apelles. 'Holbein, greatest in the brilliant art of painting, portrayed his image skillfully,' Leland argues, 'but no Apelles can portray favourably the wit and spirit of Wyatt.'[12]

If Holbein was unable to ultimately convey the full depth of Wyatt's wit and spirit, he could certainly express his own ingenuity through continued experimentation and use of conceit in his work. Holbein expanded and explored the use of classical references in this period in an entirely innovative manner – not least when he depicted Wyatt's friend and fellow poet Henry Howard, Earl of Surrey, another exponent of the sonnet.

Hans Holbein, *Thomas Wyatt the Younger*, oil opanel, 1539–42.

Holbein and Howard had an ongoing relationship, with the painter capturing the earl several times across his life and career. In 1542 a substantial portrait of the poet depicts him with his hand wrapped in his cloak in a manner very similar to the classical depictions of Aeschines, the Athenian debater and rhetorician, or Sophocles, the Greek tragedian. The use of a classical pose such as this, which goes beyond the generic contrapposto that had been widely used by Renaissance artists, is one Holbein explored in England long before eighteenth-century portrait painters such as Sir Joshua Reynolds, who are more typically recognized as exploiting this kind of device.

However, it is in the portrait of the junior Thomas Wyatt that Holbein's latest interrogation of classicism reaches an entirely new height. Again around this time, Holbein painted the most exquisite roundel of the younger Wyatt, in which he is depicted in sharp, crisp profile against a plain, blue background. But the difference in this work is that it consciously quotes the form of an antique cameo.

The young man is depicted looking upwards to the sky, his chin raised slightly to create a strong straight line along the back of his neck through his hairline. This line bisects the roundel, with Wyatt's

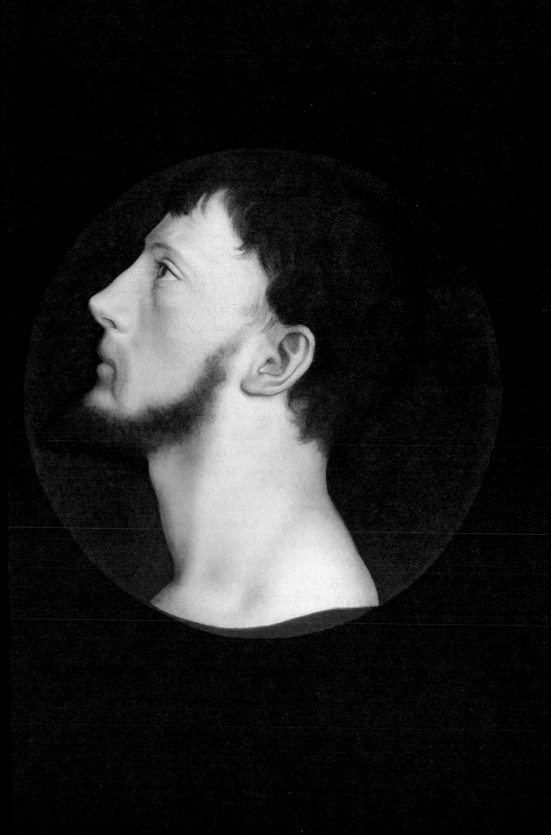

ear placed centrally. The obvious subservience of portraiture to aesthetics here is further accentuated by a stylized treatment of the neck. Rather than conceal the neck and shoulders in drapery in a nod to verisimilitude, it is simply cut off, or cut out, in a manner typical of antique gems or medals. In a new exploration of the dialogue between truth and artifice, the real and imagined worlds, here Holbein has extended the debate between painting and sculpture to that between painting and metalwork or jewellery.

Holbein shows us not Thomas Wyatt but a classical cameo of Wyatt, such as might appear on a ring or brooch, which he has, through the magic and artistry of painting, made appear almost human. But *almost* is the key. While the colouration, shading and sense of dimension are persuasive, the crisp outlines, formulaic composition and perfect condition of the 'skin' actually suggest something more gem-like and flawless than any young man could really be, no matter how beautiful he was. Here is an icon of a young man, to be idolized by a loving, devoted father. Here is also an allusion to the Ephebe of Ancient Greece – the young man who as part of his route to citizenship trains as a soldier and is often sent to war. This indeed chimes with Wyatt's circumstances at this moment and his forthcoming career as a celebrated soldier who by 1543 was seeking military adventure overseas.

It is an idealization that marks a new step in English art, and alongside the portrait of Surrey and the roundel of Sir Thomas Wyatt feels like the beginning of a whole new episode in Holbein's career, informed by the era's most exciting poets.

The other aspect of his career that takes off in the 1540s is Holbein's architectural design. For a man who had been imagining fantastic architectural edifices as part of his painted work throughout his career, it seems surprising that, unlike his contemporaries such as Michelangelo, he had not been asked to act as the architect of an actual building. So much of this period of Tudor history is unrecorded and has subsequently disappeared, that one cannot rule out that Holbein may have designed some of Tudor London. The determination among Londoners to incorrectly ascribe one of the gates to Henry's Whitehall Palace to him might well be a reflection that his skills as an architect had already been proven, and have simply slipped through history's net. One account of his design for a major building does however seem plausible.

In 1542 Henry VIII granted yet another dissolved abbey, that at Wilton in Wiltshire, to a rapidly rising star of his court, William Herbert – who would in due course become the Earl of Pembroke. Like Audley before him, Herbert began converting the monastic buildings into a grand, stately home, incorporating aspects of the old buildings into a rectangular house, wrapped around a central courtyard. Anecdotally, it was Holbein who conceived the design with him.

Without documentation or even preparatory drawings to support this, one can never know, not least given the property was largely demolished just eighty years later. However, one aspect of the former building still exists and bears the fingerprints of Hans Holbein. The grand entrance porch to the mansion survives, now moved to the grounds and used as a garden pavilion. When compared to the monumental fireplace that Holbein designed for Henry at Nonsuch, there are remarkable similarities.

Like the Nonsuch fireplace, the porch at Wilton was conceived with two storeys, though scaled up to accommodate a large entrance and reconceived as a three-sided structure with a square plan. Like the fireplace, the lower section is framed by pairs of columns standing on large pediments, surmounted by pairs of smaller columns – though the porch features a pair of ionic columns at the lower level, surmounted by smaller corinthians instead of an arrangement of doric and ionic columns in the Nonsuch drawing. As in the fireplace, the second storey features a combination of roundels framing a central panel. At Wilton the roundels contain busts, and a panel of arms.

There are of course important differences. The fireplace design is ornately decorated, whereas the Wilton porch enjoys much plain stonework – however, there are indications that it was painted and may have enjoyed further decoration. Also, the porch is surmounted by fan pediments, griffins and urns. Nevertheless the overall conception and design feels very much from the same hand.

Herbert was a Protestant sympathizer. So too was Sir William Butts, who brought the Barber Surgeons commission to Holbein. Holbein painted portraits of him and his wife in addition. Suffolk's young wife Catherine Willoughby was also a firm reformist. So too was Surrey. And another portrait that Holbein painted in 1541, that of Henry's Gentleman of the Privy Chamber Sir Anthony Denny, is also the visage of a man who, though moderate, was pro religious reform.

Another portrait from around this time is of William Parr, who also shared reformist views. This nobleman was given a baronetcy in 1539 by Henry. Holbein captured a man full of ambition, his hat adorned with a badge featuring a classical figure and a feather, a fur-edged gown and a very visible medallion. Holbein makes particular note of the white and purple velvet, the white satin and gold in which Parr is clad, and the details of the gold chains and aglets that are clearly of interest to sitter and artist alike – some of which are engraved with MORS, a reminder of death.

In short, Holbein's post-Cromwell commissions owe much to the patronage of England's eminent Protestant sympathizers. This, along with the reformist propaganda he had contributed to, and his role in the communications between Protestant campaigners in the late 1530s, suggests more than anything that Holbein had by this time become recognized as one of them.

What makes an artist paint a self-portrait? Perhaps after spending a lifetime memorializing others, inevitably there comes a moment when the desire to record oneself becomes irresistible. For Holbein, experiencing a cooler market for his work post-Cromwell, a self-portrait could be deployed as a marketing tool, reminding his clientele of his services, a practice Holbein had learned all those years ago from Erasmus. However, unlike Erasmus, who had the luxury of having his likeness made by another, to make a self-portrait, Holbein had to look in the mirror.

Hans Holbein?, Porch at Wilton House, c.1542, now used as a pavilion in the garden.

Holbein's self-portrait dates from 1542 or 1543, when the artist was forty-five, according to its inscription. It exists as a drawing, not a painting, worked in coloured chalk and showing evidence of later hands in the treatment of the clothing, and some ambiguity in what was once intended to be a cap, but now seems to have been reinterpreted as hair. Nevertheless the face is untouched, and represents Holbein's interrogation of himself.*

Unsurprisingly for a man whose defining and consistent aspect throughout his work is ambiguity, his is a face bearing an expression full of contradictions. At first glance the high cheekbones and hooded eyes combine in broad features that appear remarkably unscathed.

* The self-portrait is in the Uffizi Gallery in Florence.

Look again and one wonders if the nose, a little flattened, has been broken? A piercing, intense gaze from the painter's right eye contrasts with a left eye that seems a little less secure, the heavy lid thickened, with signs of tiredness and sagging not only in the lid, but in the bag and crease just below it. His expression is of intense concentration. He is resolute, determined, yet perhaps the furrowed brows suggest some discontent. His arched left eyebrow is at once knowing, but also questioning. Above all it shows a man who is serious. The satire and humour of which he was so capable are not expressed here.

One element of Holbein's self-portrait is the extremely plain dress the painter wears. For a man who once accepted to be paid in black-work collars, who wore ostentatious velvet on his return to Basel in 1538, and who left an array of splendid garments there, it must be significant that in his self-portrait he chooses to be seen not as the fashionably clad figure of success, but wearing modest clothing: a plain white shirt and a dark doublet that seems to be of simple fabric. Is this also a reflection of a new sartorial austerity associated with Protestantism?

Hans Holbein, *Self-portrait*, coloured chalk and ink on paper, 1542–3.

Significantly the inscription describes Holbein as being from Basel, yet we know he had just taken English citizenship. Is this a drawing then as much for Elsbeth and his Swiss family as for clients, looking out in much the same way as his depictions of the Easterlings? Or is this a picture of a man who has left his past behind? Unfortunately the answer to this question was not forthcoming, since months after he painted it, Holbein was dead.

As if providing a fitting backdrop for a country in political and religious turmoil, the early 1540s in England became increasingly sickly. The summer of 1540, when Cromwell sat sweating in the Tower, saw a new type of disease emerge: 'hot agues', with 'laskes' or dysenteries. 1541 fared little better, and then in the summers of 1542 and 1543 London fell prey to 'the Great Death', the source of which was once again the plague.

For those suffering in the summer of 1542, the natural world offered little solace. It was exceptionally wet, bringing yet more misery as crops were battered and rotted. The plague persisted into the autumn. In October it took William Fitzwilliam, Earl of Southampton, who, already ill, had travelled to Newcastle on the king's business in a

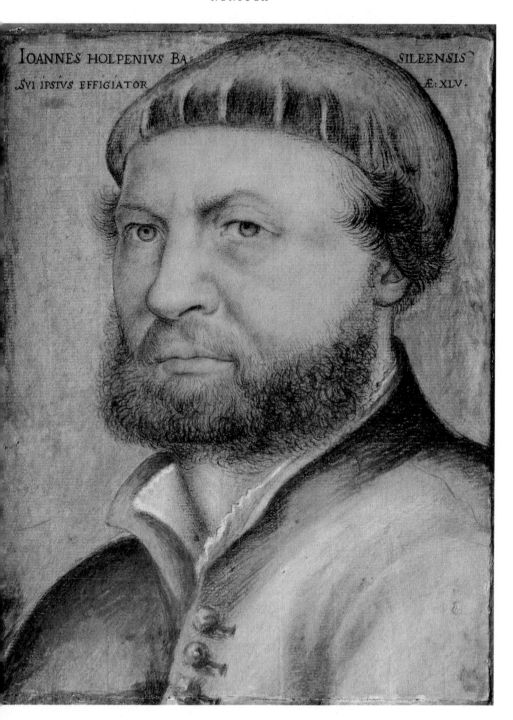

IOANNES HOLPENIVS BA⸱ SILEENSIS⸱
SVI IPSIVS EFFIGIATOR Æ: XLV.

litter. He died on arrival. Another casualty in the same month was Sir Thomas Wyatt. Travelling on a diplomatic mission to meet Charles V he was suddenly overcome by a fever, and met his maker instead, in Dorset.

The following spring was unusually, bitterly cold. Lambs and calves perished and by the summer of 1543 meat was in short supply. Now the Great Death descended for a second time on the capital. An ordinance of the Privy Council reveals the plague was in London as early as 21 May.

On 12 July Henry married his sixth wife, Catherine Parr, the sister of William Parr, whose portrait had already been painted by Holbein. Typically, the ascendancy of the Parr family was marked by William Parr's admission to the prestigious Order of the Garter just ahead of the marriage.

For Holbein, the rise once again of a court faction could be nothing but good news. It suggested new opportunities. But just three days after the king's sixth marriage a panicked court issued a proclamation forbidding Londoners from 'entering the gates of any house wherein the King or Queen lie, and forbidding servants of the Court to go to London and return to Court again'. The same declaration was also 'Forbidding (considering the peril of infection) persons who inhabit London and its suburbs, not being the King's household servants or necessary for provision of his household, from resorting to Court'.[13] These restrictions on movement were a barrier to new commissions, not least to take the likeness of the new queen.

The disease did not abate, but continued into the winter. The Michaelmas law term had to be postponed before finally being kept at St Albans rather than in the capital. On 7 October 1543, with the city still in the grip of plague, Holbein made a will. A precautionary measure for a man living in the midst of an epidemic for sure, but in Holbein's case it proved a necessary one. Referring to himself by his English name, 'John Holbeine', and describing himself as 'servaunte to the Kynges Magestye', Holbein askes that in the event of his death all his goods be sold, along with his horse, in order to settle his debts to Mr Anthony of Greenwich, to whom he owed 10 pounds, 30 shillings and 7, 'and moreover I will that he shall be contented for all other thynges between hym and me'. Holbein goes on to make sure that the 6 pounds he owed to the goldsmith Hans of Antwerp also be seen to.

The implications of such specific amounts to these two men are clear. Holbein, just like his Uncle Sigmund, had a real premonition that he would likely die, and was putting immediate matters in order. In addition he needed to look to the future of his London family, and made sure provision was made: 'I bequeythe for the kynpyng of my two chylder which are at nurse, for every monthe sewyn shyllynges and sex pence sterlynge'.

This is the full extent of Holbein's wishes; his family in Basel not mentioned, though as recent beneficiaries of Sigmund's estate overseas, he may have felt they had been taken care of already. Witnessing the will were four men: Hans of Antwerp, Olryke Obrynger, a merchant, Anthony Snecher, an armourer, and Harry Maynert, a painter. Hans of Antwerp and Harry Maynert were almost certainly associated with the Holbein workshop as either partners, or, in Maynert's case, as a member. Snecher was part of Henry's Greenwich armoury, with which Holbein continued to collaborate closely.

The prevalence of the plague at the time has led many to believe that it was the cause of Holbein's death. For a painter who had envisioned Death across his career, it seems appropriate that it took him, if not quite by surprise, certainly quickly. The lack of a clearly marked or recorded grave adds some credence to the theory that his was one of the many bodies buried in haste in communal plague pits. Though technically in the parish of the Church of St Andrew Undershaft, living within Audley's Cree-Church Mansion, it makes sense that the painter was buried in St Katharine Cree Church. The two churches are so close one can walk between them in three minutes. Even though the great seventeenth-century collector of Holbein's work, the Earl of Arundel, went to look for Holbein's grave in the latter place and failed to find it, in 1668 Mayor Payne Fisher made a catalogue of tombs and inscriptions in London's churches and 'Hans Holben' was noted there. It may well have been that his was one amid a long list of names of the plague dead. The inscription, such as it was, no longer exists.

On 29 November Hans of Antwerp appeared before Master John Croke, of the Commissary Court, to execute the will of his former friend. There is no doubt that despite his recent troubles, Holbein died the most celebrated artist that England could ever claim as its own. For those who had secured his final designs, the impetus to see them

completed must have been intense. Rather than start over, Holbein's designs already on the table were seen through by a workshop that apparently thereafter disbanded.

And so despite Holbein's death, important works continued. The painters in the Holbein workshop completed the large painting for the Barber Surgeons Guild, while the masons at Wilton interpreted his designs for the home of the Earl of Pembroke. And there was one more magnificent legacy – one that reveals Holbein's continuing collaboration with Nicolaus Kratzer a decade after the two of them conceived *The Ambassadors*. Together they had designed a clock salt, for Sir Anthony Denny to present to the king as part of those New Year's Day gifts.

A clock salt was just that, an ornate cellar that held that precious commodity, but that also had a clock incorporated within it. Henry VIII was an avid collector of them and had been the recipient of a rather splendid clock salt executed by the French goldsmith Pierre Mangot from Francis I in the 1530s, possibly as a wedding gift when he married Anne Boleyn. Keen to deliver something even more novel than their French counterpart, Holbein and Kratzer worked on a design that would not only incorporate a clock with a salt well, but also an hourglass, sundials, and a compass. In doing so they elevated a delightful piece of tableware into something far more profound.

Hans Holbein, *Design for a clock salt* for Sir Anthony Denny, black ink with grey wash, and some red wash, 1543.

The British Museum holds a single drawing of this extraordinary object, portrayed in elevation. This reveals that the salt cellar formed the base of the device, probably of cylindrical form and therefore standing on three feet, and decorated with male torsos. The lid of the cellar comprised the four instruments for measuring time and place. The base of the lid featured a tiny cabinet, the doors of which opened up or folded back to reveal an hourglass, the handle which turned it in the shape of a satyr. Above this a compass was concealed within a secondary lid, upon which two putti held curved metal sheets that were sundials. Upon their heads balanced a clock, at the centre of which was a sun, and on top of which was a crown. This was almost certainly to be made in silver gilt and enamelled, as was the salt clock made by Mangot and the cellar made for Francis I by Benvenuto Cellini at this time. It would have been a shimmering talking point at

a banquet, combining art and science, function and frivolity.

But as in the other collaborations between Kratzer and Holbein, the decision to include so many instruments of measurement invites further contemplation. After all, with a compass included in it, this was an instrument that allowed one to get one's bearings. And as a receptacle containing salt, one's position relative to it indicated one's seniority in a court pecking order, where the most important members sat above the salt, and others below. The elements of the device dedicated to time allowed one to position oneself further within the fourth dimension. This was therefore an instrument against which one measured one's social status, at a particular place, at a particular moment. The inclusion of the hourglass, however, offered a pointed reminder of fleeting mortality, and that one's enjoyment of the pleasures of life was ultimately finite.

Denny presented his extremely expensive gift to the king in the new year of 1545. Holbein had already been dead for over a year. Henry's time was also running out. Denny became the executor of Henry's will when the king died in 1547.

The remarkable clock salt he designed with Kratzer reminds us not only of the protean nature of Holbein's genius, but also that underlying his astonishing and varied output stretching across thirty years, there is a common theme. Holbein's work is ultimately about measurement: the measurement of time, of place, and the need for members of the human race to map their trajectories through this life and into the next.

Holbein's portraits, so breathtaking in their closeness to life, reflect his contemporaries' sense of their own position on the social ladder of their day. They reveal an encoded world where a particular fur, a certain ring or jewel, a particular colour or type of cloth, signals their status in a social matrix in which every man and woman knew their place and how to indicate it. They mark key points in a life, the achievements and rites of passage that punctuate it. Of course many of Holbein's portraits commemorate those who have risen up, leveraged power, and beaten the system, much like Holbein himself. However, above all they express the all too human desire to defy time and preserve an image for posterity. Here are people shown at their best or happiest; perhaps in the prime of their youth, or at the most prestigious moment in their career. Their desire to grasp a moment,

to capture a memory, is a human trait that is familiar to us today. As such as it provides us with a connection and point of identification with those faces from a long-lost past.

Holbein remains the supreme master of dimension. He positioned his depictions of people in imagined spaces that were so carefully conceived, so precisely constructed that one is still deceived into believing one might reach into his fictional space. Certainly his creations reach out into ours, momentarily fusing the past and present, the imagined and the real. But Holbein's sense of perspective is more than a mathematical calculation. He also sees and places his subjects in the wider context of their time. His renditions of globes, maps and astronomical devices give us glimpses of an era in which people were fascinated with science and discovery. The lands and constellations therein conveyed present a scale against which to measure human achievement.

The tradition that Holbein understood as a boy, that art, through contemplation, allowed one to commune with the spiritual realm, is one that he continues throughout his work. His determination to engage his viewers in a meditation on the meaning of life, death and resurrection is apparent in his religious pieces such as the *Dead Christ* and the *Darmstadt Madonna*. But even in his secular work, particularly in *The Ambassadors* or *Sir Thomas More and his Family*, there is a profound reflection on the transitory nature of existence, in which one merely plays a role, and beyond which a greater spiritual dimension awaits.

In many ways Holbein was confined by his time, subject to the whim of patrons and the harsh economic pressures under which even great painters worked. And yet his supreme creative energy and determination to innovate delivers a sense of freedom nevertheless. Here is an artist who, with almost every commission, sought to express his own individual brilliance. Sometimes it is merely a joke or witticism, a conceit either slight or complex, but in the greater paintings, he presents complex arguments concealed with intricate puzzles laid out for his viewers to decipher and engage.

Holbein also presented art as an event. His work, once delivered to its patron, endowed with its own independent, creative energy, surprised and delighted those who came across it, whether it was a diptych opening like a book to reveal a brilliant world, a façade on a house that tricked the eye, or the depiction of a king that could make

men quake in its presence. His work represents a new confidence in the power and value of art, and a new hope and ambition for the status of the artist.

Finally, perhaps as part of his determination to persuade his peers that the painter could indeed match the poet and writer, Holbein sought to deliver ambiguity and symbolic depth in his work. In effect, he creates enough intellectual space within it to allow multiple interpretations. This has given his work a remarkable longevity. It has allowed his paintings to continue to speak to viewers, across the ages. He has presented images and narratives, the meanings of which have taken on different hues in different centuries. Thus the *Dead Christ* can speak to a sixteenth-century humanist, a nineteenth-century novelist and a twentieth-century psychoanalyst in an equally profound, but distinctly different manner. Similarly his portraits of Henry VIII, designed so cleverly to speak to Henry and his followers, can also offer the modern viewer not so much a depiction of magnificence but of bloated self-indulgence. Holbein's ability to place the significance of his work entirely in the eye of its beholder is a measure of his true greatness. Above all this work was truthful, and the truth offers many readings.

Holbein's extensive oeuvre serves up a series of coordinates that chart one of the most fascinating eras in the history of Europe, England and the evolution of Christianity. Through Holbein one meets the humanists rediscovering Europe's classical heritage, the entrepreneurs in the vanguard of publishing and communications, those at the forefront of religious debate and reformation, and the men and women holding the reins of political power.

But the persuasive veracity of his work, the sense that the faces he shows us might at any moment blink or take a sudden breath, represents something more than just glimpses into a fascinating and undeniably tumultuous past. They remind us that the truly great artists, those in whom creativity is such a vigorous force, offer something almost magical. As if weaving a spell, his work has allowed those long dead to live on. And so Holbein himself lives on. The long-lost faces are the markers that locate the painter too. In seeing them we feel his presence still; it is *his* lens through which we view the past, we take *his* cue for the sounds he wanted us to hear, the debates he and his clients wanted to air. Nicholas Bourbon, in a dedication to

the painter, imagined Apelles desperate to see Holbein's work. How fortunate then, that we can.

Apelles wandered in the Elysian fields;
Zeuxis and Parrhasius were near
And happy in that pleasant region;
They spoke lively and were noisy, though
Apelles sought solitude and was sad.
His companions found this strange and gently urged him to speak.

The great artist, downhearted and sombre, sighed
And with deep emotion in his voice said:
Alas! you know not of the bad news
That came from the human world and reached the infernal regions.
O, if God could make this report untrue!
From among the mortal people, one gifted with the power of his art,

Has made nothing of us.
We are painters only in name,
To speak without jealousy and envy,
We never were experienced and skilful in handling our brushes in
our own time.
Holbein is the name of the man.

Holbein puts all our names in shadow and reduces them to nothing.
Many other similar complaints were made by infernal spirits,
Who had, I believe, cause to complain.
If one could only see these pictures
Painted by Hans.
Hans the most famous.
The most honoured for his splendid art.
Then a voice said:

'No human hand has ever wrought,
with brush and colour, such great and rare achievement'.
They could do nothing.
That statement was false
God had done the work.
God alone achieved such deeds.

Nicholas Bourbon[14]

NOTES, BIBLIOGRAPHY

& INDEX

NOTES

1 Anne

1 *Dives and Pauper*, an early fifteenth-century tract, cited by Marks, Richard, *Image and Devotion in Late Medieval England*, Sutton Publishing, Gloucestershire, 2004, p. 17.

2 'Letters and Papers: September 1539, 1–5', *Letters and Papers, Foreign and Domestic, Henry VIII*, Volume 14 Part 2, August–December 1539. Gairdner, James and Brodie, R. H. (Eds.), London: Her Majesty's Stationery Office, 1895, pp. 34–39, *British History Online*, www.british-history.ac.uk/letters-papers-hen8/vol14/no2/pp34-39.

3 Van Mander, Carel, *Dutch and Flemish Painters, Translation from the Schilderboeck*, Mcfarlane Warde Mafarlane, New York, 1936. p. 86.

4 Ibid p. 95.

5 Norton, Elizabeth, *Anne of Cleves: Henry VIII's Discarded Bride*, Amberley, UK, 2010, p. 31.

6 McCulloch, Diarmaid, *Cromwell: A Life*, Allen Lane, Penguin, Random House, London, 2018, p. 494.

7 7 Hacker, Peter and Kuhl, Candy, 'A Portrait of Anne of Cleves', *The Burlington Magazine*, 134: 1068 (Mar., 1992), pp. 172–175, www.jstor.org/stable/885027.

8 'Letters and Papers: June 1539, 26–30', *Letters and Papers, Foreign and Domestic, Henry VIII*, Volume 14 Part 1, January–July 1539. Gairdner, James and Brodie, R. H. (Eds.), London: Her Majesty's Stationery Office, 1894, pp. 520–538. *British History Online*, www.british-history.ac.uk/letters-papers-hen8/vol14/no1/pp520-538.

9 Ibid.

10 'Letters and Papers: July 1539, 16–20', *Letters and Papers, Foreign and Domestic, Henry VIII*, Volume 14 Part 1, January–July 1539, Gairdner, James and Brodie, R. H. (Eds.), London: Her Majesty's Stationery Office, 1894, pp. 561–566. *British History Online*, www.british-history.ac.uk/letters-papers-hen8/vol14/no1/pp561-566.

11 Rowlands, John, *Holbein: The Paintings of Hans Holbein the Younger*, Phaidon, Oxford, 1985, p. 117.

12 'Letters and Papers: August 1539, 1–15', *Letters and Papers, Foreign and Domestic, Henry VIII*, Volume 14 Part 2, August–December 1539, Gairdner, James and Brodie, R. H. (Eds.), London: Her Majesty's Stationery Office, 1895, pp. 1–15, *British History Online*, www.british-history.ac.uk/letters-papers-hen8/vol14/no2/pp1-15.

13 Ibid.

14 Ibid.

2 Holbain

1 Woltmann, Alfred, *Holbein and His Time*, translated by F. E. Bunnett, Richard Bentley & Son, London, 1872, p. 35.

2 MacCulloch, Diarmaid, *Reformation: Europe's House Divided*, Penguin, London, 2004, pp. 11–16.

3 Museums which also have remnants of Holbein the Elder's sketchbooks include Berlin's Staatliche Museum and Basel's Kunstmuseum.

4 McCusker, Alicia, 'Collecting Himself: Hans Holbein the Elder's Portrait Drawings', *Collecting Prints and Drawings*, Galdy, Andrea and Heudecker, Sylvia (Eds.), Cambridge Scholars Publishing, Newcastle upon Tyne, 2018, p. 221.

3 Young Hans

1 As part of his review of this book in its preparatory stage, Dr Bodo Brinkmann also assessed this image and has also concluded that this is an early portrait of a young Holbein by his father.

2 Having been alerted to the presence of young Hans in the work, Brinkmann also identified Ambrosius in the work.

3 The nuns of St Catherine's had negotiated a degree of leeway which allowed them to take trips into Augsburg and to visit family; nevertheless pilgrimage was out of the question. Mullin, Misty, *The Practice of Piety and Virtual Pilgrimage at St Katherine's Convent in Augsburg*, a thesis presented to the Faculty of the Graduate School at the University of Missouri-Columbia, Dr Anne Rudloff Stanton, Thesis Supervisor, May 2012, https://mospace.umsystem. edu/xmlui/bitstream/handle/10355/15317/research. pdf?sequence=2

4 Cuneo, Pia F., 'The Basilica Cycle of Saint Katherine's Convent: Art and Female Community in Early-Renaissance Augsburg', *Woman's Art Journal*, 19:1 (Spring-Summer 1998), pp. 21–25, www.jstor.org/stable/1358650.

5 Wunder, Heide, *He is the Sun, She is the Moon: Women in Early Modern Germany*, translated by Thomas J. Dunlap, Harvard University Press, 1998, p. 43.

6 Jecmen, Gregory and Spira, Freyda, *Imperial Augsburg: Renaissance Prints and Drawings 1475–1540*, National Gallery of Art, Ashgate, Lund Humphries, Washington, 2012, p. 51.

7 Steinmetz, Greg, *The Richest Man Who Ever Lived: The Life and Times of Jacob Fugger*, Simon & Schuster, 2017, p. 94.

8 Müller, Christian and Kemperdick, Stephan, *Hans Holbein the Younger: The Basel Years 1515–1532*, Prestel, Munich, Berlin, London, New York, 2006, p. 14.

9 Broadhead, P. J., 'Guildsmen, religious reform and the search for common good: the role of the guilds in the early Reformation in Augsburg', *The Historical Journal*, 39, 3 Sept., Cambridge University Press, 1996, p. 577.

10 Woltmann, Alfred, *Holbein and His Time*, translated by F. E. Bunnett, Richard Bentley & Son, London, 1872, p. 55.

11 Wilson, Derek, *Hans Holbein: Portrait of an Unknown Man*, Weidenfeld & Nicolson, London, 1996, p, 27.

12 Woltmann, p. 106.

13 Steinmetz, pp. 125–6.

4 Erasmus

1 Müller, Christian and Kemperdick, Stephan, *Hans Holbein the Younger: The Basel Years 1515–1532*, Prestel, Munich, Berlin, London, New York, 2006, p. 294.

2 Some scholars have suggested the Basel portrait of Erasmus owned by Basilius was in fact the one taken to France and then returned. Buck, Stephanie and Sander, Jochen, *Hans Holbein the Younger*, 2003, p. 18.

3 Sebastiani, Valentina, 'Sixteenth-Century Polymaths in the Print and Publishing Business in Basel: An Intersection of Interest and Strategies (1472–1513)', *Renaissance and Reformation*, 39:2, pp. 9–25 (Spring 2016).

4 Hilgert, Earle, 'Johann Froben and the Basel University Scholars, 1513–1523', *The Library Quarterly*, 41:2 (Apr., 1971), pp. 141–169, www.jstor.org/stable/4306069.

5 Sebastiani, p. 17.

6 Ibid, p. 19.

7 Nuechterlein, Jeanne, *Translating Nature into Art: Holbein, the Reformation and Renaissance Rhetoric*, Pennsylvania State University Press, 2011, p. 28.

8 Chamberlain, Arthur B., *Hans Holbein the Younger* Vol. 1, George Allen and Company, London, 1913, p. 58.

9 Saxl, F., 'Holbein's Illustrations to the "Praise of Folly" by Erasmus', *The Burlington Magazine for Connoisseurs* 83: 488, Holbein Number (Nov. 1943), pp. 274–279.

10 Michael, Erika, *The Drawings by Hans Holbein the Younger for Erasmus' 'Praise of folly'*, Garland, New York, 1986.

11 Gerlo, Aloïs, *Erasme et ses portraitists – Metsijs, Dürer, Holbein*, B de Graaf, Nieuwkoop, 1969, p. 46.

12 Erasmus, Desiderius, *Praise of Folly*, translated by Betty Radice, Penguin Books, 1993, p. 63.

13 Ibid, p. 124.

14 Alexander Marr has explored the idea of a pun or conceit as a structural principle in much of Holbein's work, and has noted the artist's interest in ambiguity. Marr, Alexander, *Holbein's Wit*, a lecture delivered as part of Hans Holbein's Ingenuity, a conference organized by the Centre for Research in the Arts, Social Sciences and Humanities, Cambridge University, June 28 2019.

15 Gerlo, p. 46.

16 This observation that the sign may be a faux sign, a novelty, was suggested to me by Dr Bodo Brinkmann.

17 The alphabet is also missing J and V; however, this is not an error, since at the time J and I were written the same, as were U and V. Brinkmann has also observed the missing H but has not suggested this as a possible reference by omission to Hans Holbein. Bürgi, Bernhard and Zimmer, Nina (Eds.), *The Masterpieces*, Kunstmuseum Basel, 2011, p. 34 and p. 338.

18 Brinkmann pointed out that this is a prototype for the genre painting.

19 Sebastiani, Valentina, *Johann Froben, Printer of Basel*, Library of the Written Word, Volume 65, Brill, p. 717.

20 Ibid, p. 718.

21 Bodo Brinkmann reminded me that this could have been a playful double reference.

22 www.bloomberg.com/news/articles/2011-07-14/holbein-madonna-sells-for-at-least-56-million-to-german-magnate-wuerth

5 Death

1 Flood, John L. '"Safer on the Battlefield than in the City": England, the "Sweating Sickness", and the Continent', *Renaissance Studies*, 17: 2 (2003), pp. 147–176, www.jstor.org/stable/24413344

2 Chamberlain, Arthur B., *Hans Holbein the Younger* Vol. 1, George Allen and Company, London, 1913, pp. 58–59.

3 Sebastiani, Valentina, *Johann Froben: Printer of Basel* (including a catalogue of Froben's publications), Brill, 2008, p, 450. According to the catalogue of Froben's publications a possible new Holbein design *Dolphin Motifs with Weapons and Music Instruments* appears in August 1520.

4 Butts, Barbara and Hendrix, Lee, *Paintings in Light: Drawings and Stained Glass in the Age of Dürer and Holbein*, J. P. Getty Trust, 2000, pp. 300–301.

5 The figure of the Virgin, by a follower of Holbein, acquired for the Amerbach Cabinet is now in Basel Kunstmuseum. The figure of Emperor Heinrich II is still at Wettingen Abbey (Kloster Wettingen).

6 Bätschmann, Oskar and Griener, Pascal, *Hans Holbein*, Reaktion Books, London, 2014, p. 51.

7 The Metropolitan Museum of Art's catalogue entry points out this phenomenon, which of course anticipates Holbein's *Ambassadors*. www.metmuseum.org/art/collection/search/436657

8 www.wilden-mann.ch/pdf/historie/Broschuere_Wilden-Mann_EN.pdf

9 Nineteenth-century descriptions suggest some of the interior paintings were dated 1517. Chamberlain, p. 70.

10 Rappaport, Steve, *Worlds Within Worlds: Structures of Life in Sixteenth-Century London*, Cambridge University Press, 2002, p. 15.

11 Preparatory drawings for the 'Zum Tanz' house are in the Kunstmuseum Basel.

12 Cummings, Brian, 'Naked Luther: The Politics of Culture in Three Early Images of Luther', Marginalia, *Los Angeles Review of Books*, 16 February 2018.

13 Nuechterlein, Jean, *Translating Nature into Art: Holbein, the Reformation, and Renaissance Rhetoric*, Pennsylvania State University Press, 2011, pp. 30–31.

14 Sebastiani, Valentina, *Johann Froben: Printer of Basel*, Library of the Written Word, Vol 65, Brill, 2008.

15 Massing, Jean Michel, 'The Illustrations of Lucian's Imago Vitae Aulicae', *Journal of the Warburg and Courtauld Institutes*, 50 (1987), pp. 214–219, www.jstor.org/stable/751329 accessed 15 October 2020.

16 *Collected Works of Erasmus, Vol 7, The Correspondence of Erasmus, 993–1520, 1519–1520*, Mynors, R. A. B. (ed.), annotated by Bietenholz, P., University of Toronto Press, 1987, letter 1084, Bonifacius Amerbach to Erasmus, Basel, 19 March 1520, p. 232.

17 Müller and Kemperdick, *Hans Holbein the Younger: The Basel Years 1515–1532*, Prestel, Munich, Berlin, London, New York, 2006, p. 259.

18 Kristava, Julia, *Black Sun: Depression and Melancholia*, Columbia University Press, New York, 1993, p. 110.

19 Nuechterlein points out that the tomb described by Holbein is very similar indeed to such a 'holy grave' in the Lorrach region, in Baden-Wittenburg, just over the border from Basel, where many parish churches had horizontal niches above which a rectangular niche would hold the Eucharist. Nuechterlein, p. 90.

20 Duffy, Eamon, *The Stripping of the Altars*, Yale Univerity Press, 1992, pp. 31–33.

21 Brinkmann, Bodo, 'Das Grab bei Holbein: Versuch über den Toten Christus'. *Archäologie Des Heils. Das Christusbild Im 15. Und 16. Jahrhundert*. Kunstverlag Joseph Fink. Kunstmuseum Basel.

22 Ibid.

23 Müller and Kemperdick, p, 257.

24 Brinkmann, Bodo, 'Das Grab bei Holbein: Versuch über den Toten Christus'.

6 Elsbeth

1 Wandel, Lee Palmer, *Voracious Idols and Violent Hands: Iconoclasm in Reformation Zurich, Strasbourg and Basel*, Cambridge University Press, 1995, p.176.

2 Wiesner, Merry E. 'Wandervogels and Women: Journeymen's Concepts of Masculinity in Early Modern Germany', *Journal of Social History*, 24: 4 (1991), pp.767–782, www.jstor.org/stable/3788856

3 Burckhardt, Hans Holbeins Ehefrau und ihr erster Ehemann Ulrich Schmid : Baselr Zeitschrift für Geschichte und Altertumskunde 1906 PDF erstellt am: 25.11.2019 Persistenter Link: http://doi. org/10.5169/seals-111775

4 Nuechterlein, Jean, *Translating Nature into Art: Holbein, the Reformation, and Renaissance Rhetoric*, Pennsylvania State University Press, 2011, p.22.

5 Chamberlain, Arthur B., *Hans Holbein the Younger* Vol. 1, George Allen and Company, London, 1913, p.83.

6 Bodo Brinkmann pointed this out to me.

7 Sebastiani, Valentina, *Johann Froben: Printer of Basel* (including a catalogue of Froben's publications), Brill, 2008, p.55.

8 Ibid, p.56.

9 Bätschmann, Oskar and Griener, Pascal, *Hans Holbein*, Revised and Expanded Second Edition, Reaktion Books, 2014, p.152.

10 Müller and Kemperdick, *Hans Holbein the Younger: The Basel Years 1515–1532*, Prestel, Munich, Berlin, London, New York, 200 p.114.

11 The Venus painting is discussed further in Müller and Kemperdick, where a potential author is identified as Basel based Balthasar Han, also a painter of stained glass. Müller and Kemperdick, pp.359–60.

12 Van Mander, Carel, *Dutch and Flemish Painters, Translation from the Schilderboeck*, Mcfarlane Warde Mafarlane, New York, 1936, p.85.

7 The Dance

1 Ziolkowsk , Jan M. (ed.) *Obscenity: Social Control and Artistic Creation in the European Middle Ages*, Brill, 1998, p.198.

2 Erasmus, Desiderius, trans. White Kennet, *Moriæ encomium: or, A panegyrick upon folly, done into Engl. [by W. Kennett] and illustr. by H. Holbeine*. To which is prefix'd, Erasmus's epistle to sir Thomas More, and an account of Hans Holbeine's pictures, London, 1709, p.xvi. Kennett credits the sum of 60 shillings to Zwinger's Meth Apodemica. But Wornum (*Some Account of the Life and Works of Hans Holbein: Painter, of Augsburg, with Numerous Illustrations*, Chapman and Hall, 1867, p.128) credits the same reference as citing a sum of 40 shillings.

3 Tipton, Susan, 'Pygmalions Werkstatt – Ein Künstlerhaus der Spätrenaissance in Basel', *Artists' Homes in the Middle Ages & the Early Modern Era*, eds Tacke, Andreas; Schauerte Thomas and Brenner, Danica, Michel Imhof , Peterberg, Germany, 2018, p.139.

4 Woltmann, Dr Alfred, *Holbein and His time*, Richard Bentley and Son, London, 1872 p.429. The account comes from Dr Ludwig Iselin and must relate an account by his father the Basel lawyer Johann Iselin who was contemporary with Holbein.

5 Groebner, Valentin (translated by Pamela E. Selwyn), *Liquid Assets, Dangerous Gifts, Presents and Politics at the End of the Middle Ages*, University of Pennsylvania Press, 2002, Chapter Five.

6 Ibid.

7 Ibid, p.128.

8 Bätschmann, Oskar and Griener, Pascal, *Hans Holbein*, Revised and Expanded Second Edition, Reaktion Books, London 2014, p 119, note 26.

9 Ibid, p.132.

10 Chamberlain, Arthur B., *Hans Holbein the Younger*, Vol. 1 (George Allen and Company, London), 1913, p.123.

11 Albert Dürer, Public Domain Poetry, Public-domain-poetry.com.

12 *Collected Works of Erasmus, Vol 10, The Correspondence of Erasmus: Letters 1356–1534, 1523–1524*, translated by R. A. B. Mynors and Alexander Dalzell, annotated by James M. Estes, University of Toronto Press, 1992, p.85, letter 1385, Erasmus to Henry VIII.

13 Ibid, 1408, Erasmus to Willibald Pirckheimer, 8 January 1524, p.152.

14 Peterson, Harold L,, *Daggers and Fighting Knives of the Western World*, NY 2001, p.39.

15 Müller, Christian and Kemperdick, Stephan *Hans Holbein the Younger: The Basel Years 1515–1532*, Prestel, Munich, Berlin, London, New York, 2006, p.314.

16 Rowlands, John, Terminus, The Device of Erasmus of Rotterdam: A Painting by Holbein, *The Bulletin of the Cleveland Museum of Art* 67: 2 (Feb., 1980), pp.50–54.

17 Bätschmann and Griener, p.298.

18 Van Mander, Carel, *Dutch and Flemish Painters, Translation from the Schilderboeck*, Mcfarlane Warde Mafarlane, New York, 1936 p.92. It is not quite clear who this old Lord Cromwell might be. Thomas Cromwell was executed in 1540; his son Gregory, Baron Cromwell and his nephew Sir Richard Cromwell survived him and had families.

19 *Erasmus Letters vol 10* pp.109–110, letter 1397, Erasmus to Johannes Fabri, 21 November 1523. Faber and Fabri were one in the same.

20 *Erasmus Letters vol 10* p, 279, letter 1452, Erasmus to Willibald Pirckheimer, 3 June 1524.

21 Rublack,Ulinka, *Hans Holbein The Dance of Death*, Penguin Books, London 2016, p.150–64.

22 Cox-Rearick, Janet, *The Collection of Francis I: Royal Treasures*, Fonds Mercator Paribas, Antwerp, 1995.

23 Holbein's Passion altarpiece is in the Kunstmuseum at Basel. Solario's Crucifixion is in the Louvre. The possible link between the two has been noted by Jochen Sander, Müller and Kemperdick, p.326.

may be a reference to a son who died as a boy. The baby possibly alludes to another son lost at birth. Kemperdick and Roth, 2016, pp.27–41.

5 Ibid.

6 Gerlo,Aloïs, *Erasme et ses portraitistes, Metsijs, Dürer, Holbein*, B. De Graaf, Nieuwkoop, 1969 p.56–9.

7 Collected Works of Erasmus 12 The Correspondence of Erasmus letters 1658 to 1801, Jan 1526- March 1527, translated by Alexander Dalzell, annotated by Charles G Nauert. Jr , University of Toronto Press, 2003, p.312.

8 Silver, Larry, *The Paintings of Quentin Massys with catalogue Raisonne*, Phaidon, Oxford, 1984, p.4.

9 Gerlo, p.59.

10 Hand, John Oliver, and Wolff, Martha, *Early Netherlandish Painting*, Washington National Gallery of Art, Cambridge University Press, 1986, pp.60–61.

11 Sir Thomas More to Bishop Fisher *Thomas More: Selected Letters*, edited by E. F. Rogers, New Haven, 1961, Letter no.17.

12 Hale, John, *Civilisation of Europe in the Renaissance*, Scribner, 1995, p.62.

13 Ibid.

14 *Nicholas Hilliard's Art of Limning*, Northeastern University Press, Boston, 1983, p.19.

15 Weir, Alison, *Henry VIII: King and Court*, Random House, 2011, p.168.

16 *Nicholas Hilliard's Art of Limning*, p, 19.

8 Meyer's Madonna

1 Nuechterlein, Jeanne, *Translating Nature into Art: Holbein, the Reformation, and Renaissance Rhetoric*, Pennsylvania Sate University Press, 2011, p.36.

2 Kemperdick, Stephan, 'Ein Meisterwek, Ein Rätsel. Mutmassungen über Hans Holbeins Madonnentafel Des Jakob Meyer Sum Hasen', *Holbein in Berlin, Die Madonna der Sammlung Wurth mit Meisterwerken der Staatlichen Museen zu Berlin*. Kemperdick, Stephan, Roth, Michael with Seidel Christine, Michale Imhof Verlag, Berling, 2016, pp.27–4, note 42.

3 Kemperdick, Stephan, 2016, pp.27–41.

4 Kemperdick has discovered a record indicating that Meyer had at least one son. He may well have had another for whom documentary evidence no longer exists. The fact that the boy in the alterpeice has no attributes associated with a holy figure suggests this

9 Thomas

1 Gerlo, Aloïs, *Erasme et ses portraitistes, Metsijs, Dürer, Holbein*, B. De Graaf, Nieuwkoop, 1969 p.52.

2 Collected works of Erasmus Vol 7, Letters 993-1121, 1519-1520, Trans Mynors, R. A. B., Annotated Bietenholz P., University of Toronto Press 1987, Letter 999 Erasmus to Ulrich Von Hutten , 23 July 1519, p.15.

3 Heywood, Ellis, *Il Moro: Ellis Heywood's Dialogue in Memory of Thomas More*, Ed. Trans. R. L. Deakins, Harvard University Press, 1972, p.3.

4 Schulte Herbrüggen, Hubertus, ed. *Morus ad Craneveldium: Litterae Balduinianae novae. / More to Cranevelt: New Baudouin Letters*. Supplementa Humanistica Lovaniensia, XI. Louvain: Leuven University Press, 1997 p166, see also Mitjans, Frank,

'Thomas More's Veneration of Images, Praying to Saints and Going on Pilgrimages', *Thomas More Studies*, 3 (2008), p. 64–9.

5 Ibid, p. 88.

6 String, Tatiana C., *Art and Communication in the Reign of Henry VIII*, Routledge, Taylor and Francis Group, London, 2016, p. 115.

7 Gerlo, p. 52.

8 Reed, A. W., 'John Clement and his Books', *The Library, Fourth Series, Volume VI* (1926), pp. 329–339.

9 Mitjans, Frank, p. 64–9.

10 Nichols, F. M., 'On Some Works Executed by Hans Holbein During his First Visit to England 1526–1529', *Proceedings of the Society of Antiquaries*, 2nd series (17 March 1898), pp. 132–145.

11 These are the dimensions of the copy at Nostell Priory.

12 Hall, Edward, *Hall's Chronicle: Containing the History of England, During the Reign of Henry the Fourth, And the Succeeding Monarchs, to the End of the Reign of Henry the Eighth, In Which Are Particularly Described the Manners And Customs of Those Periods*, J. Johnson, London, 1809, p. 817.

13 Collected works of Erasmus Vol 7, Letters 993–1121, 1519–1520, Trans Mynors, R. A. B., Annotated Bietenholz P., University of Toronto Press, 1987, Letter 999, Erasmus to Ulrich Von Hutten, 23 July 1519, p. 19.

14 Collected works of Erasmus Vol 7, Letters 993–1121, 1519–1520, Trans Mynors, R. A. B., Annotated Bietenholz P., University of Toronto Press, 1987, Letter 999, Erasmus to Ulrich Von Hutten, 23 July 1519, p. 18.

15 Catherine Hunt has discussed this idea of role playing in her excellent essay on this painting, on which I draw here. 'Role Playing in Hans Holbein's *The Family of Sir Thomas More*', *British Art Journal*, 19: 1 (Spring 2018) pp. 62–71.

16 Ibid.

17 Erasmus, Letter to John Faber, 1532, www.thomasmorestudies.org/docs/Erasmus_on_More_1532_to_Faber.pdf

18 Angelo, Sydney, 'The Evolution of the Early Tudor Disguising, Pageant and Mask', *Renaissance Drama*, Vol 1, 1968, pp. 3–44.

10 Nicolaus

1 Hall, Edward, *Hall's Chronicle: Containing the History of England, During the Reign of Henry the Fourth, And the Succeeding Monarchs, to the End of the Reign of Henry the Eighth, In Which Are Particularly Described the Manners And Customs of Those Periods*, J. Johnson, London, 1809, p. 721.

2 National Archives currency converter.

3 'Henry VIII: May 1527, 6–10', in Letters and Papers, Foreign and Domestic, Henry VIII, Volume 4, 1524–1530, ed. J. S. Brewer (London, 1875), pp. 1392–1416. *British History Online* www.british-history.ac.uk/letters-papers-hen8/vol4/pp1392-1416.

4 Susan Foister has provided a very useful timeline analysis of the court records, providing this interpretation in *Hans Holbein: Painting, Prints and Reception*, Symposium, Washington, D.C., 1997, Yale University Press, 2001 p. 112.

5 Ibid, p. 110.

6 Hall, p. 719.

7 'Went to see the furniture and riches of the King, who ordered a suit of armour to be made for Turenne, like his own, which are said to be the safest and the easiest that are made'. 'Henry VIII: May 1527, 6–10', in Letters and Papers, Foreign and Domestic, Henry VIII, Volume 4, 1524–1530, ed. J. S. Brewer (London, 1875), pp. 1392–1416. *British History Online* www.british-history.ac.uk/letters-papers-hen8/vol4/pp1392-1416.

8 Hall, p. 719.

9 Ibid, p. 722.

10 Ibid.

11 Ibid, p. 723.

12 Ibid.

13 Ibid.

14 Ibid, p. 124.

15 These are listed as part of a legal battle between Rastell and another theatre producer, during which several witnesses gave evidence that the costumes in question had been made for the 1527 revels at Greenwich. Dillon, Janette, 'John Rastell v. Henry Walton', *Leeds Studies in English*, 28 (1997), pp. 57–75, https://ludos.leeds.ac.uk:443/R/-?func=dbin-jump-full&object_id=124890&silo_library=GEN01

16 Reed, A. W., 'John Clement and His Books', *The Library*, Fourth Series, Volume VI (1926), pp. 329–339.

17 Collected Works of Erasmus, vol 13, Correspondence of Erasmus letters 1802–1925, University of Toronto Press, 2018. Letter 1831, Erasmus to William Warham, 29 May 1527, p. 153.

18 This translation by Shomit Dutta, from the Latin noted in Bätschmann, Oskar and Griener, Pascal, Hans Holbein, Revised and Expanded Second Edition, Reaktion Books, London 2014, p. 301.

19 David King made these important associations in Apollo Magazine, May 2004, pp. 43–48, where he also identified Holbein's portrait of a lady with a squirrel as Anne Lovell.

20 Ibid.

21 Gatty, Margaret Scott, The Book of Sun-dials, Enlarged and re-edited by H. K. F. Eden and Eleanor Lloyd, Fourth edition. London, George Bell & Sons, 1900, pp. 116–131.

11 Easterlings

1 Early map-view of Basel, drawn by Christoph Schweicker and engraved by Hans Rudolf Manuel Deutsch, published in Sebastian Münster's 'Cosmographia'.

2 Holbein's portrait of Asper is lost, but copies and a record of it exist. The British Museum for example has a print by Wenceslaus Hollar of it. Museum number 1870,0625.41.

3 Collected Works of Erasmus Vol 15, The Correspondence of Erasmus: Letters 2082–2203 (1529), trans Alexander Dalzell, annotated James Estes, University of Toronto Press, 2012, Erasmus to Willibald Pirckheimer, 9 May letter 2158, p. 242.

4 Ibid.

5 Collected Works of Erasmus Vol 16 The Correspondence of Erasmus: Letters 2204–2356 (August 1529–July 1530), University of Toronto Press, Erasmus to Lorraine, September 1529, letter 2217, p. 53.

6 Ibid, Erasmus to More 5 September 1529, letter 2211, p. 35.

7 Ibid, Erasmus to Margaret Roper 6 September 1529, letter 2212, p. 40.

8 Wilson, Derek, Hans Holbein, Portrait of an Unknown Man, Weidenfeld and Nicolson, London 1996, p. 167.

9 Ibid, p. 168.

10 Ibid, p. 188.

11 Darkes, Giles, Tudor London, The City and Southwark in 1520, Town and City Historical Maps. The London Topographical Society and The Historic Towns Trust Dennins Maps, Frome, 2018.

12 Jardine, Lisa, Wordly Goods, A New History of the Renaissance, Macmillan, London, 1996, p. 305.

13 Markow, Deborah, 'Hans Holbein's Steelyard Portraits, Reconsidered', Wallraf-Richartz-Jahrbuch, 40 (1978), pp. 39–47, www.jstor.org/stable/24657567.

14 Ibid.

15 Ibid.

16 Marr, Alexander, Holbein's Wit, a lecture delivered as part of Hans Holbein's Ingenuity, a conference organized by the Centre for Research in the Arts, Social Sciences and Humanities at Cambridge University, June 28, 2019.

17 MacCulloch, Diarmaid, Thomas Cromwell: A Life, Penguin, London, 2018, p. 174 – the observation about the significance of the green cloth is entirely his.

12 The Ambassadors

1 The identity of the two men had in fact become lost in the nineteenth century until in 1900 historian Mary Hervey identified the sitters. Hervey, Mary Holbein's "Ambassadors":the picture and the men;an historical study, George Bell and Sons, London, 1900.

2 Hall, Edward, Hall's Chronicle: Containing the History of England, During the Reign of Henry the Fourth, And the Succeeding Monarchs, to the End of the Reign of Henry the Eighth, In Which Are Particularly Described the Manners And Customs of Those Periods, J. Johnson London 1809. p. 810.

3 What is unclear is whether the tassel and dagger are imagined designs by Holbein since both are similar to other designs by him, or whether they were based on real commissions delivered by the Holbein workshop specifically for de Dinteville's coronation outfit.

4 Jardine, Lisa, Worldly Goods: A New History of the Renaissance, Macmillan, London, 1996, p. 427.

5 Jardine identifies this as Behaim's terrestrial globe. She suggests the astronomical globe is based on one made by the Nuremberg-based Johann Schöner, loaned to Holbein by another German merchant resident in London. Jardine, p. 306.

6 Alciato's Book of Emblems, The Memorial Web Edition

in Latin and English, https://www.mun.ca/alciato/e010.html

7 Marr, Alexander, *Holbein's Wit*, a lecture delivered as part of Hans Holbein's Ingenuity, a conference organized by the Centre for Research in the Arts, Social Sciences and Humanities at Cambridge University, June 28 2019.

8 North, John, *The Ambassadors' Secret: Holbein and the World of the Renaissance*, Phoenix, London, 2002.

9 Ives, Eric, *The Life and Death of Anne Boleyn*, Blackwell, 2004, Chapter 16: 'Art and Taste'. Anne's use of an armillary sphere as a personal device is evidenced in a French Book of Hours that once belonged to her, now at Hever Castle, once her childhood home. Alongside it Anne has written 'le temps viendra, je Anne Boleyn'. This inscription is below a miniature of the second coming.

10 Hall, p. 812.

11 Ibid.

13 Anna Bolina Regina

1 www.christies.com/lotfinder/Lot/circle-of-hans-holbein-ii-augsburg-14978-1543-6136843-details.aspx

2 Colet had died in 1519 and so this was a posthumous work based on Torrigiano's account.

3 Wells, Kathleen, 'The Iconography of Sir Thomas More', *Studies: An Irish Quarterly Review*, 70: 277 (1981), pp. 55–71, www.jstor.org/stable/30090322.

4 'Henry VIII: January 1534, 1–5.' Letters and Papers, Foreign and Domestic, Henry VIII, Volume 7, 1534. Ed. James Gairdner. London: Her Majesty's Stationery Office, 1883. 4–12. *British History Online*, www.british-history.ac.uk/letters-papers-hen8/vol7/pp4-12.

5 Ives, Eric, *The Life and Death of Anne Boleyn*: 'The Most Happy', Blackwell, 2004, Chapter 16, p. 231–45.

6 Ibid., p. 237.

7 Taylor, Andrew W., 'Between Surrey and Marot: Nicolas Bourbon and the Artful Translation of the Epigram', *Translation and Literature*, 15: 1 (2006), pp. 1–20, www.jstor.org/stable/40340022 accessed 17 November 2020, p. 13.

8 Susan Foister speculates that Leland may have been the patron behind Holbein's painting of John Colet since he wrote in praise of the bust and had also been educated at St Paul's School, which was founded by Colet. Foister, Susan S. Humanism and Art in the Early Tudor Period: John Leland's Poetic Praise of Painting, Woolfson J. (ed) *Reassessing Tudor Humanism*. Palgrave Macmillan, London, 2002, p. 129–50.

9 Ibid.

10 Ibid.

11 Foister, Susan *Holbein in England*, Tate, 2006 p. 165 gives a much more fulsome analysis of the imagery being deployed in England and what purpose the Holbein woodcuts may have served.

14 The King's Painter

1 London Metropolitan Archives, CLA/007

2 Van Mander, Carel, *Dutch and Flemish Painters*, Translation from the Schilderboeck, Mcfarlane Warde Mafarlane, New York, 1936 p. 86.

3 Rodwell, Kirsty and Bell, Robert, *Acton Court: The Evolution of an Early Tudor Courtier's House*, English Heritage, p. 115.

4 Ibid, p. xv.

5 Ibid, p. xiv.

6 Ibid, p. 187.

7 Brigden, Susan, *Thomas Wyatt: The Heart's Forest*, Faber and Faber, p. 176.

8 Bernard, George.W., *Anne Boleyn: Fatal Attractions*, Yale University Press, 2011, p. 218. Bernard notes the reference in the judgement to testimony by Lady Wingfield could have been a mistake meant to have been a reference to Countess Worcester.

9 Seymour papers held at Longleat House detail a payment to 'Hance that made quene Janes Pycture', 1542. Vol.X.f.89.

10 M'Clintoch, John and Strong, James, *Cyclopædia of Biblical, Theological, and Ecclesiastical Literature*, Vol X. Harper & Brothers, New York, 1894, p. 271–2.

11 Buck, Stephanie, *Hans Holbein: Masters of German Art*, Könemann, 1999, p. 116.

12 Van Mander, p. 88.

13 Foister, *Holbein in England*, p. 94.

15 Christina

1 'Henry VIII: October 1537, 21–25.' Letters and Papers, Foreign and Domestic, Henry VIII, Volume 12 Part 2, June–December 1537. Ed. James Gairdner. London: Her Majesty's Stationery Office, 1891. 335–345. British History Online, www.british-history.ac.uk/letters-papers-hen8/vol12/no2/pp335-345.

2 'Henry VIII: October 1537, 26–31.' Letters and Papers, Foreign and Domestic, Henry VIII, Volume 12 Part 2, June–December 1537. Ed. James Gairdner. London: Her Majesty's Stationery Office, 1891. 345–355. British History Online, www.british-history.ac.uk/letters-papers-hen8/vol12/no2/pp345-355.

3 'Henry VIII: December 1537, 26–31.' Letters and Papers, Foreign and Domestic, Henry VIII, Volume 12 Part 2, June–December 1537. Ed. James Gairdner. London: Her Majesty's Stationery Office, 1891. 443–481. British History Online, www.british-history.ac.uk/letters-papers-hen8/vol12/no2/pp443-481.

4 John Rowlands has suggested that by this period Holbein's time was so monopolized by his business for the king that any other individual hoping to secure a sitting with Holbein would have to take opportunity where they could, and the fact that relatively few of such drawings ever developed into finished paintings served as further evidence of just how little time Holbein had to make work outside his work for the crown. Rowlands, John, '"Holbein and the Court of Henry VIII" at the Queen's Gallery, Buckingham Palace', The Burlington Magazine, 121: 910 (Jan., 1979), pp. 50, 53–55.

5 Woltmann, Dr Alfred, Holbein and His time, Richard Bentley and Son, London, 1872, pp. 423–424.

6 'Henry VIII: March 1538, 11–15.' Letters and Papers, Foreign and Domestic, Henry VIII, Volume 13 Part 1, January–July 1538. Ed. James Gairdner. London: Her Majesty's Stationery Office, 1892. 176–192. British History Online, www.british-history.ac.uk/letters-papers-hen8/vol13/no1/pp176-192.

7 Woltmann, p. 424.

8 Ibid.

9 'Henry VIII: March 1538, 21–25.' Letters and Papers, Foreign and Domestic, Henry VIII, Volume 13 Part 1, January–July 1538. Ed. James Gairdner. London: Her Majesty's Stationery Office, 1892. 207–223. British History Online, www.british-history.ac.uk/letters-papers-hen8/vol13/no1/pp207-223.

10 Woltmann, p. 427, convincingly points out that a painting in the Royal Collection of Christina that is half length including hands is probably a copy of Holbein's original drawing, since it deviates from Holbein's finished painting in a number of details.

11 'Henry VIII: May 1538, 21–25.' Letters and Papers, Foreign and Domestic, Henry VIII, Volume 13 Part 1, January–July 1538. Ed. James Gairdner. London: Her Majesty's Stationery Office, 1892. 384–393. British History Online, www.british-history.ac.uk/letters-papers-hen8/vol13/no1/pp384-393.

12 Chamberlain, Arthur B., 'Holbein's Visit to "High Burgony"', The Burlington Magazine for Connoisseurs, 21: 109 (Apr., 1912), pp. 25–30, www.jstor.org/stable/858965.

13 'Henry VIII: June 1538, 11–20.' Letters and Papers, Foreign and Domestic, Henry VIII, Volume 13 Part 1, January–July 1538. Ed. James Gairdner. London: Her Majesty's Stationery Office, 1892. 435–455. British History Online, www.british-history.ac.uk/letters-papers-hen8/vol13/no1/pp435-455.

14 Chamberlain.

15 Ibid.

16 Ibid.

17 A frontispiece designed by Holbein's brother Ambrosius illustrated the title page of Cantiuncula's first major published work – Topica. Meanwhile Holbein's own designs illustrated two of Cantiuncula's translations in 1524, that of Erasmus's Exomologesis into the French Maniere de se Confesser, and in the same year Thomas More's Utopia into German.

18 Chamberlain.

16 Edward

1 Definition of Clerk of the Signet from the Law Dictionary: 'An officer, in England, whose duty it is to attend on the king's principal secretary, who always has the custody of the privy signet, as well for the purpose of sealing his majesty's private letters, as also grants which pass his majesty's hand by bill signed; there are four of these officers' https://thelawdictionary.org/clerk-of-thesignet/

2 Written on the back of the grant: 'Expedited at Greenwich on 28 May, the 30th regnal year of Henry VIII reign, by Godsalve' (National Archives C 82/740).

3 Woltmann, Dr Alfred, Holbein and His time, Richard Bentley and Son, London, 1872, p, 429.

4 Mikhaila, Ninya and Malcolm-Davies, Jane, The Tudor Tailor: Reconstructing Sixteenth-Century Dress, Batsford, 2006.

5 Woltmann, p. 430–431.

6 Ibid.

7 Ibid.

8 Wilson, Derek, *Hans Holbein, Portrait of an Unknown Man*, Weidenfield and Nicolson, London 1996 p. 273. In the inventory of her property after Elsbeth's death this chest and its contents were noted.

9 Thomas Eser, Holbeins Söhne: zur berufsstrategischen Alternative 'Goldsmeid oder Maler' in 16. Jahrhundert. In Brinkmann, Bodo, Schmid Wolfgang , *Hans Holbein und der wandel in der kunst des frühen 16. Jahrhundrets*. Turnhout, 2005, pp. 113–146.

10 Müller, Christian and Kemperdick, Stephan *Hans Holbein the Younger: The Basel Years 1515–1532*, Prestel, Munich, Berlin, London, New York, 2006 p. 32.

11 Woltmann, p. 429.

12 MacCulloch, Diarmaid, *Thomas Cromwell: A Life*, Allen Lane, Penguin Random House, London, 2018, p. 462.

13 For a good contextual piece of the issues see Davis, Natalie Zemon, 'Holbein's Pictures of Death and the Reformation at Lyons', *Studies in the Renaissance*, 3 (1956), pp. 97–130, www.jstor.org/stable/2857103.

14 Though he had been responsible for designing New Year's gifts for the king previously, including Anne Boleyn's gift to the king in 1534, a frontispiece in a book given to the king in 1529 by his astronomer Nicolaus Kratzer, and a gift from Jane Seymour. See Hayward, M., 'Gift Giving at the Court of Henry VIII: The 1539 New Year's Gift Roll in Context', *The Antiquaries Journal*, 85 (2005), pp. 126– 175. doi:10.1017/S0003581500074382

15 Ibid.

16 Ibid.

17 'Letters and Papers: June 1539, 6–10.' Letters and Papers, Foreign and Domestic, Henry VIII, Volume 14 Part 1, January–July 1539. Eds. James Gairdner, and R. H. Brodie. London: Her Majesty's Stationery Office, 1894. 494–502. *British History Online*, www.british-history.ac.uk/letters-papers-hen8/vol14/no1/pp494-502.

18 Sept 1 Marillac to his superior in France Montmorency 'Letters and Papers: September 1539, 1–5.' Letters and Papers, Foreign and Domestic, Henry VIII, Volume 14 Part 2, August–December 1539. Eds. James Gairdner, and R. H. Brodie. London: Her Majesty's Stationery Office, 1895. 34–39. *British History Online*, www.british-history.ac.uk/letters-papers-hen8/vol14/no2/pp34-39.

19 Ibid.

20 Marillac to Francis I 15 Sept 1539 'Letters and Papers: September 1539, 11–15.' Letters and Papers, Foreign and Domestic, Henry VIII, Volume 14 Part 2, August–December 1539. Eds. James Gairdner, and R. H. Brodie. London: Her Majesty's Stationery Office, 1895. 44–53. *British History Online*, www.british-history.ac.uk/letters-papers-hen8/vol14/no2/pp44-53.

21 Ibid.

22 Ibid, Fitzwilliam to Cromwell, 17 September.

17 The Earl of Essex

1 MacCulloch, Diarmaid, *Thomas Cromwell: A Life*, Allen Lane, Penguin Random House, London, 2018 p. 506, referencing Paisey, David and Bartrum, Giulia, 'Holbein and Miles Coverdale: A New Woodcut', *Print Quarterly*, 26: 3 (September 2009), pp. 227–253.

2 Ibid.

3 Eser Thomas, Holbeins Söhne: zur berufsstrategischen Alternative 'Goldsmeid oder Maler' in 16. Jahrhundert. In Brinkmann, Bodo, Schmid Wolfgang , *Hans Holbein und der wandel in der kunst des frühen 16. Jahrhundrets*. Turnhout, 2005, pp. 113–146.

4 Grosvenor, Bendor, 'A Rare Tudor Survival', *Art History News*, 15 March 2012. www.arthistorynews.com/articles/1149_A_rare_Tudor_survival

5 'Gregory Cromwell to his father, Dec 3 1539. Letters and Papers: December 1539, 1–5.' Letters and Papers, Foreign and Domestic, Henry VIII, Volume 14 Part 2, August–December 1539. Eds. James Gairdner, and R. H. Brodie. London: Her Majesty's Stationery Office, 1895. 226–233. *British History Online*, www.british-history.ac.uk/letters-papers-hen8/vol14/no2/pp226-233 accessed 25 August 2020.

6 'Letters and Papers: December 1539, 11–15.' *Letters and Papers, Foreign and Domestic, Henry VIII, Volume 14 Part 2, August–December 1539*. Eds. James Gairdner, and R. H. Brodie. London: Her Majesty's Stationery Office, 1895. 243–255. *British History Online*, www.british-history.ac.uk/letters-papers-hen8/vol14/no2/pp243-255.

7 'Letters and Papers: December 1539, 26–31.' Letters and Papers, Foreign and Domestic, Henry VIII, Volume 14 Part 2, August–December 1539. Eds. James Gairdner, and R. H. Brodie. London: Her Majesty's Stationery Office, 1895. 274–303. *British*

History Online, www.british-history.ac.uk/letters-papers-hen8/vol14/no2/pp274-303.

8 Weir, Alison, *Henry VIII: King and Court*, Random House, 2011, p. 437.

9 Ibid.

10 'Henry VIII: January 1540, 1–10.' Letters and Papers, Foreign and Domestic, Henry VIII, Volume 15, 1540. Eds. James Gairdner, and R. H. Brodie. London: Her Majesty's Stationery Office, 1896. 1–19. *British History Online*, www.british-history.ac.uk/letters-papers-hen8/vol15/pp1-19.

11 https://www.arthistorynews.com/entries_by_date/2011/December/2

12 Heather Darsie's work drew my attention to the portrait iof Anne of Cleves in the Rosenbach Museum, Philidelphia. Darsie, Heather, *Anna Duchesse of Cleves, The King's' Beloved Sister'*, Amberley Publishing, Stroud, 2019.

13 Farnese to Paul III 'Henry VIII: February 1540, 1–10.' Letters and Papers, Foreign and Domestic, Henry VIII, Volume 15, 1540. Eds. James Gairdner, and R. H. Brodie. London: Her Majesty's Stationery Office, 1896. 55–70. *British History Online*, www.british-history.ac.uk/letters-papers-hen8/vol15/pp55-70.

14 Weir, Alison, *Henry VIII: King and Court*, Vintage Books, Random House, London, 2011, p. 443.

15 'Henry VIII: June 1540, 1–10.' Letters and Papers, Foreign and Domestic, Henry VIII, Volume 15, 1540. Eds. James Gairdner, and R. H. Brodie. London: Her Majesty's Stationery Office, 1896. 349–364. *British History Online*, www.british-history.ac.uk/letters-papers-hen8/vol15/pp349-364.

16 Ibid.

17 'Henry VIII: July 1540, 21–31.' Letters and Papers, Foreign and Domestic, Henry VIII, Volume 15, 1540. Eds. James Gairdner, and R. H. Brodie. London: Her Majesty's Stationery Office, 1896. 445–481. *British History Online*, www.british-history.ac.uk/letters-papers-hen8/vol15/pp445-481.

18 Henry VIII: August 1540, 11–20.' Letters and Papers, Foreign and Domestic, Henry VIII, Volume 15, 1540. Eds. James Gairdner, and R. H. Brodie. London: Her Majesty's Stationery Office, 1896. 488–495. *British History Online*, www.british-history.ac.uk/letters-papers-hen8/vol15/pp488-495.

19 Ibid.

20 'Henry VIII: August 1540, 21–31.' Letters and Papers, Foreign and Domestic, Henry VIII, Volume 15, 1540.

Eds. James Gairdner, and R. H. Brodie. London: Her Majesty's Stationery Office, 1896. 495–510. *British History Online*, www.british-history.ac.uk/letters-papers-hen8/vol15/pp495-510.

21 'Henry VIII: July 1540, 1–10.' Letters and Papers, Foreign and Domestic, Henry VIII, Volume 15, 1540. Eds. James Gairdner, and R. H. Brodie. London: Her Majesty's Stationery Office, 1896. 412–436. *British History Online*, www.british-history.ac.uk/letters-papers-hen8/vol15/pp412-436.

18 Nonsuch

1 *History and antiquities of London*, Vol 3 Thomas Allen 1827, p. 82.

2 Schofield, John and Lea, Richard, *Holy Trinity Priory, City of London: An Archaeological Reconstruction and History*, MoLAS Monograph 24, London, 2005, p. 225.

3 Ibid.

4 'Henry VIII: August 1540, 11–20.' Letters and Papers, Foreign and Domestic, Henry VIII, Volume 15, 1540. Eds. James Gairdner, and R. H. Brodie. London: Her Majesty's Stationery Office, 1896. 488–495. *British History Online*, www.british-history.ac.uk/letters-papers-hen8/vol15/pp488-495.

5 Western Manuscripts, Stowe MS 554, [1542]–1684.

6 Black, W. H., *Discovery of the Will of Hans Holbein*, with remarks on the same by A. W. Franks, Esq., Director, Communicated to the Society of Antiquiarues in a letter to the Earl Stanhope, President. Nichols & Sons, London, 1863.

7 Eser Thomas, Holbeins Söhne: zur berufsstrategischen Alternative 'Goldsmeid oder Maler' in 16. Jahrhundert. In Brinkmann, Bodo, Schmid Wolfgang , *Hans Holbein und der wandel in der kunst des frühen 16. Jahrhundrets*. Turnhout, 2005, pp. 113–146.

8 Biddle, Martin, Nicholas Bellin of Modena, An Italian Artificer in the Courts of Francis I and Henry VIII *Journal of the British Archaeological Association*, 1966, vol 29, issue 1, pp. 106–121.

9 Surrey History Centre, Losely MSS, LM/1891

10 Byrne, Conor, *Katherine Howard, Henry VIII's Slandered Queen*, The History Press 2019, p. 130, 163–4.

11 'Henry VIII: August 1540, 1–10.' *Letters and Papers, Foreign and Domestic, Henry VIII, Volume 15, 1540.*

Eds. James Gairdner, and R. H. Brodie. London: Her Majesty's Stationery Office, 1896. 481–488. *British History Online*, www.british-history.ac.uk/letters-papers-hen8/vol15/pp481-488.

 l & P Aug 6 1540 Marillac to Anne de Montmorency.

12 Taylor, Andrew W. 'Between Surrey and Marot: Nicolas Bourbon and the Artful Translation of the Epigram.' *Translation and Literature*, vol. 15, no. 1, 2006, pp. 1–20. *JSTOR*, www.jstor.org/stable/40340022.

13 'Henry VIII: July 1543, 11–15.' Letters and Papers, Foreign and Domestic, Henry VIII, Volume 18 Part 1, January–July 1543. Eds. James Gairdner, and R. H. Brodie. London: Her Majesty's Stationery Office, 1901. 480–489. *British History Online*, www.british-history.ac.uk/letters-papers-hen8/vol18/no1/pp480-489.

14 Van Mander, Carel, *Dutch and Flemish Painters, Translation from the Schilderboeck*, Mcfarlane Warde Mafarlane, New York, 1936, p. 94.

SELECT BIBLIOGRAPHY

Below are some of the books and resources on Holbein, the Reformation and the Tudor court, which I have consulted and which represent a selection of further reading. Other more specialist publications and articles are cited in footnotes.

Bätschmann, Oskar and Pascal Griener, *Hans Holbein*, Revised and Expanded Second Edition, Reaktion Books, London, 2014

Bernard, George. W., *Anne Boleyn: Fatal Attractions*, Yale University Press, New Haven and London, 2011

Buck, Stephanie, *Hans Holbein: Masters of German Art*, Könemann, Cologne, 1999

Buck, Stephanie and Sander, Jochen, *Hans Holbein the Younger: Portraitist of the Renaissance*, Waanders Publishers, Zwolle, 2003

Bushart, B., Reinking, K. F., Reinhardt, H., *Hans Holbein de Ältere*, Augsburg, 1966

Butts, Barbara, Hendrix, Lee, and Wolf Scott, *Painting on Light: Drawings and Stained Glass in the Age of Dürer and Holbein*, J. P. Getty Trust, St. Louis Art Museum, Los Angeles, California and St Louis, Missouri, 2000

Chamberlain, Arthur, *Hans Holbein the Younger*, George Allen, London, 1913

Duffy, E., *The Stripping of the Altars: Traditional Religion in England 1400–1580*, Yale University Press, New Haven and London, 2005

Foister, Susan, *Holbein in England*, Tate Publishing, London, 2006

Foister, Susan, *Holbein and England*, Paul Mellon Centre for Studies in British Art, Yale University Press, New Haven and London, 2004

Foister, Susan, *Drawings by Holbein from the Royal Library, Windsor Castle*, Johnson Reprint co, Harcourt Brace Jovanovich, London and New York, 1983

Foister, Susan, Roy, Ashock and Wyld, Martin, *Making and Meaning in Holbein's Ambassadors*, National Gallery Publications, London, 1997

Ganz, Paul, *The Paintings of Hans Holbein*, Phaidon Press, London, 1956

Gerlo, Aloïs, *Erasme et ses portraitistes, Metsijs – Durer – Holbein*, B de Graaf, Nieuwkoop, 1969

Groebner, Valentin (translated by Pamela E. Selwyn), *Liquid Assets, Dangerous Gifts, Presents and Politics at the End of the Middle Ages*, University of Pennsylvania Press, 2002

Ives Eric, *The Life and Death of Anne Boleyn: 'The Most Happy'*, Blackwell, 2005

Jardine, Lisa, *Worldly Goods: A New History of the Renaissance*, Macmillan, London, 1996

Jecmen, Gregory, Spira, Freyda, *Imperial Augsburg: Renaissance Prints and Drawings 1475–1540*, National Gallery of Art, Ashgate, Lund Humphries, Washington, 2012

Krause, Katherina, *Hans Holbein der Ältere*, Deutscher Kunstverlag, Munich and Berlin, 2002

MacCulloch, Diarmaid, *Reformation: Europe's House Divided*, Penguin, London, 2004

MacCulloch, Diarmaid, *Thomas Cromwell: A Life*, Allen Lane, Penguin Random House, London, 2018

Van Mander, Carel, *Dutch and Flemish Painters*, Translation from the Schilderboeck, Mcfarlane Warde Mafarlane, New York, 1936

Marks, R., *Image and Devotion in Late Medieval England*, Sutton Publishing, Stroud, 2004

Massing, Michael, *Fatal Discord: Erasmus, Luther, and the Fight for the Western Mind*, Harper, 2018

Michael, Erika, *Hans Holbein the Younger: A Guide to Research*, Garland Publishing, New York and London, 1997

Müller, Christian and Kemperdick, Stephan *Hans Holbein the Younger: The Basel Years 1515–1532*, Prestel, Munich, Berlin, London, New York, 2006

North, John, *The Ambassadors' Secret*, Phoenix, London, 2004

Nuechterlein, Jean, *Translating Nature into Art: Holbein, the Reformation, and Renaissance Rhetoric*, Pennsylvania State University Press, 2011

Parker, K. T., *The Drawings of Hans Holbein in the collection of Her Majesty the Queen at Windsor Castle*, 2nd edition, appendix by S. Foister, London and New York, 1983

Roskill, Mark and Hand, John Oliver, *Hans Holbein: Paintings, Prints and Reception*, National Gallery of Art, Yale University Press, Washington, New Haven, 2001

Rowlands, John, *Holbein: The Paintings of Hans Holbein the Younger*, Phaidon, Oxford, 1985

Rowlands, John and Bartrum, Giulia, *The Age of Durer and Holbein: German Drawings 1400–1550*, British Museum Publications, 1988

Rublack, Ulinka, *Hans Holbein: The Dance of Death*, Penguin, 2016

Sebastiani, Valentina, *Johann Froben: Printer of Basel*, Library of the Written Word, Vol 65, Brill, 2008

Strong, Roy, *Holbein and Henry VIII*, Routledge & K. Paul for the Paul Mellon Foundation for British Art, 1967

Wandel, Lee Palmer, *Voracious Idols and Violent Hands: Iconoclasm in Reformation Zurich, Strasbourg and Basel*, Cambridge University Press, 2010

Weir, Alison, *Henry VIII: King and Court*, Vintage Books, Random House, London, 2011

Woltmann, Dr Alfred, *Holbein and His time*, Richard Bentley and Son, London, 1872

Websites

British History Online: Letters and Papers provides a wonderful account of daily life in Henry VIII's court:

www.british-history.ac.uk/search/series/letters-papers-hen8

The British Museum, the Royal Collection Trust and the Kunstmuseum in Basel all have excellent digital collections of their Holbein holdings. Between these three sources one can see the vast majority of Holbein's work:

www.britishmuseum.org/collection

http://sammlungonline.kunstmuseumbasel.ch/eMuseumPlus

www.rct.uk/collection/search#/page/1

The National Gallery meanwhile has good accounts of its important collection of Holbein piantings, including an important talk on *The Ambassadors* by Susan Foister:

www.nationalgallery.org.uk/paintings/hans-holbein-the-younger-the-ambassadors

LIST OF
ILLUSTRATIONS

[p.201]
Hans Holbein, Fragment of the mural from the east wall of the Meeting Hall of the Great Council in Basel Townhall, *Manius Curius Dentatus Refuses the Gifts of the Samnites: Three Heads of Envoys*, 1521–22, Kunstmuseum Basel. (Kunstmuseum Basel, Sammlung Online)

[pp.204–5]
Hans Holbein (copy after), *Design for dagger sheath featuring a Dance of Death*, c.1523, pen and brown ink, grey wash against black background, 5.7 × 28.7 cm, Kunstmuseum Basel. (Kunstmuseum Basel, Sammlung Online)

[p.208]
Hans Holbein, *Cartoon for a stained-glass window with Terminus*, 1525, pen in black, brush in grey, over pre-drawing chalk, washed in grey, with watercolours in places, 31.5 × 21 cm, Kunstmuseum Basel. (Kunstmuseum Basel, Sammlung Online)

[p.211]
Hans Holbein, *Erasmus*, 1523, oil on wood, 73.6 × 51.4 cm, on loan from the Longford Castle Collection, The National Gallery, London. (© Longford Castle Collection)

[p.212]
Hans Holbein, *Erasmus*, c.1523, oil on panel, 43 × 33 cm, The Louvre, Paris, (Photo © RMN-Grand Palais, Musée du Louvre / Michel Urtado)

[pp.219–221]
Woodcuts for *The Dance of Death*: Hans Holbein (design), Hans Lützelburger (block cut by): *The Doctor*, *The Rich Man/Miser* and *The Ploughman*, c.1526, The Cleveland Museum of Art, USA. (Gift of the Print Club of Cleveland)

[p.227]
Hans Holbein, *Jean de France, Duc de Berry* by Jean de Cambrai, 1523–24, black and coloured chalk on paper, 39.6 × 27.5 cm, Kunstmuseum Basel. (Kunstmuseum Basel, Sammlung Online)

[pp.232–3]
Hans Holbein, *Battle Scene*, c.1524, pen and some brush in black, washed in grey, on paper, 28.6 × 44.1 cm, Kunstmuseum Basel. (Kunstmuseum Basel, Sammlung Online)

[p.237]
Hans Holbein, *The Darmstadt Madonna*, 1526–8, oil on wood, 146.5 × 102 cm, Würth Collection, Johanniterkirche, Schwäbisch Hall, Germany. (© Hans Hinz – ARTOTHEK)

[p.238]
Hans Holbein, *Jeanne de Boulogne, Duchesse de Berry*, 1523–4, black and coloured chalk on paper, 39.6 × 27.5 cm, Kunstmuseum Basel. (Kunstmuseum Basel, Sammlung Online)

[p.245]
Hans Holbein, *Portrait of an Unidentified Woman*, c.1526, black and coloured chalk on paper, 40.5 × 29.2 cm, The Collection of Her Majesty the Queen at Windsor Castle, London. (Royal Collection Trust / © Her Majesty Queen Elizabeth II 2021)

[p.246]
Joos van Cleve, *Margarethe Boghe*, c.1518, oil on panel, 55.1 × 37.2 cm, National Gallery of Art, Washington D.C. (Ailsa Mellon Bruce Fund)

[p.255]
Hans Holbein, *Sir Thomas More*, 1527, oil on oak, 74.9 × 60.3 cm, The Frick Collection, New York. (Google Art Project)

[p.262]
Rowland Lockey, copy/adaptation of *Sir Thomas More and his Family* by Hans Holbein, 1592, oil on canvas, 249 × 343 cm, Nostell Priory, Yorkshire. (National Trust Photographic Library/ John Hammond / Bridgeman Images)

[pp.264–5]
Hans Holbein, *The Family of Sir Thomas More*, 1527, ink over a chalk sketch, on Japanese paper, 38.9 × 52.4 cm, Kunstmuseum Basel. (Kunstmuseum Basel, Sammlung Online)

[pp.280–1]
Hans Holbein (design for decoration), Royal Almain Armoury at Greenwich Palace (execution), Armour Garniture for Henry VIII, c.1527, The Metropolitan Museum of Art, New York. (Purchase, William H. Riggs Gift and Rogers Fund, 1919)

[p.288]
Hans Holbein, *William Warham*, 1527, oil on oak, 92 × 66 cm, The Louvre, Paris. (Photo © RMN-Grand Palais, Musée du Louvre / Tony Querrec)

[p.291]
Hans Holbein, *Lady Guildford*, 1527, black and coloured chalk on paper, 52.2 × 38.5 cm, Kunstmuseum Basel. (Kunstmuseum Basel, Sammlung Online)

[p.293]
Hans Holbein, *Mary, Lady Guildford*, 1527, oil on panel, 87 × 70.6 cm, Saint Louis Art Museum, Missouri. (Museum purchase)

[p.292]
Hans Holbein, *Sir Henry Guildford*, 1527, oil on oak, 82.7 × 66.4 cm, The Collection of Her Majesty the Queen, Hampton Court Palace. (Royal Collection Trust / © Her Majesty Queen Elizabeth II 2021)

[p.296]
Hans Holbein, *A Lady with a Squirrel and a Starling* (Anne Lovell?), c.1527, oil on oak, 56 × 38.8 cm, The National Gallery, London. (Google Art Project)

[p.298]
Jean Clouet, *The Dauphin*, 1524, oil on panel, 16 × 13 cm, Museum of Fine Arts, Antwerp. (© Lukas – Art in Flanders VZW / Bridgeman Images)

[p.298]
Jean Clouet, *Prince Henri*, 1524, oil on panel, 30 × 23 cm, Musée Condé, Chantilly, France. (© Musée Condé, Chantilly / Bridgeman Images)

[p.298]
Jean Clouet, *Francis, Dauphin of France*, c.1526, watercolour on vellum, 6.2 cm diameter, The Collection of Her Majesty the Queen at Windsor Castle. (Royal Collection Trust / © Her Majesty Queen Elizabeth II 2021)

[p.387]
Hans Holbein, *Courtly Couple* from the 'English Sketchbook', 1533–36, black ink over a chalk sketch, 2.5 × 4.5 cm, Kunstmuseum Basel. (Kunstmuseum Basel, Sammlung Online)

[p.388]
Hans Holbein, *Table ornament* from the 'English Sketchbook', 1533–36, black ink, over a chalk sketch, on Japanese paper, 26.5 × 12.4 cm, Kunstmuseum Basel. (Kunstmuseum Basel, Sammlung Online)

[p.389]
Hans Holbein, *Table ornament with caryatids* from the 'English Sketchbook', 1533–6, black ink, over a preliminary drawing of chalk, on paper, 17.1 × 10 cm, Kunstmuseum Basel. (Kunstmuseum Basel, Sammlung Online)

[p.393]
Hans Holbein, *Solomon and the Queen of Sheba*, c.1534, brown and grey wash, blue, red and green bodycolour, white heightening, gold, black ink over metalpoint on vellum, 22.9 × 18.3 cm, Collection of Her Majesty the Queen at Windsor Castle. (Royal Collection Trust / © Her Majesty Queen Elizabeth II 2021)

[p.399]
Hans Holbein, *Title page of the Coverdale Bible*, 1535, British Library. (© British Library Board. All Rights Reserved / Bridgeman Images)

[p.402]
Hans Holbein, *Charles de Solier*, 1534–5, oil on oak, 92.5 × 75.5 cm, Gemäldegalerie Alte Meister, Staatliche Kunstsammlungen, Dresden. (Google Art Project)

[p.412]
Hans Holbein, *Sir Nicholas Poyntz*, c.1533–43, black and coloured chalks, ink on pale pink prepared paper, 28.4 × 18.3 cm, Collection of Her Majesty the Queen at Windsor Castle. (Royal Collection Trust / © Her Majesty Queen Elizabeth II 2021)

[p.415]
Hans Holbein, *John Poyntz*, c.1532–43, black and coloured chalks, ink, on pale pink prepared paper, 29.5 × 23.3 cm, Collection of Her Majesty the Queen at Windsor Castle. (Royal Collection Trust / © Her Majesty Queen Elizabeth II 2021)

[p.416]
Hans Holbein, *Sir Charles Wingfield*, 1532–43, black and coloured chalks, ink, on pale pink prepared paper, 28.3 × 19.7 cm, Collection of Her Majesty the Queen at Windsor Castle. (Royal Collection Trust / © Her Majesty Queen Elizabeth II 2021)

[p.419]
Hans Holbein, *Jane Seymour*, 1536–7, oil on oak, 65.5 cm × 47 cm Kunsthistorisches Museum, Vienna. (Google Art Project)

[p.423]
Hans Holbein, *King Henry VIII* (cartoon for the Whitehall mural), 1536–37, ink and watercolour on paper, 257.8 × 137.2 cm, National Portrait Gallery, London. (© National Portrait Gallery, London)

[pp.424–5]
Remigius van Leemput, *Copy of the Whitehall Mural*, 1667, oil on canvas, Collection of Her Majesty the Queen, Hampton Court Palace. (Royal Collection Trust / © Her Majesty Queen Elizabeth II 2021)

[p.427]
Hans Holbein (school of), *Henry VIII*, 1543–7, oil on panel, 237.5 × 120.7 cm, Petworth House, West Sussex. (Bridgeman Images)

[p.428]
Hans Holbein (school of), *Henry VIII*, c.1537, oil on panel, 239 × 134.5 cm, Walker Gallery, National Museums Liverpool. (National Museums Liverpool)

[p.429]
Hans Holbein (school of), *Henry VIII*, after 1557, oil on panel, 217.2 × 123.2 cm, The Devonshire Collections, Chatsworth. (Reproduced by permission of Chatsworth Settlement Trustees / Bridgeman Images)

[p.443]
Hans Holbein, *Henry VIII of England*, c.1537, oil on panel, 28 × 20 cm, Museo Nacional Thyssen-Bornemisza, Madrid (© Museo Nacional Thyssen-Bornemisza, Madrid).

[p.444]
Hans Holbein, *Christina of Denmark, Duchess of Milan*, 1538, oil on oak, 179.1 × 82.6 cm, National Gallery, London. (Google Art Project)

[p.451]
Hans Holbein, *Antoine, Duke of Lorraine*, c.1543, oil on oak, 52.4 × 37.8 cm, Gemäldegalerie, Berlin. (bpk / Gemäldegalerie, SMB / Jörg P. Anders)

[p.465]
Hans Holbein, *Edward VI as a Child*, 1538, oil on panel, 56.8 × 44 cm, National Gallery of Art, Washington D.C. (Andrew W. Mellon Collection)

[p.466]
Hans Holbein, *Roundel portrait of Prince Edward* from the 'English Sketchbook', 1538, ink on paper, 5.1 cm diameter, Kunstmuseum, Basel. (Kunstmuseum Basel, Sammlung Online)

[p.472]
Hans Holbein, *Thomas Howard, 3rd Duke of Norfolk*, 1539, oil on panel, 80.1 × 61.4 cm, Collection of Her Majesty the Queen at Windsor Castle. (Royal Collection Trust / © Her Majesty Queen Elizabeth II 2021)

[pp.482–3]
Hans Holbein, design for woodcut, *Luther and the Pope*, published 1539, Magdalene College, Cambridge. (By permission of the Pepys Library, Magdalene College, Cambridge)

[p.485]
Hans Holbein, *Portrait of a Lady, probably a Member of the Cromwell Family*, 1534–40, oil on wood, 72.1 × 49.5 cm, Toledo Museum of Art, Ohio. (Gift of Edward Drummond Libbey)

[p.486]
Hans Holbein, *William Fitzwilliam, Earl of Southampton*, c.1536, black and coloured chalks, and metalpoint on pale pink prepared paper, 38.3 × 27 cm, Collection of Her Majesty the Queen at Windsor Castle. (Royal Collection Trust / © Her Majesty Queen Elizabeth II 2021)

[p.490]
Hans Holbein, *Henry VIII*, 1540, oil on panel, 88.5 × 74.5 cm, Gallerie Nazionali Barberini Corsini, Rome. (Bridgeman Images)

INDEX

An Apollo book
First published in the UK in 2021 by Head of Zeus Ltd

© Franny Moyle 2021

The moral right of Franny Moyle to be identified as the author of this work
has been asserted in accordance with the Copyright,
Designs and Patents Act of 1988.

All rights reserved. No part of this publication may be reproduced, stored
in a retrieval system, or transmitted in any form or by any means, electronic, mechanical,
photocopying, recording, or otherwise, without the prior permission of both
the copyright owner and the above publisher of this book.

The image credits on page 560 constitute an extension of this copyright page.
Every effort has been made to contact copyright holders for permission to reproduce material
in this book, both visual and textual. In the case of any inadvertent oversight,
the publishers will include an appropriate acknowledgement
in future editions of this book.

1 3 5 7 9 10 8 6 4 2

A CIP catalogue record for this book is available
from the British Library.

ISBN [HB] 9781788541213
ISBN [E] 9781788541206

Designed and typeset by Isambard Thomas at Corvo
Colour separation by DawkinsColour
Printed and bound in Wales by Gomer

Head of Zeus Ltd
5–8 Hardwick Street
London EC1R 4RG
www.headofzeus.com